Urnes Stave Church
and its
Global Romanesque Connections

Studies in the Visual Cultures of the Middle Ages
VOL. 18

Series Editor:
Kathryn A. Smith, New York University

Editorial Board:
Sharon E. J. Gerstel, University of California, Los Angeles
Adam S. Cohen, University of Toronto

Urnes Stave Church

and its Global Romanesque Connections

Edited by

Kirk Ambrose, Margrete Syrstad Andås, and Griffin Murray

BREPOLS

© 2021, Brepols Publishers n.v., Turnhout, Belgium.

All rights reserved. No part of this publication
may be reproduced, stored in a retrieval system, or
transmitted, in any form or by any means, electronic,
mechanical, photocopying, recording, or otherwise,
without the prior permission of the publisher.

ISBN 978-2-503-59451-4
D/2021/0095/294
Design and production: Blacker Design, East Grinstead,
West Sussex RH19 4LY, UK
Printed and bound in the EU on acid-free paper

FRONT COVER: Urnes stave church and the Lustrafjord.
Photo: Leif Anker, © Riksantikvaren.

BACK COVER: Capital depicting two beard-pullers and manticore,
Urnes. Photo and ©: Kjartan Hauglid.

Contents

Acknowledgments	7
Contributors and Editors	8
Introduction Kirk Ambrose, Margrete Syrstad Andås, and Griffin Murray	10
List of Illustrations	22
The Plates	27

Part One SITUATING URNES

CHAPTER 1 Urnes Stave Church: A Monument Frozen in Time? 114
Øystein Ekroll

CHAPTER 2 Urnes: Some Current Research Issues 142
Leif Anker

CHAPTER 3 The Landscape of Urnes: Settlement, Communication, and Resources in the Viking and Early Middle Ages 179
Birgit Maixner

Part Two THE ELEVENTH-CENTURY CHURCH

CHAPTER 4 The Decoration of Buildings in the North in the Late Viking Age: A Tale of Bilingualism, Code-Switching, and Diversity? 196
Margrete Syrstad Andås

CHAPTER 4A	Appendix: Alphabetical List of Fragments from Eleventh-Century Decorated Buildings in the North Margrete Syrstad Andås	229
CHAPTER 5	The European Significance of Urnes: An Insular Perspective on Urnes and the Urnes Style Griffin Murray	274
CHAPTER 6	"Who is this King of Glory?": The Religious and Political Context of the Urnes Portal and West Gable Margrete Syrstad Andås	304

Part 3: The Twelfth-Century Church

CHAPTER 7	Soft Architecture: Textiles in the Urnes Stave Church Ingrid Lunnan Nødseth	332
CHAPTER 8	Trueing the Capitals at Urnes Kirk Ambrose	356
CHAPTER 9	Norse Encounters with the Mediterranean and Near Eastern Worlds in the Capitals of Urnes Kjartan Hauglid	374
CHAPTER 10	Plants, Beasts, and a Barefoot Cleric Elizabeth den Hartog	398
CHAPTER 11	Monstrosity, Transformation and Conversion: The Program of the Urnes Capitals in Its European Context Thomas E. A. Dale	419

Bibliography	448
Index	474

Acknowledgments

THE EDITORS GRATEFULLY ACKNOWLEDGE the many generous contributions that made this volume possible. Funding for the site seminar at Urnes that resulted in the present publication was provided by UNESCO, the Norwegian University of Science and Technology (NTNU), and The Directorate for Cultural Heritage, Norway (Riksantikvaren). The NTNU provided funds for the new photography included in this book. The NTNU and the Eugene M. Kayden Award at the University of Colorado Boulder provided funding to assist with publication costs. Thanks are likewise due to the Fortidsminneforeningen (Society for the Preservation of Ancient Norwegian Monuments) for their unflagging support.

Several individuals generously lent their support and expertise to this publication. From the start, Kathryn Smith and Adam S. Cohen expressed enthusiasm for this project and offered invaluable feedback. Linda Safran's incomparable editorial skills improved the text immeasurably. Leif Anker offered assistance on multiple fronts, and Kjartan Hauglid's photographs of Urnes make a substantial contribution to our understanding of this remarkable building.

Contributors and Editors

Kirk Ambrose is professor of art history and founding faculty director of the Center for Teaching & Learning at the University of Colorado, Boulder. In addition to dozens of scholarly articles, book chapters, and reviews, he has published three books on Romanesque sculpture.

Margrete Syrstad Andås studied art, art history, theology, and liturgy at the universities of Oslo, St. Andrews, Yale, and Copenhagen, and she currently holds a postdoctoral research position in the Department of Arts and Media Studies at The Norwegian University of Science and Technology (NTNU). She has published dozens of articles on medieval art, architecture, iconography, and liturgy and was an editor of *The Medieval Cathedral of Trondheim: Architecture and Ritual Constructions in their European Context* (2007).

Leif Anker is an art historian (Cand.philol., University of Oslo, 2000). He is senior stave church and medieval buildings adviser at the Directorate for Cultural Heritage, Norway, and the author of *The Norwegian Stave Churches* (2005). Among his other works are several articles on stave church issues and an extensive article on the research history of stave church architecture (2016), which was also published in English.

Thomas Dale is professor of art history at the University of Wisconsin–Madison. His publications include *Relics, Prayer, and Politics in Medieval Venetia* (1997); with John Mitchell, *Shaping Sacred Space and Institutional Identity in Romanesque Mural Painting* (2004); *Pygmalion's Power: Romanesque Sculpture, The Senses, and Religious Experience* (2019); and articles in *Art Bulletin*, *Gesta*, and *Speculum*. His current research explores race in the art of medieval Venice.

Øystein Ekroll, Fellow of the Society of Antiquaries, received his MA (1986) from the University of Bergen and PhD (2015) from The Norwegian University of Science and Technology (NTNU), Trondheim, with a dissertation on "The Octagonal Shrine Chapel of St. Olav at Nidaros Cathedral." Since 1992 he has been cathedral archaeologist at the Nidaros Cathedral Restoration Workshop. He has published several books and over 100 papers and articles.

Elizabeth den Hartog is an associate professor at the Leiden University Centre for the Arts in Society in the Netherlands, specializing in medieval art and architecture in the Low Countries. Her special interest is in architectural sculpture. She has published *Romanesque Sculpture in Maastricht* (2002) for the Bonnefantenmuseum in Maastricht and has written several books on Gothic architectural sculpture for the Rijksdienst voor het Cultureel Erfgoed in Amersfoort.

Kjartan Hauglid is an art historian and researcher at NIKU, the Norwegian Institute for Cultural Heritage Research. He is writing his doctoral thesis on French Romanesque architectural sculpture and has published several articles on Norwegian medieval churches. His main publications in English are "Understanding Islamic Features in Norwegian Romanesque Architecture" (2019) and "A Deliberate Style: The Patronage of Early Romanesque Architecture in Norway" (2016). He also contributes to publications as a photographer and copyeditor.

Birgit Maixner obtained her PhD in archaeology in 2003 and was awarded a travel grant by the German Archaeological Institute in 2004/5. She is associate professor of archaeology and head of the archaeological and cultural-historical collections at the NTNU University Museum at the Norwegian University of Science and Technology (NTNU) in Trondheim. Her primary research interest is in the material culture and landscape archaeology of the Scandinavian Iron Age and Viking Age.

Griffin Murray, Fellow of the Society of Antiquaries, is a lecturer in archaeology at University College Cork, Ireland. Principally researching Insular metalwork (400–1200 CE) within its European context, he also works on Insular-Scandinavian relations, Viking art, and museum and antiquarian collections history. He completed his PhD in 2007 and is author of *The Cross of Cong: A Masterpiece of Medieval Irish Art* (2014) and of numerous articles published in journals and books.

Ingrid Lunnan Nødseth holds a postdoctoral position at the Department of Language and Literature, Norwegian University of Science and Technology (NTNU), where she investigates popular print culture in eighteenth-century Europe. Her PhD (2020) examined preserved liturgical vestments from the late medieval period across Scandinavia and explored the performative and rhetorical potential of cloth, arguing that textiles were fundamental to how the ecclesiastical space was experienced and perceived by laypeople and clerics in the medieval period.

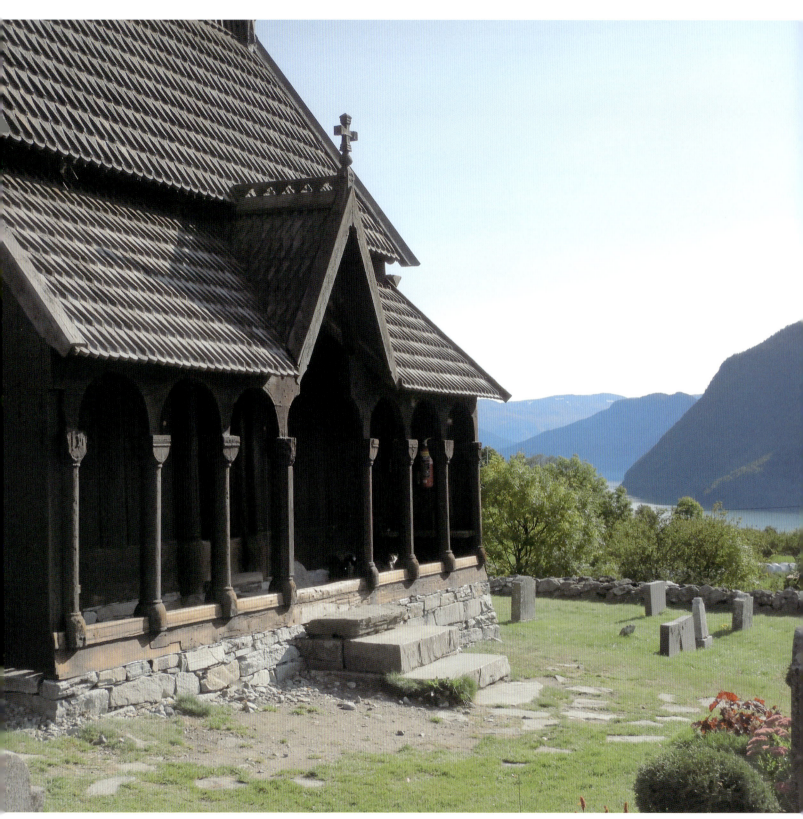
Pentice of Urnes church from northwest. Photo and © Kjartan Hauglid

Introduction

Kirk Ambrose, Margrete Syrstad Andås, and Griffin Murray

With its late Viking-age ornamentation,[1] Urnes is the oldest and best-known stave church in Norway. Yet despite its rich sculptural programs, complex building history, fine medieval furnishings, and UNESCO World Heritage status,[2] Urnes has attracted scant scholarly attention beyond Scandinavia.[3] Broadly speaking, scholarship to date has examined stave churches primarily through the lens of Nordic artistic traditions. Perhaps the most salient testimony to this approach can be found in the term "Urnes style," often used to designate the final phase of Viking art. Urnes has quite literally become synonymous with the arts of northern Europe. While in no way denying or diminishing the importance of local and regional traditions, this book examines Urnes, and stave churches more generally, from a global perspective, considering how this monument engaged with international developments from across Europe, the Mediterranean, and western Asia. In adopting this alternative approach, the essays collected here offer the most current research on Urnes, deliberately published in English to reach a broad audience. The aim is to reinvigorate academic interest in and debate on one of the most important churches in the world and in the rich artistic and architectural heritage of northern Europe.

Urnes Stave Church and Its Global Romanesque Connections grew out of a seminar held at Urnes from 22 to 25 September 2018, organized by Margrete Syrstad Andås with support from Riksantikvaren, the Norwegian University of Science and Technology (NTNU), and UNESCO.[4] Participants included archaeologists and art historians from France, Germany, Ireland, the Netherlands, Norway, and the United States. Many of the themes discussed *in nuce* over the course of that seminar appear in more developed form in the following pages. Not only do contributors pursue more traditional iconographic questions regarding the meaning of the Urnes-style imagery on the exterior and the Romanesque sculpture in the interior but they also interrogate questions of the global transmigration of motifs, how visual language developed, and the relationships among different media, as well as how and when the imagery of small-scale objects was transferred to architectural ornamentation. Additional topics include the plan, form, and use of stave churches from liturgical and social perspectives, the relationship between stone and wood as building materials, and the significance of Urnes as a source for the lost wooden religious architectural heritage of Europe.

Building in stone was central to ancient Roman culture, but with the demise of the western empire the significance of wood as a building material increased. Although stave churches have

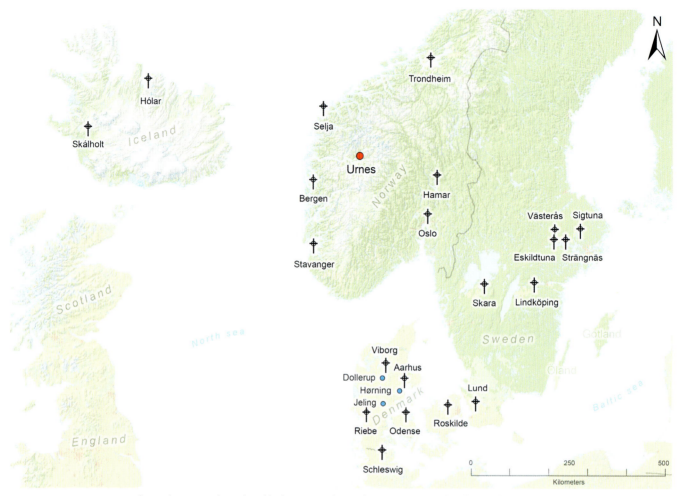

Fig. I.1. Map of Scandinavia, with medieval bishoprics and Danish sites mentioned in the book. Map: Magnar Mojaren Gran.

principally survived in Norway, along with one example in Sweden, excavations have shown that similar frame constructions with interior posts—whether these posts were set in the earth or rested on a stone still—also existed across northern Europe.[5] While most of these buildings are far from Urnes in time, place, and construction techniques, in all likelihood they evince some form of long-lasting tradition of decorated wooden buildings, now lost in most places except for remote sites by fjords and in the mountainous regions of Norway. Today, twenty-eight medieval examples survive in Norway largely intact.[6] If Urnes is the most lavishly decorated of these extant buildings, portals and other sculptures from a large number of medieval sites are preserved in collections in Bergen, Oslo, Trondheim, and elsewhere, many dating to the twelfth century and suggesting that richly decorated churches were common. From medieval Norway alone, 126 stave church portals are preserved; most of them postdate Urnes. Specific designs, like the Sogn-Valdres composition with confronted dragons spreading their wings and curling their bodies across jambs and lintels, would certainly benefit from cooperative scholarly endeavors like the present volume. New dendrochronological analyses and the study of contemporary material, such as manuscripts, may provide not only

INTRODUCTION

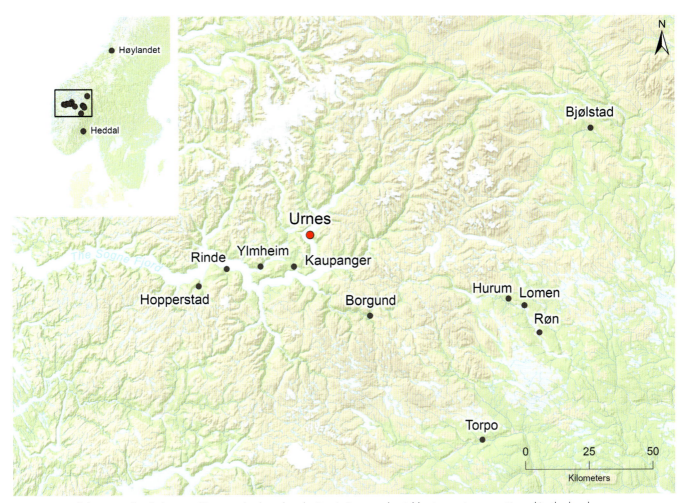

Fig. I.2. Map of the Sognefjord, showing Urnes and other church sites in Sogn and neighboring regions mentioned in the book. Hurum is also known as Høre. Map: Magnar Mojaren Gran.

new dates for the adoption of iconographic and formal motifs but also a better understanding of the interactions between Scandinavia and the Continent. Looking at the various elements from a shared European perspective, rather than focusing on the specific motifs as they were combined or coined in Scandinavia, would help move these magnificent pieces from the margins into the center of discussions on European art, where they properly belong.

As buildings, Urnes and its Norwegian relatives feature the use of posts to raise the central section of the roof, akin to a basilica. (Figs. I.3–I.5). Nancy L. Wicker has argued that throughout the Viking Age, when the Northmen settled in Normandy, Britain, Ireland, and Sicily, their art was formative rather than derivative, but with the twelfth century this changed.[7] With Christianization, the Church established itself as an organization, and with it new stylistic and iconographic impulses arrived. Yet in a region where stone never replaced wood as the main building material, the stave church, with its characteristic roofline, endured as a vibrant form of architecture.

Recent reinterpretation of a series of limited archaeological excavations at Urnes in the 1950s has revealed that the present church is the fourth on the spot, the last in a series of small wooden

structures of similar size (Fig. 2.12).[8] Reliable dendrochronological data developed in Scandinavia over the past two decades likewise provides specific dates for a range of monuments and fragments, a rarity in medieval art historical studies. These results have yet to be fully mined for their significance. With respect to Urnes, we now know that trees used for the third church (Urnes III) were felled in the winter of 1069–70 and carved immediately thereafter.[9] Elements from this structure that were incorporated into the fabric of the present church (Urnes IV) are the celebrated portal on the exterior of the north wall, two of the gables, a corner post, and some wall planks (Plates 1–12). Knud Krogh's recent reconstruction of the *c.*1070 church shows a building with an exterior largely covered with rich ornamental carvings (Fig. 6.1).[10] This permits a renewed discussion of what eleventh-century architecture might have looked like across the North.

Whereas previous studies typically dated much of the present church to the 1160s, dendrochronology dates this fourth church to 1131–32 (Plates 13–105).[11] The influence of Romanesque stone architecture is obvious in the interior, such as the use of arches (Plates 34–36), which here serve no structural purpose, and a series of elaborately carved cushion capitals with nearly fifty scenes commonly found in Continental buildings, including mythical and hybrid creatures, hunting motifs, lions in acrobatic positions, lilies, and vegetal motifs (Plates 39–95). This ensemble of twisting lions and coiling dragons, hybrids, bicorporates, and fantastic birds resonates with Bernard of Clairvaux's celebrated *Apologia*,[12] but it predates that text by almost a decade. The recent archaeological findings have shaped and informed the structure of the current volume.

The first section of the book, "Situating Urnes," places the church in its geographical, archaeological, historical, architectural, and art historical contexts. Norway's Ornes peninsula preserves one of the finest surviving medieval buildings in Scandinavia—the church traditionally spelled with a *U*, Urnes, in the scholarship—but its interior also contains important Renaissance features, especially in the choir. In the opening chapter, Øystein Ekroll examines the historiography of the church and the restoration works of the late nineteenth and early twentieth century. He demonstrates that its continued use as a church in recent times has preserved Urnes's post-Reformation interior and saved it from the heavy-handed "medievalizing" that befell some other Norwegian stave churches. Ekroll examines the evidence for both the medieval and the postmedieval interior, using a combination of archaeological, art historical, and historical analyses. Through this he charts the continued development of the interior and its changing liturgical use over nine centuries.

The next chapter, by Leif Anker, introduces the architecture of Urnes, its archaeology, and its complex building and construction history. He also examines the patronage of the church and the local economy using historical sources. Anker situates Urnes in its current research landscape, addressing the main theoretical questions with respect to its rich ornament and highlighting future avenues for research, some of which are dealt with in succeeding chapters. Anker also discusses Urnes in relation to other stave churches in the region, notably those at Kaupanger and Hopperstad (Figs. I.4–I.5), as well as other, demolished churches, and cautions that our interpretations rely on very fragmentary and fragile evidence.

The subjects of physical landscape, economy, and communication are discussed by Birgit Maixner. She uses archaeological, historical, and onomastic evidence to situate Ornes in its

Viking-age and medieval landscapes, arguing that the availability of natural resources and its location on one of Norway's major routeways, the Sognefjord (Figs. I.1–I.3), were critical for the local economy. Maixner challenges the modern perception of the Urnes church as being remote and proves its centrality in a landscape where, until the mid-twentieth century, boats were the principal form of transport. Maixner's study reminds us that what may be the most remote of locations today were not always that. At the end of the Viking Age and into the medieval period, fjords were the highways of the North; controlling them promised power and income. The political structure in Norway during the period discussed here was one of an itinerant court and king, and a large manorial estate like Ornes could be just as influential as any town in terms of adopting new ideas.[13] This was a global period in Scandinavian history, and, as discussed by Kjartan Hauglid in the third section, kings and lords traveled with their retinue to Byzantium, the Mediterranean, and the Holy Land as tradesmen, mercenaries, plunderers, and crusaders. As participants in international networks, these individuals must have established personal connections with European nobles and the religious elite. Such contacts would have affected the arrival and adoption of foreign influences in Norway. Most interpretive models imagine a handful of urban centers, such as Trondheim and Bergen, as the earliest adopters of foreign ideas that were subsequently diffused to the provinces.[14] Yet recent dendrochronology has demonstrated that stave churches date much earlier than previously thought,[15] which suggests that there was no discernible lag in

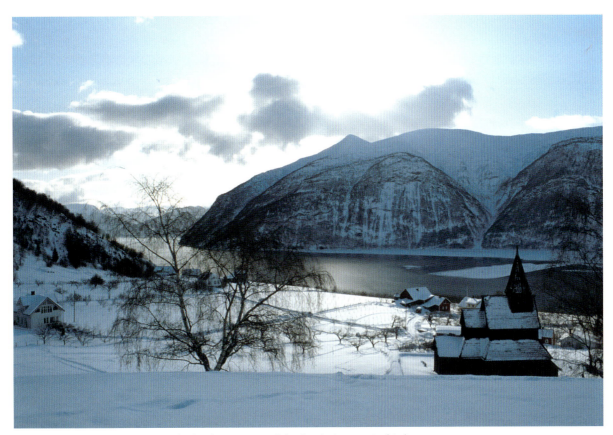

Fig. I.3. Urnes church as situated in the landscape, view of the fjord. Photo: © Leif Anker.

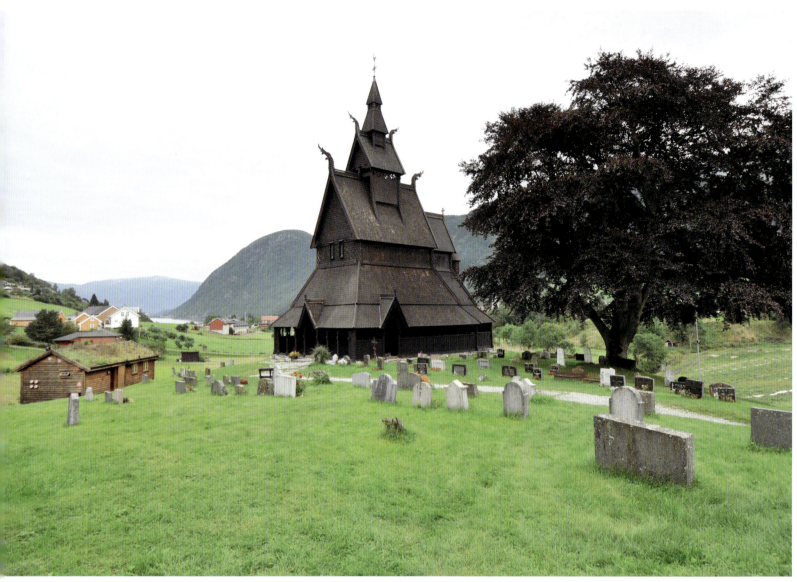

Fig. I.4. Hopperstad church, exterior from the southwest. Photo: © Leif Anker.

artistic developments between urban and rural contexts. Indeed, the provinces could be vibrant centers of innovation.

The remote region of Sogn is an apt example (Figs. I.1–I.2). Dendrochronology has shown that the neighboring stave churches of Urnes (Fig. I.3), Hopperstad (Fig. I.4), and Kaupanger (Fig. I.5) all date to the 1130s,[16] but they differ significantly in terms of style, iconography, and overall design. This demonstrates a greater diversity and tolerance for artistic experimentation than previously assumed. While it appears that the same hand may have worked on the Urnes capitals and the Hopperstad chancel portal,[17] the west portals, interiors, and ground plans of the two churches manifest completely different designs and solutions. Moreover, sometime in the first half of the eleventh century a stone church was erected at Hove, only a few hundred meters from Hopperstad. Three tiny communities along the same fjord in the same period thus display a variety of forms and influences, appropriating elements from contemporary English and Continental sculpture and manuscripts and combining them in various fashions.

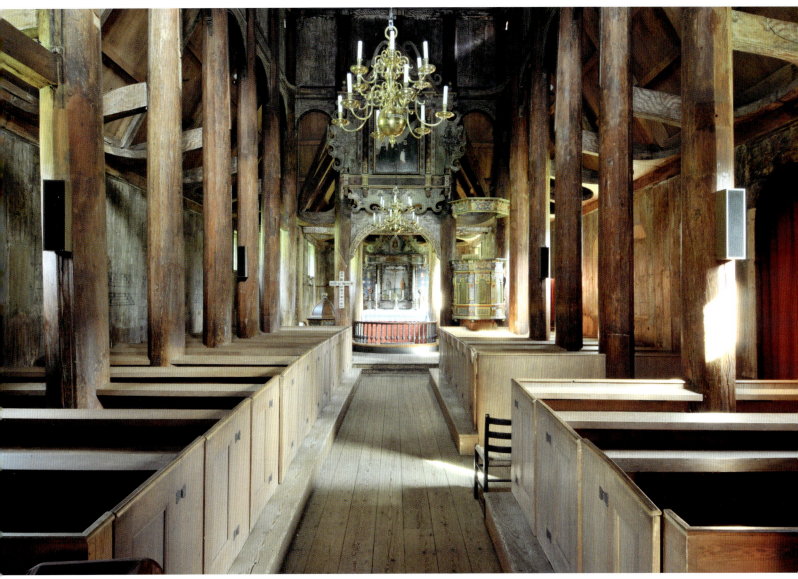

Fig. I.5. Kaupanger church interior, view toward the chancel. Photo: © Leif Anker.

The second part of this book, "The Eleventh-Century Church," examines the fragments from the third Urnes church. Andås contributes two chapters to this section. In her first essay she reviews the fragmentary remains of eleventh-century architectural decoration across the North. She applies recent dendrochronological studies as a corrective to stylistic analysis, and the picture that emerges is diverse. Although one portal with blossoming vegetation like that in Winchester manuscripts survives, and vine and rope ornaments occur toward the end of the century, most of the exterior fragments are dominated by Urnes-style loopwork. Several examples demonstrate how the ornamentation was draped across the surface with little regard to architectural form in a manner quite different from the Continental Roman heritage. The few remains of interior decoration feature compositional clarity, motifs of regeneration, and sacred figures. This indicates that the people of the North were visually bilingual, practicing a form of code-switching. The chapter is supplemented by an appendix with images and information about the different fragments and groups.

The broader European context of Norwegian stave churches is discussed by Griffin Murray, using

archaeological, art historical, and documentary evidence from Ireland. While the fragmentary nature of the evidence for timber churches makes it very difficult to assess whether Urnes was typical, evidence from the Insular world indicates that a number of features of the surviving stave churches were well established in northern Europe long before Norway was Christianized. Murray examines the major influence that the Urnes style exerted in Ireland, demonstrating its impact as one of the most important styles of northern Europe in the Middle Ages. He also questions whether timber churches with Urnes-style decoration existed in Ireland and discusses what the lost metalwork of the 1070s church might have looked like.

Andås's second chapter examines the exterior decoration of Urnes in the 1070s, taking a fresh approach to the old question of meaning. She traces motifs at Urnes back to the Danish royal site of Jelling and the Swedish runestones. Finally, she examines the eleventh-century liturgical context to illustrate how the choice of motifs was also compelling from a religious point of view.

The final section of the book, "The Twelfth-Century Church," considers the present church and focuses on its interior. Ingrid Lunnan Nødseth's chapter explores one of the most fragile aspects of the interior, which has been almost completely lost: its original wall hangings. She discusses the importance of textiles as a form of "soft architecture" and, using such sources as the fragmentary remains of medieval wall hangings and the placement of nails, demonstrates how the now bare wooden walls of Urnes and other stave churches were once richly and colorfully decorated. Furthermore, Nødseth emphasizes the performative role of these textiles in framing and enhancing the liturgical space.

In Romanesque architecture it is relatively rare to have a series of nearly fifty sculpted capital faces in mint condition and in situ (Plates 39–95). The ensemble at Urnes provides an opportunity to pose questions about the group as well as about individual motifs. The new photographs taken for this volume allows for a closer inspection of the various woodcarving techniques and of iconographic and formal features. Four essays on the capitals address the wider theological context of these motifs, their organizational system, how their meaning was communicated, and what they meant to the patron and his household. They also consider how a capital's location inside the building may have been meaningful in light of allegorical homilies that engage with various parts of a stave church.[18]

Kirk Ambrose applies the woodworking process of trueing, that is, modifying existing woodwork for a new context, to shed light on how artists created new forms through an iterative engagement with artistic traditions. He concludes that, over time, the decoration of Urnes increasingly aligned with Continental norms, a process that has parallels in the ecclesiastical history of Norway. Hauglid identifies among the capitals a number of motifs that have strong parallels in Islamic and Mediterranean art. Pointing to the extensive evidence for travel between Scandinavia and the Mediterranean as a likely mode of transmission, he suggests that these motifs could function both as subtle crusading propaganda and as manifestations of the international orientation of the church's patron. Elizabeth den Hartog examines the carved animals' strong parallels to pan-European exegetical traditions, particularly in bestiary manuscripts. In identifying a thematic coherence among the capitals that advances a moralizing and universalizing message, she suggests that there may have been an Augustinian influence, and even presence, in the design process. Finally, Thomas Dale focuses on the monsters and animal motifs carved throughout the nave.

Recognizing that these had broad currency in monumental arts across western Europe, he considers how the representational modes of these creatures align with pan-European notions of religious transformation and conversion.[19] Dale argues that these notions would have had particular salience for a local audience in view of the shape-shifting abilities (*berserkr*) ascribed to heroic warriors. In sum, these four very different approaches to the same set of carvings offer glimpses into the dense social significance that these works would have held.

All four essays on the Urnes capitals concur that these works merge elements of international Romanesque with local traditions. The quadruped and the sinuous animals or snakelike creatures of late Viking-age style were being abandoned and replaced by dragons and vegetal motifs, but familiar stylistic elements are maintained. The visual language of "Urnes Romanesque" is not unique to Urnes. Rather, it dominated the North from the late eleventh to the mid-twelfth century, reaching across Scandinavia, from the islands of the North Sea and Ireland in the west to the Baltic Sea and Gotland toward the east.[20]

The four iconographic studies of the capitals demonstrate that motifs in this period traveled fast and far. This challenges the notion that the early stave churches were remote from European culture. There was clearly an adoption of new motifs, the trueing of the Continental with the visual culture of the local past, yet this was not a matter of adopting random models. Instead, we see in twelfth-century Urnes what certainly looks like an in-depth understanding of foreign influences and an active appropriation of motifs. The scenes may at first glance appear familiar—indeed, many can be recognized from Bernard of Clairvaux's description of fierce lions, hunters, and hybrids with fish tails or multiple heads—but the execution is distinctly Scandinavian. The perception of the people of the North as mere recipients of foreign culture, which filtered into their art decades or generations after the same formal and iconographic elements appeared on the Continent, is fundamentally revised in this book.

Whether the fourth church at Urnes was a unique commission by a well-connected and well-traveled local lord or whether other churches that are no longer preserved had similar interiors filled with fantastic motifs from the pan-Romanesque vocabulary cannot be answered definitively at present. However, we can say that there is no material evidence to suggest a comparable sculptural program elsewhere. The way in which the Urnes capitals blend traditional features of Viking art with motifs appropriated from Romanesque art on the Continent has led to the application of the label "Urnes-Romanesque."[21] One might privilege the regional or local component of this hybrid term to identify a regional misprision of artistic developments from the Continent. Yet the present volume regards this hybridity in more positive terms, as evidence of a dynamic and active engagement with other cultures and as exemplifying the creativity of Northern artists and patrons.[22] Rather than seeing the fourth Urnes church as not fully Romanesque, this book underscores how it retained, reinvigorated, and reinterpreted local traditions through the lens of Continental developments. The marked internationalism, even cosmopolitanism, of twelfth-century Urnes is worth highlighting. The studies presented here shed light on how artists adopted motifs from international traditions and repurposed them to address the local context. If there is any suggestion of a lingua franca of eleventh- and twelfth-century art at Urnes in these pages, it is consistently spoken with a distinct dialect and with the concerns of a local community in mind.

Note

This book discusses Scandinavian material. The Scandinavian languages include several letters that do not occur in other European languages, including æ, ø, and å at the end of the Norwegian/Danish alphabets. The Swedish equivalent of æ is ä, and the Swedish ö is the Norwegian/Danish ø. The Swedish alphabet ends with å, ä, ö. The Icelandic letter á comes after the English a, ð after d, í after i, ó after o, and þ after y. Because Urnes is in Norway, the editors have elected to prioritize the Norwegian/Danish alphabet in cases of alphabetical conflict.

Notes

1. In art historical scholarship (such as Andås's two essays), 'late Viking Age' is used to describe the arts from the second half of the eleventh century, imagery dominated by zoomorphic designs and loopwork like that at Urnes, distinctly different from the Romanesque style of the period that followed. See David M. Wilson, "The Development of Viking Art," in *The Viking World*, ed. Stefan Brink with Neil Price (Abingdon, UK, 2008), 323–40, at 333–34. The common archaeological periodization (as applied in Maixner's essay) uses the same phrase to describe the period up to *c.*1050. In historical scholarship, the end of the Viking Age is considered to be *c.*1060–70, as discussed in Stefan Brink, "Who Were the Vikings?," in ibid., 4–7, at 5.

2. Inscribed on UNESCO's World Heritage List in 1979; https://whc.unesco.org/en/list/58/.

3. For an international perspective, see Evgeny Khodakovsky and Siri Skjold Lexau, eds., *Historical Wooden Architecture in Europe and Russia: Evidence, Study and Restoration* (Basel, 2015); and Claus Ahrens, *Die frühen Holzkirchen Europas* (Stuttgart, 2001). For the Scandinavian perspective, see Kristin Bakken, ed., *Preserving the Stave Churches: Craftsmanship and Research*, trans. Ingrid Greenhow and Glenn Ostling (Oslo, 2016); https://ugc.futurelearn.com/uploads/files/dc/18/dc189ac6-2fff-46d6-9aed-e1374c26431f/Preserving_the_stave_churches.pdf; Knud J. Krogh, *Urnesstilens kirke: Forgængeren for den nuværende kirke på Urnes* (Oslo, 2011); Håkon Christie, *Urnes stavkirke: Den nåværende kirken på Urnes* (Oslo, 2009); Leif Anker, *The Norwegian Stave Churches*, trans. Tim Challman (Oslo, 2005); and Erla Bergendahl Hohler, *Norwegian Stave Church Sculpture*, 2 vols. (Oslo, 1999). In this last title, see 1:334–41 for Urnes.

4. The full list of participants in the seminar comprised: Kirk Ambrose, University of Colorado Boulder, USA; Margrete Syrstad Andås, The Norwegian University of Science and Technology; Leif Anker, the Directorate for Cultural Heritage, Norway; Thomas Dale, University of Wisconsin-Madison, USA; Øystein Ekroll, Nidaros Cathedral Restoration Workshop, Norway; Elizabeth den Hartog, Leiden University, Netherlands; Kjartan Hauglid, The Norwegian Institute of Cultural Heritage, Oslo; Nathalie le Luel, Université Catholique de l'Ouest, Angers, France; Griffin Murray, University College Cork, Ireland; Ingrid Lunnan Nødseth, The Norwegian University of Science and Technology; and Stefanie Westphal, Herzog August Bibliothek, Wolfenbüttel, Germany. Birgit Maixner, The Norwegian University of Science and Technology, later joined the group.

5. Ahrens, *Die frühen Holzkirchen Europas*.

6. Fantoft, the twenty-ninth, was burned down as a result of arson on 6 June 1992. This church was originally from Fortun in Sogn and was moved and reerected in 1883. Chris Campion, "In the Face of Death," *The Guardian*, 20 February 2005. See also Benjamin J. Teitelbaum, *Lions of the North: Sounds of the New Nordic Radical Nationalism* (Oxford, 2017); and Anker, *Norwegian Stave Churches*. Another stave church was moved from Norway to Germany (now part of Poland) in the nineteenth century, and one more survives in Sweden.

7. Nancy L. Wicker, "Would There Have Been Gothic Art without the Vikings? The Contribution of Scandinavian Medieval Art," in "Confronting the Borders of Medieval Art," ed. Jill Caskey, Adam S. Cohen, and Linda Safran, special issue, *Medieval Encounters* 17.1–2 (2011): 198–229.

8. Krogh, *Urnesstilens kirke*.

9. Terje Thun et al., "Dendrochronology Brings New Life to the Stave Churches: Dating and Material Analysis," in Bakken, *Preserving the Stave Churches*, 91–116, at 107–9.

10. Krogh, *Urnesstilens kirke*.

11. Thun et al., "Dendrochronology Brings New Life to the Stave Churches," 105–6.

12. Bernard of Clairvaux, *Apologia*, 12:29: "Ceterum in claustris, coram legentibus fratribus, quid facit illa ridicula monstruositas, mira quaedam deformis formositas ac formosa deformitas? Quid ibi immundae simiae? Quid feri leones? Quid monstruosi centauri? Quid semihomines? Quid maculosae tigrides? Quid milites pugnantes? Quid venatores tubicinantes? Videas sub uno capite multa corpora, et rursus in uno corpore capita multa. Cernitur hinc in quadrupede cauda serpentis, illinc in pisce caput

quadrupedis. Ibi bestia praefert equum, capram trahens retro dimidiam; hic cornutum animal equum gestat posterius. Tam multa denique, tamque mira diversarum formarum apparet ubique varietas, ut magis legere libeat in marmoribus, quam in codicibus, totumque diem occupare singula ista mirando, quam in lege Dei meditando." "Apologia ad Guillelmum Abbatem Bernard of Clairvaux," in *Sancti Bernardi Opera*, ed. Jean Leclercq, C. H. Talbot, and Henri Rochais (Rome, 1957), 3:106. Trans. in Conrad Rudolph, *The "Things of Greater Importance": Bernard of Clairvaux's "Apologia" and the Medieval Attitude toward Art* (Philadelphia, 1990), 283: "But apart from this, in the cloisters, before the eyes of the brothers while they read— what is that ridiculous monstrosity doing, an amazing kind of deformed beauty and yet a beautiful deformity? What are the filthy apes doing there? The fierce lions? The monstrous centaurs? The creatures, part man and part beast? The striped tigers? The fighting soldiers? The hunters blowing horns? You may see many bodies under one head, and conversely many heads on one body. On one side the tail of a serpent is seen on a quadruped, on the other side the head of a quadruped is on the body of a fish. Over there an animal has a horse for the front half and a goat for the back; here a creature which is horned in front is equine behind. In short, everywhere so plentiful and astonishing a variety of contradictory forms is seen that one would rather read in the marble than in books, and spend the whole day wondering at every single one of them than in meditating on the law of God."

13 On the lords of Urnes as patrons of the church, see Margrethe C. Stang, "Luksus i Luster: Høgendeskirken Urnes," *Årbok: Foreningen til norske fortidsminnesmerkers bevaring* 171 (2017): 159–78, at 165, 175.

14 See, e.g., Martin Blindheim, *Norwegian Romanesque Decorative Sculpture, 1090–1210* (London, 1965); Hohler, *Norwegian Stave Church Sculpture*, 2:17–26 for an introduction to the debates, 2:63, 67, 73–83 for the use of such models.

15 See esp. the essays by Anker (17–22), Thun et al. (91–116), Anker (135–66), and Pedersen (167–90) in Bakken, *Preserving the Stave Churches*.

16 Thun et al., "Dendrochronology Brings New Life to the Stave Churches," 91–97 on the methodology.

17 Kjartan Hauglid, unpublished observation.

18 "In dedicatione tempeli sermo" and "In dedicatione ecclesie, sermo ad populum," in *Gamalnorsk homiliebok: Cod. AM. 619 4°*, ed. Gustav Indrebø (Oslo, 1966), 95–100.

19 Late conversion is commonly defined in recent scholarship as *c.*1020–1150. On the conversion, as both moments and as a lengthy structural process, see Ildar Garipzanov, ed., with Rosalind Bonté, *Conversion and Identity in the Viking Age* (Turnhout, 2014); and Sæbjørg Walaker Nordeide, *The Viking Age as a Period of Religious Transformation: The Christianization of Norway from AD 560–1150/1200* (Turnhout, 2011).

20 Signe Horn Fuglesang, "Stylistic Groups in Late Viking and Early Romanesque Art," *Acta ad archaeologiam et artium historiam pertinentia* 8.1 (1981): 79–125.

21 Ibid., 96–117; and James Graham-Campbell, *Viking Art* (London, 2013), 187.

22 Wicker, "Would There Have Been Gothic Art without the Vikings?"

List of Illustrations

PLATES

All plates are by Kjartan Hauglid unless indicated otherwise.

THE REUSED MATERIALS FROM THE 1070s

Plate 1 Reused materials on the north exterior wall of the nave and chancel. Photo: Leif Anker © Riksantikvaren, Directorate for Cultural Heritage, Norway
Plate 2 Portal and two decorated wall planks
Plate 3 Portal
Plate 4 Detail of portal, upper center
Plate 5 Detail of portal, upper center. Photo: Leif Anker, © Riksantikvaren, Directorate for Cultural Heritage, Norway
Plate 6 Detail of portal, oblique view of upper center. Photo: Leif Anker, © Riksantikvaren, Directorate for Cultural Heritage, Norway
Plate 7 Detail of portal, upper right
Plate 8 Detail of portal left jamb. Photo and © Leif Anker.
Plate 9 Detail of relief carving on wall plank, north wall exterior. Photo and © Leif Anker.
Plate 10 Corner post on north wall exterior. Photo: Birger Lindstad, © Riksantikvaren.
Plate 11 East gable. Photo: Birger Linstad and Joppe Christensen in cooperation with Knud J. Krogh, © Riksantikvaren, Directorate for Cultural Heritage, Norway
Plate 12 West gable

EXTERIOR

Plate 13 Exterior view from west
Plate 14 Exterior view from southwest
Plate 15 Exterior view from southeast
Plate 16 Exterior view from northeast. Photo and © by Thomas E.A. Dale
Plate 17 Exterior view from northwest. Photo and © by Thomas E.A. Dale
Plate 18 Detail of roof and openings
Plate 19 Column base, north exterior wall
Plate 20 Grave slab with cross

PENTICE

Plate 21 Pentice from northwest
Plate 22 Pentice from southwest
Plate 23 Pentice detail
Plate 24 Detail of pentice base
Plate 25 Detail of pentice capital
Plate 26 Detail of pentice capital
Plate 27 Detail of pentice capital
Plate 28 Detail of Pentice capital
Plate 29 West portal

INTERIOR

Plate 30 Interior from west
Plate 31 Interior from southwest corner
Plate 32 Interior from east
Plate 33 Chancel from west
Plate 34 North arcade of nave
Plate 35 Nave from east
Plate 36 Nave arcade. Inserted arches with added moldings
Plate 37 Nave, port holes / light openings

CAPITALS

Plate 38 Schematic plan of capitals
Plate 39 Cap. 1N Winged dragon (damaged)
Plate 40 Cap. 1S Winged dragon (damaged)
Plate 41 Cap. 1W Winged dragon (damaged)
Plate 42 Cap. 2N Lion biting tail
Plate 43 Cap. 2E Lion with knotted tongue
Plate 44 Cap. 2S Aquiline Bird
Plate 45 Cap. 3E Man on horseback holding spear
Plate 46 Cap. 3S Stag pierced by spear, dog
Plate 47 Cap. 3N Camel (slightly damaged)
Plate 48 Cap. 4E Vegetal tendrils
Plate 49 Cap. 4S Vegetal tendrils

LIST OF ILLUSTRATIONS

Plate 50 Cap. 5N Uncarved
Plate 51 Cap. 5E Currently obscured. Winged lion. Drawing by Edda Distler. From Distler, *Stavkirkernes billedsprog.*
Plate 52 Cap. 5S Contorted lion
Plate 53 Cap. 5W Two-headed lion
Plate 54 Cap. 6E Contorted lion
Plate 55 Cap. 6S Aquiline Bird
Plate 56 Cap. 6W Lion
Plate 57 Cap. 7E Winged dragon
Plate 58 Cap. 7S Winged dragon
Plate 59 Cap. 7W Winged dragon
Plate 60 Cap. 8E Lion with knotted tongue
Plate 61 Cap. 8S Lion with aquiline head
Plate 62 Cap. 8W Lion
Plate 63 Cap. 9S Mask spewing vegetal tendrils
Plate 64 Cap. 9W Mask spewing vegetal tendrils
Plate 65 Cap. 10N Lion
Plate 66 Cap. 10S Lion spewing a winged dragon
Plate 67 Cap. 10W Feet and tail of a lion, dragon or bird
Plate 68 Cap. 11N Aquiline bird with human leg dangling from beak
Plate 69 Cap. 11W Two addorsed aquiline birds
Plate 70 Cap. 11S Lion
Plate 71 Cap. 12E Lion
Plate 72 Cap. 12S Lion biting own neck
Plate 73 Cap. 12W Lion biting own neck
Plate 74 Cap. 13N Mask spewing vegetal tendrils
Plate 75 Cap. 13W Mask spewing vegetal tendrils
Plate 76 Cap. 14N Hybrid creature holding ax
Plate 77 Cap. 14E Two beard-pullers
Plate 78 Cap. 14W Lion
Plate 79 Cap. 15N Man wrestling lion
Plate 80 Cap. 15E Addorsed lions
Plate 81 Cap. 15W Lion and vegetal tendril hybrid
Plate 82 Cap. 16N Contorted lion
Plate 83 Cap. 16E Contorted lion
Plate 84 Cap. 16W Contorted lion
Plate 85 Cap. 17N Cleric holding crosier
Plate 86 Cap. 17E Currently obscured. Acrobat with swords, drawing by Edda Distler. From Distler, *Stavkirkernes billedsprog.*
Plate 87 Cap. 17W Centaur holding sword and shield
Plate 88 Cap. 18N Vegetal tendrils
Plate 89 Cap. 18E Vegetal tendrils (damaged)
Plate 90 Cap. 19N Lion with extended neck (damaged)
Plate 91 Cap. 19S Lion (?) (damaged)
Plate 92 Cap. 19W Uncarved
Plate 93 Cap. 20N Winged dragon (damaged)
Plate 94 Cap. 20S Winged dragon (damaged)
Plate 95 Cap. 20W Winged dragon (damaged)

ABATEMENTS

Plate 96 Abatement I
Plate 97 Abatement II
Plate 98 Abatement III
Plate 99 Abatement IV
Plate 100 Abatement V
Plate 101 Abatement VI
Plate 102 Abatement VII
Plate 103 Abatement VIII
Plate 104 Abatement IX
Plate 105 Abatement X

FURNISHINGS

Plate 106 Crucifixion group
Plate 107 Crucifixion group, detail of Christ
Plate 108 Crucifixion group, detail of Mary
Plate 109 Crucifixion group, detail of John
Plate 110 Candle holder in form of ship. Photo: Jiri Havran, © Fortidsminneforeningen
Plate 111 Limoges candle holders. Photo: Jiri Havran, © Fortidsminneforeningen
Plate 112 Medieval chair
Plate 113 Baptismal font cover

POST MEDIEVAL CHANCEL AND FURNISHINGS

Plate 114 The altar retable of 1699, donated by the minister Jens Ørbech and his fiancée
Plate 115 Painting of the apostles from 1607 on the chancel walls
Plate 116 Roof of chancel. Detail
Plate 117 1697 pulpit
Plate 118 Post-medieval private pew
Plate 119 Post-medieval door in the nave
Plate 120 Post-medieval baptismal font enclosure
Plate 121 The Catechism retable, dated 1610
Plate 122 The brass baptismal dish, donated in 1640
Plate 123 Altar. Presumably rebuilt *c.*1600 reusing the medieval altar stones
Plate 124 The Heavenly Jerusalem, painting, donated 1663
Plate 125 Christ's Way to Golgotha, painting, donated 1678
Plate 126 The Crucifixion, painting, donated 1688

CHAPTER FIGURES

INTRODUCTION

Fig. I.1. Map of Scandinavia, with medieval bishoprics and Danish sites
Fig. I.2. Map of the Sognefjord, showing Urnes and other church sites
Fig. I.3. Urnes stave church in the landscape
Fig. I.4. Hopperstad (Norway) church
Fig. I.5. Kaupanger (Norway) church

CHAPTER ONE

Fig. 1.1. Plan of Urnes church, 1836, drawing by F. Schiertz
Fig. 1.2. Urnes church, north side, 1836, drawing by F. Schiertz
Fig. 1.3. Urnes church, section and interior toward the east, 1836, drawing by F. Schiertz
Fig. 1.4. Urnes church decorated corner post and two wall planks, 1836, drawing by F. Schiertz
Fig. 1.5. Urnes church, three nave capitals, 1836, drawing by F. Schiertz
Fig. 1.6. Urnes church, north portal, 1836, drawing by F. Schiertz
Fig. 1.7. Urnes church, plan, longitudinal and nave sections, 1854, drawing by G. A. Bull
Fig. 1.8. Urnes church, north portal, chancel section, pentice, and details, 1854, drawing by G. A. Bull
Fig. 1.9. Urnes church, nave capitals and abatements, 1854, drawing by G. A. Bull
Fig. 1.10. Urnes church, nave capitals, 1854, drawing by G. A. Bull
Fig. 1.11. Urnes church *c.* 1890, still looking as it did in 1823
Fig. 1.12. Urnes church, late medieval church bell, 1894, drawing by P. A. Blix
Fig. 1.13. Urnes church, reconstruction of side-altar traces in the nave, drawing by Håkon Christie
Fig. 1.14. Roof of a medieval tabernacle model

CHAPTER TWO

Fig. 2.1. View of Urnes church and Ornes promontory
Fig. 2.2. Urnes church, drawing of nave construction
Fig. 2.3. Urnes church, west exterior drawing with reused parts
Fig. 2.4. Urnes church, east exterior drawing with reused parts
Fig. 2.5. Urnes church, north exterior drawing with reused parts
Fig. 2.6. Urnes church, south exterior drawing
Fig. 2.7. Urnes church, ground plan with remains of different phases
Fig. 2.8. Urnes church, interior of nave looking north, drawing
Fig. 2.9. Urnes church, interior of nave looking east, drawing
Fig. 2.10. Urnes church, interior of nave looking west, drawing
Fig. 2.11. Urnes church, interior of chancel looking east, drawing
Fig. 2.12. Urnes church, plan showing excavated post-holes and medieval graves
Fig. 2.13. Urnes church, reconstruction drawing of original context of carved planks
Fig. 2.14. Urnes church, reconstruction drawing of connection between wall plank and corner post
Fig. 2.15. Urnes, reconstruction drawing of west facade of 1070s church
Fig. 2.16. Urnes church, drawing of former sills and reconstructed west wall
Fig. 2.17. Urnes church, reconstruction drawing of west gable
Fig. 2.18. Urnes church, schematic drawing of chancel gable with reused panels

CHAPTER THREE

Fig. 3.1. Map of the inner Sognefjord
Fig. 3.2. The inner Sognefjord, map of Viking-age graves and medieval churches
Fig. 3.3. The inner Sognefjord, map of place-names indicating trade
Fig. 3.4. The inner Sognefjord, map of nonmonetary Viking-age hoards and Insular metal objects
Fig. 3.5. The inner Sognefjord, map of single finds and hoards of iron ingots
Fig. 3.6. The inner Sognefjord, map of soapstone artefacts, deposits, quarries, and related place-names

CHAPTER FOUR

Fig. 4.1. Map of sites with decorated eleventh-century architectural fragments
Fig. 4.2. Kvikne (Norway) church fragments, drawing
Fig. 4.3. Development of stylistic details in eleventh-century carvings
Fig. 4.4. Bowl from Lilla Valla (Gotland, Sweden)
Fig. 4.5. Hemse (Gotland, Sweden) church portal

LIST OF ILLUSTRATIONS

Fig. 4.6. Hopperstad (Norway) church, west portal, drawing by P. A. Blix
Fig. 4.7. Lisbjerg (Denmark) altar panel
Fig. 4.8. Urnes, detail of door leaf from third church. Photo and © by Thomas E.A. Dale
Fig. 4.9. Trondheim (Norway) fragment
Fig. 4.10. Rødven church (Norway), details of portal
Fig. 4.11. Sacramentary of Robert of Jumièges (England), Nativity and the Flight into Egypt
Fig. 4.12. Benedictional of Æthelwold (England), Entry into Jerusalem

CHAPTER FOUR APPENDIX

Fig. 4A.1. Bjarnastaðahlíð (Iceland) panels
Fig. 4A.2. Bjølstad (Norway) jambs, drawing
Fig. 4A.3. Brågarp (Sweden), lintel fragment
Fig. 4A.4. Eke, Gotland (Sweden) fragments, drawing of incised decoration
Fig. 4A.5. Flatatunga (Iceland) panels
Fig. 4A.6. Gaulverjabæ (Iceland) plank
Fig. 4A.7. Glanshammar (Sweden) planks, drawing
Fig. 4A.8. Hadseløy (Norway) plank
Fig. 4A.9. Hammarby (Sweden) planks
Fig. 4A.10. Hopperstad (Norway), drawing of corner-post fragments
Fig. 4A.11. Hólar (Iceland) plank
Fig. 4A.12. Humptrup (Germany) wall-plates
Fig. 4A.13. Hørning (Denmark) painted wall-plate, (a) exterior and (b) interior
Fig. 4A.14. Kvikne (Norway) plank, drawing of incised quadruped
Fig. 4A.15. Mosjö (Sweden) planks, drawing by E. Ekhoff
Fig. 4A.16. Myresjö (Sweden) planks
Fig. 4A.17. Möðrufell (Iceland) panels
Fig. 4A.18. Novgorod (Russia) half-columns
Fig. 4A.19. Rinde (Norway) fragment
Fig. 4A.20. Rødven (Norway) jamb planks
Fig. 4A.21. Torpo (Norway) jamb fragment
Fig. 4A.22. Trondheim (Norway) jamb fragment
Fig. 4A.23. Vrigstad (Sweden) fragments

CHAPTER FIVE

Fig. 5.1. Map of Ireland with sites mentioned in the text
Fig. 5.2. Book of Kells, Temple of Jerusalem
Fig. 5.3. Finial from an early stone church, Church Island (Ireland)
Fig. 5.4. Carved animal head, Dublin
Fig. 5.5. Plank fragment in Ringerike style, Dublin
Fig. 5.6. Shrine of St Patrick's bell (Ireland)
Fig. 5.7. Mounts from Dollerup church, near Viborg (Denmark)
Fig. 5.8. Bearnán Chúláin bell shrine, from Glenkeen (Ireland)
Fig. 5.9. Trial piece with Hiberno-Urnes ornament, from Killaloe (Ireland)
Fig. 5.10. Fragment of stone cross with runic inscription, Killaloe (Ireland)
Fig. 5.11. Stone fragment from Donaghenry (Ireland)
Fig. 5.12. Sarcophagus at Cashel (Ireland)
Fig. 5.13. Shrine of St. Manchan, from Lemanaghan (Ireland)

CHAPTER SIX

Fig. 6.1. Urnes church, reconstruction and west facade, c.1070
Fig. 6.2. Jelling (Denmark), runestone of Haraldr blátǫnn Gormsson, quadruped with serpent
Fig. 6.3. Jelling (Denmark), runestone of Haraldr blátǫnn Gormsson, Christ
Fig. 6.4. Jelling (Denmark), runestone of Haraldr blátǫnn Gormsson, text
Fig. 6.5. Näle (Sweden), U 248 runestone, quadruped with serpent
Fig. 6.6. Mällösa (Sweden), U 244 runestone, quadruped with serpent
Fig. 6.7. Källunge (Gotland, Sweden) standard ("weather-vane"), quadruped with serpent
Fig. 6.8. Urnes, c. 1070 church, drawing of remains of consecration crosses
Fig. 6.9. Urnes, c. 1070 church, drawing of west gable
Fig. 6.10. Tierp church (Sweden), U 1144 runestone, quadrupeds (lambs) adoring the cross
Fig. 6.11. Urnes-style brooch, Sør-Fron vicarage (Norway), winged dragon
Fig. 6.12. Jevington (England), stone relief, Christ treading on beasts

CHAPTER SEVEN

Fig. 7.1. Gokstad (Norway) ship burial, tent boards
Fig. 7.2. Överhögdal (Sweden) tapestries
Fig. 7.3. Høylandet (Norway) embroidery, detail
Fig. 7.4. Hopperstad (Norway), church interior with textiles, drawing by P. A. Blix
Fig. 7.5. Urnes church, iron hooks
Fig. 7.6 Røn (Norway), embroidery and detail
Fig. 7.7. Urnes church, fragment of "Signe's Weave"
Fig. 7.8. Uvdal church (Norway), painted linen fragments

Fig. 7.9. Kaupanger church (Norway), painted linen fragment

CHAPTER EIGHT

Fig. 8.1. Oseberg (Norway) ship burial, animal head
Fig. 8.2. St. Menas ampulla, Egypt
Fig. 8.3. Jelling church (Denmark), fresco with John the Baptist preaching to the Jews
Fig. 8.4. Råsted church (Denmark), detail of fresco with Adoration of the Magi
Fig. 8.5. Stavanger Cathedral (Norway), capital with manticore

CHAPTER NINE

Fig. 9.1. Eagle silk, from shrine of St. Knútr, Odense Cathedral (Denmark)
Fig. 9.2. Borradaile oliphant, from southern Italy or Sicily
Fig. 9.3. San Baudelio de Berlanga (Spain), fresco with camel and beast roundels
Fig. 9.4. Roda Bible (Catalonia), musicians and acrobats
Fig. 9.5. New Testament from Bury St. Edmonds (England), Salome dancing
Fig. 9.6. Prayers and Meditations of St. Anselm (England), Salome dancing
Fig. 9.7. Josephus manuscript from Christ Church, Canterbury (England), beard pullers with snakes and dragons
Fig. 9.8. Saint-Sever Beatus (France), beard pullers
Fig. 9.9. Roda Bible (Catalonia), animals in Nebuchadnezzar's dream
Fig. 9.10. Roda Bible (Catalonia), winged dragons in Mardochai's dream

CHAPTER TEN

Fig. 10.1. Hopperstad (Norway) church, cushion capital in nave
Fig. 10.2. Hildesheim (Germany), St. Michael, cushion capital in transept
Fig. 10.3a–b. Stylistic comparison, (a) Urnes church, pentice capital; (b) Hyde Abbey (England), cloister capital
Fig. 10.4a–b. Lions, (a) Urnes church, drawing of graffito in the nave; (b) Urnes church, nave capital with somersaulting lion
Fig. 10.5. The Old Norse *Physiologus B* (Iceland), kite

CHAPTER ELEVEN

Fig. 11.1. Ramsey Psalter (England), *Beatus vir* initial
Fig. 11.2. Jelling (Denmark), runestone of Haraldr blátǫnn Gormsson, Christ
Fig. 11.3. Bestiary (England), stag and serpent
Fig. 11.4. Vézelay (France), Sainte-Marie-Madeleine, nave capital with St. Eustace hunting
Fig. 11.5. Silos (Spain), Santo Domingo, cloister capital with beard pullers
Fig. 11.6. Bonn (Germany), St. Martin, cloister capital with lion and griffin
Fig. 11.7. Saint-Michel-de-Cuxa (France), cloister capital with double-bodied lions
Fig. 11.8. Bestiary (England), manticore
Fig. 11.9. The Old Norse *Physiologus B* (Iceland), centaur
Fig. 11.10. Västerplana (Gotland, Sweden) font

REUSED MATERIALS | PLATE 2

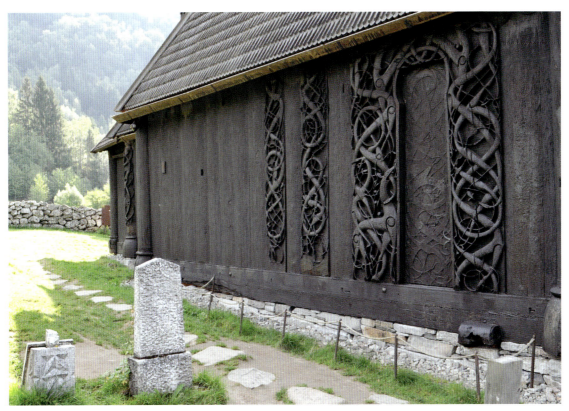

Plate 1. Reused materials on the north exterior wall of the nave and chancel. Photo: Leif Anker © Riksantikvaren, Directorate for Cultural Heritage, Norway

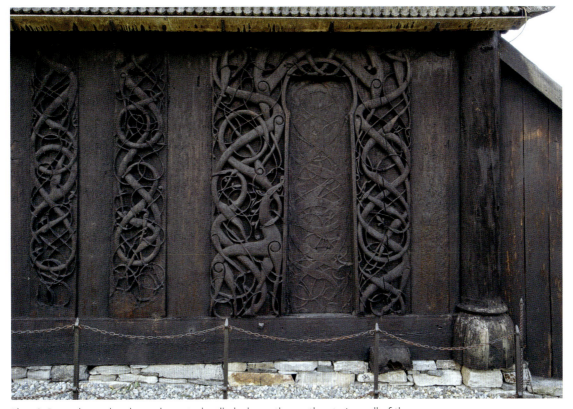

Plate 2. Reused portal and two decorated wall planks on the north exterior wall of the nave

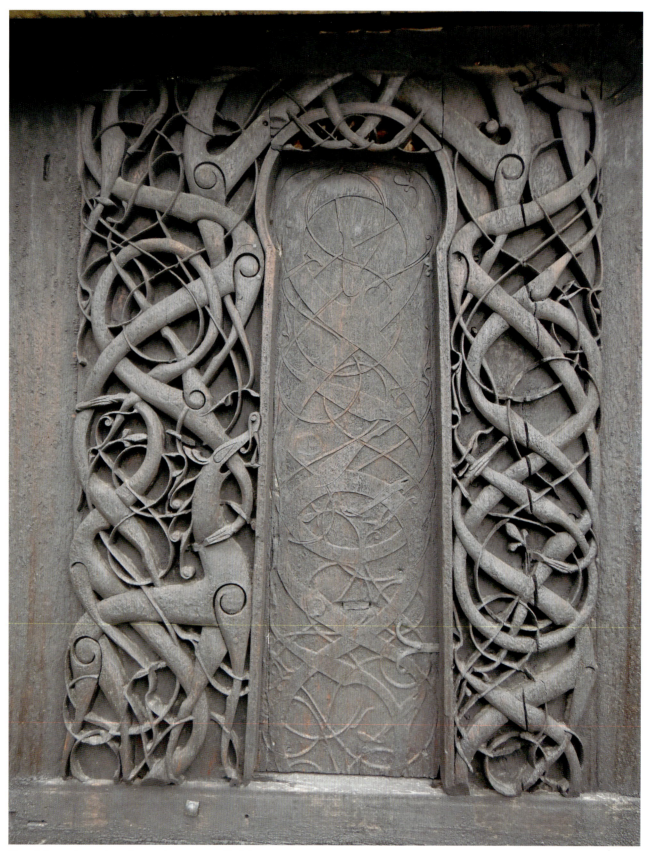

Plate 3. Reused portal on the north exterior wall of the nave

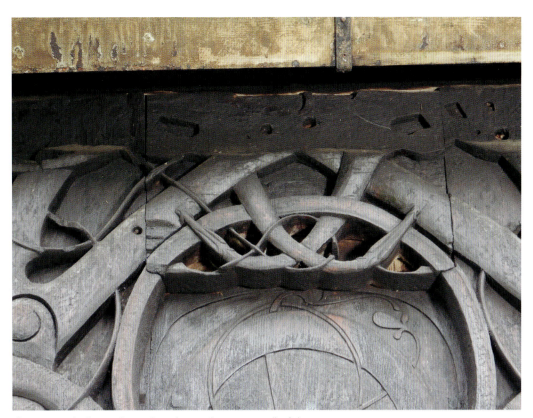

Plate 4. Detail of reused portal on the north exterior wall of the nave, upper center

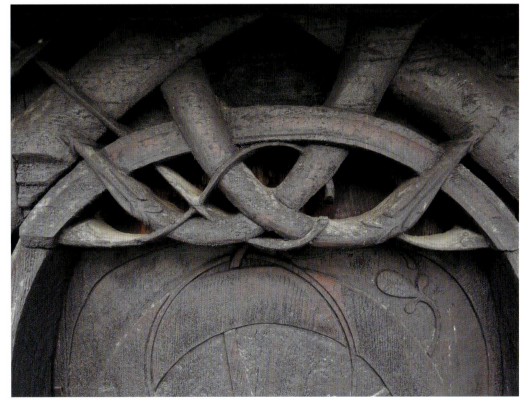

Plate 5. Detail of reused portal on the north exterior wall of the nave, upper center. Photo: Leif Anker, © Riksantikvaren, Directorate for Cultural Heritage, Norway

URNES STAVE CHURCH AND ITS GLOBAL ROMANESQUE CONNECTIONS

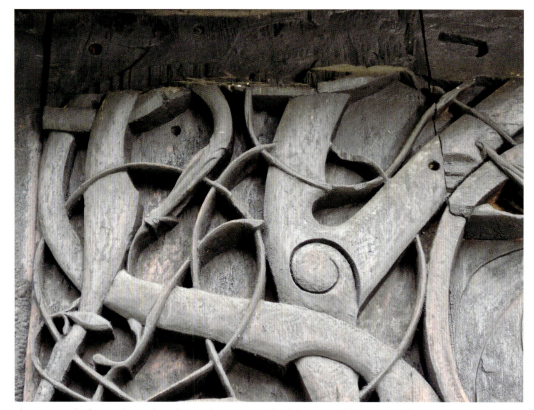

Plate 6. Detail of reused portal on the north exterior wall of the nave, oblique view of upper center.

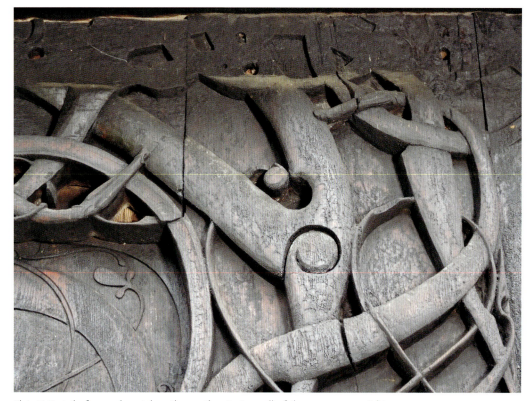

Plate 7. Detail of reused portal on the north exterior wall of the nave, upper right

REUSED MATERIALS | PLATE 8

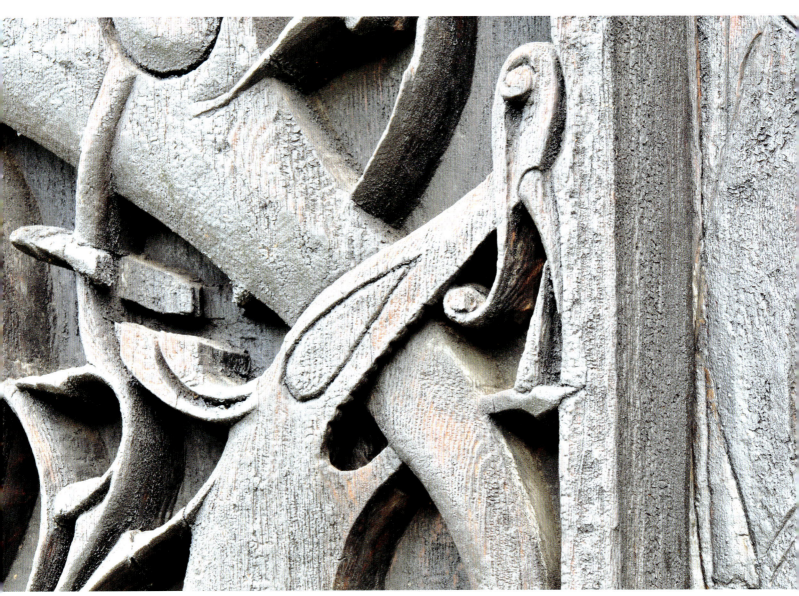

Plate 8. Detail of reused portal on the north exterior wall of the nave, left jamb. Photo and © Leif Anker.

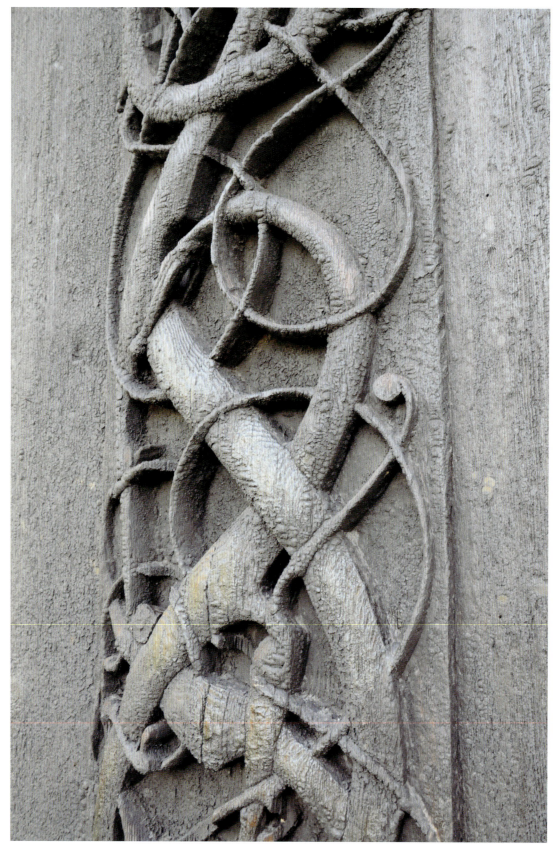

Plate 9. Detail of reused relief carving on wall plank, north wall exterior. Photo and © Leif Anker.

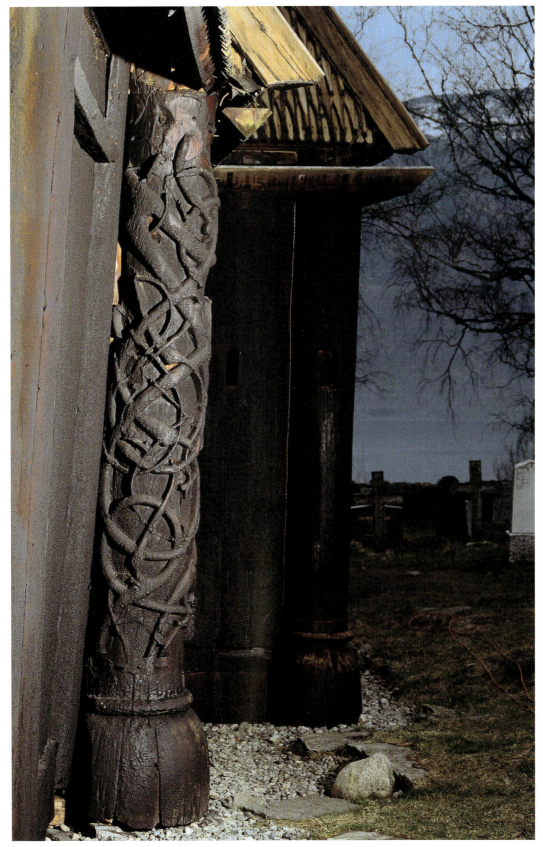

Plate 10. Reused corner post on north wall exterior. Photo: Birger Lindstad, © Riksantikvaren.

URNES STAVE CHURCH

RIGHT: Plate 11. Reused east gable. Photo: Birger Linstad and Joppe Christensen in cooperation with Knud J. Krogh, © Riksantikvaren, Directorate for Cultural Heritage, Norway

BELOW: Plate 12. Reused west gable

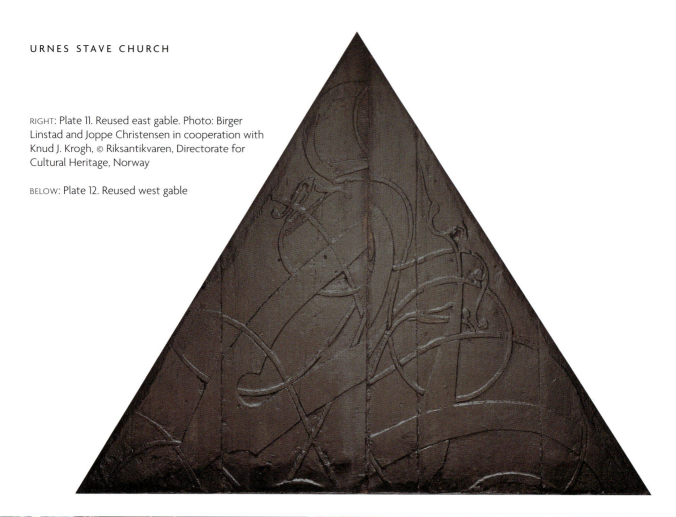

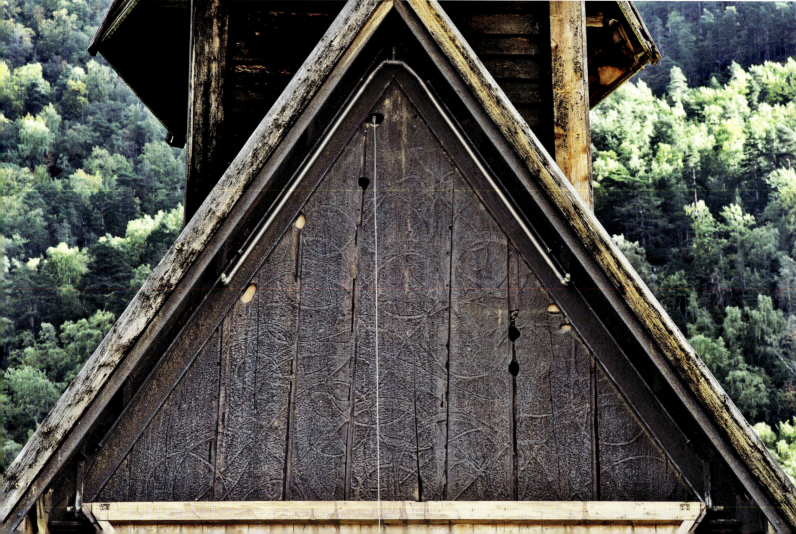

Plate 13. Exterior view from west

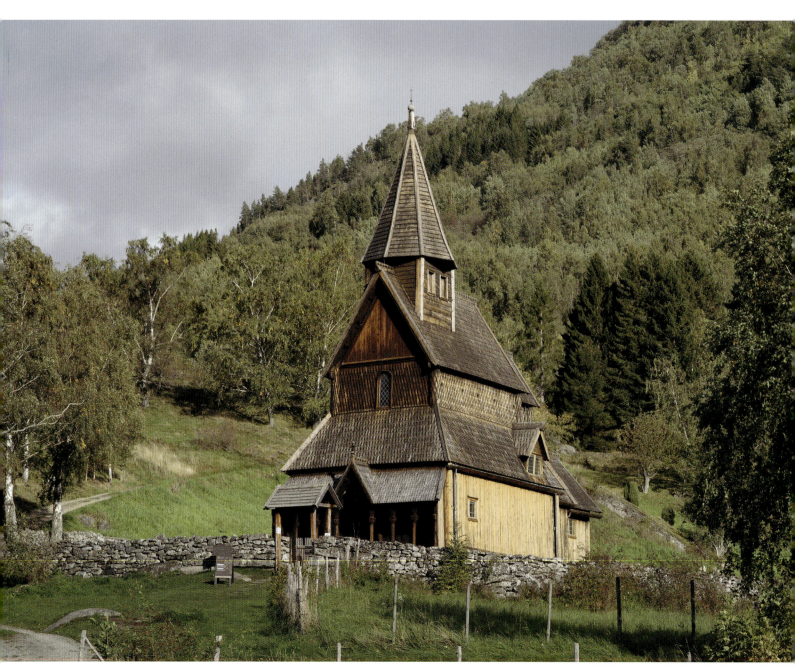
Plate 14. Exterior view from southwest

EXTERIOR | PLATE 15

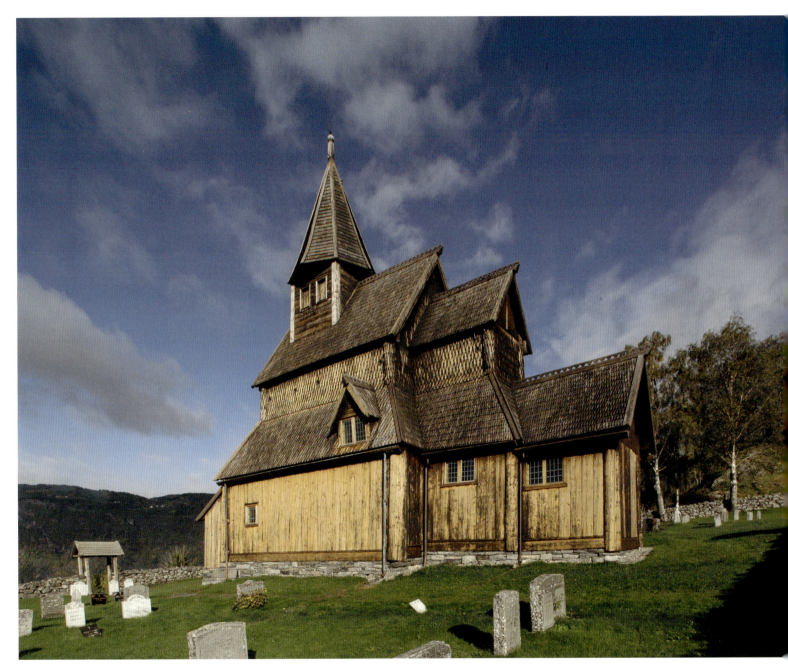

Plate 15. Exterior view from southeast

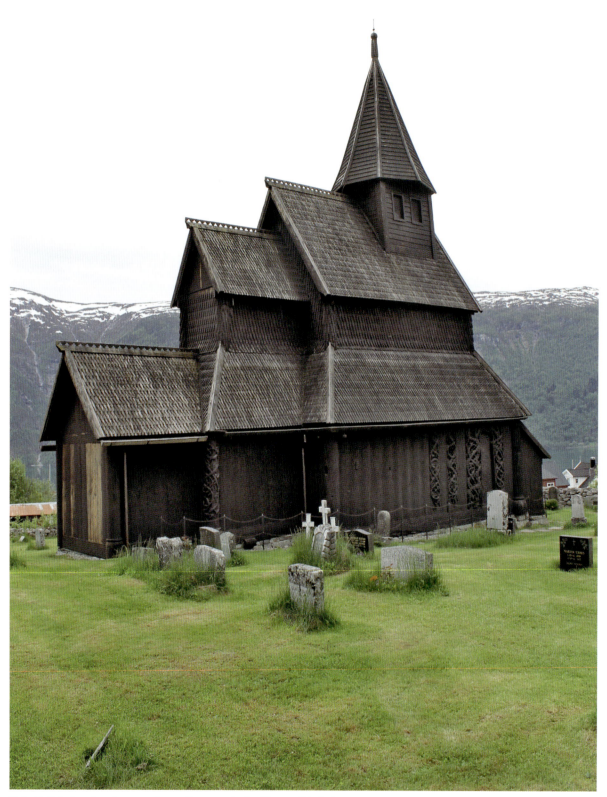

Plate 16. Exterior view from northeast. Photo and © by Thomas E.A. Dale

EXTERIOR | PLATE 17

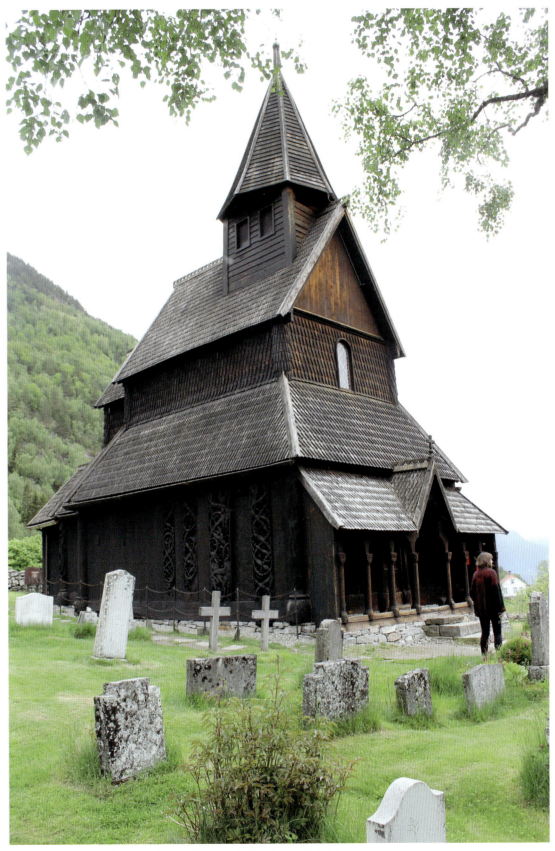

Plate 17. Exterior view from northwest. Photo and © by Thomas E.A. Dale

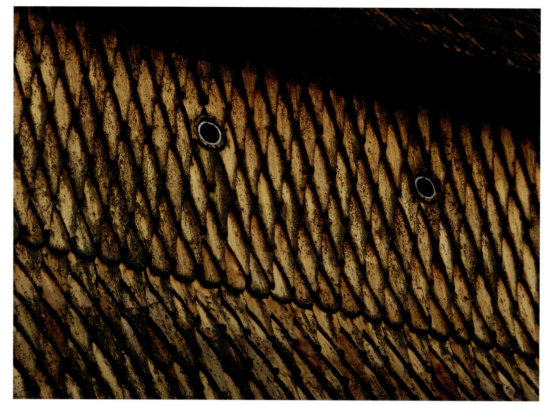
Plate 18. Detail of shingle roof and porthole/ oculi light openings

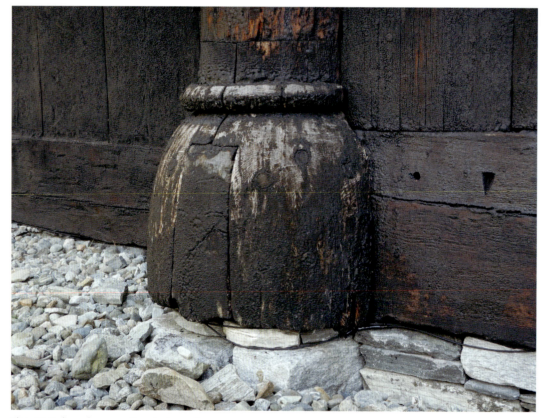
Plate 19. Column base, north exterior wall

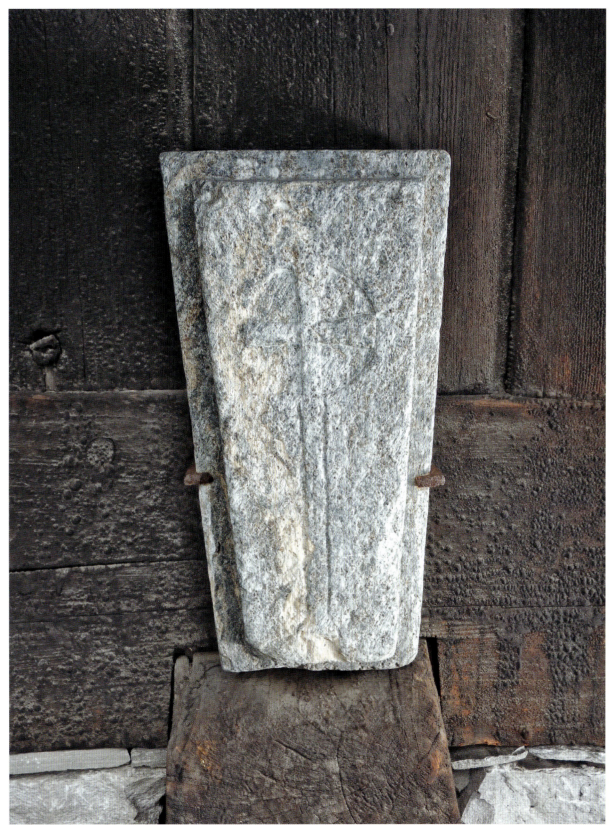

Plate 20. Grave slab with cross

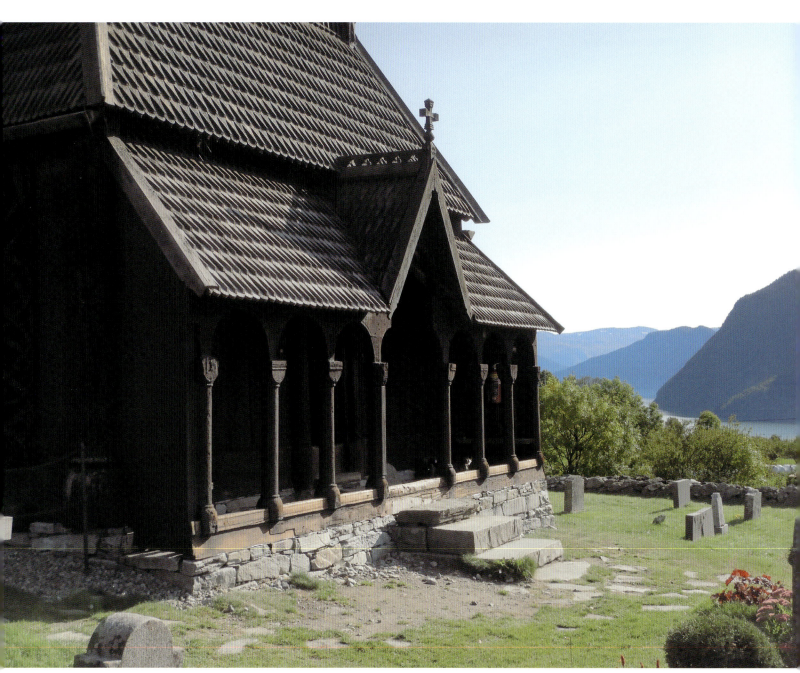
Plate 21. Pentice from northwest

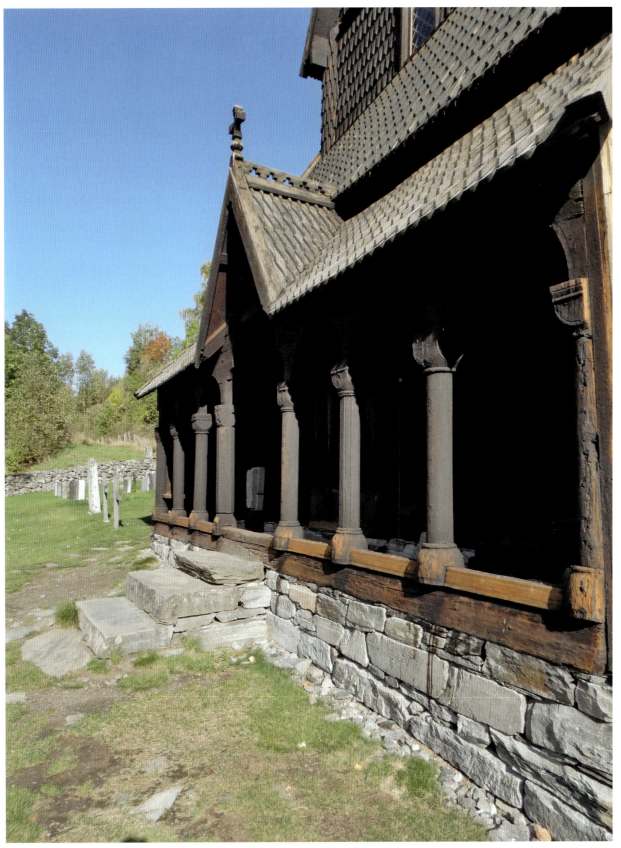

Plate 22. Pentice from southwest

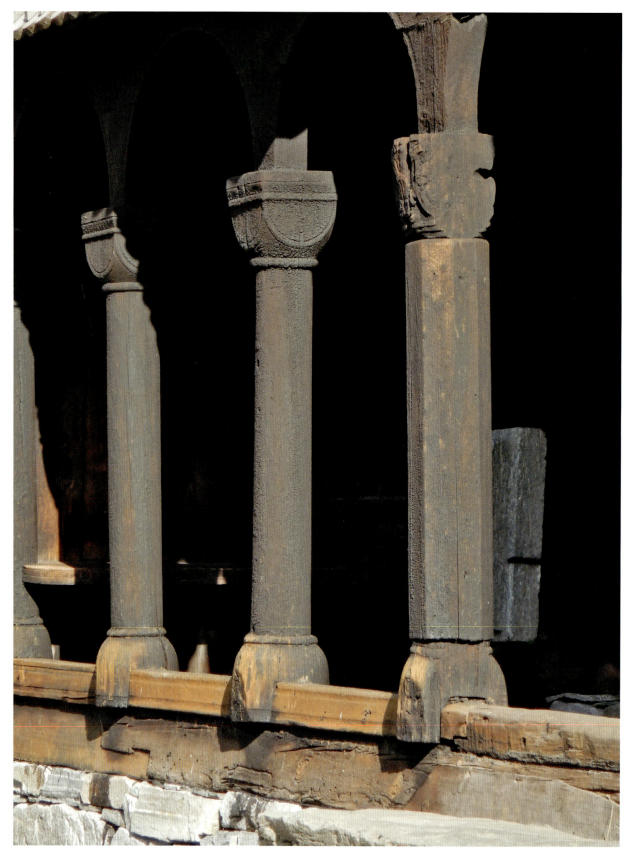

Plate 23. Pentice detail

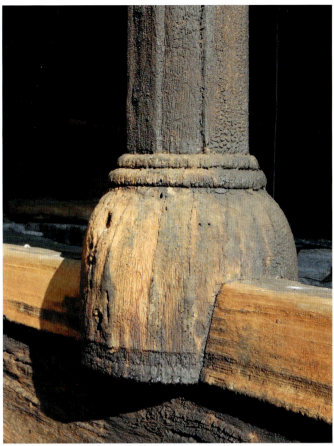
Plate 24. Detail of pentice base

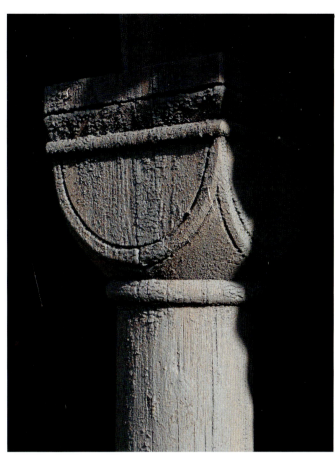
Plate 25. Detail of pentice capital

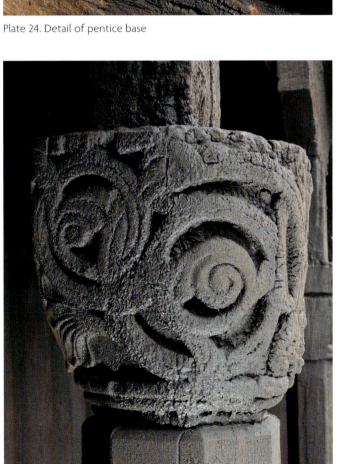
Plate 26. Detail of pentice capital

Plate 27. Detail of pentice capital

Plate 28. Detail of Pentice capital

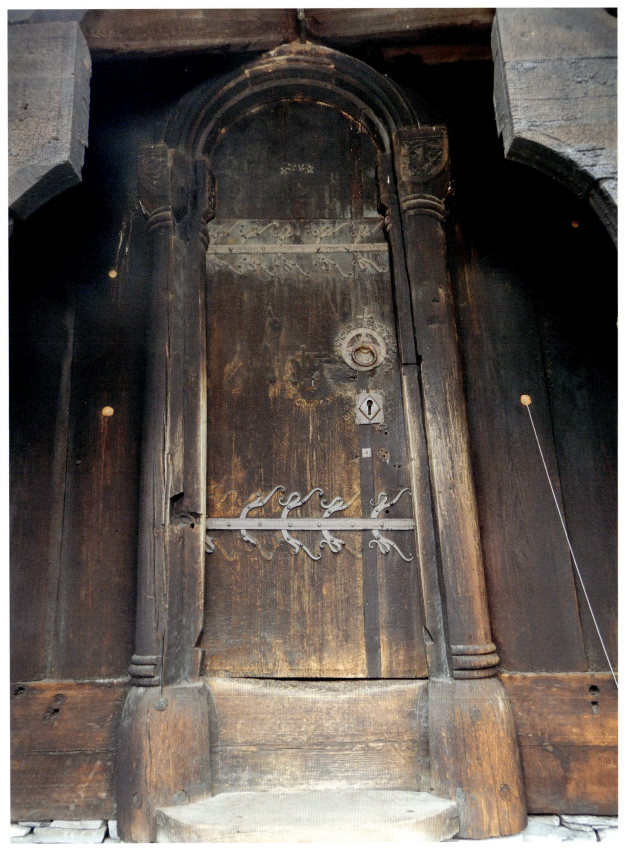
Plate 29. West portal

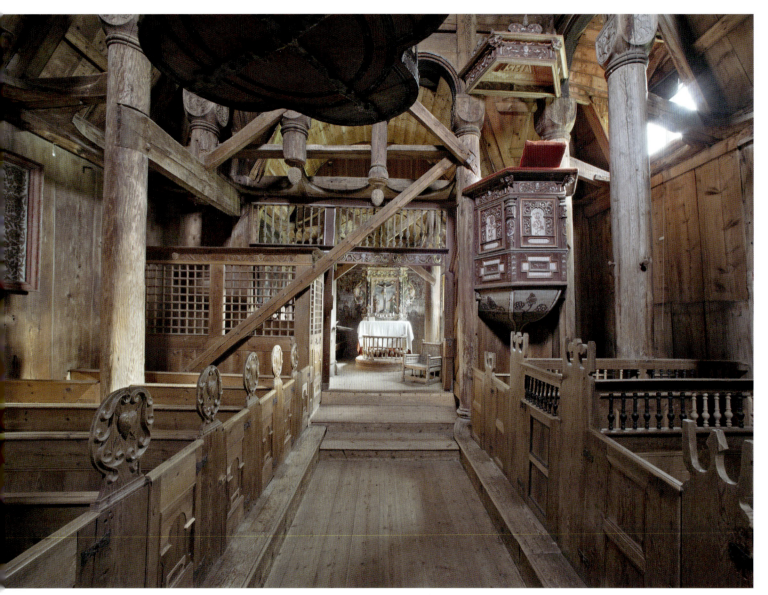

Plate 30. Interior from west

INTERIOR | PLATE 31

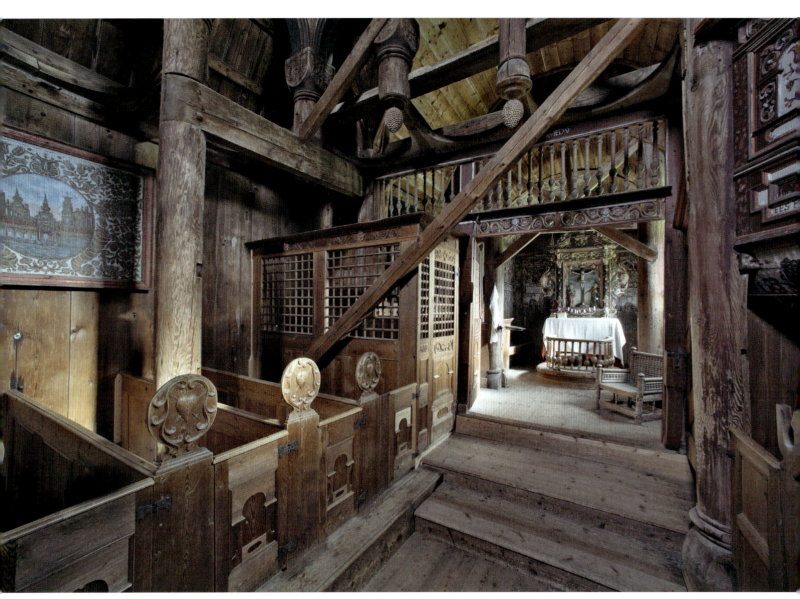

Plate 31. Interior from southwest corner

49

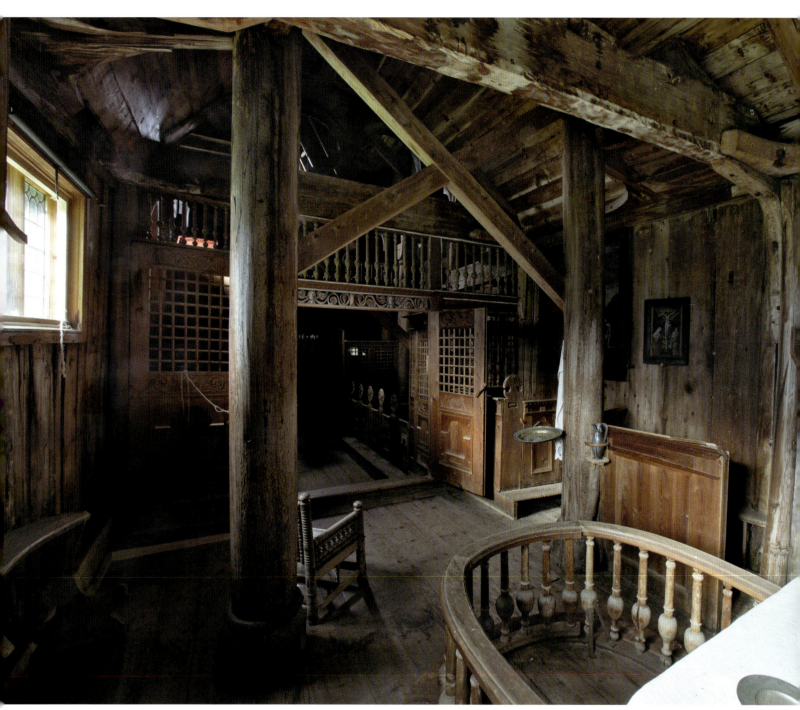

Plate 32. Interior from east

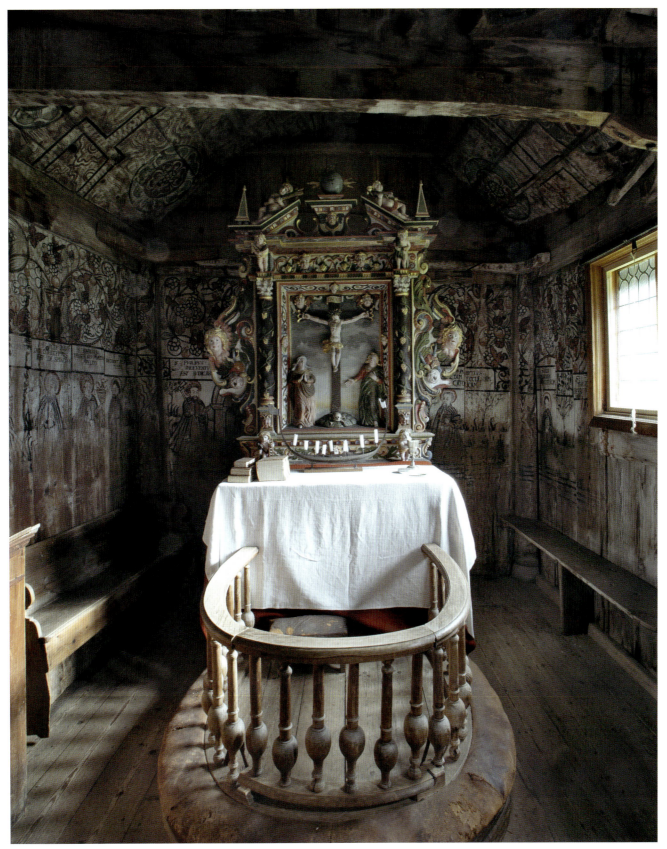

Plate 33. Chancel from west

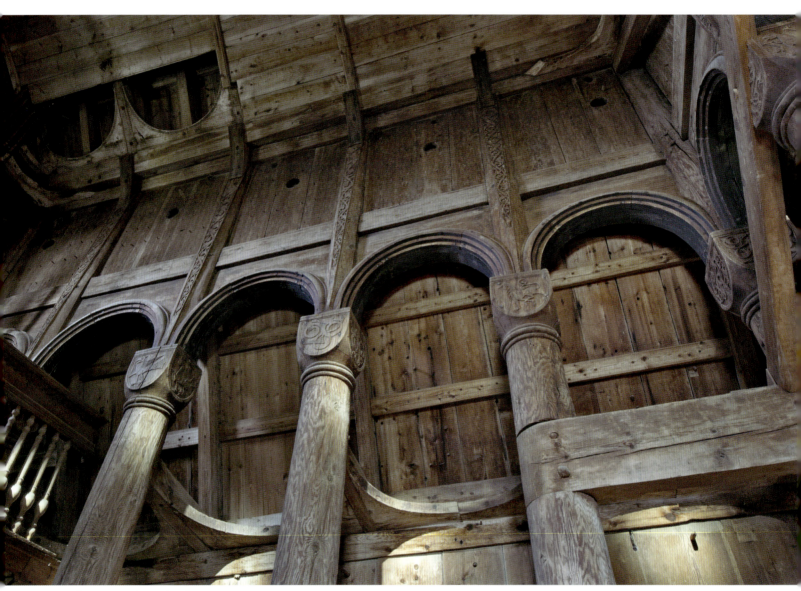

Plate 34. North arcade of nave

INTERIOR | PLATE 35

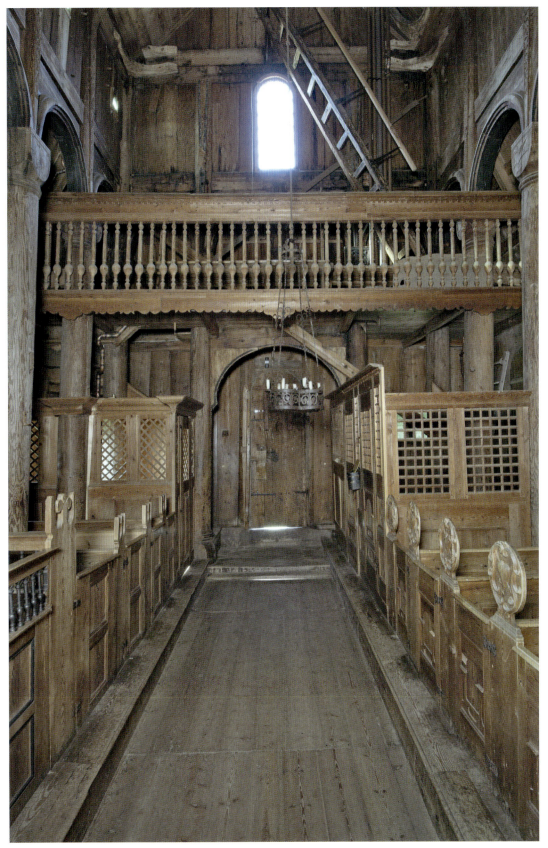

Plate 35. Nave from east

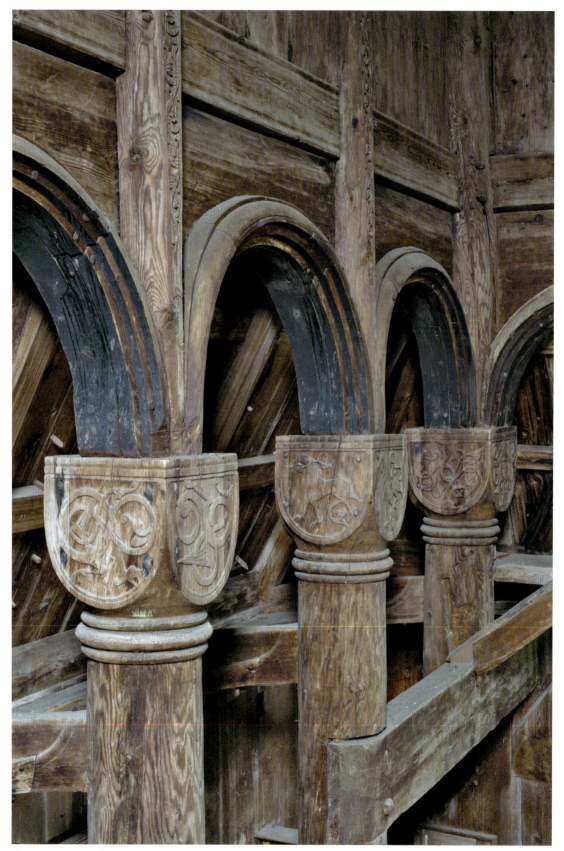

Plate 36. Nave arcade. Inserted arches with added moldings

INTERIOR | PLATE 37

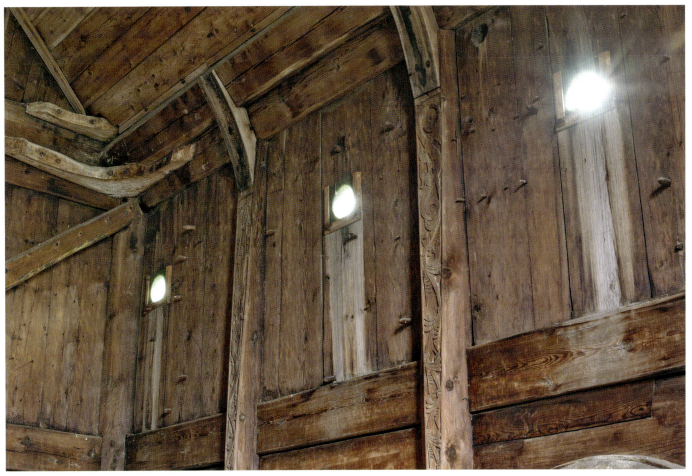

Plate 37. Nave, portholes / oculi light openings

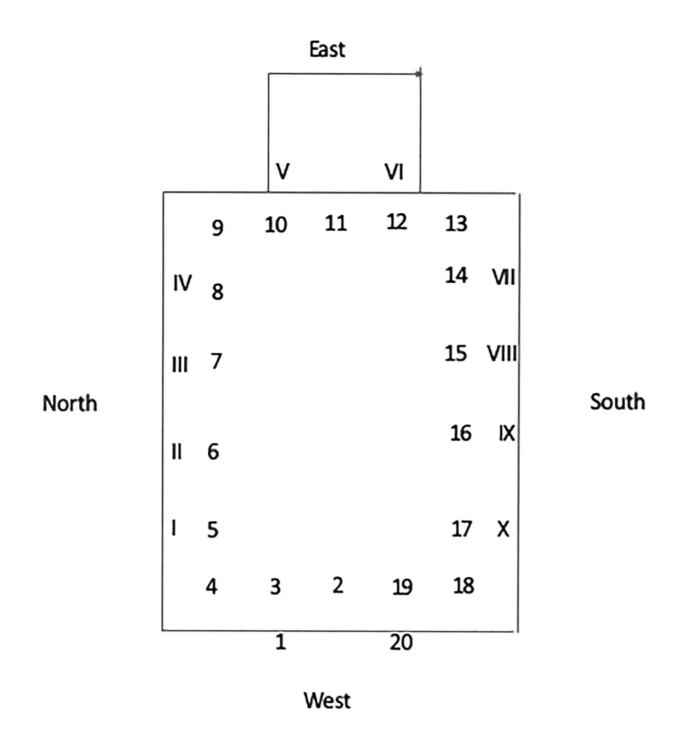

Plate 38. Schematic plan of capitals

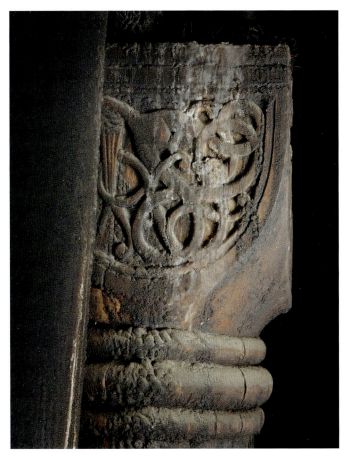

Plate 39. Cap. 1N. Winged dragon (damaged).

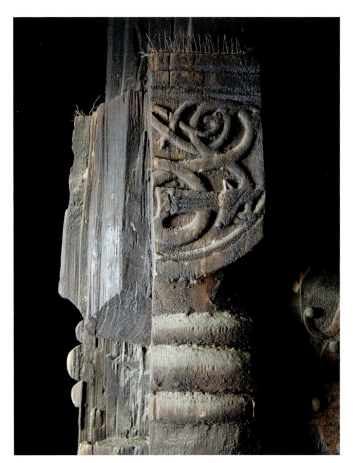

Plate 40. Cap. 1S. Winged dragon (damaged)

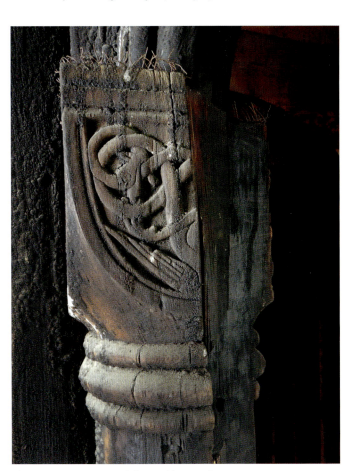

Plate 41. Cap. 1W. Winged dragon (damaged)

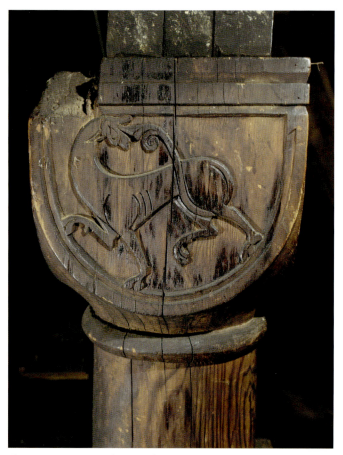

Plate 42. Cap. 2N. Lion biting tail

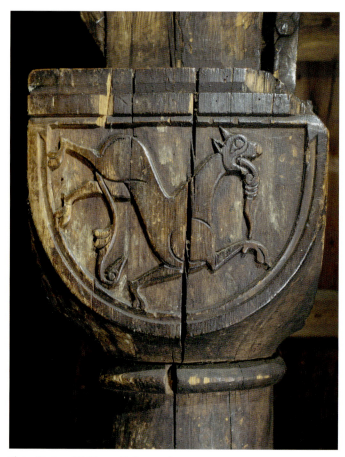

Plate 43. Cap. 2E. Lion with knotted tongue

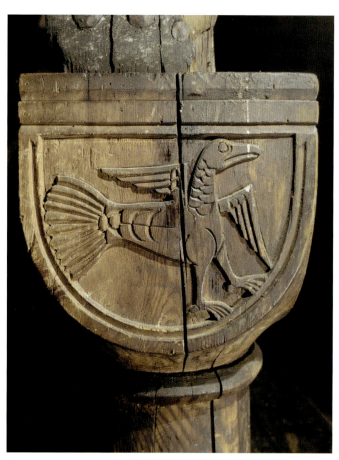

Plate 44. Cap. 2S. Aquiline Bird

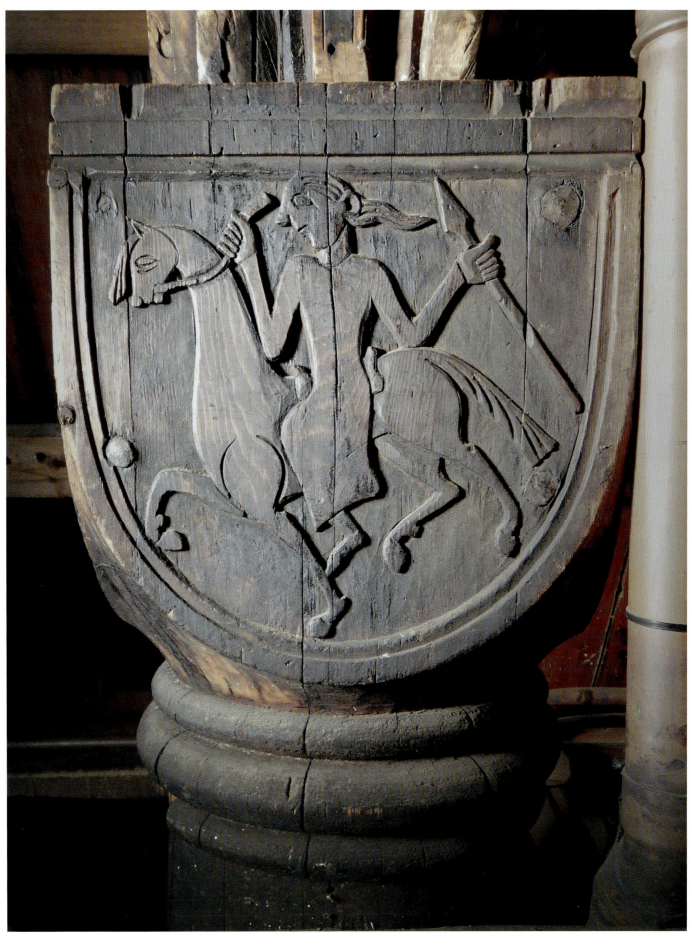
Plate 45. Cap. 3E. Man on horseback holding spear

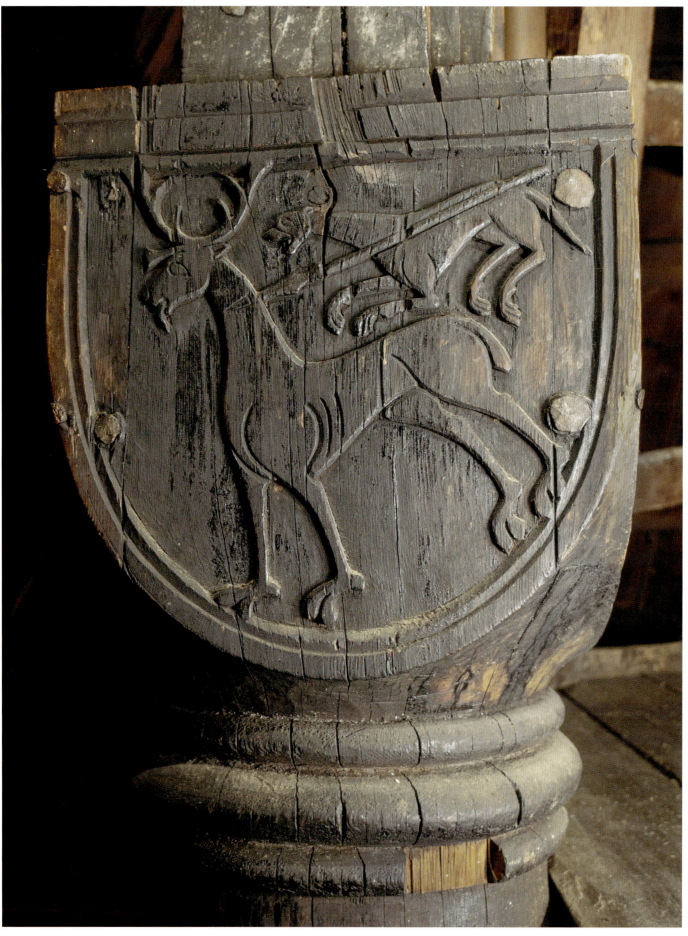

Plate 46. Cap. 3S. Stag pierced by spear, dog

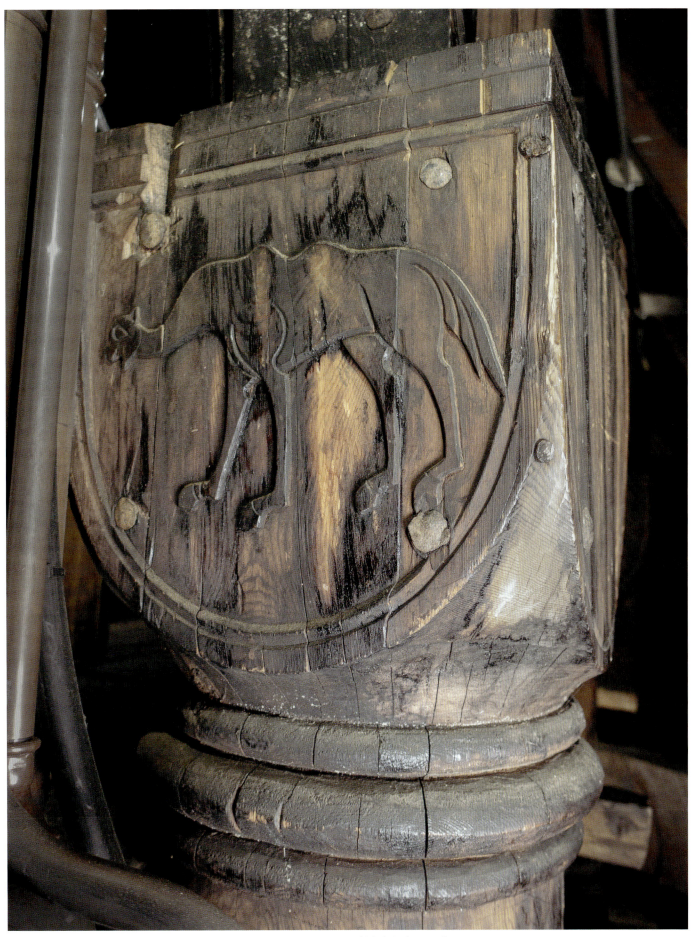

Plate 47. Cap. 3N. Camel (slightly damaged)

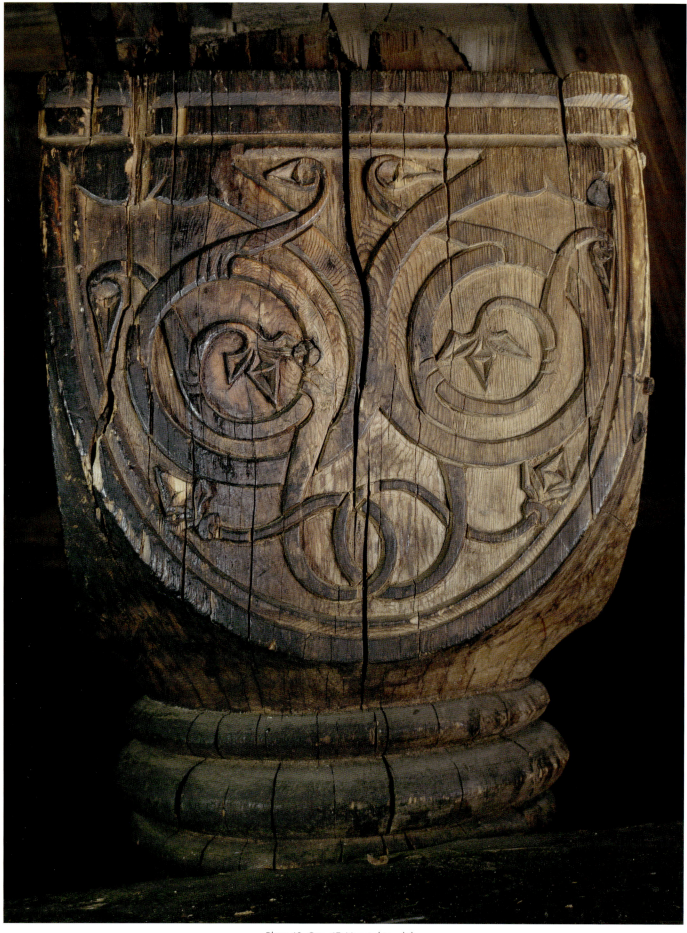
Plate 48. Cap. 4E. Vegetal tendrils

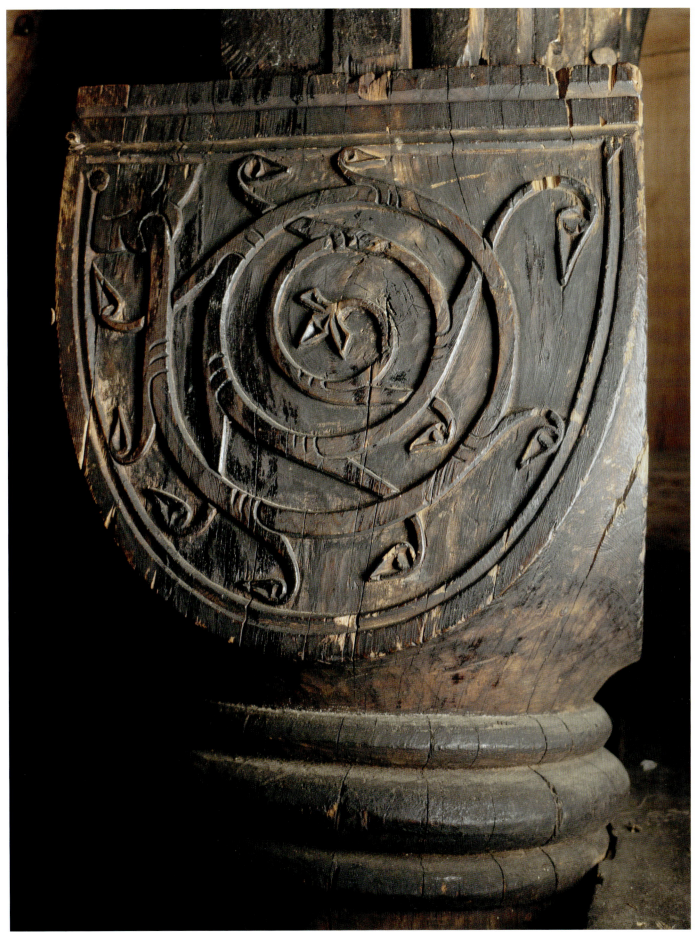
Plate 49. Cap. 4S. Vegetal tendrils

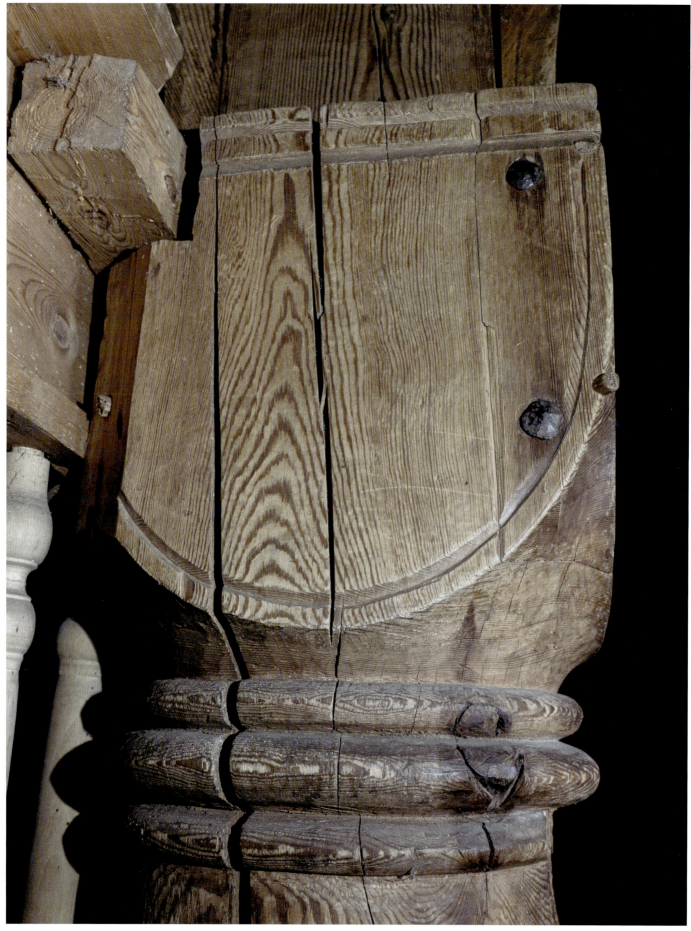

Plate 50. Cap. 5N. Uncarved

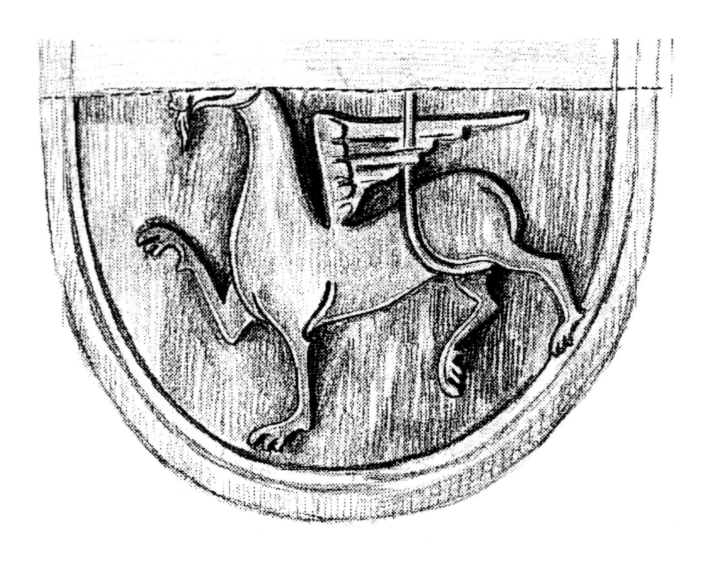

Plate 51. Cap. 5E Currently obscured. Winged lion, Drawing by Edda Distler. From Distler, *Stavkirkernes billedsprog*, 36

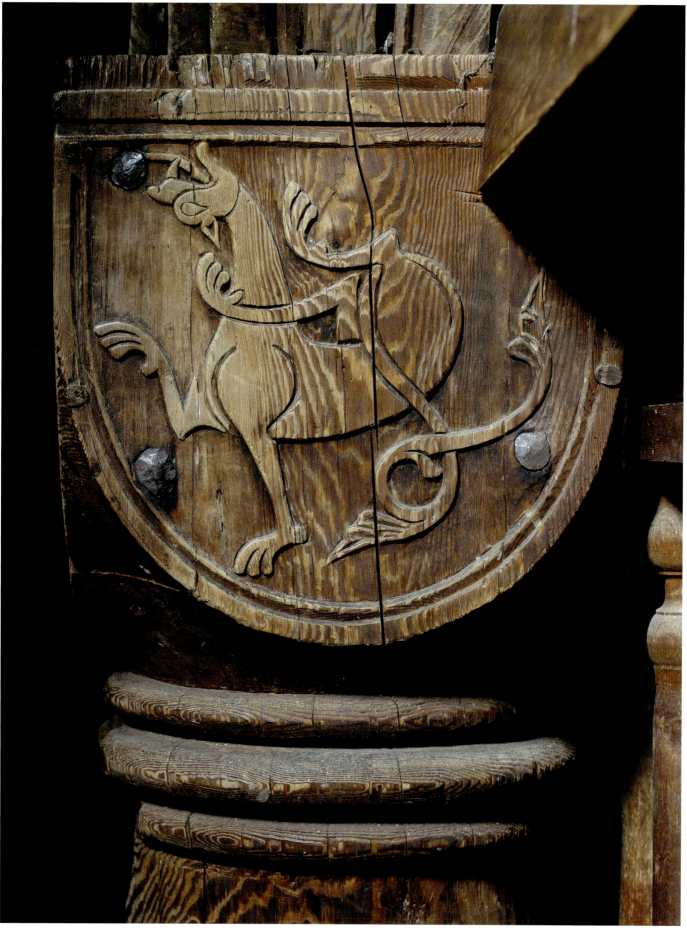

Plate 52. Cap. 5S. Contorted lion

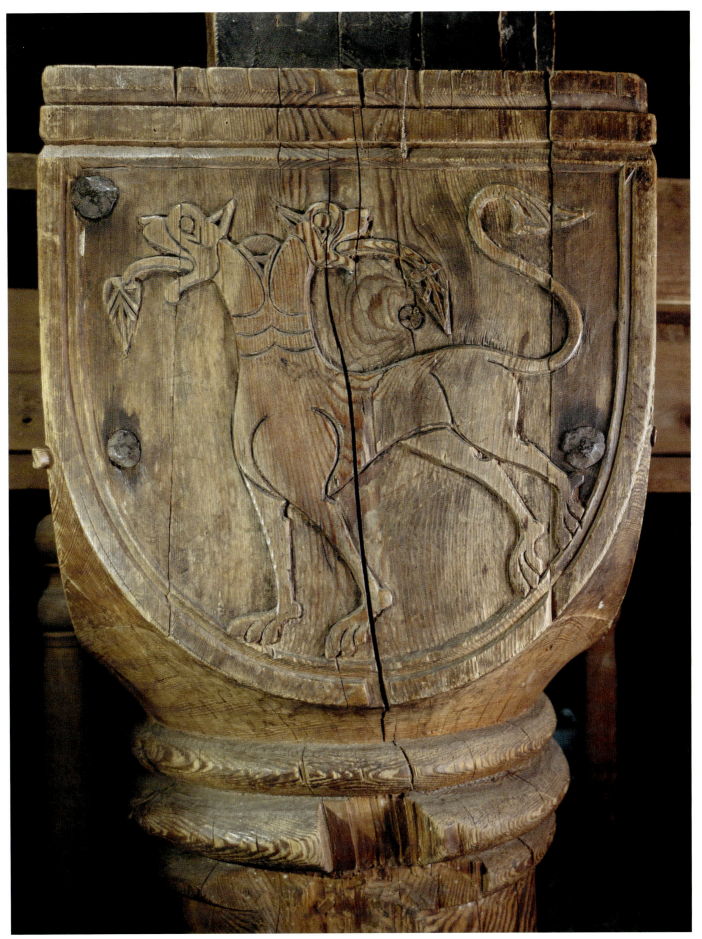
Plate 53. Cap. 5W. Two-headed lion

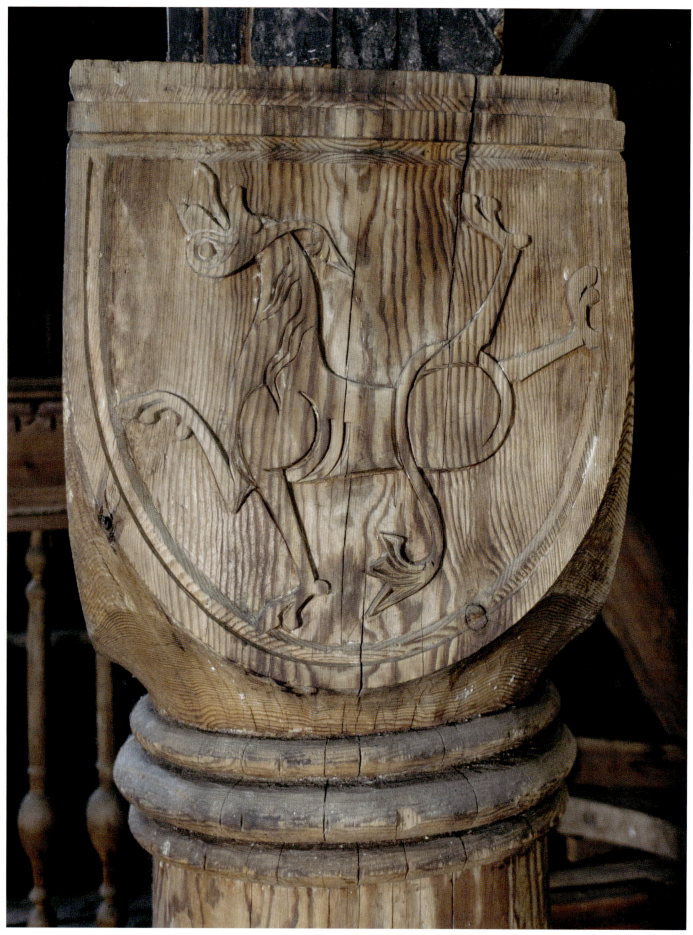

Plate 54. Cap. 6E. Contorted lion

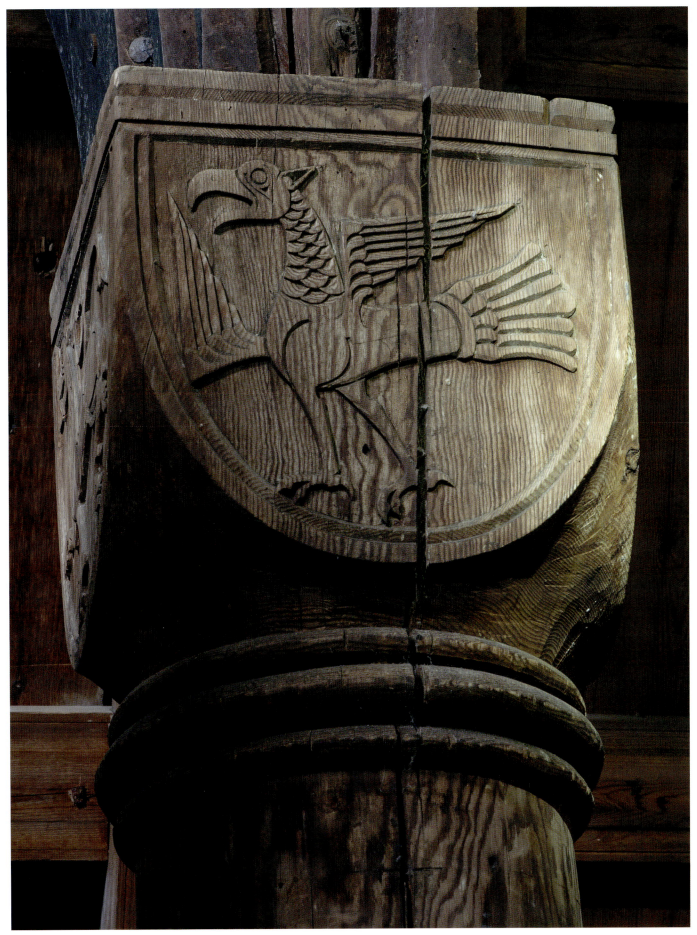

Plate 55. Cap. 6S. Aquiline Bird

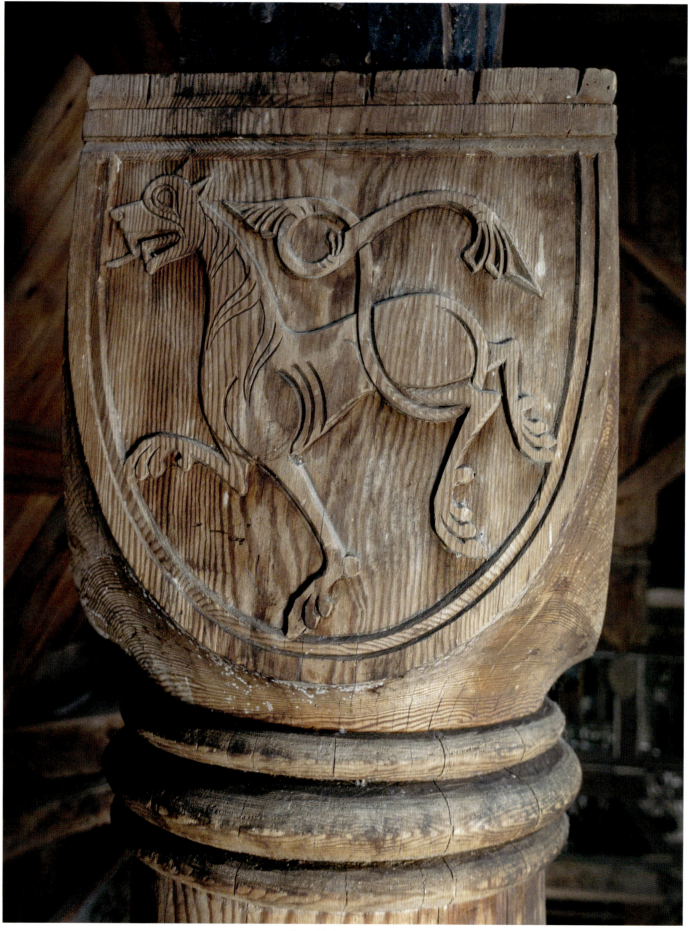

Plate 56. Cap. 6W. Lion

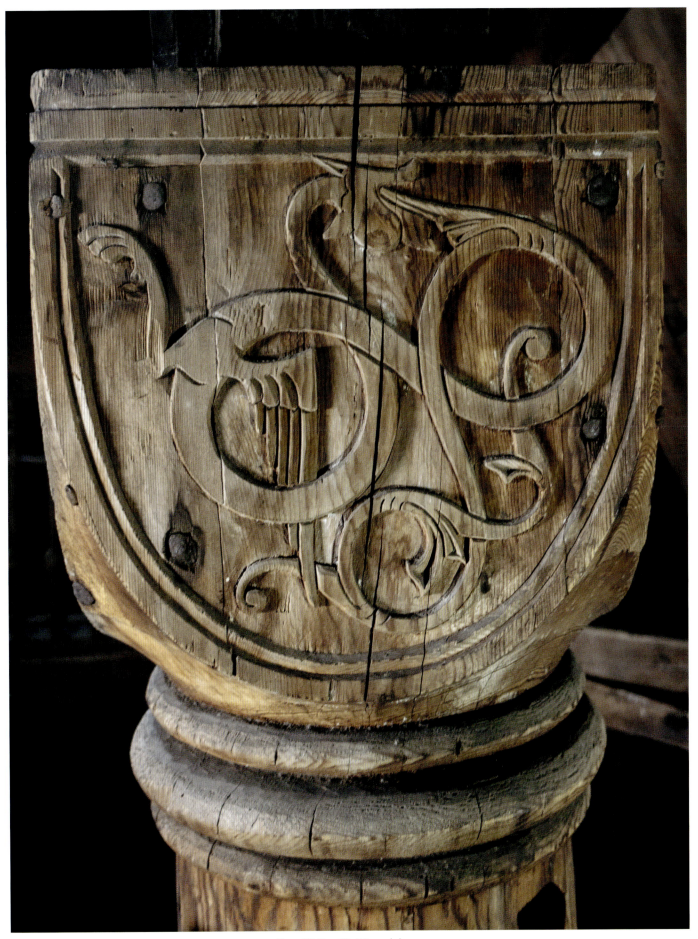
Plate 57. Cap. 7E. Winged dragon

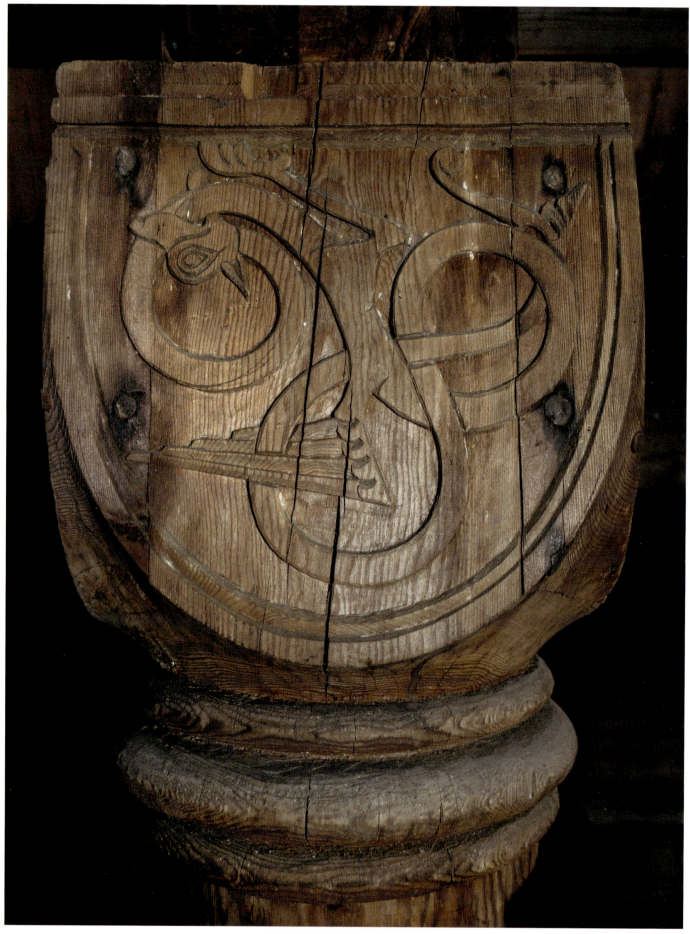
Plate 58. Cap. 7S. Winged dragon

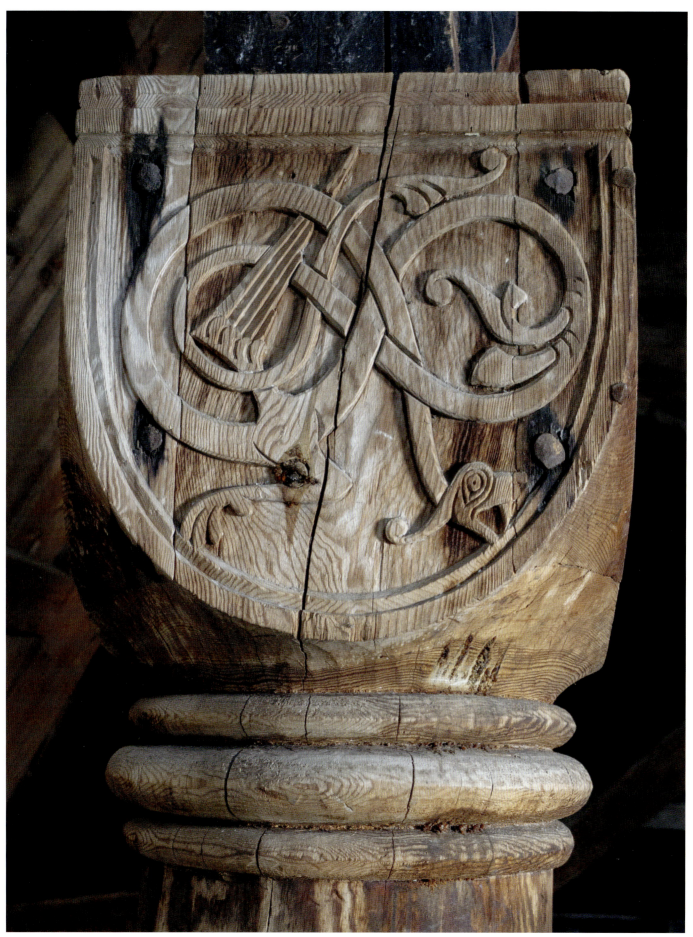

Plate 59. Cap. 7W. Winged dragon

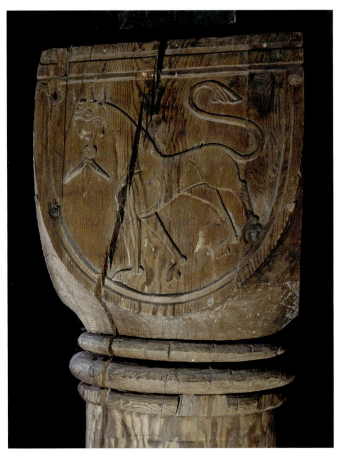

Plate 60. Cap. 8E. Lion with knotted tongue

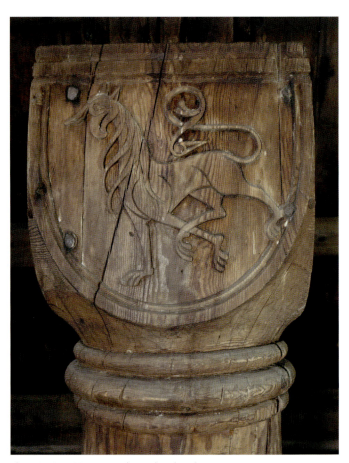

Plate 61. Cap. 8S. Lion with aquiline head

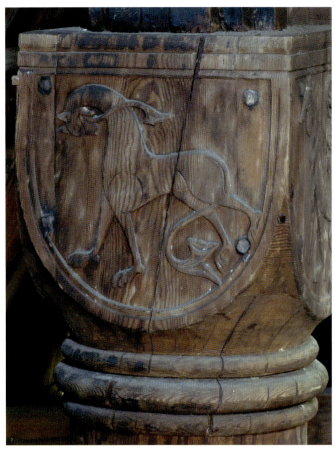

Plate 62. Cap. 8W. Lion

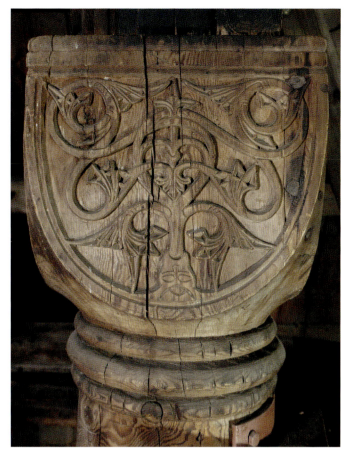 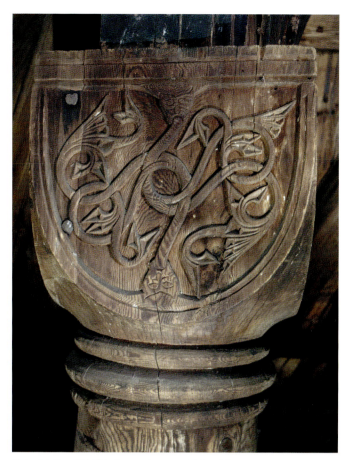

Plate 63. Cap. 9S. Mask spewing vegetal tendrils

Plate 64. Cap. 9W. Mask spewing vegetal tendrils

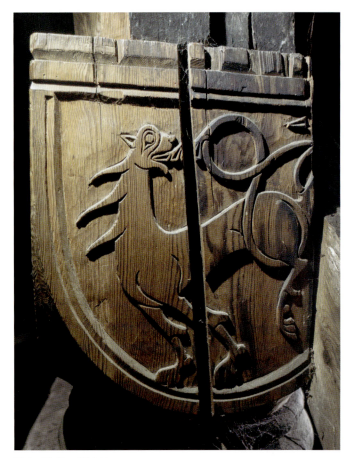
Plate 65. Cap. 10N. Lion

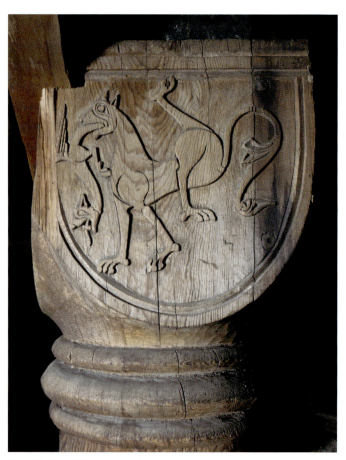
Plate 66. Cap. 10S. Lion spewing a winged dragon

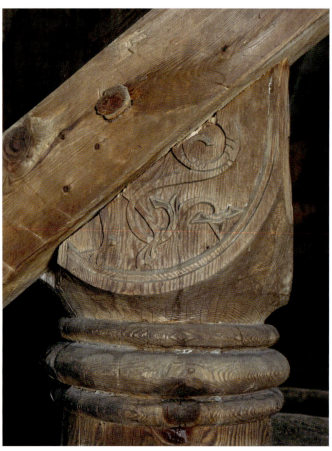
Plate 67. Cap. 10W. Feet and tail of a lion, dragon or bird

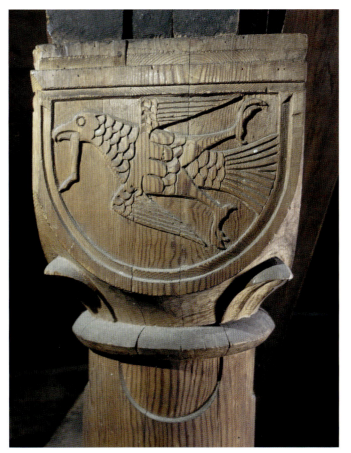

Plate 68. Cap. 11N. Aquiline bird with human leg dangling from beak

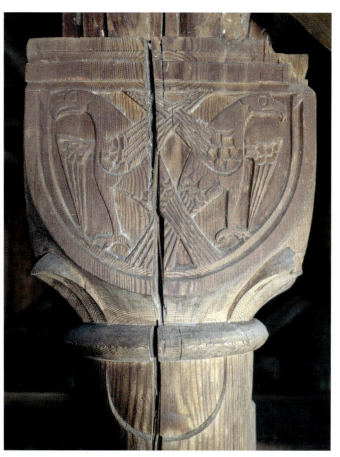

Plate 69. Cap. 11W. Two addorsed aquiline birds

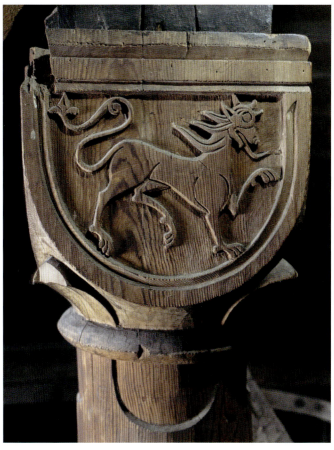

Plate 70. Cap. 11S. Lion

77

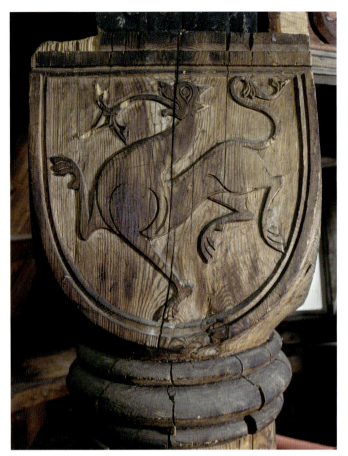

Plate 71. Cap. 12E. Lion

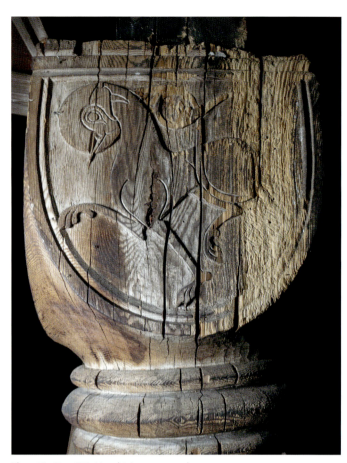

Plate 72. Cap. 12S. Lion biting own neck

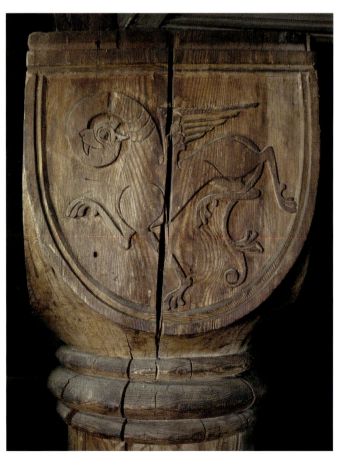

Plate 73. Cap. 12W. Lion biting own neck

CAPITALS | PLATE 75

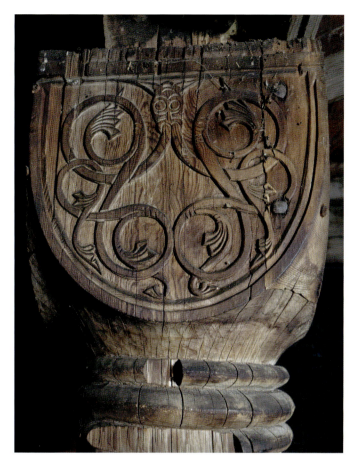

Plate 74. Cap. 13N. Mask spewing vegetal tendrils

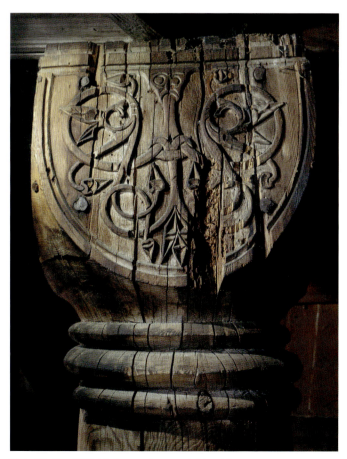

Plate 75. Cap. 13W. Mask spewing vegetal tendrils

79

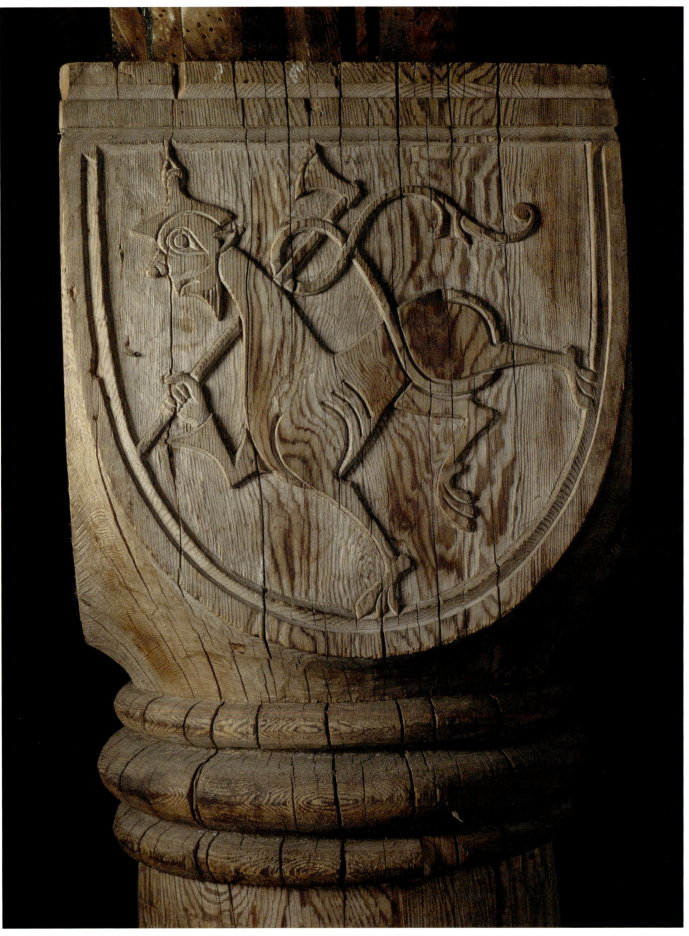

Plate 76. Cap. 14N. Hybrid creature holding ax

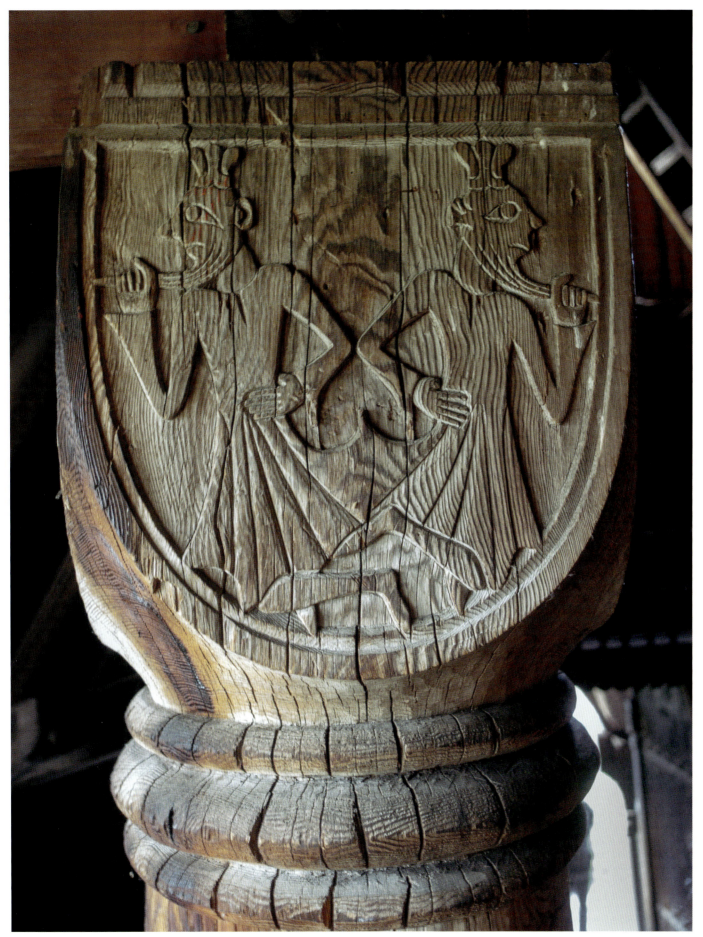

Plate 77. Cap. 14E. Two beard-pullers

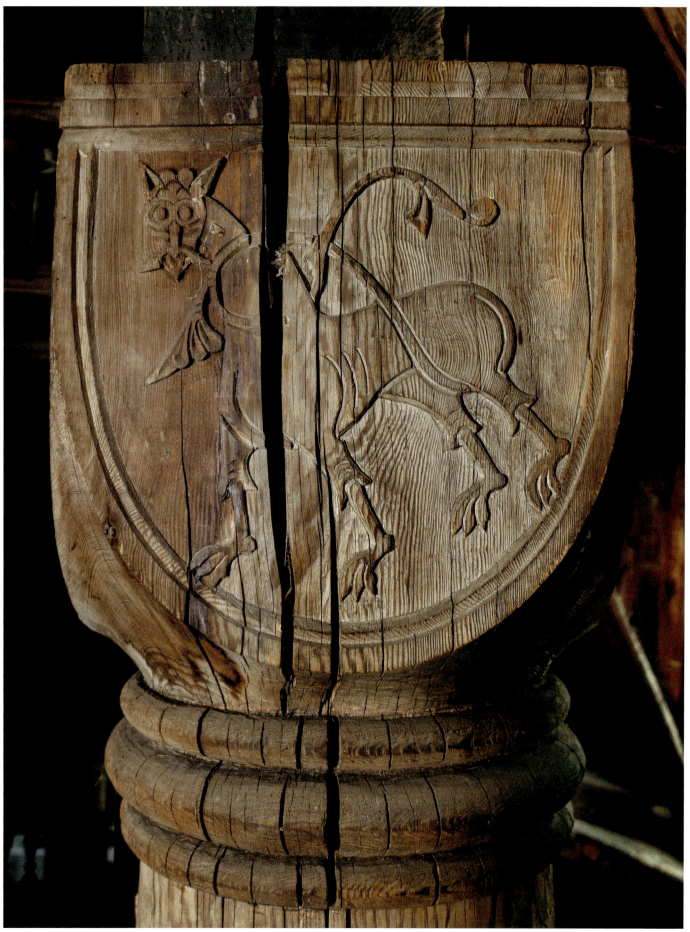

Plate 78. Cap. 14W. Lion

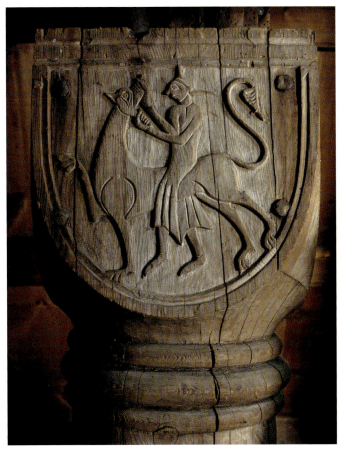

Plate 79. Cap. 15N. Man wrestling lion

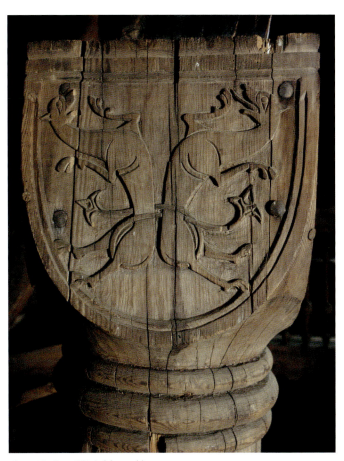

Plate 80. Cap. 15E. Addorsed lions

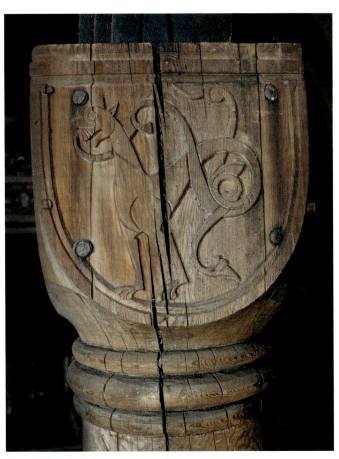

Plate 81. Cap. 15W. Lion and vegetal tendril hybrid

83

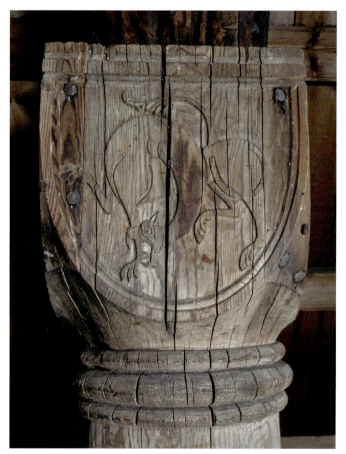

Plate 82. Cap. 16N. Contorted lion

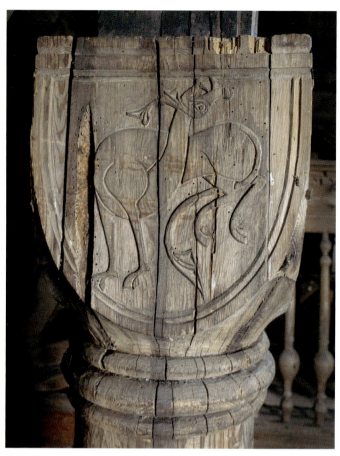

Plate 83. Cap. 16E. Contorted lion

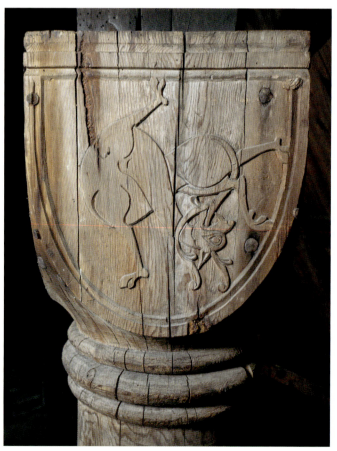

Plate 84. Cap. 16W. Contorted lion

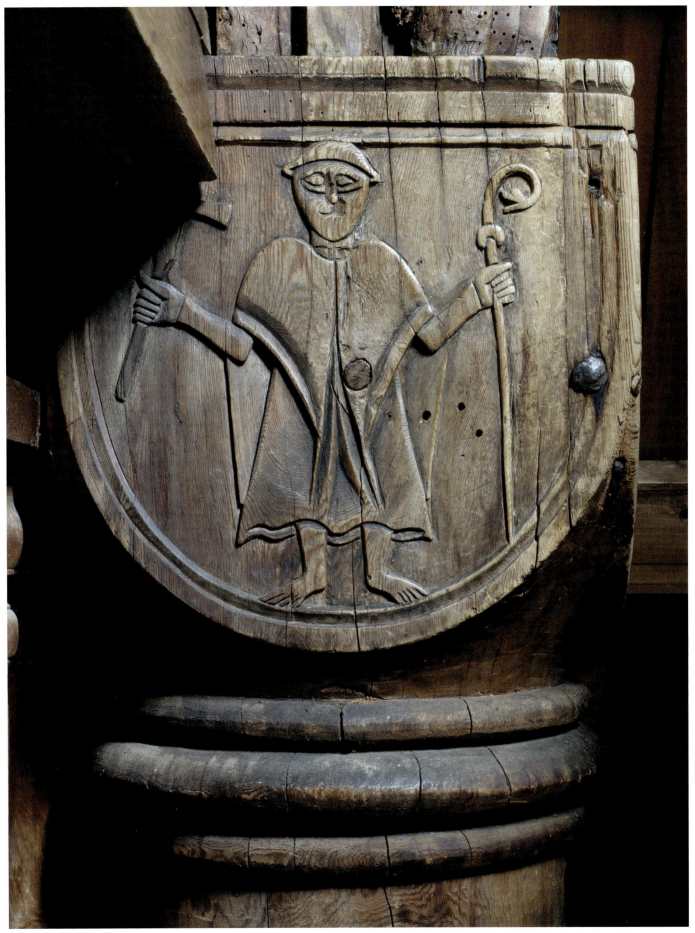

Plate 85. Cap. 17N. Cleric holding crosier

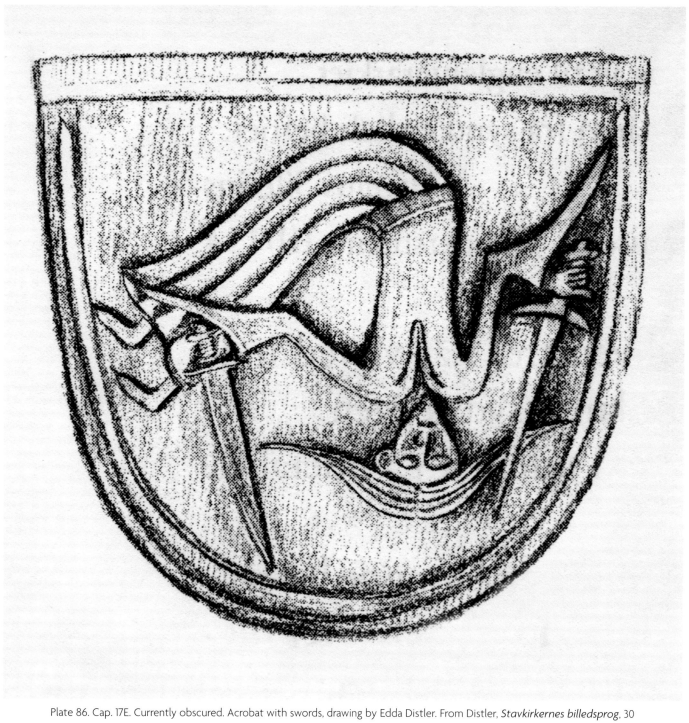

Plate 86. Cap. 17E. Currently obscured. Acrobat with swords, drawing by Edda Distler. From Distler, *Stavkirkernes billedsprog*, 30

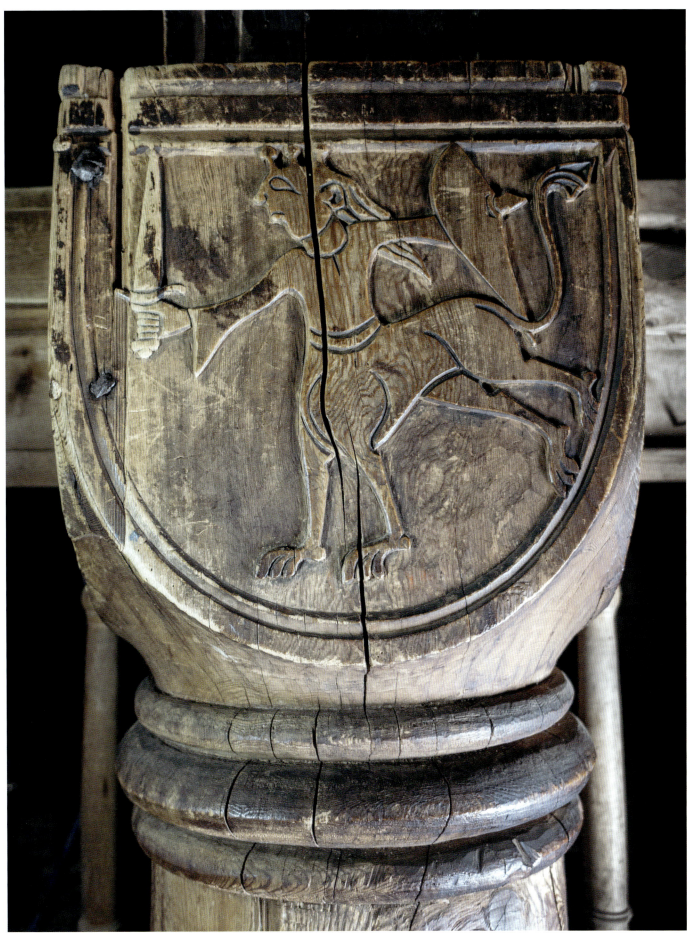

Plate 87. Cap. 17W. Centaur holding sword and shield

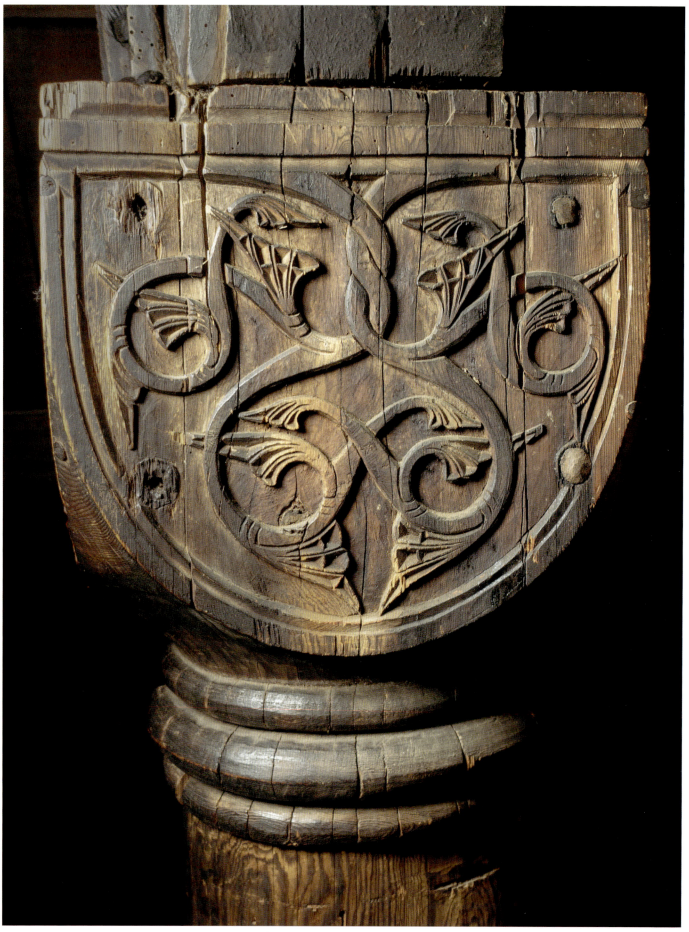

Plate 88. Cap. 18N. Vegetal tendrils

Plate 89. Cap. 18E. Vegetal tendrils (damaged)

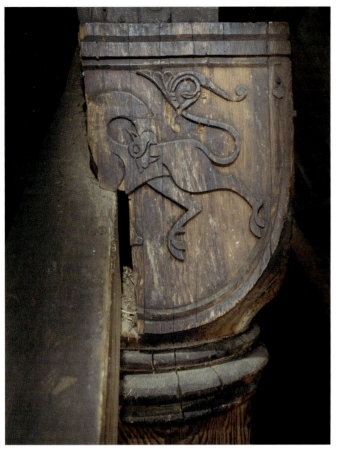

Plate 90. Cap. 19N. Lion with extended neck (damaged)

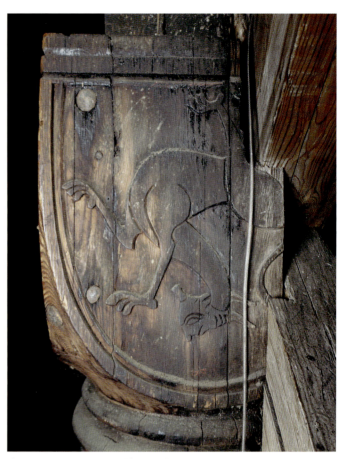

Plate 91. Cap. 19S. Lion (?) (damaged)

Plate 92. Cap. 19W. Uncarved

CAPITALS | PLATE 95

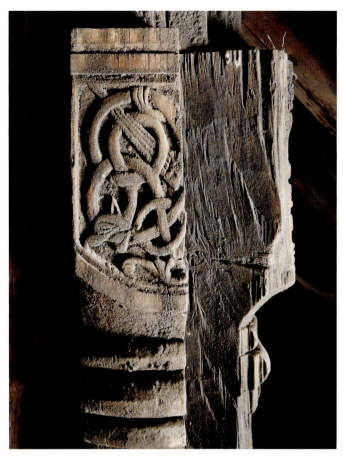

Plate 93. Cap. 20N. Winged dragon (damaged)

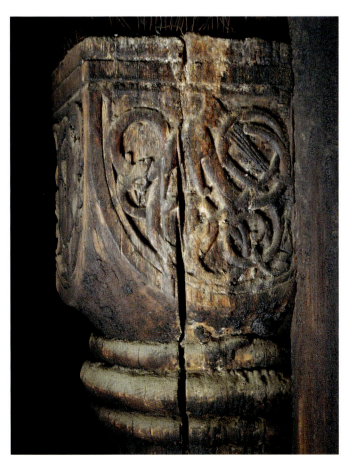

Plate 94. Cap. 20S. Winged dragon (damaged)

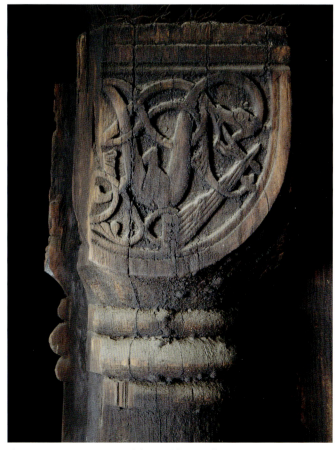

Plate 95. Cap. 20W. Winged dragon (damaged)

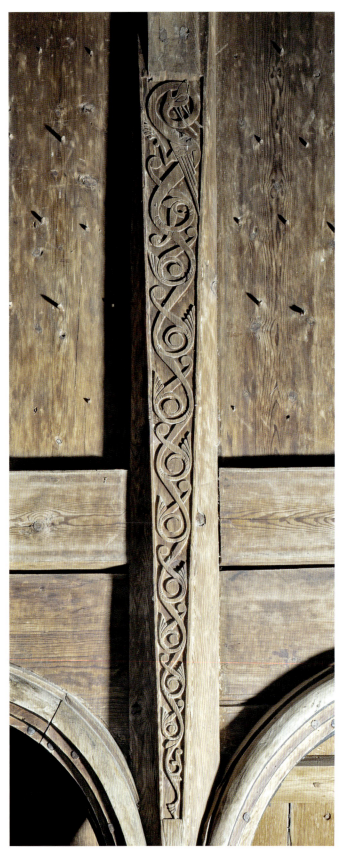
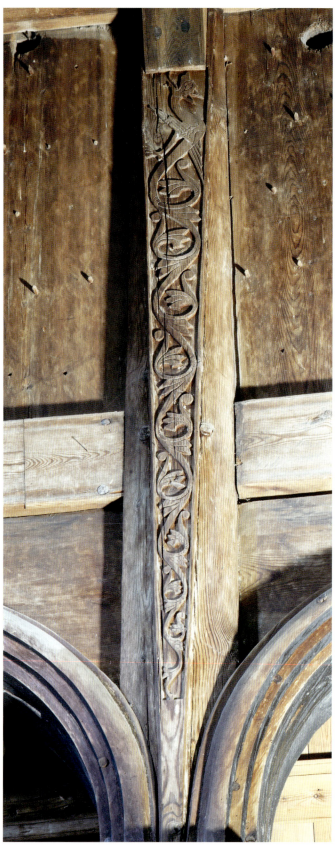

Plate 96. Abatement I

Plate 97. Abatement II

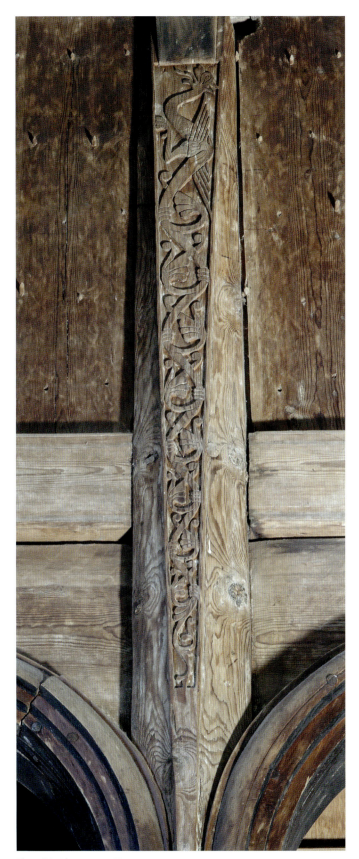
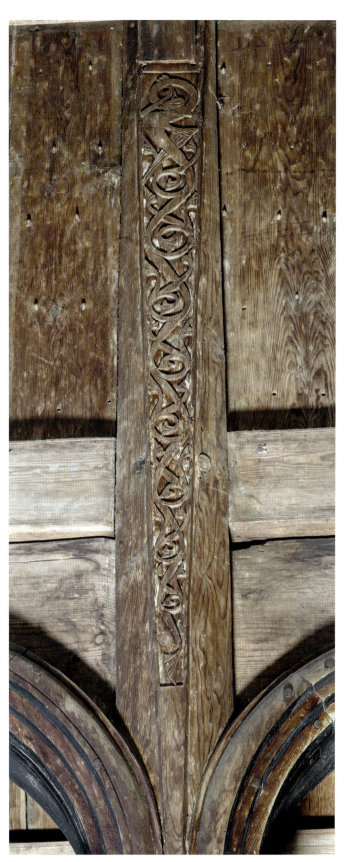

Plate 98. Abatement III

Plate 99. Abatement IV

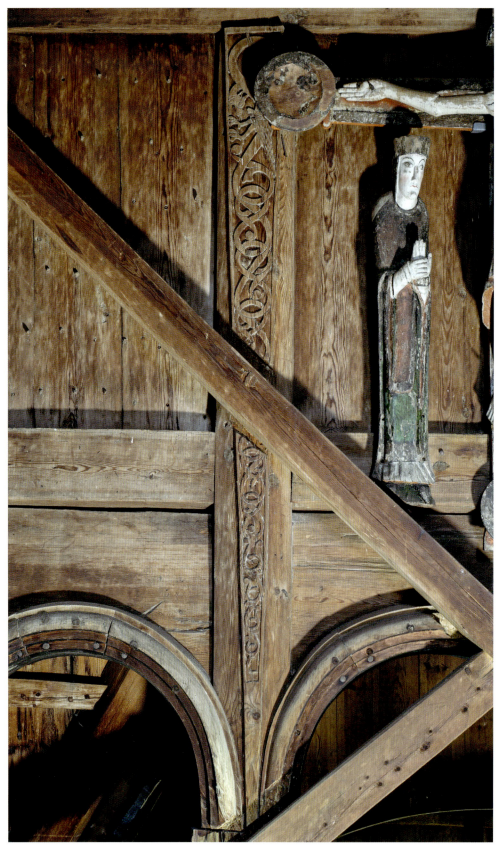
Plate 100. Abatement V

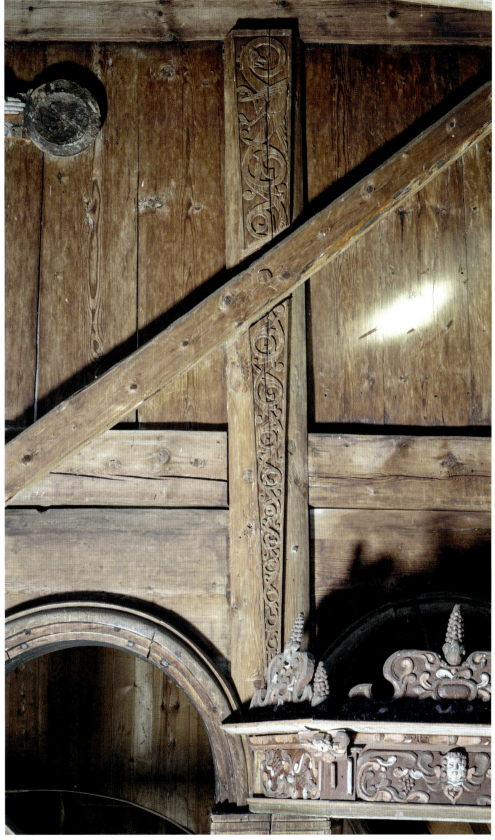

Plate 101. Abatement VI

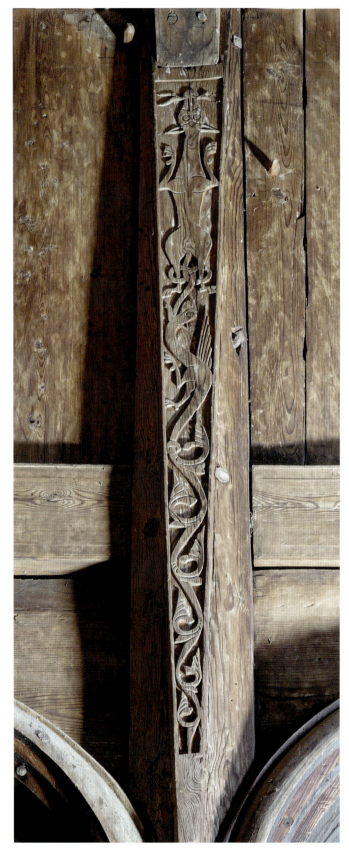

Plate 102. Abatement VII

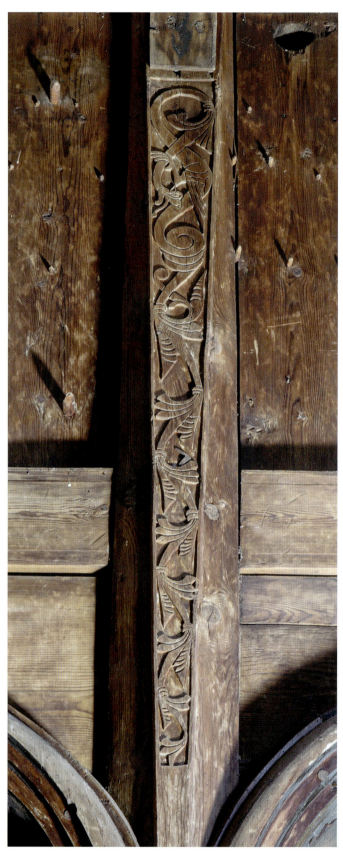

Plate 103. Abatement VIII

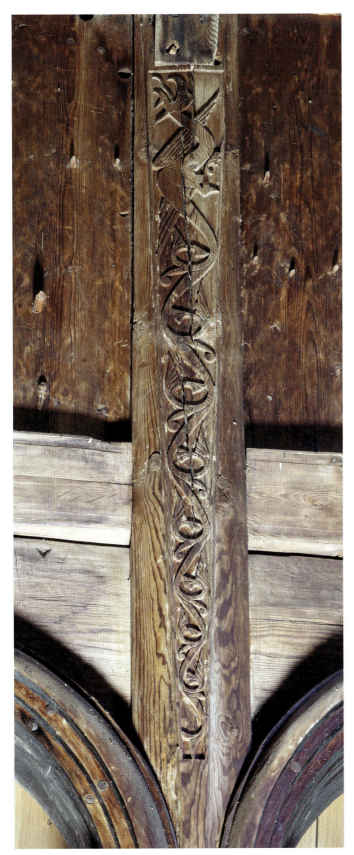
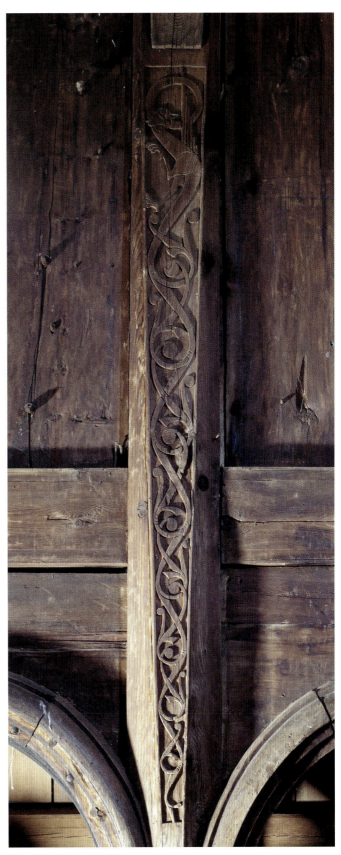

Plate 104. Abatement IX

Plate 105. Abatement X

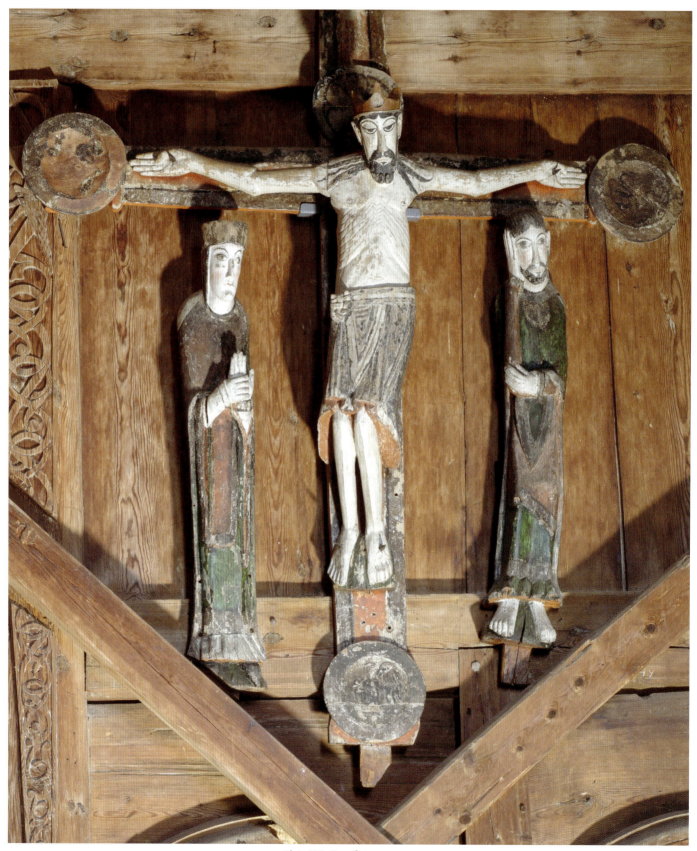

Plate 106. Crucifixion group

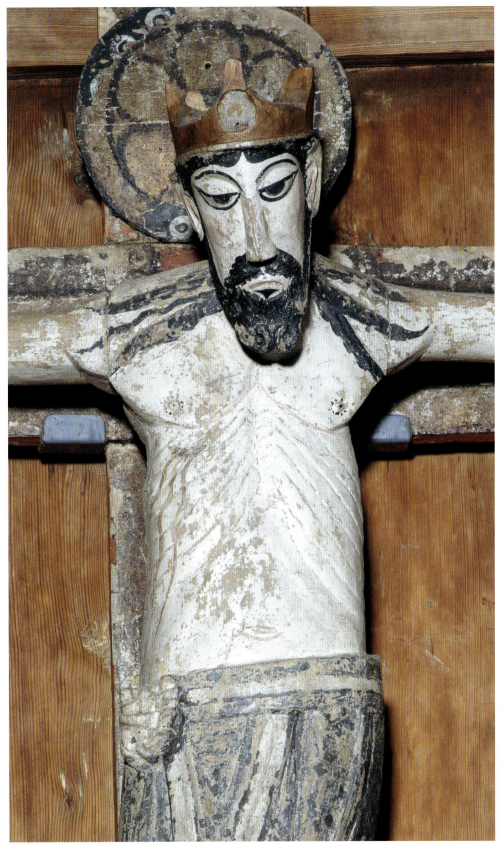

Plate 107. Crucifixion group, detail of Christ

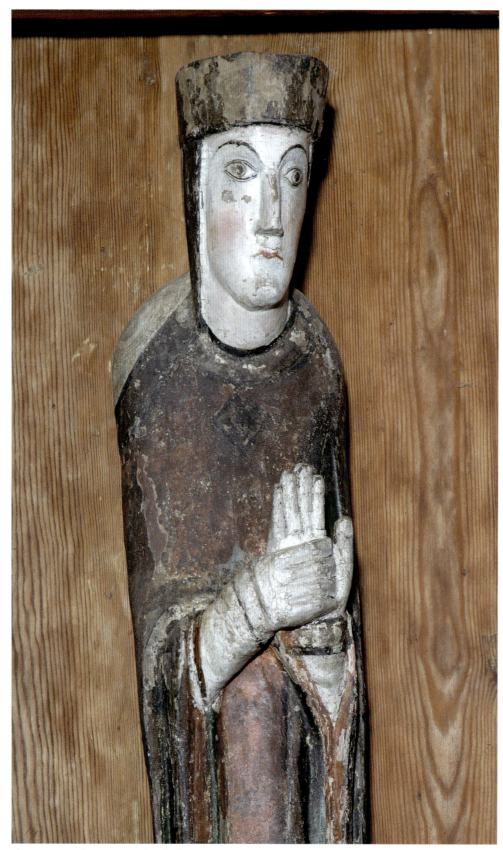

Plate 108. Crucifixion group, detail of Mary

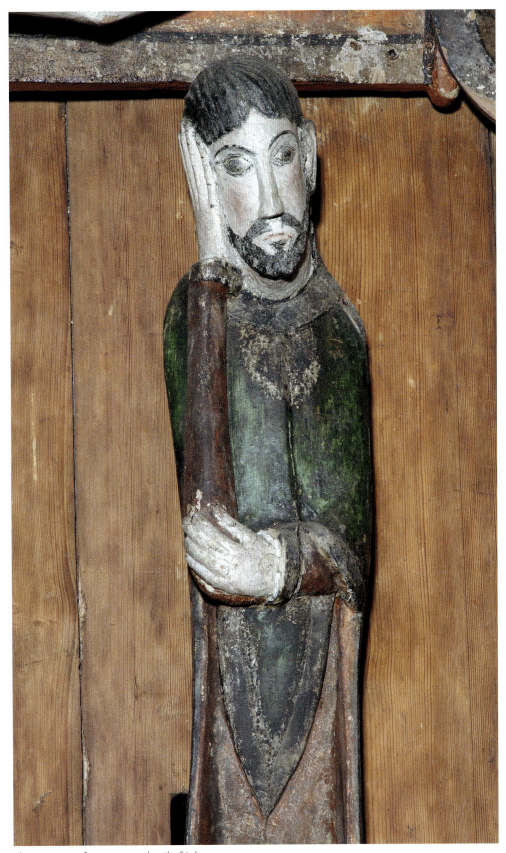

Plate 109. Crucifixion group, detail of John

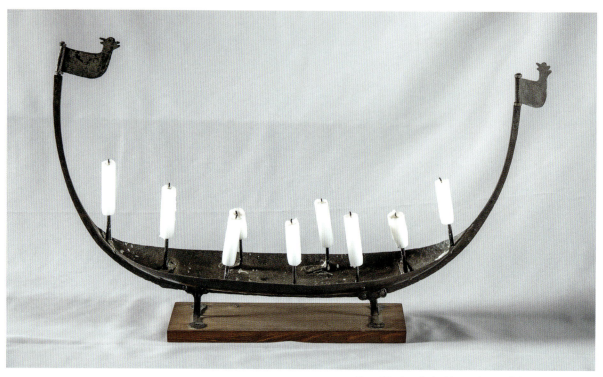

Plate 110. Candle holder in form of ship. Photo: Jiri Havran, © Fortidsminneforeningen

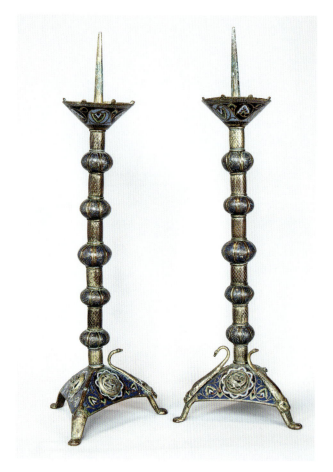

Plate 111. Limoges candle holders. Photo: Jiri Havran, © Fortidsminneforeningen

FURNISHINGS | PLATE 113

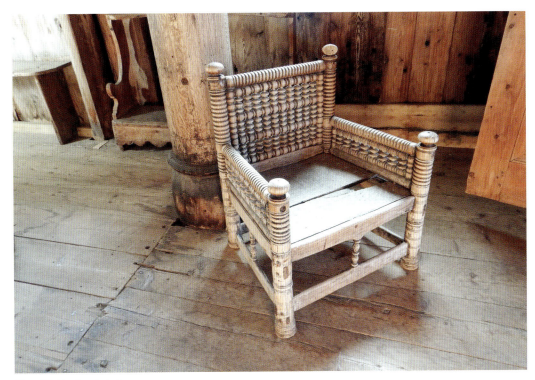

Plate 112. Medieval chair

Plate 113. Baptismal font cover

103

URNES STAVE CHURCH AND ITS GLOBAL ROMANESQUE CONNECTIONS

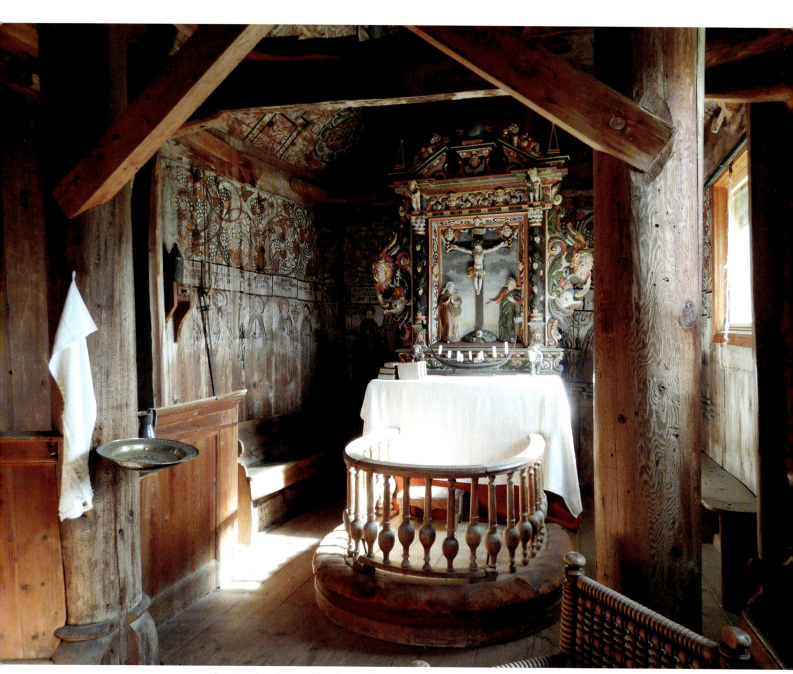

Plate 114. The altar retable of 1699, donated by the minister Jens Ørbech and his fiancée

POST MEDIEVAL CHANCEL AND FURNISHINGS | PLATE 116

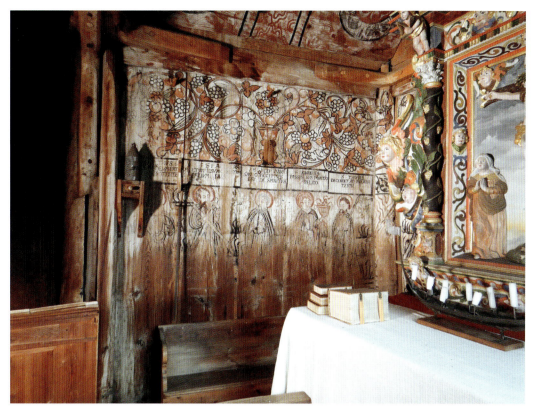

Plate 115. Painting of the apostles from 1607 on the chancel walls

Plate 116. Roof of chancel. Detail

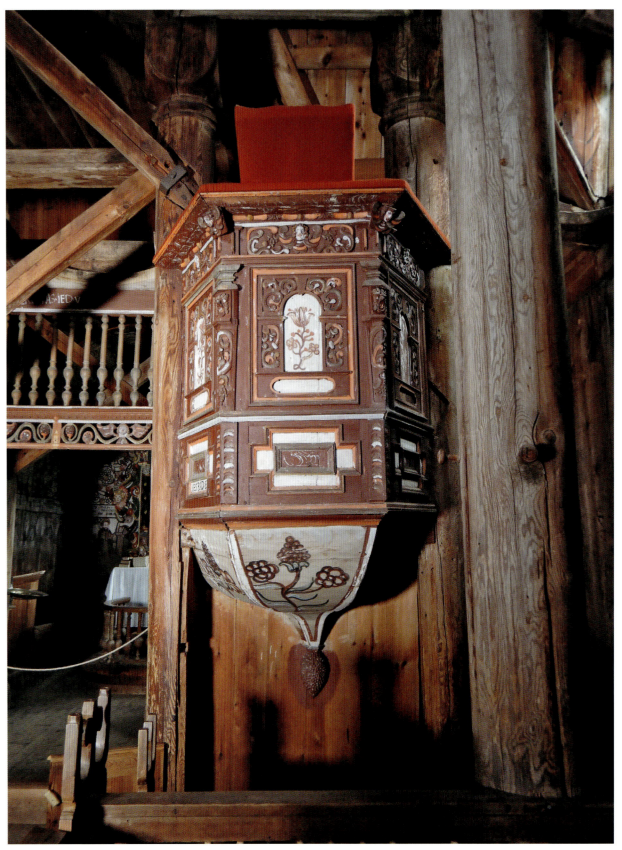

Plate 117. 1697 pulpit

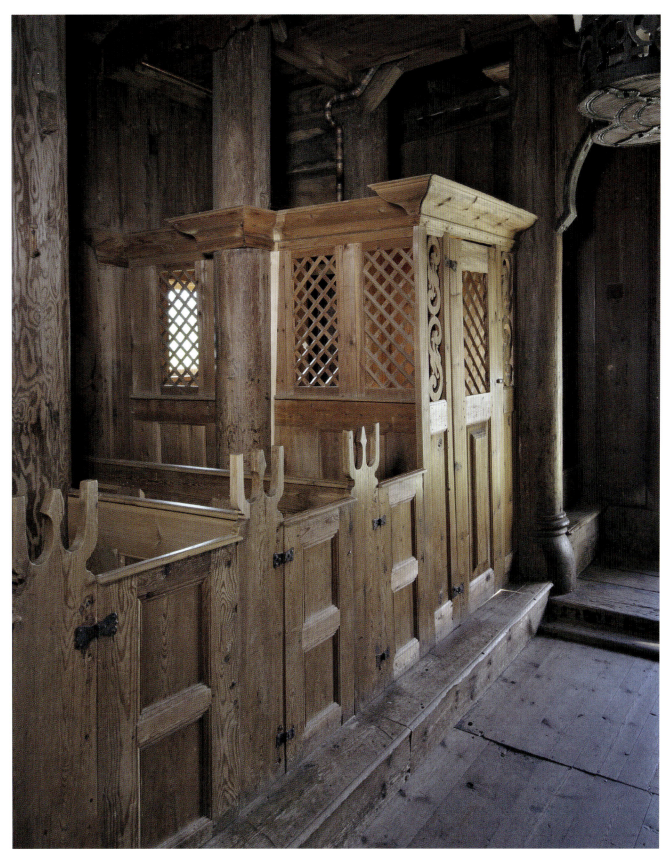

Plate 118. Post-medieval private pew

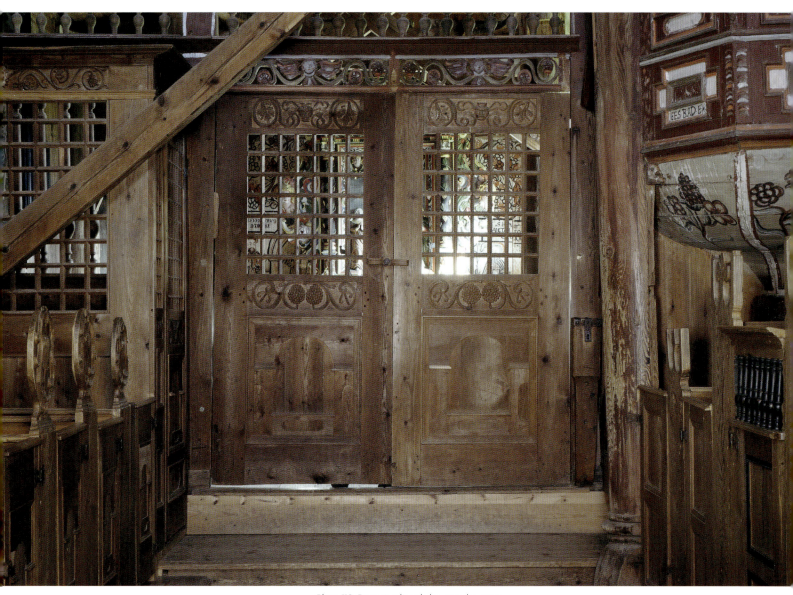

Plate 119. Post-medieval door in the nave

POST MEDIEVAL CHANCEL AND FURNISHINGS | PLATE 120

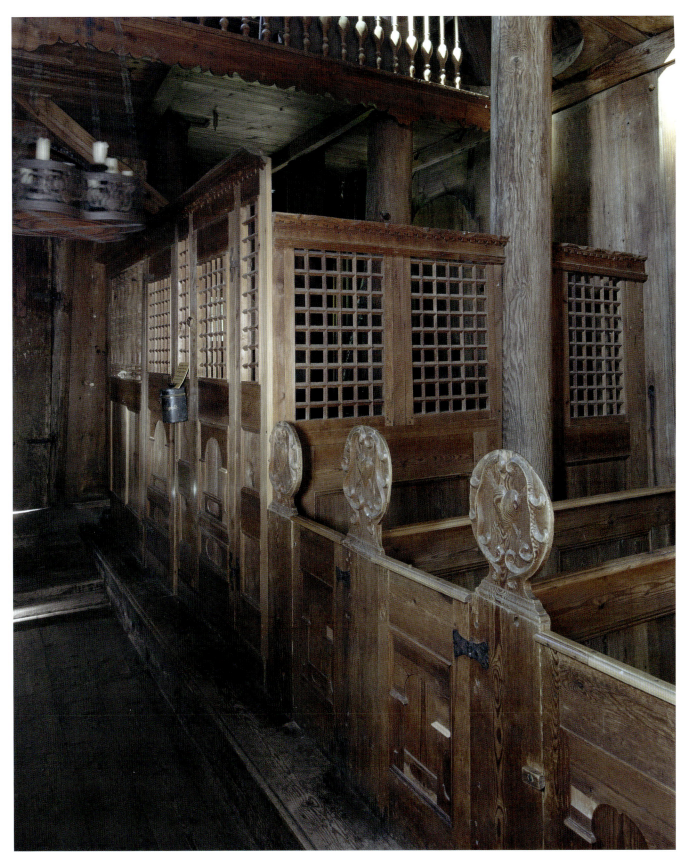

Plate 120. Post-medieval baptismal font enclosure

109

Plate 121. The Catechism retable, dated 1610

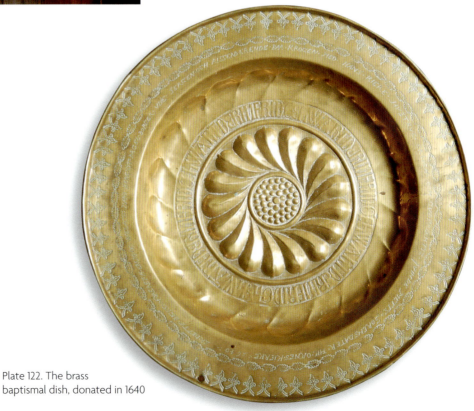

Plate 122. The brass baptismal dish, donated in 1640

POST MEDIEVAL CHANCEL AND FURNISHINGS | PLATE 124

Plate 123. Altar. Presumably rebuilt c.1600 reusing the medieval altar stones

Plate 124. The Heavenly Jerusalem, painting, donated 1663

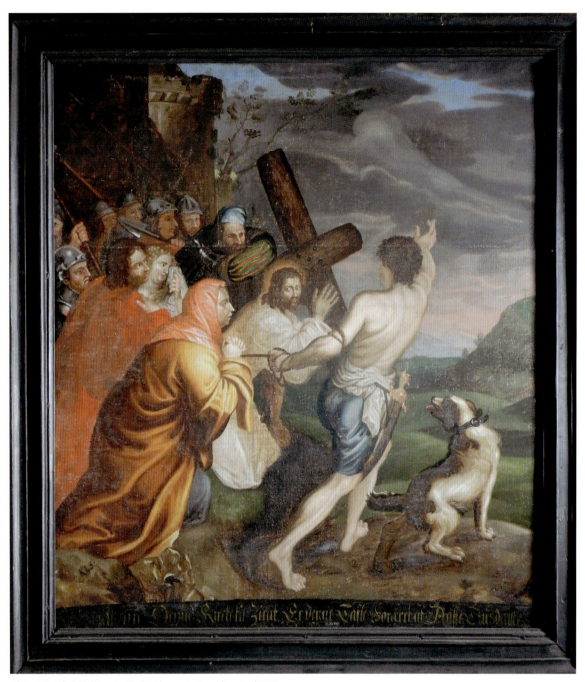

Plate 125. Christ's Way to Golgotha, painting, donated 1678

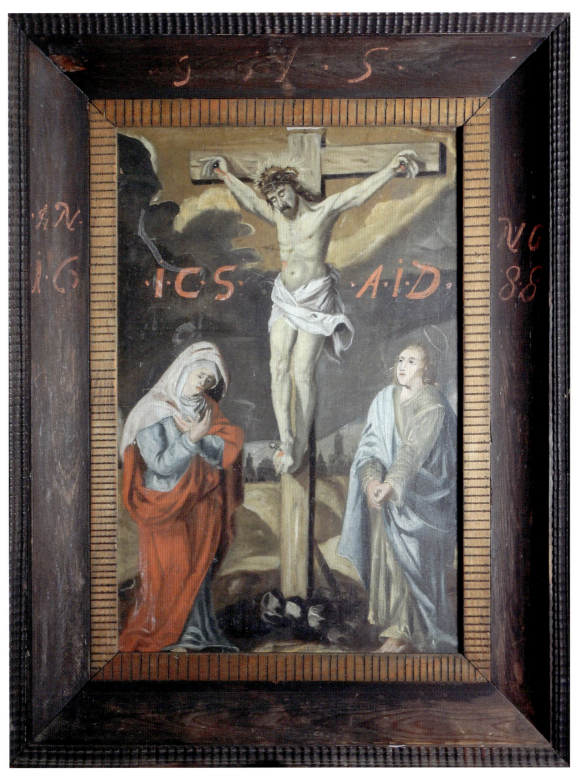

Plate 126. The Crucifixion, painting, donated 1688

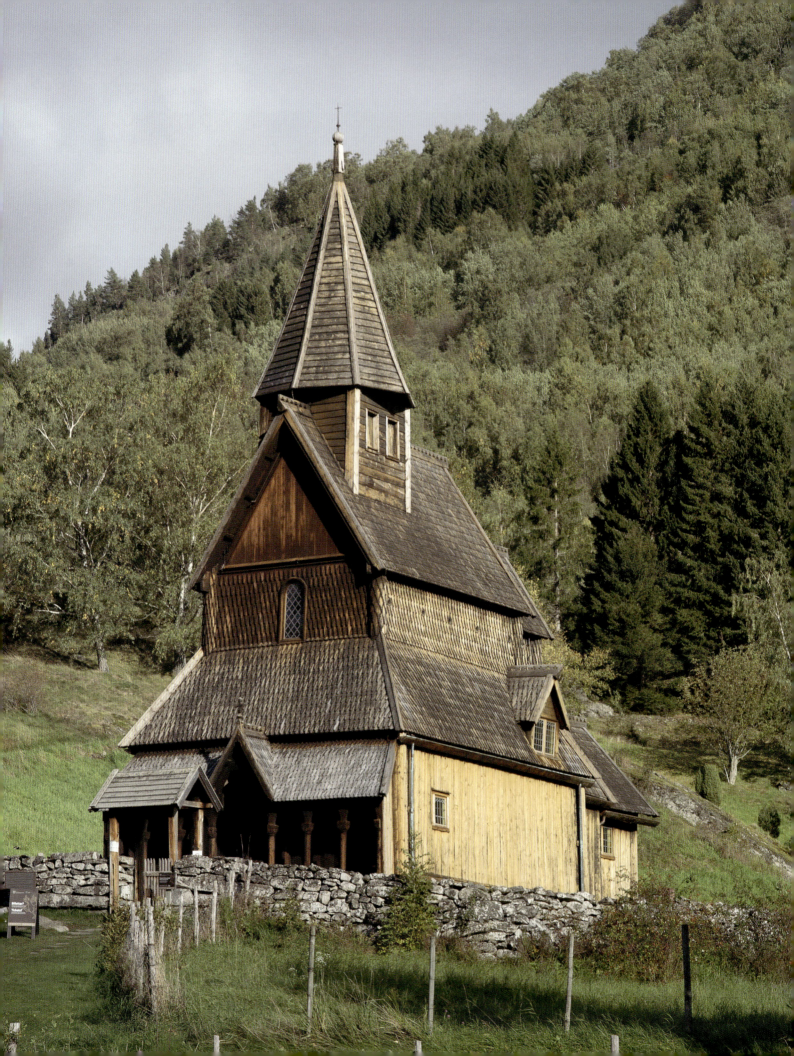

CHAPTER ONE

Urnes Stave Church: A Monument Frozen in Time?

Øystein Ekroll

Introduction

U RNES STAVE CHURCH ON THE SOGNE FJORD in western Norway enjoys a well-deserved position on the UNESCO World Heritage List, to which it was added in 1979 as the first Norwegian site together with the German Wharf area in Bergen. For nearly two centuries scholars have studied the church and its oldest, reused parts, which defined and gave its name to a whole artistic style from the eleventh century: the Urnes style. In addition to its reused components, the decoration of the standing church built in the 1130s has attracted attention, especially the carved nave capitals, which are further explored in this volume. The church's medieval furnishings, such as the Calvary group and the Virgin Mary, likewise rank among the finest preserved medieval objects in Norway.

Archeological excavations under the church floor have revealed traces of three small stave-built predecessors, and parts of the most recent of these, probably dating to *c.*1070, are incorporated into the walls of the church.[1] The location of these small predecessors dictated the location for later construction, a slightly sloping hillside that necessitated a tall foundation stone wall on the south side of the new church.

Amid the understandable interest in the spectacular carvings, the building itself, and especially its usage, has received less attention. It is worth remembering that this is first and foremost a church

Exterior view from southwest, see Plate 14.

that has been in continuous use for Christian worship for nearly nine centuries. Consideration of the ritual functions of this space raises several questions: How do the church's design and plan reflect its religious function? How was its internal space adapted to changes in use and liturgy during the medieval period? Were there side altars in the nave, and what was the original chancel screen design? What happened with the church and its furnishings during the Lutheran Reformation of 1537? What changes were made to the building over the following three centuries? What was done with the church after it became the property of the Society for the Preservation of Ancient Norwegian Monuments in 1881? This chapter examines the present Urnes church to find answers to these questions.

Urnes and the Discovery of the Stave Churches

In 1824 Jacob Neumann (1772–1848), a minister with antiquarian interests, introduced the Urnes church to a broad audience. Two years earlier he had been appointed bishop of the diocese of Bergen, which includes Urnes. Neumann was one of the two founders of the Bergen Museum in 1825 (after 1948 the University Museum of Bergen), and on visits around his large diocese he made a point of collecting historic objects for this new museum. Thanks to the efforts of Bishop Neumann, many treasured objects that would otherwise have been lost were preserved in the museum.

In a long article in the journal *Budstikken* about his 1824 visit to the churches in Sogn, Neumann described his trip to Urnes the previous year.[2] He was fascinated by the carved portals and especially the nave capitals, but he also mentions the old chair in the vestry, the Limoges candlesticks on the altar, and two paintings from 1663 and 1678. But more than the church itself, Neumann was intrigued by the legend of Hagbard (Hagbart) and Signe, tragic lovers known from medieval legends and ballads, and most of his description of Urnes concerns nearby sites that local folklore connected to this tradition. The ballad was very popular well into the nineteenth century, and many places across Scandinavia claimed to be the location for this story, including Urnes.[3] In addition to nearby burial mounds and rock formations, local tradition connected the legend with the church and its furnishings. A modern reader yearns for more hard facts about the church and its contents than the few scraps that Neumann conveys.

The remains of an ancient tapestry in the church, said to have been c. 16 m (50 feet) long originally, was called "Signe's Weave"; it is discussed in Chapter 7. By 1823 it was in tatters, and the bishop was told that long ago it was soaked with water and used to protect the church wall from a fire. Adding to the destruction of this artwork was the fact that visitors attracted by the site's legendary connections cut off pieces to bring home as souvenirs; even Bishop Neumann brought a piece of the tapestry home to Bergen.[4] In contrast to this process of destruction, local folklore likely helped preserve other objects from Urnes. The statue of the Virgin, now in the University Museum of Bergen, was claimed to be an image of Signe, and a figure of an apostle or saint was said to depict Hagbard.[5] Even though there was no historical truth to these associations, they ultimately saved the works of art and also lent the church a romantic dimension.

At the same time that Neumann came to Bergen, the slightly younger Swedish minister and poet Esaias Tegnér (1782–1846) serially published his enormously popular verse cycle *The Saga of Fridtjof* (1820–25), the narrative of which centers on Vangsnes and Balestrand in Sogn, both sites located only a short distance from Urnes. Neumann was surely aware of this work, which fired the imagination of a whole generation in Scandinavia and Germany. Tegnér was appointed bishop of Växjö in 1824, and his career in many ways closely paralleled Neumann's.

Budstikken was published in Christiania (later Oslo), the small capital of the new kingdom, which also housed the first university of Norway. Neumann's journal article brought the church to the attention of other early antiquarians and historians in Norway who then began to discover the historic monuments of the country. The landscape painter Johan Christian Dahl (1788–1857), from Bergen, who was a professor of painting in Dresden and a neighbor and good friend of Caspar David Friedrich, had seen many of these strange old "stave churches" when he traveled through southern Norway seeking inspiration for his landscape paintings. No one knew their age or who had built them, and as they were replaced by new and larger churches their numbers were rapidly shrinking. Dahl wanted to present these fascinating buildings to an international audience, and in 1836 he engaged his young German student Franz W. Schiertz (1813–87) to go to Norway and draw and survey the stave churches at Urnes, Borgund, and Hitterdal (today's Heddal).

Schiertz's lithographed drawings, accompanied by Dahl's short texts, were published in Dresden in the 1837 book *Denkmale einer sehr ausgebildeten Holzbaukunst aus den frühesten Jahrhunderten in den innern Landschaften Norwegens* (*Monuments of a Refined Wooden Architecture from the Earliest Centuries in the Inner Landscapes of Norway*).[6] In his texts Dahl drew comparisons among Urnes, Byzantine architecture, and the illustrations in the First Bible of Charles the Bald of *c*.845.[7] The book firmly established these three stave churches as the most significant ones extant, with Urnes as the oldest, Borgund the best preserved, and Heddal the largest. Urnes was presented in six plates, showing its plan, an external view of its north side, a view of the interior, three of the carved posts, the north portal, and three of the nave capitals (Figs. 1.1–1.6). The interior view shows the post-Reformation pews, but Schiertz omitted the crossing tie beams that disfigure the interior of the nave.

In 1844, at Dahl's initiative, the Society for the Preservation of Ancient Norwegian Monuments was founded in Christiania. One of its main goals was to survey medieval buildings and publish these findings. Beginning in the 1850s, old buildings, including churches, were torn down and replaced at an alarming rate all over the country. A new and more detailed survey of the Urnes church was made in the early 1850s by the architect Georg A. Bull (1829–1917).[8] In 1859 it was published in four engraved plates as an appendix to the Society's annual journal (Figs. 1.7–1.10).[9] These drawings were accompanied by texts in Norwegian and English written by State Antiquarian Nicolay Nicolaysen (1817–1911), who had not yet seen the church;[10] he later visited it on his honeymoon, in 1861.[11] Like most contemporary surveys of medieval buildings, Bull's ignored the existence of any post-Reformation furnishings, showing only the preserved medieval woodwork. He even went a step further, reconstructing the removed parts of staves as if the church were perfectly preserved, offering no hint of the existence of any post-Reformation furnishings. The first comprehensive study of the Urnes church, one that situated it in a larger context, was made by the art history professor

PART ONE | SITUATING URNES

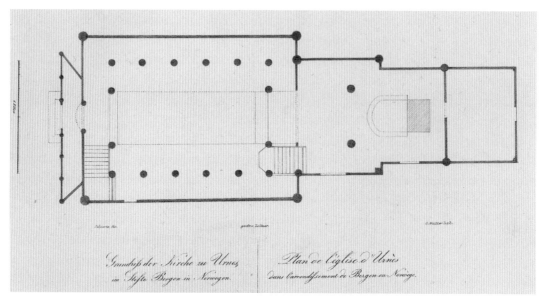

Fig. 1.1. Plan of Urnes church. Plan: F. W. Schiertz, 1836; lithograph published in J. C. Dahl, *Denkmale einer sehr ausgebildeten Holzbaukunst aus den frühesten Jahrhunderten in den innern Landschaften Norwegens* (Dresden, 1837), Tab. 1.

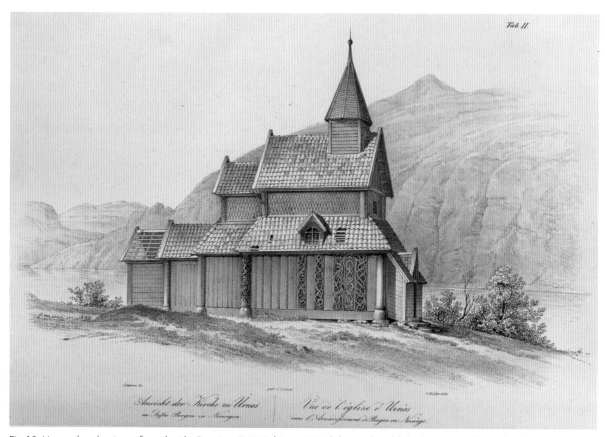

Fig. 1.2. Urnes church, view of north side. Drawing: F. W. Schiertz, 1836; lithograph published in J. C. Dahl, *Denkmale einer sehr ausgebildeten Holzbaukunst aus den frühesten Jahrhunderten in den innern Landschaften Norwegens* (Dresden, 1837), Tab. II.

CHAPTER ONE | URNES STAVE CHURCH: A MONUMENT FROZEN IN TIME?

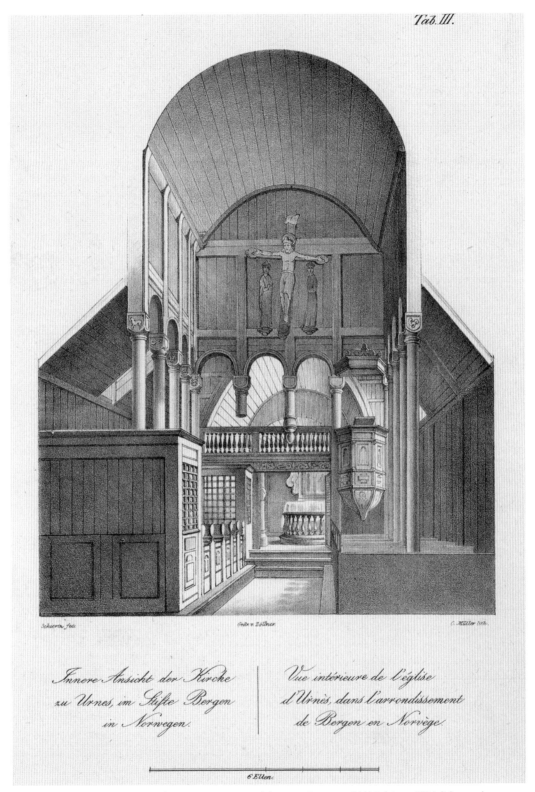

Fig. 1.3. Urnes church, section and interior view toward the east. Drawing: F. W. Schiertz, 1836; lithograph published in J. C. Dahl, *Denkmale einer sehr ausgebildeten Holzbaukunst aus den frühesten Jahrhunderten in den innern Landschaften Norwegens* (Dresden, 1837), Tab. III.

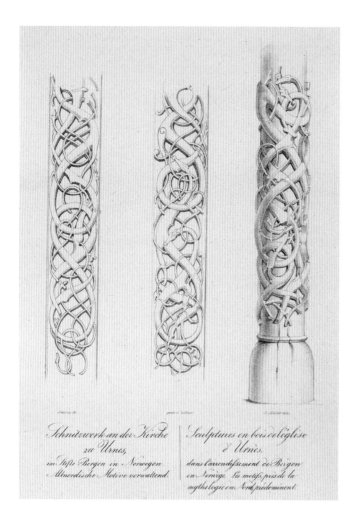

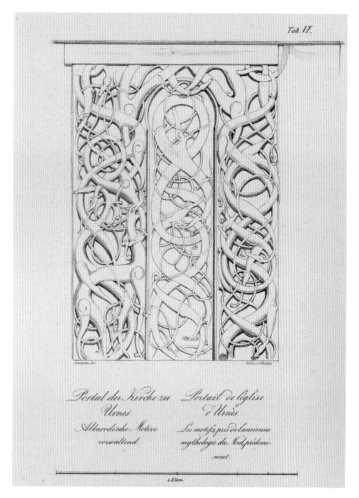

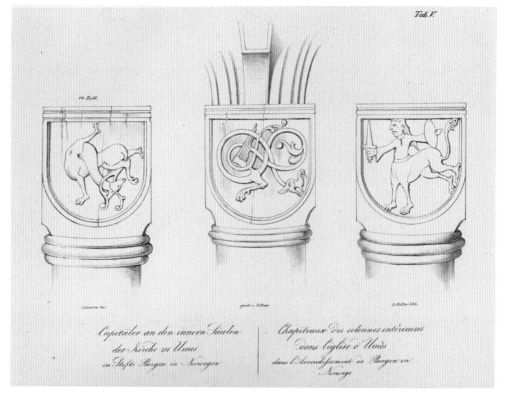

Above: Fig. 1.4. Urnes church, decorated corner post and two wall planks. Drawing: F. W. Schiertz, 1836; lithograph published in J. C. Dahl, *Denkmale einer sehr ausgebildeten Holzbaukunst aus den frühesten Jahrhunderten in den innern Landschaften Norwegens* (Dresden, 1837), Tab. IV.

Above right: Fig. 1.6. Urnes church, north portal. Drawing: F. W. Schiertz, 1836; lithograph published in J. C. Dahl, *Denkmale einer sehr ausgebildeten Holzbaukunst aus den frühesten Jahrhunderten in den innern Landschaften Norwegens* (Dresden, 1837), Tab. VI.

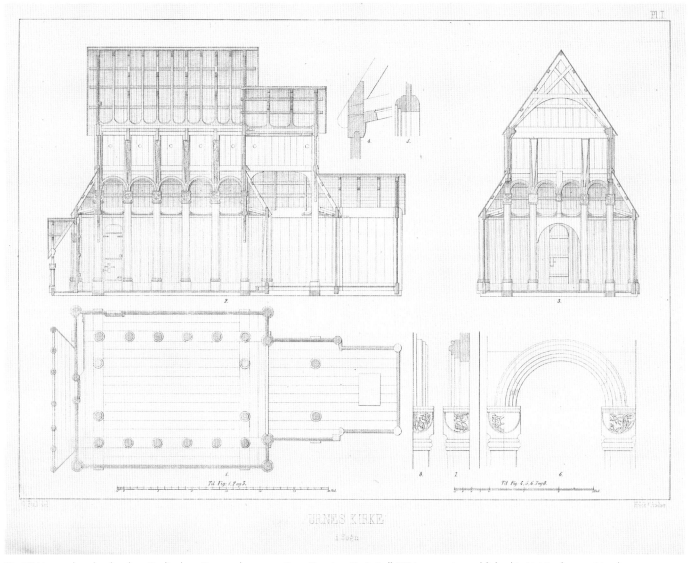

Fig. 1.7. Urnes church, plan, longitudinal section, and nave section. Drawing: G. A. Bull, 1854; engraving published in N. Nicolaysen, *Norske bygninger fra fortiden* (Christiania, 1859), Plate I.

Left: Fig. 1.5. Urnes church, three decorated nave capitals. Drawing: F. W. Schiertz, 1836; lithograph published in J. C. Dahl, *Denkmale einer sehr ausgebildeten Holzbaukunst aus den frühesten Jahrhunderten in den innern Landschaften Norwegens* (Dresden, 1837), Tab. V.

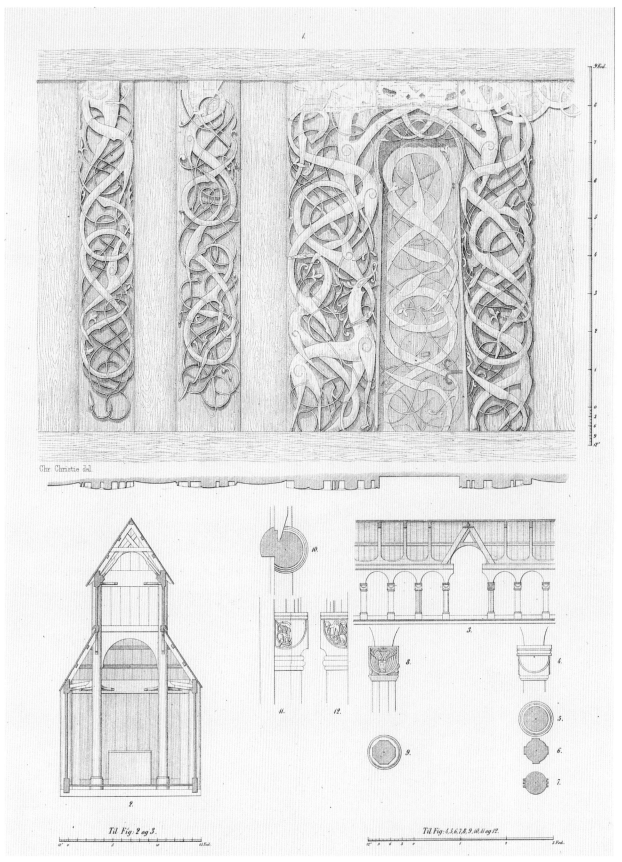

Fig. 1.8. Urnes church, north portal, chancel section, pentice, and details. Drawing: G. A. Bull, 1854; engraving published in N. Nicolaysen, *Norske bygninger fra fortiden* (Christiania, 1859), Plate II.

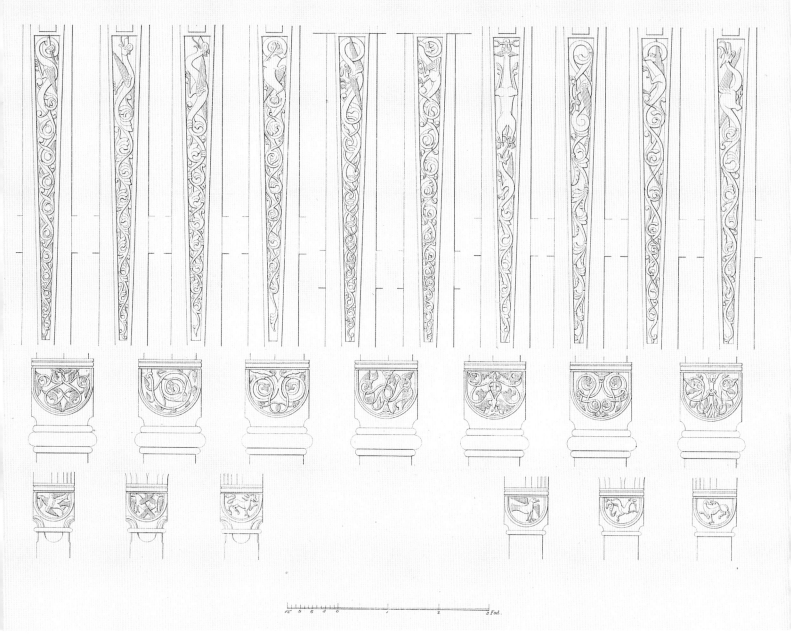

Fig. 1.9. Urnes church, decorated nave capitals and abatements. Drawing: G. A. Bull, 1854; engraving published in N. Nicolaysen, *Norske bygninger fra fortiden* (Christiania, 1859), Plate III.

Lorentz Dietrichson (1834–1917) in his seminal 1892 book, *De norske stavkirker* (*The Norwegian Stave Churches*). He gathered and analyzed all the information he could find about standing and demolished stave churches, much of it gathered from written accounts, accounts, surveys, and other sources.[12]

After the Society obtained the church in 1881, it was left unchanged for two decades (Fig. 1.11). The church was thoroughly restored and repaired between 1901 and 1907, and much new information about its construction and building history was uncovered. The architects of the project wrote an article about the work in the Society's journal, but most of the documentation was filed in the Society's archive in Oslo.[13] It was fortunate that the restoration did not begin in the 1880s:

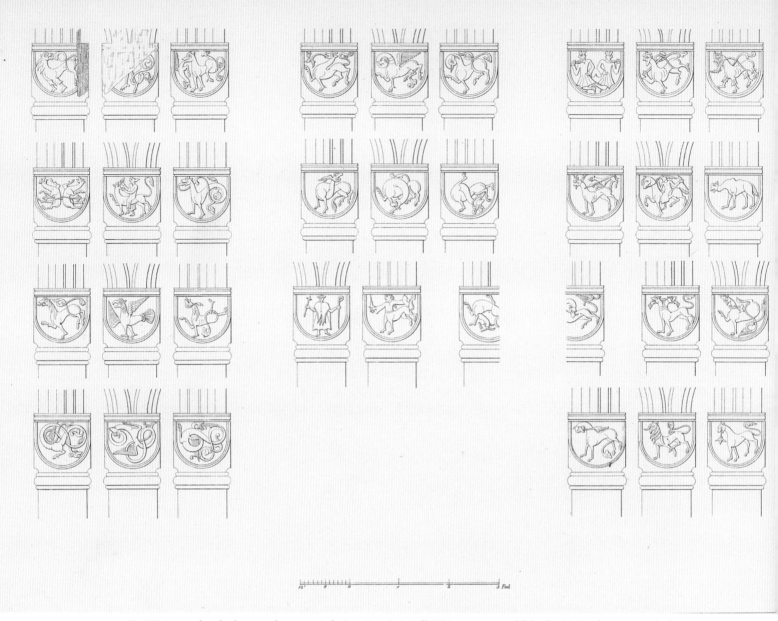

Fig. 1.10. Urnes church, decorated nave capitals. Drawing: G. A. Bull, 1854; engraving published in N. Nicolaysen, *Norske bygninger fra fortiden* (Christiania, 1859), Plate IV.

the young architects in charge of the 1901–7 work were influenced by William Morris's ideas about "repair rather than restoration," and they repaired damages rather than trying to bring the church back to its medieval appearance. The red roof tiles were replaced with tarred wooden shingles, but otherwise the external appearance of the church was left unchanged.

During the first half of the twentieth century little new research was done at Urnes. A new period of investigation began in 1951 with an excavation under the floor and a detailed survey of the entire church. This work was conducted by architects Kristian Bjerknes, Håkon Christie, and Knud Krogh, and it proceeded sporadically for several decades. The results of these investigations were finally published in 2009 by Christie, who surveyed the standing church, and in 2011 Krogh published a book concentrating on the earlier buildings on the site, including the preserved parts of the church

CHAPTER ONE | URNES STAVE CHURCH: A MONUMENT FROZEN IN TIME?

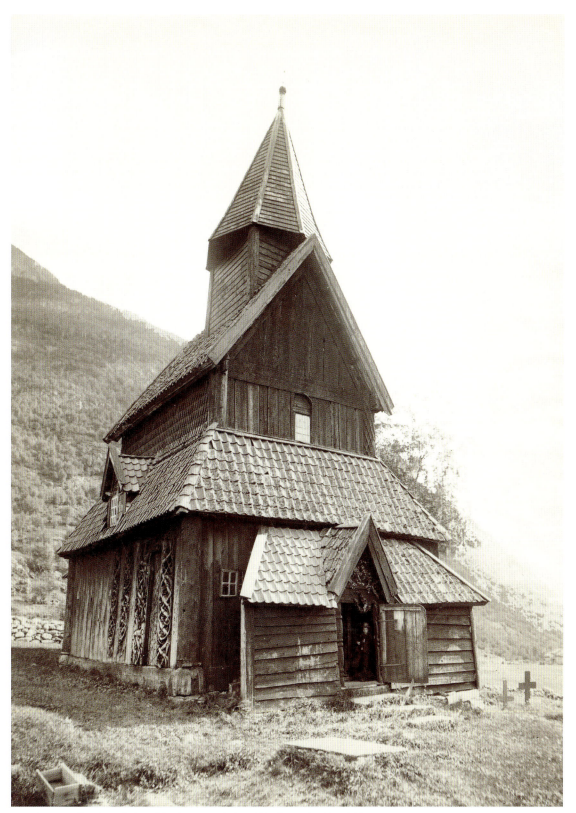

Fig. 1.11. Urnes church, *c.*1890, still looking as it did in 1823. Photo: Axel Lindahl.

from *c.*1070. Finally, in 1975 Erla Bergendahl Hohler published a substantial article on the capitals, which was followed in 1999 by the two-volume *Norwegian Stave Church Sculpture*; both remain critical reference works for the carved decorations.[14]

The dates of the various parts of the Urnes church have long been hotly debated. Early authors like Dietrichson often dated the standing church to the late eleventh century,[15] whereas the art historian Anders Bugge in his 1953 book *Norske stavkirker* (*Norwegian Stave Churches*) dated it to 1125–40.[16] In his large, two-volume *Norske stavkirker* (*Norwegian Stave Churches*) of 1973–76, State Antiquarian Roar Hauglid stated that it was built *c.*1200 or later.[17] The development of the dendrochronological method put an end to this debate, securely dating the standing church to the early 1130s and its immediate predecessor to *c.*1070.

The Church Today

The church and its adjacent churchyard are still used by the local community, and, at first glance, the church gives the impression of being frozen in time, as there are no noticeable changes from the past two centuries. An examination of the church's history during the past two hundred years reveals, however, that it has been subject to several changes and modifications to bring it more into accordance with what was understood to be its historical appearance, especially after the Society for the Preservation of Ancient Norwegian Monuments became its owner in 1881. At that time the church was in bad repair, and the Society conducted a thorough restoration and repair of the church during the years 1901–07.

The oldest known picture of the church, the 1837 lithograph by Schiertz, shows it from the north (Fig. 1.2). Its roofs are covered with red tiles, a window is inserted in the north aisle roof, a sacristy with a dilapidated roof stands east of the chancel, and the pentice on the west facade is covered with planks to protect it against the elements. The sacristy was torn down soon after.[18] Between 1901 and 1906 the roof tiles and the north window were removed, and the roof was covered with tarred shingles and carved roof ridges to make it look more medieval. The western pentice was "liberated" of its protective cladding and two of the three small windows in the south wall of the nave aisle, which gave light to the pews, were closed.[19] Fewer changes were made internally, but some of the medieval furnishings were transferred to the Bergen museum, depriving the church of some of its medieval opulence and historical context.

Most of the post-Reformation furnishings are preserved, probably because the church continued to be used by the local community for burials and weddings after 1881. At Borgund stave church, which the Society bought in 1879, a new church was erected alongside and the old church was almost completely cleared of its post-Reformation furnishings, leaving only the pulpit and the altar retable in an otherwise barren church. If a new church had been built at Urnes, there is every reason to assume that the pews, gallery and other post-Reformation furnishings in the old church would have been removed to make it as "medieval" as possible. Fortunately, Urnes was saved from this fate.

The Medieval Church

The first written mention of the church "á Ornesi" dates to 1322–23 when its priest, "sira Ærlender," is mentioned in a document,[20] but what saint it was dedicated to is not recorded. Otherwise, only some building accounts from the late seventeenth and early eighteenth centuries give information about the church before it was "discovered" by Bishop Neumann in 1823. The information is also scarce for the next half-century until it was donated to the Society for the Preservation of Ancient Norwegian Monuments. Christie's thorough investigation and documentation of the church's walls over five decades have revealed numerous clues about how its exterior and interior appeared during the Middle Ages.[21] Ever since the first surveys were published in 1837 and 1859, there has been a continuous debate about the medieval appearance of the church.

In 1721 the whole church was still surrounded by a 1-m-wide pentice, of which only the part in front of the west facade is preserved today.[22] This consists of an open arcade of eight shafts with seven round-headed arches. The shafts have bell-shaped bases and cushion capitals, making this side of the pentice almost contemporary with the church.[23] However, the support of the lean-to roof was cut into the wall planks in a way that shows it was not an integral element of the original plan.[24] The pentice could have functioned as a kind of narthex, sheltering the various liturgical rituals taking place in front of the portal. The pentice roof protected the aisle walls against rain and snow and helped preserve the north portal for centuries, but it also obscured the view of the portal, leaving its upper part in darkness. The gable of the western pentice is a later addition; originally, when the pentice was in place, the upper part of the western portal would not have been visible from outside.[25] Excavated foundations for pentices on the north and south sides of the nave and chancel prove that they existed,[26] but whether these were later additions is uncertain.[27] Under the floor of the seventeenth-century chancel extension, the sill-beam of the east pentice is still preserved as part of the foundation of the stone altar.[28] It is possible that the large, open pentice arches were only used on the west side and that the rest of the pentice had a wall filled with planks and a small open arcade like the one at Borgund and many other stave churches. In addition to protecting the walls, the pentice provided a processional pathway during the winter season, with its deep snow, and people could gather there if the church was full.

The question of whether the chancel originally had an apse has been fiercely debated.[29] The latest investigation concludes that the chancel did not originally have an apse, but one might have been added in the thirteenth century. If so, it disappeared no later than $c.1600$ when the chancel was extended eastward.[30] Some other stave churches do have apses, such as Borgund and Hopperstad, but it is generally assumed that they were added later and had no liturgical function. These apses supported small turrets, and they resemble small versions of the Nidaros Cathedral octagon, built $c.1220–20$, which was probably the inspiration for these turrets.[31] If an apse did exist at Urnes before $c.1600$, it was a secondary addition. The remains of the old east wall preserved under the floor reveal no indication of an apse, and the original chancel was probably square, as at the Kaupanger church.

In addition to entering via the two portals, daylight was originally admitted to the interior only by the small circular openings (diam. 14 cm) in the upper "clerestory" walls, five on each side of the nave and two on each side of the chancel (Plate 37). The pentice precluded any openings for light in the

ambulatory walls. The large roundheaded window opening in the west gable wall might be medieval, but it is not as old as the 1130s;[32] it probably dates to the fifteenth or early sixteenth centuries. Light was also provided by two Limoges candlesticks on the altar and the ship-shaped candle-holder (both discussed below) that probably stood on one of the side altars in the nave.

The bell turret on the nave roof is first mentioned in 1661, but it was repaired or rebuilt in 1686, 1702, and 1771. During repairs in 1902, the architect found no traces of a medieval bell turret.[33] In the Middle Ages a bell tower was situated on the small hill just northeast of the church, which is still called Støpulhaugen (Bell Tower Hill).[34] A medieval, freestanding stave-built bell tower is still preserved at the Borgund church, and a construction of similar design probably stood on Bell Tower Hill at Urnes. A freestanding tower with two bells is depicted on the Skog Tapestry from northern Sweden, which is dated to the thirteenth century.[35]

Urnes likely possessed several bells before the Reformation, but only one is preserved (Fig. 1.12). It probably dates to the late Middle Ages and is decorated with a series of fourteen heraldic shields or badges, among them the arms of several northern German towns and of the Norwegian monarchy.[36] This is a very uncommon type of decoration for church bells in Norway, and it is possible that the bell was a gift from a group of people connected with those places. These badges could have been the private collection of the bell founder, however, used purely for decoration. During the later Middle Ages a small Prime bell was often hung above the chancel, but at Urnes the roof construction shows no trace of such an arrangement.

The church has only two portals, both providing access to the nave. The famous north portal will not be dealt with here, but its opening is 250 cm tall and only 70 cm wide; the sill-beam is 45 cm high. Like the pentice and the nave arcades, the west portal is decorated with shafts, bell-shaped bases, and cushion capitals. The west portal arch is decorated with a molding, but there are no sculptures or floral decorations. The portal opening is 250 cm tall and only 80 cm wide, and in order to enter the church one has to step over the 45-cm-high sill-beam. Surprisingly, there is no trace of a south portal or one in the chancel.[37] In Norwegian medieval churches, both stone and stave, the nave usually has two or three portals and the chancel has a south portal for the priest. It seems to me that churches without a chancel portal are often, if not always, built as private manor churches. In such cases, the priest appears to have been a part of the household and thus did not require a separate entrance. There are no written sources for this phenomenon, but it seems to have been common in twelfth-century Norway.[38]

The sloping terrain toward the south might explain the lack of a south portal in the nave, but given that there was a pentice, there could also have been a portal on this side. The north portal is so narrow that it was difficult to use, so the west portal must have been the main entrance to the church. The manorial buildings probably stood on the more level terrain to the south or west of the church, but this area has not been excavated. In 1907 a small medieval gravestone made of steatite was found a few meters from the northwest corner of the nave. It is trapezoidal in shape, only 59 cm long and 24–32 cm wide, and its sole decoration is a ringed cross carved into the surface. The stone is now fastened to the west wall of the nave under the pentice (Plate 20).

CHAPTER ONE | URNES STAVE CHURCH: A MONUMENT FROZEN IN TIME?

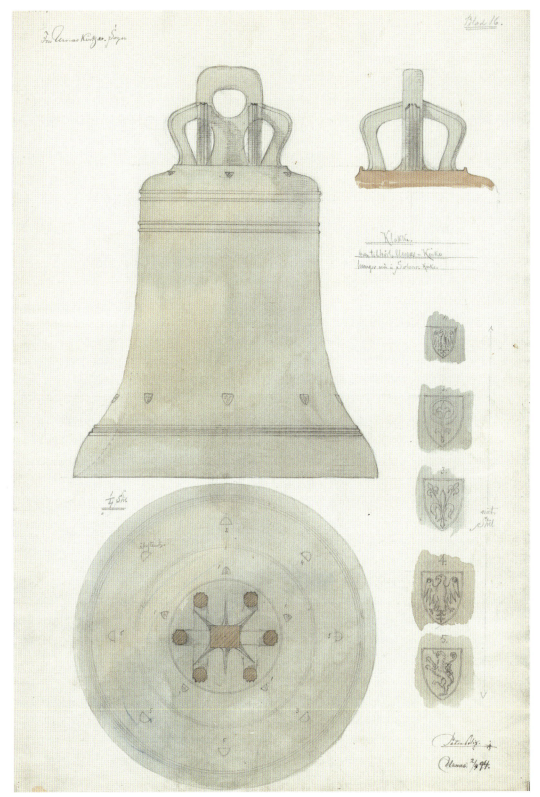

Fig. 1.12: Urnes, late medieval church bell, decorated with heraldic shields and badges. Drawing: Peter Andreas Blix, 1894.

The Medieval Interior

The interior of the church has been subject to more changes than the exterior. Today the nave is filled with post-Reformation furnishings, such as pews, a gallery, and a pulpit, which make it difficult to study many parts of the interior. During the medieval period the nave was a more open space, but it was not empty. The sixteen posts or staves that support the nave roof interrupt the inner space. The nave's roof construction, now hidden by a wooden barrel vault, was originally open to the rafters, making the central room 10.5 m high. The only daylight came through the small ocular windows between the staves, 6.5 m above floor level (Plate 37). The carved capitals stand 4 m above the floor, so their decoration would normally not be very visible in the semidarkness of the room, but when the doors were open and candles were burning, the carvings would come to life (Plate 34). A wrought-iron chandelier mentioned in the 1686 inventory belonged to a group of medieval iron chandeliers in Norway, but it does not seem to have survived. The iron chandelier that hangs in the nave today seems to be a modern reconstruction from *c.*1900, but it may be a restoration of the old one.[39]

The nave has always had a wooden floor consisting of thick, heavy planks fastened with wooden pegs, and most of the medieval floor is still preserved under the current one. In the central space the floor level was 20 cm below that of the aisle, and it is possible that this ledge or step was also used as a bench to sit on, as the edge has a molding. The different floor levels indicate that the central space and aisle served different functions.

Many stave churches have low wooden benches along the aisle walls, notched into the floor and the sill-beams. It is assumed that they were intended for the old and infirm. There are no written sources for this phenomenon, but it appears to have been common in twelfth-century Norway. On the west wall of the nave Urnes has preserved a 35-cm-high wall bench resting on brackets, and there are traces of a similar bench along the north aisle wall. Christie assumes that there were also benches along the south wall of the nave, but here the wall sill and its adjoining floor planks are renewed and all traces have been lost.[40]

The aisle wall planks contain considerable medieval graffiti, but there are no indications that the walls had painted decorations. The aisle wall-plate (*stavlegjen*) has a number of iron hooks and notched wooden pegs that were clearly intended to carry the wall hangings or tapestries that were put up for feast days and other special occasions.[41] Similar hooks and pegs are found in many stave churches, such as Hopperstad, were they were first noticed and interpreted by Peter Blix in the 1880s. The tapestries hung more than 2.5 m above floor level, so their motifs were not very visible unless candles were lit. The use of textiles is further discussed in Chapter 7.

The medieval font at Urnes has not survived, but its wooden lid now hangs on the south nave wall (Plate 113). It is quadrilobed with rope moldings dividing the lobes, suggesting that the font had the same design.[42] On stylistic grounds it can thus be dated to the thirteenth century or somewhat later.[43] The head of a monk or deacon, now in the University Museum of Bergen, served for a long time as the knob for lifting the lid.[44] After the Reformation the font stood in the separate enclosure under the gallery in the northwest corner of the nave (Plate 120). A small window was cut into the west wall to provide some daylight. This may also have been the font's position in the medieval

period, as it may have been placed in the corner between the two portals so that baptism could take place just inside the church.[45]

The Lutheran Reformation replaced the medieval practice of immersing the child three times in the water with affusion, that is, the minister scooping three handfuls of water over the child's head; this is still the practice in Norway. Most of the medieval fonts were discarded and replaced by metal dishes better suited for the new method of baptism. In the seventeenth century the medieval Urnes font was replaced by a brass dish placed on an iron ring, today positioned in the choir. Archaeological investigations in some Danish stone churches have shown that the medieval baptismal font was prominently placed in the middle of the nave floor.[46] At Urnes, much of the original nave floor is preserved and displays no traces of a font, but this possibility cannot be completely dismissed if the font was made of wood, like many Norwegian examples.

When one enters the church through the west door, the east wall of the nave immediately commands attention. The original chancel screen is not preserved, but based on what we know from the neighboring Hopperstad church—whose chancel screen dates to the 1130s—it is likely that the one at Urnes was filled with planks and had a central door. It may even have been altered in the thirteenth century, like the one at Hopperstad, where a row of small arches was cut into the wall flanking the entrance to provide a view of the altar.[47] In front of the screen wall, two semicircular steps (sing. *gradus*) led up to the door, and this small podium was where the priest delivered his sermon in the Middle Ages and was the location for performance of the Gradual.[48] The choir-screen portal has only left traces in the sill-beam, but it may well have been designed like the west portal of the nave, with semidetached shafts, cushion capitals, and a molded arch.[49] The door would normally be closed, but it was kept open during mass, like its seventeenth-century replacement in the church today.

At a later date, perhaps around 1200, two side altars were inserted toward the east wall of the nave, flanking the choir-screen door (Fig. 1.13). Both altars were removed after the Reformation, but sufficient traces are preserved to give a good idea of their original design.[50] They were not identical, which may indicate that they were built at different dates. The wooden statue of the Virgin now in the University Museum of Bergen would have stood on one of these side altars. This statue is dated to the last third of the twelfth century,[51] indicating when one of the side altars was constructed, and its height suggests that it stood in the north altar niche. The wooden head of a deacon saint that was later placed on top of the font cover, probably St. Stephen or St. Lawrence (also in the Bergen museum), might have belonged to a statue standing on the south altar.[52]

The construction of the north altar demanded a major intervention in the construction of the church, and it seriously weakened the building's stability. Two of the large staves, one of them a corner post, were cut *c.*3 m above floor level, and the remaining parts rested on inserted beams. In the void thus created, a wooden tabernacle was inserted. This was shaped like a miniature church, measuring 2.35 × 2.30 m, with sill-beams, plank walls, and a pointed roof. It was divided into two small "rooms" separated by wainscoting or a balustrade.[53] A step led up to the altar table, which was made of wood and measured *c.*100 × 90 cm. Traces of paint show that the tabernacle was decorated, and it seems to be a close parallel to the preserved north altar in the nave of the Hopperstad stave church.

PART ONE | SITUATING URNES

Fig. 1.13: Urnes church, reconstruction of traces of side altar outlining dimensions of the north altar. Drawing: Håkon Christie, *Urnes stavkirke: Den nåværende kirken på Urnes* (Oslo, 2009), 220.

The side altar on the south side was smaller. It was inserted between two staves cut back to create space for a 110-cm-wide and 100-cm-deep niche. The altar was placed toward the east wall of the nave. A rebate was cut into the staves, showing that the niche had plank walls on each side and was covered by a wooden vault. The difference in size and design of the side altars indicates that they were not contemporary; if this had been the case, they would surely have been more uniform in size and design to give the chancel wall a more harmonious impression. It is possible that the older church from *c.* 1070 also had side altars. Krogh interpreted the dripping of wax and some scorched patches on a reused sill-beam as traces of an altar,[54] but in my opinion this evidence is far too circumstantial to permit such a conclusion.

The painted roof of a church model with a turret seems to belong to a group of small church models that crowned the tabernacles of statues of saints (Fig. 1.14). This model could have crowned the tabernacle on one of the altars at Urnes.[55]

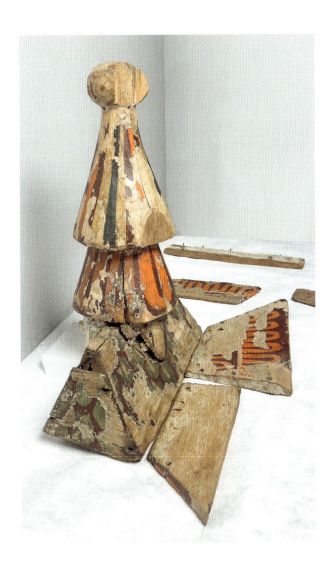

Fig. 1.14: Roof of a medieval tabernacle model, probably decorating the top of an altar retable. University Museum of Bergen. Photo: Elisabeth Andersen.

The Chancel

Before its extension 2.5 m eastward around 1600, the chancel was almost square, and it was large enough to require two roof-supporting staves flanking the altar. After the extension, the altar was moved and rebuilt farther east (Plate 123). It was probably a stone-and-mortar construction even before 1600, the only one in the church. In the Borgund stave church the medieval stone altar is preserved, but this consists of two large soapstone ashlars with a single slab on top. The wall planks of the south wall at Urnes show traces of a cupboard for the altar utensils, books, and other objects.[56]

On the Urnes altar stood two exquisite thirteenth-century Limoges candlesticks made of copper and enamel (Plate 111).[57] They are mentioned in the 1686 inventory and probably belonged to the church from the time of their manufacture. Today a medieval wrought-iron candle holder in the form of a ship, with spikes for nine candles, stands on the altar (Plate 110).[58] A similar "candle-ship" in the Bergen museum comes from the neighboring stone church at Dale, but it has only three candle spikes. The bow and stern of the Urnes candle-ship have small weather-vanes with animal heads similar to those of real vanes found on some church spires. The Urnes weather-vanes are strikingly similar to the one dated *c.*1300 from the Norderhov church.[59]

The chancel also contains a splendid chair constructed of turned posts (Plate 112). There are several parallels, chairs as well as benches, preserved in Sweden and Germany and usually dated to the twelfth or thirteenth centuries.[60] Chairs like these were very rare, and if it was indeed made for the church, the chair would have been the seat of the bishop during visitations. Alternatively, this could have been the Urnes magnate's private seat in the nave, later moved into the chancel for the use of the clergy.

The medieval altar decoration is unknown. Originally only two candlesticks and a cross stood on the altar, but in the later Middle Ages there would have been some sort of retable or figure of a saint standing on the altar as well. The altar front was probably covered by a painted frontal. Several such frontals are preserved from neighboring churches, so there is every reason to assume that each of the three known altars at Urnes had one. The high altar was probably also covered by a decorated wooden canopy shaped like a barrel vault, like the one from the Årdal stave church in Sogn, today in the University Museum in Bergen, which is dated between 1300 and 1350.[61]

The Post-Reformation Church

Compared with many European countries, the Lutheran Reformation of 1537 in Norway was a rather benign affair. Not a single person was killed, and the policy of King Christian III was to not rock the boat and provoke popular feelings. The Catholic bishops were arrested and the monasteries closed, but this affected relatively few people. All parish priests were permitted to continue in their position as long as they accepted the new religious system, and the vast majority of them agreed to do so. Some of the liturgy, such as masses for the dead and the veneration of saints, was removed, but the whole process was more a reform than a revolution.[62]

There was no iconoclasm in Norway, but most of the medieval furnishings were gradually replaced with new ones as fashions changed and objects and textiles wore out. In places like Urnes, a church with a small congregation without a resident minister and with a Sunday service perhaps only once a month, there was less wear and tear on the furnishings and less need for new things than in larger churches with weekly services. The Lutheran ministers were often affluent and gave gifts to their churches, and other wealthy families in the parish also donated works of art or furnishings. Despite the many studies of the Urnes church, very little research has been done on its post-Reformation furnishings, and this material tends to be neglected in the literature. Sources before the nineteenth century are scarce, but accounts preserved from 1678 to 1722 give valuable insight into the modernization of the church.[63]

Transforming a Catholic Church into a Lutheran Church

The transformation of the Church lasted several generations, and it took more than a century and a half before it was completed. The Sunday service was the focus of the new Lutheran denomination. The written sermon lasted much longer than the short Catholic sermon, and it was combined with baptisms, weddings, and funerals. In order to better address the congregation, a raised pulpit on the south side of the nave was introduced into churches. A canopy above the pulpit acted as a primitive loudspeaker for the minister, and a window was opened in the south wall to give him reading light for his sermon.

This arrangement was already ordained in the 1540s by Peder Palladius, the foremost Lutheran reformer in Denmark and superintendent of Sjælland (Zeeland), which included Copenhagen, the joint capital of Denmark and Norway. In his Visitation Book, Palladius gave advice to congregations on how to deal with new practical and liturgical matters, and his advice became the guide for all churches in the united kingdoms.[64]

In seventeenth-century Norway, churches were made to reflect the state's conception of an ideal society in which every member had a place according to gender, age, and social standing. Every able person was expected to attend the Sunday service, and repeated absence was admonished by the minister. To keep order and make people hold out during the long service, benches and pews were gradually introduced on both sides of the nave. At first families sat together, but beginning in the mid-seventeenth century the genders were separated, with men and boys on the south side and women, girls, and small children on the north. Each family was seated according to their social standing, with the richest farming families seated closest to the altar. The few families belonging to the local gentry owned closed family pews, isolating them from the commoners, or they were seated in the choir with the minister's family to maintain social distance.[65] At Urnes, the minister's family occupied a pew inside the chancel while the secular gentry built pews in the nave, one in the northeast corner and one under the gallery.

The choir was extended *c.*1600, and in 1607 the walls were painted with figures of the twelve apostles below floral motifs with grapes and vines (Plate 115). The flat ceiling was also decorated (Plate 116). An altar was soon placed below (Plate 123), and when the communicants knelt at it, they joined the circle of the apostles around Christ. The retable of this altar, dated 1610, is the oldest item in the Lutheran inventory; it was rediscovered and restored in the 1980s (Plate 121).[66] It is decorated with text only, in gold letters on a black background. The text is the Lord's Prayer and the introduction to Communion, the most important words spoken by God and thus a symbol of his presence. Only the central panel is preserved, but it probably had wings or doors that contained more text. These so-called catechism retables were popular in Norway from the 1590s to the 1630s, and they reflect the early Lutheran dislike of images.[67]

In 1640 the Bergen citizen Berendt Nagel, who resided at nearby Kroken, and his wife, Mette Sørensdatter, donated a brass baptismal dish, which was made in Germany or the Low Countries; an inscription commemorates their gift (Plate 122).[68] By this time the medieval font had gone out of use. In 1648 Simen Nielssøn and Karen Christophersdatter donated a new silver-plated chalice and paten, and their names and the year are engraved on the chalice.[69]

The size of the Urnes population increased during the seventeenth century, and more space was necessary. In order to seat them all, a gallery was built across the western end of the nave (Plate 35), and young and unmarried people were seated there alongside those who did not own land. Most of the current furnishings were installed in the 1680s and 1690s. Some replaced older and more temporary furnishings so that the church interior appeared more harmonious.

In 1660 King Frederik III made himself an absolute monarch, crushing the political power of the nobility. This led to increased state intervention in all matters, including the Church of which the king was the head.[70] Royal officials checked the accounts of the churchwardens and made regular visits to ensure that churches were properly maintained and their income not squandered. These accounts are an invaluable source for ecclesiastical history. After 1660 merchants and royal officials, such as ministers and bailiffs, became patrons of local churches, and almost all new acquisitions were gifts from members of this group. Unlike in the medieval period, these gifts almost always contain inscriptions identifying the donors.

The accounts from 1678 onward give a good impression of the effort that was made to bring the Urnes church up to date. The choir-screen door was widened somewhat in 1663,[71] and in 1699 the present choir screen with two doors and a balustrade was made (Plate 119).[72] That same year, the minister Jens Ørbech and his fiancée donated a new carved and painted altar retable made in Bergen, depicting the Crucifixion (Plates 33 and 114).[73] At 202 cm tall and 154 cm wide, it dominates the small chancel.[74] There was surely a connection among these works, as the new choir screen gave an improved view of the altar. To make room for the retable, the chancel's flat ceiling was made into a wooden barrel vault,[75] and the window by the pulpit was inserted the following year.[76] In 1697 a new pulpit with a canopy replaced the old one (Plate 117).[77] Two years later, the western end of the nave was transformed by building the gallery supported on posts,[78] and a private pew was constructed under it on the south side (Plate 118), with the baptism room on the north side (Plate 120). The pew would have been used for the churching ceremony, when women who had given birth were reintroduced to the congregation. A private pew for the noble Munthe family of Kroken was built

into the northeast corner of the nave in the 1660s, giving them a full view of the altar and the pulpit but obscuring the view from the women's pews.

Between 1660 and 1732 the local gentry donated many works of art to the church, "to the glory of God and embellishment of the church," to cite a common formula on many gifts. One could also add: in remembrance of the donor. In 1663 the noble Teiste family gave a painting imitating a costly brocade, depicting the Heavenly Jerusalem, which hangs today on the north wall of the nave (Plate 124).[79] Fifteen years later Aasle Thunesdatter (c.1630–1702), widow of the merchant Lauritz S. Heiberg (c.1610–68), gave the large painting depicting Christ's path to Golgotha "for the glory of God and the embellishment of the church" (Plate 125).[80] In 1688 the churchwarden Einar Eikjum and his wife donated a smaller scene of the Crucifixion. Both of these paintings hang in the choir (Plate 126).[81]

The bailiff Christian Gjertsen Morgenstierne (1619–79) donated a small brass chandelier, and his wife Birgitte Ludvigsdatter Munthe (1634–1708) gave a silver box for the oblates, both of which are now missing.[82] Two widows of local ministers gave a new chasuble and an alb, which they probably made themselves. The chasuble is made of dark blue velvet and decorated with a cross of brown velvet and an embroidery of the Crucifixion, the initials of the donors, and the year 1681.[83] An old alb is still in the church, perhaps the same one. In 1707 the minister Jens Ørbech (1656–1717) and his wife, Margrethe (1649–1714), donated two brass candlesticks for the altar that are no longer in the church.[84] The new windows were filled with glass painted with biblical imagery. Some shards and a nearly complete pane depicting St. John were found under the floor during repair work in 1902.[85]

The last addition to the church was a combined sacristy and confessional that was added to the east side of the chancel in 1720–22.[86] Behind the altar retable a door was broken through the wall to give the minister a direct connection with the chancel. Confession before taking Communion was mandatory in the Lutheran service well into the nineteenth century, and it took place in a room separated from the rest of the church.[87] Most people took communion only once a year. The minister also needed a place to change into his vestments, so the space served a double function. The sacristy was demolished in the mid-nineteenth century and the door was blocked up.[88]

In 1690 an inventory was made of the furnishings in the Urnes church.[89] It is quite unremarkable for this period: two silver chalices with patens, one silver box for the Communion bread, one old and one new chasuble, one alb, one red altar cloth, one hourglass, one collection box, two old enameled copper candlesticks, one small brass chandelier, one iron chandelier, one large church bell, one baptismal bowl, one old Gradual, one collection box for the poor, three paintings on the walls, and one tar kettle (for tarring the roof and walls) weighing c.22 kg. Most of these things are still in the church, although one of the silver chalices was given a few years later to the neighboring church at Joranger, where thieves had stolen the church silver.[90]

We recognize the two Limoges candlesticks that were still in the church. The Virgin statue and the Calvary group are not mentioned, presumably because they had no liturgical or practical function or monetary value. The "old" chasuble and the Gradual might have been medieval. Most of the other objects were gifts made during the preceding decades by local dignitaries or churchwardens, part of the effort to bring Urnes up to date as a Lutheran parish church. Since the Reformation, the regular

maintenance of a parish church had become the responsibility of its congregation, who were also regarded as owners of the church. The church also received a part of the parish tithe, but there was very little money for anything but the annual costs.

The Modern Ownership History of Urnes

After the long, costly, and inconclusive Nordic War in 1700–22 between Denmark-Norway and Sweden, the king of Denmark-Norway desperately needed money, and one of the means to raise it was to sell Norway's country churches at public auction to the highest bidder.[91] The legal foundation for this was dubious, but the authority of the absolute monarch was not questioned. Some congregations scrambled to collect money to buy their own parish church, but most were sold in 1723 to what we would now call investors and speculators. Most were merchants and royal officials, but there were also ministers. The new owners received all the church income, but they also became responsible for maintenance and upkeep. Needless to say, in many congregations this caused friction and conflict between ministers on one side and church owners on the other.

At Urnes, the local minister Christoffer Munthe bought all five of the churches in his district. The church remained in private ownership until 1850, when it was sold to the municipality for 20 *riksdaler*.[92] This helps explain the lack of any new elements or changes to the church after the building of the sacristy in 1722, and its relative poverty clearly helped preserve many old furnishings from being replaced with new ones.

In 1677, through inheritance, Urnes manor became the property of the Bugge family, and in 1720 Jens Bugge (1693–1770) settled there. He was buried under the chancel floor, and the coffin with his well-preserved remains still survives there. An inscription on the coffin says that he was married twice and had eleven children. Bugge's son and heir Samuel was buried in 1803 next to his father. The remains of a number of infants and adults were also found, all of them probably belonging to the Bugge family and buried before 1805, when burials inside churches were forbidden by law.[93] A rapier hanging on the chancel wall is a visible memory of a burial, as the arms of officers were often donated to their funeral churches.

The Law of Local Self-Governance (*Formannskapsloven*) introduced in 1837 gave newly established local municipalities the legal authority to buy churches if their private owners were willing to sell. In 1851 a further Law of Rural Churches and Churchyards extended this authority to buying back the churches even if the private owners were unwilling, and this authority was renewed in a revision of the law in 1897.[94] In the decades after 1851, almost all country churches became the property of the municipality, the borders of which were identical with the parish. Many old churches were promptly demolished and replaced by new and larger ones, while others were modernized, resulting in the loss of old furnishings and of such fabric as portals and windows.

At Urnes, the parish bought the church back from its last private owner in 1850. This led to local discussion about the future of the church, which was in disrepair and too small. In 1881 the small parish of Urnes was merged with Solvorn, across the fjord, and the seventeenth-century log church

at Solvorn was demolished and replaced by a new wooden church large enough to serve the new, merged parish. The Urnes church thus became superfluous, and it could easily have been demolished as well. The fortunate solution was that the municipality donated the church to the Society for the Preservation of Ancient Norwegian Monuments, preserving it for the future and, at the same time, saving the future cost of maintenance.

Conclusion

For the past 140 years, the Society for the Preservation of Ancient Norwegian Monuments has preserved this small church, which has become a vital part of the historic legacy of Norway; today the Urnes portal lion adorns the Norwegian passport together with the royal coat of arms. The church may be the smallest site on the UNESCO World Heritage List, but it has become the property of the whole world. The initial question—is the Urnes stave church a monument frozen in time?—can be answered in the negative. This church has been subject to changes in every century of its existence, mostly to bring it more up to date. Over the past 150 years, however, this development has been reversed, once again bringing to light many of its historic qualities. Today Urnes presents a unique example of a living church that has endured through nine centuries.

Notes

1. Knud J. Krogh, *Urnesstilens kirke: Forgængeren for den nuværende kirke på Urnes* (Oslo, 2011).
2. Jacob Neumann, "Bemærkninger paa en Reise i Sogn og Søndfjord 1823," *Budstikken* (1824): 84–90; offprint in the Gunnerus Library, Norwegian University of Science and Technology, Trondheim.
3. Line Esborg, "Hagbard," *Store norske leksikon*; https://snl.no/Hagbard.
4. Neumann, "Bemærkninger," 87. It appears that this fragment is now lost; see Ingrid Lunnan Nødseth's chapter in this volume.
5. Ibid., 86.
6. J. C. Dahl, *Denkmale einer sehr ausgebildeten Holzbaukunst aus den frühesten Jahrhunderten in den innern Landschaften Norwegens* (Dresden, 1837).
7. Today in Paris, Bibliothèque nationale de France, MS lat. 1.
8. Bull was engaged by the Society from 1851 to 1855 to travel around Norway and survey old churches.
9. N. Nicolaysen, *Norske bygninger fra fortiden* (*Norwegian Buildings from Former Times*) (Christiania, 1859), 1: plates I–IV.
10. Nicolay Nicolaysen was president of the Society from 1851 to 1899 and State Antiquarian from 1860 onwards. *Norsk biografisk leksikon* (Norwegian Dictionary of Biography) (Oslo 1949), 10:37–42; https://nbl.snl.no/Nicolay_Nicolaysen.
11. Hans-Emil Lidén, *Nicolay Nicolaysen: Et blad av norsk kulturminneverns historie* (Oslo 2005), 51.
12. Lorentz Dietrichson, *De norske stavkirker: Studier over deres system, oprindelse og historiske udvikling; et bidrag til Norges middelalderske bygningskunsts historie* (Christiania, 1892), 212–26.
13. Jens Z. M. Kielland, "Undersøgelser ved Urnæs, Undredal, Gaupne og Røldal kirker: Samt iagttagelser paa en reise gjennem Valdres," *Aarsberetning: Foreningen til norske fortidsminnesmerkers bevaring*, 1902 (1903): 158–201, at 158–76.
14. Erla Bergendahl Hohler, "The Capitals of Urnes Church and Their Background," *Acta Archaeologica* 46 (1975): 1–60 (repr., Copenhagen, 1976); and Hohler, *Norwegian Stave Church Sculpture* (Oslo, 1999).
15. Dietrichson, *De norske stavkirker*, 214.
16. Anders Bugge, *Norske stavkirker* (Oslo, 1953), 25.
17. Roar Hauglid, *Norske stavkirker: Dekor og utstyr* (Oslo, 1973), 241.
18. No exact date for its demolition is given, but it had disappeared by 1880.
19. Håkon Christie, *Urnes stavkirke: Den nåværende kirken på Urnes* (Oslo, 2009), 217. The picture shows the south wall during the 1901–7 restoration, prior to the closing of the two easternmost windows. Later pictures, for example on p. 14, show the south nave wall with only the westernmost small window preserved.
20. *Diplomatarium Norvegicum* 7.1 (Christiania, 1867), no. 98. The letter concerns the duty of the individual priests in Sogn to support the bishop of Bergen with food and drink during his visit to the area.
21. Christie, *Urnes stavkirke*, 212–25.
22. Ibid., 161.
23. Kielland, "Undersøgelser ved Urnæs," 161. The author regarded it as a later addition, but this conclusion can be questioned. The capitals show that it must have been added shortly after the church was built.
24. Ibid., 168; and Christie, *Urnes stavkirke*, 169, and photo, 166.
25. Christie, *Urnes stavkirke*, 162. The date of the gable is uncertain, but it has several parallels in other stave churches and may date to the medieval period.
26. Ibid., 161–76. The plan on 171 shows the foundation for the pentice on the north and east side of the church. No foundations are recorded on the south side.
27. Kielland, "Undersøgelser ved Urnæs," 168.
28. Christie, *Urnes stavkirke*, 170–76.
29. Nicolaysen, *Norske bygninger*; Dietrichson, *De norske stavkirker*, 216; Peter Blix, *Nogle undersøgelser i Borgund og Urnæs kirker med bemærkninger vedkommende Hoprekstadkirken* (Christiania, 1895), 7; Kielland, "Undersøgelser ved Urnæs," 174; and B. E. Bendixen, "Lidt om stavkirker i Hordaland og Sogn," *Aarsberetning: Foreningen til norske fortidsminnesmerkers bevaring*, 1903 (1904): 154–57, at 156.
30. Christie, *Urnes stavkirke*, 174–76.
31. Hauglid, *Norske stavkirker* (Oslo, 1969), 31 and plate 31.
32. Christie, *Urnes stavkirke*, 157–59.
33. Kielland, "Undersøgelser ved Urnæs," 169.
34. Christie, *Urnes stavkirke*, 175.
35. Margareta Nockert, "Textilkonsten," *Signums svenska konsthistoria 2* (1995): 336–55. Rather than placing the tapestry in the Romanesque period, Nockert concludes that it was made during the thirteenth century after Romanesque models.
36. Mr. Terje de Groot, Oslo, has kindly provided me with this information from his forthcoming work on medieval church bells in Norway.
37. Christie, *Urnes stavkirke*, 150.
38. This feature is a novel observation made by the present author while investigating the social context of medieval stone churches. Churches without a separate chancel portal invariably seem to stand on the farms of early medieval magnates.
39. Inv. no. F 284/38. It measures 55 × 53.5 cm and holds nine candles. Unlike all other medieval chandeliers, it has a wooden bottom strengthened with iron bands, which seems to be inspired by some preserved medieval shields.
40. Christie, *Urnes stavkirke*, 224ff.
41. Ibid., 225.
42. It measures 58.5 × 69 cm and is 23.5 cm high; inv. no. F 284/41.
43. Mona Bramer Solhaug, *Middelalderens døpefonter i Norge* (Oslo, 2001), 2:53. The size of the lid indicates that this was a stone font.
44. Museum object no. MA_0077.
45. The first part of the baptism ceremony, the exorcism, took place outside the entrance to the church.

46 Birgit Als Hansen, "Arkæologiske spor efter døbefontens placering i kirkerummet gennem middelalderen," *Hikuin* 22 (1995): 27–41.

47 Only a small part of the plank wall is preserved on the north side, and it is impossible to say whether it was solid or pierced by small openings in addition to the central portal. The small arches at Hopperstad were inserted later, probably in the thirteenth century.

48 The steps have disappeared, but traces in the wooden floor reveal their existence. Christie, *Urnes stavkirke*, 149, and photo, 148.

49 Christie, *Urnes stavkirke*, 149.

50 Ibid., 220–23; and Margrethe C. Stang, "Luksus i Luster: Høgendeskirken Urnes," *Årbok: Foreningen til norske fortidsminnesmerkers bevaring* 171 (2017): 159–78, at 165, 175.

51 Martin Blindheim, *Painted Wooden Sculpture in Norway c.1100–1250* (Oslo, 1998), 60. Museum object no. MA_0046.

52 Museum object no. MA_0077.

53 Christie, *Urnes stavkirke*, 220.

54 Krogh, *Urnesstilens kirke*, 84.

55 The photograph belongs to the Museum of Cultural History in Oslo, photo Cf11957 (CC BY-SA 4.0). The object is now kept in University Museum of Bergen.

56 Christie, *Urnes stavkirke*, 219.

57 The candlesticks are presently kept in a vault for safety reasons.

58 It is 84 cm long, 13.5 cm wide, and 41.5 cm tall.

59 Morten Stige, "Tingelstadfløyen: Skipsfløy på land," in *Gamle Tingelstad: Liten kirke med stort innhold*, ed. Morten Stige and Kjartan Hauglid (Gran, 2020), 93–119 at 93.

60 Erland Lagerlöf and Bengt Stolt, *Stånga kyrka* (Stockholm, 1968); B. Deneke, "Möbel," in *Lexikon des Mittelalters* 5 (Munich, 1991), 701; and Rune Norberg, "Benk," in *Kulturhistorisk leksikon for nordisk middelalder: Fra vikingtid til reformasjonstid*, ed. Finn Hødnebø (Oslo, 1956), 1:458–61, esp. 460.

61 Anne Wichstrøm, "Maleriet i høymiddelalderen," *Norges kunsthistorie*, vol. 2, *Høymiddelalder og Hansatid*, ed. Hans-Emil Lidén et al. (Oslo, 1981), 252–315, at 264, fig. 3.35

62 Carl Fr. Wisløff, *Norsk kirkehistorie* (Oslo, 1966), 1:405–18.

63 Kielland, "Undersøgelser ved Urnæs," 176; and Jon Laberg, *Hafslo: Bygd og ætter* (Bergen, 1926), 74.

64 K. Støylen, ed., *Peder Palladius' Visitasbok* (Oslo, 1945).

65 Øystein Ekroll, "State Church and Church State: Churches and Their Interiors in Post-Reformation Norway, 1537–1705," in *Lutheran Churches in Early Modern Europe*, ed. Andrew Spicer (Farnham, UK, 2012), 277–309, at 283.

66 Inv. no. F 284/6 in the Society's catalogue. It measures 126.5 × 100 cm.

67 Eivor Andersen Oftestad and Kristin Bliksrud Aavitsland, "Minnekultur," in *Å minnes de døde: Døden og de døde i Norge etter Reformasjonen*, ed. Tarald Rasmussen (Oslo, 2019), 69–90.

68 Inv. no. F284/7 in the Society's catalogue. Diam. 38.5 cm.

69 Inv. no. F 284/30, 31.

70 Wisløff, *Norsk kirkehistorie*, 408–10.

71 Christie, *Urnes stavkirke*, 216.

72 Roar Hauglid, "Urnes stavkirke i Sogn," *Årbok: Foreningen til norske fortidsminnesmerkers bevaring* 124 (1970): 34–69, at 68.

73 Ibid.

74 Mille Stein, *Sikring og oppbevaring av kunst og inventar i A 284 Urnes stavkirke, Luster kommune, i forbindelse med bygningsarbeid i kirken*, NIKU Rapport Kunst og inventar 8 (2008), 18; https://ra.brage.unit.no/ra-xmlui/handle/11250/176421.

75 Hauglid, "Urnes stavkirke i Sogn," 68.

76 Laberg, *Hafslo*, 74.

77 Hauglid, "Urnes stavkirke i Sogn," 68.

78 Ibid.

79 Its frame measures 151 × 119 cm; inv. no. F 284/4.

80 Its frame measures 151.5 × 133.5 cm; inv. no. F 284/5.

81 Its frame measures 60 × 45 cm; inv. no. F 284/3. It was probably secondhand, as the initials *ICS* and *AID* point to another married couple.

82 They are not listed in the inventories from 1978 and 2019. In 1938 Jacob Bugge donated a new silver box for the oblates, indicating that the old one was by then missing.

83 Inv. no. F 284/28.

84 Laberg, *Hafslo*, 74.

85 Einar Lexow, *Norske glassmalerier fra laugstiden* (Oslo, 1938), 33, 99. The glass is kept at Sogn Folkemuseum (De Heibergske Samlinger), cat. no. 49.

86 Kielland, "Undersøgelser ved Urnæs," 176.

87 *Gudstjenestebok for Den norske kirke: del II, Kirkelige handlinger* (Oslo, 1992), 13.6; and Anne Stensvold, "Skriftemål," *Store norske leksikon*; https://snl.no/skriftem%C3%A5l.

88 Christie, *Urnes stavkirke*, 176 and photo, 177.

89 Laberg, *Hafslo*, 74.

90 Ibid.

91 Laberg, *Hafslo*, 74.

92 Dietrichson, *De norske Stavkirker*, 214.

93 Berit J. Sellevold, *Kistebegravelser i Urnes stavkirke*, NIKU Rapport Antropologiske undersøkelser 1 (2008); http://hdl.handle.net/11250/176389.

94 Tore Schei and Frederik Zimmer, eds., *Norges lover: 1685–1991* (Oslo, 1992), 107ff., section 2.

PART ONE | SITUATING URNES

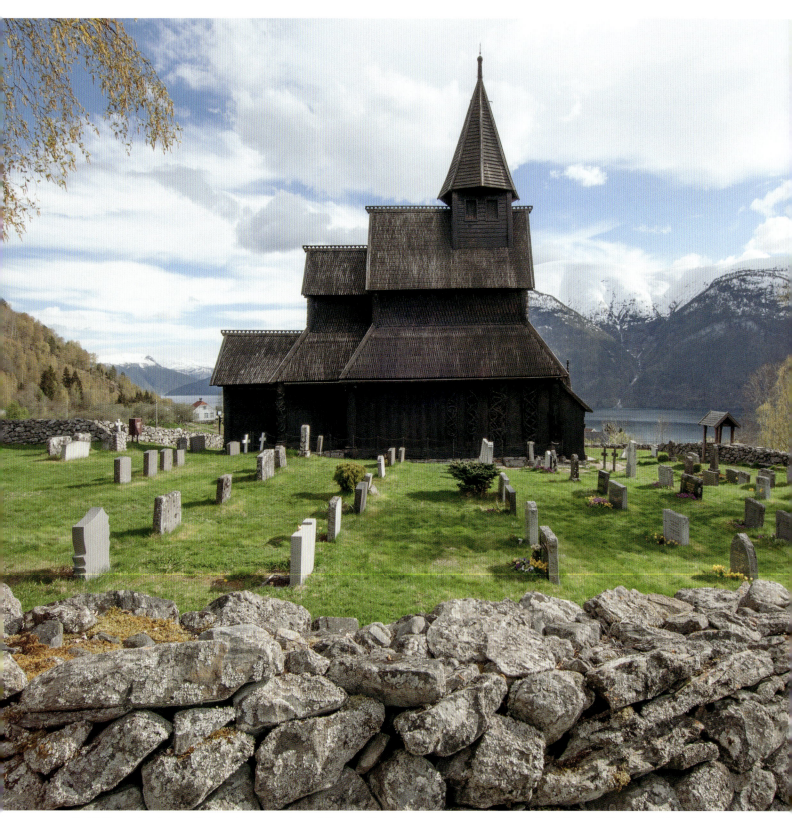

Fig. 2.1. Urnes church, on a plateau atop promontory of Ornes, with a view to the west and the Lustrafjord. Photo: Leif Anker, © Riksantikvaren.

CHAPTER 2

Urnes: Some Current Research Issues

Leif Anker

The Urnes stave church stands on a headland deep in the innermost of the northern branches of the Sognefjord, about 140 km from the sea. The tarred wooden church faces west, up a narrow 1-km-long road that runs from the shore through fruit and berry orchards. The view extends over the village of Ornes and the Lustrafjord. Today the village is remote, if one is coming by car; the road link did not arrive until 1982. Prior to the advent of the motor vehicle, the fjord was the major transport artery between neighboring villages and the outside world (see Chapter 3). Since antiquity a route has run from Skjolden, at the end of the fjord, across the mountains to Gudbrandsdalen and eastern Norway. During the summer, routes also ran from here across the Jostedal glacier to the villages in Jølster on the other side.

In spite of its modest size, the Urnes stave church is the most distinctive and undoubtedly the most richly decorated of the thirty stave churches preserved from the Middle Ages. This small, slightly tilting wooden church is inscribed in UNESCO's World Heritage list (Fig. 2.1 and Plates 13–17). Together with the transept of Trondheim Cathedral, Urnes is, in its own way, the most highly decorated Romanesque church in Norway, and along with that cathedral it is the most widely discussed and important church in Norwegian medieval scholarship. It has been dated to shortly after 1130, but it is partly built with materials from an older church, including the north portal and other carved elements (Figs. 2.3–2.7).[1] Traces of post-holes and associated Christian burials under the floor indicate that there have been several churches here prior to the current stave church. For this reason, Urnes plays a central role in stave church research. In a condensed form, the church manifests most of the elements of, and questions relating to, stave church decoration and architecture.

The Church Today

The church and churchyard are located slightly apart, framed by rocky outcrops above the village. The church building consists of two main elements: the nave to the west and the chancel to the east. Both have raised central spaces and shingled roof surfaces. The current roof turret dates from shortly after 1700. At the far eastern end is a short chancel extension, built using staves about 1600. An open pentice is located in front of the main entrance to the west (Plates 21–22); traces in the corner staves and walls indicate that this gallery previously ran around the entire church. The church has two portals. The main entrance is to the west, through a simple round-arched portal with columns and cube-shaped capitals. On the north side is the large, magnificent portal with animal ornamentation from an earlier church (Plates 1–3). The carving is in the last, or most recent, of the Viking-age styles, the Urnes style, named for its main exemplar, the stave church at Urnes.

Inside the church one encounters a sparsely lit, richly decorated interior (Plates 30–37). Light and shadow play across the medieval wood carvings and the seventeenth-century carpentry and wall decoration. The church has retained an extraordinary amount of its medieval inventory. Above the opening to the chancel hangs a crucifix, where the crucified Christ wears a king's crown, flanked by the figures of John and Mary (Plate 106). The group in Urnes is one of the finest and oldest preserved in Norway. It probably dates to around 1150 but was partly repainted about a century later.[2]

Of the medieval fixed inventory, such as the chancel screen, only a few sawn planks remain, and only traces remain of the altars on each side of the chancel opening. The fittings, comprising an altarpiece, pulpit, the boxed pews, and church chairs, date to the seventeenth century. The original light openings, small gaps at the top of the central wall, can still be seen on the south exterior (Plate 18). The window opening in the west gable is possibly from the Middle Ages, but the window frame itself is of relatively recent date. Two central staves next to the chancel have been cut off since the church was completed. This intervention was due to the need for space for a side altar in the Middle Ages. In order to stabilize the building, struts were inserted; the current ones date to the eighteenth century and are possibly a replacement for older beams.[3]

As the stave church stands today, it has changed little in the past 300 years. In 1881 the Urnes parish was incorporated into the parish of Solvorn. The Society for the Preservation of Ancient Norwegian Monuments (*Fortidsminneforeningen*), now the National Trust of Norway, took over the church in the same year and has been the owner ever since.

Stave Churches as Research Objects: Sources and Methods

Only a few stave churches remain today. In Norway there are twenty-eight; in Sweden there is just one.[4] In 1840 a stave church was moved from Norway to what is now Poland and rebuilt there in a greatly altered form.[5] A church built of upright timbers with a stavelike construction has also been

preserved in Greensted, Essex, England.[6] This is a very small part of the large number of wooden churches that we know were built during the Middle Ages from the Mediterranean to the west coast of Greenland. Hundreds are known from written sources and archaeological excavations.[7] In Norway, a cautious estimate suggests between 1,000 and 2,000 stave churches,[8] if not more.[9] It is uncertain how many were built in the other Nordic countries, but there must have been many. In Sweden there were probably hundreds. In Denmark all such churches have disappeared, but they are known from archaeological excavations and scattered preserved structural elements. There is one known wooden church in Greenland.[10] In Iceland and the Faroe Islands, almost all medieval churches were timber constructions. In Norway, preserved written sources from before the thirteenth century are scarce, and few if any deal with stave church construction in particular. Some inscriptions from or in stave churches are preserved, but not many, and their dates, if recoverable at all, are disputed.[11] Additional material, mostly fragments of varying size and significance from lost churches, has been preserved from all over Scandinavia and Iceland. A good handful of stave churches are known from later descriptions, such as travel accounts, church records, sketches, and surveys. Archaeology has been and remains absolutely central to uncovering new knowledge about the lost wooden churches and widening the perspective from the small number of extant churches to the wider European context.

In Norway, art historians' attention has primarily been directed to the relatively large number of carved portals, a total of 128 in different states of preservation.[12] Supplementing this diverse but scattered and partly fragmentary material are the preserved buildings that are the central objects of research. The buildings and the carvings are their own primary sources. Against such a background, the question arises about what the material expresses. How representative is the extant Norwegian stave church material of what was actually built and decorated in the period between the arrival of Christianity in the first half of the eleventh century and the Reformation half a millennium later (1536–37)? None of the remaining churches are dated before the second quarter of the twelfth century, and most of the preserved or documented churches and portals date between *c.* 1150 and 1300, with a handful from a later period.[13] The churches are of different types. Some are simple constructions with no inner roof-supporting structures, while others have different variants of internal staves with a raised central room ("roof above the roof"), and yet others have a central post. All the preserved Norwegian stave churches are in the southern part of the country. Northern Norway is so far virtually devoid of physical traces relating to stave churches, as is the case with large parts of the border regions with Sweden and the outer coastal areas of southern Norway. Most of the preserved and well-known stave churches are located in the inner valleys and fjord areas. We have little or no knowledge of the vanished wooden churches in and around medieval towns, the assumed centers for the dissemination of new ideas from abroad.

Stave churches are in many ways like a jigsaw puzzle from which most of the pieces are lost. Research attempts to put the pieces that remain into meaningful contexts, and here Urnes plays a central role. The dates of the current church and its immediate predecessor, both with extensive carvings, are reasonably certain. The first two churches are known only from post-holes but bear witness to continuity on the site, possibly dating back to the earliest Christian era in the region. The extent of the decoration puts both churches into their respective periods and sheds light on

connections that might otherwise hardly have been imagined. The church and its site thus form a frame of reference, a fixed point in an otherwise fluid picture of fragments.

Scholarship on the Urnes church is varied and multifaceted. In the context of this book, it can be sorted broadly into five main themes.[14] In part the research relates to the archaeological findings and their interpretation, in part to the church's fixed decoration—that is, the sculptural elements. These sculptural elements are from two different construction periods and have quite different designs. Each period's sculpture presents distinct interpretive issues: in the pre-Romanesque period the material reused from the earlier church; and in the Norwegian context of the early Romanesque, the permanent decoration contemporaneous with the present church. As one of the oldest dated stave churches in Norway, the constructional and architectural solutions at Urnes have been central to the 150-year-old discussion of the stave churches' development history. Its reused materials are central both in the building's archaeological context and because they are the best-preserved examples of pre-Romanesque monumental architectural sculpture in Scandinavia.

Some of the medieval decoration and furnishings have been preserved inside the Urnes church, including, candlesticks, a wrought-iron chandelier, and figurative sculpture. These are furnishings and equipment that are not specific to the stave churches but that situate this church in a historical and social context. Urnes is also an important point of reference in the discussion of early church building and the establishment of a church system in this part of Norway. The first church on the site was probably built in the first half of the eleventh century, if not earlier, and the present church is one of the few that can be associated with a specific important family.

The attention paid to this church over the years has given rise to an extensive literature, much of which is cited in this volume.[15] This chapter presents some of the key issues in research today, seen from a Norwegian perspective. First, a brief description of the outline of the twelfth-century building and its construction is necessary.

Urnes as an Architectural Construction

The term *stave church* refers to the way the church was built. The Norwegian word for stave churches is *stavkirker*, which derives from the Old Norse *stafr*, meaning a pillar or post—the vertical posts in the stave building's framework. In modern Danish and Swedish the term *stave* means the upright wall planks. From the outside Urnes has a characteristic profile with a roof over both the nave and chancel. The upper parts are carried by internal posts or staves that form a row of posts around the whole nave, with surrounding lower aisles on all four sides (Fig. 2.2, with glossary, and Figs. 2.9–2.11).

Stave construction is a method of building with posts—staves—as the load-bearing elements. In principle, a stave building is a frame construction consisting of horizontal and vertical elements resting on stone foundations that are laid without mortar. On these are first laid the ground beams, which are cross-halved so that the crossing points are located a short distance from the ends. On top of this lower frame is a frame of wall sills resting on the outer ends of the ground beams. At Urnes

CHAPTER TWO | URNES: SOME CURRENT RESEARCH ISSUES

1. Plank floor in central space
2. Ground beam
3. Plank floor in aisle
4. Sill-beam in aisle
5. Wall planks in aisle
6. Intermediate post in central space
7. Corner post, aisle
8. West portal in nave
9. Jamb plank
10. Lintel
11. Transom beam
12. West-wall colonnette in nave
13. Wall-plate in aisle
14. Quadrant bracket
15. Strut in aisle
16. Rafter in aisle
17. Purlin in aisle
18. Plank boarding in aisle roof
19. Shingle cladding in aisle roof
20. Nave window
21. Arcade molding in nave
22. Arcading in nave
23. Girding beam (bressummer) in nave
24. Wall planks in nave
25. Horizontal batten in gable
26. Porthole
27. Brace
28. Wall-plate in central space
29. Roof bearer
30. Quadrant bracket in nave
31. Soffit-arch supplement in nave
32. Collar beam in nave
33. Scissor brace in nave
34. Rafter beam in nave
35. Roof purlin in nave
36. Plank boarding in nave roof
37. Shingle cladding in nave roof
38. Ridge piece
39. Ridge crest

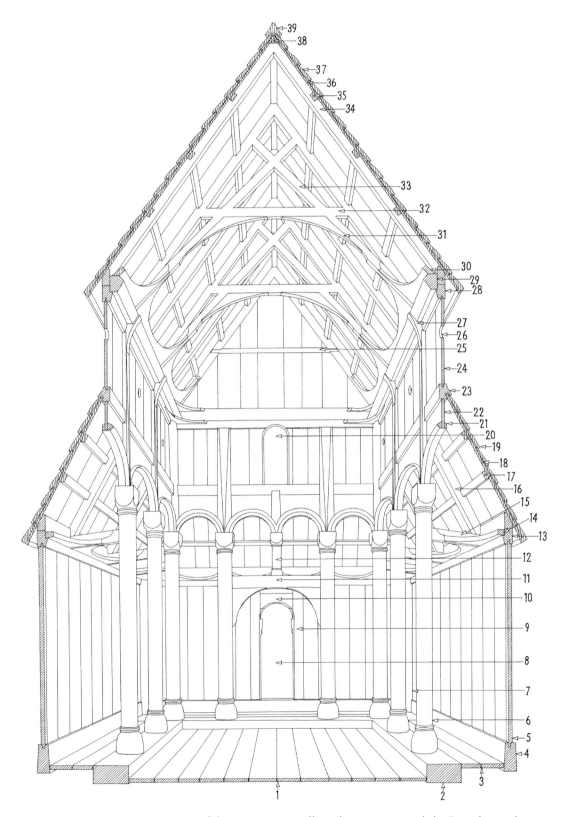

Fig. 2.2. Urnes church, construction of the nave. Drawing: Håkon Christie, *Urnes stavkirke: Den nåværende kirken på Urnes* (Oslo, 2009), 22–23.

147

the sills are cross-halved, with the corner staves clasping the joints (Fig. 2.2, nos. 2 and 7). The top ends of the staves have recessed grooves for the wall-plates that compose the upper frame (Fig. 2.2, nos. 6 and 28). The wall consists of vertical planks, mortised tongue and groove into one another and fitted into grooves or slits in the sills and wall-plates. The aisle roof has rafters, mortised into the wall-plates and the inner staves (Fig. 2.2, nos. 30–34).

The inner staves carry the upper part of the construction (Fig. 2.2, no. 6). They stand on the ground beams, tenoned through and with a wooden dowel locking the joint (Fig. 2.2, nos. 2 and 6). The inner staves have supporting struts mortised to the aisles' wall-plates (Fig. 2.2, nos. 13–15). Horizontally the staves are connected by girding beams that carry the upper wall (Fig. 2.2, no. 23). The girding beams are mortised into the staves and the joints are secured with wooden dowels. Between the staves and below the girding beams are horizontal planks with a semicircular profiled segment forming arcades around the whole nave (Fig. 2.2, nos. 21 and 22). At their upper end the staves carry the wall-plates, which rest in grooves. The planks of the upper walls are tenoned into grooves in the girding beams, staves, and wall-plates. The roof has alternating trusses, simple ones with rafters and every second one consisting of rafters, scissor braces, and a collar beam. The scissor braces and the rafters rest on roof bearers doweled to the lower part of the wall-plate; the rafters rest on the upper part of the wall-plate. The roof itself has vertical boarded cladding with horizontal board cladding; the boards are convex with longitudinal profiles along the edges. Today the boards are covered by shingles, but it is uncertain whether shingle cladding was an original feature or a later addition.

All angled joints are reinforced with quadrants made of wood taken from roots or branches. These form rhythmic patterns in the construction, both between the scissor braces in the roof and in the aisle struts. Except for the staves and planks, most of the vertical and horizontal load-bearing members have simple, broad profiles, even the rafters and scissor beams.

At Urnes the middle staves in the longitudinal central axis rest (or originally rested) on a beam halfway up from the floor, and this marked the position of the entrance in the west and the opening in the chancel screen in the east. The floor in the central space of the nave lies one step below the floor of the aisles. Together with the surrounding "forest" of staves and the elevated central roof, this must have been an impressive room before its later alterations. Sometime in the Middle Ages the two northernmost staves (posts) in the eastern row were cut away below the upper wall (Fig. 2.9 and Plate 30), probably to make room for a side altar. This resulted in the need for the later diagonal supporting beams at the east and west ends of the nave. Together with the later furnishings, this gives an impression of the nave quite different from what was intended originally. What has been lost, however, is offset by one of the finest mixtures of medieval and Renaissance church interiors in Norway.

Patronage, Wealth, Economy

Urnes is one of the few medieval Norwegian church sites that can reasonably be associated with historical figures known from contemporary written sources. The philologist Halvard Magerøy has argued convincingly that *Sverris saga* mentions two brothers, Jón and Munán, sons of Gautr from Ornes (Urnes), as King Magnús Erlingsson's men at the Battle of Bergen Bay in 1181.[16] Members of the same family are mentioned several times in contemporary sagas, where they are referred to as active participants in the Baglarr faction during the civil wars of the late 1100s. This faction had the support of the Church in the battle over the royal throne. The name is derived from *bagall*, which is Old Norse for a bishop's crosier. One of King Hákon Hákonarson's *lendrmenn* (lords), Arnbjørn Jónsson, who died in 1240, was also from this Ornes family.

The construction of the present church must have been planned at the latest in the winter of 1129–30, when the oldest dated timber for this construction phase was felled.[17] This is half a century before the Baglarr family name appears in the contemporary written sources.[18] It is possible, but by no means certain, that the same family could have been behind one or more of the earlier churches, given that the church's rich decoration has been regarded by some scholars as evidence for its being built as a private church for a prominent landowner.[19] According to later sources, Urnes, or Ornes as it is spelled today,[20] was a very large farm. Ornes is mentioned in a bequest in 1308 by one of Norway's most powerful and richest men, the king's chancellor Bjarne Erlingsson, to Bjarkøy, who at the time apparently owned the farm.[21] According to a deed of conveyance from 1380, Ornes (the farm) was assessed for an annual rent, or valuation,[22] of at least 128 *lauper* of butter.[23] This rent corresponds to an annual rental income of just over 3 kg of silver based on contemporary fourteenth-century valuation.[24] According to medieval sources, this was not only one of the largest farms in Sogn but also in the whole country; the average farm size in Sogn around 1300 was about 30 *lauper*. The vast majority of farms, however, were divided among several owners for multiple uses, and the minimum size of a whole farm (*fullgård*) in western Norway was probably 8–12 *lauper*.[25] Many farms were smaller. There must have been a social and economic abyss between even self-sufficient farmers and the owner of a farm like Ornes. There is no direct evidence that the farm was the center of a large estate at the beginning of the Middle Ages.[26] Owners of large farms often had considerable assets beyond the main property.[27] It is very likely that Ornes was a single farm with one owner in 1100 and that the church site was originally founded by the landed gentry of Ornes.

The church's estate, as known from shortly before 1350, stands out in comparison to most other parish churches in the district of Indre Sogn because almost all of its land rents came from farms in other parishes.[28] The church assets consisted of rent from farms or parts of farms, which in practice meant a fixed annual rental income from those farms' profits. Two of these properties were notably large in comparison with other local church estates in Indre Sogn, and together these two properties yielded a rental income well above that of a *fullgård*. The size does not indicate that this property was given as penalties for breaches of Christian laws or for unpaid tithes. One possible explanation is that at least some farms, or parts thereof, were given to the church by benefactors with substantial property to look after. It is uncertain when the actual parts became local church property. We lack the evidence to conclude that property was given to finance the building of any of the churches on

PART ONE | SITUATING URNES

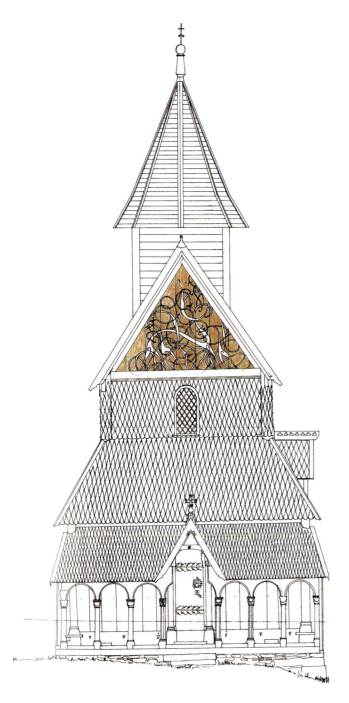

Fig. 2.3. Urnes church, west exterior. Reused parts in brown; carved gable shown without the protection of a movable panel. Drawing: Einar Oscar Schou, colored by Knud J. Krogh in Krogh, *Urnesstilens kirke: Forgængeren for den nuværende kirke på Urnes* (Oslo, 2011), 15.

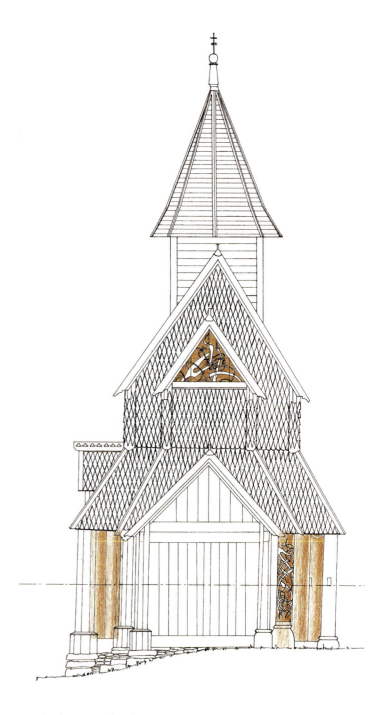

Fig. 2.4. Urnes church, east exterior. Reused parts in brown; carved gable shown without the protection of a movable panel. Drawing: Einar Oscar Schou, colored by Knud J. Krogh in Krogh, *Urnesstilens kirke: Forgængeren for den nuværende kirke på Urnes* (Oslo, 2011), 15.

CHAPTER TWO | URNES: SOME CURRENT RESEARCH ISSUES

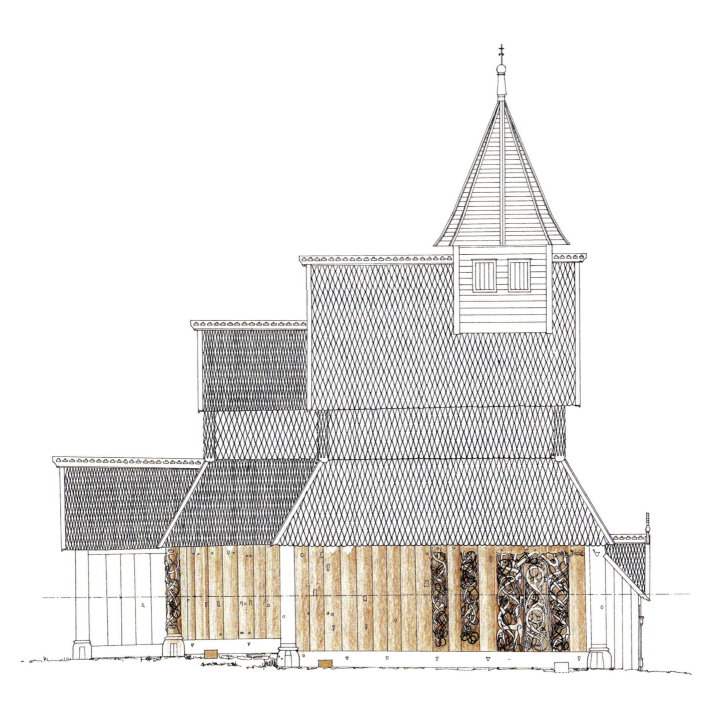

Fig. 2.5. Urnes church, north exterior. Reused parts in brown. End of ground beam in chancel and the eastern ground beam of nave are rehewn wall sills from third church; lower walls on south also made from reused panels. Drawing: Einar Oscar Schou, colored by Knud J. Krogh in Krogh, *Urnesstilens kirke: Forgængeren for den nuværende kirke på Urnes* (Oslo, 2011), 16.

PART ONE | SITUATING URNES

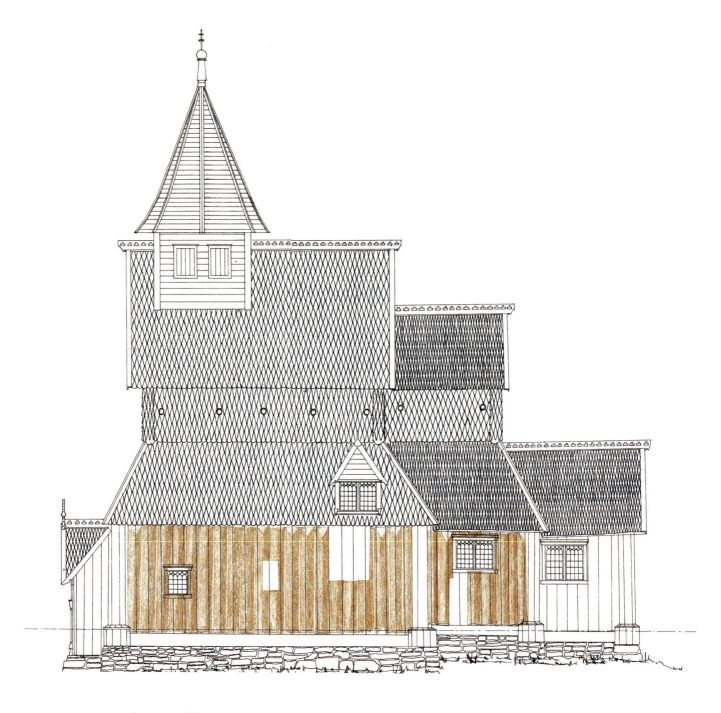

Fig. 2.6. Urnes church, south facade. Drawing: Einar Oscar Schou, colored by Knud J. Krogh in Krogh, *Urnesstilens kirke: Forgængeren for den nuværende kirke på Urnes* (Oslo, 2011), 14.

the site, but the possibility should not be dismissed.[29] Shortly before 1350, these assets provided the Ornes church and its priest with an annual income of 59 *lauper* of butter, worth barely 1.4 kg of silver.[30]

The present church must also have been built to accommodate a congregation of a certain size, beyond a landowner and his household. The status of the church at the time of construction is unknown. Private churches, or chapels of ease, are described in the Older Gulaþing Law together with other church categories, such as main churches and district churches.[31] The size of the nave is approximately 57 m² (8.5 × 6.7 m), which is larger than the somewhat later Borgund stave church, which has a nave of about 43 m² (7.2 × 6 m). Borgund is the only known medieval church site from the upper part of Lærdal, and it likely served as a parish church from the beginning. In the 1130s the church system must have been well developed in Sogn, and the establishment of parishes was probably well under way. On the east side of the Lustrafjord, where the Urnes church is located, there are no traces of other medieval church sites that could have served such a function, whereas such sites are like beads on a necklace on the fjord's west side.[32] The high quality of decoration and design of both the current church and its predecessor strongly suggest that they were products of the aristocracy's demands for modern church buildings. This does not exclude that the church also had a parish function, as is clear from written sources in the 1300s. Based on tithes, the Ornes parish was among the smallest in Indre Sogn.[33]

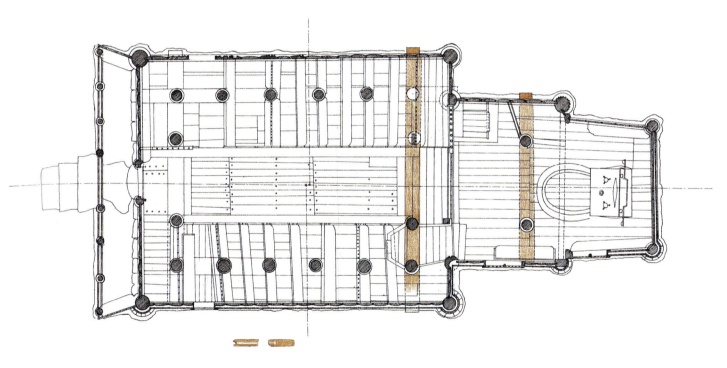

Fig. 2.7. Urnes church, plan. Eastern volume is a postmedieval extension of the chancel. Ground beams colored brown are reused and rehewn wall sills from third church. Two northern posts (staves) in east row of nave are marked with dotted lines; both were cut off some meters above floor level, probably to make space for a medieval side altar. Two smaller pieces colored brown below the south wall are parts of the sill of the chancel screen in the third church. Drawing: Einar Oscar Schou, colored by Knud J. Krogh in Krogh, *Urnesstilens kirke: Forgængeren for den nuværende kirke på Urnes* (Oslo, 2011), 17.

PART ONE | SITUATING URNES

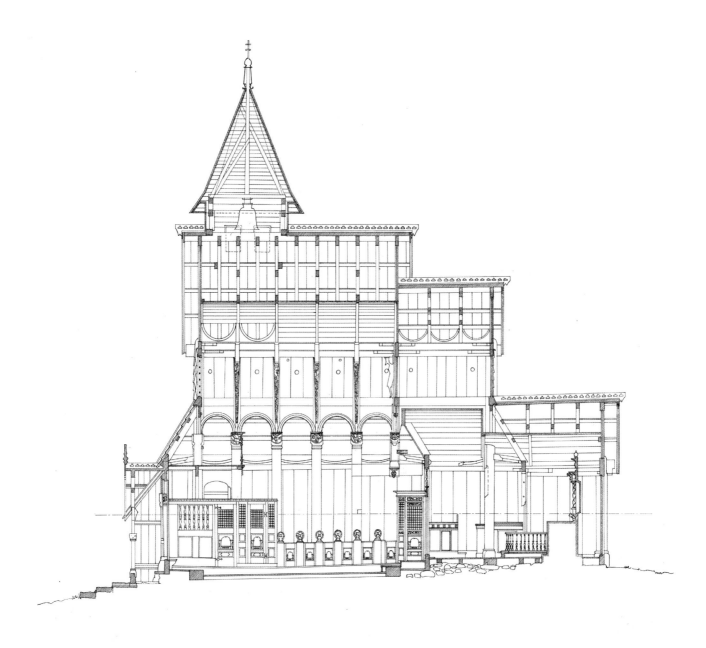

Fig. 2.8. Urnes church, interior of nave looking north. Furnishings, turret, and vaults are postmedieval. Drawing: Einar Oscar Schou, © Riksantikvaren Archives.

CHAPTER TWO | URNES: SOME CURRENT RESEARCH ISSUES

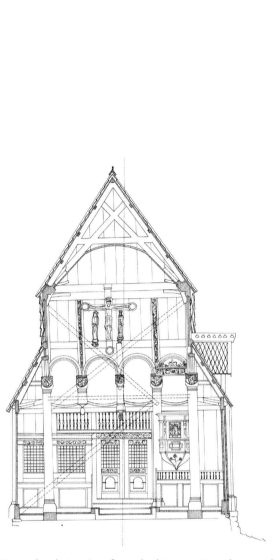

Fig. 2.9. Urnes church, interior of nave looking east. Furnishings and diagonal crossing beams are postmedieval; the beams are supporting the construction due to the absence of the two northern posts in the eastern row. Drawing: Einar Oscar Schou, © Riksantikvaren Archives.

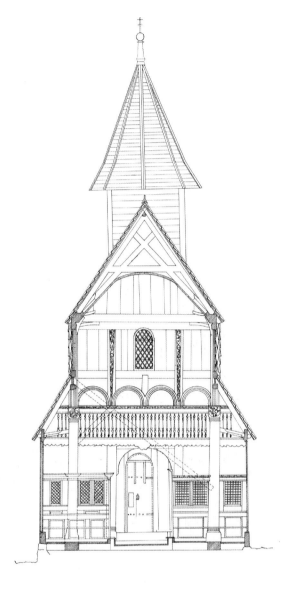

Fig. 2.10. Urnes church, interior of nave looking west. Furnishings, pulpit, and diagonal crossing beams are postmedieval; the beams are supporting the construction due to the absence of the two northern posts in the eastern row. Drawing: Einar Oscar Schou, © Riksantikvaren Archives.

PART ONE | SITUATING URNES

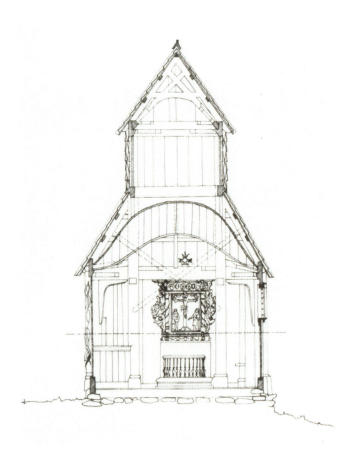

Left: Fig. 2.11. Urnes church, interior of chancel looking east. Vaults and furnishings are postmedieval. Drawing: Einar Oscar Schou, © Riksantikvaren Archives.

Below: Fig. 2.12. Urnes church, plan showing excavated post-holes and medieval graves. Plan in black: Håkon Christie, "Urnes stavkirkes forløper: Belyst ved utgravninger under kirken," Årbok: *Foreningen til norske fortidsminnesmerkers bevaring* 113 (1959), 53, fig. 3; burials marked with Roman numerals. The colors represent interpretations by Knud J. Krogh, "Kirkene på Urnes," *Aarbøger for nordisk oldkyndighed og historie*, 1971, fig. 20, and Krogh, *Urnesstilens kirke: Forgængeren for den nuværende kirke på Urnes* (Oslo, 2011), 198. Brown = current church plan; red = Krogh's suggested outline of the first church; green = Krogh's suggested outline of the second church, with a central axis diverging slightly southeast from the red. This is one of Krogh's reasons for suggesting two churches and not one with a pentice, as suggested by Christie in 1958 (pub. 1959). Because of the slightly different central axes of these two buildings, the corner post-holes of the second (green) church cuts into the post-holes of the first (red) church in the northeast and southwest. This implies that the red is older than the green. Graves marked I, IV, V, and IX do not conflict with the outline of the red church, but graves II and III are disturbed by the eastern wall of the red church and must be older. Graves I, IV, and V are disturbed by the posts of the green church and must be older. Light blue outside the southern wall of the present (fourth) church = possible placement of a stone foundation, reported in 1956–57 but not documented. Drawing: Knud J. Krogh, *Urnesstilens kirke: Forgængeren for den nuværende kirke på Urnes* (Oslo, 2011), 199 and 225.

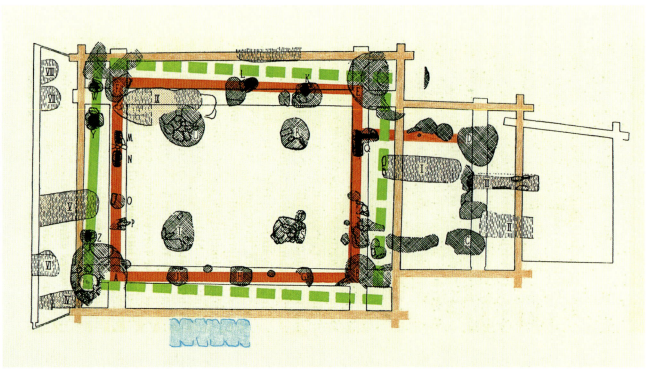

Post-Holes and Church Archaeology

Excavations at Urnes from 1955 to 1957 uncovered several post-holes that were interpreted as traces of an earlier wooden church with a pentice within the exterior walls of the current church (Fig. 2.12).[34] The excavation was led by Håkon Christie, an architect and research fellow in the research project "Churches of Norway," in collaboration with architect Kristian Bjerknes, director of the Old Bergen Museum. Christie interpreted the post-holes as traces of a church surrounded by a pentice, the posts of which were also fixed into the earth. Based on a coin find (Haraldr harðráði, r. 1046–66), he dated this church to the middle of the 1000s or sometime thereafter.[35] Four post–holes formed the corners of a small square in the middle of the floor, which Christie interpreted as pillars for a roof structure. In other words, he thought the first church on the site had some kind of raised central space.[36]

The excavation also showed that both the northern sill-beam of the current church's nave and the chancel's ground-beam were hewn subsequently; they have neatly recessed grooves on the underside. Christie's view was that these were construction elements that had not been used but, rather, had been reworked for new uses in accordance with plans for the current church. He interpreted the post-holes as being from the same building as the reused parts in the stave church, the one for which the current north portal was originally made. Bjerknes, however, thought the foundations were reworked sill-beams from a previous church with a sill-beam frame, one that should be dated after the church with post-holes and before the existing one: in other words, there had been two churches before the current one. This intermediate church had a complete sill frame on the ground, and Bjerknes thought that this was the Urnes north-portal church.

In a 1971 article, the Danish architect and archaeologist Knud Krogh criticized both Bjerknes's and Christie's interpretations.[37] Based on the excavation plan, Krogh determined that there were traces of two earlier churches, both with corner posts sunk into the ground. What Christie interpreted as holes resulting from pentice posts Krogh took to be a separate, later building because the holes showed a wall with a slightly rotated orientation (Krogh outlined these two churches in red and green, respectively, on Christie's excavation plan, Fig. 2.12). He pointed out that Christie's interpretation of the four inner post-holes in the middle of the floor as foundations for an elevated central space depended not on archaeological proof but on a theoretical development hypothesis.[38] Krogh thought it possible that these holes resulted from scaffolding from one of the construction phases. He therefore concluded that the post-holes provide a basis for a hypothesis of *two* churches before the current one, but there was not enough stratigraphic information to conclude this with certainty.

Forty years later, after extensive, meticulous studies of the reused materials, Krogh concluded that *three* churches had been erected at Urnes before the present one.[39] In *Urnesstilens kirke*, he presented careful documentation of all the reused components and pointed out that further recycled materials may have been reworked to such an extent that they cannot be identified except by a complete dendrochronological investigation of all parts of the church. All the reused materials were cut or hewn from the previous (third) church to fit into the current one (colored brown by Krogh in Figs. 2.3–2.7). The nave's eastern ground-beam and the chancel's ground-beam are both reworked

PART ONE | SITUATING URNES

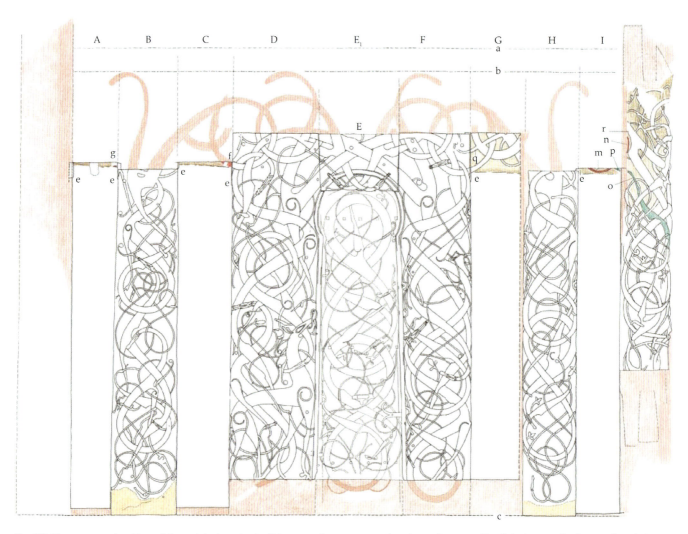

Fig. 2.13. Urnes, reconstruction of the original context of the carved planks in the third church. This underpins Krogh's theory about the western wall of that church. Krogh has marked what he sees as the indisputable outline of missing parts of the main animals, based on meticulous survey of the reused wall planks and the chancel's carved northeast corner post. Continuous black lines show preserved parts; dotted lines suggest original extent. The posts show that the carvings are complete on the right outer side but continued on the left. This implies that the post must have been in the southern corner (on the right, seen from the front). The top end of the post is partly intact, whereas the bottom end is cut off and shortened (shown in light brown). Planks *A*, *C*, and *I* have small traces of carving at the upper end (shown in red, similar to plank *G*). A thin incised line indicates the lower limits for the carved parts. Green marked as *p* on plank *I* shows the possible connection between the carving on the plank and the animal figure marked *o* on the corner post, also shown in green. The light brown shading marks missing parts on the bottom and sides of the plank. Darker brown without contour lines suggests the possible extension of the main figures on the missing parts. The height of the wall planks under the wall-plate is indicated by the top end of the post, which has a partly preserved upper end. The bottom of the wall is defined by the carving on wall plank *B* and *H*. The carvings on this end are undamaged, while the bottom ends of the wall planks are obviously reworked and shortened slightly to fit into the present building. This also fits well with the missing carving at the bottom of the door and the missing parts of the carvings on the portal sides. Plank *H* confirms the relationship in height between the upper parts of the portal and of the once continuous frieze on planks *A*, *C*, and *I*. Drawing: Knud J. Krogh, *Urnesstilens kirke: Forgængeren for den nuværende kirke på Urnes* (Oslo, 2011), 24–25, 72–73.

CHAPTER TWO | URNES: SOME CURRENT RESEARCH ISSUES

Fig. 2.14. Urnes, reconstruction of the connection between plank *I* and the corner post. Line *X* is the likely original diameter of the post. One most imagine the connection between post and wall plank in roughly 90 degrees. Figures *m* and *n*, and *p* and *o* in red show the uninterrupted continuation of the carving. The letter *e* is the original rebate for the tongue. Drawing: Knud J. Krogh, *Urnesstilens kirke: Forgængeren for den nuværende kirke på Urnes* (Oslo, 2011), 73.

sills from the previous church. The wall planks of the nave in the north, east, and south, as well as the planks in the chancel's north wall and, with two exceptions, those in the south wall are reused as well. The chancel's richly carved northeastern corner stave has also been reused, as have the planks in the chancel's east gable and the nave's western gable.

A number of authors have pointed out that these carved elements must originally have been located in a different, interrelated context.[40] The reconstruction proposals show variations on a continuous frieze placed in the west wall of the previous church. These hypotheses, however, are mainly based on visual analysis of the carving motifs, without a critical evaluation of the pieces' measurements in their current condition or in previous conditions, or of traces of their possible original jointing. In his extensive investigation and documentation, Krogh identified three additional wooden planks with remnants of carved decoration on the upper part. These three planks, with fragments of carvings, play a key role his reconstruction of the previous church. By systematically reviewing all the reused materials, he was able to create an overall picture of the shape and dimensions of the earlier Urnes church.

Fig. 2.15. Urnes, reconstruction of the west facade of the third Urnes church (yellow) compared to the outline of the post-holes of the second church (green); compare Fig. 2.12. The width of the reconstructed facade is *c.* 5.2 m, while the distance between the center of the post-holes of the corner posts is *c.* 6 m. Krogh concluded that the Urnes-style church at Urnes was built without excavated structures, with a sill frame on stone foundations, and therefore that it was the third church. Drawing: Knud J. Krogh, *Urnesstilens kirke: Forgængeren for den nuværende kirke på Urnes* (Oslo, 2011), 196.

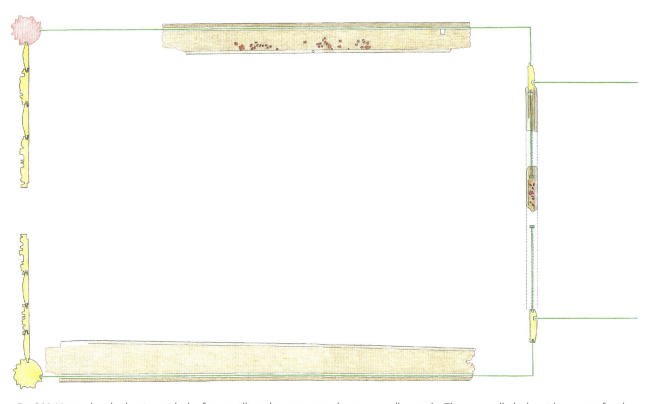

Fig. 2.16. Urnes church, drawing with the former sills and reconstructed western wall to scale. The two wall planks with grooves for the connection to the chancel are given an approximately place, together with the two fragments of the sill of the chancel screen. Red = traces of burned wood and fragments of wax on the northern sill. The location of the wall sills on the drawing is hypothetical. The longest sill measures 7.2 m; no traces of connections to corner posts or any thresholds can be seen, which suggests that the original sill was longer than the preserved one. Green = the wall, following the preserved grooves in the sills. Drawing: Knud J. Krogh, *Urnesstilens kirke: Forgængeren for den nuværende kirke på Urnes* (Oslo, 2011), 172–73.

The fundamentally new idea in Krogh's work is not that the reused carved parts belong together but, rather, *how* they do so, and what the consequences are for the interpretation of the post-holes, the number of churches, their construction methods, and their order. Construction fragments and small or unnoticed traces indicate a plausible order and thus a continuous connection among certain carvings (Figs. 2.13 and 2.14), which Krogh identified as the west wall and main facade of the earlier church, with the carved western pediment rising above it (Fig. 6.1). He placed the current chancel's northeast corner stave in the southwestern corner of the previous church and used its measurements to extrapolate a similar corner stave in the northwest. This reconstruction of the west facade is essential for an aesthetic and iconographic assessment of this building's decoration. It provides an estimated measurement for the wall height of the sill and wall-plate of *c.*4.5–4.6 m and a total height to the ridge of up to 8.5–9 m. Krogh's reconstruction shows the width of the building with a fair degree of accuracy as *c.*5.2 m.[41] This width is significantly less than the width between the post-hole traces from the second church (Fig. 2.15). Krogh therefore concluded that the previous church at Urnes—the Urnes-style church—was built without excavated structures, with a sill frame on stone foundations, and that consequently this must have been the third church at Urnes.[42] He maintained that the two reused sills from the earlier church must have formed the basis for the long walls of the nave. These provide a minimum length of the nave of 7.2 m, and Krogh considered it likely that the chancel was between 3.2 and 3.4 m wide, with a somewhat lower wall height than the nave and an unknown length.[43]

Krogh's conclusion was that the previous church had a rectangular nave with a narrower and lower chancel of unknown length (Fig. 2.16). He pointed out that the original workmanship of the reused materials is more meticulous than what was done for the existing church; not only the carvings but also the craftsmanship testify to a high-quality building. Significantly, none of the reused materials from the Urnes-style church show any signs of rot or other decay. Krogh therefore concluded that the church must have been in good condition, and there must have been reasons other than decay that led to this church being demolished after barely sixty years. Krogh highlighted traces of fittings for a gabled roof on the upper end of one of the planks of the north wall of the chancel. There are also a number of scorch marks in one area on the (former) top of one of the sills and on a fragment of the sill from the chancel screen (colored red in Fig. 2.16). Together with traces of wax, Krogh regarded these as possible evidence for side altars in the nave of the preceding church.

Dendrochronology and Construction History

As part of the investigations at Urnes from the 1990s to 2015, a large number of dendrochronological analyses were conducted to establish the felling year for the timber, both of the reused material and the wood that was new in the current church. As part of this work, methods for nondestructive sampling were developed in the form of photographing tree-rings on cleaved materials. In particular, wall planks consisting of cleaved timber can be dated in this way. Almost all the wall planks in the church were examined, and a large number of samples were taken using core drills.[44]

Of the reused materials, sapwood has only been detected in the western jamb plank of the north portal. This portal plank is the only one with large drying cracks, and these run across the carvings such that these have been displaced along the cracks. This shows that the plank continued to dry out after it had been worked. The wood was relatively fresh when it was carved, which means that not much time could have elapsed between felling and construction. The outermost tree ring on this plank dates to 1069.[45] However, it is possible that a small number of tree rings may have been lost, which means that the tree could have been felled in one of the years immediately after 1069.

Together with Krogh's findings, this shows the potential of other kinds of analysis to increase our knowledge of stave church archaeology, architecture, function, and decoration. As Krogh asserted, it is now possible to renounce the long-standing hypothesis that Urnes provides evidence that the so-called fully developed stave churches (those with freestanding inner staves and an elevated central area) evolved from the earliest Christian churches and that their method of construction originated in pagan cult buildings.[46] On the contrary, the surveys show that the existing church is a completely new type of church on the site, with spatial conditions, volumes, and construction methods very different from those of the previous church of c.1070.

The tree-ring dating of this earlier church accords with the generally accepted art historical dating to the third quarter of eleventh century but narrows this time frame and gives it greater specificity.[47] It can be concluded with a high degree of certainty that sill frames on stone foundations were known and in use at this time, as confirmed by the dated finds of dry-stone foundations for stave constructions in Lund (Sweden) and Jelling (Denmark).[48] The dating of the first sill-beam church at Urnes to 1070 or shortly after has consequences for how we consider the two previous churches on the site. In 1958 Christie found traces from one building that he dated around the mid-1000s, but this dating hypothesis can no longer be maintained. The coin on which Christie based his dating from was not found in a clear stratigraphic context;[49] strictly speaking, it only shows that there was a church on the site at the time the coin ended up in the ground. With two churches built on the site before 1070, neither of which burned down, it is reasonable to assume that the first of these may have been built in the early decades of the 1000s, if not before. There was probably a church built at Urnes before 1030, when Christianity prevailed in the country as a whole. In other words, the Urnes-style church of c.1070, the third on the site, was built well into Christian times, after the missionary period in this part of the country and probably a generation or more after the first church. By the time that first church was erected, people had already been buried in accordance with Christian customs at the site.[50]

The Interior of the Urnes-Style Church

The two reused sill fragments are large and lie on their broad sides. There is a groove for the wall planks along the outer edge and carefully drawn profiles along the other. The profiles and dimensions of the sills show that they may have served earlier as benches in the longitudinal nave. The shape of the sills in the nave's east and west walls is unknown. Two fragments of the sill in the opening to

the chancel have been heavily reworked, but part of the threshold of the chancel opening is intact and has distinct scorch marks. Krogh noted that these probably resulted from burnt wicks of wax candles,[51] which must have hung above the chancel opening or close to it.

Materials reused from this previous church have traces of one or two possible side altars in the nave, and one of them may have been a permanent fitting. These traces indicate the possible fixtures and use of the church interior in the eleventh century and, more broadly, raise the question of how the oldest preserved stave churches were used. The current church at Urnes contains clear evidence of later inserted altarpieces, which have led to obvious deterioration of the building structure. Similar secondary changes can be seen on several later stave churches. We must therefore consider whether these secondary changes might be due to the fact that the side altars were eventually given more prominence in the church interior, rather than being a later phenomenon.[52]

This leads to a problem as old as the research on the stave churches itself: Where and when did the church type with an elevated central space appear? Given the known preserved material and the absence of sources, it is impossible to give a sound answer to this question. But if we limit the question to Urnes, it is now possible to get a clearer picture thanks to the interdisciplinary research of the past decade. The plans for the current church at Urnes must have been drawn up before the building material was felled. The oldest dated sections devoted to today's church were felled during the winter of 1129–30. As far as one can judge, this construction used tried and tested methods; it was not an experiment. There must have been important reasons for a fully functional and richly decorated building such as the previous church to be demolished after a maximum of sixty years. Krogh asserted that new architectural ideas were applied at Urnes.[53] Buildings with a raised central section in the nave and chancel must have been more or lesser familiar prior to 1129 because the construction techniques are expert, not experimental. The questions of when and where those earlier churches were built have occupied research since the mid-1800s.[54] Were stave churches with elevated central sections the result of ecclesiastical initiatives? Peter Anker highlighted this as a possibility, and he thought it possible that this type of church might have originated in Norway.[55] Both Christie and Anker argued that the Church needed to develop wooden structures in order to erect enough churches in a country with marginal resources.[56] It is therefore relevant to consider the lost contemporary wooden architecture and wooden churches on the Continent and in Britain and Ireland. Church types, construction methods, and decoration may have come as a package, as Erla Bergendahl Hohler proposed as one of several possibilities.[57] A stave construction without earth-fast posts rests on stone foundations laid on the ground, and the traces of such foundations are often removed by later construction work and easily overlooked in excavations.[58] Krogh rightly highlighted research-driven church archaeology as an opportunity to move forward, especially in medieval towns. At Urnes, the direction for future research is clearer now that the architectural relationship between the previous church and the present one has been clarified.

The Exterior Decoration

Urnes is also a key monument for both pre-Romanesque and early Romanesque church decoration in Norway. Three main questions have dominated academic discourse about its decoration. The first is the dating of the various phases. This has now been largely clarified, as shown above. The second is the question of parallel phenomena and possible models for the decoration in each of these two periods. This question has not been addressed to any great extent, but current thinking rests,[59] to some extent, on whichever view is used as a basis for the dissemination of motifs and ideas.[60] Did Romanesque stave church sculpture in Norway originate in stone sculpture in such large centers as Trondheim or Bergen, or were influences carried via other lines and/or materials? The third question concerns the iconography of both the older exterior carving of the 1070s and the carving done in the 1130s for the current church. The issue today is whether the sculpture at Urnes and the later stave church portals should be understood as allegorical or symbolic images with a religious message, or whether they are "simply" ornamental.[61] A starting point for this discussion is the north portal at Urnes, which, as the oldest work, is usually treated as a more or less complete and sometimes even as an independent object.

The pre-Romanesque carvings of the north portal have given this style a name: the Urnes style. The relationship of these carvings to other works in this style (runestones, wood carving, manuscripts, and metalwork) has been examined in detail and is now widely recognized.[62] In many ways the situation is similar for the early Romanesque carving at Urnes, which is also without parallel in the extant stave churches. Here too there is consensus about stylistic connections; the main questions have to do with the iconography of the portals (or the lack of it). Since Lorentz Dietrichson in 1892 (the first Norwegian professor of art history), the iconography of the early Romanesque carving at Urnes had been considered only by the art historian Ellen Marie Magerøy.[63]

The question of whether stave church portals had intentional meaning or symbolic or allegorical significance has been the subject of extensive debate.[64] Only two strands of biblical motifs have been preserved, and here there is consensus.[65] However, as far as we can understand today, the vast majority of the portals are devoid of clear religious motifs or messages. Scholars agree that stave church carvings and portals originated in and date to Christian times;[66] their positions can be divided into "iconographers" and "iconophobes," to borrow Hohler's expression. It is tempting to add a third group, the "questioners," as not all scholars adopt clear positions on this question.

The north portal and other exterior carving at Urnes are composed of intertwined, long, slender, smoothly tapering creatures, with forelimbs that have ribbonlike feet and hindquarters without legs that terminate with the same ribbon shapes as the forelimbs (Fig. 2.13 and Plates 3, 11, and 12). The animals bite themselves and each other. Between them, narrow ribbonlike reptiles bend and intertwine in coils and loops, biting the larger creatures. The larger animals are seen from the side, while the ribbonlike reptiles are seen from above. This motif is repeated and varied on all the decorative material.

The relief on the portal frame and the two carved side planks is up to 7–8 cm deep with a curving, convex surface. The archivolt of the portal is unique among the stave churches: the opening is circular in 240 degrees, and together with the upward-slanting sides it gives the impression of a modern

CHAPTER TWO | URNES: SOME CURRENT RESEARCH ISSUES

Fig. 2.17. Urnes church, schematic drawing of west gable with the reused panels in a possible original context. The panels have been cut, mostly at the bottom and on the south (right) side. Red = what Krogh saw as indisputable patterns; uncolored areas without black contours = eroded parts. Drawing: Knud J. Krogh, *Urnesstilens kirke: Forgængeren for den nuværende kirke på Urnes* (Oslo, 2011), 44.

keyhole. The frame molding of the archivolt projects. The detailed, precisely executed carving is an outstanding work of wooden craftmanship. The corner stave relief is somewhat shallower, up to 4–5 cm, while the gable planks and door leaf have a flat relief, only 4–5 mm deep. The left (eastern) side of the portal is considerably wider than the right; the maximum widths are 82 cm and 65 cm, respectively. Two distinct motifs stand out: a four-legged animal at the bottom of the left portal side plank and a more elongated four-legged creature centered on the west gable of the nave (Fig. 2.17). Both quadrupeds are encircled and attacked by surrounding animals. These four-legged animals are central to the discussion about possible meaning.

Today there is consensus that the four-legged animal among the fighting creatures on the portal side plank is based on one of the two figural sides of the large runestone in Jelling and that the four-legged animal there must be a lion (Plate 8).[67] There is also agreement that the Danish work is the first time the motif appears in Scandinavia and in a Christian context.[68] The later runestones in Sweden continue this design based on the prestigious monument at Jelling. The discussion revolves around

165

what the four-legged animal door, the "lion," at Urnes symbolizes. Anders Bugge emphasized that the lion could be a Christian symbol of victory, winning the battle against the evil powers represented by the serpent. He sees the myriad animals and snakes as destructive forces, held back in fear of the lone lion. Signe Horn Fuglesang perceived the lion–snake motif in Jelling primarily as a ruler symbol, noting that both lion and dragon are military and ruler symbols from the time of the Roman Empire onward.[69] Jelling and its context is one issue; another is whether the motif's significance at Urnes could have been the same about a hundred years later. It is generally agreed that the animal at Urnes is a ruler symbol, but there is a schism when it comes to matters of religious significance.

In Norwegian scholarship, the "iconographers" regard the decoration of the church portals as meaningful, with an explicit preaching function; animal motifs can be seen as guardians marking the transition from the secular to the sacred.[70] Hohler argued quite strongly against such an approach.[71] She regarded both Urnes and the later decorative and dragon portals as generic ornament, without a religious function, and suggested that portals like the one at Urnes may be inspired by those in chieftains' halls and thus have a nonecclesiastical origin.[72] This is plausible, but it draws a line of demarcation that unnecessarily narrows the range of interpretations. The Swedish runestones and picture stones are the preserved monuments that come closest to the Urnes carvings in time, style, and format. They are characterized precisely by their ambiguous design and function as markers of faith, relationships, and property rights. In her MPhil. thesis on the Urnes portal, Elin Lønngeroth Pedersen concluded that in the eleventh century there was not necessarily any contradiction between ruler symbols and Christian ones.[73] She underscored the ambiguity in motif and function in the Swedish stones. The Urnes style and the four-legged animal are found on a wide range of objects and in all materials throughout Scandinavia, England, and Ireland over a long period, so the context of the object is essential for the interpretation that Fuglesang emphasized.[74] The exterior carvings at Urnes can be seen as a symbol with religious, political, and social connotations. Such an approach allows portals and friezes that may have been meaningful at Urnes also to have been meaningful in chieftains' halls and nonecclesiastical contexts, such as Swedish runestones in the Urnes style.

This raises the question of whether the style and religious-historical meanings of stave church portals changed during the two centuries between the Urnes portal and the last decorated examples. Like Hohler's suggestion of a secular background for portal art, this has scarcely been addressed in stave church research.[75] There are difficulties with source material. About 250 secular timber buildings from the Middle Ages are known in Norway,[76] and few of these have been dated before 1200 on the basis of dendrochronology.[77] No major study of medieval secular portal art in Norway has been carried out since the 1950s.[78] To the extent that there are similarities among thirteenth-century portals, these are, with a few exceptions, close to motifs that ultimately derive from Romanesque stone architecture and were presumably disseminated through stave church carvings.[79] Any possible secular portal art, independent of and older than the churches, has thus disappeared without obvious traces in the preserved material.

With Krogh's reconstruction of the third Urnes church's west facade, there is a good opportunity for a renewed discussion of its composition and the individual motifs as a whole, not just as individual pieces with the main emphasis on the portal. In this discussion, the east gable is also important. As mentioned above, the west gable has a centralized slim, elongated, four-legged animal that is biting

CHAPTER TWO | URNES: SOME CURRENT RESEARCH ISSUES

Fig. 2.18. Urnes church, schematic drawing of the chancel gable with reused panels in a possible original context. Red = what Krogh saw as indisputable patterns. Several parts are missing, and all the preserved planks are heavily reworked to fit in their current location. Planks 3, 4, and 5 (from the left) are displaced to a lower level compared to planks 1 and 2 (right). Note the small part of a carved animal at the lower right side. This is wider (approx. 2.5 cm) than the reptiles (1.1–1.4 cm) and may be a second animal, supplementing the main motif. Drawing: Knud J. Krogh, *Urnesstilens kirke: Forgængeren for den nuværende kirke på Urnes* (Oslo, 2011), 153, and Plate 11 in this volume.

and at the same time being bitten by a reptile surrounded by ribbonlike animals with and without limbs and by a plethora of ribbonlike snakes. The east gable today consists of parts of the original motif that have been heavily trimmed, resulting in a displaced composition (Fig. 2.18 and Plate 11). Several parts are missing, and planks 3, 4, and 5 (from the left) are displaced to a lower level compared to 1 and 2. As Krogh pointed out, these last two have at the lower ends fragments of a small part of an animal (approx. 2.5 cm) that is slightly broader than the reptiles (1.1–1.4 cm). This may be a second animal, supplementing the main motif of a ribbon-shaped, tapering animal with the upper part of a forelimb and hindquarters that swing down and run uninterrupted to a writhing intersection with the tail. The animal is surrounded by one or more slim, ribbonlike reptiles that it appears to be biting.

Part of the subject has been cropped, so this is uncertain. The preserved parts provide no basis for concluding that the main subject is a four-footed animal, as it has often been described;[80] rather, this is a one-legged creature of the same kind as can be seen on the carved planks, the corner stave, and the portal in the north wall.[81] Based on the size of the animal and the probable roof angle and width of the gable, this creature was the original gable's main motif: there is no other room for any others. The east gable thus had a motif unlike that on the west gable. It may be worth noting that the east gable and the carved corner stave are the only parts of the preserved decoration where the animals' shoulders lack spiral articulation.

Is the motif on the west gable a variant of the one on the bottom of the left portal plank? The four-legged animals are carved differently. On the portal it is more powerful, standing upright with long, straight limbs, now almost twice as high as it is long and with a long tail terminating in leaves. The body is relatively short and has a hint of a curved abdomen. In the gable, the four-legged animal is today about as long as it is high, and it lacks a tail. It was located higher up; the lower part of the pediment with the termination of the limbs is cut off, as in the portal. The similarities and differences between these two four-limbed creatures are noted in the research, but there has been little discussion about whether they may be different motifs.[82] The differences in carving can perhaps be explained by the fact that the low relief on the gables required a composition and treatment different from that of the portal. This is plausible, but not obvious, and it is less clear now than before.

Krogh's reconstruction of the west facade (Fig. 2.13) and a clearer understanding of the main motif of the east gable (Figs. 2.18 and 2.11) should facilitate renewed discussion of the motifs in the reused carvings, including their possible or probable iconography as a coherent composition. Krogh highlighted the possibility that the carvings were painted,[83] referring, *inter alia*, to the preserved fragment of a wall-plate carved in the Urnes style from Hørning in Denmark, which has visible residues of yellow ochre, red, and charcoal black. Questions about the portals' possible liturgical function have not previously been considered seriously in stave church research, but they have emerged with renewed energy in the wake of research at the cathedral in Trondheim (on this topic, see Chapter 6).

The Capitals and the Romanesque Carving

The church has eighteen freestanding staves, or columns, that carry the elevated central space. The middle stave on the central axis rested on a cross-beam supported by brackets. To the east, in front of the chancel, this beam and the supporting brackets were removed during a rebuilding so that the stave hangs freely in the space. These two smaller staves do not support the wall-plate but, rather, the sill-beams of the upper walls. Below the upper-wall sills, horizontal planks lie in each section between the staves. Toward the central space of the nave, arch-shaped profiled segments are doweled to these planks, forming an arcade around the entire nave interior. These arch segments terminate against the capitals, thus giving the impression that they carry the arcades. The cushion capitals have carvings in low, flat relief on the sides visible from the church's central space. The capitals on

the central staves have carved decoration on three sides, while the corner staves have decoration on two sides. The short stave on the central axis in front of the chancel opening also has a profiled column shaft. The other staves continue up to the roof. Against the upper wall they are tapered with an elongated triangular section. The tapered staves are carved with meandering dragons seen in profile; their tails are shaped like long undulating vines. On one of the tapered staves there are two animals: the upper one, with four feet shown from above, is being attacked from below by a dragon shown in profile.

There were fifty-four carved capital surfaces in total (Plates 38–95). Some are hidden or were destroyed in later rebuilding, but overall the carving is very well preserved. There are various types of lions; sprawling, writhing dragons; centaurs; a camel with two rather small humps; and a cleric, probably an abbot, barefoot with a crosier and cross.[84] Birds and smaller winged creatures are also included, as well as plants with stems and foliage. The motifs are clearly presented as individual figures against the background. Framed by the capital contours, they are reminiscent of coats of arms of more recent times.

There are faint traces of color on the tapered staves and on some of the capitals. Ultramarine and red have been found,[85] and there are also clear vestiges of red on the surfaces above the arcades. This means that both the carving and at least some of the building elements were colored, which must have had a major impact on the perception of the carving. It also raises questions about possible original coloration of the exterior sculpture.[86]

The west portal of the church has columns and an archivolt motif that echoes the arcades on the interior but is executed as half-columns pegged to the wall with wooden dowels (Plate 29). Here we find the same upright shield-shaped cushion capitals as on the staves in the nave. The surfaces have been partly destroyed, damaged after the door was rehinged to open outward rather than inward after a fire at Grue church in 1822, when a large part of the attending congregation lost their lives. The dragon motifs are nevertheless clear and easy to perceive. The relief is modeled more softly than in the interior of the church.

This rich decoration is mentioned in a number of scholarly papers. Attention has primarily been paid to stylistic features and the extent of motifs and their use. A connection to Romanesque sculpture from Jutland, with frequent use of high cushion capitals, is a key element (see below). The question is whether the carving from the 1130s is an independent collection of motifs from the large catalogue of available Romanesque motifs,[87] or whether there is a connection among the individual motifs to create stories or multiply symbolic meaning across one or more capitals.[88]

The capitals' iconography has received limited attention.[89] In the late nineteenth century Dietrichson pointed to models from classical antiquity for the multiheaded dog Cerberus, the centaur, and the stag hunt.[90] He also noted medieval examples, such as the creature's role in the legend of St. Anthony and a floor tile from Hovedøya with a centaur carrying a sword and a shield like the one at Urnes.[91] When Magerøy later discussed the ecclesiastical figure at Urnes, she returned to Dietrichson's idea and suggested that he represented St. Anthony.[92] She also pointed to possible connections between St. Anthony and other fabulous animals in the church, and Harry Fett argued that the main theme in the capitals of Urnes was the struggle between good and evil.[93] Rolf Mowinckel found support in Bernard of Clairvaux's letter to William of Saint-Thierry and described

the Urnes ensemble as devoid of symbolic or religious meaning, inspired instead by extraordinary things the artist had heard about in legends, poems, apocryphal histories, and marvelous stories about nature.[94] In her study of the capitals, Hohler, like Martin Blindheim, also rejected the idea that there is some deeper meaning in the motifs.[95] This leaves a number of questions unanswered, some of which are discussed by Kirk Ambrose, Kjartan Hauglid, Elizabeth den Hartog, and Thomas Dale in later chapters in this book.

Magerøy's views raise the question of whether there is any logical connection between the carved motifs and their locations. It is worth noting that vines are exclusively used on the corner capitals of the central space and that all but one of the surfaces of those capitals are symmetrical.[96] Some capitals have motifs that can be linked together, such as deer hunting and riders, but it is unclear what significance can be assigned to this. The west portal capitals are adorned with dragons, probably by deliberate choice. They add to what we have of the church's older decoration on the north wall, as well as a host of later portals with animals in pairs, whether mythical creatures like dragons or species-specific lions. It is hard not to see this as an ancient protective motif, whether the dragon guardians are related consciously to the reused north portal or are used purely conventionally. The composition of the portal capitals is less dense than those inside the church, and they have a more rounded relief. Hohler saw both the motif treatment and the modeling as deliberately archaizing adaptations to the reused north portal (Plates 39–41 and 93–95).[97] This may affect how we interpret the meaning of the previous church's sculpture, its reuse, and the decoration of the present church.

The pentice in the west is carried on staves shaped like columns with cushion capitals (Plate 23). The church previously had an encircling pentice, of which only the west vestibule remains, and a new pillar was added to it in 1907.[98] Only one of the pentice capitals is decorated, and it has a very unusual design. On three sides there is a convex funnel shape of deeply engraved, twisting vines that originally ran symmetrically, or nearly so, on each side (Plates 26–28). The vines sprout from a mask and are tied together with a central knot. The back side of the capital, facing into the church, has a shield-shaped surface like the sides of the decorated cushion capitals inside. One side of the capital has been cut off, probably when the pentice was enclosed and a door added. Despite this, the original design and motif are legible. The motifs on the capital are distinctive, with clear parallels not with Jutland but, as Hohler asserted, with the carvings at Hopperstad, the so-called Sogn-Valdres group I. She noted that this does not separate the creation of this capital from the church in terms of time.[99] The other capitals of the pentice are not carved. They have roughly semicircular shield surfaces (height-to-width ratio 1:2) and are not as tall as the capitals inside the church, those on the west portal, or the decorated pentice capital (7:8) (Plates 25 and 28). This, together with the connection to Hopperstad, led Hohler to conclude that the pentice was made by craftsmen who belonged to a different tradition or school. Curiously, she did not consider the shape and lack of profiled abacus on the cushion side of the decorated pentice capital and its similarity to all the other decorated cushion capitals.

The similarity between the pentice and the church proper is further underscored by the different profiled shafts of the pentice columns. The one with the decorated capital has an octagonal pillar shaft with a triple neck ring and base ring, now covered with protective cladding. Two other columns in the pentice have elaborate, varying profiles along the shaft and double neck rings and base rings.

This decoration of the pillars has a parallel inside the church, where the dwarf stave above the chancel opening is carved to allow the shaft to unfold into four leaves held together by a neck ring under the capital. These similarities between the pentice and the church interior indicate not only that they were deliberate but that they were planned and executed by the same craftsman or craftsmen. The carver(s) mastered and created both capital types at the same time, using a wide vocabulary of motifs. The capitals' height–width ratio need not be seen as a stylistic feature; it may have been determined by the opportunity it provided for elevating each design.[100] There is good reason to think that the pentice is contemporary with the present church.[101]

The Romanesque carving at Urnes is diverse in terms of motifs, modeling, and location. In my opinion, any discussion of iconography and the current church carvings must embrace the entirety of Romanesque sculpture, including the carved abatements on the staves, the capitals in the church, the west portal, and the pentice capitals. A complicating element in such a discussion is the reused material. One issue is its possible significance in the Urnes-style church of $c.1070$; it is not obvious that this significance would have been the same in the church begun around 1130.

Use and Reuse of Imagery

The church as it stands today contains, to a greater or lesser extent, two decorative programs (to use an anachronistic phrase). What could lie behind such a striking choice? Reuse of older materials with Urnes-style carvings was also done in the later stave churches at Torpo, Hopperstad, and Rinde (Feios), the latter demolished in 1866 (for the eleventh century material, see also Chapter 4). In the so-called Bjølstad chapel in Heidal, two large fragments of a portal have also been preserved and reused.[102] At Kvikne, in Tynset, fragments of stave church planks with carved four-legged Urnes creatures are preserved from the interior.[103] Construction elements in wood decorated in the Urnes style have also been preserved in Sweden (Hemse, Brågarp, and Guldrupe) and Denmark (Hørning). However, with the exception of the Bjølstad chapel, there is a very important difference from Urnes: all of these Urnes-style carvings were recut and reused so that their decoration was not visible.[104] It was evidently the use value of the wood that was significant. At Hopperstad, two parts of one or two carvings of the Urnes type were reused as floor joists in the present stave church. At Torpo a fragment of a portal was preserved as a floorboard in the now demolished apse of the preserved church. A plank from Rinde, probably part of a gable decoration, was likely reused in a suspended ceiling in the subsequent stave church, which was demolished in 1858.[105] The fragments reveal that these sites also had churches with grand decoration in the Urnes style, although it is impossible to determine whether their scale and quality were on a par with Urnes. The decoration at Hemse was far more modest than at Urnes, while at Brågarp and Guldrupe we only know that the carved pieces were originally from stave church portals. As noted above, Hørning's wall-plate with figure-eight-shaped Urnes creatures was painted black, yellow, and red on the outside. Color may have been important in highlighting motifs on the exterior carving at Urnes and other churches with similar decoration.

At Urnes, by contrast, the reused materials were displayed so that parts of the decoration could be seen, but at the same time they were reworked and moved from their original context to fit into the new church. The pieces were reused more or less as individual elements; this is most apparent in the chancel's east gable. On the one hand, emphasis was placed on retaining significant parts of the decoration; on the other hand, less care was taken with details and original connections.

What could lie behind such choices, and why only at Urnes? The southern Scandinavian stave churches were followed by churches made of stone, which helps explain why the conditions for reusing carvings were lacking. But why were the carvings not reused as decoration in the wooden churches at Hopperstad, Rinde, and Torpo?[106] Did the carvings at Urnes have special significance, perhaps forging a link between the previous church and those who decided what the new one should look like? This is one of the issues that should be considered in any discussion of iconography. It is also appropriate to bring the Romanesque carvings into that discussion, because the west portal represents a likely link between reused and new materials. If this is the case, might it indicate a form of legitimacy, continuity, or transformation of possible meaning in content or symbolic use?

Urnes and the Early Church Building Activity in Indre Sogn

The centrality of Urnes in stave church research and church archaeology is primarily due to its preservation; there is no reason to believe that the existing stave church or its predecessors were exceptional structures when erected. The archaeological traces of the previous churches here are also not unique in the district. Similar post-holes from two earlier churches have been found under the floor of the Kaupanger stave church in Sogndal, near Urnes.[107] The current Kaupanger church, the third on that site, has been dated by dendrochronology to 1140 or shortly after.[108] A coin minted between 1065 to 1089, found in the layer of the preceding church,[109] indicates that this one came into use by about 1090 at the latest. The first church at Kaupanger is not dated, but it may well have been built around the mid-eleventh century, if not before.

The preserved parts of the buildings from Hopperstad and Rinde with Urnes-style carvings indicate that there were churches there at about the same time as the third church at Urnes (*c.* 1070). It is unclear whether those church sites might be older than Urnes, but it would not be surprising if they were. Archaeological excavations in other medieval churches and church sites from Sogn may provide a broader picture in the future. In the period beginning about 1130, and for some decades thereafter, there must have been a stave church construction boom in the area. Hopperstad is about as old as the present church at Urnes, and Kaupanger was built a few years later. The demolished churches at Rinde and Vangsnes, together with the destroyed stave church from Fortun, are stylistically dated by their portals to the second quarter of the twelfth century.[110]

The church building at Urnes is part of a larger picture. Its parish was one of many small parishes in Indre Sogn, according to sources from the early fourteenth century.[111] By contrast, Stedje in

Sogndal stands out as the ecclesiastical center, with the main church for the county of Sognafylke and one of three district churches at Hopperstad in Vik. The clergy in these churches had a major role in the regional ecclesiastical system,[112] which may go back a long way, possibly to the first days of the Church in Sogn.[113] According to the sources, Stedje and Hopperstad were very large farms, albeit somewhat smaller than Ornes.[114] Both of them are likely to have had early aristocratic church buildings. Other farms are also possible sites of early churches built by great landowners. Kvåle in Sogndal was the same size as Ornes and was also a church site in the 1300s.[115] Vangsnes was also probably a farm of a similar size,[116] and a stave church dated *c*.1150 stood there until 1861.[117] The point is that based on the historical context in Sogn, the church site and churches at Urnes are not very special. There were other farms with church sites that lack extant church remains. Only the two stave fragments from Hopperstad suggest what might have been there, and the same is true of the plank from Rinde, where the church site offers no signs of an aristocratic context.

Comparing Rinde and Urnes makes this very clear. Both had new churches before and around 1150. At the former, this was a simple church with no elevated central space and with a chancel the same width as the nave. At Urnes, by contrast, one of the earliest churches in Norway (as far as we know) with a raised central space was erected, with an outstanding, lavishly decorated interior. From Rinde we only know of two portals with semicolumns, cushion capitals, and a round-arched archivolt with stepped profiles. There are no sources to indicate that a great landowner was the patron or builder at Rinde. Yet both sites had churches with monumental exterior decoration in the Urnes style in the decades before 1100. The fragment from Rinde probably comes from a carved gable, and no other decoration from this early church has been preserved. Even a single decorated gable would have created an impressive facade, however. Because its motifs cannot be determined, it is not possible to compare Rinde with Urnes beyond noting that the former was carved in the Urnes style. This is a useful reminder that, shortly before 1100, the church at Urnes was not unique in its decoration, either in Sogn or in Scandinavia; it may or may not have been unusual in its motifs or combinations thereof. A comparison with motifs on contemporary Swedish runestones might shed light on this.

Even extensive decoration may not have been rare on wooden churches in Scandinavia and in Sogn before the year 1100. In Sogn, such decoration provides no clear evidence of being linked exclusively to the top tier of medieval society. Yet, for unknown reasons, the carving on the previous church at Urnes must have been accorded special significance at the time of demolition, a significance that did not apply at Hopperstad and Rinde at about the same time. Rinde's plank fragments provide a useful corrective to the temptation to link decoration and exclusive social context. They remind us of the random nature of the material that has been preserved and also how slim our written sources are for early church building. Had the stave church at Urnes been lost, like most others built in Norway, what kind of picture of medieval stave churches and carvings would we have today? Stave church research offers fragile constructions of the past. Nevertheless, or perhaps precisely because of this, the testimony of even small building fragments is crucial and can be far-reaching in specific contexts, as at Urnes. The potential for future stave church research is great.

Notes

1. Terje Thun et al., "Dendrochronology Brings New Life to the Stave Churches: Dating and Material Analysis," in *Preserving the Stave Churches: Craftsmanship and Research*, ed. Kristin Bakken, trans. Ingrid Greenhow and Glenn Ostling (Oslo, 2016), 91–116, at 105–9.
2. Martin Blindheim, *Painted Wooden Sculpture in Norway c. 1100–1250* (Oslo, 1998), 29, 47–48 (dating); and Tine Frøysaker, "Kalvariegruppen i Urnes stavkirke," *Årbok: Foreningen til norske fortidsminnesmerkers bevaring* 157 (2003): 125–36, at 128–30 (dating and coloring).
3. Frøysaker, "Kalvariegruppen i Urnes," 128.
4. Hedared stave church in Västergötland; description in Erland Lagerlöf, *Medeltida träkyrkor II* (Stockholm, 1985), 100–109. For Swedish stave churches, see also Emil Ekhoff, *Svenska stavkyrkor: Jämte iakttagelser över de norska samt redogörelse för i Danmark och England kända lämningar av stavkonstruktioner* (Stockholm, 1914–16), 179–214; Marian Ullén, *Medeltida träkyrkor I* (Stockholm, 1983); Marian Ullén, "Holzkirchen im mittelalterlichen Stift Växjö," 321–42, and Gustaf Trotzig, "Holzkirchen archäologie auf Gotland und der Sonderfall von Silte," 227–93, both in *Frühe Holzkirchen im nördlichen Europa*, ed. Claus Ahrens (Hamburg, 1981).
5. Vang/Wang stave church in Karpacz; description in Arne Berg, "Stavkyrkja frå Vang og hennar lange ferd," *Årbok: Foreningen til norske fortidsminnesmerkers bevaring* 134 (1980): 105–40; and Arne Berg, "Die Stabkirche von Vang und ihre lange Reise," in Ahrens, *Frühe Holzkirchen im nördlichen Europa*, 481–98.
6. Mark Gardiner, "Timber Churches in Medieval England: A Preliminary Study," in *Historic Wooden Architecture in Europe and Russia: Evidence, Study and Restoration*, ed. Evgeny Khodakovsky and Siri Skjold Lexau (Basel, 2016), 28–41, esp. 32; and Håkon Christie, Olaf Olsen, and H. M. Taylor, "The Wooden Church of St. Andrew at Greensted, Essex," *Antiquaries Journal* 59.1 (1979): 92–112.
7. Claus Ahrens, *Die frühen Holzkirchen Europas* (Stuttgart, 2001); and Jørgen H. Jensenius, "Trekirkene før stavkirkene: En undersøkelse av planlegging og design av kirker før ca år 1100" (PhD diss., AHO, Oslo, 2001), appendix 1 with catalogue of thirty-one sites in Norway with direct and indirect traces of wooden churches with earthen structures.
8. Håkon Christie, "Stavkirkene: Arkitektur," in *Norges kunsthistorie*, vol. 1, *Fra Oseberg til Borgund*, ed. Knut Berg et al. (Oslo, 1981), 139–252.
9. Leif Anker, *The Norwegian Stave Churches*, trans. Tim Challman (Oslo, 2005).
10. Knud J. Krogh, "Bygdernes kirker: Kirkerne i de middelalderlige, norrøne grønlandske bygder," *Tidsskriftet Grønland* 8–9 (1982): 263–74; and Knud J. Krogh, *Erik den Rødes Grønland* (Copenhagen, 1982).
11. See Erla Bergendahl Hohler, *Norwegian Stave Church Sculpture*, 2 vols. (Oslo, 1999); and Leif Anker, "Between a Temple and a House of Cards," in Bakken, *Preserving the Stave Churches*, 135–66, at 136.
12. Volume 1 of Hohler, *Norwegian Stave Church Sculpture*, contains a catalogue of preserved stave-church sculpture; volume 2 contains plates in alphabetical order.
13. Heddal and Reinli are dated to the thirteenth century on the basis of style; see Hohler, *Norwegian Stave Church Sculpture* 1:150–56 and 203–4. Some stave churches, such as those at Grip, Kvernes, and Rollag, have no significant (preserved) sculpture and have been generally dated to the period from the thirteenth century onward, with unpublished research even indicating early postmedieval datings. The preserved portals from Hof and a fragment from Dovre also have had a disputed dating; see ibid., 1:166.
14. Other issues around Urnes are also relevant. Interdisciplinary work has been carried during the extensive dendrochronological investigations, which included methodological developments; see Thun et al., "Dendrochronology Brings New Life to the Stave Churches." This has raised new issues, including material quality and material use. Hans Marumsrud and Kristen Aamodt have analyzed material use and traces of workmanship in the stave churches at Nore and Uvdal. Marumsrud and Aamodt, "Nore og Uvdal Stavkirker: Tømmerkvaliteter og materialframstilling," unpub. report for Riksantikvaren, Oslo, 2002 (manuscript in the library of The Directorate of Cultural Heritage, Oslo). This has not yet been carried out at Urnes. See Leif Anker, "Stave Church Research and the Norwegian Stave Church Programme: New Findings–New Questions," in Khodakovsky and Lexau, *Historic Wooden Architecture in Europe and Russia*, 94–109.
15. Hohler, *Norwegian Stave Church Sculpture*, vol. 2, provides a thorough overview of the research history with an emphasis on sculpture. Leif Anker gives an outline of the stave church architecture's research history in "Between a Temple and a House of Cards"; and Ragnar Pedersen discusses empiricism and methodology in stave church research in "A Complex Field of Knowledge: Empiricism and Theory in Stave Church Research," in Bakken, *Preserving the Stave Churches*, 167–90.
16. Halvard Magerøy, "Urnes stavkyrkje, Ornes-ætta og Ornes-godset," *Historisk tidsskrift* 67.2 (1988): 121–44.
17. Thun et al., "Dendrochronology Brings New Life to the Stave Churches."
18. Snorre Sturluson's (1178/79–1241) *Heimskringla*, also known as the Norwegian kings' sagas, includes kings and events until 1177. These sagas make no mention of people from Ornes. *Heimskringla* was written down about 1230 and builds partly on older written sources, of which many have been lost, and partly on oral transfer. See Hallvard Lie, "Heimskringla," in *Kulturhistorisk leksikon for nordisk middelalder: Fra vikingetid til reformationstid*, 2nd ed. (Viborg, 1981), 6: cols. 299–302; and Finn Hødnebø, "Innledning," in *Norges kongesagaer*, ed. Finn Hødnebø and Hallvard Magerøy (Oslo, 1979), ix–xxi. *Heimskringla*'s value as a source of historical events has been much debated by scholars.
19. Erla Bergendahl Hohler, "The Capitals of Urnes Church and Their Background," *Acta Archaeologica* 46 (1976): 1–60, at 8n9; Magerøy, "Urnes stavkyrkje, Ornes-ætta"; and Anker, *Norwegian Stave Churches*, 63, 118.
20. The spelling of the place-name Urnes stems from the time when Danish was the ruling language. The modern place-name for the site and the farm is Ornes. The name Urnes is, however, so well-known and so widely used in previous literature that it is also employed in this book.
21. *Diplomatarium Norvegicum* (hereafter *DN*), 23 vols. (Christiania–Oslo, 1847–2011), 15 (1970), no. 1. https://www.dokpro.uio.no/.

22 Land debt was at this time a public valuation of utility value, about 1/6 or slightly lower than the gross return. Hallvard Bjørkvik, "Landskyld," in *Kulturhistorisk leksikon for nordisk middelalder*, 10: cols. 278–80.

23 *DN* I (1847), 463.

24 Calculated as follows: A *laup* is equal in monetary value to 3 marks, equivalent to 1/3 of a "'burnt'" mark. One "burnt" mark = 1 mark silver = 214 g, according to Guttorm Steinnes, "Mål, vekt og verderekning i Noreg i millomalderen og ei tid etter," in *Maal og vægt*, ed. Svend Aakjær (Stockholm, 1936), 84–154.

25 A *fullgård* was a farm with at least one adult worker in addition to the farmer. Audun Dybdahl, "Agrarkrisa i Årdal, Lærdal og Borgund," in *Seinmiddelalder i norske bygder: Utvalgte emner fra det nordiske ødegårdsprosjekts norse punktundersøkelser*, ed. Lars Ivar Hansen (Oslo, 1981), 141–88, at 159–62; and Ingvild Øye, "Sogndal i mellomalderen ca.1050–1537," in *Sogndal bygdebok*, vol. 1, *Allmen bygdesoge: Tida før 1800*, ed. Per Sandal (Sogndal, 1986), 239–419, at 320. There were also farms smaller than that.

26 Frode Iversen, "Var middelalderens lendmannsgårder kjerner i eldre godssamlinger?: En analyse av romlig organisering av graver og eiendomsstruktur i Hordaland og Sogn og Fjordane" (MA thesis, University of Bergen 1997), 92–99. Hallvard Magerøy ("Urnes stavkyrkje, Ornes-ætta," 138) considers it likely that the owner of the farm at Ornes must also have had a lot of property outside the main estate.

27 Magerøy, "Urnes stavkyrkje, Ornes-ætta," 138, refers to sources and conditions in the 1300s.

28 Finn Hødnebø, ed., *Bergens kalvskinn: AM 329 fol. i Norges Riksarkiv* (hereafter *BK*) (Oslo, 1989), 37b. This edition is a facsimile of the parchments, probably written shortly after the Black Death using older registrations. Ole-Jørgen Johannessen, *Bergens kalvskinn* (Oslo, 2016), 186, 189. Johannessen (191) lists a farm at Ornes as disappeared. The *Bergens kalvskinn* lists a part in the farm *Hygheimi* of 24 *lauper* (ed. Hødnebø, *BK* 37b) and a part in the farm *Hyghini* of 14 *lauper* (ed. Hødnebø, *BK* 38a). Peter Andreas Munch, in his edition of *BK* [*Registrum prædiorum et redituum ad ecclesias diocesis Bergensis sæculo P.C. de XIVto pertinentium, vulgo dictum "Bergens kalvskind" (Björgynjar kálfskinn)*] (Christiania, 1843)], 40, cites *Hygheimi* as a transcription error for *Hyghenni*, but *Hyghenni* is listed as no. 7. Høgi in Hafslo (across the fjord from Ornes), in O. Rygh, *Norske gaardnavne: Oplysninger samlede til brug ved matrikelens revision*, vol. 12, *Forord og indledning* (Christiania, 1919), 32. Johannessen follows Munch's interpretation. *Hygheimi* is probably not a copy error, but site no. 71, Høyheim (Høyeim) in Luster, as listed in Rygh, *Norske gaardsnavne*, 21. Following the tax return in 1647, in *Skattematrikkelen 1647 XII Song og fjordane fylke* (Oslo, 1995), 14, 16, the parish of Urnes was part of Hafslo parish, and the vicarage in Hafslo wholly owned one of the small holdings in Høyheim in Luster with a land rent of 3.3 *lauper*. This is probably the same as the part listed for the priest's income at Urnes according to *BK*. The difference in value of the part before 1350 and in 1647 shows the decrease and change in agricultural yield and taxation after the Black Death continuing through the late Middle Ages.

29 Leif Anker, "Stokk eller stein? Kirker, byggemåter og mulige byggherrer i indre Sogn omlag 1130–1350 belyst ved et utvalg kirker fra perioden" (MA thesis, University of Oslo, 2000), 88–89.

30 Johannessen, *Bergens kalvskinn*, 188–91; Hødnebø, *Bergens kalvskinn*, 37b, 38 a; and cf. Steinnes, "Mål, vekt og verderekning i Noreg," note 24.

31 Knut Robberstad, ed., *Gulatingslovi* (Oslo, 1952), 22–26.

32 Solvorn, Hafslo, Joranger, Fet, Gaupne, Nes, Saue and Dale, with Fortun and Jostedalen some way inland. All are mentioned in *BK*, which means that the church sites are older than 1350.

33 Leif Anker, "Om stokk og stein: Middelalderens stav- og steinkirker i Sogn i lys av økonomiske forhold," *Årbok: Foreningen til norske fortidsminnesmerkers bevaring* 155 (2001): 97–109, table 5.

34 Kristian Bjerknes, "Urnes stavkirke: Har det vært to bygninger forut den nuværende kirke?," 75–96, and Håkon Christie, "Urnes stavkirkes forløper: Belyst ved utgravninger under kirken," 49–74, both in *Årbok: Foreningen til norske fortidsminnesmerkers bevaring* 113 (1959).

35 Christie, "Urnes stavkirkes forløper," 71.

36 The elevated central space of several of the stave churches has been regarded in older scholarship as a further development of the construction method for presumed pre-Christian cult buildings, the so-called "hovs." This still lacks empirical evidence after more than 150 years. See Hohler, *Norwegian Stave Church Sculpture*, 2:23; and Anker, "Between a Temple and a House of Cards," 143, 147, 152–53.

37 Knud J. Krogh, "Kirkene på Urnes," *Aarbøger for nordisk oldkyndighed og historie*, 1971, 146–94.

38 Ibid., 170.

39 Knud J. Krogh, *Urnesstilens kirke: Forgængeren for den nuværende kirke på Urnes* (Oslo, 2011).

40 Rolf Mowinckel, "De eldste norske stavkirker," *Universitetets Oldsaksamlings skrifter* 2 (1929): 383–424; and Ole Henrik Moe, "Urnes and the British Isles: A Study of Western Impulses in Nordic Styles of the 11th Century," *Acta Archaeologica* 26 (1955): 1–30. Roar Hauglid, "Urnes stavkirke i Sogn," *Årbok: Foreningen til norske fortidsminnesmerkers bevaring* 124 (1970): 34–69, makes clear that the author believed the two carved wall planks in the nave's north wall are a reworked south portal.

41 Krogh, *Urnesstilens kirke*, 169.

42 Ibid., 194–96.

43 Ibid, 169.

44 Thun et al., "Dendrochronology Brings New Life to the Stave Churches," 105–9; and Krogh, *Urnesstilens kirke*, 211–15.

45 Thun et al., "Dendrochronology Brings New Life to the Stave Churches," 107–9.

46 Krogh, *Urnesstilens kirke*, 181–85; see also Anker, *Norwegian Stave Churches*, 151–52, with references.

47 Haakon Shetelig, "Urnesgruppen: Det sidste avsnit av vikingetidens stilutvikling," *Årbok: Foreningen til norske fortidsminnesmerkers bevaring* 65 (1909): 75–107; cf. Peter Anker, "Om dateringsproblemet i stavkirkeforskningen," *Historisk tidsskrift* 56.2 (1977): 103–42; Hohler, *Norwegian Stave Church Sculpture*, 1:236; Signe Horn Fuglesang, "Stylistic Groups in Late Viking and Early Romanesque Art," *Acta ad archaeologiam et artium historian pertinentia* 8.1 (1981): 79–125, at 104; Signe Horn Fuglesang, "Dekor,

bilder og bygninger i kristningstiden," in *Religionsskiftet i Norden: Brytinger mellom nordisk og europeisk kultur 800–1200 e. Kr*, ed. Jón Viðar Sigurðsson, Marit Myking, and Magnus Rindal (Oslo, 2004), 197–294, at 207.

48 Knud J. Krogh, "The Royal Viking-Age Monuments at Jelling in the Light of Recent Archaeological Excavations: A Preliminary Report," *Acta Archaeologica* 53 (1983): 183–216; and Anders W. Mårtensson, "Stavkyrkor i Lund," *Hikuin* 9 (1983): 143–62, at 155–59.

49 The coin discovery was made in the area of the chancel of the present church'; see Christie, "Urnes stavkirkes forløper," 71. Christie interpreted the post-holes to be from one building, and he considered today's church to be the second on the site. In an unpublished manuscript for an intended volume on the excavations ("Urnes kirke (2)," in the archives of The Norwegian Directorate of Cultural Heritage), Christie describes the circumstances of the finds in detail. The coin was found in the earth under the chancel, where groundwork was being carried out in the church in 1902 and 1906. Christie (manuscript, 10–11) does not rule out that the coin "may have ended up there in connection with the aforementioned refinement of the stone walls (under the chancel)," but he points out that if the coin was in untouched ground, this would have a bearing on the dating. Given the circumstances, however, this cannot be determined. In the manuscript Christie reassessed several of his views on the excavation results in light of later research and concluded that the stone foundation was built for the second church on the site (56–57). The coin's possible connection with the various construction phases has not been considered by other researchers.

50 Christie "Urnes stavkirkes forløper," 55–56. Christie points to graves (nos. II and III in Fig. 2.12) that were disturbed by the foundations for the first church. These graves were oriented east–west and contained no traces of grave gifts. Christie saw these as Christian and most likely older than the first church. In another unpublished manuscript for an intended volume on the excavations ("Del III Innholdsfortegnelse," in the archives of The Norwegian Directorate of Cultural Heritage), this was elaborated further in light of Krogh, "Kirkene på Urnes," and later research (16–18, 60–64).

51 Krogh, *Urnesstilens kirke*, 174.

52 Signe Horn Fuglesang, "Kirkenes utstyr i kristningstiden," in *Fra hedendom til kristendom: Perspektiver på religionsskiftet i Norge*, ed. Magnus Rindal (Oslo, 1996), 78–104. Signe Horn Fuglesang, "Kristningstidens kirkeinventar: Objekter og symboler," in *Middelalderens symboler*, ed. Ann Christensson, Else Mundal, and Ingvild Øye (Bergen, 1997), 106–25, discusses the decoration and furnishings of the period of Christianization and the early churches but is primarily a presentation of liturgical objects and portable inventory; the church interior itself is not considered at any length.

53 Krogh, *Urnesstilens kirke*, 184–85.

54 Nicolay Nicolaysen, *Mindesmerker af middelalderens kunst i Norge* (Christiania, 1854–55), on Reinli, Hurum (Høre), and Lomen; Nicolay Nicolaysen, "Om hov og stavkirker," *Historisk tidsskrift*, ser. 2, 6 (1888): 265–305, at 301–05; and see also Anker, "Between a Temple and a House of Cards," 139–41.

55 Peter Anker, *The Art of Scandinavia*, 2 vols. (London, 1970), 1:390, further discussed in Peter Anker, *Stavkirkene,*

deres egenart og historie (Oslo 1997), 201–21; Christie, "Stavkirkene: Arkitektur," 183, 188; Ahrens, *Frühe holzkirchen im nördlichen Europa*; and Ahrens, *Die frühen Holzkirchen Europas*, all point to England. See also Gardiner, "Timber Churches in Medieval England."

56 Anker, *Art of Scandinavia*; and Christie, "Stavkirkene: Arkitektur," 175–76.

57 Hohler, *Norwegian Stave Church Sculpture*, 2:34, 36–37.

58 Harald Langberg, *Stavkirker: En hilsen til Norge i anledning af rigsjubilæet 872–1972* (Copenhagen, 1972), 34–35; Anker, "Om dateringsproblemet i stavkirkeforskningen"; Christie, "Stavkirkene: Arkitektur"; and Krogh, *Urnesstilens kirke*. Urnes is illustrative so far; hindsight has shown that the situation is far more complex than the problem at the time of the excavation.

59 Hohler, "Capitals of Urnes"; and Hohler, *Norwegian Stave Church Sculpture*: 2:70–88.

60 Hohler, *Norwegian Stave Church Sculpture*, 2:86–87; and Anker, *Norwegian Stave Churches*, 58–60.

61 The discussion is extensive. See Erla Bergendahl Hohler, "Stavkirkeportaler og deres symbolikk," *Årbok: Foreningen til norske fortidsminnessmerkers bevaring* 149 (1995): 169–90; Hohler, *Norwegian Stave Church Sculpture*: 2:22–24; Elin Lønngeroth Pedersen, "Urnesportalen: Monumental ornamentikk eller dekorativt meningsverk?: En diskusjon om motiv og ikonografi" (MPhil. thesis, University of Oslo, 1997); and Fuglesang, "Dekor, bilder," with further references.

62 Fuglesang, "Stylistic Groups in Late Viking and Early Romanesque Art"; and David M. Wilson, *Vikingatidens konst*, trans. Henrika Ringbom (Lund, 1995).

63 Ellen Marie Magerøy, "'Biskopen' i Urnes stavkirke," *Årbok: Foreningen til norske fortidsminnesmerkers bevaring* 126 (1971): 13–24.

64 For the latest overview and the various interpretations, see Hohler, "Stavkirkeportaler og deres symbolikk"; Hohler, *Norwegian Stave Church Sculpture*, 2:22–25; Pedersen, "Urnesportalen," 2–7, 125–28; and, more briefly, Anker, *Stavkirkene, deres egenart og historie*, 265–67.

65 A portal from Hemsedal (Buskerud) and a portal from Nesland (Telemark); see Hohler, *Norwegian Stave Church Sculpture*, 1:162–65, 197–200.

66 Questions and answers about any meaningful content must be viewed in the context of a Christian worldview. The view of the Urnes portal as "pagan" has been rejected by almost everyone who has considered the problem in the most recent generation. See Wilson, *Vikingatidens konst*, 190–91, 193; Pedersen, "Urnesportalen," 5–6, with additional references; and Fuglesang, "Dekor, bilder," 231–32. Hauglid, "Urnes stavkirke i Sogn," is a lone dissenting voice.

67 Anders Bugge, "Norge," in *Kirkebygninger og deres udstyr*, ed. Vilhelm Lorenzen (Oslo, 1934), 189–270; Anders Bugge, *Norske stavkirker* (Oslo, 1953); Anders Bugge, *Norwegian Stave Churches*, trans. Ragnar Christophersen (Oslo, 1953); Signe Horn Fuglesang, "Ikonographie der scandinavischen Runensteine der jüngeren Wikingerzeit," in *Zum Problem der Deutung frühmittelalterliche Bildinhalte: Akten des 1. Internationalen Kolloquiums in Marburg a.d. Lahn, 15. bis 19. Februar 1983*, ed. Helmut Roth (Sigmaringen, 1986), 183–210; Hohler, "Stavkirkeportaler og deres symbolikk"; Hohler, *Norwegian Stave Church Sculpture*; Anker, *Stavkirkene*; and Pedersen, "Urnesportalen."

68 The context is also clear, given that the stone's other image shows the crucified Christ and the inscription states that Harald raised the monument after his father and mother conquered the whole of Denmark and Norway and converted the Danes to Christianity. Fuglesang, "Ikonographie der scandinavischen Runensteine," note 67, points out that this does not preclude the lion on the Jelling stone also being regarded as a symbol of Christ.

69 Ibid., 189–90.

70 Bugge, *Norske stavkirker*, 36–38; Anker, *Art of Scandinavia*, 1:416; and Pedersen, "Urnesportalen."

71 Hohler, "Stavkirkeportaler og deres symbolikk."

72 Ibid., 71; and Hohler, *Norwegian Stave Church Sculpture*, 2:22–25, 55–58.

73 Pedersen, "Urnesportalen," 112; 101–28 for discussion of the problem in more detail. On 106–7, Pedersen states that, "a categorization that assumes that the conceptual pairing [sacred-secular] represents an absolute duality can come at the expense of the complexity that characterizes not only the thinking of the 1000s, but the premodern mentality in general. . . . Consequently, it is far from unproblematic to operate with a definite distinction between two types of artworks: those to be included in the sacred context and those belonging to a secular context, and to assume that one can immediately grasp their meaning" (my trans. from Norwegian). For the research history and the Jelling–Urnes relationship, ibid., 24ff. See also Fuglesang, "Dekor, bilder," 231–32.

74 Fuglesang, "Dekor, bilder," 206.

75 Anker, *Stavkirkene*, 267, highlights the possibility that the original use of symbols may have been diluted over time and become a purely secular tradition.

76 The number is steadily increasing with new tree-ring dating of older timber buildings.

77 None of the dates are academically published, as far as I know. One example is the loft at Vindlaus, Vest-Telemark Museum in Lårdal, which has been dated by dendrochronology to "shortly after 1167" according to NIKU Report "Bygninger og omgivelser 33/2006 B-176 Vindlausloftet, Vest-Telemark Museum," doc. 06/00370-4.

78 Per Gjærder, *Norske pryd-dører fra middelalderen* (Bergen, 1952). Arne Berg's mapping and descriptions of Norwegian secular medieval houses have changed the picture fundamentally since Gjærder's work: Berg, *Norske tømmerhus frå mellomalderen*, 6 vols. (Oslo, 1989–98), with summaries. At the same time, the development of reference curves in dendrochronology has resulted in more secure dating. Knowledge and dating of medieval secular houses is constantly evolving.

79 Gjærder, *Norske pryd-dører fra middelalderen*, 238; and see also Peter Anker, "Retardering eller renessanse? Om draker og rabarbrablader i 16–1700-årenes folkelige kunsthåndverk," *By og Bygd* 30 (1983–84): 13–44.

80 Lorentz Dietrichson, *De norske stavkirker: Studier over deres system, oprindelse og historiske udvikling; et bidrag til Norges middelalderske bygningskunsts historie* (Kristiania, 1892), 223; German translation in L. Dietrichson and H. Munthe, *Die Holzbaukunst Norwegens in Vergangenheit und Gegenwart* (Berlin, 1893), 49; Shetelig, "Urnesgruppen," 79; Bugge, *Norske stavkirker*, 14; and Hohler, *Norwegian Stave Church Sculpture*, 1:237.

81 Krogh, *Urnesstilens kirke*, 141–47.

82 Pedersen, "Urnesportalen," 21–22, asks whether there are different motifs or whether it reflects different stages of the development of the motif in the Urnes style.

83 Krogh, *Urnesstilens kirke*, 224.

84 Hohler, "Capitals of Urnes."

85 Tine Frøysaker, Francesco Caruso, and Sara Mantellato, "Preliminary Report, Urnes Stave Church Project following Mission on 19–20 October 2019," Department of Archaeology, Conservation, and History, University of Oslo (2020), unpublished report, Urnes stavkirke doc. 20/12364-1, archive of the Directorate for Cultural Heritage.

86 Few color traces have been found on the stave church portals that are demonstrably original. See Hohler, *Norwegian Stave Church Sculpture*, 1:25; Martin Blindheim, "Primær bruk av farve og tjære ved utsmykning av norske stavkirker," 109–32, and Unn Plahter, "Kapitél-løven fra Vossestrand, en maleteknisk undersøkelse," 133–41, both in *Årbok: Universitetets oldsaksamling*, 1986–88 (1989); and Grete Gundhus, "Fragmenter forteller: Verdslig middelaldermaleri i Lydvaloftet på Voss," *Årbok: Foreningen til norske fortidsminnesmerkers bevaring* 155 (2001): 206–16.

87 Martin Blindheim, *Norwegian Romanesque Decorative Sculpture, 1090–1210* (London, 1965), 32–37; and Hohler, "Capitals of Urnes."

88 Magerøy, "'Biskopen' i Urnes stavkirke."

89 Dietrichson, *De norske stavkirker*, 219–20; Dietrichson and Munthe, *Die Holzbaukunst Norwegens*, 48; and Magerøy, "'Biskopen' i Urnes stavkirke." Dietrichson gives an iconographic interpretation, but at the same time he believes that the motifs are used without any deeper understanding of what they represent. This latter view has been advanced by Blindheim and Hohler. I am indebted to Kjartan Hauglid for kind guidance on this paragraph.

90 L. Dietrichson, *Den norske Træskjærerkunst, dens oprindelse og udvikling: En foreløbig undersøgelse* (Christiania, 1878). Most of Dietrichson's discussions on Urnes can be found in this early work, published fourteen years before his book on the Norwegian stave churches.

91 Dietrichson, *De norske stavkirker*, 219–20.

92 Magerøy, "'Biskopen' i Urnes Stavkirke.'"

93 Harry Fett, *Norges kirker i middelalderen* (Kristiania, 1909), 33–34.

94 Rolf Mowinckel, *Vor nationale billedkunst i middelalderen* (Oslo, 1926).

95 Hohler, "Capitals of Urnes," 32; and Blindheim, *Norwegian Romanesque Decorative Sculpture*, 36.

96 Anker, *Norwegian Stave Churches*, 114.

97 Hohler, *Norwegian Stave Church Sculpture*, 1:238; and Blindheim, *Norwegian Romanesque Decorative Sculpture*.

98 Håkon Christie, *Urnes stavkirke: Den nåværende kirken på Urnes* (Oslo, 2009), 161–72.

99 Hohler, "Capitals of Urnes"; and Hohler, *Norwegian Stave Church Sculpture*, 1:241, 2:83. The stylistic dating is supported by a dendrochronological sample with a bark edge from one of the staves in Hopperstad. The felling is dated to winter 1130–31. A number of wall planks in Hopperstad are also dated. All of these boards are missing a number of tree-rings, but the growth pattern is consistent

with the stave with the bark edge. "Hopperstad Stave Church," NIKU Report 103/2016, doc. no 06/02080–28; and Thun et al., "Dendrochronology Brings New Life to the Stave Churches," 111.

100 A point also made by Blindheim, *Norwegian Romanesque Decorative Sculpture*, 36.

101 Cf. Christie, *Urnes stavkirke*, who considered it impossible to decide whether the pentice was original to the church or a somewhat later addition—a view held by several scholars.

102 For the Norwegian material, see Hohler, *Norwegian Stave Church Sculpture*. See also Krogh, *Urnesstilens kirke*, 204–7, for the fragments from Hopperstad and Rinde. For the second, demolished stave church at Rinde, see Anker, "Stave Church Research and the Norwegian Stave Church Programme," 104–5; and Stig Nordrumshaugen, "Stavkyrkja på Rinde i Feios," in *Rinde kyrkjestad: Feios kyrkje 150 år*, ed. Jan Magne Borlaug Rinde (Feios, 2016), 59–93. In the scholarship, the stave church has the name of the farm at Rinde where the church site is located, while the parish church and the nineteenth-century church are named after the village of Feios. The name *Rinde* for the stave church is so widespread in the literature that I use it here.

103 Martin Blindheim, *Graffiti in Norwegian Stave Churches, c. 1150–c. 1350* (Oslo, 1985), 37.

104 The Hørning plank, which is a remnant of a wall-plate, was found buried in the eighteenth-century stone church in 1887. Knud J. Krogh and Olfert Voss, "Fra hedenskab til kristendom i Hørning: En vikingetids kammergrav og en trækirke fra 1000tallet under Hørning kirke," *Nationalmuseets Arbejdsmark*, 1961, 5–34, at 7.

105 Krogh, *Urnesstilens kirke*, 204–5. The nail holes in the boards correspond to the distance between the roof rafters in G. A. Bull's survey sketches of the stave church that was demolished in 1858. Krogh believes the carving is from about the same time as the Urnes-style church. Hohler, *Norwegian Stave Church Sculpture*, 1:206, regards the plank as part of a door leaf due to the nail holes. The thickness of the door leaf and gable boards at Urnes and the fragment from Rinde are approximately equal, 4–5 cm. The Rinde fragment is too small to determine the motif beyond the fact that it is an animal with an articulated limb spiral, i.e., it had one or more limbs and a horizontal or diagonal orientation. The width of the body at the joint is just over 3 cm, about the same as the band animals on the gable sections at Urnes. The animals on the Urnes door leaf are much wider and move vertically.

106 The relevance of the Bjølstad chapel in this context is uncertain because only parts of the carved subject are preserved, and we do not know whether the portal has been reused one time or more than once. The chapel where the two portal planks flank the front door dates to after the Reformation, probably from the first half of the seventeenth century. See Thomas Bartholin's report, "Bjølstad kapell I Heidal, Sel kommune," 0450099.115. Skibet.Bjølstad.foto.doc, doc. no. 16/00622–1, archive of the Directorate for Cultural Heritage. The chapel was relocated twice before it was restored at the Heidal church in 1955–56; see Roar Hauglid, "Bjølstad kirke i Heidal: Datering og konstruksjon," *Årbok: Foreningen til norske fortidsminnesmerkers bevaring* 112 (1958): 119–34; and "Bjølstad," in Hohler, *Norwegian Stave Church Sculpture*, 1:113–14.

107 Hans-Emil Lidén, "The Predecessors of the Stave Church of Kaupanger," in *The Stave Churches of Kaupanger: The Present Church and Its Predecessors*, ed. Kristian Bjerknes and Hans-Emil Lidén, trans. Elisabeth Tschudi-Madsen (Oslo, 1975), 9–46.

108 Thun et al., "Dendrochronology Brings New Life to the Stave Churches"; and Hohler, *Norwegian Stave Church Sculpture*, 2.

109 Lidén, "Predecessors of the Stave Church of Kaupanger," 27.

110 Hohler, *Norwegian Stave Church Sculpture*, 2:70–72. The dating of the demolished church is based on G. A. Bull's survey sketches from 1854. Anker, "Stave Church Research and the Norwegian Stave Church Programme," 104–5, refers to source-critical conditions for dating from survey sketches and tree-ring dating of one preserved wall plank out of context from Rinde. Nordrumshaugen, "Stavkyrkja på Rinde i Feios," points out that this dated plank, based on Bull's measurements, matches the wall height of the belfry that was built adjacent to the church; the wall there was somewhat lower than the church. The belfry could be from a different construction period. Two other demolished stave churches, at Hafslo and Årdal, may have been erected at about the same period, based on a number of commonalities with Kaupanger and partly with Urnes. Dating based on building typology and rapid survey sketches is, methodologically, a demanding exercise. Torpo has a somewhat later dating than Hopperstad, Rinde, and the present church at Urnes. The portal fragment from Torpo is also from a later phase of the Urnes style and is dated to the first half of the twelfth century by Bilndheim, *Norwegian Romanesque Decorative Sculpture*, 45; and Fuglesang, "Stylistic Groups in Late Viking and Early Romanesque Art," 125. See also Chapter 4 in this volume.

111 Anker, "Om stokk og stein."

112 Anna Elisa Tryti, "Kirkeorganisasjonen i Bergen bispedømme i første halvdel av 1300-tallet" (MA thesis, University of Bergen, 1987), 456, 524.

113 See the Older Gulaþing Law, chap. 10 (G 10), which mentions *hovudkyrkje* and *fjerdingskyrkje* for a part or district of the county. Robberstad, *Gulatingslovi*; and Bjørn Eithun, Magnus Rindal, and Tor Ulset, eds., *Den eldre Gulatingslova* (Oslo, 1994).

114 Andreas Holmsen, "Økonomisk og administrativ historie," in *Sogn*, ed. Hans Aall et al., Norske bygder 4 (Oslo, 1937), 39–103.

115 In 1330 Kvåle had a land debt of 120 mmb (*laup*), DN I:207. The church site is referred to in Johannessen, *Bergens kalvskinn*, 163–65, 32b.

116 Holmsen, "Økonomisk og administrativ historie," 54; and Anker, "Stokk eller stein?," 149.

117 Hohler, *Norwegian Stave Church Sculpture*, 2:70–72.

CHAPTER 3

The Landscape of Urnes: Settlement, Communication, and Resources in the Viking and Early Middle Ages

Birgit Maixner

Introduction

A MODERN VISITOR'S EXPERIENCE OF THE URNES STAVE CHURCH on the Ornes peninsula might be dominated by two impressions. On the one hand, it appears very remote, situated on an isolated headland, difficult to access, and located far away from what at present is considered central. On the other hand, when exploring the site one is impressed by the craftsmanship and quality of the building and its decoration as well as by its European connections, which are reflected in its stylistic influences and its iconographic program.

This chapter takes its point of departure from this apparent paradox and examines whether a similar impression existed in the late Viking Age and early Middle Ages.[1] Did the site of Ornes appear as remote when the first church was erected as it does today? What were the local economic preconditions that enabled its patron to construct such a splendid building at the northern edge of Europe? To solve these questions, I explore the site in the context of its surrounding landscape, its communication networks, and its resource base. For this purpose, four issues will be investigated: the topographical situation of Ornes in relation to transport routes; the settlement evidence and structure, based on a mapping of Viking-age graves and medieval churches; the communication network, as reflected by insular imports in Viking-age graves and by place-names indicating cargo loading and trade; and, finally, the probable resource base for the district in which Ornes is situated, including both transit trade and local exploitation of goods.

PART ONE | SITUATING URNES

The Topographical Situation and Administrative Affiliation

The Sognefjorden in the modern county of Vestland is the largest fjord in Norway, stretching from the coast of western Norway inland for 205 km. Its innermost section branches into several arms, the longest of which is the 40-km Lustrafjorden along which the Urnes stave church is situated (Fig. 3.1). From the perspective of transport geography, in the Viking and early Middle Ages the Sognefjorden was of central importance for several reasons. First, because of its length and multiple branches, it is a complex traffic artery that spans large distances in multiple directions. Second, it connected with the seaborne trading route along the coastline of Atlantic Norway, in Old Norse called *Norðvegr*, "the Northern Way." Third, two of its branches led to important overland routes heading inland. One of the routes, in a prolongation of the Lustrafjorden, crossed the mountain region Sognefjellet and could be followed via Lom and the Otta River up to the Gudbrandsdalen Valley, which was the most important north–south route through inland Norway. The other route started in the Lærdalsfjorden and continued through the Lærdalen Valley. At present-day Borlaug, it split into two further routes: one passed across the Filefjell mountain area to Valdres and the other followed the Mørkedalen Valley and continued through the Hemsedalen Valley to Hallingdal. By comparing early medieval coin finds from both sides of the mountains, Svein H. Gullbekk and Anette Sættem have proved that close contacts existed between the area around the Sognefjorden and the Gudbrandsdalen Valley and Valdres.[2]

The landscape of the inner part of the Sognefjorden is wild and magnificent; it has inspired artists for centuries, especially such Romantic painters as Johan Christian Dahl, Hans Gude, and Thomas Fearnley. Mountains, which rise steeply up from the fjord, are interrupted by areas where the landscape opens up into gentle valleys. Geologically, the landscape around the inner part of the Sognefjorden is dominated by exposed bedrock and weathered material, which alternate with smaller areas shaped by glacial till, marine deposits, or glacial-lake deposits. These create conditions suitable for agriculture. Areas with exposed bedrock and weathered material were unsuitable for farming but could be rich in "outfield" resources, such as iron, soapstone, antlers and skin, which were commodities in demand in western Europe in the Viking and early Middle Ages.[3] Hence, the landscape around the Sognefjorden is characterized by relatively small settlement units and valleys, which were separated from each other by large outfield areas. With some exceptions, road building did not take place between these areas prior to the modern era. Consequently, the Sognefjorden formed the most important traffic artery in the region. The single settlement units on opposite banks of the fjord arms were closely connected by water, supported by the advanced ship-building technology of the Viking Age, which offered excellent conditions for travel by boat. The former parishes, which in many cases ranged over territories on both banks of the fjord, reflect this. Today the fjords primarily constitute barriers, and the municipality borders have in many cases been adjusted to take into consideration that traffic and transportation mostly takes place by road.

Ornes is situated on a prominent headland on the eastern bank of the Lustrafjorden. The tip of the headland, where the Urnes stave church is located, consists of fertile soils built up by glacial

CHAPTER THREE | THE LANDSCAPE OF URNES: SETTLEMENT, COMMUNICATION, AND RESOURCES

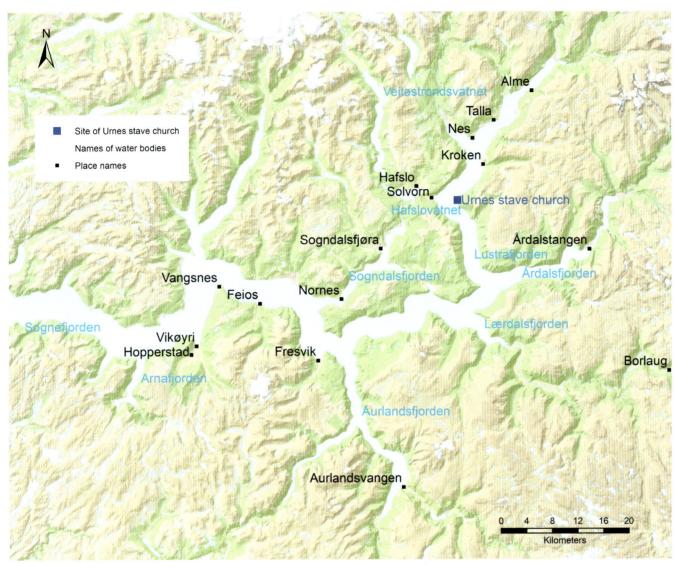

Fig. 3.1. Map of the inner Sognefjorden with place-names mentioned in the text. Map: Author.

till, whereas the surrounding landscape is formed of bedrock covered by a thin layer of humus, constituting a natural barrier around the settlement area. Similar topographic settings occur at three other nesses in the inner Sognefjorden: at Vangsnes on the Sognefjorden itself, at Nes on the Lustrafjorden, and at Nornes on the Sogndalsfjorden. In all these cases, medieval churches are situated on the fertile headlands.

The Ornes peninsula belonged to the former parish of Hafslo, which encompassed the eastern bank of the Lustrafjorden from its inlet up to the farm of Kroken, the western bank of the Lustrafjorden from its inlet to the southern bank of the Gaupnefjorden, and the surroundings of the Hafslovatnet and Veitastrondsvatnet lakes. The establishment of a parish system is assumed to have begun before the second half of the twelfth century, and it seems to have been completed in the thirteenth century.

After that, adjustments of the parish boundaries were rare until the modern era.[4] The fact that the borders of the former parish of Hafslo ran across the Lustrafjorden and included territories on both sides of it may indicate a territorial structure with roots in the Iron Age. Around the year 1600 the Urnes church had the status of a chapel of ease, which was dependent on the main church at Hafslo on the Hafslovatnet lake.[5] Both archaeological finds from the early Iron Age, among them a rich female grave with a golden berlock (pendant) from the Roman Iron Age excavated at Beim,[6] and place-names from that period, such as Venjum (meadow) and Beim, a *-hem* name,[7] identify the fertile lands north of the Hafslovatnet as a central settlement district in the early Iron Age. Its remote location appears to be characteristic of the economic and administrative centers of that time in Scandinavia. Vis-à-vis Ornes, the modern village of Solvorn is situated in a settlement unit on the Lustrafjorden. Prior to the construction of modern roads, Solvorn was a central location for transit between the Lustrafjorden and the Hafslovatnet. The lost place-name *Tune* can be reconstructed in this area,[8] indicating a farm with special status in the Iron Age.[9] Ornes, by contrast, was the property of powerful families from the late Middle Ages up to the modern era.[10]

The Settlement, Evidence and Structure

How densely populated were the districts around the inner Sognefjorden during the Viking and early Middle Ages, and where were the settlements located? To answer these questions, the distribution of two settlement indicators—Viking-age graves and medieval churches—were chosen for investigation. More than 6,000 graves from the Viking period are known from Norway.[11] In western Norway, they are usually located close to the farm cores,[12] so they can indicate where the contemporary settlements were situated. Figure 3.2 shows the distribution of known Viking-age graves in the area of the inner Sognefjorden.[13] This distribution shows a striking affinity to waterways, as the graves are most cases located adjacent to fjords, lakes, or rivers. Unsurprisingly, these sites are tied to those types of subsoils that are useful for agriculture. The Viking-age settlements in the area, as indicated by grave finds, were consequently located on fertile soil adjacent to the fjord in locations where the steep mountainsides open up into gentle valleys, at river estuaries, along river valleys, or adjacent to lakes. Particular concentrations of graves occur at the present-day villages of Vikøyri, Feios, Fresvik, Sogndalsfjøra, and Aurlandsvangen, and may indicate dense settlements in the Viking Age. In the district of the outer Lustrafjorden, there is, apart from the headland of Ornes, no evidence of Viking-age graves. Partly this may be due to the topography of this part of the Lustrafjorden, dominated by steep mountains. However, at the present village of Solvorn and the farm at Kroken, Viking-age settlements could be expected by reason of topography. This highlights a central challenge when using graves as a source material: most of the ones in this area were discovered as a result of farming or private building activity, and the findspots and grave goods were reported by private individuals. Therefore, the current state of knowledge is partly influenced by accident and individual engagement, and it may not always be representative of conditions in the Viking Age.

Comparing the incidence of medieval churches and Viking-age graves in the inner Sognefjorden

CHAPTER THREE | THE LANDSCAPE OF URNES: SETTLEMENT, COMMUNICATION, AND RESOURCES

reveals a striking coincidence in their distribution and a strong affinity to waterways. Prior to the Reformation, a large number of churches in Norway were privately built and owned and were located close to farms. In this way, the distribution of the medieval churches supports the overall picture of the location of the settlements as indicated by Viking-age graves. However, in contrast to the grave material, the medieval churches permit an understanding of the hierarchy of the early medieval community of the inner Sognefjorden. This is because the earliest churches in Norway were usually erected at the most important and wealthiest farms within a district.[14] In this respect, it is not only river estuaries that appear most significant in a settlement historical perspective but also those in strategically outstanding positions, such as on headlands like Ornes and Vangsnes.

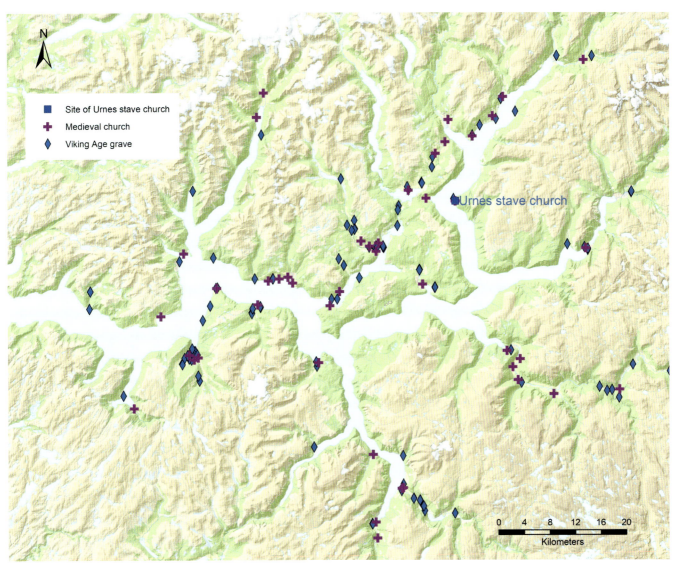

Fig. 3.2. Distribution of Viking-age graves and medieval churches in the area of the inner Sognefjorden. Map: Author.

183

Onomastic and Archaeological Evidence for Trade and Communication

As already noted, before the modern era the Sognefjorden was a waterway of high traffic and geographical significance, from both a local and a supraregional perspective. This is demonstrated by the numerous maritime place-names in the inner part of the fjord, which are related to affairs of communication and trade (Fig. 3.3). The oldest ones are represented by three examples of the place-name Seim. Two occur at the main branch of the fjord itself, at the present-day villages of Vikøyri and Fresvik; the third is in the inner Årdalsfjorden, near the modern village of Årdalstangen. The place-name Seim derives from Old Norse *Sæheimr, "the settlement by the sea," and it seems

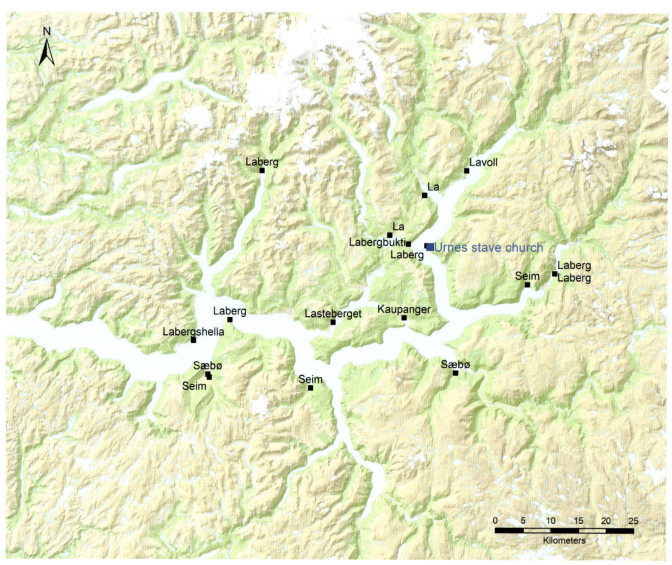

Fig. 3.3. Distribution of place-names indicating cargo loading and exchange in the inner Sognefjorden. Map: Author.

to denote places with maritime activities such as landing, trade, and seasonally practiced crafts. Place-names of this type date from the Roman Iron Age and Migration period, but the functions of the sites continued in many cases up to the Viking and early Middle Ages. The place-name Sæbø, which occurs at the Lærdalsfjorden and near the place-name Seim at Vikøyri, may be a Viking-age successor to the *Sæheimr names and may point to similar activities.[15]

Another group of maritime place-names that occur frequently in the area under investigation are those that contain the element la-/laberg. Some of these are composed of lada/hlada (loading) and helle/berg (plain rock) and are presumably related to cargo-loading places, harbors, and ports of shipment that likely date to the Viking Age.[16] Most numerous are variants of the place-name Laberg, of which there are seven known examples in the inner Sognefjorden. One of these Laberg-names is found at the top of the headland of Ornes. The place-name Labergbukti (bukti = bay) on the opposite bank of the Lustrafjorden indicates a lost place-name Laberg even at Solvorn. This means that there were two loading places in the area across the fjord, facing each other. At the headland of Vangsnes, the place-name Laberg occurs in a setting similar to Ornes. At the Havslovatnet, the place-name La points to shipment; the same is the case at the Dalselvi River estuary at the modern village of Marifjøra on the neighboring Gaupnefjorden. The place-name Lavoll is found farther up the Lustrafjorden, also related to cargo loading. Worth mentioning in this regard is the place-name Lasteberget at the headland of Nornes, even if this may be of a later date than the other examples.

Apart from Seim and La-/Laberg/Lavoll, there is a third category of maritime place-names represented in the inner Sognefjorden that is closely related to the exchange and transshipment of goods. This is Kaupanger, located at a sheltered bay not far from the point, where the Sognefjorden branches into its three inner arms. The etymology of the kaupang names, of which nine specimens are known from Norway, has been discussed intensively and somewhat controversially. Related words in the other Scandinavia languages, such as köping (Swedish), købing (Danish), or kaupangur (Icelandic), are usually translated as (market) town. However, as suggested by Tom Schmidt, the original meaning must have been trading place. The origin of the kaupang-names appears to have been borrowed during the Viking Age from Old English cēaping, cēapung, which can mean "trade" as well as "marketplace." The Norwegian form, ending in -ang(r), is supposed to have developed in analogy with common names of fjords, such as Hardangerfjorden or Geirangerfjorden, due to the fact that the earliest trading posts often were located in bays or inlets on the coast. The fact that the first component of the word is a loan from Old English has been interpreted as an indication of the early exchange of goods with foreign merchants.[17] Sverris saga, written in the twelfth century, calls Kaupanger at the Sognefjorden Lúsakaupangr, "small Kaupang," and mentions merchants (kaupángsmenn) at the site.[18] So far, however, the limited archaeological excavations at Kaupanger have not proved trading functions at the site, even if they revealed numerous traces of activity, especially from the thirteenth century on.[19]

Most of the place-names related to maritime trade are located near medieval churches; the name Laberg near the Urnes stave church is a salient example. This may be due to several factors. Trade and exchange can be expected to have been under the control of the leading and most powerful farms in the area, where people had the means to raise private churches on their property. Additionally,

PART ONE | SITUATING URNES

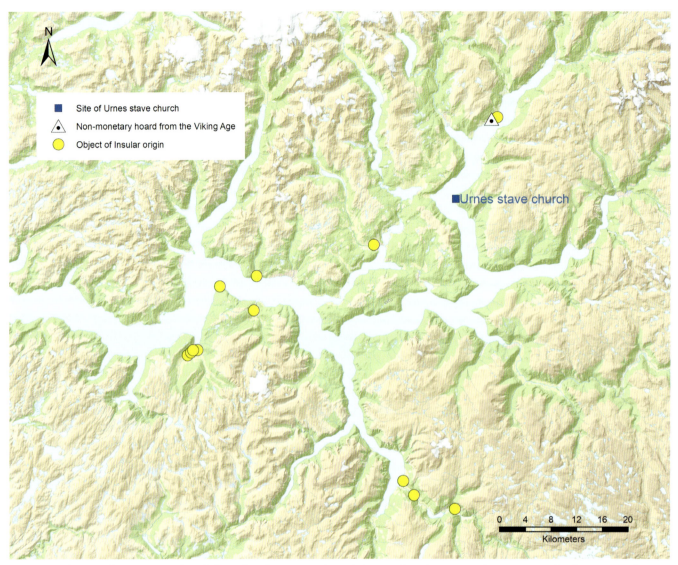

Fig. 3.4. Distribution of nonmonetary hoards from the Viking Age and metal objects of Insular origin in the inner Sognefjorden. Map: Author.

religious gatherings supported market activities, which would demand cargo-loading places for the goods traded near the churches.

Evidence of trade is indicated not only by place-names but also by archaeological material from the Viking Age. Two find complexes are worth mentioning here. First, a nonmonetary silver hoard, consisting of at least two arm rings, was found at the site of Talla at the Lustrafjorden, about 13 km northeast of the headland of Ornes (Fig. 3.4).[20] Second, a female burial discovered at Hopperstad, nearby Vikøyri on the Sognefjorden, contained among other objects five weights, a balance, and a part of an Umayyad dirham.[21] This burial is of interest not only because of these objects, which reflect the northern European metal-weight economy—a monetary system where weighed silver was used as payment—but also because of the far-reaching contacts it suggests. Two of the weights

are made of lead with small Insular decorative mounts. The grave goods included further Insular artifacts: three bronze bowls, a bronze ladle, and a wooden bucket with bronze mountings.[22] The Hopperstad burial is only one of a number of Viking-age graves from the inner Sognefjorden that contained metal objects of Insular origin and are associated with westward Viking activity in the ninth and tenth centuries.[23] Their distribution shows distinctive concentrations at present-day Vikøyri and the Lærdalen Valley but is otherwise dispersed fairly equally in the districts around the inner Sognefjorden.

The density of maritime place-names that indicate cargo loading and trade, as well as the traces of Viking-age trade in the archaeological record, signal that the inner Sognefjorden was a region where the exchange of goods played an important role in economic life. Not all sites with names that indicate trade must necessarily have existed simultaneously, and they may have fulfilled partly different functions. Some might have served a single farm or a group of settlements as loading places for local products, whereas others may have held a key position in the transit trade, and some might have combined both functions.

The Resource Base: Transit Trade

A special aspect of the Sognefjorden was the convergence of waterways and overland routes from many directions. Its role as connector between the interior and the fjord landscape of western Norway seems to have been particularly important.

An important trade good in the Viking and Middle Ages was iron, a basic raw material for tools and weapons. Developments in agricultural technology in northern Europe, especially the introduction of major plow colters, resulted in an increasing demand for iron from the eleventh century on.[24] Iron had been extracted in Norway since the pre-Roman Iron Age, but from the ninth century onward production increased considerably. This was due partly to a more effective process of iron extraction and the introduction of new types of furnaces and partly because of a relocation of production sites. Prior to the ninth century mainly local bog-ore deposits near the settlements had been extracted, but after about 800 extensive, specialized exploitation of the rich bog-ore deposits in the mountain regions increased.[25] In order to transport the raw material easily, iron was often forged into ingots of standardized forms and length.[26] These forms changed over time, and regional differences did exist. Four principal types of iron ingots were common in Viking-age Norway: slightly modified blooms with a chap (*fellujern/blesterjern*); axe-shaped ingots; bar-shaped ingots; and steel bars that are flat at one end and have a small hole punched at the other. This last type, classified by archaeologists as R.438,[27] is associated with iron from production areas inland in southern Norway, specifically Østerdalen, Valdres, and Hallingdal. The axe-shaped ingots are regarded as older than those of type R.438. The latter seem to have been produced between the late Viking Age and the High Middle Ages.[28]

Compared to southern Norway, iron extraction in the country's west is assumed to have been more modest. In order to meet the local demands, most of it was probably imported from inland,

where great amounts of iron were produced in the late Viking and Middle Ages.[29] Iron ingots have been recorded from several sites around the head of the Sognefjorden (Fig. 3.5). They presumably derive from production areas in the inland regions of southern Norway and may have reached the Sognefjorden by the aforementioned overland routes, for instance between Valdres/Hallingdal and the Lærdalsfjorden. The findspots are all located along the Sognefjorden or the adjacent eastward-running river valleys, which means along the traffic arteries. A single ingot,[30] and a hoard consisting of two ingots,[31] belong to the older, axe-shaped type. There are also three deposits of iron ingots of the standard form R.438, which dates from the late Viking Age onward. One of them contained four ingots,[32] another twenty-eight.[33] The largest deposit consisted of 300 iron ingots of the type R.438. It was discovered in scree at the present-day farm of Alme on the Lustrafjorden, just 20 km northeast of the headland of Ornes.[34]

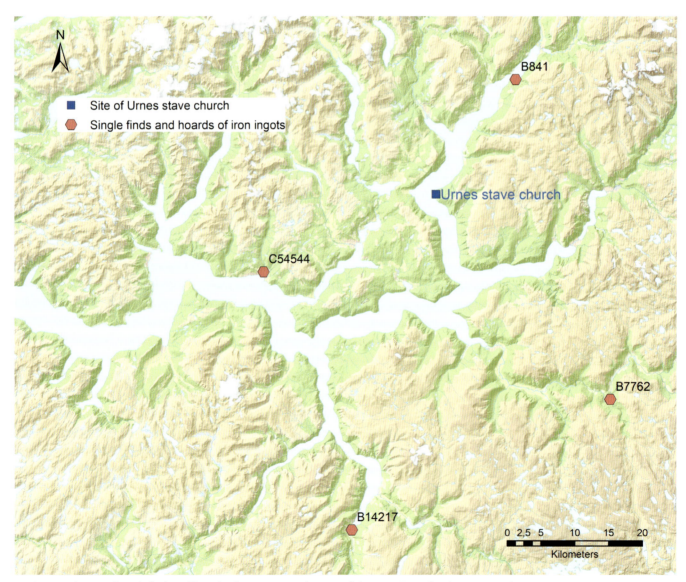

Fig. 3.5. Distribution of single finds and hoards of iron ingots in the area of the inner Sognefjorden. Map: Author.

A passage in one of Norway's oldest medieval laws, the Frostaþing Law from the thirteenth century,[35] gives an impression of the value that this deposit represented. The law claimed that a *leidang* ship, which became unseaworthy during a journey, should be burned and its iron rivets collected and taken home to the farmers who had built the ship.[36] The Alme hoard consequently must have represented considerable wealth at that time. It is very likely that iron from the inland areas was distributed at Kaupanger and other loading and marketplaces on the Sognefjorden. Moreover, a further processing of this iron into tools and weapons at these places is probable.[37] Pits with large quantities of slag were excavated at Kaupanger and interpreted as forge furnaces.[38] According to Askeladden, the Directorate for Cultural Heritage's database of monuments and sites, several concentrations of charcoal pits are recorded in the area around the inner Sognefjorden, of which a great many were near Kaupanger. Charcoal was necessary for crafts that required high temperatures and thus can, in combination with slag, indicate forging at the marketplace of Kaupanger.

Additionally, the so-called smiths' graves offer an indirect indication that extensive processing of iron was done in the districts around the inner Sognefjorden in the late Iron Age. Nowhere in Norway have more graves with tools for metalworking been found than in the county of Vestland.[39] The custom of including blacksmiths' equipment with human burials started almost simultaneously with the intensification of iron extraction in Norway. The specific grave goods in these Sognefjorden burials are interpreted as expressing a transformation: iron from the mountain areas was forged into weapons and tools in the settlements at the Sognefjorden, partly to meet local requirements, partly to produce a surplus directed for export and trade, and partly to fabricate arms for overseas raids.[40]

Local Production

Evidence for cargo loading and mercantile activity is, as already noted, strong in the area of the inner Sognefjorden. Especially significant was the supraregional trade in iron from inland. However, the high number of loading places indicated by place-names might also be due to requirements linked to local production.

The farming economy of western Norway in the Viking Age was a mixed economy in which animal husbandry was combined with cereal cultivation and supplemented with fishing and hunting.[41] Wild-reindeer exploitation is vividly illustrated by major trapping systems for larger animals and stray finds of arrowheads in the surrounding mountains. However, the arable land in the river valleys and settlement units along the Sognefjorden must have been too limited to result in overproduction of cereal cultivation or husbandry of real importance, even if it has been suggested that Vikøyri, for example, might have had a rich production of woolen textiles in the late Iron Age.[42] Consequently, outfield resources should be considered as commodities that might have enabled the accumulation of economic wealth evidenced by the splendid building of the Urnes stave church. But what kind of desired outfield resources did the hinterland of the inner Sognefjorden offer? Apart from wild reindeer, the archaeological sources from the area point to one in particular: soapstone.

Soapstone is a metamorphic rock composed primarily of chlorite and talc. The stone is soft, easy

to work, and largely heat resistant. It was a material needed for the production of several types of artifacts used in the household and in crafts in the Viking and early Middle Ages.[43] The exploitation of soapstone has a long tradition in Norway through history, starting in the Bronze Age and continuing to the modern era.[44] In the Viking Age, soapstone quarries became widely distributed, and extensive production of pots and vessels largely supplanted the former pottery tradition. Soapstone was one of the commodities that was exported from the Scandinavian Peninsula to western Europe during the Viking Age.[45] Besides vessels, primarily spindle whorls, loom weights, sinkers, molds, and forge stones were fabricated of soapstone. In the Middle Ages and up to modern times the production of these types of artifacts continued, but soapstone was also used for architecture, both as a building material and for decorative elements.[46] The Romanesque church at Hove, Vikøyri, on the Sognefjorden, is an example of a twelfth-century church built of local soapstone.

In Old Norse the word *grjót* meant "stone," and it was usually applied as a collective term for a stone that was used as a material, such as soapstone, whetstone, or millstone. However, the word seems to have developed gradually into a synonym primarily for soapstone. *Grøtsten* is one of the established names for soapstone in Norwegian, as is *klebersten*.[47] The designation *grýta*, which comes from *grjót*, became the name for cooking pots made of soapstone.[48]

Approximately one-third of the known Norwegian soapstone quarries are located in the Hordaland region in western Norway, south of the Sognefjorden, and the exploitation of this resource in the Viking Age and the Middle Ages is considered an important industry in the area.[49] Several soapstone deposits are documented in the hinterland of the inner Sognefjorden (Fig. 3.6). Southwest of the Arnafjorden, which is a southern branch of the Sognefjorden, is a quarry called Gryteberget where a half-finished soapstone vessel was found.[50] Its bowl shape suggests a likely date in the Viking Age. Another soapstone deposit that provides evidence for the quarrying of bowl-shaped vessels is Kleberhytta, located in the hinterland of the western bank of the Lustrafjorden, upstream from the Dalsdalen near present-day Luster.[51] Finally, a soapstone quarry called Klebereggen is mentioned in connection with the building of the Fet church in the inner Hafslo area, opposite the headland of Ornes.[52] The natural-stone database of the Geological Survey of Norway (NGU) does not include these soapstone deposits, but it lists two others in the area of the inner Sognefjorden: one near the village of Feios, east of the headland of Vangsnes, and a series of deposits located at the Framfjorden/Arnafjorden. In the latter area, the place-name Klyberga can be found. The coincidence of the place-names Gryteberget, Kleberhytta, and Klebereggen with known soapstone deposits provides an indication that names with these elements might denote soapstone deposits and quarries. Figure 6 maps place-names featuring *grøt-/gryt-* and *kle-/kly-*. If this assumption is correct, they reveal soapstone deposits and quarries that are otherwise unknown. Moreover, in combination with the archaeologically proven soapstone quarries, they present the inner Sognefjorden as a region rich in soapstone deposits and where the exploitation of this resource was of major importance in the Viking and early Middle Ages.

CHAPTER THREE | THE LANDSCAPE OF URNES: SETTLEMENT, COMMUNICATION, AND RESOURCES

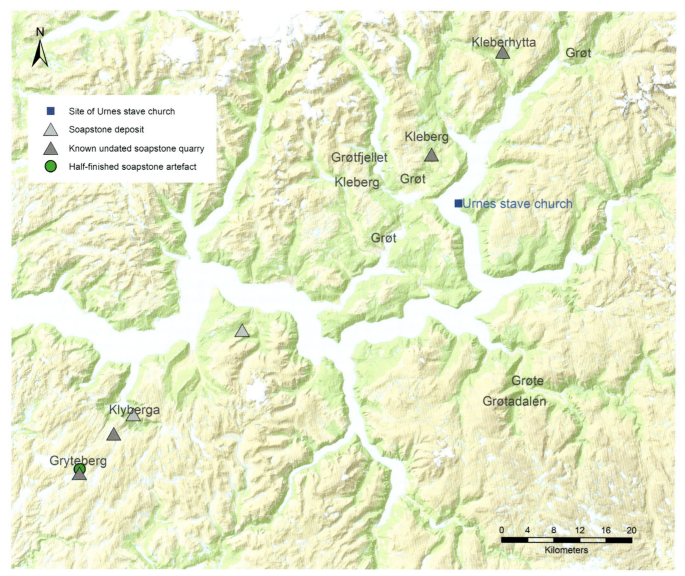

Fig. 3.6. Distribution of half-finished soapstone artifacts, known soapstone deposits, known undated soapstone quarries, and place-names indicating soapstone in the area of the inner Sognefjorden. Map: Author.

PART ONE | SITUATING URNES

Overview and Conclusions

This chapter began with the question of whether the headland of Ornes was as remote in the early Middle Ages, when the Urnes stave church was built, as it appears to a visitor today. After investigating the topography, settlement, communication landscape, and resource base of the surrounding districts in the Viking and Middle Ages, we can conclude that this was not the case. The Urnes stave church is located in a prominent position at a traffic artery that connected important, far-reaching waterways and overland routes in several directions. Wherever the geographical preconditions enabled it, the innermost part of the Sognefjorden was densely settled in the periods in question, as indicated by Viking-age graves and medieval churches. The headland of Ornes with the Urnes stave church was integrated into this cultural-historical landscape. In addition, a number of Viking burials containing Insular imports demonstrate not only the extent of the contacts between western Norway and Britain and Ireland in the Viking Age in general but also the mobility of the Viking settlers around the Sognefjorden in particular. The distribution of the imported objects suggests that many settlement districts in the area were actively involved in overseas voyages westwards.

Analyzing the onomastic sources reveals an astonishing number of sites related to cargo loading, trade, and communication and thus contributes to a better understanding of the external influences that are apparent at the Urnes stave church. The place-names in question, Seim, La-/Laberg/Lavoll, and Kaupanger, identify the inner Sognefjorden as an area where trade and the loading of goods held a prominent role in economic life. The maritime location of these place-names confirms again the Sognefjorden´s function as the main arterial route in the area; it provided the essential infrastructure that enabled participation in far-reaching networks of exchange and communication.

Two types of outfield resources had a significant impact on the economic prosperity of the region, which is reflected not only in the Urnes stave church but also in other splendid, privately built church buildings, such as the twelfth-century examples at Hopperstad, Hove, and Kaupanger. The first of these outfield resources is soapstone. The evidence of soapstone deposits, quarries, and relevant place-names suggests that the local exploitation and export of soapstone might have been one of the major sources of income for the area. The other important outfield resource was probably iron. Hoards of imported iron ingots and a striking number of burials with blacksmiths' equipment imply that the inner Sognefjorden held a key position in the transfer and processing of iron, which had been extracted in the mountainous inland areas. Both soapstone and iron constituted commodities in high demand in western Europe in the Viking and Middle Ages, and consequently a high profit could be gained from their exploitation and trade. Via the Sognefjorden and the sailing route along the coastline of Atlantic Norway, the *Norðvegr*, the region around the bottom of the Sognefjorden was connected to the markets in southern Scandinavia.

It is likely that the economic prosperity of the settlement on the Ornes peninsula, underscored by the construction of the lavish Urnes stave church, was rooted in its exploitation of natural resources and its strategic position along important trade routes. The opportunities to collect duties on passing cargo could have brought great prosperity to those who ruled over the headland. The place-name Laberg at the tip of the headland of Ornes can perhaps be understood in this context. Indeed, it is probable that those who ruled Ornes were not as independent as might be presumed, at least in the

CHAPTER THREE | THE LANDSCAPE OF URNES: SETTLEMENT, COMMUNICATION, AND RESOURCES

Iron Age periods prior to the Viking Age. Earlier archaeological studies of Ornes have investigated it in the local context of the peninsula,[53] or seen it merely in connection with the settlement districts around the Lustrafjorden and the Årdalsfjorden.[54] However, if we consider the dependence of the Urnes stave church on the main church at Hafslo and the course of the former parish borders, which encompassed territories on both sides of the Lustrafjorden, this raises the possibility that Ornes might originally have belonged to the districts in the hinterland of the opposite bank of the Lustrafjorden. This includes the settlement at present-day Solvorn and the settlement areas of the inner Hafslo (Indre Hafslo) and along the Hafslovatnet and the Veitastrondsvatnet. In this view, the headland of Ornes could be understood as an outpost of a higher-ranking center at the Hafslovatnet, at least prior to the Viking Age. Together with those who controlled Solvorn, which was situated 3 km away on the opposite side of the fjord, the rulers of Ornes might have controlled traffic along the Lustrafjorden and taxed the goods being transported. In that case, they most likely received not only appropriate rewards for their effort and loyalty but also part of the taxes collected. In the Viking Age, the rulers of Ornes might have become more autonomous, and from the late Middle Ages to the modern era Ornes was demonstrably in the possession of powerful families.

The strategic position of Ornes on a peninsula on the main curve of the Lustrafjorden allowed for the observation and control of shipping traffic on the fjord over a distance of 18 km in both directions. No other site on the Lustrafjorden has such a command of the fjord. Undoubtedly, signaling and defense in relation to hostile ships was part of the role played by those at Ornes. The peninsula would have been a key position in the control and dominance of the waterway and consequently of the important overland route between the Sognefjorden and the inland Gudbrandsdalen. Economic advantages linked to the transfer of semimanufactured iron from production areas in the inland and to the exploitation and export of such local resources as soapstone and wild-reindeer antlers offer a plausible explanation for the wealth and outside influences that produced the magnificent Urnes stave church.

Notes

1. The following chronology of archaeological periods is used in this article: pre-Roman Iron Age: 500–1 BCE; Roman Iron Age: 1–400 CE; Migration period: 400–550; Merovingian period: 550–750; Viking Age: 750–1050; early Middle Ages: 1050–1130; high Middle Ages: 1130–1350. In Norwegian archaeology, the Iron Age denotes the periods from the pre-Roman Iron Age to the end of the Viking Age. The early Iron Age (1–550 CE) spans from the Roman Iron Age to the end of the Migration period, whereas the late Iron Age (550–1050 CE) encompasses the Merovingian period and the Viking Age.

2. Svein H. Gullbekk and Anette Sættem, *Norske myntfunn 1050–1319: Penger, kommunikasjon og fromhetskultur* (Oslo, 2019), 215.

3. The Scandinavian concept of *utmark* lacks a corresponding denotation in English terminology, but it is usually translated as "outfield." According to a definition given by Ingvild Øye, "the term denotes natural-geographical environments such as forests, moorland, mountains and coastal areas, and economic, social and cultural aspects of these landscapes as parts of agricultural systems, as a complementary component to the infield." See Øye, "Introduction," in *"Utmark": The Outfield as Industry and Ideology in the Iron Age and the Middle Ages*, ed. Ingunn Holm, Sonja Innselset, and Ingvild Øye (Bergen, 2005), 9–20; quote at 9.

4. Anna Elisa Tryti, "Fra åsatro til reformasjon," in *Vestlandets Historie*, vol. 3, *Kultur*, ed. Knut Helle et al. (Bergen, 2006), 55–103.

5. Jan Brendalsmo and Jan-Erik G. Eriksson, *Kildegjennomgang: Middelalderske kirkesteder i Sogn og Fjordane fylke* (Oslo, 2016), 122.

6. University Museum of Bergen, inv. no. B11538.

7. Names ending in -*heim* or -*hem* are considered among the oldest in the Scandinavian place-name chronology, dating primarily from the early Iron Age. See Stefan Brink, "Iakttakelser rörende namnen på –hem i Sverige," in *Heiderskrift til Nils Hallan på 65-årsdagen 13. desember 1991*, ed. Gulbrand Alhaug, Kristoffer Kruken, and Helge Salvesen (Oslo, 1991), 66–80.

8. O. Rygh, *Norske gaardnavne: Oplysninger samlede til brug ved matrikelens revision* (Kristiania, 1897–1924).

9. For the central place indicating place-name –*tuna*, see Stefan Brink, "Political and Social Structures in Early Scandinavia: A Settlement-Historical Pre-Study of the Central Place," *Tor* 28 (1996): 235–81.

10. See G. F. Heiberg, "Sogns Kirker i fortid og nutid," *Tidsskrift utgjeve av historielaget for Sogn* 23 (1970): 7–56.

11. Bergljot Solberg, *Jernalderen i Norge: Ca. 500 f. Kr.–1030 e. Kr.* (Oslo, 2000), 222.

12. Berit Gjerland and Christian Keller, "Graves and Churches of the Norse in the North Atlantic: A Pilot Study," *Journal of the North Atlantic* 2, special issue 2 (2009): 161–77.

13. The map is based on data from the Norwegian University Museums' collection databases (Universitetsmuseenes samlingsdatabaser). Only grave finds that by classification, description, or photographs of the grave goods could be identified as Viking were included. An examination of the grave finds in the collections of the University Museum of Bergen will likely increase the number of Viking-age graves from the area.

14. Jan Brendalsmo, "Kirker og sogn på den trønderske landsbygda ca.1000–1600," in *Ecclesia Nidrosiensis 1153–1537: Søkelys på Nidaroskirkens og Nidarosprovinsens historie*, ed. Steinar Imsen (Trondheim, 2003), 233–53.

15. Birgit Maixner, "*Sæheimr: Just a Settlement by the Sea? Dating, Naming Motivation and Function of an Iron Age Maritime Place Name in Scandinavia," *Journal of Maritime Archaeology* 15.1 (2020): 5–39.

16. Sigurd Grieg, "Lahellnavnet i arkeologisk og kulturhistorisk lys," *Årbok: Universitetets Oldsaksamlings*, 1969 (1972): 5–66.

17. Tom Schmidt, "Marked, torg og kaupang: Språklige vitnemål om handel i middelalderen," *Collegium Medievale* 13 (2000): 79–102; Knut Helle and Arnved Nedkvitne, "Sentrumsdannelser og byutvikling i norsk middelalder," in *Urbaniseringsprosessen i Norden: Det 17. Nordiske historikermøte, Trondheim 1977*, vol. 1, *Middelaldersteder*, ed. Grethe Authén Blom (Oslo, 1977), 189–286; and Frans-Arne Stylegar and Oliver Grimm, "Place-Names as Evidence for Ancient Maritime Culture in Norway," *Årbok: Norsk sjøfartsmuseum*, 2002, 79–109.

18. See *Saga Sverris konúngs* (Copenhagen, 1834), chap. 79.

19. Ingvild Øye, "Kaupangen i Sogn i komparativ belysning," *Viking* 52 (1989): 144–65; and Christoffer Knagenhjelm, "Kaupanger i Sogn: Etablering, vekst og bydannelse," in *De første 200 årene: Nytt blikk på 27 skandinaviske middelalderbyer*, ed. Hans Andersson, Gitte Hansen, and Ingvild Øye (Bergen, 2008), 57–71.

20. University Museum of Bergen, inv. no. B5925.

21. University Museum of Bergen, inv. no. B4511.

22. For a detailed description of this burial and its inventory, see Helge Sørheim, "Three Prominent Norwegian Ladies with British Connections," *Acta Archaeologica* 82 (2011): 17–54.

23. Egon Wamers, *Insularer Metallschmuck in wikingerzeitlichen Gräbern Nordeuropas: Untersuchungen zur skandinavischen Westexpansion* (Neumünster, 1985).

24. Kjetil Loftsgarden, "Marknadsplasser omkring Hardangervidda: Ein arkeologisk og historisk analyse av innlandets økonomi og nettverk i vikingtid og mellomalder" (PhD diss., University of Bergen, 2017), 182–83.

25. Randi Barndon and Asle Bruen Olsen, "En grav med smedverktøy fra tidlig vikingtid på Nordheim i Sogndal: En analyse av gravgods, handlingsrekker og symbolikk," *Viking* 81 (2018): 63–88.

26. Jan Petersen, "Jernbarrer," *Oldtiden: Tidsskrift for norsk forhistorie* 7 (1918): 171–86.

27. O. Rygh, *Norske oldsager* (Christiania, 1885), 1: fig. 438.

28. Loftsgarden, "Marknadsplassar omkring Hardangervidda," 186, 194.

29. Ibid., 69, 184.

30. Museum of Cultural History, University of Oslo, inv. no. C54544.

31. University Museum of Bergen, inv. no. B18032.

32. University Museum of Bergen, inv. no. B7762.

33. University Museum of Bergen, inv. no. B14217.

34 University Museum of Bergen, inv. no. B841.
35 The Frostaþing Law we know dates to the thirteenth century, but it is assumed to have had a predecessor, an older lawbook called Grágás that might have been from the late eleventh century. See the chapter "Om lova og lagdømmet" in Jan Ragnar Hagland and Jørn Sandnes, *Frostatingslova* (Oslo, 1994), IX–XI.
36 See chapter 19 in "Leidangsbolk," in ibid., 127.
37 Loftsgarden, "Marknadsplassar omkring Hardangervidda," 194.
38 Knagenhjelm, "Kaupanger i Sogn," 60.
39 See Michael Müller-Wille, "Der frühmittelalterliche Schmied im Spiegel skandinavischer Grabfunde," *Frühmittelalterliche Studien* 11 (1977): 127–201; and Loftsgarden, "Marknadsplassar omkring Hardangervidda," 190–93.
40 Barndon and Olsen, "En grav med smedverktøy fra tidlig vikingtid på Nordheim i Sogndal," 77–80.
41 Gjerland and Keller, "Graves and Churches of the Norse in the North Atlantic," 165–66.
42 Sigmund Matias Bødal, "Vik i Sogn 750–1030: Lokalsamfunn med overregionale kontakter" (MA thesis, University of Bergen, 1998), 92–93; Sigmund Matias Bødal, "Vik og Sogn i tida kring førre årtusenskiftet," *Årbok: Vik Historielag*, 2000, 42–60; and Liv Helga Dommasnes and Alf Tore Hommedal, "One Thousand Years of Tradition and Change on Two West-Norwegian Farms AD 200–1200," in *The Farm as a Social Arena*, ed. Liv Helga Dommasnes, Doris Gutsmiedl-Schümann, and Alf Tore Hommedal (Münster, 2016), 127–69.
43 Irene Baug, "Soapstone Finds," in *Things from the Town: Artefacts and Inhabitants in Viking-Age Kaupang*, ed. Dagfinn Skre (Aarhus, 2011), 311–37.
44 Per Storemyr and Tom Heldal, "Soapstone Production through Norwegian History: Geology, Properties, Quarrying, and Use," in *Interdisciplinary Studies on Ancient Stone: Proceedings of the Fifth International Conference of the Association for the Study of Marble and Other Stones in Antiquity, Museum of Fine Arts, Boston, 1998*, ed. John J. Hermann Jr., Norman Herz, and Richard Newman (London, 2002), 359–69.
45 For soapstone artifacts in the Danish Viking emporium Hedeby/Haithabu, see Heid Gjöstein Resi et al., *Die Specksteinfunde aus Haithabu* (Neumünster, 1979), 9–167. For imported soapstone objects in southern Scandinavia in general, see Ole Risbøl, "Socialøkonomiske aspekter ved vikingetidens klæberstenshandel i Sydskandinavien," *Lag* 5 (1994): 115–61.
46 Arne Skjølsvold, *Klebersteinsindustrien i vikingetiden* (Oslo, 1961).
47 Amund Helland, *Tagskifere, heller og vekstene* (Kristiania, 1893).
48 Skjølsvold, *Klebersteinsindustrien*, 5.
49 Gitte Hansen, Øystein J. Jansen, and Tom Heldal, "Soapstone Vessels from Town and Country in Viking Age and Early Medieval Western Norway: A Study of Provenance," in *Soapstone in the North: Quarries, Products and People, 7000 BC–AD 1700*, ed. Gitte Hansen and Per Storemyr (Bergen, 2017), 249–328.
50 Per Fett, *Vik Prestegjeld* (Bergen, 1954).
51 Per Fett, *Luster Prestegjeld* (Bergen, 1954).
52 Brendalsmo and Eriksson, *Kildegjennomgang*, 118.
53 Vibeke Lia, "Ornes i Luster: En arkeologisk landskapsanalyse med punktundersøkelser i innmark" (MA thesis, University of Bergen, 2005).
54 Frode Iversen, *Var middelalderens lendmannsgårder kjerner i eldre godssamlinger? En analyse av romlig organisering av graver og eiendomsstruktur i Hordaland og Sogn og Fjordane* (Bergen, 1999).

CHAPTER 4

The Decoration of Buildings in the North in the Late Viking Age: A Tale of Bilingualism, Code-Switching, and Diversity?

Margrete Syrstad Andås

THIS ESSAY EXAMINES WHAT REMAINS of eleventh-century architectural ornamentation from the North, primarily from church buildings (Fig. 4.1).[1] Until the end of that century numerous wooden churches were built across the region, and stone was not used as building material.[2] From Iceland in the west to Novgorod (Russia) in the east, wherever Scandinavians lived and traveled, we find great similarities but also significant differences. What remains from these churches are fragments, such as corner posts, portals, wall-plates (which hold the tops of the wall planks), wall planks, lintels, and a few cases of decorated interior paneling. This architecture was a vital part of the visual and material culture of the late Viking Age, and it reveals important information about a society undergoing substantial structural changes.

To determine what actually remains is both challenging and important, and this essay is therefore accompanied by an alphabetically organized appendix—Chapter 4A—that lists surviving fragments from eleventh-century decorated buildings in the North. The images of the various fragments can be found in the appendix, alongside a more thorough discussion of the dates of the fragments and information about provenance, measurements, and other details. In this chapter, I suggest a relative chronology for the various fragments based on style and compare this with the dates recently made available by dendrochronological analyses. Once the extent of the eleventh-century material has been established, it is possible to ask whether any trends are discernible and to examine how stylistic and iconographic motifs were used in that period. It may be that different influences were not simply adopted but, rather, consciously applied depending on the symbolic and social situation. My aim is thus to give an overview of what remains, provide

CHAPTER FOUR | THE DECORATION OF BUILDINGS IN THE NORTH IN THE LATE VIKING AGE

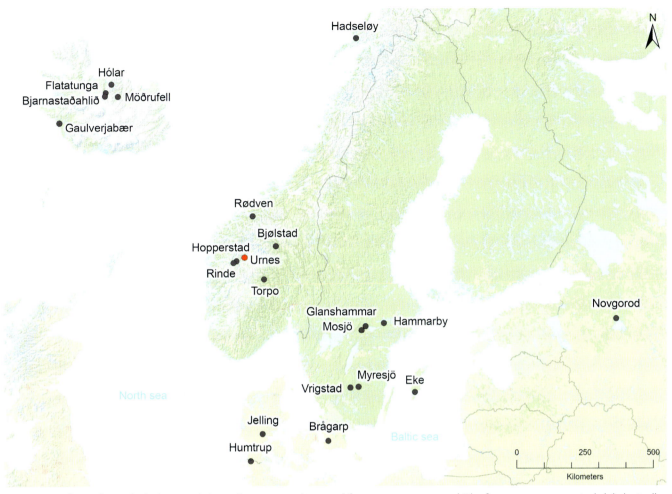

Fig. 4.1. Map of sites from which decorated eleventh-century architectural fragments are preserved. The fragments are presented alphabetically in Chapter 4A. Map: Magnar Mojaren Gran.

dendrochronological dates where those exist, and draw attention to the potential variety of styles and iconographic languages that may have coexisted in the North at the end of the Viking Age.

The Use of *Spolia*

The wooden fragments of eleventh-century architecture have survived through their continuous use or reuse. These fragments have been preserved as floorboards or in the roof construction of later stone churches, or they were incorporated into new wooden churches and other buildings. Some church portals continued to serve as entryways into new churches. The present church at Urnes, built in the 1130s, followed current trends in iconography and architecture but also reused elements from the previous church on the site, dated *c.*1070. With the exception of the remains of interior

197

paneling in Iceland, all the objects discussed in this chapter were, as far as I know, reused in their original place and not transported to a new locality.

The reuse of building materials was also common in Continental Romanesque churches.[3] Over the past forty years much has been written about the use of *spolia*. Arnold Esch brought the intention behind the practice into focus, setting aside the element's original context and looking instead at the transformation of materials through their reuse.[4] In a study of the reuse of stone sculpture in Lincolnshire, David Stocker and Paul Everson suggested three categories of reuse: casual, functional, and iconic.[5] These categories also work for wooden architectural and sculptural reuse, but I would propose a possible fourth category: ritual. Some of the reused materials at Urnes have dedication crosses from the *c.*1070 consecration ceremony (Fig. 6.7), and we cannot exclude the likelihood that these materials were therefore perceived to be sacred. The same may be suggested for a series of wall planks reused as floorboards from Myresjö (Sweden) (Fig. 4A.16), as well as some floorboards preserved in the seventeenth-century church of Kvikne (Norway)(Fig. 4.2). The Kvikne planks feature consecration crosses and the remains of Urnes-style graffiti.[6]

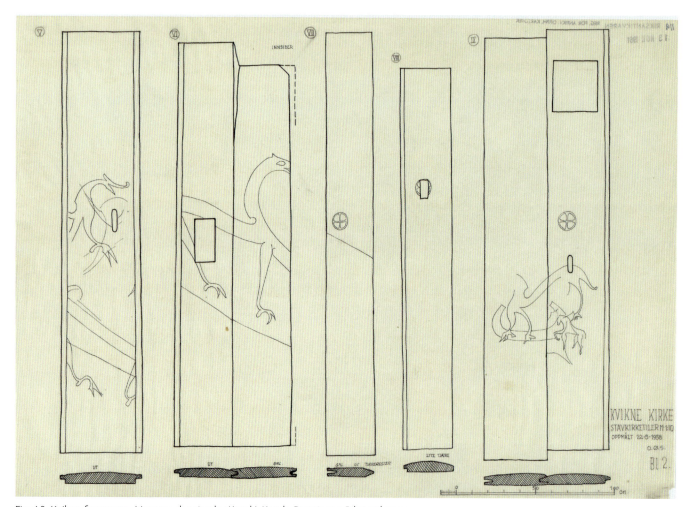

Fig. 4.2. Kvikne fragments, Norway, drawing by Knud J. Krogh. Drawing: © Riksantikvaren.

CHAPTER FOUR | THE DECORATION OF BUILDINGS IN THE NORTH IN THE LATE VIKING AGE

There are early written indications that the materials from a church should be reused in another church or sacred building; if this was not possible, they were to be burned.[7] Whether this was also the case with eleventh-century churches in the North, we do not know. When the reused item was a church portal, as at Urnes, Bjølstad, and Rødven (all in Norway), it would certainly embody both iconic and ritual qualities; the portal was sacred because of its dedication, location and use. In his work on collective memory, Jan Assmann notes that groups, which do not possess memory, tend to make themselves one by means of things meant to serve as reminders; he refers to the "remembering mind" and the "reminding object."[8] A church portal, or the remains of an older building when reused as visible *spolia*, may be such a "reminding object." A portal was certainly an important element in the performance of religious rituals, some of which were linked to major feasts in the annual calendar whereas others would mark the most important days in an individual's life. Accordingly, a cluster of associations and memories for the local community would be related to the portal, making it a type of mnemonic object.

In 2017–18 the foundations of what was most likely the early eleventh-century church of St. Clement were uncovered in Trondheim (Norway). In the post-holes of this church were a series of fragments from a baptismal font belonging to an earlier church.[9] The font had been destroyed intentionally and reemployed as packing material for the posts of the new church. St. Clement's was the church of the Viking kings Óláfr Tryggvason (r. *c.*995–99), and St. Óláfr (Óláfr Haraldsson, r. 1015–28), men who traveled widely and were familiar with both Christian and pre-Christian faith and practices. The systematic use of consecrated material incorporated into the foundations of the new building suggests that the reuse was ritualized and carried religious meaning.

When *spolia* from an earlier building, such as the Urnes portal from 1070, are on prominent display, this may also be a matter of aesthetic appreciation. In such cases the *spolia* from the earlier church must have been appreciated locally for their craftsmanship and aesthetic qualities. The beauty and splendor of buildings were also praised in contemporary poetry. In his study of reused building materials in Romanesque buildings and contemporary attitudes towards the past, John McNeill has pointed out that medieval authors rarely mention ideological intent; they tend to focus on the aesthetic qualities of reused materials.[10] When looking at the fragments of late Viking-age architectural decorations, it is important to keep in mind that they may have been preserved for a number of different reasons, from the practical or aesthetic to the symbolic and ritualistic.

Urnes and the Style Groups of Late Viking-Age Scandinavia

In the Scandinavian material, the sequence of Mammen–Ringerike–Urnes styles is largely accepted as helpful categorizations of mid- to late Viking-age stylistic groups. Yet it is also acknowledged that features overlap, and objects cannot always be easily categorized.[11] The dates must also be expected to vary from place to place.

Mammen and Ringerike have a number of common elements, such as the large quadruped and the use of vines as central motifs, as well as spirals and tendrils.[12] Both tend toward an additive approach, in which each compositional element retains its independence while at the same time forming part of a larger pattern. Often the fluency of the line is disturbed by dents, and in Ringerike also by the addition of tightly scrolled single or double tendrils or fanned-out clusters of tendrils. The Ringerike style features symmetry, and the backbone of compositions in such key objects as the Vang stone is axiality. Moreover, Ringerike compositions may include human figures, figural scenes, or narrative scenes. Even though assessing eleventh-century architectural ornament from the North mostly means examining objects made in the Urnes style, some of the Swedish fragments shows Ringerike elements, as does the Icelandic material and perhaps even the half-columns from Novgorod (Figs. 4A.5–8 and 17–18).

Unlike Mammen and Ringerike, the Urnes style is dominated by slim and stylized beasts that are interwoven into tight patterns with an absolute lack of human figures.[13] Vegetation is largely absent from the style in its early phase and in the decades around the mid-eleventh century, but single leaves may occur, like the lily tails of the lion and the beasts at Urnes (Fig. 4.8 and Plate 3). Toward the end of the century vegetal elements appear in Swedish examples, as at Vrigstad (Fig. 4A.23). The Urnes style consists of three types of creatures:[14] type I beasts are quadrupeds seen in profile; type II beasts are snakelike, with one clear limb and a second that mixes a limb with a tail; and type III beasts are ribbon-shaped serpents with no limbs, often recognizable by their triangular heads seen from above. The distinctive Urnes loopwork consists of type II and III beasts intertwined with one another. In the Urnes style, the motifs are never isolated; they are integrated within a larger composition. The style appears ornamental and dominated by movement, and often we find combat among the beasts, as they seize each other by their jaws.

Signe Horn Fuglesang distinguishes between two main compositional types. The first features double-crossing loops, often creating figure-eight shapes that, unlike the loops and stems of the Ringerike style, are not axially arranged. The second has patterns of multiple loops, where three or four of these figure-eight shapes cross each other multiple times.[15] The multiloop pattern appears to be an innovation of the Urnes style.[16] Another novelty of this style is the winged type II beast, which first occurred on the early runestones carved by Ásmundr, but wings remained rare until the end of the eleventh century.[17] Similarly, the tightly scrolled tendrils of the earlier Urnes-style phases were replaced by lobed tendrils with a disklike appearance, as in Torpo (Fig. 4A.21). Another late element is vine shoots growing from the heel of the tendril interrupting the flow of the loopwork, as in Vrigstad (Fig. 4A.23). Except for the later phase of Urnes, the development of the style appears to have followed a remarkably similar pattern across Scandinavia. From c.1100, the Urnes style in Scandinavia appears alongside, or rather combined with, Romanesque features, and thus is sometimes referred to as Urnes-Romanesque.[18] In the religious center of Lund in the Swedish province of Scania, the remains of molds and brooches from two workshops producing Urnes-style jewelry have been stratigraphically dated c.1070–1150, suggesting that the style was certainly still in vogue in Scandinavia around 1100.[19] Although the Urnes style was primarily used in Scandinavia, it also occurs elsewhere. In England the style appears on a handful of metal finds; more significantly, beginning in the early twelfth century the Urnes style flourished in Ireland.[20]

The Ringerike and Urnes styles apparently had a rather long coexistence.[21] Commenting on the formal qualities and the simultaneous presence in some workshops of both Urnes and Ringerike models, Fuglesang describes them as "two genetically unrelated styles" and suggests that Urnes probably represented a separate innovation partly due to influences from abroad (England or the Continent).[22] In Ringerike-style objects there are examples of the ribbon-shaped beast referred to as Urnes type II, but these are rare.[23] Some motifs, such as the large quadruped fighting the serpent, are retained though several style groups. Mammen and Ringerike often feature lions, stags, birds, masks, vines, and tendrils, many obviously influenced by contemporary Continental art.[24]

Given the intellectual and religious development of the time, with Christian conversion progressing steadily, one might have expected a development more in line with what we see among the Ottonians and Anglo-Saxons.[25] David M. Wilson notes that the zoomorphic loopwork of Urnes could not be more different from its stylistic predecessors, with the beasts' flexible, fluid, and rounded lines, combined with the tendency to create large, nonaxial loops.[26] The extensive and, in certain regions and periods, exclusive use of zoomorphic motifs is certainly striking in the Urnes style, and presumably it carried reference to the Viking past, when animal ornament had been the dominant form of expression. In their study of the Swedish runestones, Anne-Sofie Gräslund and Linn Lager are concerned with how material culture reflects identities. They note how foreign ornamental influences often seem to have been discarded in the indigenous production of artefacts, while a form of what might have been perceived as a Scandinavian vernacular was apparently developed intentionally.[27] The conversion to Christianity was a change of religious identity. By the eleventh century Christianity was far more than just a system of religious beliefs; it was a cultural, political, and social institution, and it defined most kingdoms and empires in Europe. For the Scandinavians, Christianity had for a long time been synonymous with "the other."[28] Gräslund and Lager suggest that while many Scandinavians were willing to convert and change their religious identity, they may not have been equally willing to change their Scandinavian identity. The maintenance of a sense of integrity was important: "Christianity itself had to be, at least seemingly, converted from something that used to define 'the others' into something that could also define themselves: as Christian Scandinavians."[29] Seen from such a perspective, the late Viking-age Urnes style was innovative, yet it secured a sense of cultural continuity.[30]

Given the date and quantity of Urnes-style brooches found in Denmark, it has been argued that the "invention of the style," in the sense that certain "new" elements were consciously introduced, took place in Denmark.[31] Yet Fuglesang has suggested that the work of the runestone masters was probably not restricted to memorial stones; rather, their principal responsibility may well have been the building and decoration of churches.[32] She thus agrees with those who believe that Ásmundr was the innovator of the Urnes style, and she places this innovation at the court of Uppsala, in Sweden, in the second quarter of the eleventh century.

Establishing Criteria for the Dating of Decorated Architectural Fragments

The Swedish region of Uppland preserves more than 1,300 runestones, many with Urnes-style ornamentation. Gräslund has developed a systematic list of runestone motif-elements and their development from Ringerike to Urnes and Romanesque (Fig. 4.3).[33] With Morellian attention to detail, she lists the shape of the heads of the beasts, the type of eyes and ears, the claws or feet, the shape of the lobed tendrils, the type of union knots tying the loops together,[34] and, finally, the overall design. Because the number of runestones with zoomorphic loopwork is substantial, a detailed relative chronology has been established and correlated with finds from hoards and with the runic inscriptions themselves (e.g., the phrases used, the forms of writing, names mentioned).

In what follows, I apply Gräslund's observations concerning the development of style. She uses the abbreviation *B-e-v* for *Bird's-eye-view* and *Pr.* For *Profile*, referring to how the heads of the beasts are depicted. Her relative chronology suggests the following dates for the runestones:[35]

B-e-v	c.1010–1050
Pr. 1	c.1010–1040
Pr. 2	c.1020–1050
Pr. 3	c.1045–1075
Pr. 4	c.1070–1100
Pr. 5	c.1100–1130

The earliest style groups, Pr. 1 and Pr. 2, are closely related to the Ringerike style, which is not surprising given that Ringerike was widely used in the first half of the eleventh century.[36] Pr. 3 and Pr. 4 are Urnes and Urnes style proper, while Pr. 5 is late Urnes.[37]

Gräslund's observations on the development of style are considered reliable, but the time frames for the style groups also rely in part on the dates assigned to certain groups of runestones, some of which have been a matter of dispute since the early twentieth century.[38] The disputes relate to twenty-five early stones in the Lake Mälaren region that commemorate the expedition of Ingvaldr and his men (dated by Gräslund to c.1041); the "Knut stones" that mention *Danegeld* or journeys to England; and works by the carvers Ásmundr and Öpir, who were either men with long careers working across different style groups (Gräslund's assumption) or carvers who had the same names at different points in time.[39] Gräslund's position on the Ingvald stones pushes the beginning of her group Pr. 3 to about 1045, and her later dates follow from this. She dates certain developments later than Fuglesang. Most of the architectural cases discussed below resemble Gräslund's Pr. 3 and Pr. 4, which in her runestone chronology correspond to c.1045–c.1100. Important as this discussion of dates may be to the present study, Gräslund's stylistic chronology is far more important than the dates attached to it.

Fig. 4.3. Anne-Sofie Gräslund's scheme for the development of stylistic details, showing the shape of heads and lip-lappets, scrolled tendrils, and union knots in the runestone material. Birds-eye-view (U 644, U 1172); Pr.1 (U 160, U 201); Pr.2 (U 438, U 1149); Pr.3 (U 167, U 808); Pr. 4 (U 177, U 1006); Pr.5 (U 311, U 485); U = Uppland. After Gräslund, "Dating the Swedish Viking-Age Rune Stones on Stylistic Grounds," in *Runes and Their Secrets: Studies in Runology*, ed. Marie Stoklund et al. (Copenhagen, 2006), 132–33. Drawing: © Anne-Sofie Gräslund.

My goal is to present an overview of what remains of eleventh-century decorated architecture from the North. Linking actual dates to the relative chronology requires help from other disciplines, including archaeology. Sometimes finds have a stratigraphic context, and sometimes hoards are datable though coin deposits. The silver bowl from Lilla Valla, Gotland (Sweden) (Fig. 4.4), is a key object that, based on coins in the same hoard, is normally dated c. 1050.[40] Brooches in the Urnes style are common across the North and were certainly produced until c. 1100 or even later.[41] Ringerike metalwork also sometimes appears in hoards, of which the earliest is dated 1026 and the latest to the 1060s.[42] Excavations of the library plot in Trondheim uncovered a series of wooden objects, including spoons and pieces of furniture in the Ringerike and Urnes styles, in which the Urnes-style objects belonged to layers dated either c. 1050–1100 or c. 1100–1150.[43]

Some architectural fragments have been dated by dendrochronology. Because this method has provided dates for such key monuments as Urnes and Hørning (Denmark), it deserves particular attention. In Norway and the northern regions of Sweden the earliest wooden churches were mostly

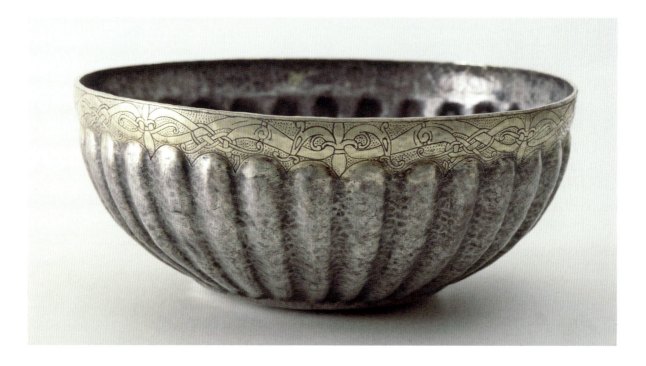

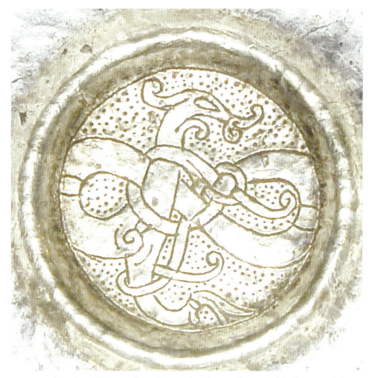

Fig. 4.4. Silver bowl from Lilla Valla, Gotland, Sweden. Stockholm, Swedish History Museum, inv. SHM-3099. Photo Sören Hallgren, © Statens Historiska Museum.

made of pine, whereas Scania and Denmark mostly used oak, but there are cases where fir and oak appear alongside each other in the same building. Specific regional sequences for dating these species have been developed over the last decades, along with a more refined methodology.[44] Fresh wood is generally more attractive to work with than hardened wood, so it is fair to assume that high-quality objects cut by skilled artisans were made of recently felled trees. At Urnes, for instance, it is very visible how the wood dried after it was carved, creating cracks across the ornamentation on the right jamb (Plate 3). For Norway most of these dendrochronology studies have been published and are available in a 2016 book by the Directorate of Cultural Heritage, which features a detailed chapter on the various stave churches.[45] However, only Urnes has thus far yielded an eleventh-century date (c.1070),[46] while the other fragments from Norway discussed below—from Rødven (Fig. 4.10 and 4A.20), Bjølstad (Fig. 4A.2), Torpo (Fig. 4A.21),

CHAPTER FOUR | THE DECORATION OF BUILDINGS IN THE NORTH IN THE LATE VIKING AGE

Rinde (Fig. 4A.19), and Hopperstad (Fig. 4A.10)—are either not sufficiently preserved to provide dates or have yet to be examined. In the case of Denmark, only Hørning (Fig. 4A.13) has been dated by dendrochronology (c.1060–70); and Humptrup, in present-day Germany (Fig. 4A.12), has proved impossible to date by any scientific method.[47]

The situation for the Swedish material is more complex. Quite a few monuments and fragments were dated in the 1980s and published in the two volumes of *Medeltida träkyrkor* in the series "Sveriges kyrkor," some in the series "Signums Svenska konsthistoria" from 1995, and others in Claus Ahrens's 2001 catalogue of the stave churches of Europe.[48] Since then, however, the reference curves have been developed further, the statistical material enlarged, and the methodology improved, so the earlier dates must be treated with caution. Another challenge is that the reports from dendrochronological examinations are often held by client institutions, such as a local museum, and are not necessarily published. Still, we now have reliable dates for Myresjö (1095) (Fig. 4A.16),[49] Vrigstad (1097)

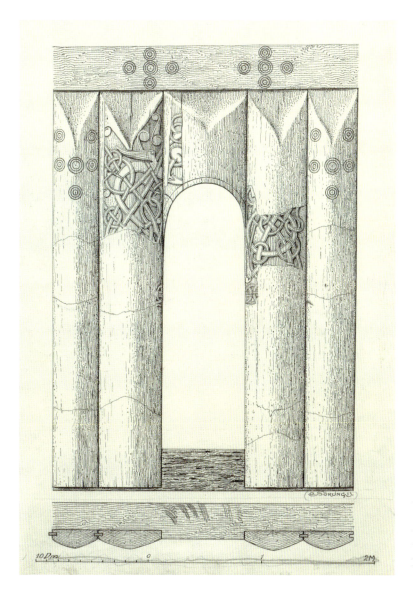

Fig. 4.5. Hemse church portal, Gotland, Sweden. Drawing: Olof Sörling, 1913, in Emil Ekhoff, *Svenska stavkyrkor: Jämte iakttagelser över de norska samt redogörelse för i Danmark och England kända lämningar av stavkonstruktioner* (Stockholm, 1914–16), 122.

(Fig. 4A.23),[50] and Eke (Sweden) (*c.*1050) (Fig. 4A.4).[51] Other decorated wooden fragments that were once thought to date to the eleventh century, such as Hagebyhögda (1120)[52] and Väversunda (1160),[53] both in Sweden, have turned out to be later. The portal from Hemse on Gotland (Fig. 4.5), which often figures in discussions on the Urnes style in Sweden, has recently been redated to 1145.[54]

We also have several extant twelfth-century churches in Norway dated by dendrochronology, such as the fourth church at Urnes and the one at Hopperstad (Fig. 4.6), both from the 1130s.

Fig. 4.6. Hopperstad church, Norway, drawing of west portal. Drawing: Peter Andreas Blix, © Riksantikvaren.

CHAPTER FOUR | THE DECORATION OF BUILDINGS IN THE NORTH IN THE LATE VIKING AGE

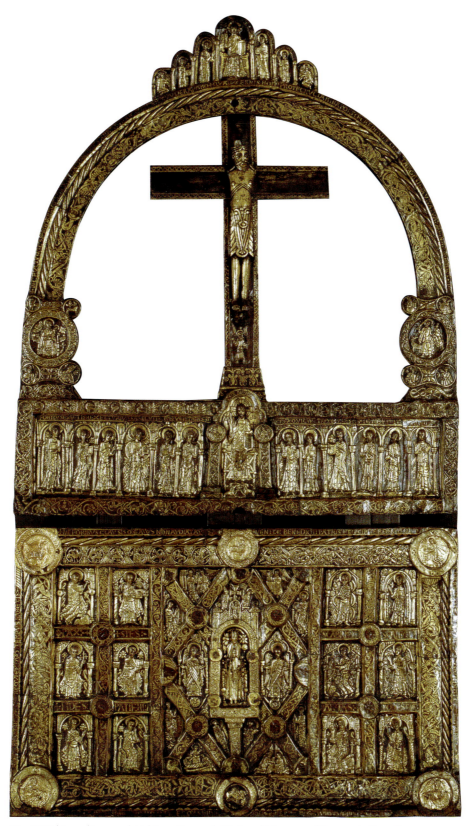

Fig. 4.7 Lisbjerg altar panel, Lisbjerg, Denmark. National Museum of Denmark, Copenhagen. Photo: John Lee, © Nationalmuseet.

207

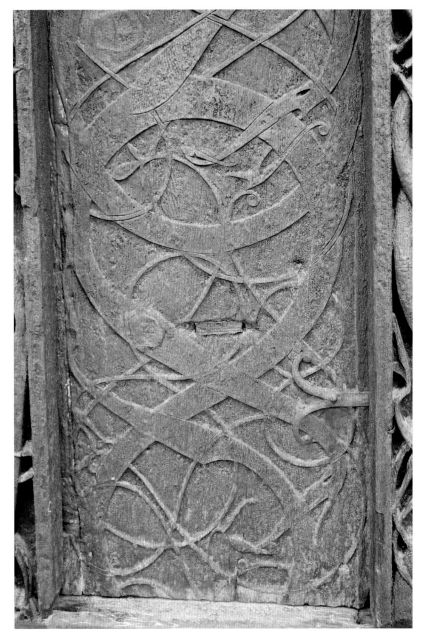

Fig. 4.8. Urnes church, detail of door leaf from third church, showing the shape of the beasts' heads and the lily tail. Photo: © Thomas E. A. Dale.

Even though these monuments fall outside the scope of the present study, these late dates give valuable insight not only into the development of style but also to the significance of geography and regional developments.[55] Hemse essentially confirms what is hinted at in the Romanesque stone sculpture from Gotland, namely, that a late version of the Urnes style flourished there in the second quarter of the twelfth century. Dendrochronology has further confirmed that Urnes elements sometimes appear in predominantly Romanesque works in Scandinavia in the 1130s, such as the Lisbjerg altar (Fig. 4.7) and the capitals of the fourth Urnes church (Plates 39–95).[56]

Gräslund's observations on the development of heads, tendrils, claws, and knots on the runestones (Fig. 4.3) may be compared with the same elements in works dated by dendrochronology. The head of the Urnes portal's quadruped (Plate 8) has features that place it somewhere between her Pr. 3 and Pr. 4, and its mane is executed in the same manner as the lobed tendrils of the Pr. 4 group. The heads and the curled-up tails of the filiform ornament on the door of Urnes clearly fall within Pr. 4 (Fig. 4.8), as do the heads in the gable. It should be noted, however, that the type III beasts there have bird's-eye-view heads (Plate 9), and in architectural sculpture this cannot be considered an early element. The serpent's head on the Hørning wall-plate has the chubby features of Pr. 3 (Fig. 4A.13), but its tail terminates in a lobe more like those of Pr. 4. The Vrigstad fragments are very different from one another, but one has beasts' heads with Pr. 3- and Pr. 4-type profiles, and the lobed tendrils are primarily like Pr. 4 (Fig. 4A.23). Hagebyhögda has Urnes beast heads resembling Gräslund's latest style group, Pr. 5.[57] In conclusion, with the exception of the head profiles of Vrigstad, the dates derived from Gräslund's system correspond fairly well with the dates of the decorated architectural fragments provided by dendrochronology.

Decorated Architectural Fragments from the Eleventh Century

The fragment from Urnes holds a key position in the art history of the late Viking Age, both because so much of the eleventh-century building has been preserved and because it has been firmly dated to *c.*1070. It is unlikely, however, that these are the oldest decorated architectural fragments from the North, as others show features that appear stylistically older than Urnes.

The text of runestone U 687 in Sjusta (Sweden) records that a man named Spjallbude went to Novgorod sometime in the late eleventh century and died there.[58] Novgorod at that time was an important town for the Vikings heading east and a melting pot of tradesmen and travelers. Excavations of the Nerev quarter have uncovered two half-columns (Fig. 4A.18) in a stratigraphic context dated *c.*1040–80,[59] but nothing is known about their original location or what type of building they came from.[60] Along the top of both runs a frieze of chainlike interlace. The upper half of one of the columns has two vertically placed medallions surrounded by loopwork, and within these medallions are a griffin and a centaur. The second half-column is decorated with loosely thrown loopwork. Nadezhda N. Tochilova and Anna Slapinia describe eleventh-century Novgorodian art as "a stylistic polyphony" in which analogies to Polish and Czech material are evident but Byzantine and Scandinavian influences also appear.[61]

As Erla Bergendahl Hohler noted, the loopwork of the Novgorod half-columns does not find parallels in the Norwegian material,[62] but it is related to loopwork in the otherwise rather open composition of the right jamb at Hemse (1145), on Gotland (Fig. 4.5). In this regard Hemse may reflect much older influences. More interesting, however, are the creatures inside the medallions, where the feathered wing of the griffin terminates in what looks like the distinct Ringerike style of

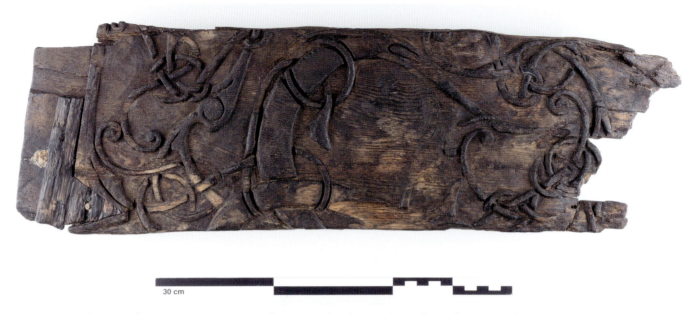

Fig. 4.9. Fragment from Trondheim. Norwegian Institute of Science and Technology (NTNU), Trondheim, Vitenskapsmuseet, inv. no. T 30000. Photo: © NTNU Vitenskapsmuseet.

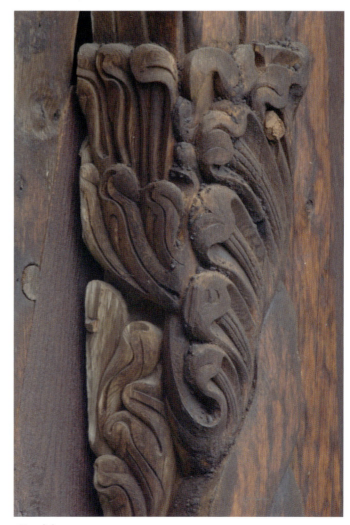

Fig. 4.10a–b. Rødven church, Møre, Norway, details of portal. Photo: © Kjartan Hauglid.

fanned-out, tightly scrolled tendrils, whereas the tail of the centaur finds its closest parallel is the bushy tail of the lion on the Ringerike-style Norwegian Vang stone.[63] Moreover, the loopwork that encases the griffin and centaur within each medallion echoes that surrounding the large animals on Urnes-style brooches. These are all minor details, possibly indicating the influence of Viking-style metalwork (such as brooches), but the way the ornament is draped across the Novgorod half-columns with no regard to curvature is an important parallel to Scandinavian work. It is reminiscent of the arrangement of the ornament on the corner posts at Urnes and Hopperstad or the twelfth-century portal at Hemse. When interlace and loopwork are used in architecture elsewhere, they are restricted to capitals or abaci and located within their frame in a different manner.

These few but significant Scandinavian features correspond well to the stratigraphic information first provided for these columns. We know that there were wooden buildings throughout the North in this period, but very little is preserved. The Novgorod half-columns provide evidence for a decorated wooden architecture in which interlace and loopwork draped across the surface were important ornamental features. They are important finds in a northern context, since they offer either a glimpse of what churches of the generation before Urnes may have looked like, or—depending on whether they are closer to 1040 or to 1080—what the same generation looked like in another location.

Another relevant find is a plank discovered in 1989 during the plowing of a field at Hadseløy (Norway) (Fig. 4A.8).[64] Preliminary radiocarbon dates indicate the early eleventh century as the latest possible date for the plank,[65] but the decoration features a mix of Ringerike- and Urnes-style elements, possibly indicating a carving time later than what is suggested by the radiocarbon dates.[66] The mixing of styles in a Norwegian context suggests a mid-eleventh-century date, so the plank may be the earliest surviving piece from a church in Norway.

Among the earliest fragments from Sweden are the materials from Eke, on Gotland (Fig. 4A.4), where two jamb planks feature the remains of legs belonging to Urnes type II beasts.[67] They have been dated by Thomas S. Bartholin to *c.*1050.[68] A lintel piece with two confronted Urnes-style beasts comes from Brågarp (Sweden)(Fig. 4A.3), near the bishop's seat of Lund. The creatures are united by loopwork growing from the back of their heads. Such loopwork is also found in the Trondheim material,[69] in the oldest stratigraphic context (*c.*1050–1100) (Fig. 4.9), while the heads, snouts, and almond-shaped eyes are all very close to Hørning, dated *c.*1060–70 (Fig. 4A.13).[70] A similar date is therefore likely for Brågarp. The condition of the two fragments from Humptrup in Schleswig-Holstein, a region that was under Danish rule in the eleventh century, is exceptionally poor, but they can be assumed to date from *c.*1040 to 1100 (Fig. 4A.12).[71]

Two wooden beams are reused in the Romanesque church in Hammarby (Sweden) (Fig. 4A.9).[72] Cecilia Ljung described the Hammarby ornaments as "palmettes and elegant Urnes-style loops," and the union knot motif corresponds to the period *c.*1025 to 1100.[73] It therefore seems that the Hammarby fragments should be dated *c.*1050–1100.[74] This may also be the case for the oak fragments from Glanshammar (Sweden) (Fig. 4A.7).[75] The symmetrically arranged plant stems are held together by transverse fillets and loops, but the ornamentation lacks the Urnes features and can only be dated loosely to the eleventh century.[76]

PART TWO | THE ELEVENTH-CENTURY CHURCH

Fig. 4.11. Sacramentary (Missal) of Robert of Jumièges, England, the Nativity and the Flight into Egypt. Rouen, Bibliothèque municipale, MS 274 (Y-6), fol. 32v. Photo: © Bibliothèque municipale de Rouen.

Completely different, but possibly also belonging to the early generations of church building in the North, is the reused portal of the Rødven stave church (Figs. 4.10 and 4A.20). Rødven is located off the west coast of Norway, south of Trondheim. In Hohler's work on the Norwegian stave church portals, she distinguishes between ornamented jamb portals and column portals.[77] Unlike other eleventh-century portals, Rødven belongs to the latter type. This has led scholars to assume a later date, under the influence of local stone sculpture, but we should instead consider the possibility that jamb and column portals coexisted in the eleventh century.

In 1965 Martin Blindheim briefly noted the Rødven portal's "twisted stalks and possibly

212

CHAPTER FOUR | THE DECORATION OF BUILDINGS IN THE NORTH IN THE LATE VIKING AGE

Fig. 4.12. Benedictional of Æthelwold, England, London, British Library, Add. MS 49598, fol. 45v. Photo: © The British Library Board.

Winchester style affiliations."[78] The arch of the Rødven portal is adorned with leaves growing from both sides that wrap the flat, double-roll structure that lies underneath. The way in which the architectural elements are treated like vegetation, akin to a blossoming arch, with twisting stems and sprouting leaf capitals, also appears in the portals that frame scenes in the Sacramentary of Robert of Jumièges (Fig. 4.11), dated to the first quarter of the eleventh century.[79] In the scenes of the Nativity and the Flight into Egypt, the architectural framework literally blossoms with leaf-covered columns and arches, both trefoil and round in shape. Moreover, at Rødven the central veins of the capital leaves are accentuated, and the tips of the leaves are turned down. This appears in

213

illuminations beginning in the tenth century and continues in various forms into the early decades of the twelfth, as in the medallions that frame the Entry into Jerusalem (through a horseshoe-shaped arch) in the late tenth-century Benedictional of St. Æthelwold (Fig. 4.12).[80]

Rødven is unique in the preserved material, but the sprouting leaves, blossoming architectural frame, intertwined stems, and beginning of what was either a horseshoe-shaped or a trefoil arch seem more like a version of Saxon traditions than an odd version of Romanesque or, even less likely, Gothic style. All things considered, Rødven may very well predate Urnes. In the last half of the eleventh century, in the period of kings Haraldr harðrádí (r. 1046–66) and his more pious son Óláfr (r. 1067–93), the ties to England were strong, churches were being built across the country, and there is thus little reason to assume that Rødven was unique in Norway in its own day, even though it seems unusual now.

The date of the two Bjølstad jambs is another disputed topic (Fig. 4A.2). They have a very weathered appearance—the lintel is missing, as are the top and bottom sections of the jambs—but next to Urnes and Rødven, this is the most complete early portal. Each jamb must have had at least two overlapping quadrupeds. Thin serpentine Urnes-style beasts create loopwork that surrounds or ties down the quadrupeds, but the loops do not create the typical figure-eight pattern or the three-loop composition associated with Urnes. In comparison with Urnes, Bjølstad appears poorly adapted to its architectural setting. The animals seem to move up and down within their frame in order to create an elegant pattern. In their present state the jambs come across primarily as ornamental, as there are no main characters, nothing to indicate decipherable animal types, no biting or struggle, and no lilies. It is elegant but static, and it appears to reflect the older heritage of ambiguous animal designs. In previous scholarship Bjølstad has been described as "degenerate,"[81] but also as the earliest surviving architectural fragment, due, among other things, to its lack of typical Urnes-style loopwork.[82] If we also apply Gräslund's Morellian system, the long almond-shaped eyes and tapering snouts suggest a date similar to Hørning and to the Urnes portal's quadruped, and the shapes of the heads and claws are closest to her group Pr. 4. Based on style, a date around 1070 seems most likely. Bjølstad may thus be another version of the Urnes style rather than a later or earlier one.[83]

Based on their similarities to Urnes, a date around 1070 also seems likely for the two Hopperstad corner-post fragments (Fig. 4A.10). A pine fragment decorated on both sides with Urnes-style designs was discovered at Trondheim during archaeological excavations (Fig. 4A.22).[84] It features thin serpentine strands in large, sweeping Urnes-style loops executed in flat relief, evoking the decoration at Rinde (Fig. 4A.19). Based on style, a date around 1070 is possible for both the Trondheim fragment and Rinde, but they may also be slightly later.

A single jamb plank from Torpo features Urnes-style carvings in a flat, two-plane relief and an open design (Fig. 4A.21). Unusually, one of the beasts is winged, but the wing is not of the Romanesque kind; rather, it resembles the wings found in the runestone material. The lobed tendrils and the feet, as well as one of the beasts' heads with a distinctive ear springing from the back of its head, clearly place the Torpo animals in Gräslund's group Pr. 4, whereas details of the head resemble Gräslund's Pr. 5. Given these stylistic details, I would suggest that Torpo dates to *c.* 1100.

Some oak planks from Myresjö, dated by dendrochronology "after 1095," feature the remains of Urnes-style friezes (Fig. 4A.16).[85] A rather complex pattern is composed of incised double contours

in which the backbone of the design is the classic Urnes figure eight. There are no serpents' heads visible, but some wings (or leaf shoots?) are visible inside the loopwork. All of these elements correspond well with the dendrochronological date.

Moving on to the remains of interior decorations, a series of wall planks with large crosses have been preserved from Mosjö (Fig. 4A.15). The present stone church built before 1150 is the third on this spot,[86] and Erland Lagerlöf concluded that the wooden church from which the materials come most likely belonged to the eleventh century.[87] No dendrochronological analysis has been undertaken to support this, but based on style it seems likely. Thirteen planks from Möðrufell (Fig. 4A.17), in Icelandic Eyjafjor, feature motifs both found in Ringerike and Mammen, such as crossing double stems, single tendrils, lilylike tendrils, spearheads, tightly scrolled spiral tendrils, tendrils with a pear-shaped jutting lobe, spirals, and knotwork.[88] These seem to place the fragments in the mid-eleventh century.

Remains of interior decoration are also preserved from the Flatatunga farm in Iceland (Fig. 4A.5).[89] Some panels from Flatatunga were reused in a nearby barn at Bjarnastaðahlið (Fig. 4A.1). The panels from Flatatunga and Bjarnastaðahlið differ in both form and style and clearly fall into separate groups. The tops of the vertically arranged Flatatunga panels have incised plant ornament linked by union knots with typical pear-shaped pendants and tightly scrolled, fanned-out tendrils.[90] The plant ornament thus features distinct Ringerike elements, which implies an eleventh-century date.[91] Metalwork finds demonstrate the use of Urnes style in Iceland toward the end of the eleventh century.[92] Hörður Ágústsson argued that both the Flatatunga and Bjarnastaðahlið panels originally came from Hólar Cathedral, begun by the bishop-saint Jón Ögmundsson *c.* 1106.[93] If so, given their style, the panels were either consciously executed in Ringerike style at a time when that style was no longer in fashion, or reused from an earlier church. In this regard it is interesting to note that *Bishop Jón's saga* describes another church at Hólar prior to the cathedral that was destroyed by fire.[94]

Preliminary radiocarbon analyses published in 2007 suggested a date for one of the Bjarnastaðahlið panels between 930 and 1065.[95] Wood used in Icelandic buildings was either driftwood or imported.[96] The assumption that underlies discussion of the Scandinavian material—that the wood would be carved shortly after the tree was cut—is thus not necessarily viable for Iceland. An eleventh-century date does, however, correspond to Selma Jónsdóttir's stylistic analysis, which places the panels in the last quarter of the eleventh century.[97] Given the radiocarbon date of Bjarnastaðahlið, Guðrún Harðardóttir has suggested that since the panels most likely came from Hólar, they should be assumed to have come from Jón's cathedral and must then have been ready-mades, possibly received as gifts.[98] Such a suggestion opens up the possibility that the carvings were executed on the mainland, but neither the date nor the origin of the panels can be pursued further here.

This survey thus indicates that the following fragments belong to the eleventh century. See Table overleaf.

Fragments from exterior	Suggested date	Dendrochronology (C-14 or stratigraphic date, if specified)	Fig. number in Appendix
Humptrup (Germany)	c.1040–1100		4A.12
Novgorod (Russia)	c.1040–1080	1040–80 (stratigraphy)	4A.18
Glanshammar (Sweden)	c.1050–1100		4A.7
Hadseløy	c.1040–1080		4A.8
Hammarby (Sweden)	c.1050–1100		4A.9
Eke (Sweden)	c.1048	1028 (+20)	4A.4
Brågarp (Sweden)	c.1060–1070		4A.3
Urnes (Norway)	c.1070	1070	4.8, 4A.23, Plates 1–13
Hørning (Denmark)	c.1060–1070	1060–1070	4A.13
Rødven (Norway)	c.1050–1100		4.10a–b, 4A.20
Hopperstad (Norway)	c.1070–1080		4A.10
Rinde (Norway)	c.1070		4A.19
Bjølstad (Norway)	c.1060–1080		4A.2
Trondheim (Norway) T16383:1	c.1070		4A.22
Vrigstad (Sweden)	c.1195	1075 + 20	4A.23
Torpo (Norway)	c.1090–1100		4A.21
Myresjö (Sweden)	c.1095–1115	After 1095	4A.16
Fragments from interior	**Suggested date**	**Dendrochronology (or C-14, when specified)**	
Hørning (Denmark)	c.1060–1070	1060–1070	4A.13
Mosjö (Sweden)	c.1100		4A.15
Flatatunga (Iceland)	c.1050–1100		4A.5
Bjarnastaðahlið (Iceland)	c.1070–1120	930–1065 (C-14)	4A.1
Hólar (Iceland)	c.1070–1100		4A.11
Möðrufell (Iceland)	c.1050–1080		4A.17

CHAPTER FOUR | THE DECORATION OF BUILDINGS IN THE NORTH IN THE LATE VIKING AGE

Exterior Architectural Decoration

The survey of fragments from the North shows that several styles coexisted in the region in the eleventh century. The only fragments preserved from Denmark (from Hørning and Humptrup) admittedly show typical Urnes designs, but in Norway, the Anglo-Saxon influences visible at Rødven are very different from the other fragments adorned with zoomorphic loopwork. In Sweden we see Urnes designs, as at Eke, Brågarp, and Myresjö, but also ornament with lobes and union knots, as at Glanshammar and Hammarby.

Any attempt to discern trends must mention the carpetlike decoration draped across certain sections of buildings in Norway. At Urnes this decoration is not attentive to architectural detail; rather, it covers parts of the surface in a manner very different from architecture of the Romanesque period, even the door leaf. The door leaf and the gables are set apart in the design through the use of unusually flat relief. Such alteration of high and low relief is also found in metalwork in this period. The corner-post fragments from the nearby church at Hopperstad show that a related design certainly must have existed there (Fig. 4A.10). These feature thick and thin loops, and one of the fragments appears to show the shoulder and foreleg of a large beast tied down by filiform loopwork. A fragment from Rinde (Fig. 4A.19), in all likelihood also from around 1070, may have come from a church of the Urnes type, where much of the building was decorated.[99] Knud Krogh and Leif Anker (see Chapter 2) have suggested that the Rinde plank comes from the gable of the eleventh-century church, whereas Hohler thought it might have been part of a door.[100] Rinde may have been a church in which only the gable or door leaf was decorated, but it may also have been a church like Urnes.

Decorating the top section of a wall with friezes of ornamentation is another feature that might have been common in parts of eleventh-century Scandinavia. Hørning and Humptrup clearly featured designs with decorated wall-plates, but to what extent other parts of those buildings were also decorated is unknown (Figs. 4A.12 and 4A.13). The fragments from Hammarby, Glanshammar, and Myresjö (Figs. 4A.7, 9, 16) are all remains of horizontal decorations reused in Romanesque churches, and it is difficult to determine whether they might have come from stave churches. Gerd Stamsø Munch pointed out that the Hadseløy plank appears to have been fastened to the horizontal part of the frame of a building, possibly to the wall-plate of a stave church.[101] The designs of five of the Vrigstad fragments closely resemble that at Hørning, with a twisted single- or double-roll ornament running horizontally along the top with loopwork beneath (Fig. 4A.23).[102] The tongue is visible along the top of the Hørning and Vrigstad fragments. No fragments of decorated wall-plates exist from Norway, with the possible exception of the Hadseløy plank; nor does this element appear in any of the twenty-eight extant stave churches in Norway.

The horseshoe-shaped arch appears at Urnes and probably also at Rødven. The shape was common in the pre–Romanesque period, as it appeared in Roman, Syrian, Visigothic, Coptic, Mozarabic, Lombard, and Anglo–Saxon architecture, and it is depicted in the architectural framework of canon tables and illuminations in Anglo-Saxon and other manuscripts. Hohler discussed the likelihood that this shape reflected a sort of Roman vernacular in Anglo-Saxon architecture that in turn influenced the Norwegian churches.[103] James Graham-Campbell compared the shape to Gotlandic picture stones and proposed that they may be "viewed as doorways, shaped like that of the later

217

Urnes church in Norway. In other words, they might have been erected not just as memorials to the dead Vikings, but also as portals, forming thresholds to the afterlife."[104]

Another question is to what extent we may infer design programs at these churches. I discuss the iconography of Urnes in Chapter 6; here it is sufficient to point out that the original west portal and west gable are not merely decorated with the typical Urnes-style beasts but, rather, that the quadrupeds have different distinguishing marks and figure as main characters in a larger composition. Unfortunately, Urnes is the only site where large parts of the building are preserved, so we cannot say to what extent such programs were common.

A central concern in Norwegian scholarship in the postwar years has been to explore how "the late-Viking-age struggle motif," to use Hohler's description of Urnes, evolved into the composition with confronted upper dragons attacking a middle dragon, known as the Sogn-Valdres design, as seen, for instance, in the west portal of Hopperstad c.1130–40 (Fig. 4.6).[105] Versions of this motif are found in about forty of the later Norwegian portals, from the second quarter of the twelfth century onward, as well as in Swedish Blomskog.[106] Hohler has argued that both Bjølstad and Torpo may have had confronted beasts on the missing lintel.[107] Ole Henrik Moe argued in 1955 that the Torpo plank(Fig. 4A.21) had previously been depicted upside-down and that the elongated body that comprises the slightly curved diagonal main line of the composition was actually the body of the left jamb's central dragon, rising up to meet its opponent in the missing top section of the portal.[108] In early scholarship Urnes was thought to represent the last example of Viking art and the Sogn-Valdres design a wholly separate innovation, but Moe's observation about Torpo suggested a continuity. It should be noted, however, that the torso stretching diagonally across the Torpo plank may be akin to the quadrupeds of Bjølstad (Fig. 4A.2), which, despite being less stiff, it certainly resembles.

The earliest preserved version of what appears to be a confronted-beast portal design is the incised decoration on the two poorly preserved jamb planks from Gotlandic Eke, which both show the foreleg of an Urnes type-II beast (Fig. 4A.4).[109] The lintel piece is missing, but Ahrens suggested that it may have been something like that at Brågarp, where the motif presumably dwindled on the flanking jamb planks (Fig. 4A.3). The knot that ties together the Brågarp beasts continues diagonally downward onto the missing bottom section of the lintel, and it may have ended in a pendant ornament, but since the loopwork grows from the back of the beasts' heads it seems unlikely that it should be perceived as a struggle with a third beast as in the Sogn-Valdres design.[110] The knot that unites symmetrically paired beasts is a frequent motif in the picture stones from Bornholm and Uppland in the late Ringerike and Urnes styles (such as Skrukeby, in Sweden, Og 220), sometimes centered around a third beast (as at Flåreng, Sweden, U 1149). A later version appears in a group of Romanesque stone portals from Randers (Denmark), which has led scholars to suggest that that the union-knot portal design may have been common in the now lost wooden churches of Denmark.[111] Certain compositional motifs undoubtedly remained popular in the North for quite some time, serving both as main compositions and as compositional elements to be mixed and matched in a variety of different ways.

Finally, exteriors cannot be discussed without addressing the question of color. The serpent of the Hørning wall-plate was originally painted bright yellow, with red pigment used for details, such

as the eye and the snout, set against a background of charcoal black (Fig. 4A.13).[112] Red also colored the outline of the frame, while the rope ornament along the top was red and black. To what extent this polychromy was unique we do not know,[113] but in the eleventh century other elite monuments were similarly colorful. Fragments of runestones painted red, black, and white were retrieved from the walls of the stone church of Köping (on the Baltic Sea island of Öland, Sweden), and the Ringerike-style stone from St. Paul's cemetery in London also has traces of original color.[114] Some of the eleventh-century runestone masters signed their work, and one inscription even mentions the painter as an artist distinct from the carver.[115] Moreover, some twelfth-century architectural fragments from the North reveal painted exteriors.[116] Most interesting are the stave church fragments from Kinnarumma (Sweden), where black horizonal lines frame a frieze of ornamental loopwork in black and red, suggesting a design that resembles Hørning.[117]

None of the exterior fragments come from Iceland, where most churches, with the exception of cathedrals, were turf buildings. These exteriors would have been very different from those of churches on the Scandinavian mainland, but in some cases they may have had wooden west facades allowing for some exterior decoration. In sum, there appears to have been great diversity in this early phase of church building in Scandinavia, although versions of the Urnes style seem to have been dominant. The style varied, possibly depending the region, and we find some churches with partial carpet designs and others with decorated wall-plates. It seems likely that the exteriors were polychromed.

Style and the Choice between Alternatives

James Ackerman defined "style" as a distinguishable ensemble of traits in a work of art, with certain characteristics that are more or less stable (in the sense that they appear in other products of the same artist or era), and others that are flexible (in that they change according to a definable pattern).[118] The line between style and transition may, however, be challenging to draw, a problem that has concerned art historians and that is certainly an issue in the study of late Viking-age material from the North.[119] In the 1960s researchers in linguistics explored the concept of style and suggested such definitions as "the choice between alternative expressions" and "the deviations from a norm."[120] Certainly, stylistic competence, in which the signs are placed in a particular system to follow the rules of that system, presupposes visual (linguistic) competence in choosing from different patterns of expression. In the selection process, the single most appropriate mode of expression is chosen from a set of alternatives as a reflection of the stylistic competence of the maker or the patron.[121]

Very different styles appear to have coexisted in Scandinavia toward the end of the Viking Age, but in architecture the different styles never merged. If the styles at Urnes and the blooming architectural framework of Rødven are contemporary, they should perhaps be understood as reflecting disparate influences reaching different parts of the country, but they may also be seen through the lens of identity. In the runestone material, some basic designs are repeated in many versions. Gräslund suggested that the choice of similar designs might reflect a political system, a way for the person

who raised the stone to show his loyalty to the local lord who was the first to erect a stone with a specific design. The distribution of very similar runestones might therefore be an expression of social organization.[122] Like runestones, architecture is a very explicit expression of identity. Although forms of social organization differed across the North, the idea that certain decorative schemes were expressions of belonging to a particular group may be another way to explain their coexistence. Ornamenting church exteriors in the style of the earl with whom the local lord was associated would communicate these ties. Whether the possible coexistence of such different designs as Urnes and Rødven might be seen through such a lens we do not know, but it is feasible.

Interior Architectural Decoration

Little is preserved from the eleventh century to inform us about the interior architectural decoration of churches or houses. We must, however, use what we have: a series of panels from various churches in Iceland, the Swedish planks from Mosjö, and the Danish wall-plate from Hørning (Figs. 4A.1, 6, 11, 13, 15, 17). There are no preserved written accounts of what the interiors of the early churches looked like, but we do have descriptions of secular buildings. Whether the decoration of halls can tell us anything about the decoration of churches is uncertain. The famous Icelandic tenth-century scald Úlfr Uggason's poem *Húsdrápa* (House Song) describes a hall in Iceland, allegedly built in the 980s, in which the walls were adorned with narrative scenes from Norse mythology.[123] Both wall paintings and hangings are said to belong to the same building. For churches it may not have been a situation of either-or but, rather, of having both types of decoration if funds permitted.[124] To what extent figural scenes and narration were common in the North in the eleventh century is difficult to say, but quite a few examples of what appear to be codified scenes, or scenes referring to mythological figures and their stories, have survived from earlier centuries. Small plaques of gold foil (*guldgubber*) with depictions of gods, the Oseberg ship finds, some Viking-age rock carvings, as well as some of the picture stones—particularly those from Gotland—bear figural scenes.[125] Narrative iconography clearly existed outside of the sacred church space in the eleventh century, as exemplified by the Swedish Sigurd rock carvings (e.g., Sö 101) and the Norwegian Dynna stone, with the journey of the Magi and the Nativity. Although the stable depicted on the Dynna stone was inspired by local buildings, the carver clearly had an iconographic model available.[126] This makes it rather likely that a narrative iconography also existed inside the sacred space, for instance in the textiles (see Chapter 7), but whether it was common is less clear.

The exterior of the wall-plate from Hørning has already been discussed, but the interior is equally interesting (Fig. 4A.13b).[127] The main lines of the interior composition were incised before paint was added, and the conservation report lists bright reds, yellows, green, gray, brown, white, grayish-blue, and black, finished with a heavy black outline.[128] The plate features a frieze of medallions made of vine scrolls framed by horizontal bands of egg-and-dart ornament painted with double red lines on a white background.[129] The motifs inside the medallions are a three-lobed palmette, a cluster of

grapevines, and what seem to be the remains of a hand, indicating a human figure. This recalls the metal frame of the cover of the Fulda Sacramentary, dated between 1007 and 1024, as well as the borders of fols. 16v and 17r of the slightly earlier Egbert Psalter.[130] On this last folio, the motifs are what scholars often call marginalia—drolleries, fantastic creatures, masks—but the Hørning figure, although poorly preserved, appears to gesture in the manner of figures in religious iconography of the time. Motifs set within scrolls are also common in Ottonian metalwork and in other arts and architecture, and so is the frieze, whether used architecturally as a horizontal marker or in the borders of manuscript illuminations. Inhabited and ornamental vine scrolls are also found in Anglo-Saxon stone sculpture. The interior face of the Hørning wall-plate does not indicate northern origins; it might have been produced almost anywhere in the Holy Roman Empire. In fact, Hørning offers us something more than the other cases discussed in this essay: the outside is decorated with Urnes-style ornamentation, but the inside features a palmette and a cluster of grapes, symbols of regeneration often used in Christian art. In this way, the Hørning wall-plate is "bilingual," a term and a topic to which I return below.

The eight wall planks from Mosjö assumed to date from the eleventh century have crosses measuring approximately 50 cm high toward the top or the middle (Fig. 4A.15). Some span two or three planks, but one plank has two crosses, which has led scholars to conclude that they were not consecration crosses. The cross was one of the most prominent symbols of the faith, but it could also serve a more practical purpose. Later liturgical commentators such as William Durandus (*ca.*1230–96) stated that consecration crosses were painted on the walls partly to terrify demons, which would be true for all crosses whether or not they were marked with chrism.[131] The crosses of Mosjö are reminiscent of the interior decoration from Möðrufell (Fig. 4A.17). Here, the flat relief narrows toward the top of the panels and terminates in crosses, sprouting crosses, and fleurs-de-lis.[132] A similar type of fir plank with such Mammen- and Ringerike-style elements as crossing double stems is preserved from Hólar (Iceland), also in Eyjafjörður (Fig. 4A.11).[133] In these designs we see no traces of beasts, serpents, or any animals whatsoever. The decoration is ornamental, yet laden with symbolism, dominated by distinctly positive Christian symbols such as the cross and vegetal elements associated with regeneration.

The Flatatunga panels feature figural scenes and Ringerike-style ornament in a large-scale composition, an arrangement that is unique in the preserved material. Across the composition a horizontal band separates the plant ornament of the upper field from the row of robed and haloed figures standing below (Fig. 4A.5). These figures are depicted frontally, gesticulating with their hands. They are most likely saints.[134] This figural section displays a clarity in composition that is quite unlike the Urnes-style exteriors discussed above. Kristján Eldjárn, who first published the panels, pointed to Anglo-Saxon manuscript illumination as possible models for the figures, whereas Ellen Marie Magerøy related their style to Ottonian miniatures.[135] Given that the contemporary fragment from Hørning also conveys the impression of salvific themes in the church interior, the parallel may be pertinent despite the geographical distance.

The thirteen panels from Bjarnastaðahlíð also feature incised figures (Fig. 4A.1).[136] These pieces differ from all the other fragments discussed above both technically and ichnographically. They were arranged horizontally, not vertically, and several peg holes indicate that they were fastened against

a wall. The panels are devoid of ornament but instead show, among other things, the gesticulating hands, bare feet, and despairing faces of the damned, a serpentine monster that may be Leviathan devouring a man, and parts of what is presumably the head of Christ. Jónsdóttir identified the panels as sections of a Byzantine-inspired Last Judgment.[137] Unlike Flatatunga, the composition is dominated by movement and shows more naturalism.

Ágústsson made the important observation that the Bjarnastaðahlið panels did not serve as wall planks but, rather, as surfaces for decoration, providing the illusion of murals at a time when churches in stone were just being introduced in Scandinavia. Although we have nothing like the Flatatunga or the Bjarnastaðahlið panels from the mainland, there are Swedish examples from Hånger and Väversunda from the twelfth century with incised decorations.[138] The simplicity of all these examples, and the fact that paint was added after the pattern had been incised on the Hørning wall-plate, makes it very likely that they were originally polychromed.[139] The remains of painted interiors with biblical scenes from wooden churches on Gotland have been preserved at Eke, Sundre, and Dalhem, all dated to the twelfth century.[140] All three have been described as reflections of Byzantine art in Rus', but Svetlana Vasilyeva observed that no interior decoration painted on wood has survived from this period in Russia; only icons reveal how Russian artists painted on wood.[141] The technique of icon painting differs significantly from that found on the Gotlandic interior panels, however, so it is possible that these panels, like the Icelandic ones, may reflect a lost Scandinavian tradition of interior decoration.

In conclusion, the few scattered remains of preserved interior decoration either show Ringerike stylistic features or reflect Continental schools, as we see in Hørning. There is no zoomorphic loopwork. Whether what remains is truly representative of interior church decoration is unknown, but the differences between the interior and exterior architectural fragments are striking. They may be a matter of style, but they may also be due to fundamental differences in vocabulary and iconographic communication in addition to conscious stylistic choices.

The Bilingual North

Looking at both sides of the Hørning piece reveals not so much a coexistence of styles as a visual bilingualism. Bilingualism is the phenomenon in which an individual (or a group) speaks and understands two languages. In defining bilingualism, Britannica.com uses the example of English children growing up in India in the colonial period, where they would be learning languages in two distinct social settings: while being taught English in school, they learned an Indian language from their nurses and servants.[142] Visual bilingualism has been discussed in analyses of arts and art-producing groups in times of cultural change.[143] A visual language is to some extent different from a period style or even a regional style, as it is essentially a matter of appropriateness, of directing (visual) communication toward different audiences or toward audiences in different modes and states of reception. It is not merely a matter of forms and shapes but also of the motifs depicted.

Based on what little is preserved, it seems that a vernacular zoomorphic visual language lived

alongside the iconography of the Latin church in the North in the eleventh century.[144] This may reflect a visually bilingual culture that considered serpentine beasts fitting for the exterior of churches (possibly even with prophylactic properties, see Ch. 6), and paradisiacal palmettes and holy figures more suitable for the interior. From a theological perspective, such differentiation makes sense; outside and inside have different symbolic roles. In effect, at least in certain regions, we see a form of code-switching or language alternation, a shift from one visual code to another.[145]

At the end of this essay, I offer a final example. The oak core of the Lisbjerg altar (Denmark) has been dated by dendrochronology to 1135, so it was made just after the final Urnes church was built (Fig. 4.7).[146] The Lisbjerg altar is a high-status object, made in a workshop of skilled artists who created a sophisticated theological program of images and texts. Its iconographic program is organized around a central axis dominated by the Crucifixion, Christ in Majesty, the *Agnus Dei*, and the Virgin enthroned; these are flanked by figures of holy people. The borders, on the other hand, display a variety of men, beasts, and hybrids, combined with sequences of zoomorphic loopwork in the Urnes style. Kristin Bliksrud Aavitsland's work on the altar addresses its design strategies.[147] She points out that seeing the Lisbjerg altar as a clash of indigenous and imported ornamental styles is only one way of looking at it; she proposes instead to consider the juxtaposed decorative idioms as rhetorical modulations within the same visual order.[148] The primacy of the central axis and the frontality of the religious figures in an orderly architectural framework express the divine. The sacred figures are erect and frontal, and the center of the altarpiece aims for order, clarity, and symmetry. Latin text phrases are appended, sometimes with references and explanations.[149] The Urnes beasts are here the opposite of the sacred characters: they are seen from above or in profile; they curl up, twist, bend, and make no attempt to engage with someone standing in front of the altar. Rather unusually, the altar itself offers an explanation, implying that these creatures have not been enlightened by Christ. One of the texts reads, "Believe, and doubt not: My death is thy life," followed by a quote from St. Jerome's epistle 60, "Without knowledge of his creator, every man is a beast."[150] Like the examples above that indicate an opposition between inside and outside, the Lisbjerg altar too reflects this bilingualism, employing different visual languages for different purposes.

Notes

I am grateful to Gunnar Almevik, Kirk Ambrose, Leif Anker, Thomas Seip Bartholin, Niels Bonde, Axel Christophersen, Guðrún Harðardóttir, Terje Masterud Hellan, Cecilia Ljung, Karl-Magnus Melin, Griffin Murray, Nadezhda N. Tochilova, Jón Viðar Sigurðsson, Terje Thun, and Randi Wærdahl for their assistance in the process of writing this article.

1. This study does not discuss Ireland, Scotland, and England. The Urnes style in Ireland is treated in Griffin Murray's chapter in this volume (Chapter 5). In historical studies, the Viking Age has traditionally ended with the death of Haraldr harðráði in 1066, but from an art historical perspective the Urnes style is considered the last of the Viking Age stylistic groups, and the cultural shift is visible in the material from the decades around 1100. The decorated architectural remains discussed in this essay are therefore best characterized as late Viking Age. Moreover, these fragments belong to the late conversion period in Scandinavia, loosely defined as the period from c.1020 to 1150. The long time frame reflects the deep structural changes that the new religion brought about, along with the establishment of a church organization.

2. Claus Ahrens, *Die frühen Holzkirchen Europas*, 2 vols.; vol. 2 = *Katalog* (Stuttgart, 2001). Ahrens demonstrates that wooden churches were also common elsewhere in Europe.

3. John McNeill and Richard Plant, eds., *Romanesque and the Past: Retrospection in the Art and Architecture of Romanesque Europe* (Leeds, 2013).

4. John McNeill, "*Veteres statuas emit Rome*: Romanesque Attitudes to the Past," in McNeill and Plant, *Romanesque and the Past*, 1–24; and Arnold Esch, "Spolien: Zur Wiederverwendung antiker Baustücke und Skulpturen im Mittelalterlichen Italien," *Archiv für Kulturgeschichte* 51.1 (1969): 1–64.

5. David Stocker and Paul Everson, "Rubbish Recycled: A Study of the Re-Use of Stone in Lincolnshire," in *Stone: Quarrying and Building in England, AD 43–1525*, ed. David Parsons (Chichester, 1990), 83–101.

6. Martin Blindheim, *Graffiti in Norwegian Stave Churches, c.1150–c.1350* (Oslo, 1985), 37, 56–59, plates XLI–XLII; and Knud J. Krogh, *Urnesstilens kirke: Forgængeren for den nuværende kirke på Urnes* (Oslo, 2011), 210.

7. For Theodore of Canterbury, see John T. McNeill and Helena M. Gamer, *Medieval Handbooks of Penance: A Translation of the Principal "Libri poenitentiales" and Selections from Related Documents* (New York, 1938), 199. From medieval Norway, the same perception is expressed in Archbishop Eilífr's tenth paragraph concerning textiles. See Ingrid Lunnan Nødseth, "Clothing the Sacred: Ecclesiastical Textiles from Late Medieval Scandinavia" (PhD diss., Norwegian University of Science and Technology, 2020), 120–21.

8. Jan Assmann, "Communicative and Cultural Memory," in *Cultural Memory Studies: An International and Interdisciplinary Handbook*, ed. Astrid Erll and Ansgar Nünning (Berlin, 2008), 109–18, at 111.

9. A. Petersén, I. Sæhle, P. N. Wood, and K. Brink, "Arkeologiske undersøkelser i Søndre gate 7–11, Peter Egges Plass, Krambugata 2–4 m.fl., Trondheim, Trøndelag (TA 2016/21, TA 2017/03)," Del 1, *Landskapsutvikling, tidlig urban aktivitet og middelaldersk kirkested*, NIKU Rapport 90/2019 (Trondheim, 2020); and Anna Petersén, "Klemenskirke, Kongekirke, Olavskult, symbolikk og skjulte budskap," *SPOR: Arkeologi og Kulturhistorie* 1 (2020): 18–24.

10. McNeill, "*Veteres stautas emit Rome*," 3.

11. Signe Horn Fuglesang, "Stylistic Groups in Late Viking and Early Romanesque Art," *Acta ad archaeologiam et artium historiam pertinentia* 8.1 (1981): 79–125, at 80–81.

12. Signe Horn Fuglesang, "The Axehead from Mammen and the Mammen Style," in *Mammen: Grav, kunst og samfund i vikingetid*, ed. Mette Iversen (Højbjerg, 1991), 83–107.

13. On the development of the Urnes style, see Signe Horn Fuglesang, "Swedish Runestones of the Eleventh Century: Ornament and Dating," in *Runeninschriften als Quellen interdisziplinärer Forschung: Abhandlungen des Vierten Internationalen Symposiums über Runen und Runeninschriften in Göttingen vom 4.–9. August 1995*, ed. Klaus Düwel (Berlin, 1998), 197–218.

14. Griffin Murray, *The Cross of Cong: A Masterpiece of Medieval Irish Art* (Dublin, 2014), 79, 167–68; Griffin Murray, "The Art of Politics: The Cross of Cong and the Hiberno-Urnes Style," in *The Vikings in Ireland and Beyond: Before and after the Battle of Clontarf*, ed. Howard B. Clarke and Ruth Johnson (Dublin, 2015), 416–37; and Signe Horn Fuglesang, "Animal Ornament: The Late Viking Period," in *Tiere, Menschen, Götter: Wikingerzeitliche Kunststile und ihre neuzeitliche Rezeption: Referate gehalten auf einem von der Deutschen Forschungsgemeinschaft geförderten Internationalen Kolloquium der Joachim Jungius-Gesellschaft der Wissenschaften, Hamburg*, ed. Michael Müller-Wille and Lars Olof Larsson (Göttingen, 2001), 157–94, at 175n32.

15. Fuglesang, "Stylistic Groups," 91.

16. Elisabeth Farnes, "Some Aspects of the Relationship between Late 11th and 12th Century Irish Art and the Scandinavian Urnes Style" (MA thesis, University College Dublin, 1975), 1:32.

17. James Graham-Campbell, *Viking Art* (London, 2013), 146, 204–6; and Fuglesang, "Animal Ornament," 175–77, 180.

18. Fuglesang, "Stylistic Groups"; and Nadezhda N. Tochilova, "Transition Style in Scandinavian Art, Late 11th–First Half of 12th Century," in *Migrations in Visual Art*, ed. Jelena Erdeljan et al. (Belgrade, 2018), 151–63.

19. Ingunn Marit Røstad, "En fremmed fugl: 'Danske' smykker og forbindelser på Østlanden I overgangen mellom vikingtid og middelalter," *Viking* 75 (2012): 181–210, at 193.

20. Olwyn Owen, "The Strange Beast That Is the English Urnes Style," in *Vikings and the Danelaw: Select Papers from the Proceedings of the Thirteenth Viking Congress, Nottingham and York, 21–30 August 1997*, ed. James Graham-Campbell et al. (Oxford, 2001), 203–22, at 205–6; and Murray, *Cross of Cong*. The flowering of the Urnes style in Ireland is discussed in Chapter 5.

21. Iben Skibsted Klæsøe, "Hvordan de blev til: Vikingetidens stilgrupper fra Broa til Urnes," *Hikuin* 29 (2002): 75–104.

22. Signe Horn Fuglesang, *Some Aspects of the Ringerike Style: A Phase of Eleventh Century Scandinavian Art* (Odense, 1980), 26–28; See also Wilhelm Holmqvist, "Viking Art in the Eleventh Century," *Acta Archaeologica* 22 (1951): 1–56; Ole Henrik Moe, "Urnes and the British Isles: A Study of Western Impulses in Nordic Styles of the 11th Century," *Acta Archaeologica* 26 (1955): 1–30, at 20, 24–26.

23 Fuglesang, *Some Aspects of the Ringerike Style*, 19.

24 Fuglesang, "Animal Ornament." For Continental and Anglo-Saxon influences on the Ringerike style and the importance of manuscript illumination and certain scriptoria, see Fuglesang, *Some Aspects of the Ringerike Style*.

25 Signe Horn Fuglesang, "Art," in *From Viking to Crusader: The Scandinavians and Europe, 800–1200*, ed. Else Roesdahl and David M. Wilson (Copenhagen, 1992), 176–83; and David M. Wilson, *Vikingatidens konst*, trans. Henrika Ringbom (Lund, 1995).

26 Wilson, *Vikingatidens konst*, 188.

27 Anne-Sofie Gräslund and Linn Lager, "Runestones and the Christian Missions," in *The Viking World*, ed. Stefan Brink with Neil Price (Abingdon, UK, 2008), 629–38; and Anne-Sofie Gräslund, "Runensteine," in *Reallexikon der germanischen Altertumskunde*, 2nd ed., ed. Heinrich Beck, Dieter Geuenich, and Heiko Steuer (Berlin, 2003), 25:585–91.

28 Linn Lager, "Art as a Medium in Defining 'Us' and 'Them': The Ornamentation on Runestones in Relation to the Question of 'Europeanisation,'" in *The European Frontier: Clashes and Compromises in the Middle Ages; International Symposium of the Culture Clash or Compromise (CCC) Project and the Department of Archaeology, Lund University, Held in Lund October 13–15 2000*, ed. Jörn Staecker (Lund, 2004), 147–55.

29 Gräslund and Lager, "Runestones and the Christian Missions," 637.

30 Lager, "Art as a Medium in Defining 'Us' and 'Them,'" 147.

31 Røstad, "En fremmed fugl"; and Fuglesang, "Animal Ornament," 175.

32 Fuglesang, "Animal Ornament," 186.

33 Gräslund has written a number of articles on this topic since the 1990s. I will use the dates put forward in Anne-Sofie Gräslund, "Dating the Swedish Viking-Age Rune Stones on Stylistic Grounds," in *Runes and Their Secrets: Studies in Runology*, ed. Marie Stoklund et al. (Copenhagen, 2006), 117–39. See also Anne-Sofie Gräslund, "The Late Viking Age Runestones of Västergötland: On Ornamentation and Chronology," *Lund Archaeological Review* 20 (2014): 39–53.

34 A union knot is a type of knot typical in late Viking-age art; see, e.g., Fuglesang, *Some Aspects of the Ringerike Style*, 100–101.

35 Gräslund, "Dating the Swedish Viking-Age Rune Stones," 126.

36 For references to the debate on Ringerike and Urnes styles, see Cecilia Ljung, "Under runristad häll: Tidigkristna gravmonument i 1000-talets Sverige," *Stockholm Studies in Archaeology* 67.1–2 (2016): 1:32–33; Klæsøe, "Hvordan de blev til?".

37 Gräslund, "Dating the Swedish Viking-Age Rune Stones".

38 Fuglesang, "Swedish Runestones of the Eleventh Century"; and Gräslund, "Dating the Swedish Viking-Age Runestones," 126–28; and Ljung, *Under runristad häll*, 1:32–35.

39 The beginning of the Urnes style had previously been placed in the second quarter of the eleventh century, but Fuglesang argued that these so-called "Ingvaldr stones" were a prerequisite for the development of the Urnes style; she dismissed the earlier hypothesis that Ingvaldr was the man with that name later mentioned in the Icelandic sources. Fuglesang listed the runestone masters Ulf and Alli as pre-Urnes masters; Ásmund as the beginning of the Urnes style, in the Swedish Uppland region from the 1020s on; the masters Balli and Fot in the mid-eleventh century; and Öpir toward 1100. Wilson claims that the Ingvladr stones should be dated c.1041–50. On this debate, see Gräslund, "Dating the Swedish Viking-Age Rune Stones,"126–28; Ljung, *Under runristad häll*, 1:32–35; Gräslund and Lager, "Runestones and the Christian Missions"; Gräslund, "Runensteine"; Fuglesang, "Swedish Runestones of the Eleventh Century," 205; Fuglesang, "Animal Ornament," 175–80; and David M. Wilson, "The Development of Viking Art," in Brink and Price, *Viking World*, 323–40, at 335–36.

40 Wilson, *Vikingatidens konst*, 207.

41 The Urnes brooch from Lindholm Høje in Denmark was found together with a coin dated between 1039 and 1046. Lise G. Bertelsen, "Urnesfibler i Danmark," *Aarbøger for nordisk oldkyndighed og historie*, 1992 (1994): 345–70; Wilson, "Development of Viking Art," 336; and Røstad, "En fremmed fugl," 194.

42 Wilson, *Vikingatidens konst*, 182.

43 Aase Folkvord, "Dekorerte tresaker fra folkebibliotekstomta i Trondheim: Beskrivelse, analyse og vurdering." 2 vols. (MA thesis, Art History, University of Oslo, 2007); https://www.duo.uio.no/handle/10852/24681.

44 For an overview of the dendrochronological examinations of the standing stave churches, see Terje Thun et al., "Dendrochronology Brings New Life to the Stave Churches: Dating and Material Analysis," in *Preserving the Stave Churches: Craftsmanship and Research*, ed. Kristin Bakken, trans. Ingrid Greenhow and Glenn Ostling (Oslo, 2016), 91–116; 91–97 for the methodology.

45 Ibid.

46 Ibid., 96.

47 Mads Chr. Christensen, "Painted Wood from the Eleventh Century: Examination of the Hørning Plank," in *Medieval Painting in Northern Europe: Techniques, Analysis, Art History; Studies in Commemoration of the 70th Birthday of Unn Plahter*, ed. Jilleen Nadolny (London, 2006), 34–42, at 35; and Karola Kröll, "Eine wikingerzeitliche Stabkirche in Südjütland? Studien zu einem verzierten Eichenbalken aus Humptrup, Kreis Nordfriesland," *Offa* 56 (1999): 421–79, at 438–39. The earlier conservation of the Humptrup fragments caused substantial damage, making neither dendrochronology nor carbon-14 dating possible.

48 Marian Ullén, *Medeltida träkyrkor I* (Stockholm, 1983); Erland Lagerlöf, *Medeltida träkyrkor II* (Stockholm, 1985); Marian Ullén, "Bygga i trä," in *Den romanska konsten*, ed. Lennart Karlsson et al. (Lund, 1995), 35–52; Ahrens, *Die frühen Holzkirchen Europas*, vol. 2, *Katalog*; and Marian Ullén, "Medeltidens kyrkor," in *Småland: Landskapets kyrkor*, ed. Marian Ullén (Stockholm, 2006), 41–98.

49 Ullén, *Småland*, 63.

50 Niels Bonde, "Vrigstad Kyrka, Småland, Sverige," NNU rapportblad 1997, j.nr. A7875, Dendro tsb 4" (Nationalmuseet, Copenhagen); https://natmus.dk/fileadmin/user_upload/Editor/natmus/nnu/Dendro/1997/A7875delrap.pdf.

51. Gunnar Almevik and Jonathan Westin, "Hemse Stave Church Revisited," *Lund Archaeological Review* 23 (2017): 7–25. See also n. 68.
52. Ann Catherine Bonnier, "Medeltidens kyrkor," in *Östergötland: Landskapets kyrkor*, ed. Ingrid Sjöström and Marian Ullén (Stockholm, 2004), 32–62, at 40.
53. Ibid.
54. Almevik and Westin, "Hemse Stave Church Revisited."
55. Thun et al., "Dendrochronology Brings New Life."
56. On so-called Urnes Romanesque as a local vernacular of Romanesque in Scandinavia in the first half of the twelfth century, see Fuglesang, "Stylistic Groups."
57. Bonnier, "Medeltidens kyrkor," 40. For illustrations, see Lennart Karlsson, *Romansk träornamentik i Sverige = Decorative Romanesque Woodcarving in Sweden* (Stockholm, 1976), figs. 149–50.
58. Elias Wessén and Sven B. F. Jansson, eds., *Sveriges runinskrifter*, vol. 8, *Upplands runinskrifter* (Stockholm, 1949–51), 193–95; and Graham-Campbell, *Viking Art*, 146.
59. Nadezdha N. Tochilova and Anna Slapinia, "From Wawel Hill to Volkhov River Bank: To the Question of the Presumptive Influence of the Pre-Romanesque Polish Architecture to the Decoration of So-Called 'Columns of Oak Sophia from Novgorod,'" *Quaestiones Medii Aevi Novae* 23 (2018): 405–26.
60. Erla Bergendahl Hohler, "Two Wooden Posts Found in Novgorod: A Note on Their Date and Stylistic Connection," *Collegium Medievale* 16 (2003): 37–50; and Tochilova and Slapinia, "From Wawel Hill to Volkhov River Bank."
61. Tochilova and Slapinia, "From Wawel Hill to Volkhov River Bank," 422.
62. Hohler, "Two Wooden Posts Found in Novgorod."
63. Martin Blindheim, *Norwegian Romanesque Decorative Sculpture, 1090–1210* (London, 1965), 43 and fig. 161.
64. Signe Horn Fuglesang and Gerd Stamsø Munch, "Den dekorerte planken fra Haug i Hadsel," *Årbok: Foreningen til norske fortidsminnesmerkers bevaring* 145 (1991): 245–52.
65. Ibid., 247.
66. Ibid., 245–52.
67. Ahrens, *Die frühen Holzkirchen Europas*, 2:223.
68. Unpublished report by Thomas S. Bartholin. The samples from Eke have the numbers 12475–94. I am grateful to Gunnar Almevik for providing me with this report.
69. NTNU, Vitenskpasmuseet, Trondheim, nos. T 91695 and T30000. See Folkvord, "Dekorerte tresaker fra folkebibliotekstomta."
70. This was also the parallel intended by Lennart Karlsson when he placed these images together in *Nordisk form: Om djurornamentik* (Stockholm, 1976), 76.
71. Kröll, "Eine wikingerzeitliche Stabkirche in Südjütland?"
72. Karlsson, *Romansk träornamentik i Sverige*, 68–69, 82, 163–64; and Ljung, *Under runristad häll*, 1:116, 123.
73. Ljung, *Under runristad häll*, 1:116' quote at 123.
74. Ibid., 1:116.
75. Ibid., 1:117–23, at 123.
76. Ibid., 1:123–24.
77. Erla Bergendahl Hohler, *Norwegian Stave Church Sculpture*, 2 vols. (Oslo, 1999), 2:29–38.
78. Blindheim, *Norwegian Romanesque Decorative Sculpture*, 33.
79. Rouen, Bibliothèque municipal, MS 274 (Y.6). J. O. Westwood, *Facsimiles of the Miniatures and Ornaments of Anglo-Saxon and Irish Manuscripts* (London, 1868); H. A. Wilson, ed., *The Missal of Robert of Jumièges* (London, 1896); Peter J. Lucas and Angela M. Lucas, *Anglo-Saxon Manuscripts in Microfiche Facsimile*, vol. 18, *Manuscripts in France* (Binghamton, NY, 2012), 117–25; and Brandon W. Hawk, *Preaching Apocrypha in Anglo-Saxon England* (Toronto, 2018), 144–45. The manuscript was possibly made at Christchurch, Canterbury, or somewhere in southern England.
80. London, British Library, Add. MS 49598, fol. 45v; http://www.bl.uk/manuscripts/FullDisplay.aspx?ref=Add_MS_49598.
81. David M. Wilson and Ole Klindt-Jensen, *Viking Art* (London, 1966), 148; and Hohler, *Norwegian Stave Church Sculpture*, 1:114, 2:11.
82. Roar Hauglid, *Norske stavkirker: Dekor og utstyr* (Oslo, 1973), 24–26; and Hohler, *Norwegian Stave Church Sculpture*, 1:114.
83. Rolf Mowinckel entertained the idea of several parallel developments: Mowinckel, "De eldste norske stavkirker," *Universitetets Oldsakssamlings skrifter* 2 (1929): 383–424.
84. Vitenskapsmuseet, NTNU, Trondheim, T16383:1. Grethe Authén Blom, *Trondheims bys historie* (Trondheim, 1957), 62; and Hauglid, *Norske stavkirker: Dekor og utstyr*, 70–71. I am grateful to Axel Christophersen of NTNU Vitenskapsmuseet for providing this information. His observations are based on the find context of the fragment.
85. Ullén, *Småland*, 63; and Karlsson, *Romansk träornamentik i Sverige*, 140, 150, and figs. 88, 187.
86. Lagerlöf, *Medeltida träkyrkor* 2:233–37, at 233. Lagerlöf refers to Sune Zachrison's excavation in 1963.
87. Ibid., 260; and Ahrens, *Die frühen holzkirchen Europas*, 1:369, 2:251–52.
88. Ellen Marie Magerøy, "Tilene fra Mödrufell i Eyjafjord," *Viking* 17 (1953): 43–62, at 59–60; and Fuglesang, *Some Aspects of the Ringerike Style*, 27, 69.
89. Guðrún Harðardóttir, "A View on the Preservation History of the Last Judgement Panels from Bjarnastaðahlið, and Some Speculation on the Medieval Cathedrals at Hólar," in *The Nordic Apocalypse: Approaches to "Vǫluspá" and Nordic Days of Judgement*, ed. Terry Gunnell and Annette Lassen (Turnhout, 2013), 205–20.
90. Kristján Eldjárn, "Carved Panels from Flatatunga, Iceland," *Acta Archaeologica* 24 (1953): 81–101.
91. Selma Jónsdóttir, *An 11th Century Byzantine Last Judgement in Iceland* (Reykjavík, 1959); Fuglesang, *Some Aspects of the Ringerike Style*, 197; and Signe Horn Fuglesang, "Vikingtidens kunst," in *Norges Kunsthistorie*, vol. 1, *Fra Oseberg til Borgund*, ed. Hans-Emil Lidén et al. (Oslo, 1981), 36–138, at 95.
92. Ellen Marie Magerøy and Håkon Christie, "Dómsdagur og helgir menn á Hólum: Bokanmeldelse," *Årbok: Foreningen til norske fortidsminnesmerkers bevaring* 144 (1990): 227–32, at 229.

93 Hörður Ágústsson, *Dómsdagur og helgir menn á Hólum* (Reykjavík, 1989).

94 Magerøy and Christie, "Dómsdagur og helgir menn á Hólum."

95 Karen Þóra Sigurkarlsdóttir, "Varðveislusaga Bjarnastaðahlíðarfjala á Þjóðminjasafní Íslands" in *Á efsta degi: Bysönsk dómsdagsmynd frá Hólum*, ed. Bryndís Sverrisdóttir (Reykjavík, 2007), 41–47, at 45.

96 The saga states that Jón bought the wood for his stave church cathedral in Norway. Harðardóttir, "View on the Preservation History," 205–6.

97 Jónsdóttir, *An 11th Century Byzantine Last Judgement*; and Harðardóttir, "View on the Preservation History," 210.

98 Harðardóttir, "View on the Preservation History," 9–10, n14.

99 Hohler, *Norwegian Stave Church Sculpture*, 1:206, 2:256; and Krogh, *Urnesstilens kirke*, 204–5.

100 Krogh, *Urnesstilens kirke*, 204–5; and Hohler, *Norwegian Stave Church Sculpture*, 1:206.

101 Fuglesang and Munch, "Den dekorerte planken fra Haug i Hadsel," 247–48.

102 Ullén, *Medeltida träkyrkor*, 245.

103 Hohler, *Norwegian Stave Church Sculpture*, 2:33n34. Her use of the term "Roman vernacular" is borrowed from Eric Fernie's work on Anglo-Saxon architecture and its heritage from the Roman world.

104 Graham-Campbell, *Viking Art*, 44–45.

105 For the reconstruction of the top section of the Urnes portal on which Hohler and others based their discussion, see Hohler, *Norwegian Stave Church Sculpture*, 2:59.

106 Ibid., 1:37–38, 236; 2:10; Blindheim, *Norwegian Romanesque Decorative Sculpture*, 41–45; and Martin Blindheim, "The Romanesque Dragon Doorways of the Norwegian Stave Churches: Traditions and Influences," *Acta ad archaeologiam et artium historiam pertinentia* 2 (1965): 177–93.

107 Moe, "Urnes and the British Isles"; and Hohler, *Norwegian Stave Church Sculpture*, 1:37–38, 2:59 and cat. no. 222.

108 Moe, "Urnes and the British Isles"; Hohler, *Norwegian Stave Church Sculpture*, 1: 222; Hauglid, *Norske stavkirker: Dekor og utstyr*, 46–47, 98–99; and Blindheim, *Norwegian Romanesque Decorative Sculpture*, 45.

109 Ahrens, *Die frühen holzkirchen Europas*, 2:223.

110 Brågarp has also been presumed to be an early version of the Sogn-Valdres design. See Hohler, *Norwegian Stave Church Sculpture*, 2:5; and Karlsson, *Romansk träornamentik i Sverige*, 20.

111 Elna Møller and Olaf Olsen, "Danske trækirker," *Nationalmuseets Arbejdsmark*, 1961, 35–58, at 57; Fuglesang, *Some Aspects of the Ringerike Style*, 23; and Blindheim, *Norwegian Romanesque Decorative Sculpture*, 44.

112 Christensen, "Painted Wood from the Eleventh Century," 9.

113 Ahrens (*Die frühen holzkirchen Europas*, 1:510) notes that the background of the door leaf at Urnes is colored "blackish-violet," whereas the details are in plain wood. I have not been able to see this and have not found any other sources that make this observation.

114 Wilson, *Vikingatidens konst*, 186.

115 The stone from Gerstaberg in Södermanland(S) (Sö 347) asks God and God's mother to have mercy on the soul of of Frœkn and Bjórsteinn and lists those who raised the stone, Ásbjörn who carved (*risti*) the runes, and Ulfr, who painted(*stæindi*) it. Erik Brate, *Södermanlands runinskrifter* (Stockholm, 1924), 303–54.

116 As seen on a twisted roll ornament from Hånger and a number of split wood wall planks from Lisbjerg with chalk foundation and remains of colored paint. Ullén, *Småland*, 47; and Ahrens, *Die frühen holzkirchen Europas*, 1:509–11, 2:204.

117 Ahrens, *Die frühen holzkirchen Europas*, 1:510, 2:243.

118 James S. Ackerman, "Style," in *Art and Archaeology*, ed. James S. Ackerman and Rhys Carpenter (Englewood Cliffs, NJ, 1963), 164–86, at 164. For a critical discussion of the role of style in art historical studies, see Jás Elsner, "Style," in *Critical Terms for Art History*, ed. Robert S. Nelson and Richard Shiff, 2nd ed. (Chicago, 2003), 98–109.

119 Willibald Sauerländer, "Style or Transition? The Fallacies of Classification Discussed in the Light of German Architecture 1190–1260," *Architectural History* 30 (1987): 1–29.

120 Inger Rosengren, "Style as Choice and Deviation," *Style* 6.1 (1972): 3–18.

121 Ibid., 3, 12; and Margaret W. Conkey, "Experimenting with Style in Archaeology: Some Historical and Theoretical Issues," in *The Uses of Style in Archaeology*, ed. Margaret W. Conkey and Christine A. Hastorf (Cambridge, 1993), 5–17. For a Scandinavian perspective, see Lena Liepe, "Om stil och betydelse i romansk stenskulptur," *2. Skandinaviske symposium om romanske stenarbejder: 1999 i Silkeborg*, ed. Jens Vellev (Højbjerg, 2003), 161–76.

122 Anne-Sofie Gräslund, "Similarities or Differences? Rune Stones as a Starting Point for Some Reflections on Viking Age Identity" in *Viking Settlements & Viking Society: Papers from the Proceedings of the Sixteenth Viking Congress, Reykjavík and Reykholt, 16th–23rd August 2009*, ed. Svavar Sigmundsson (Reykjavík, 2009), 147–61, at 149; and Gräslund, "Late Viking Age Runestones of Västergötland."

123 Hauglid, *Norske stavkirker: Dekor og utstyr*, 19; and *Laxdæla saga 29*, trans. Muriel A. C. Press (Project Gutenberg e-book, 2006); http://www.gutenberg.org/files/17803/17803-h/17803-h.htm#Chap_XXIX. The source, which dates to the thirteenth century, is supposedly giving an account of the tenth century.

124 See the chapter by Ingrid Lunnan Nødseth in this volume.

125 Graham-Campbell, *Viking Art*, 37–47, 159–84.

126 The Dynna stone is in The Museum of Cultural History, Oslo. Magnus Olsen, *Norges innskrifter med de yngre runer*, vol. 1, *Østfold fylke, Akershus fylke og Oslo, Hedmark fylke, Opland fylke* (Oslo, 1941), 191–202; Dag Strömbäck, "The Epiphany in Runic Art: The Dynna and Sika Stones," *The Dorothea Coke Memorial Lecture in Northern Studies delivered at University College London 22 May 1969* (London, 1970), 1–19; and Claiborne W. Thompson, "Review of Dag Strömbäck, *The Epiphany in Runic Art: The Dynna and Sika Stones*," *Scandinavian Studies* 44.1 (1972): 130–31.

127 Christensen, "Painted Wood from the Eleventh Century," 35; and Else Roesdahl, "Dendrochronology and Viking Studies in Denmark, with a Note on the Beginning of the Viking Age," in *Developments around the Baltic and the North*

Sea in the Viking Age: Twelfth Viking Congress, ed. Björn Ambrosiani and Helen Clarke (Stockholm, 1994), 106–16.

128 Christensen, "Painted Wood from the Eleventh Century," 39, and Line Bregnhøi and Mads Chr. Christensen, "Sagnlandet Lejre: Vikingetidens farvepalet," Nationalmuseet, Bevaring & Naturvitenskab, 1–8; https://natmus.dk/fileadmin/user_upload/Editor/natmus/historisk-viden/Viking/Vikingernes_farvepalet/Vikingetidens_farvepalet_Rapport.pdf.

129 Mads Chr. Christensen points out that a very similar motif has been found in the Carolingian abbey of Corvey, in Rhine-Westphalia. Christensen, "Painted Wood from the Eleventh Century," 38, 42n14.

130 On the Egbert Psalter, see: Josef Kirmeier et al., eds., Kaiser Heinrich II: 1002–1024 (Augsburg, 2002), 341, cat. no. 172. The Egbert Psalter is Cividale del Friuli, Museo archeologico nazionale, MS 136.

131 William Durandus, Guillelmi Duranti: Rationale divinorum officiorum I–IV, ed. A. Davril and T. M. Thibodeau, CCCM 140 (Turnhout, 1995), I.iv.27, p. 69.

132 Fuglesang, Some Aspects of the Ringerike Style, 27, 69, 196–97; and Magerøy, "Tilene fra Mödrufell i Eyjafjord."

133 Kristján Eldjárn, "Forn útskurður frá Hólum í Eyjafirði," Àrbók hins Íslenzka Fornleifafélag 64 (1967): 5–24; Fuglesang, Some Aspects of the Ringerike Style, 197; and Ágústsson, Dómsdagur og helgir menn á Hólum.

134 Ágústsson, Dómsdagur og helgir menn á Hólum; and Þóra Kristjánsdóttir, "Islandsk kirkekunst," in Kirkja ok Kirkjuskrud: Kirker og Kirkekunst på Island og i Norge i middelalderen, ed. Lilja Árnadóttir and Ketil Kiran (Oslo, 1997), 53–60.

135 Ellen Marie Magerøy, "Flatatunga Problems," Acta Archaeologica 32 (1961): 153–72.

136 Kristjánsdóttir, "Islandsk kirkekunst"; and Ágústsson, Dómsdagur og helgir menn á Hólum.

137 Jónsdóttir, An 11th Century Byzantine Last Judgement; Ágústsson, Dómsdagur og helgir menn á Hólu; Þóra Kristjánsdóttir, "A Nocturnal Wake at Hólar: The Judgement Day Panels as Possible Explanation for a Miracle Legend?," in Gunnell and Lassen Nordic Apocalypse, 221–31.

138 Karlsson, Romansk träornamentik i Sverige, 67, figs. 163–65, 222; Emil Ekhoff, Svenska stavkyrkor: Jämte iakttagelser över de norska samt redogörelse för i Danmark och England kända lämningar av stavkonstruktioner (Stockholm, 1914–16), 143–45; Ahrens, Die frühen holzkirchen Europas, 1:241–42, 2:234; and Bonnier, "Medeltidens kyrkor," 40.

139 Signe Horn Fuglesang, "Vikingtidens ristninger: Dekorasjonsteknikk, skisse og tidtrøyte," in Ristninger i forhistorie og middelalder: Det norske Arkeologmøtet Symposium, Voksenåsen, Oslo 1979, ed. Diana Stensdal Hjelvik and Egil Mikkelsen (Oslo, 1980), 19–36.

140 Eke, Sundre, and Dalhem (fragments in Gotlands fornsal). Ahrens, Die frühen holzkirchen Europas, 1:246, 2: 221, 264. Erland Lagerlöf, "De bysantinska målningarna från Sundre kyrka," in Gotlandia irredenta: Festschrift für Gunnar Svahnström zu seinem 75. Geburtstag, ed. Robert Bohn (Sigmaringen, 1990), 143–51.

141 Svetlana Vasilyeva, "Bysantinska traditioner i Gotlands konst under 1100-talet," Fornvännen 104.2 (2009): 97–111.

142 "Bilingualism," Britannica.com.

143 For instance, in analyses of the funerary art of Ptolemaic Alexandria ("bilingual style," "visual bilingualism") or the colonial Spanish Americas, albeit sometimes in a broader sense than applied here. See Marjorie Susan Venit, "Theatrical Fiction and Visual Bilingualism in the Monumental Tombs of Ptolemaic Alexandria," in Alexandria: A Cultural and Religious Melting Pot, ed. George Hinge and Jens A. Krasilnikoff (Aarhus, 2009), 42–65; Heather Graham and Lauren G. Kilroy-Ewbank, "Introduction: Visualizing Sensuous Suffering and Affective Pain in Early Modern Europe and the Spanish Americas," in Visualizing Sensuous Suffering and Affective Pain in Early Modern Europe and the Spanish Americas, ed. Heather Graham and Lauren G. Kilroy-Ewbank (Leiden, 2018), 1–34.

144 Gräslund and Lager, "Runestones and the Christian Missions"; and Gräslund, "Runensteinene."

145 Britannica.com defines code-switching as "The process of shifting from one linguistic code (a language or a dialect) to another depending on the social context or conversational setting."

146 Kristin B. Aavitsland, "Ornament and Iconography: Visual Orders in the Golden Altar from Lisbjerg, Denmark," in Ornament and Order: Essays on Viking and Northern Medieval Art for Signe Horn Fuglesang, ed. Margrethe C. Stang and Kristin B. Aavitsland (Trondheim, 2008), 57–97.

147 Ibid.

148 Ibid., 87–88.

149 Ibid., 86.

150 Ibid., 85.

CHAPTER 4A

Appendix: Alphabetical List of Fragments from Eleventh-Century Decorated Buildings in the North

Margrete Syrstad Andås

Bjarnastaðahlíð, Iceland (Fig. 4A.1)

Reykjavík Þjóðminjasafn Íslands (National Museum of Iceland), inv. nos. 8891a–m

Description
The thirteen pieces derive from nine incised panels, and all are in a fragmentary state. Their size varies from 39 to 172 cm long, 13 to 28 cm wide.[1] The panels are fir and were presumably poly-chromed. Hörður Ágústsson observed that the panels were much too thin to have served as walls; rather, they would have been surfaces for decoration, likely providing the illusion of murals.[2] They were arranged horizontally, not vertically as in the other Icelandic examples, and several peg holes show that they were fastened against something, such as a wall or roof.

Ágústsson's suggested reconstruction of the Bjarnastaðahlíð scene measures 280 × 724 cm.[3] The panels are arranged in rectangular picture fields divided by undecorated bands. The narrow horizontal planes are sometimes so short that the human figures are shown only from head to waist.[4] When the motifs are examined, it is clear that most of the arrangement is missing. All the scenes are figural, without ornamentation. The preserved panels from the lower section of the reconstruction show naked figures and disembodied heads (skulls); above this, a large frontal head is flanked by a smaller figure to the right and a series of figures to the left, all gesticulating toward the large figure. One panel depicts the body of a crooked serpent with a man hanging from his jaws, while the head of a serpentine animal on another panel chases people. Another plank shows the snout of an animal, a section of an arch, and a raised arm.

The composition is dominated by movement and agitation, and Selma Jónsdóttir identified the lower registers as the torments of hell and the composition as a Last Judgment scene inspired by Byzantine models, a theory that has not been disputed.[5] She notes the bare feet and despairing faces

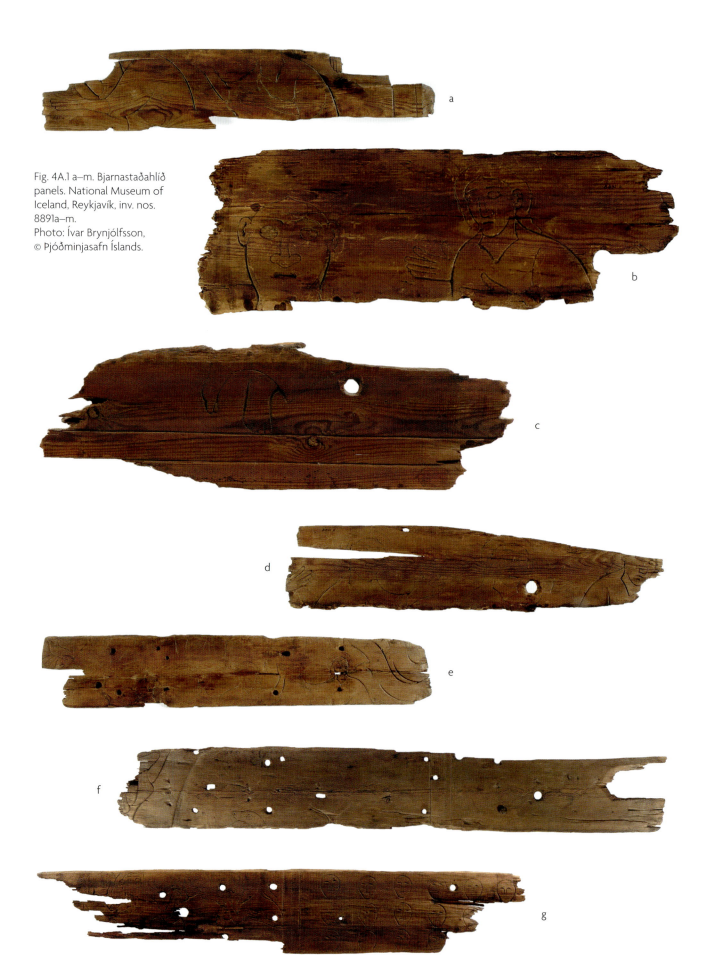

Fig. 4A.1 a–m. Bjarnastaðahlíð panels. National Museum of Iceland, Reykjavík, inv. nos. 8891a–m.
Photo: Ívar Brynjólfsson, © Þjóðminjasafn Íslands.

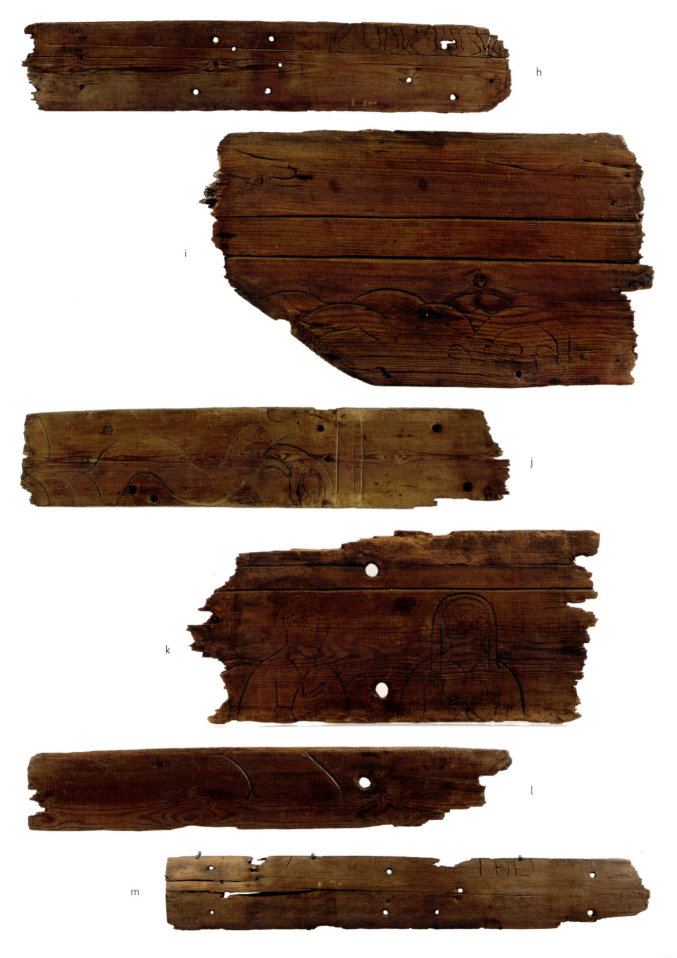

of the damned, a serpentine monster, and parts of what is presumably the head of Christ.[6] Jónsdóttir suggested the mosaic in the Torcello (Italy) Cathedral as a possible parallel. The oldest phases of the much-restored Torcello mosaic are generally thought to date to the eleventh century. It has the same floating, disembodied heads as Bjarnastaðahlið, as well as the scenes arranged in framed panels. Jónsdóttir also pointed to details like the pose of the feet and hands.

Date
Based on style, Jónsdóttir dated the panels to the last quarter of the eleventh century, whereas Ágústsson placed them in the second decade of the twelfth century because he believed that they belong to the first cathedral (see below), given the supposed size of the arrangement.[7] Preliminary radiocarbon analyses published in 2007 suggest that the date for one of the Bjarnastaðahlið panels is between 930 and 1065.[8]

Provenance
The preservation history of the Bjarnastaðahlið panels was discussed by Guðrún Harðardóttir.[9] The panels were discovered in 1952,[10] and according to oral tradition they came to Flatatunga (see below) from Bjarnastaðahlið.[11] Jónsdóttir referred to scholars who visited Flatatunga in the nineteenth century and described the great Flatatunga hall as having images that may have been parts of a judgment scene. Kristján Eldjárn, however, pointed to the scale of the program and asserted that they must have come from a church.[12] Given that both the Flatatunga and Bjarnastaðahlið panels show traces of multiple reuse, it has been suggested that all the materials came from the post-Reformation cathedral at Hólar demolished in 1759.[13] Hólar is in the same region, and its first cathedral was built in conjunction with the establishment of the episcopal see in 1106. Ágústsson argued that the Bjarnastaðahlið panels must have come from the cathedral's interior west wall and should be dated *c.*1120.[14] Given the radiocarbon date of Bjarnastaðahlið, however, Harðardóttir has suggested that the panels were ready-mades reused in the new cathedral built for Jón Ögmundsson, the first bishop of Hólar, perhaps received as a gift.[15] The wood for Jón's new cathedral, which was a large stave church, was bought in Norway.[16] An earlier church existed at Hólar prior to the building of the cathedral, and this is described in *Bishop Jón's saga* as richly adorned and the largest in the country.[17] This is thought to have been built in the mid–eleventh century, but according to the saga it was destroyed by fire, so it has not figured in discussions about the origins of the Flatatunga panels.

Bjølstad, Norway (Fig. 4A.2)

Now in Bjølstad chapel

Description
Two surviving fragments from Bjølstad are interpreted as jamb planks based on their ornamentation and composition. Both have damaged bottom and top sections and now measure *c.*185 × 45 cm.[18] The jamb motifs appear to have continued onto the missing lintel.[19] The jambs are executed in a

CHAPTER 4A | APPENDIX: ALPHABETICAL LIST OF FRAGMENTS

Fig. 4A.2. Bjølstad, Norway, door jambs. Bjolstad chapel. Photo: Leif Anker, © Riksantikvaren.

sharply cut, flat two-plane relief. In its present state, much of the ornamentation of the jambs is worn and details like thinner serpentine strands have broken off; as a result, the full motif cannot be determined. The main motifs on each of the Bjølstad jambs are two highly stylized, elongated, and overlapping quadrupeds, one facing up, the other down. Their hips are marked partly by vague spirals and partly by indentations. It appears that they originally had forward-pointing, long almond-shaped eyes, elaborate looped lip-lappets, and arched clawlike feet. The quadrupeds intertwined among thicker and thinner strands of loosely thrown loopwork. There is a tendency for the minor elements to form close loop knots around major and minor crossing points. The large curled C-shaped loops are uncharacteristic of the Urnes style, while the shift between thinner and thicker is consistent with it. In the fragments' present state, it is difficult to determine whether the thinner loopwork originally represented Urnes type II and III animals.[20] These end in miniature small-lobed tendrils growing from the heel of the strand or serpent. In its current state, the design is open and dominated by the crossing of the elongated bodies of the quadrupeds on the jambs, the C shapes, and the loop knots formed by the minor elements.

Date
As the first to distinguish the Urnes style, Haakon Shetelig grouped Bjølstad with Urnes in the period *c.*1060–80, but he saw it as a later and less refined version. This opinion was repeated by David Wilson and Ole Klindt-Jensen, who described Bjølstad as "less accomplished," and "more degenerate" and therefore probably later than Urnes.[21] Erla Hohler and Roar Hauglid, however, pointed to the lack of typical Urnes-style features as a possible indication that Bjølstad predates Urnes.[22] Hauglid also referred to Irish work, where the motifs are kept within their frame in a manner quite different from the work at Urnes; to the beast on one of the Swedish Eskilstuna sarcophagi (thought to predate 1100),[23] with its elongated torso; and to the legacy of Jelling and Ringerike, which typologically would make Bjølstad earlier than Urnes.[24] Compared to Urnes, the jaw of the Bjølstad quadruped is smaller; and when considered alongside Anne-Sofie Gräslund's relative chronology of stylistic features in runestones (Fig. 4.3),[25] it is closest to Pr. 3, which in terms of style is transitional from Ringerike to Urnes. The feet resemble Gräslund's Pr. 4, which is Urnes style proper. The slim, small-lobed tendril at the end of one of the loops has exactly the same pattern as Pr. 3. These details indicate a date in the 1060s or 1070s.

Provenance
The jamb planks from an older stave construction were preserved due to their multiple reuses, most recently in a log-built church on the farm at Bjølstad in Heidal,[26] which was disassembled and moved after 1794. Bjølstad farm has given its name to the portal.

Brågarp, Sweden (previously Denmark) (Fig. 4A.3)

Lunds Universitets Historiska Museum (Historical Museum at Lund University), inv. no. LUHM 28733:a

Description
The stave church fragment from Brågarp is a lintel plank in oak. The size and shape of the lintel indicate that it derives from a door with a width of 85 cm, and the top section was probably not flat but converging upward.[27] The groove for the upper lintel plank is still preserved, and so are the tongues for the flanking jambs, making the construction and its format obvious even if the exact shape of the portal opening cannot be determined with certainty. The composition clearly continued onto the jambs.

Two symmetrically arranged Urnes-style creatures with distinctive elongated and narrow heads, almond-shaped forward-pointing eyes, and small-looped snouts appeared above the entrance with their snouts pointing to each side. Thin loops grow from the back of the heads of the beasts and form pretzel-like knots above their heads, tying their necks together with a figure-eight shape that continued diagonally downward onto the missing bottom section of the lintel.

Date
Hohler considered this the oldest preserved decorated lintel.[28] Elna Møller and Olaf Olsen pointed to the work of Ásmundr (active *c.*1020–50; see Chapter 4) and the succeeding period for the closest

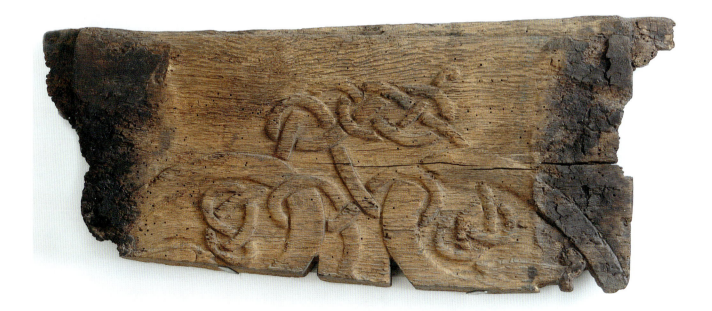

Fig. 4A.3. Brågarp, Sweden (previously Denmark), lintel fragment. Historical Museum at Lund University, inv. no. LUHM 28733:a. Photo: © Historiska Museet vid Lunds Universitet.

parallels to the Brågarp serpents' large drop-shaped eye, upper neck, and snout shape.[29] Lennart Karlsson compared the shape of the creatures' heads with those on the Lille Valla bowl (Sweden) (Fig. 4.4) of c.1050, the Ölandic Resmo stone (Öl 41),[30] and the Danish Hørning plank (c.1060–70; see below) (Fig. 4A.13).[31] Because it lacks the large looped snout of works like Urnes, the Brågarp lintel appears to belong to the mid-eleventh century or slightly later. This date also fits with the overall composition. An obvious parallel is the Swedish slab from Östra Skrukeby (Ög 220), where two thick-necked type II Urnes beasts are tied down by thin worms in figure-eight-shaped knots.[32] Cecilia Ljung placed this slab in the later eleventh century.[33] What is left of the Brågarp lintel gives the impression of a composition more crowded and less refined than that on the slab, but the main compositional principles are the same. The union knot tying down symmetrically paired beasts is a frequent motif in the picture runestones from Bornholm and Uppland in the period from c.1050 to 1100. Knotwork growing from the back of the head is also found in material from Trondheim, on a spoon (in Vitenskapsmuseet, NTNU, Trondheim, inv. no. T 91695) from a stratigraphic context of c.1050–1100, and on a larger fragment (inv. no. T 30000) of c.1100–1150 (Fig. 4.9).[34]

Brågarp is not yet dated by dendrochronology,[35] but its context sheds light on the date indicated by its style. Brågarp is situated 7–8 km from the episcopal town of Lund, which housed a number of churches in the eleventh century. Oak from St. Drotten is dated 1057, from St. Stephan's 1049–50, St. Andreas between 1058 and 1065, and St. Trinitatis also appears to date to the mid-eleventh century.[36] The Brågarp lintel likely belongs to the mid-eleventh century or slightly later.

Provenance
The plank decorated in the Urnes style was found in an opening in the gable between the chancel and nave of the Romanesque stone church of Brågarp, together with wall planks from an earlier stave building.[37]

Eke, Gotland, Sweden (Fig. 4A.4)

Statens Historiska Museer (Swedish History Museum), Stockholm, inv. nos. 15844:1–70

Description
From Eke we have seventy wall planks from a stave construction, of which twenty-six are oak, the others fir. In their lacerated state they are of varying height; the tallest is c.380 cm tall and c.15–50 cm wide.[38] Most have traces of tar. Two planks, possibly door jambs,[39] feature poorly preserved, badly weathered remains of incised decoration on the exterior side.[40] One shows the forelegs of an Urnes type II beast, with the typical notch at the "heel." This closely resembles the stiff foreleg of the type II animal of the Urnes door leaf (Fig. 4.8), which, unlike the modeled type II animals of the Urnes jambs, lacks hip spirals. The other jamb plank shows a pointed element that may also be part of a leg of which the "foot" is missing. Traces in the top section of the jambs show that they originally carried a lintel piece, and Claus Ahrens has interpreted the incised decoration as part of a confronted-beast design, but given the state of preservation, this identification should be considered hypothetical.

Ahrens reproduced a drawing of another wall plank from Eke.[41] This has a height of c.313 cm and very weak remains of what appears to be incised or cut decoration on the lower section. In the twelfth century the plank was painted with a Byzantine-inspired scene that should probably be understood as the Ascension.[42] The painting would have covered the vague incised decoration.

Date
The materials from Eke have recently been redated by dendrochronology, and the results are found in an unpublished report by Thomas S. Bartholin, with the numbered series 12475–94.[43] In this report on Sproge, Eke, and Hemse, Bartholin concluded (translation from Swedish):

> The samples from Eke are a lot more heterogeneous, and it cannot be excluded that the materials are from two different periods, the first c.1050 (1028+20), the second c.1120

Fig. 4A.4. Eke church, Gotland, Sweden, incised decorations on the fragments. Statens Historiska Museer, Stockholm, inv. nos. 15844:1–70. Drawing: J. Söderberg, in Erland Lagerlöf and Bengt Stolt, *Eke kyrka* (Stockholm, 1974), 464, © Riksantikvarieämbetet.

(1097+20). The older samples appear to be trees with a much higher age and a different growth pattern than the younger set of the samples; the later are more in line with the samples from Sproge and Hemse and in theory may be contemporaneous with those.

The twenty years are added to compensate for the absence of sapwood.

Provenance
The seventy wall planks from an earlier stave construction were discovered in 1916 during the restoration of the floor of the thirteenth-century stone church.[44]

Flatatunga, Iceland (Fig. 4A.5)

Reykjavík Þjóðminjasafn Íslands (National Museum of Iceland), inv. nos. 15296a–d

Description
Four fragmentarily preserved, vertically arranged pieces in fir with tongue-and-groove edges are referred to in the scholarly literature as the Flatatunga panels.[45] They clearly belonged to a large-scale interior decoration, and they were fastened to the framework of the wall with wooden nails. Both top and bottom are missing, so their original height is unknown, but the tallest of the fragments today measures 75 cm; their width is *c.*22 cm. According to Eldjárn, the incisions were carved with a knife.[46]

A horizontal band drawn across the composition separates the plant ornament of the field above from a row of robed and haloed figures standing below. The top section features a diagonal composition of stems and tightly scrolled double or fanned-out clusters of tendrils, partly intertwined with the stems and its double contour. In line with the Ringerike style, some of the tendrils are held together by, or terminate in, union knots with pear-shaped lobes.[47] The figures gesticulate and are depicted frontally. It has been suggested that the panels were part of a depiction of Christ and the apostles, but the figures had attributes, their haloes are all of the same type, and it seems more likely that they are saints.[48]

Date
The vegetal ornament has been characterized by Signe Horn Fuglesang as belonging to the "classical phase" of the Ringerike style, which would indicate a date toward the mid- rather than the late eleventh century, assuming a correspondence with the general Scandinavian time frame.[49] In its present fragmented state, the decoration disregards the axiality of the early Ringerike phase, but it should also be noted that no comparable large-scale Ringerike material exists, and the full composition might have given a different impression. In her doctoral dissertation, Jónsdóttir suggested a date around 1070 for the panels.[50] Ágústsson later argued for an early twelfth-century date.[51]

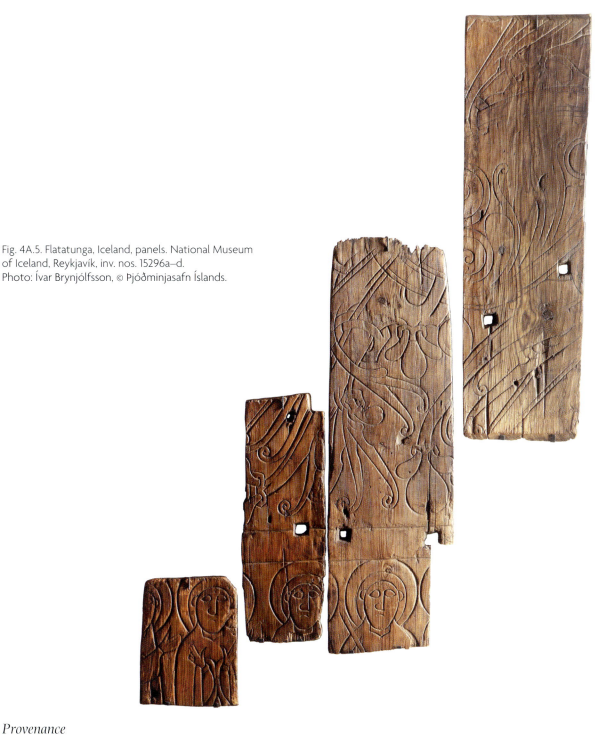

Fig. 4A.5. Flatatunga, Iceland, panels. National Museum of Iceland, Reykjavík, inv. nos. 15296a–d. Photo: Ívar Brynjólfsson, © Þjóðminjasafn Íslands.

Provenance

The Flatatunga panels were discovered in 1952, reused as rafters in the ceiling of a farmhouse. For the history of the panels, see Harðardóttir's recent essay.[52] They show traces of multiple reuse and are thought to have survived through secondary use in the post-Reformation cathedral at Hólar.[53] Eldjárn argued that the panels must originally have come from a church.[54]

The first Hólar Cathedral was built to coincide with the establishment of the episcopal see there in 1106. Ágústsson proposed that the Flatatunga panels were part of the decoration of the chancel, possibly from a high-altar ciborium, and that these eastern parts of the building would have been constructed first and completed by *c.*1108.[55]

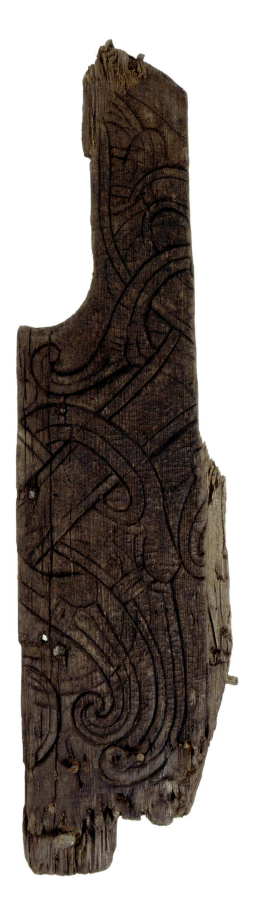

Gaulverjabæ, Iceland (Fig. 4A.6)

Reykjavík Pjóðminjasafn Íslands (National Museum of Iceland), inv. no. 1974:217

Description
A single damaged fir plank measuring 68.3 × 17.9 × 2.7 cm.[56] The ornamentation is well preserved, composed of deeply incised double contour lines. A *U*-shaped piece has been cut out of the plank; the ornamentation may have continued onto this part. This ornamentation is in the Ringerike style, with elements such as tendrils, cuffs,[57] pear-shaped lobes, and a stem cutting diagonally across the composition. The plank may have been part of an interior or a piece of furniture. The arched opening might indicate the side panel of a seat, or it may be an oculus for a window opening, or part of a screen. It is the only surviving decorated eleventh-century piece from southern Iceland, but given the uncertainty that surrounds it, the plank is not discussed in Chapter 4.

Date
The plank features typical Ringerike elements, and based on style it should be dated to the eleventh century. *Þór* Mágnússon placed the plank in the eleventh century, and in the Sarpur database it is dated *c.*1000–1100.[58]

Provenance
In 1973 a farmer at Gaulverjabær tore down an old turf building located *c.*50 m northeast of the local church.[59] The following spring he flattened the stone, rubble, and unusable materials with a bulldozer, and later he came across the decorated plank. Mágnússon noted that it is a fragment of a larger piece, most likely not from a wall but, rather, from some other part from Gaulverjabær church, possibly a chair or bench.

Fig. 4A.6. Gaulverjabæ, Iceland, plank. National Museum of Iceland, Reykjavík, inv. no. 1974:217. Photo: Ívar Brynjólfsson, © Pjóðminjasafn Íslands.

Glanshammar, Sweden (Fig. 4A.7)

In situ, Glanshammar church

Description
Two badly weathered, decorated oak planks are still in Glanshammar.[60] They are reused and incorporated into the stone church, so their full size is hard to determine, but they appear to measure *c.*175–180 × *c.*40–50 × *c.*4 cm; one bears a runic inscription (Nä 24).[61] Whether the Glanshammar fragments were sections of the wall-plate of a stave church or part of a plank-wall construction cannot be determined, but the horizontal arrangement of the decoration confirms that they were not

Fig. 4A.7. Glanshammar, Sweden, sketch of decoration on the planks. Drawing: from Sigurd Curman et al., *Kyrkor i Glanshammars härad: Sydvästra delen; Konsthistoriskt inventarium* (Stockholm, 1961), 396, figs. 341–42.

vertical wall planks.[62] Ahrens suggested that they were part of a frame or a horizontal plank-wall construction.[63] The ornamentation is symmetrically arranged and executed in low relief, and each fragment show versions of double-lobed tendrils tied together by Ringerike-style loops and cuffs.[64]

Date
Ahrens described the motifs as "Bandschlingen-Ornamenten … die dem Ringerikestil nähen stehen."[65] The motifs display kinship with the Hammarby fragments and with gravestones and runestones.[66] They have been related to the above-mentioned Eskilstuna grave monuments, thought to date to the eleventh century.[67] Karlsson pointed to a Ringerike-style grave slab from Otley, Yorkshire, considered by Wilson to be the work of Scandinavians, but also noted that certain runestones from the Södermanland region may also be related (Kjula, Sö 106; Åker, Sö 331).[68] It has also been noted that these fragments resemble an ornamented frieze reused in the south wall of

the Sanda church, Gotland, which in turn is thought to have been influenced by the decoration of some eleventh-century grave monuments.[69] Ljung concluded that the style of the Glanshammar ornament has its closest parallels in the runestone material and that this indicates that they belong to the eleventh century.[70] A date after 1100 seems unlikely.

Provenance

The remains of the oak planks can be found high up on the second floor in the small openings of the Romanesque church tower of Glanshammar.[71] This is the oldest part of the church, which excludes that the wood was originally part of the roof of the nave or chancel.[72] It is more likely that the planks belonged to an earlier wooden church, which was torn down (or possibly damaged by fire, since recent archaeological excavations indicate a burnt layer) before the stone church was erected in the late eleventh century.[73] Remains of stone foundations from an older building confirm the presence of an earlier church on the site, as do early grave monuments.[74]

Hadseløy, Norway (Fig. 4A.8)

Norges Arktiske Universitetsmuseum (Arctic University Museum of Norway, formerly Tromsø Museum), inv. no. N. 3000

Description

In its current state the Hadseløy plank measures 163 cm.[75] The pine plank seems unfinished, but it does not appear to have been longer, and the full length of the ornament is therefore preserved even if all the details are no longer legible. It is not preserved in its full width, however, as it varies from 20.5 cm on one end to 8.5 cm at the other; at its widest point it measures 26.7 cm. It also varies in thickness from 2.5 to 3.5 cm, which is thought to be original. The plank has been reused and reworked at least once, if not twice, and this has removed any traces of tongue and groove on the horizontal sides. It also has five nail holes. The decoration shows that it was originally arranged vertically and the nail holes indicate that it was fastened against a horizonal structural element, possibly in some kind of building.

The plank is carved in a shallow two-plane relief with a distinct double contour. Type II beasts are tied down by type III serpentine creatures arranged in asymmetrical figure eights. The main composition is symmetrical, with the figure eights mirrored around the central axis. The coiling main beasts on each side are similar but not identical, and the left side is less skillfully executed than the right. The middle section appears unadorned, but close inspection reveals vague traces of an incised pattern, a continuation of the rest of the relief.

Date

The heads lack the typical elongated, narrow eyes and are not easily compared to any of Gräslund's types (Fig. 4.3). The spirals of the limbs and the little cuffs that break up the composition evoke the Lilla Valla bowl (Fig. 4.4), and both the symmetry of the overall composition and the paired tendrils

indicate Ringerike heritage. As Fuglesang demonstrated, it also resembles the archaeological finds from Trondheim (T 30000) (Fig. 4.9). The way the loopwork is organized in figure eights shows Urnes-style influences.[76] Fuglesang noted that even though this plank appears somewhat older typologically, its style resembles that of the Swedish Eskilstuna coffins (in particular Sö 356), thought to date to the eleventh century.[77] She also pointed to Irish finds from Fishamble Street (Figs. 5.4 and 5.5) and Christchurch Place, Dublin, where the same form of interlace, long sprouting tendrils, and beast heads appear. Moreover, she mentioned two bone trial pieces from High Street that offer a parallel to the figure-eight shapes and the double-contoured drawing of the animals, as well as to metalwork such as the "Cathach" book shrine, dated by its inscription between 1062 and 1094.[78]

Like the Swedish comparanda, the Irish material indicates a date between 1025 and 1075. The mixed style in a Norwegian context suggests a mid-eleventh century date, and preliminary radiocarbon dates for the plank give the early eleventh century as the latest possible date. Wooden coffins found near the two churches at Haug (known only from archaeological excavations) have been radiocarbon dated c.1030–1160 and suggest that a church existed there in the mid-eleventh century.[79] The preliminary radiocarbon date of the plank appears to be too early for the stylistic features of its ornamentation, but it is possible that the tree was felled some time before it was carved. Whether the Hadseløy plank was intended for the first of these churches at Haug and why it is unfinished are open questions, but this may be the earliest surviving piece of architectural decoration in the North. Base on style, a mid-eleventh century date seems most likely, and it corresponds with the dates of the coffins.

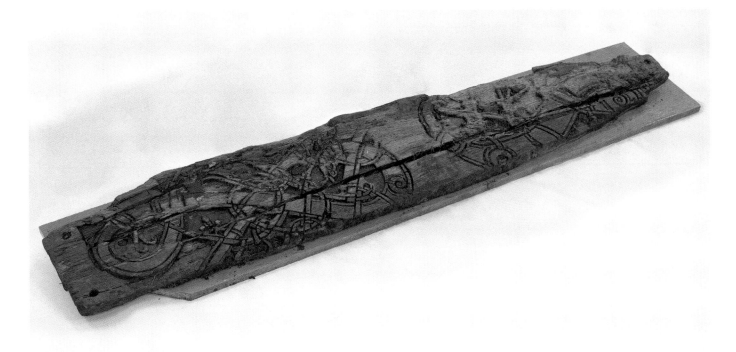

Fig. 4A.8. Hadseløy, Norway, plank. Arctic University Museum of Norway, Tromsø, inv. no. N. 3000. Photo: Helga Kvalheim, © Norges Arktiske Universitetsmuseum.

Provenance

This is a find of unknown original use, discovered during the plowing of a field in 1989.[80] It may subsequently have served as the lid of a coffin, since it was found together with parts of other coffins. It may have come from a bench or from a building. Gerd Stamsø Munch pointed out that the plank appears to have been fastened to the horizontal part of a building frame.[81] The relative shortness of the plank would be unusual if it decorated a wall-plate, but Munch noted that if the building had intermediate posts in its nave walls, this could explain the length.[82]

Hammarby, Sweden (Fig. 4A.9)

In situ, Hammarby church

Description

The remains of four oak planks are incorporated into the Romanesque church; two of these fragments are decorated. The relief on one of the planks is shallow, flat, and slightly rounded toward the edges, with double contour lines, and the motif is a three-lobed palmette. The other plank features flat, two-plane relief. This ornament consists of a three-lobed leaf rising from a union knot that ties together two symmetrically arranged, double-strand lobed tendrils.[83] One of the palmettes has the pear-shaped pendant typical of early materials and Ringerike objects.

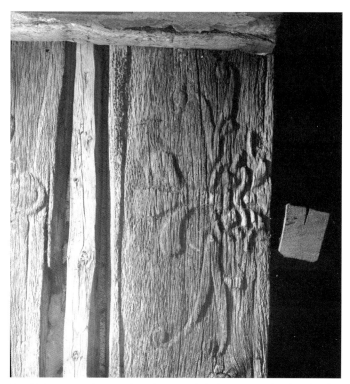 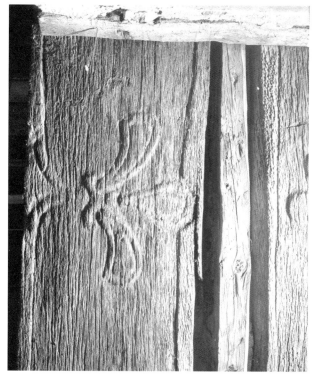

Fig. 4A.9. Hammarby, Sweden, decorated planks. Hammarby church. Photo: © Riksantikvarieämbetet.

Date
Karlsson classified the planks as "transitional toward medieval."[84] He compared them to the silver bowl from Lilla Valla (*c.*1050) (Fig. 4.4) and a stone relief found in the Vamlingbo church on Gotland.[85] In his study of the churches of Södermanland, Ivar Schnell considered the ornaments Romanesque.[86] Ljung's more recent work, however, notes the elegant Urnes-style loops, as found in the gravestone material.[87] In her overview of style elements Gräslund traced the development of the union knot (Fig. 4.3), and Hammarby is closer to the earlier versions and especially the union knot motif of Örberga.[88] Eskilstuna sarcophagi have also been found at Hammarby.[89] Ljung noted that in the region of Södermanland, the production of these coffins peaked in the mid-eleventh century.[90] A fragment from Linköping Cathedral with features much like those at Hammarby has been dated to the first half of the eleventh century based on the text of its inscription.[91] The Hammarby fragments may thus be from the mid- or late eleventh century, and it is highly unlikely that they postdate 1100.

Provenance
The four planks have been reused in the light opening in the loft of Hammarby's Romanesque church, just outside the old center of Eskilstuna (Tuna).[92] Their original use is unknown, but their condition is weathered. Their present location is sheltered and probably did not cause this, so scholars assume that they come from an earlier building.[93] A decorated stone coffin (Sö 89) stylistically dated to the mid-eleventh century is also preserved from Hammarby, suggesting that an earlier church existed on this spot.[94] Södermanland is one of the regions where Christianity is thought to have been established early.[95] Ljung concluded that even though we cannot know for certain that the grave monuments preserved from Hammarby were contemporary with the wooden church from which the fragments come, it is certainly likely.[96]

Hopperstad, Norway (Fig. 4A.10)

Bergens Historisk Museum (Historical Museum, University of Bergen), inv. no. 4829, and Sogn Folkemuseum (Sogn Folk Museum), inv. no. DHS 4672

Description
The two very badly weathered Hopperstad fragments are parts of the same or two different corner posts. One is 90 cm high, the other 86 cm, but their precise original diameter is difficult to make out.[97] They are covered with Urnes-style ornamentation in the same type of relief seen on the corner post of the Urnes stave church.[98] Whereas one of the fragments features thick and thin loops, the other appears to show the shoulder and foreleg of a large type II animal with filiform animals looped around it.

Date
The large animal does not have a hip spiral, so it differs from the Urnes portal's quadruped and most of the type II beasts of that church, but Urnes does have a type II beast without hip spirals on the

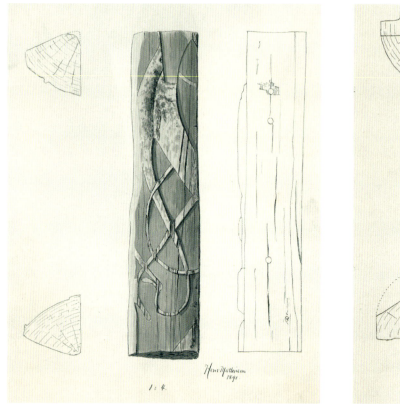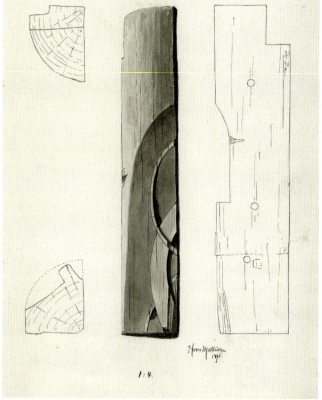

Fig. 4A.10. Hopperstad, Norway, drawings of corner-post fragments. Historical Museum, University of Bergen, inv. no. 4829, and Folk Museum, Sogn, inv. no. DHS 4672. Drawings: Henrik Mathiesen, © Riksantikvaren.

corner post and in the east gable. The bodies and crossing points of the creatures have the same modeling as those at Urnes. Based on style, technique, and proximity to Urnes, there is no reason why Hopperstad should not be of approximately the same date, *c.*1060–80.

Provenance
The current Hopperstad church dates to the 1130s. During restorations, two fragments from an earlier Urnes-style church were found reused in the current building.[99] They are housed today in two different museums, one locally in Sogn and the other in Bergen.

Hólar, Iceland (Fig. 4A.11)

Reykjavík Þjóðminjasafn Íslands (National Museum of Iceland), inv. no. 1966–294

Description
A single fir plank with Mammen-Ringerike–style features is preserved from Hólar in Eyjafjörður. It measures 230 × *c.*25 cm and is *c.*2.5 cm thick. The top section of the plank shows the termination of a crossing double stem ending in loosely scrolled tendrils within a vine.[100]

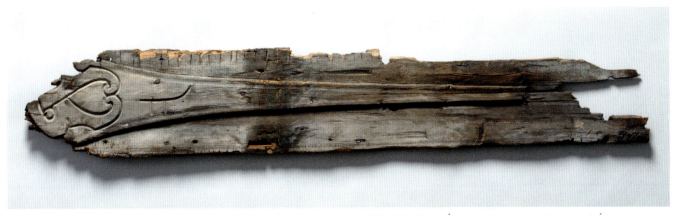

Fig. 4A.11. Hólar, Iceland, plank. National Museum of Iceland, Reykjavík, inv. no. 1966–294. Photo: Ívar Brynjólfsson© Þjóðminjasafn Íslands.

Date
The Ringerike- and Mammen-style elements point to the eleventh century, most likely the first rather than the second half. It is not known to what extent or for how long, these styles were mixed, or whether they endured alongside each other throughout the century. In the Sarpur database the plank is dated *c.*1100–1300.[101]

Provenance
Discovered in 1966 as a rafter in the ceiling of a farmhouse.

Humptrup, Germany (Fig. 4A.12)

Schleswig-Holsteinische Landesmuseen (Schleswig-Holstein State Museum), Schleswig, inv. nos. 1928–1929/120

Description
The remains of two decorated wall-plates in oak have been preserved from Humptrup (Humtrup) in Schleswig-Holstein (Germany), very close to the modern Danish border.[102] Parts of the tongues that were fitted into the corner posts of the construction are still extant.[103] The plates are both *c.*395 cm long and feature the same type of ornamentation.

The relief of the Humptrup fragments is high and slightly rounded, unlike the flat two-plane relief of the other Danish fragment, from Hørning.[104] The Humptrup fragments have been extremely damaged by modern conservation methods, and their design is now known only from earlier drawings and photographs.[105] Karola Kröll's reconstruction suggests loopwork featuring Urnes type II and III animals creating a pattern of tightly coiled loops, both types seizing each other by their jaws. Elongated hip spirals mark the limbs of the type II animals, which are thicker than the thin, even bodies of their opponents.[106] Kröll concluded, however, that "Das entstandene Muster

stellt jedoch nur eine Rekonstruktionsversuch dar, möglicherweise hat es vollkommen anders ausgesehen."[107] This means that the original relief may in fact have been completely different from her reconstruction, which was also reproduced by Ahrens.[108]

Date
Sadly, Humptrup has proved impossible to date by any scientific method.[109] Previous research placed the fragments anywhere from the mid-eleventh to the early twelfth century.[110] Møller and Olsen described the beats as "dragons" and noted that the rounded relief suggested an association with the early Romanesque period in Scandinavia, rather than the late Viking Age with its more common flat, two-plane relief.[111] Kröll concluded that, based on style, the Humptrup pieces were carved sometime between 1050 and 1150.[112] Her reconstruction suggests that the heads of both types of beasts were carved in a bird's-eye view. This may be an early feature, as the more triangular bird's-eye-view heads in the runestone material often appear in older works. The possibility that the pieces are early is strengthened by drawings made by Søren Alfred Claudi-Hansen when the materials were first discovered.[113] These show tightly scrolled, coiled tails, quite unlike the lobed tendrils of later stylistic phases, akin to Gräslund's Pr. 1 (Fig. 4.3).[114] It should be noted, however, that the third Urnes stave church of *c.*1070 also has type II and III beast-serpents whose heads are in bird's-eye view, albeit a rather elongated one, and that in architectural sculpture this feature continues well past the mid-eleventh century. Also, both Urnes and Hopperstad have high and not flat relief. The loopwork is chaotic and crowded, in no way typical of the Urnes style. Kröll noted that it is nonetheless closer to Urnes than to any earlier or later work.[115] In conclusion, these wall-plates are certainly eleventh-century works, but it is difficult to be more specific.

Provenance
The fragments came to light in the nineteenth century, as they had been reused in the present Romanesque stone church.[116]

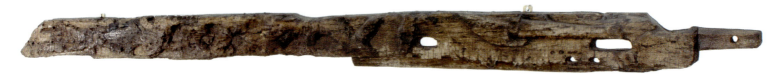

Fig. 4A.12. Humptrup, Germany, wall-plate. Schleswig-Holstein State Museum, Schleswig, inv. nos. 1928–1929/120. Photo: © Stiftung Schleswig-Holsteinische Landesmuseen Schloss Gottorf.

Hørning, Denmark (Fig. 4A.13a–b)

Nationalmuseet (National Museum of Denmark), Copenhagen, inv. no. DR 2309

Description
A piece of a wall-plate in oak has been preserved from Hørning in Jutland. In its fragmentary current state it measures 91 × 57cm with a thickness of *c*.14 cm.[117] This is the only late Viking-age architectural find that has both interior and exterior decoration. The exterior frieze is decorated with a sharply cut, flat two-plane relief, where a thin line against a plain background shows an Urnes type III serpent. The loopwork has the classic Urnes-style figure eight with sharp diagonal lines. The serpent's head has the chubby features of Gräslund's Pr. 3 (Fig. 4.3), while the tail (of another serpent) terminates in a lobe more like those of Pr. 4. A twisted rope ornament runs along the top of the frieze. The serpent was originally yellow, with red iron pigment used for such details as the eye and the snout; the background was colored with charcoal black. Red was also used to outline the frame, whereas the rope ornament was drawn in red and black.[118]

On the interior side, the ornamentation was incised before paint was added.[119] The conservation report concludes that the colors were reds, yellows, green, gray, brown, white, grayish-blue, and black.[120] The design of medallions composed of vine scrolls was drawn in a heavy black outline. The motifs inside the medallions are a three-lobed palmette, a clusters of grapes, and what appears to be the remains of a hand, indicating a human figure. The frieze was framed by egg-and-dart borders set between double red horizontal lines on a white background.[121]

Date
It has been suggested that the interior decoration is later that that on the exterior, but technical examination does not support this hypothesis.[122] The fragment has been dated by dendrochronology to *c*.1060–70.[123]

Provenance
The fragment of the wall-plate was discovered in the filling of the chancel wall during restoration of the Romanesque church at Hørning in 1887.[124] The site has been excavated and post-holes, were revealed; the earlier church was clearly destroyed by fire.[125]

OVERLEAF:
Fig. 4A.13a–b. Hørning, Denmark, wall-plate, exterior (a) and interior (b). National Museum of Denmark, Copenhagen, inv. no. DR 2309.
Photo: John Lee, © Nationalmuseet.

PART TWO | THE ELEVENTH-CENTURY CHURCH

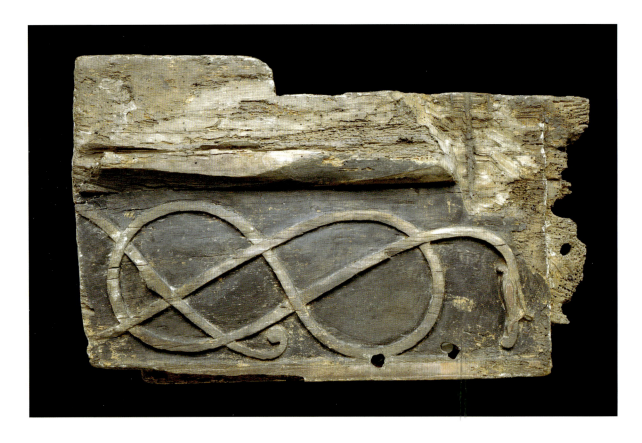

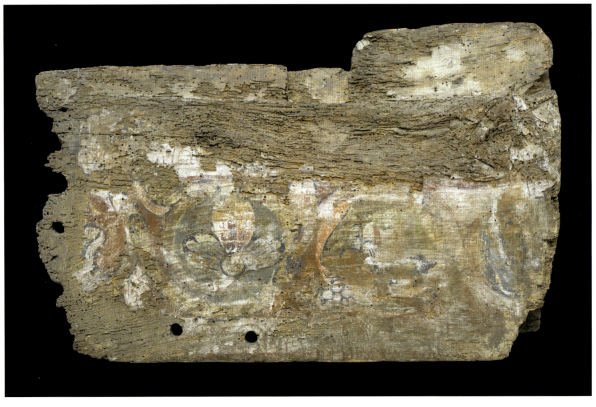

250

Kvikne, Norway (Figs. 4A.14 and 4.2)

In situ, eighteenth-century Kvikne church

Description
Eight planks, two with small consecration crosses inscribed in a circle, show remains of incised decoration.[126] Their size varies: the tallest is *c.* 262 cm, the widest *c.* 52 cm.[127] On these planks at least four large, unfinished Urnes-style quadrupeds, a ship, and a horse are depicted. Martin Blindheim noted that, "Untidy as the whole is, the idea cannot at any rate have been to produce wall decorations for the new stave church."[128] The animals are depicted in profile, and one of them resembles that on the Urnes west gable. The largest has an almond-shaped eye, a small ear atop its head, and a thick, elongated neck. There are no traces of serpentine loopwork.

Fig. 4A.14. Kvikne, Norway, incised quadruped on one plank. Kvikne church. Drawing: Knud J. Krogh, © Riksantikvaren.

Date

Stylistically, these planks should be described as Urnes. They have so far proved difficult to date by dendrochronology, but examinations are ongoing. Despite the Urnes- style elements, Blindheim proposed a date in the first half of the twelfth century. He described the ship as unusual in shape but conforming to the eleventh or twelfth centuries, while the horse displays Romanesque influences. Graffiti are not uncommon in medieval churches, and the incised images at Kvikne appear to be graffiti. For this reason, they are not included in Chapter 4.

Provenance

The planks are preserved in the eighteenth-century church.

Mosjö, Sweden (Fig. 4A.15)

Statens Historiska Museer (Swedish History Museum), Stockholm, inv. nos. SHM 12456:1–43

Description

A series of seventy-three pine wall planks are preserved from Mosjö. These are c. 300–600 cm high and c. 32–35 cm wide,[129] convex on the outside and flat on the inside. Eight of the planks have carved crosses, c. 50 cm high, with arms of approximately equal length and with straight or slightly concave ends. They are located toward the top end of the planks and/or in the middle; some span two or three planks, and one plank has two crosses.

Date

Emil Ekhoff dated the Mosjö planks to the conversion period based on their decoration.[130] By the mid-twelfth century the present stone church was built on the site, and the foundations of another, smaller stone church were uncovered in excavations in the 1960s,[131] which led Erland Lagerlöf to conclude that the wooden church likely belonged to the eleventh century.[132] No dendrochronological analysis has been undertaken to support this. Ahrens dated the fragments to the twelfth century, but he did not explain why he proposed such a late date.[133] The Swedish National Heritage Board (Riksantikvarieämbetet) dates the planks between c. 1000 and 1150.[134]

Provenance

The planks were reused as floorboards in the later Romanesque church.[135] Ekhoff assumed that Mosjö had been a stave construction, but this cannot be determined with any certainty, and it may have been a half-timbered church, as Lagerlöf suggested.[136] Ahrens believed that the planks must be part of a plank-wall structure because of the unusually long length of some of them.[137]

CHAPTER **4A** | APPENDIX: ALPHABETICAL LIST OF FRAGMENTS

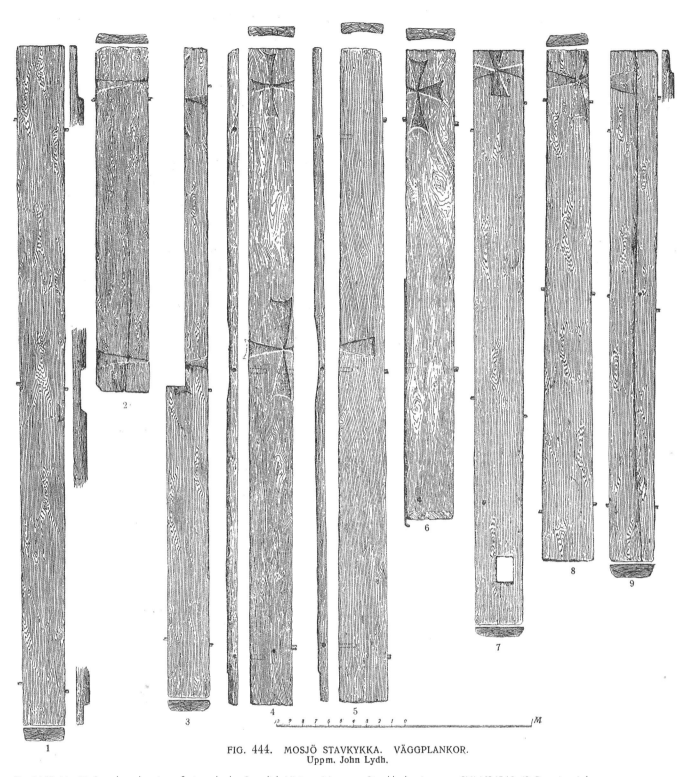

FIG. 444. MOSJÖ STAVKYKKA. VÄGGPLANKOR.
Uppm. John Lydh.

Fig. 4A.15. Mosjö, Sweden, drawing of nine planks. Swedish History Museum, Stockholm, inv. nos. SHM 12456:1–43. Drawing: John Lydh, from Emil Ekhoff, *Svenska stavkyrkor: Jämte iakttagelser över de norska samt redogörelse för i Danmark och England kända lämningar av stavkonstruktioner* (Stockholm, 1914–16), 314.

Myresjö, Sweden (Fig. 4A.16)

Statens Historiska Museer (Swedish History Museum), Stockholm, inv. no. SHM 11750

Description
Two oak planks from Myresjö measure 730 × 45 cm and 680 × 45 cm.[138] The incised decorations on both have double contours, and the Urnes-style loopwork has a complex interlace pattern.[139] Karlsson's drawing of the figure-eight loopwork also includes two wings within the loops near the end of the frieze,[140] but there are no visible beast heads, and on closer inspection they seem more like vine shoots.

Fig. 4A.16. Myresjö, Sweden, planks. Swedish History Museum, Stockholm, inv. no. SHM 11750. Drawing: Lennart Karlsson, from *Romansk träornamentik i Sverige* (Stockholm, 1976), fig. 187.

Date
The relatively complex pattern, the motif of vine shoots, and the large-lobed tendrils correspond to Gräslund's group Pr. 4 (Fig. 4.3) and suggest a date around 1100, as also indicated by dendrochronological examinations that yielded the result "after 1095."[141] Therefore, they may have been carved in the years just before 1100, but they may also be from the first or possibly even the second decade of the twelfth century.

Provenance
The planks from Myresjö were discovered in 1902 in the roofing on the east side of the nave of the Romanesque stone church. Aron Andersson wrote that they must have come from a stave church,[142] an idea that was strengthened by a discovery in the 1970s of traces of an earlier building beneath the sacristy floor.[143] Marian Ullén disagreed, however, arguing that these oak planks in the Urnes style were made for the footing of the roof construction of the stone church.[144]

Möðrufell, Iceland (Fig. 4A.17)

Reykjavík Pjóðminjasafn Íslands (National Museum of Iceland), inv. nos. 6096a–e

Description
Fragments of thirteen wall planks in fir are preserved from Möðrufell. Their size varies, but the tallest is 250 cm high; their width ranges from *c.* 21 to 28 cm.[145] The planks have a simple, nearly geometrical decoration;[146] the design was created partially by incised lines and partially by a very flat two-plane relief. The motifs narrow toward the top of the panels and terminate in crosses, sprouting crosses, and fleurs-de-lis forms. They also include crossing double stems with and without an underlying spiral, single tendrils, lilylike tendrils, spear heads, spiraling scrolled tendrils, tendrils with pear-shaped jutting lobe, and spirals.[147]

Date
Many of these motifs are found in both the Ringerike and Mammen styles. For this reason, Ellen Marie Magerøy dated the Möðrufell planks to the latter half of the eleventh century, but she noted a

Fig. 4A.17. Möðrufell, Iceland, panels. National Museum of Iceland, Reykjavík, inv. nos. 6096a–e. Photo: Ívar Brynjólfsson, © Pjóðminjasafn Íslands

certain eclectic sense of style and suggested that they were locally produced and influenced by pieces dating from different periods.[148] She pointed to the eleventh-century Swedish runestones with their many forms of crosses and the union knot motif, in particular those signed by Fótr from the mid-eleventh century.[149] Fuglesang also noted motifs found in Ringerike and Mammen, but concluded that these traits could not readily be placed within any of the subgroups.[150] The flow of the outline and the use of the tendril with pear-shaped, jutting lobe point to Ringerike influences and suggest a date in the mid- to late eleventh century.[151]

Provenance

The reused planks came from the Icelandic farm of Möðrufell in Eyjafjord, where they were preserved as building materials in the farmhouses.[152]

Novgorod, Russia (Fig. 4A.18)

The State Novgorod Museum-reserve, inv. no. НГМ КП 25405/118 A-20/118[153]

Description

The two posts or half-columns are of oak and slightly convex. The measurements given differ from one publication to another, but the museum's website says that the half-column with the medallions measures *c.*128–129 × 38 cm[154] (the second piece is not on the website). Hohler, who examined the objects personally, gave the dimensions *c.*119 × 24 cm for the second piece, with a spear-shaped palmette.[155] Both were originally taller. If reconstructed as full columns they would have had a diameter of *c.*50 cm, and Hohler reported that they show remains of grooves and that "A function as door posts, or corner posts in some vertical construction, might be envisaged."[156] Whereas Hohler described the fragments as posts, Nadezhda N. Tochilova and Anna Slapinia used the term *semi-columns*.[157] Nothing is known about the original location of the pieces.

The half-columns are executed in two-plane relief, which is slightly rounded on the edges. The top ends of the posts are identical, with a horizontal braided band of interlace made up of four two-strand ribbons. One of the half-columns has two medallions below the band, set within interlaced loosely thrown loops, some of which intertwine to make the frames of the medallions. In its fragmented state, one can barely see the hindquarters of creatures inside the medallions. The first is presumably a griffin, whose fanned-out tail consists of tightly scrolled feathers, while the second is probably a centaur holding onto his bushy tail. Both figures are encased in loopwork; that of the upper medallion is arranged in a pretzel knot.[158] The second half-column is largely undecorated except for a spear-shaped palmette growing from a pyramidal stem as its central motif.

Date

A. W. Artsikhovskii, who first published the find, initially dated the half-columns to the first part of the eleventh century. Later publications discuss the stratigraphy, and this layer was then dated more precisely between *c.*1040 and the 1080s.[159] The Novgorod half-columns were brought into

the Scandinavia debate by Hohler, but she dismissed them as wholly unrelated and said that they should be assigned to the thirteenth century, asserting that the stratigraphic date could not be correct.[160] As a result, scholarly works that discuss the arts and culture of the later Viking Age have not incorporated these objects.[161] In 2018, however, Tochilova and Slapinia disputed Hohler's analysis and redated the half-columns to the eleventh century.[162] Seven fragments from Wawel Cathedral that had come to light some twenty years after the Novgorod excavations were also brought into the discussion.[163] Tochilova and Slapinia noted the similarity in the use of medallions, the double-strand ribbons, and the way the medallions were constructed, but they also noted that the haphazardly thrown loops of the Novgorod find were dissimilar, as were other details, and the Wawel fragment is regular whereas the Novgorod piece is chaotic.[164] Tochilova and Slapinia also pointed to Slavic influences on Polish work that might have come from Carolingian-era Italian art.[165] They concluded that there is no reason to doubt the eleventh-century date suggested by the archaeological excavations.

Provenance

The two decorated half-columns were discovered in the 1953 excavations of the Nerevsky site in Novgorod, but it is not clear what building they came from originally.[166] In their recent article, Tochilova and Slapinia reviewed the circumstances of the find and considered where the columns came from and what purpose they may have served.[167]

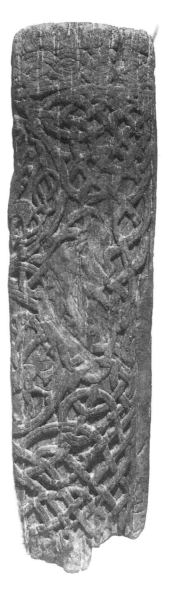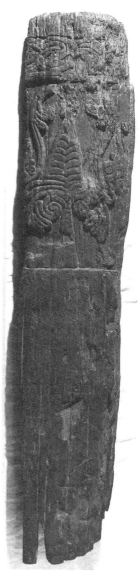

Fig. 4A.18. Novgorod, Russia, half-columns. State Novgorod Museum-reserve, inv. no. ДДД ДД 25405/118 Д-20/118. Photo: from Erla Hohler, "Two Wooden Posts Found in Novgorod: A Note on Their Date and Stylistic Connection," *Collegium Medievale* 16 (2003), 39.

Fig. 4A.19. Rinde, Norway, fragment. Folk Museum, Sogn, inv. no. DHS 4672. Photo: © Leif Anker.

Rinde, Norway (Fig. 4A.19)

Sogn Folkemuseum (Sogn Folk Museum), inv. no. DHS 4672

Description
In its present state the fragment from Rinde measures c.169–170 × 21 cm and is 4 cm thick.[168] One side is undamaged and shows a groove. The plank has nail holes, which made Hohler suggest that the piece was originally a door leaf, but Knud Krogh pointed to its thickness and cross-section, which correspond to the planks of the Urnes stave church's gables. The Rinde fragment is also most likely part of a gable.[169] Leif Anker also observed the placement of the beast on the fragment, which does not correspond to where the beast is located on the Urnes door leaf and would suit a larger composition.[170] The decoration is executed in flat, two-plane relief. Even though much of the ornament has broken off, it clearly was composed of very thin, generous loops terminating in loosely scrolled tendrils. The thin loops cross over and loop around a thicker element that appears to be the hip spiral or the joint of a type II Urnes animal.

Date
A date in the second half of the eleventh century is likely; more precision requires close examination of the piece closest to Rinde, Trondheim inv. no. N 30000 (Fig. 4.9).[171] The hip of the presumed type II Rinde creatures is similar to that on the Trondheim fragment, which features a large Urnes-style composition. The flat, two-plane relief at Trondheim is deeper and somewhat rounded, with alternating thick and thin strands, but the thinner strands end in Urnes-style spiraling tendrils of the same type as Rinde. Unlike Rinde, N 30000 also features a head with an elongated, almond-shaped eye and thin lip-lappets curving backwards over the snout. The head is close to Pr. 3, and although the features of N 30000 are more exaggerated, they are not as extravagant as Pr. 4. Returning to Rinde, the lobed tendril on the Hørning wall-plate of c.1060–70 is quite close, as is the flat, two-plane relief. Rinde and N 30000 clearly belong to the same branch of the Urnes style, so a date c.1070 is probable.

Provenance
The plank was reused in the roof of the Rinde stave church, which was demolished in 1866. In the literature the stave church has the name of the farm at Rinde where the church site is located, whereas the parish church and the nineteenth-century church are named after the village of Feios.

Rødven, Norway (Figs. 4A.20 and 4.10)

In situ, Rødven church

Description
Only the jamb planks are extant. In their fragmentary state, they are *c.* 316 cm high.[172] The lintel piece with the top section of the portal is missing, but the beginning of an arch of more than 180 degrees (either horseshoe-shaped or trefoil) is preserved. On the face of the jambs are "columns" consisting of two intertwined vine stems, and this motif is echoed on the reveal for a total of four stems on each

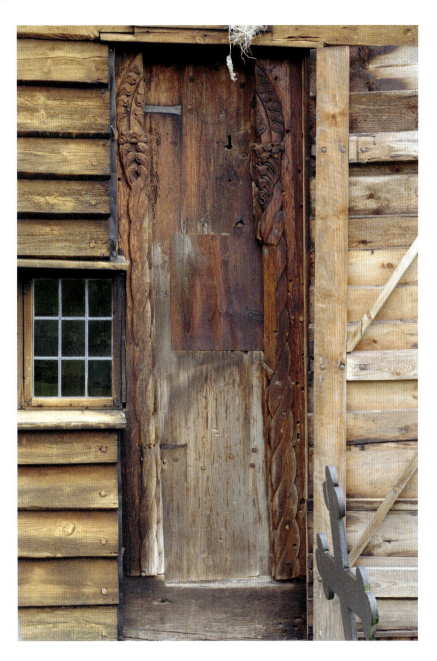

Fig. 4A.20. Rødven, Norway, jambs. Rødven church. Photo: © Kjartan Hauglid.

jamb. These terminate in "capitals" composed of bundles of leaves, cut in high, rounded relief. The leaves on the right side have distinct downward-turning tips, of which some are split. The leaves have thickly grooved central veins, and the relief creates the effect of heavy shading. The stalks of the left "column" continue into the "capital" and terminate in a symmetrical arrangement of three leaves. The leaves on this side are closed pods with distinct central veins. The top of this "capital" has a wavy ornament, mimicking an abacus, before the springing of the arch. The archivolt is molded with two flat orders and wrapped in leaf lobes that seem to grow from both sides of the back of the arch. The top of the preserved section of the arch is unadorned.

Date

Rødven has no surviving parallels. Hauglid described Rødven's leaves as "Gothic" and suggested a date in the thirteenth century.[173] Anders Bugge considered the leaf-covered arch to be an early premonition of the Gothic sensibility to nature, and he described the leaves as typically twelfth century due to their backward-turning tips.[174] Blindheim briefly noted the Rødven portal's "twisted stalks and possibly Winchester style affiliation."[175] Hohler pointed out that foliage associated with the Winchester School was an established feature of late eleventh-century English sculpture, and it would not be surprising to find it in the diocese of Nidaros, not far from Trondheim; however, she seems to have assumed that the inspiration arrived via Trondheim's stone sculpture and therefore dated the portal to the twelfth century.[176] She asserted that the way a fillet (the "abacus") bundles the foliage together has parallels in a capital from the pentice of Urnes (Plate 28) and another one from Lom.[177]

Versions of the foliage type seen at Rødven also existed in Romanesque architectural sculpture, but it is much stiffer and less exaggerated. In Chapter 4 I suggest that Rødven belongs to the eleventh century because of the shape of the arch, the foliage with the downturned tips and strong veins, the restlessness of the leaves, and the way the vegetation overgrows the architecture. There is no reason to assume that the work was influenced by stone sculpture in Trondheim.

Provenance

The portal is in the south nave wall of the present stave church, but it is now covered by paneling. The bottom of the portal shows that it has been reworked, as the twisted "columns" are cut straight off to fit into the frame, which is clearly not the original arrangement.[178] The portal may have been reused multiple times.

Torpo, Norway (Fig. 4A.21)

Kulturhistorisk Museum, Universitetet i Oslo (Museum of Cultural History, University of Oslo), inv. no. C.10814

Description
A fragment of a jamb plank from Torpo measures $c.156 \times 47$ cm, but originally it would have been taller and $c.50$ cm wide.[179] One side has the remains of a grove. The decoration is framed on both sides by fillets, and the relief is of a flat, two-plane type only 1–1.5-cm deep, with modeled crossing points and sharply cut lines. The composition is rather open in its design. One large band marks the slightly curving diagonal main line of the composition, running the full length of the plank. This is either the body of an Urnes type II animal or the elongated body of a quadruped resembling the Bjølstad beasts. Two smaller type II creatures with wings are also visible, as is another without wings. In 1955 Ole Henrik Moe argued that that the Torpo plank had thus far been reproduced upside down and that the elongated body on the diagonal was in fact that of the left jamb's main dragon, rising up to meet its opponent in the missing top section of the portal.

Date
An early twelfth-century date was suggested by both Fuglesang and Hauglid.[180] The portal plank has commonly been described as "late Urnes" in style because of the wing, an element often thought to be Romanesque despite its appearance in the much earlier runestones signed by Ásmundr.[181] Moe referred to another Norwegian portal plank, from Imshaug,[182] which features dragons encased in spiraling, hanging vine scrolls. The consensus is that Imshaug probably belongs stylistically to the first decades of the twelfth century.[183] The wings on the Imshaug beast are sharper, unlike Moe's drawing.[184] The wings of the Torpo creatures do not appear to resemble Romanesque ones; rather, they look like wings on the Upplandic picture runestone from Bräckstad (U 1039) dated $c.1070–1100$,[185] and the Resmo stone from Öland (Öl 4).[186]

The lobed tendrils and the feet clearly place the Torpo

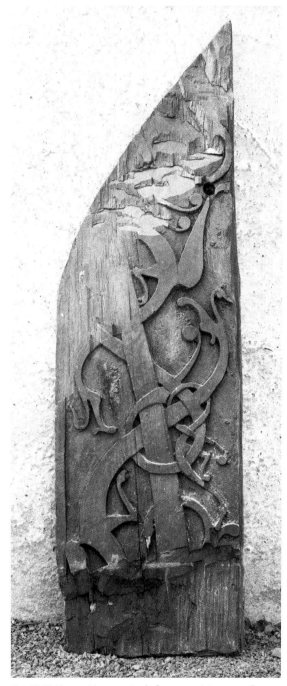

Fig. 4A.21. Torpo, Norway, jamb fragment. Museum of Cultural History, University of Oslo, inv. no. C.10814. Photo: Ørnulf Hjort-Sørensen, © Kulturhistorisk Museum, Oslo.

261

animals in Gräslund's group Pr. 4 (Fig. 4.3), whereas the upper and lower lip-lappets and the shape of the heads resemble Gräslund's Pr. 5. A second head on the Torpo fragment has a distinctive ear springing from the back, as in Gräslund's Pr. 4. Another reason for proposing a date *c.*1100 is the very open design, executed in flat relief, which appears to be an earlier version of the relief seen on the Vågå portal (Norway).[187] Vågå is widely assumed to belong to the second generation of stave church portals, which reflects Romanesque influence while still retaining elements of the old style.[188] Thus, in light of its stylistic details, Torpo appears to date *c.*1100.

Provenance
The jamb plank was one of several reused in the apse of the Torpo stave church, which was demolished in 1880.

Trondheim, Norway (Fig. 4A.22)

NTNU Vitenskapsmuseet (University Museum, Norwegian University of Science and Technology), inv. no. T16383:1

Description
This fragment is approximately 65 cm long. The bottom of the piece has grooves, meaning that it was fixed in some sort of frame, so it may have come from a stave or a log building. It has been interpreted as a jamb fragment. The carving is roughly executed. The Urnes-style ornament of thick and thin strands is drawn with deep inciced lines, with a slightly higher section in flat, two-plane relief toward one side of the jamb.

Date
Given how little is preserved, this fragment is difficult to date, but it belongs unmistakably to the eleventh century. The tendency of the minor elements to form close loop knots around the crossing points resembles Bjølstad and the other Trondheim fragment (T 30000), so a date close to these (both are dated only on stylistic grounds) seems likely, perhaps *c.*1060–80.

Provenance
Little has been published about this find. The plank was discovered in 1948 during excavation of the plot under the old fire station in Søndre gate 1. The context is poorly documented stratigraphically, but it was discovered in the remains of a small log-built house as part of the wooden floor; its decorated side faced down, indicating that it was probably reused.[189] The house appears to date no later than 1100. Archaeologist Axel Christophersen at NTNU Vitenskapsmuseet informs me that little is known about the buildings in this area. Saurlid was once the natural harbor of Trondheim, but in the eleventh century it was a marshy area in the center of the town. The earliest buildings known from this part of the town were uncovered in excavations farther to the east, west of Kaupmannastrete (Merchants' Street); they were large log constructions that were all town houses on city plots.

CHAPTER **4A** | APPENDIX: ALPHABETICAL LIST OF FRAGMENTS

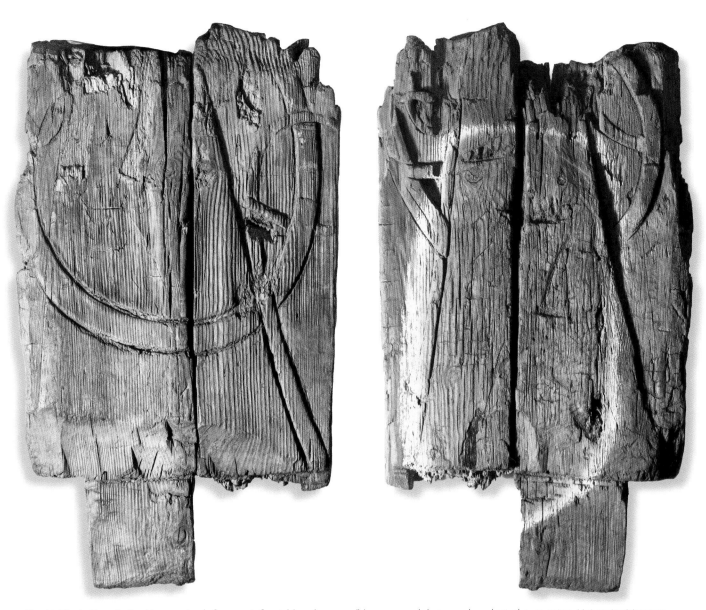

Fig. 4A.22a–b. Trondheim, Norway, jamb fragment, front (a) and reverse (b), uncovered during archaeological excavation. University Museum, Norwegian University of Science and Technology (NTNU), inv. no. T16383:1. Photo: © NTNU, Vitenskapsmuseet.

PART TWO | THE ELEVENTH-CENTURY CHURCH

Urnes, Norway (Plates 1–13)

In situ, Urnes church

Description

The present-day Urnes stave church dates to the 1130s, and since Krogh's 2011 publication it is considered to be the fourth on the site.[190] It incorporates large parts of the third church. The decorated materials from the older church are the west portal (now inserted into the north wall), the door leaf itself, most of the east and west gables, two wall planks with overall decoration, four wall planks with very modest remains of decoration along the top edges, and a corner post. In addition to the decorated elements, a series of unadorned wall planks from the west facade and elsewhere are preserved, as are two sills, both of which have been shortened to fit the current bottom frame.[191] The jambs are shorter today than they were originally, measuring $c.290 \times 65–75$ cm and $c.290 \times 52–65$ cm.[192] Hohler estimated that their original height must have been $c.350$ cm.[193] The portal is 62–80 cm wide. The wall planks were also shortened to fit into the 1130s construction, and they have different widths: $c.290 \times 45$ cm, $c.290 \times 55$ cm, and $c.290 \times 42$ cm. The corner post measures $c.245 \times 42$ cm.[194] If they were reconstructed, the bottom width of the gables would measure $c.440–500$ cm (west) and $c.300$ cm (east).[195]

There are two main types of relief on the materials from the third church at Urnes. The gables and the door leaf are very shallow and sharply cut; the relief is only 0.5 cm deep. The other type of relief, seen on the portal and the corner post, is mostly rounded on the edges and quite high, with a depth in the range of 5–7 cm (occasionally only 2 cm), which permits the heads of the beasts to be fully modeled.

The portal is horseshoe or keyhole shaped, and the archivolt measures 240 degrees.[196] It consists of jambs, with grooves along the outer edge, and two lintel planks. The left jamb is much wider than the right, and the two also differ in their design, but toward the top they are almost symmetrical. The uppermost lintel plank is missing, but it appears that two or three pairs of confronted and addorsed type II beasts came together above the portal, crossing under and over one another.[197] The apex of the arch is undercut, so that two beasts' heads that cross over each other and duck down into the arch bite the frame, while thin serpentine strands hang down and loop across the arch.

All the decorated parts feature zoomorphic loopwork in an entangled design of type II and III Urnes beasts.[198] These beasts' heads are seen in bird's-eye view, the larger ones with elongated, almond-shaped eyes. The tails of some of these creatures end in three-lobed leaves. The wider left door jamb and the west gable stand out for their related motifs. Both show large, erect type I quadrupeds in combat with type II and III Urnes-style serpents and beasts. The creatures seize each other by the jaws. The quadruped by the door has small ears atop its head, large pointed fangs, a mane consisting of typical Urnes-style scrolled lobes, a long almond-shaped eye pointing toward the elaborate hooked snout, and large, distinct hip spirals. A long tail spirals up across its body in an *S*-shape and terminates in a three-lobed leaf.

The quadruped on the west gable lacks the distinguishing marks of the one by the door. The hip spirals, elongated almond-shaped eye, and hooked lip-lappet are typical of the style, and the

quadruped shares these with its opponents, the type II beasts in the same gable. Also, here, the quadruped seizes one of the bipeds by the jaws, while both bipeds and serpents bite the quadruped. One of the serpents has a tail ending in a lily shape.

The east gable seems to resemble the west one, but on closer inspection, its main motif is a type II biped entangled in serpentine type III creatures. Notably, the zoomorphic loopwork is the same in both gables, but based on the preserved parts, the main type II beast of the east gable is not under attack; rather, the type III creatures bite themselves.

Date
Dendrochronology has shown that the trees for the third church at Urnes III were felled in the winter of 1169–70 or shortly thereafter.[199] The wood was clearly fresh when it was carved, as cracks formed after the execution of the motifs. A date much after 1070 is therefore unlikely.

Provenance
Archaeological excavations and preserved materials have revealed that the present Urnes stave church is the fourth on the site, and there is no reason to think that the materials might have come from elsewhere. Krogh has reconstructed the 1070s church based on the preserved materials, as discussed in Chapter 2.[200]

Vrigstad, Sweden (Fig. 4A.23)

Statens Historiska Museer (Swedish History Museum), Stockholm, inv. nos. SHM 3450:1–3 and 3510:1–4

Description
The database of the SHM includes two series of fragments from Vrigstad with a total of seven fragments.[201] These are not accompanied by photographs, but a series of older photos exists in the Riksantikvarieämbetet database (Fig. 4A.23). Many of the fragments were photographed several times, in different groupings, and it is difficult to identify which is which. No measurements are given except for SHM 3450, where two oak planks are each said to measure 8 feet (i.e., *c.*244 cm). These had been sent to the museum from Vrigstad as samples of the wall-plates from the top of the nave wall of the former church. In the dendrochronological examinations undertaken in 1997 on six of the fragments,[202] the following measurements are listed: inv. no. series 3510: 1–4 = 277 × 43 cm, 160 × 29 cm (the tree for this plank was felled later than the others), and 241 × 42–45 cm; inv. no. 3450: 1–3 = 238 × 27 cm, 237 × 40 cm, and 237 × 27 cm.

All the fragments are oak.[203] Six of them are stylistically and technically close. They feature single or double twisted roll ornaments running horizontally along the top, just below what appears to be the tongue (judging from the photos). Below the twisted roll ornament are different friezes of Urnes-style loopwork in flat, two-plane relief. These are primarily ornamental and do not feature serpentine creatures or beasts, although in a few cases there may be serpents' heads because their

profile is the same as some of the type III serpents' heads on the Urnes west gable of 1070. The lobed tendrils correspond to Gräslund's Pr. 4 (Fig. 4.3). The loopwork is more crowded and is stylistically clearly later than the Hørning wall-plate, but the overall design of Vrigstad closely resembles that at Hørning, with its twisted roll ornament along the outer edge of several of the fragments and loopwork underneath.

One Vrigstad plank (Fig. 4A.24, labeled D) differs from the others in that it lacks the twisted roll along the edge, and, unlike the other Urnes-style loop borders, figure-eight-shaped leaves or wings grow at the bottom.[204] On closer inspection it seems that the pattern may in fact consist of winged type II Urnes beasts, some with blossoming three-lobed tails. The other fragment that differs significantly from the rest (Fig. 4A.24, E) has a double chevron-shaped roll ornament along the top and a flat and very busy late Urnes-style pattern, with what resemble lotus flowers and the bodies of animals twisting within the loopwork. This is reminiscent of other wall-plates that served as footing for the roof construction in stone churches from the same region of Småland, such as Dädesjö and Bringetofta, and it gives the impression of being later than the other fragments.[205] This difference was also noted by Ekhoff, who wrote that floral elements appear on the materials recovered from the nave of the stone church, where the roll ornament is also double.[206] The double roll also appears in the materials from the nearby Hånger church, and a wall-plate from there is dated by dendrochronology to the 1150s.[207]

Date

Scholar have assigned the Vrigstad fragments to the early twelfth century based on their Urnes-style ornamentation, especially the loopwork and the vine shoots that grow from the base of the tendrils on one of them.[208] Wilson characterized Vrigstad as Swedish-type, Urnes-style ornament.[209] In his discussion of early wooden churches, Hauglid used Vrigstad as an example of the longevity of Urnes style and Viking ornament in later wood carving; he dated the pieces to *c.*1200.[210] Some of the material from Vrigstad has been dated by dendrochronology.[211] The report turned up several dates in the eleventh century, the latest 1075. In that case, however, the sapwood was not preserved, so the normal estimate of twenty years was added to produce a more correct date, which means that they should be dated no earlier than *c.*1095.[212] One sample is from the 1180s, and it may be the fragment that gives the impression of being stylistically younger, but, unfortunately, in the databases the dates are not matched with photos of the specific fragments.[213]

Provenance

That most if not all of the Vrigstad fragments belong to the eleventh century or *c.*1100 seems certain, but their original use is an open question. Ullén wrote that a series of five richly decorated planks from Vrigstad have been preserved due to their secondary use in the later, now demolished stone church.[214] That they were rescued from the stone church, which was razed in 1865, is well documented in letters from the late nineteenth century, where they were described as wall-plates from the roof

Fig. 4A.23. Vrigstad, Sweden, fragments. Swedish History Museum, Stockholm, inv. nos. SHM 3450:1–3 and 3510:1–4. Photo: © Riksantikvarieämbetet.

CHAPTER **4A** | APPENDIX: ALPHABETICAL LIST OF FRAGMENTS

267

construction of the stone church.[215] Ekhoff mentioned wooden fragments recovered from the stone church and described them as wall-plates from the roof, but he also noted a difference in design from chancel to nave.[216] Karlsson applied the term *remstycken*, which designates the wall–plate for the wooden roof of a stone church,[217] but David M. Wilson wrote that they may originally have been portal jambs. The latter assertion may have been based on the photo of three fragments in Wilson's 1995 publication, which is turned the wrong way around and therefore gives an erroneous impression.[218] Hauglid explicitly used the term *stavlegje* for the fragments, which means the wall-plate of a stave church; he also noted the decoration and the shape of the fragments.[219] The dendrochronological dates seem a little early for all the fragments to have been made as wall-plates for the stone church, but it is possible. An older grave monument preserved from Vrigstad indicates that it was a religious site long before the stone church was erected.[220] If Ullén's observation that the planks were reused is correct, they may have come from an older church.

Notes

In the following, the Swedish runestone material is often cited for comparison. In the established system, U signifies the Uppland region, Sö Södermannland and Öl the island of Öland.

1 For a detailed descriptions of these panels, see Selma Jónsdóttir, *An 11th Century Byzantine Last Judgement in Iceland* (Reykjavík, 1959); Kristján Eldjárn, "Carved Panels from Flatatunga, Iceland," *Acta Archaeologica* 24 (1953): 81–101; and Hörður Ágústsson, *Dómsdagur og helgir menn á Hólum* (Reykjavík, 1989), at 61, with English summary, 160–63.

2 Ágústsson, *Dómsdagur og helgir menn á Hólum*, 160–63.

3 Ágústsson's reconstruction drawing is also reproduced in Guðrún Harðardóttir recent overview: Harðardóttir "A View on the Preservation History of the Last Judgement Panels from Bjarnastaðahlið, and Some Speculation on the Medieval Cathedrals at Hólar," in *The Nordic Apocalypse: Approaches to "Vǫluspá" and Nordic Days of Judgement*, ed. Terry Gunnell and Annette Lassen (Turnhout, 2013), 205–20, at 210.

4 Jónsdóttir, *An 11th Century Byzantine Last Judgement*, 15, 27–36; See also Ágústsson, *Dómsdagur og helgir menn á Hólum*; and Þóra Kristjánsdóttir, "A Nocturnal Wake at Hólar: The Judgement Day Panels as Possible Explanation for a Miracle Legend?," in Gunnell and Lassen, *Nordic Apocalypse*, 221–31.

5 Jónsdóttir, in *An 11th Century Byzantine Last Judgement*, 27–28.

6 Ibid., 15.

7 Ibid.; Ágústsson, *Dómsdagur og helgir menn á Hólum*, 160–63; and Harðardóttir, "View on the Preservation History," 210.

8 Karen Þóra Sigurkarlsdóttir, "Varðveislusaga Bjarnastaðahliðarfjala á Þjóðminjasafní Íslands,'" in *Á efsta degi: Bysönsk dómsdagsmynd frá Hólum*, ed. Bryndis Sverrisdóttir (Reykjavík, 2007), 41–47, at 45.

9 Harðardóttir, "View on the Preservation History"; and Ágústsson, *Dómsdagur og helgir menn á Hólum*, 160.

10 Eldjárn, "Carved Panels from Flatatunga."

11 Jónsdóttir, *An 11th Century Byzantine Last Judgement*, 87.

12 Ibid., 47–55, and conclusion, 87.

13 Ágústsson, *Dómsdagur og helgir menn á Hólum*, 160–63.

14 Ibid.

15 Harðardóttir, "View on the Preservation History," 9–10n14.

16 Ibid., 212–13.

17 Ellen Marie Magerøy and Håkon Christie, "Dómsdagur og helgir menn á Hólum: Bokanmeldese," *Årbok: Foreningen til norske fortidsminnesmerkers bevarings* 144 (1990): 227–32.

18 Erla Bergendahl Hohler, *Norwegian Stave Church Sculpture*, 2 vols. (Oslo, 1999), 1:113–14; and Roar Hauglid, "Bjølstad kirke i Heidal: Datering og konstruksjon," *Årbok: Foreningen til norske fortidsminnesmerkers bevaring* 112 (1958): 119–34.

19 Hohler, *Norwegian Stave Church Sculpture*, 1:113–14.

20 As defined in Chapter 4, type I beasts are quadrupeds seen in profile; type II beasts are snakelike with one clear limb and a second that mixes a limb with a tail; and type III beasts are ribbon-shaped serpents with no limbs, often recognizable by their triangular heads seen from above.

21 Haakon Shetelig, "Urnesgruppen: Det sidste avsnit av vikingetidens stilutvikling," *Årbok: Foreningen til norske fortidsminnessmerkers bevaring* 65 (1909): 75–107; and David M. Wilson and Ole Klindt-Jensen, *Viking Art* (London, 1966), 148.

22 Hohler, *Norwegian Stave Church Sculpture*, 1: 114 and 2: 11; and Roar Hauglid, *Norske stavkirker: Dekor og utstyr* (Oslo, 1973), 24–26.

23 In Södermanland there are cists of a type often referred to as Eskilstuna sarcophagi, named after the first known example, from Eskilstuna (Tuna). These are dated to the eleventh century. The cists were apparently located near early wooden churches. See Sigurd Curman and Erik Lundberg, *Östergötland*, vol. 2, *Vreta klosters kyrka* (Stockholm, 1935), 171–78. For the most recent perspective on the Eskilstuna sarcophagi and Swedish grave monuments, see Cecilia Ljung, "Early Christian Grave Monuments and Ecclesiastical Developments in 11th-Century Sweden," *Medieval Archaeology* 63.1 (2019): 154–90.

24 Hauglid, *Norske stavkirker: Dekor og utstyr*, 24–26; and Roar Hauglid, *Norske stavkirker: Bygningshistorisk bakgrunn og utvikling* (Oslo, 1976), 235–38.

25 Anne-Sofie Gräslund, "Dating the Swedish Viking-Age Rune Stones on Stylistic Grounds," in *Runes and Their Secrets: Studies in Runology*, ed. Marie Stoklund et al. (Copenhagen, 2006), 117–39; and Anne-Sofie Gräslund, "The Late Viking Age Runestones of Västergötland: On Ornamentation and Chronology," *Lund Archaeological Review* 20 (2014): 39–53. Gräslund's proposed dates for the groups are: Pr. 1, *c.*1010–40; Pr. 2, *c.*1020–50; Pr. 3, *c.*1045–75; Pr. 4, *c.*1070–1100; and Pr. 5, *c.*1100– 30.

26 Hohler, *Norwegian Stave Church Sculpture*, 1:113–14.

27 Ibid., 2:33; Ahrens, *Die frühen Holzkirchen Europas*, 2 vols. (Stuttgart, 2001), 1:110–14, 220, 2:190–92; Elna Møller and Olaf Olsen, "Danske trækirker," in *Nationalmuseets Arbejdsmark*, 1961, 35–58, at 57; Hauglid, *Norske stavkirker: Bygningshistorisk bakgrunn og utvikling*, 212; and Lennart Karlsson, *Romansk träornamentik i Sverige = Decorative Romanesque Woodcarving in Sweden* (Stockholm, 1976), 10, 20.

28 Hohler, *Norwegian Stave Church Sculpture*, 2:30–32.

29 Møller and Olsen, "Danske trækirker," 57.

30 Cecilia Ljung, "Under runristad häll: Tidigkristna gravmonument i 1000-talets Sverige," *Stockholm Studies in Archaeology* 67.1–2 (2016), 2:140.

31 Lennart Karlsson, *Nordisk form: Om djurornamentik* (Stockholm, 1976), 76.

32 For an illustration and discussion of the slab, see Ljung, *Under runristad häll*, 2:340.

33 Ljung, "Early Christian Grave Monuments," 157.

34 Aase Folkvord, "Dekorerte tresaker fra folkebibliotekstomta i Trondheim: Beskrivelse, analyse og vurdering" (MA thesis, NTNU, Trondheim, 2007); https://www.duo.uio.no/handle/10852/24681.

35 Karl Magnus Mellin informs me that dendrochronological examinations are currently under way.

36 Gunilla Gardelin, *Kyrkornas Lund* (Lund, 2015); and Marian Ullén, "Byyga i trä," in *Den romanska konsten*, ed. Lennart Karlsson et al. (Lund, 1995), 35–52, at 38–39.

37 Monica Rydbeck, "The Two Fragments of a Timber Church at Brågarp: A Supplement," *Meddelanden från Lunds Universitets Historiska Museum*, 1946, 110–14.

38 Erland Lagerlöf and Bengt Stolt, *Eke kyrka* (Stockholm, 1974), 458–71.

39 Ibid., 465.

40 Ibid., 262–64.

41 Ahrens, *Die frühen Holzkirchen Europas*, 1:246–47. Ahrens refers to Erland Lagerlöf, "Bysantinsk måleri från en gotländsk stavkyrka," in *Den ljusa medeltiden: Studier tillägnade Aron Andersson*, ed. Lennart Karlsson et al. (Stockholm, 1984), 123–32.

42 Lagerlöf and Stolt, *Eke kyrka*, 458–71; and Ahrens, *Die frühen Holzkirchen Europas* 2:223.

43 I am grateful to Gunnar Almevik for allowing me to see this report.

44 Lagerlöf and Stolt, *Eke kyrka*, 262–64.

45 Signe Horn Fuglesang, *Some Aspects of the Ringerike Style: A Phase of Eleventh Century Scandinavian Art* (Odense, 1980), 197; and Eldjárn, "Carved Panels from Flatatunga."

46 Eldjárn, "Carved Panels from Flatatunga."

47 Hohler, *Norwegian Stave Church Sculpture*, 2:49–50.

48 Ellen Marie Magerøy, "Flatatunga Problems," *Acta Archaeologica* 32 (1961): 153–72; Ágústsson, *Dómsdagur og helgir menn á Hólum*, 160–63; and Þóra Kristjánsdóttir, "Islandsk kirkekunst," in *Kirkja ok Kirkjuskrud: Kirker og Kirkekunst på Island og i Norge i middelalderen*, ed. Lilja Árnadóttir and Ketil Kiran (Oslo, 1997), 53–60.

49 Fuglesang, *Some Aspects of the Ringerike Style*, 197; Signe Horn Fuglesang, "Vikingtidens kunst," in *Norges Kunsthistorie*, vol 1, *Fra Oseberg til Borgund*, ed. Hans-Emil Lidén et al. (Oslo, 1981), 36–138, at 95.

50 Jónsdóttir, *An 11th Century Byzantine Last Judgement*.

51 Àgústsson, *Dómsdagur og helgir menn á Hólum*.

52 Harðardóttir, "View on the Preservation History."

53 Ágústsson, *Dómsdagur og helgir menn á Hólum*, 160–63.

54 Eldjárn, "Carved Panels from Flatatunga."

55 Ágústsson, *Dómsdagur og helgir menn á Hólum*, 160–63.

56 Ibid., 152; Margrét Hermanns-Auðardóttir, "Hringaríkisstíll frá Gaulverjabæ," *Gersemar og þarfaþing: Úr 130 ára sögu Þjóðminjasafns Íslands*, ed. Árni Björnsson (Reykjavík, 1994), 234–35; and Þór Mágnússon, "Hringaríkisútskurður frá Gaulverjabæ," *Árbók hins íslenzka fornleifafélags* 71 (1974): 63–74; dimensions, 74. This article, with English summary, is available at https://timarit.is/page/2053926#page/n55/mode/2up. I am grateful to Guðrún Harðardóttir for discussing this piece, and the sources, with me.

57 A cuff consists of two parallel lines and is defined as a "*cross-band* at the ankle or wrist section of a zoomorphic limb." Uaininn O'Meadhra, *Early Christian, Viking and Romanesque Art: Motif-Pieces from Ireland*, vol. 1, *An Illustrated and Descriptive Catalogue of the So-Called Artists' "Trial-Pieces" from c.5th – 12th Cents. AD, Found in Ireland c.1830–1973* (Stockholm, 1979), 11.

58 Sarpur.is, at no. 1974:217 Gaulverjabæ: https://www.sarpur.is/Adfang.aspx?AdfangID=320863.

59 Mágnússon, "Hringaríkisútskurður frá Gaulverjabæ," 73–74.

60 Erland Lagerlöf, *Medeltida träkyrkor II* (Stockholm, 1985), 231–32, 260; Sigurd Curman et al., *Kyrkor i Glanshammars härad: Sydvästra delen; Konsthistoriskt inventarium* (Stockholm, 1961), 391–98, and figs. 341–42; Karlsson,

Romansk träornamentik i Sverige, 68, 84, ill. 142; and Ljung, *Under runristad häll*, 1:123.

61 Curman et al., *Kyrkor i Glanshammars härad*, 391; and Ljung, *Under runristad häll*, 1:123.

62 Curman et al., *Kyrkor i Glanshammars härad*, 392.

63 "vermutlich also als Rähme oder als Wandplanke eines Bohlenbaus." Ahrens, *Die frühen Holzkirchen Europas*, 304.

64 Karlsson, *Romansk träornamentik i Sverige*, 68, 84; and Ljung, *Under runristad häll*, 1:123.

65 Ahrens, *Die frühen Holzkirchen Europas*, 304.

66 Karlsson, *Romansk träornamentik i Sverige*, 68; and Ljung, *Under runristad häll*, 1:123.

67 Ljung, "Early Christian Grave Monuments."

68 Karlsson, *Romansk träornamentik i Sverige*, 68, referring to David M. Wilson, *Viking Art* (London, 1966), 142; and Ljung, *Under runristad häll*, 2:37–38.

69 Curman et al., *Kyrkor i Glanshammars härad*, 391–92; and Lagerlöf, *Medeltida träkyrkor II*, 131.

70 Ljung, *Under runristad häll*, 1:123–24.

71 Lagerlöf, *Medeltida träkyrkor II*, 231–32, 260; Curman et al., *Kyrkor i Glanshammars härad*, 391–98 and figs. 341–42; Karlsson, *Romansk träornamentik i Sverige*, 68, 84, ill. 142; and Ljung, *Under runristad häll*, 1:123.

72 Ljung, *Under runristad häll*, 1:123.

73 Ibid.; Curman et al., *Kyrkor i Glanshammars härad*, 390; and Lagerlöf, *Medeltida träkyrkor II*, 231.

74 Curman et al., *Kyrkor i Glanshammars härad*, 392.

75 Signe Horn Fuglesang and Gerd Stamsø Munch, "Den dekorerte planken fra Haug i Hadsel," *Årbok: Foreningen til norske fortidsminnesmerkers bevaring* 145 (1991): 245–52, at 246–48.

76 Ibid., 249.

77 Ibid., 250; and David M. Wilson, *Vikingatidens konst*, trans. Henrika Ringbom (Lund, 1995), 207. On the Eskilstuna sarcophagi, see Ljung, "Early Christian Grave Monuments," 155.

78 Fuglesang and Munch, "Den dekorerte planken fra Haug i Hadsel"; Griffin Murray, "Viking Influence in Insular Art: Considering Identity in Early Medieval Ireland," in *Peopling Insular Art: Practice, Performance, Perception*, ed. Cynthia Thickpenny et al. (Oxford, 2020), 51–57, at 55. See also James T. Lang, *Viking-Age Decorated Wood: A Study of Its Ornament and Style*, Medieval Dublin Excavations 1962–81, Series B, vol. 1 (Dublin, 1988), cat. nos. 32–35; Uaininn O'Meadhra, *Early Christian, Viking and Romanesque Art: Motif-pieces from Ireland* (Stockholm, 1979–87), 1: cat. nos. 26, 32, 35, 55. For the date of the "Cathach" book shrine, see Griffin Murray, "Viking Influence in Insular Art: Considering Identity in Early Medieval Ireland," in *Peopling Insular Art: Practice, Performance, Perception*, ed. Cynthia Thickpenny et al. (Oxford, 2020), 51–57, at 55.

79 Fuglesang and Munch, "Den dekorerte planken fra Haug i Hadsel," 247.

80 Ibid., 246–48.

81 Ibid., 247–48.

82 Ibid., 247.

83 Karlsson, *Romansk träornamentik i Sverige*, 68–69, 82, 163–64, and ill. 153; Karlsson, *Nordisk form*, 60; and Ljung, *Under runristad häll*, 1:123.

84 Karlsson, *Nordisk form*, 60.

85 Karlsson, *Romansk träornamentik i Sverige*, 68–69, 82.

86 Ivar Schnell, *Kyrkorna i Södermanland* (Nyköping, 1965), 31.

87 Ljung, *Under runristad häll*, 1:116, quote at 123.

88 For Örberga, see Ljung, *Under runristad häll*, 2:338.

89 Ljung, "Early Christian Grave Monuments."

90 See the Linköping stift's inventory of early Christian graves in Rikard Hedvall and Hanna Menander, *Inventering av tidigkristna gravmonument i Linköpings stift* (Linköping, 2009), no. 414.

91 The gable has a Latin inscription quoting Luke 23:24; see Anna Blennow, *Sveriges medeltida latinska inskrifter 1050–1250: Edition med språklig og paleografisk kommentar* (Stockholm, 2016), 216–18; and Ljung, "Early Christian Grave Monuments," 181–82.

92 Ljung, *Under runristad häll*, 1:116; and Schnell, *Kyrkorna i Södermanland*, 164.

93 Schnell, *Kyrkorna i Södermanland*, 31.

94 Ljung, *Under runristad häll*, 1:108–10, 116. Ljung points to Gräslund's Pr. 2 and Pr. 3 for stylistic parallels to the coffin.

95 Archaeology has revealed swift and profound changes in burial traditions resulting in unified Christian practices contemporary with early Church formation. Christian grave monuments took the form of cists or recumbent slabs. Ljung, "Early Christian Grave Monuments," 175–78.

96 Ljung, *Under runristad häll*, 1:116.

97 Hohler, *Norwegian Stave Church Sculpture*, 1:172; and Knud J. Krogh, *Urnesstilens kirke: Forgængeren for den nuværende kirke på Urnes* (Oslo, 2011), 204–5; and Hauglid, *Norske stavkirker: Bygningshistorisk bakgrunn og utvikling*, 238–39.

98 Krogh, *Urnesstilens kirke*, 206–7.

99 Hohler, *Norwegian Stave Church Sculpture*, 1:172, cat. no. 105:1–2; Krogh, *Urnesstilens kirke*, 206–7; Liv Helga Dommasnes and Alf Tore Hommedal, "One Thousand Years of Tradition and Change on Two West-Norwegian Farms AD 200–1200," in *The Farm as a Social Arena*, ed. Liv Helga Dommasnes, Doris Gutsmiedl-Schümann, and Alf Tore Hommedal (Münster, 2016), 127–69; and Alf Tore Hommedal, "Ei stavkyrkje ved Bergens museum? Om flytteplanane for Hoppestad stavkyrkje," *Årbok for Universitetsmuseet i Bergen*, 2017, 33–42.

100 Kristján Eldjárn, "Forn útskurður frá Hólum í Eyjafirði," *Árbók hins Íslenzka fornleifafélags* 64 (1967): 5–24; Fuglesang, *Some Aspects of the Ringerike Style*, 197; and Ágústsson, *Dómsdagur og helgir menn á Hólum*.

101 Sarpur.is, under Hólar no. 1966-294; https://www.sarpur.is/Adfang.aspx?AdfangID=329167.

102 Uwe Albrecht, ed., *Corpus der mittelalterlichen Holzskulptur und Tafelmalerei in Schleswig-Holstein*, vol. 2, *Schloss Gottorf* (Kiel, 2016), 25–27; Karola Kröll, "Eine wikingerzeitliche Stabkirche in Südjütland? Studien zu einem verzierten Eichenbalken aus Humptrup, Kreis Nordfriesland," *Offa* 56 (1999): 421–79; Møller and Olsen, "Danske trækirker," 50–51, 57–58; and Hauglid, *Norske stavkirker: Dekor og utstyr*, 48–49. I am grateful to Dr. Uta Kuhl, curator at the Skulpturensammlung, Museum für Kunst und

Kulturgeschichte Stiftung Schleswig-Holsteinische Landesmuseen Schloss Gottorf, for her help in my work with the Humptrup fragments.

103 Ahrens, *De frühen Holzkirchen Europas*, 2:45.
104 Møller and Olsen, "Danske trækirker," 57–58.
105 Kröll, "Eine wikingerzeitliche Stabkirche in Südjütland?"
106 Ibid., 443–44.
107 Ibid., 444.
108 Ahrens, *Die frühen Holzkirchen Europas*, 1:227.
109 Kröll, "Eine wikingerzeitliche Stabkirche in Südjütland?," 438–39.
110 See, e.g., Ahrens, *De frühen Holzkirchen Europas*, 2:45; and Kröll, "Eine wikingerzeitliche Stabkirche in Südjütland?," 438–39.
111 Møller and Olsen, "Danske trækirker," 57–58.
112 Kröll, "Eine wikingerzeitliche Stabkirche in Südjütland?," 443.
113 Ibid., figs. 5 and 9.
114 The tightly scrolled tails are comparable to the picture runestones U 644 and U 1172. See Gräslund, "Dating the Swedish Viking-Age Rune Stones," 132.
115 Kröll, "Eine wikingerzeitliche Stabkirche in Südjütland?," 443.
116 Ibid., 421–79.
117 Mads Chr. Christensen, "Painted Wood from the Eleventh Century: Examination of the Hørning Plank," *Medieval Painting in Northern Europe: Techniques, Analysis, Art History; Studies in Commemoration of the 70th Birthday of Unn Plahter*, ed. Jilleen Nadolny et al. (London, 2006), 34–42; Else Roesdahl, "Dendrochronology and Viking Studies in Denmark, with a Note on the Beginning of the Viking Age," in *Developments around the Baltic and the North Sea in the Viking Age: Twelfth Viking Congress*, ed. Björn Ambrosiani and Helen Clarke (Stockholm, 1994), 106–16; and Ahrens, *Die frühen Holzkirchen Europas*, 2:201.
118 Knud J. Krogh and Olfert Voss, "Fra hedenskab til kristendom i Hørning: En vikingetids kammergrav og en trækirke fra 1000tallet under Hørning kirke," *Nationalmuseets Arbejdsmark*, 1961, 5–34, at 9.
119 Christensen, "Painted Wood from the Eleventh Century," 39.
120 Ibid., 34–42; and Line Bregnhøi and Mads Chr. Christensen, "Sagnlandet Lejre: Vikingetidens farvepalet," Nationalmuseet, Bevaring & Naturvidenskab, 1–8; https://natmus.dk/fileadmin/user_upload/natmus/historisk-viden/Viking/Vikingernes_farvepalet/Vikingetidens_farvepalet_Rapport.pdf.
121 Christensen ("Painted Wood from the Eleventh Century," 38 and 42n14) points out that a very similar motif has been found in the Carolingian abbey of Corvey, in North Rhine-Westphalia.
122 Ibid., 38.
123 Niels Bonde, unpublished NNU Report, Nationalmuseets Naturvidenskabelige undersøgelser, J. no. A. 4340 (Copenhagen, 1991); Christensen, "Painted Wood from the Eleventh Century," 35; and Roesdahl, "Dendrochronology and Viking Studies in Denmark."
124 Krogh and Voss, "Fra hedenskab til kristendom i Hørning"; and Holger Schmidt, "Om rekonstruktion av stavkirken fra Hørning," in *Beretning fra femtende tværfaglige vikingesymposium*, ed. Preben Meulengracht Sørensen and Else Roesdahl (Højbjerg, 1996), 56–64.
125 Ahrens, *Die frühen Holzkirchen Europas*, 2:201–2.
126 Krogh, *Urnesstilens kirke*, 210.
127 Ibid., 210.
128 Martin Blindheim, *Graffiti in Norwegian Stave Churches, c.1150–c.1350* (Oslo, 1985), 37, 56–59, plates XLI–XLII.
129 Emil Ekhoff, *Svenska stavkyrkor: Jämte iakttagelser över de norska samt redogörelse för i Danmark och England kända lämningar av stavkonstruktioner* (Stockholm, 1914–16), 318.
130 Ibid., 307–25.
131 Erland Lagerlöf, *Medeltida träkyrkor II*, 233–37, 233. Lagerlöf refers to Sune Zachrison's excavation in 1963.
132 Ibid., 233–37, 260. Claus Ahrens concludes that it belongs to the first half of twelfth century because a stone church was built on the spot after 1150. Ahrens, *Die frühen Holzkirchen Europas*, 1:369 and 2:251–52.
133 Ibid., 1:305.
134 http://www.bebyggelseregistret.raa.se, s.v., "Mosjö, Närke".
135 Statens Historisk Museum, inv. no. 12456. Ahrens, *Die frühen Holzkirchen Europas*, 2:253–54.
136 Ekhoff, *Svenska stavkyrkor*, 307–25; and Lagerlöf, *Medeltida träkyrkor II*, 235–36, 260.
137 Ahrens, *Die frühen Holzkirchen Europas*, 1:305–6.
138 "Myresjö," in Riksantikvarieämbetet database. https://kringla.nu/kringla/objekt?referens=shm/media/35492; and https://kringla.nu/kringla/objekt?referens=shm/object/116189. Information about the stave church can also be found at: https://bebyggelseregistret.raa.se/bbr2/byggnad/visaHistorikText.raa?byggnadBeskrivningId=21720000080606&byggnadId=21400000443002&historikId=21000001874931.
139 Karlsson, *Romansk träornamentik i Sverige*, 140, 150, figs. 88, 187. Karlsson compares the loopwork to the much earlier Allskog stone (G 110), but the comparison is not close.
140 Ibid., figs. 88, 187.
141 Marian Ullén, ed., *Småland: Landskapets kyrkor* (Stockholm, 2006), 63. Ullén writes that Thomas Bartholin undertook dendrochronological analyses and refers to "Bartholin 1997," but this reference is not elaborated further.
142 Report on Myresjö by Aron Andersson, 1957, in the archives of the Swedish History Museum under inv. no. SHM 11750.
143 Robin Gullbrandsson, "Myresjö gamla kyrka," Jönköping Läns Museum, Byggnadsvårdsrapport 2007:22, 12; available at https://jonkopingslansmuseum.se/wp-content/uploads/2018/01/Myresjo-gamla-kyrka.pdf.
144 Ullén, *Småland*, 63.
145 Fuglesang, *Some Aspects of the Ringerike Style*, 27, 69, 196–97; and Ellen Marie Magerøy, "Tilene fra Mödrufell i Eyjafjord," *Viking* 17 (1953): 43–62, at 59–60.
146 Hohler, *Norwegian Stave Church Sculpture*, 2:49.
147 Magerøy, "Tilene fra Mödrufell i Eyjafjord," 59–60; and Fuglesang, *Some Aspects of the Ringerike Style*, 27, 69.
148 Magerøy, "Tilene fra Mödrufell i Eyjafjord," 60.

149 Ibid., 59. This depends, of course, on the chronology of the runestones. Margerøy suggest that Fótr was active from the mid-eleventh century onward.

150 Fuglesang, *Some Aspects of the Ringerike Style*, 27, 69.

151 Ibid., 69.

152 Ibid., 196–97; and Magerøy, "Tilene fra Mödrufell i Eyjafjord."

153 I am grateful to Nadezhda N. Tochilova for her help with the study of the Russian material.

154 See the museum's webpage, https://novgorod-iss.kamiscloud.ru/entity/OBJECT/127248?query=резные&fund=11&index=1.

155 Erla Bergendahl Hohler, "Two Wooden Posts found in Novgorod: A Note on Their Date and Stylistic Connection," *Collegium Medievale* 16 (2003): 37–50, at 38; Nadezhda N. Tochilova and Anna Slapinia, "From Wawel Hill to Volkhov River Bank: To the Question of the Presumptive Influence of the Pre-Romanesque Polish Architecture to the Decoration of So-Called 'Columns of Oak Sophia from Novgorod,'" *Quaestiones Medii Aevi Novae* 23 (2018): 405–26, at 406.

156 Hohler, "Two Wooden Posts found in Novgorod," 38.

157 Ibid., 37–50; and Tochilova and Slapinia, "From Wawel Hill to Volkhov River Bank."

158 Hohler, "Two Wooden Posts found in Novgorod," 40.

159 Tochilova and Slapinia, "From Wawel Hill to Volkhov River Bank."

160 Hohler, "Two Wooden Posts found in Novgorod," 41–48.

161 Else Roesdahl and David M. Wilson, eds., *From Viking to Crusader: The Scandinavians*

and Europe, 800–1200 (Copenhagen, 1992).

162 Tochilova and Slapinia, "From Wawel Hill to Volkhov River Bank"; and Marina A. Rodionova, Victor A. Popov, and Nadezhda N. Tochilova, "'Oak-Wood Cathedral of St. Sophia' Pillars from 11th Century Novgorod: Some Aspects of Russian and Scandinavian Wood Carvings in the Middle Ages"; https://www.academia.edu/11766404/OAK_WOOD_CATHEDRAL_OF_ST_SOPHIA_PILLARS_FROM_11th_CENTURY_NOVGOROD; and Victor A. Popov and Nadezhda N. Tochilova, "The Archaeological Study of the Wooden Religious Architecture of Medieval Novgorod," in *Historic Wooden Architecture in Europe and Russia: Evidence, Study and Restoration*, ed. Evgeny Khodakovsky and Siri Skjold Lexau (Basel, 2015), 42–57.

163 Tochilova and Slapinia, "From Wawel Hill to Volkhov River Bank," 415–16.

164 Ibid., 405–24. The authors refer to Barbara Malik's study of the Wawel fragments: Malik, "Relikty przedrománskiej decoracji plecionkowej na Wawelu," *Studia Waweliana* 9–10 (2000–2001): 195–204.

165 Tochilova and Slapinia, "From Wawel Hill to Volkhov River Bank," 418.

166 B. A. Kolchin, *Wooden Artefacts from Medieval Novgorod* (Oxford, 1989); and Hohler, "Two Wooden Posts found in Novgorod," 38.

167 Tochilova and Slapinia, "From Wawel Hill to Volkhov River Bank," 405–7.

168 Krogh, *Urnesstilens kirke*, 204; and Hohler, *Norwegian Stave Church Sculpture*, 1:206.

169 Hohler, *Norwegian Stave Church Sculpture*, 1:206; and Krogh, *Urnesstilens kirke*, 204–5.

170 Leif Anker, "Stave Church Research and the Norwegian Stave Church Programme: New Findings–New Questions," in Khodakovsky and Lexau, *Historic Wooden Architecture in Europe and Russia*, 94–109, at 104–5.

171 Inv. no. T 30000 NTNU Vitenskapsmuseet (Norwegian University of Science and Technology Museum, Trondheim).

172 Hohler, *Norwegian Stave Church Sculpture*, 1:210–11.

173 Hauglid, *Norske stavkirker: Dekor og utstyr*, 183.

174 Anders Bugge, *Norske stavkirker* (Oslo 1953), 40.

175 Martin Blindheim, *Norwegian Romanesque Decorative Sculpture, 1090–1210* (London, 1965), 33.

176 Ibid.

177 Hohler, *Norwegian Stave Church Sculpture* 1:210–11.

178 Ibid.

179 Hohler, *Norwegian Stave Church Sculpture*, 1:222; Hauglid, *Norske stavkirker: Dekor og utstyr*, 46–47, 98–99; and Hauglid, *Norske stavkirker: Bygningshistorisk bakgrunn og utvikling*, 236–39.

180 Hauglid, *Norske stavkirker: Dekor og utstyr*, 46–47; and Signe Horn Fuglesang "Stylistic Groups in Late Viking and Early Romanesque Art," *Acta ad archaeologiam et artium historiam pertinentia* 8.1 (1981): 79–125, esp. 125. Hohler (*Norwegian Stave Church Sculpture*, 1:222) did not discuss the date of Torpo but referred to Hauglid and Fuglesang.

181 Signe Horn Fuglesang, "Animal Ornament: The Late Viking Period," in *Tiere, Menschen, Götter: Wikingerzeitliche Kunststile und ihre neuzeitliche Rezeption: Referate gehalten auf einem von der Deutschen Forschungsgemeinschaft geförderten Internationalen Kolloquium der Joachim Jungius-Gesellschaft der Wissenschaften, Hamburg*, ed. Michael Müller-Wille and Lars Olof Larsson (Göttingen, 2001), 157–94, at 175–77, 180. Others have dated Ásmundr's work slightly later (see Chapter 4). Hauglid (*Norske stavkirker: Dekor og utstyr*, 58–60) notes other winged dragons in the Urnes material prior to the influence of Romanesque, but he still argued that Torpo was influenced by the Romanesque.

182 Universitetets Oldssaksamling (Oslo University Museum), inv. no. C21999.

183 Hohler, *Norwegian Stave Church Sculpture*, 1:182–83, and 2:36, 66–67, 107.

184 Moe, "Urnes and the British Isles," 9.

185 Belonging to Gräslund's group P4, which signifies the Urnes style proper in her study of the facial features and limbs of the serpents in the picture runestones. Gräslund, "Late Viking Age Runestones of Västergötland."

186 Other picture runestones that depict Urnes-style animals with wings are U 1171, U 887, and Öl 21, but these differ in shape from the Torpo example. For Bräckstad (U 1039), see also Karlsson, *Nordisk form*, 70.

187 Hohler, *Norwegian Stave Church Sculpture*, 1:257–58.

188 Hohler (ibid., 1: 29) also points to flat relief as an element of the early portals, listing Bjølstad, Torpo, and Vågå.

189 E-mail from Axel Christophersen, 14 September 2020.

190 Krogh, *Urnesstilens kirke*.

191 For a discussion of these parts, see ibid., 12–18.

192 All measurements from Hohler, *Norwegian Stave Church Sculpture*, 1:234–37.

193 Ibid., 1:234–35.

194 According to Hohler (ibid., 1:237), several posts from the 1070s church are preserved and reused as corner posts in the present structure.

195 Ibid.

196 Jørgen H. Jensenius, "Trekirkene før stavkirkene: En undersøkelse av planlegging og design av kirker før ca år 1100" (PhD diss., AHO, Oslo, 2001), 100, 103, 108, fig. 14.

197 Krogh, *Urnesstilens kirke*, 235; and Hohler, *Norwegian Stave Church Sculpture*, 1:235.

198 Many authors have discussed the Urnes portal and the ornamentation of the church. For an overview, with references, see Hohler, *Norwegian Stave Church Sculpture*, 1:234–37, 241.

199 Terje Thun et al., "Dendrochronology Brings New Life to the Stave Churches: Dating and Material Analysis," in *Preserving the Stave Churches: Craftsmanship and Research*, ed. Kristin Bakken, trans. Ingrid Greenhow and Glenn Ostling (Oslo, 2016), 91–116, at 96. For an overview of the dates suggested before the dendrochronological results appeared, see Hohler, *Norwegian Stave Church Sculpture*, 1:236.

200 Krogh, *Urnesstilens kirke*, 194–200.

201 https://kringla.nu/kringla/objekt?referens=shm/object/268105; and https://kringla.nu/kringla/objekt?referens=shm/object/268106.

202 Niels Bonde, "Vrigstad Kyrka, Småland, Sverige." NNU rapportblad 1997 j.nr. A7875, Dendro tsb 4" (Nationalmuseet, Copenhagen), https://natmus.dk/fileadmin/user_upload/Editor/natmus/nnu/Dendro/1997/A7875delrap.pdf. I am grateful to Niels Bonde for his assistance in my work with the Vrigstad fragments.

203 Marian Ullén, *Medeltida träkyrkor I* (Stockholm, 1983), 245.

204 These vines may also be compared to those at Skalunda; for an illustration, see Karlsson, *Nordisk form*, 86.

205 For an illustration, see Karlsson, *Romansk träornamentik i Sverige*, figs. 120, 129.

206 Ekhoff, *Svenska stavkyrkor*, 142.

207 Ullén, *Medeltida träkyrkor I*, 98–102.

208 Ljung, *Under runristad häll*, 1:20.

209 Wilson, *Vikingatidens konst*, 188–91.

210 Hauglid, *Norske stavkirker: Dekor og utstyr*, 22, 47–48.

211 Bonde, "Vrigstad Kyrka, Småland, Sverige."

212 On the methodology, see Thun et al., "Dendrochronology Brings New Life to the Stave Churches, esp. "Sapwood Statistics," 94–97. Ullén, *Medeltida träkyrkor I*, 246, discusses how the Swedish sequences were established and the earlier dates first indicated for Vrigstad.

213 Bonde, "Vrigstad Kyrka, Småland, Sverige."

214 Ahrens, *Die frühen Holzkirchen Europas*, 2:271–72; and Ekhoff, *Svenska stavkyrkor*, 141–44.

215 Available on kringla.se; see, e.g., https://kringla.nu/kringla/objekt?referens=shm/object/268105 and https://kringla.nu/kringla/objekt?referens=shm/object/268106.

216 Ekhoff, *Svenska stavkyrkor*, 141–44.

217 Karlsson, *Romansk träornamentik i Sverige*, 56, 61, 68, 89, 115, 124, and 132.

218 Wilson, *Vikingatidens konst*, 190.

219 Hauglid, *Norske stavkirker: Dekor og utstyr*, 23, 47–48.

220 Ljung, *Under runristad häll*, 1:20–21.

CHAPTER 5

The European Significance of Urnes: An Insular Perspective on Urnes and the Urnes Style

Griffin Murray

Introduction

THIS CHAPTER TAKES A FRESH APPROACH to the famous sculpture at Urnes reused from the earlier church (Urnes III), the wood for which was felled in 1069–70.[1] It uses archaeological, art historical, and documentary evidence, principally from Ireland but also from Britain, to help contextualize the older church. The rich documentary sources available for Ireland from before the twelfth century are particularly useful. The chapter is divided into two sections. The first part examines a significant, yet little explored, aspect of the background to Norwegian stave churches by discussing the evidence for timber churches in the Insular world (i.e., Ireland and areas of Irish influence in Britain). This helps elucidate some of the architectural and artistic antecedents to Urnes and also some of the potential significance and symbolism around the reuse of material in churches. The second part discusses the substantial evidence for the Urnes style in Ireland, which gives us an idea of what early church furnishings in Norway may have looked like. It reviews scholarship on the Urnes style in Ireland to date and considers why the style flourished there, examining the context of the introduction of the style to Ireland and Hiberno-Norse political relations of the time. Furthermore, it looks at the longevity of the style as it was employed on Romanesque churches in Ireland and questions what evidence we may be missing in terms of Insular wood carving. Although this chapter focuses mainly on Ireland, we may conclude from it that the Urnes style was not something marginal but, rather, was a major style of European Christian art.

CHAPTER FIVE | THE EUROPEAN SIGNIFICANCE OF URNES

Before Urnes: The Book of Kells and Timber Churches in the Insular World

Urnes and the other stave churches are survivors of what was once a long and much older tradition of timber churches in northwestern Europe. If we are to understand them fully, they need to be examined within this longer tradition. One obvious difficulty is the fact that, with only a few minor exceptions, medieval stave churches generally do not survive outside of Norway, even though they appear to have been common across Scandinavia.[2] Only one timber church has the potential to be marginally older than Urnes, the one at Greensted, Essex, in England, which is dated to the late eleventh century.[3] Yet we also know, often from archaeological excavations, that timber churches existed across northwestern Europe before the eleventh century and in some cases afterwards.[4] Therefore, Norwegian stave churches should not be seen as an isolated development but, rather, as a unique survivor of broader practices.

The situation in Norway may be compared to that in Ireland (Fig. 5.1). Although Ireland was Christianized centuries earlier, beginning in the fifth century, the Irish built their churches almost exclusively in timber up to the tenth century, with most continuing to be made of timber up to 1200.

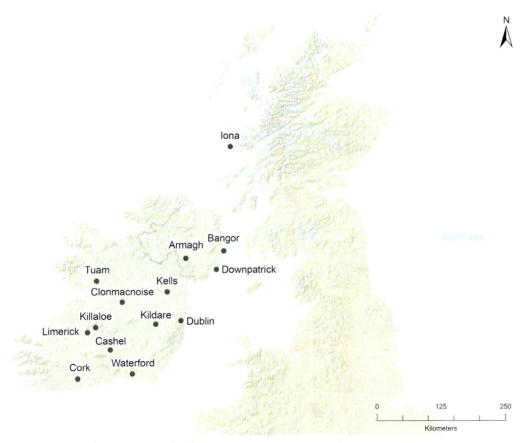

Fig. 5.1. Map of Ireland with principal sites mentioned in the text. Map: Magnar Mojaren Gran.

275

Notably, even when stone churches began to be built in Ireland, they copied features of the timber churches that they replaced.[5] Bernard of Clairvaux's account of the building of churches in the *Life of Malachy*, who lived from 1094 to 1148, gives the impression that timber churches were still dominant in Ireland in the early twelfth century: "Malachy thought a stone oratory should be built at Bangor [county (hereafter Co.) Down] similar to those which he had seen erected in other places. And when he began to lay the foundations, the natives were all amazed, because no buildings of that kind were found in the region." One of Malachy's detractors is reputed to have stated, "My good man, what are you thinking of in bringing such a novelty [stone oratory] into our area? We are Irishmen, not Frenchmen."[6]

There are dozens of references to timber churches in the Irish annals, with a number occurring in the twelfth century.[7] Furthermore, examining the current distribution of extant early stone and Romanesque churches in Ireland suggests that timber churches were dominant in Ulster, the northern part of Ireland, until the end of the twelfth century, which supports Bernard's account.[8] Although no early timber churches survive in Ireland today, there is good archaeological, historical, hagiographical, and art historical evidence for them. Therefore, Ireland may be the most appropriate place for comparative and contextual purposes for the Norwegian churches. The importance of Ireland for the study of Norwegian stave churches was first recognized in 1892 by Lorentz Dietrichson in his book *De norske stavkirker*.[9] Dietrichson believed that the Norwegian stave church tradition had its origins in Ireland and Britain. While a relationship between the wooden churches of Ireland and those of Norway is demonstrable, the precise nature of that relationship is more difficult to ascertain. The evidence for the once ubiquitous timber churches of Ireland has been comprehensively discussed by Tomás Ó Carragáin in his *Churches in Early Medieval Ireland*.[10]

One of the most useful pieces of evidence for our purposes is the depiction of the Temple of Jerusalem in the Book of Kells (Fig. 5.2).[11] As depicted in this late eighth or early ninth-century manuscript, the Temple appears to be based on a church of the Irish tradition.[12] A certain degree of artistic license may have been used, in that the door is positioned as if it were on one of the side walls of the church, whereas one would expect the door to be in the west wall in an Insular context. That aside, there are several features of the depicted church that compare favorably with surviving Norwegian examples. Most noticeable are the animal-head finials, which were surely part of a far wider northern European tradition.[13] In Ireland there are several stone finials featuring animal heads from the gables of early masonry churches. Examples are known from the tenth- or eleventh-century churches at Church Island, Valentia, Co. Kerry; St. Macdara's Island, Co. Galway; and in situ at the twelfth-century Romanesque church at Kilmalkedar, Co. Kerry (Fig. 5.3).[14] These are skeuomorphs of timber finials, which prove that the depiction in the Book of Kells reflects the reality of animal-head finials on timber churches in the Insular world. Animal-head finials on Insular house-shaped shrines probably also reflect this, as these objects seem at least partly based on contemporary churches.[15]

Other comparisons with the Temple in the Book of Kells are the steeply pitched roof and the wooden shingles, both distinctive features of Norwegian stave churches. Ó Carragáin has demonstrated how early stone churches in Ireland also had steeply pitched roofs, which may well have echoed their timber counterparts.[16] Other art historical evidence, in the form of the miniature churches that decorate the top of some of Ireland's high crosses, supports that from the Book of Kells.

CHAPTER FIVE | THE EUROPEAN SIGNIFICANCE OF URNES

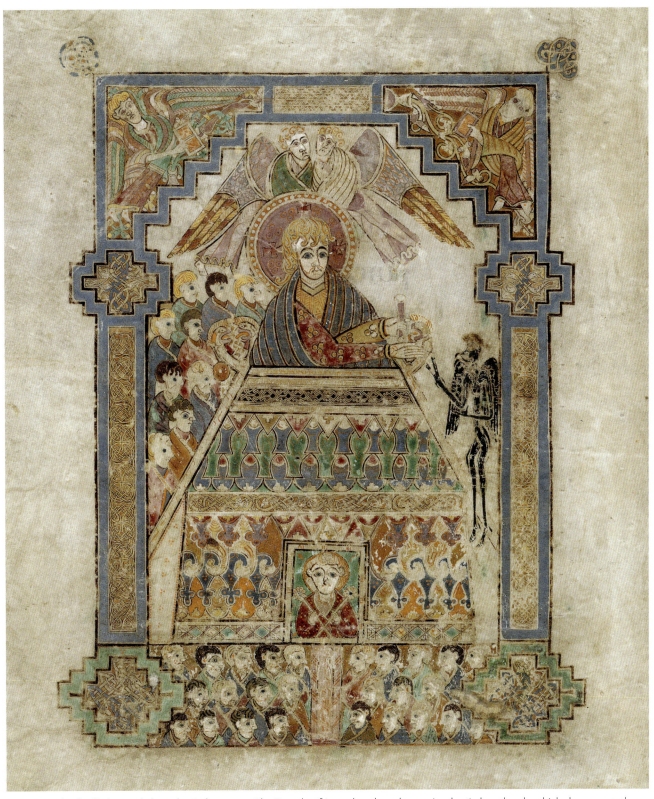

Fig. 5.2. Book of Kells, late eighth–early ninth century. The Temple of Jerusalem, based on an Insular timber church, which shares several features with later Norwegian stave churches. Dublin, Trinity College, MS 58, fol. 202v. Photo: © The Board of Trinity College Dublin.

277

Early tenth-century examples at Monasterboice, Co. Louth, and at Clonmacnoise and Durrow, Co. Offaly, depict churches with steeply pitched roofs covered in shingles and featuring finials.[17] Shingles are specifically mentioned as a roof covering in the case of the stone-built churches at Armagh and Clonmacnoise in the early twelfth century. The reference for Armagh notes that the shingles had last been replaced 130 years earlier.[18]

We have seen that several significant details of the roof of the Temple in the Book of Kells strongly resemble features of the Norwegian stave churches, and there is archaeological, historical, and art historical evidence to confirm that these details were features of timber churches in Ireland. Thus, we can say with confidence that there were features shared between timber church architecture in Ireland and Norway, features that were part of a wider northern European tradition. It is therefore worth examining some of the other elements of the Temple in the Book of Kells. Its depicted wall appears to be based on one made of timber boards, with both a sill-beam and wall-plate present.[19] Indeed, the Irish name for a timber church, *dairthech* (oak house), suggests that most were made of solid boards like the Norwegian examples. A description of the wooden oratory described in the *Hisperica famina*, from around the eighth century, also echoes aspects of the Norwegian stave churches:

> This wooden oratory is fashioned out of candle-shaped beams; it has sides joined by four-fold fastenings; the square foundations of the said temple give it stability, from which springs a solid beamwork of massive enclosure; it has a vaulted roof above; square beams are placed in the ornamented roof. It has a holy altar in the centre, on which the assembled priests celebrate the Mass. It has a single entrance from the western boundary, which is closed by a wooden door that seals the warmth. An assembly of planks comprises the extensive *porticus*; there are four finials at the top. The chapel contains innumerable objects, which I shall not struggle to unroll from my wheel of words.[20]

In Bernard's *Life of Malachy* there is an account of the building of a wooden church by the saint in the early twelfth century, which again reminds one of Norwegian stave churches: "Within a few days the chapel was finished with polished boards, firmly and tightly fastened together—an Irish work finely wrought."[21] Indeed, one of the well-preserved excavated secular buildings in Hiberno-Scandinavian Dublin was built using vertical planks of oak set in continuous sill-beams and with internal roof-supporting posts. It was tentatively dated by dendrochronology (using a loose plank inside it) to *c*.1059, which was supported by a radiocarbon date and a Dublin-minted coin of Sitric dated *c*.1035–55. As the structure, located at Christchurch Place, was built in two phases, the first could have been in the second quarter of the eleventh century, based on the coin evidence. The sill-beams of this building featured a central groove into which the vertical planks were set and:

> the wall consisted of alternate thick planks with a convex outer face, a flat inner face and grooves up both edges (A), and thin planks tapered at the edges to fit into the grooves (B). (A) planks: 250 × 45–80 mm to 320 × 60–115 mm; with grooves 15–25 mm wide and 20–50 mm deep. . . . (B) planks: 230–440 mm wide; 15–30 mm thick.[22]

CHAPTER FIVE | THE EUROPEAN SIGNIFICANCE OF URNES

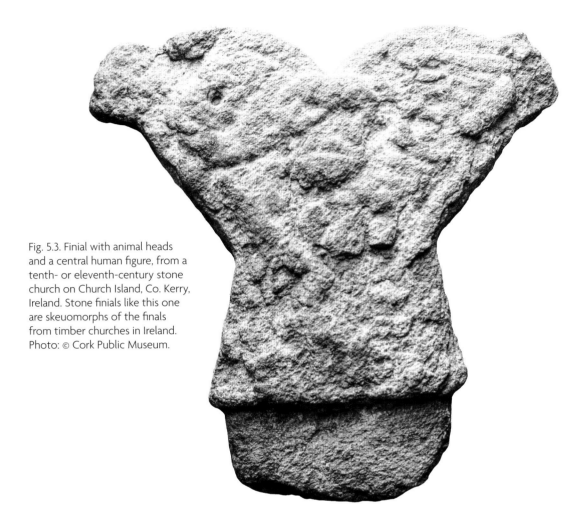

Fig. 5.3. Finial with animal heads and a central human figure, from a tenth- or eleventh-century stone church on Church Island, Co. Kerry, Ireland. Stone finials like this one are skeuomorphs of the finals from timber churches in Ireland. Photo: © Cork Public Museum.

While not identical, the construction of this building is very similar to the type of construction we later find at Urnes, and it proves that buildings of this form were being constructed in Ireland by the mid-eleventh century at the latest.

Returning to the image in the Book of Kells, the wall-plate depicted under the roofline is decorated with running animal ornament (Fig. 5.2). It is so reminiscent of the decoration one finds at Urnes that it is hard not to think that it reflects the actual wall-plate of a building rather than just decoration in the manuscript. The pattern also reminds one of the section of a wall-plate from a now lost stave church at Hørning, in Denmark, which is decorated with animal ornament in the Urnes style (Fig. 4A.13).[23] However, the stone churches that replaced the wooden ones in the tenth and eleventh centuries in Ireland are largely undecorated externally, so a note of caution must be exercised here. In these stone churches, any decoration is confined to the finials and to the doorways, some of which feature carved crosses and other motifs on the lintels.[24]

Nevertheless, excavation evidence from Dublin and other sites demonstrates that there was sophisticated wood carving taking place in Ireland in the tenth and eleventh centuries.[25] This corpus of decorated wood reveals both Insular and Viking styles and largely consists of small objects, but it also contains fragments of elaborately decorated furniture. Examples from Dublin include what has

279

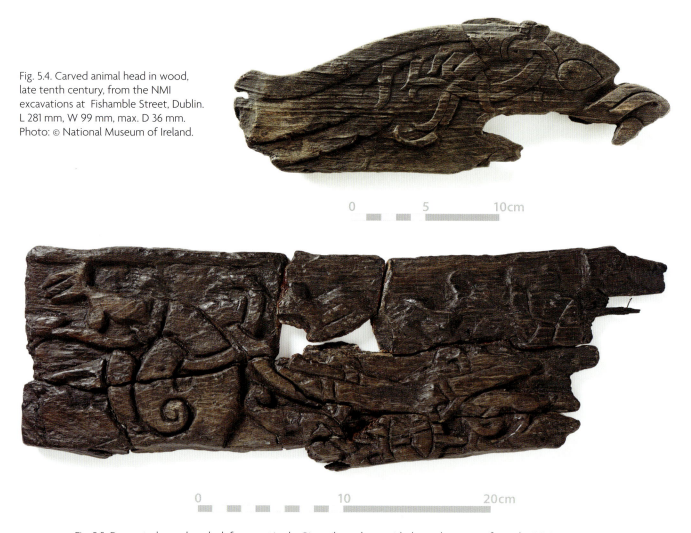

Fig. 5.4. Carved animal head in wood, late tenth century, from the NMI excavations at Fishamble Street, Dublin. L 281 mm, W 99 mm, max. D 36 mm. Photo: © National Museum of Ireland.

Fig. 5.5. Decorated wooden plank fragment in the Ringerike style, *c.* mid-eleventh century, from the NMI excavations at Christchurch Place, Dublin. L 437 mm, W 136 mm, D 19 mm. Photo: © National Museum of Ireland.

been interpreted as a chair terminal from Fishamble Street, which is said to have traces of gilding and appears to date from the late tenth century (Fig. 5.4), and a decorated plank fragment from Christchurch Place that features part of a quadruped "great beast" in the Ringerike style (Fig. 5.5).[26] The plank fragment, which measures 437 mm long, 136 mm wide and 19 mm thick, came from a disturbed layer in plot 1, adjacent to house 6/1, which produced a coin dated 1055–75. James Lang thought that it possibly derived from a piece of furniture or a doorcase.[27] Considering some of the thin vertical (B) planks used in the mid-eleventh-century building that lay underneath house 6/1 in the same plot at Christchurch Place, referred to above, it is possible that this decorated plank fragment originally belonged to that building, or perhaps to a church in the vicinity. Christ Church Cathedral was founded *c.* 1030, while the chapel of St. Michael the Archangel was founded about the same time in the adjacent episcopal palace.[28] Both buildings might initially have been built of timber, were potentially decorated with Ringerike-style ornament, and are under 100 m from the findspot of the plank fragment.

This evidence, combined with that from the Book of Kells and the mention of an "ornamented roof" in the *Hisperica famina*, makes it at least a possibility that some early wooden churches in the Insular world featured exterior carved ornament in addition to decorative finials. As early stone churches in Ireland may have been whitewashed or rendered externally,[29] we can also speculate about the possibility of some painted ornament, although there is no direct evidence for this.[30] This brings me to a final point about the depiction in the Book of Kells. Even if we acknowledge that it is part of a decorative page in a highly ornamented and complex manuscript, there is a possibility that it depicts a painted building. The description of the cathedral of Kildare in Cogitosus's seventh-century *Life of St. Brigit* mentions that, "It is adorned with painted pictures and inside there are three chapels which are spacious and divided by board walls under the single roof of the cathedral church. The first of these walls, which is painted with pictures and covered with wall-hangings, stretches widthwise in the east part of the church from one wall to the other."[31] The description indicates at the very least that this timber church was painted internally, if not also externally. The decorative section of wall-plate in the Urnes style from Hørning, dated by dendrochronology to about 1060–70, was painted black, yellow, and red, which helped a viewer distinguish the animal ornament (Fig. 4A.13).[32] We know that paint was used in the case of Scandinavian runestones,[33] and recent evidence shows its use on early medieval freestanding sculpture in both England and Scotland;[34] scholars have also argued that it was employed on high crosses in Ireland.[35] Notably, there is also evidence for polychromy on Anglo-Saxon church sculpture.[36] Therefore, as Margrete Syrstad Andås suggests in Chapter 4, it is conceivable that some of the exterior ornament at Urnes, perhaps that in low relief, was originally painted.

The Reuse of Timbers at Urnes: Some Considerations

There are accounts in Insular hagiography of miracles associated with timber churches, and these may help us think about the potential significance of the reused materials at Urnes. One account of a miracle in Cogitosus's *Life of St. Brigit* is particularly pertinent because it relates to the reuse of a door from an earlier church. When the church at Kildare was being rebuilt on a larger scale, there was a desire to incorporate material from the earlier church associated with the saint. What makes this account so significant is the practical issue that was facing the carpenters, which is worth citing in full:

> Now, when the old door to the left portal through which saint Brigit used to enter the church was hung on its hinges by the tradesmen, it was unable to fill completely the newly erected doorway. A quarter of the doorway was unfilled and an open gap was showing and, had a fourth part been added and joined to the height of the door, then it would have been possible to fill up completely the high reconstructed doorway.

And, as the tradesmen were wondering whether to make another new and bigger door which would fill up the entire doorway or to attach a piece of board to the old door so that it would afterwards be big enough, the aforementioned master and leader of all Irish craftsmen offered wise advice: "This coming night we must pray to the Lord with faith by saint Brigit's side so that in the morning she may guide us as to our course of action in this task."

And so he passed the night praying by the glorious tomb of Brigit and getting up in the morning after that night, having completed his prayer with faith, he had the old door pushed in and placed on its hinges and it filled the whole doorway. Neither did it lack anything in fullness nor was it in any respect excessive in size.

And so Brigit extended the door in height so that the whole doorway was filled by it and no gap appeared in it except when the door was pushed back for people to go into the church. And this miracle of God's power was revealed clearly to the eyes of all who saw the door and the doorway.[37]

Also relevant here is Bede's account of a miracle relating to a wooden post from the west wall of a church near Bamburgh (England) that was revered as a relic of St. Aidan, who had leaned against it when he died. Having escaped a fire, the post was reused twice in later timber churches before being moved inside the third church as an object of veneration.[38] These two accounts suggest that the reuse of materials in timber churches in both Ireland and northern Britain may have been reasonably common. There is of course a utilitarian reason for this, but these accounts suggest that there may also have been devotional motivations for it. Ó Carragáin has discussed the significance of the reuse of older materials, particularly in the case of the cathedral at Glendalough, Co. Wicklow, in the context of the perception of churches as relics in early medieval Ireland.[39] Taking all this evidence into consideration, we should consider the possibility that the reused timbers at Urnes had a religious significance through their association, real or imaginary, with some revered person.

The Urnes Style and Ireland: Scholarship to Date

The Urnes style of ornament flourished in Scandinavia during the second half of the eleventh and the early twelfth centuries and brought to a close the tradition of animal art inherited from the Germanic tradition, which is characteristic of Viking art. While classed generally as a Viking artistic style, Urnes is perhaps best understood as a Christian style that did not represent anything pagan for Scandinavians at that time.[40] Zoomorphic decoration was a prominent feature of Christian art across northern Europe for much of the early Middle Ages.[41] In particular, comparison may be made with Ireland, where zoomorphic art flourished in a Christian context from the seventh to the twelfth centuries.[42] This is perhaps one of the reasons why the Urnes style was so readily and successfully adopted in Ireland, where Irish versions of it occur principally on church and secular metalwork,

manuscripts, and stone sculpture. I have argued elsewhere that there were also significant cultural, religious, and political reasons for its widespread adoption.[43] The style appears to have taken root in Ireland, albeit in a hybridized way, to a much greater extent than it did in Britain, and it may be seen on some of the most important religious objects and buildings of the time. Notably, the versions of the style in Ireland bear little comparison with those in England.[44] The Urnes style was popular in Ireland from the late eleventh to the late twelfth century, a somewhat later time frame than in most of Scandinavia (see below).

The influence of the Urnes style in Ireland was first noted by the Norwegian archaeologist Haakon Shetelig in a groundbreaking 1909 paper, "Urnesgruppen," that established the name of the style by calling it after its most notable example.[45] In his paper he included such Irish objects as the Clonmacnoise crosier, the Shrine of St. Patrick's bell (1091–1105), and the Cross of Cong (1123).[46] Thus, in the historiography of the Urnes style Ireland was included from the outset. The influence of Viking art in Ireland, specifically on the Clonmacnoise crosier and the Shrine of St. Patrick's bell, was also noted in the same year by George Coffey, Keeper of Irish Antiquities at the National Museum of Ireland [NMI], so it seems likely that the two men were in communication with each other.[47] In fact, the reserve collections of the NMI hold plaster casts of the door, portal, decorative panels, and corner post at Urnes, which were presumably acquired around this time.[48] Shetelig had produced eight casts of the ornamented sections from the north wall at Urnes in 1907, one of which he kept at Bergen while selling the others to museums in Oslo, Berlin, Brussels, Paris, Glasgow, New York, and the V&A in London; the last was a parent museum to the National Museum in Dublin before Irish independence in 1921.[49] It is surprising, then, that more scholars did not connect Irish objects with the Urnes style, given that after their acquisition the Urnes casts were probably exhibited in Dublin.

It was not until after World War II that full recognition was given to the Urnes influences in Irish art in further work by Shetelig and in publications by Thomas D. Kendrick and Ole Henrik Moe.[50] It was, however, the presence of a number of prominent Irish objects in David Wilson and Ole Klindt-Jensen's *Viking Art* that ensured that Irish material would be included in the canon of the Urnes style internationally.[51] In Ireland itself there was little recognition of the influence of Scandinavian art until the work of Máire (née MacDermott) and Liam De Paor in the 1950s, in their popular book *Early Christian Ireland*,[52] and in the latter's paper on the late high crosses of Co. Clare.[53] The Ireland-based French art historian and archaeologist Françoise Henry was very restrained in her acknowledgment of the influence of the Urnes style in Ireland, with the exception of her analysis of the Corpus Missal manuscript, which, she stated, featured "all the chief elements of the Urnes style."[54] As the foremost scholar of Irish medieval art in the twentieth century, Henry's reluctance to acknowledge Scandinavian artistic influence in Ireland must have been influential. Going against the grain of his contemporaries' scholarship, the Swedish archaeologist Wilhelm Holmqvist completely rejected the idea that Irish art was influenced by Scandinavian art, claiming that the influences were all running the other way.[55] In the late nineteenth century Dietrichson had already asserted that the zoomorphic ornament at Urnes and other early stave churches was Irish and that the inspiration for stave churches had come from Ireland.[56]

The most comprehensive study of the Urnes style in Ireland was a master's thesis completed by Elisabeth Farnes at University College Dublin in 1975, which, unfortunately, was never published.[57]

The Norwegian art historian Signe Horn Fuglesang, in her treatment of the Ringerike style in Ireland, briefly discussed the Urnes style in relation to Irish metalwork, stone sculpture, and manuscript illumination.[58] Irish material has consistently been included by James Graham-Campbell in general discussions of the Urnes style, starting with the 1980 exhibition catalogue *Viking Artefacts* and more recently in his 2013 popular book *Viking Art*.[59] In 1981 Roger Stalley published on the stone sculpture at Tuam, Co. Galway, which was the first paper to compare the Irish Urnes style with Scandinavian versions of the style in some detail.[60]

The analysis of some of the finds from the NMI's excavations in Dublin has significantly added to the corpus of Urnes material in Ireland and shed some light on its dating, particularly in the work of Lang on the decorated wood and Uaininn O'Meadhra on the motif (trial) pieces.[61] In the 1983 catalogue *Treasures of Ireland*, Raghnall Ó Floinn unreservedly used the term *Urnes style* to describe many of the objects of Irish church metalwork surviving from the late eleventh and early twelfth centuries, while in the 2001 catalogue *The Vikings in Ireland* he discussed the style primarily in relation to evidence from the urban archaeological excavations.[62] Some objects influenced by the Urnes style were included in a 2002 exhibition on Viking art at Jelling by Lise Bertelsen, a Danish archaeologist noted for her work on Urnes-style brooches.[63] Interestingly, Anne-Sofie Gräslund has compared the Urnes-style animal ornament on some Swedish runestones with those on historically dated Irish church metalwork as a method of dating the former.[64]

The most detailed examination of the Urnes style in Ireland published to date is my own study of the Cross of Cong and related Irish objects from the early twelfth century. Building on the work of previous scholars, in particular that of Moe, Wilson and Klindt-Jensen, and Stalley, my analysis involved the examination of individual elements of the ornament to discover whether they fit more within Insular or Scandinavian art. I discovered that there were some elements of the ornament that could be classified as Insular, some that could be classified as Urnes, and some elements that were common to both styles.[65] I concluded that:

> The fact that major elements, as well as details, of the zoomorphic ornament on the Cross of Cong can be identified as being inherited from Insular art in Ireland and borrowed from the Urnes style, suggests that it is suitable to label this style Hiberno–Urnes. . . . Nevertheless, while there is nothing from Scandinavia in the Urnes style that is remarkably similar to the decoration on metalwork in Ireland, neither is there anything remarkably similar to Irish material in England.[66]

Even though the Urnes style was recognized over a century ago on Irish material, the quantity of scholarship published on the style as it occurs in Ireland has been very small, with very little in the way of detailed analysis. While a significant amount of material has been identified as displaying Urnes influence, including metalwork, ivory and bone carvings, stone sculpture, and manuscript illumination, most of this material still remains unanalyzed stylistically.

CHAPTER FIVE | THE EUROPEAN SIGNIFICANCE OF URNES

The Introduction of the Urnes Style to Ireland

Among the earliest major Irish objects to display influence from the Scandinavian Urnes style, one that is securely dated, is the Shrine of St. Patrick's bell from Armagh in the north of Ireland (Fig. 5.6).[67] It is one of the finest pieces of craftsmanship from medieval Ireland, and its large crowning animal heads and beautifully crafted openwork zoomorphic side panels show a strong connection to the Urnes style. An important difference from the Scandinavian style is its symmetry, which was apparently more in keeping with Irish tastes. I cannot analyze all the ornament here, but I will mention that the hair of the crowning animal heads and some of the fronds on the side panels bear a close resemblance to the ornament of some openwork Urnes brooches from Denmark and Sweden,[68] as well as to two openwork zoomorphic mounts that came from the floor levels of the Dollerup church, near Viborg in Jutland (Denmark), which seem to have derived from a reliquary (Fig. 5.7, and map Fig. I.1).[69]

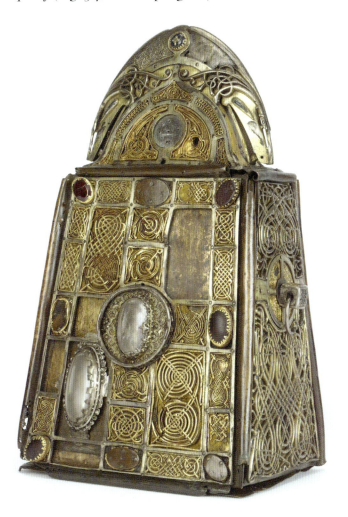

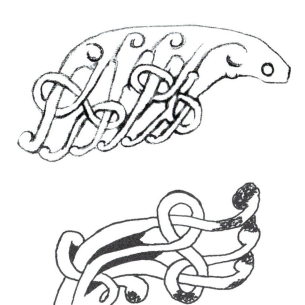

Fig. 5.7. Two openwork zoomorphic mounts, from Dollerup church, near Viborg in Jutland, Denmark, late eleventh-century. Rare survivals from an early Scandinavian reliquary in the Urnes style. Drawing: Author.

Fig. 5.6. Shrine of St. Patrick's bell, from Armagh, Ireland, 1091–1105, a masterpiece of metal craftsmanship in the Hiberno-Urnes style. Photo: © National Museum of Ireland.

285

The Shrine of St. Patrick's bell was commissioned to enshrine a handbell associated with the national saint by Domnall Ua Lochlainn, king of Cenél nEógain and sometime claimant to the high kingship of Ireland, and by Domnall Mac Amalgadha, the *coarb* of Patrick at Armagh, Ireland's most senior cleric. The inscription states:

> OR DO DOMHNALL U LACHLAIND LASIN DERNAD IN CLOCSA
> [A prayer for Domhnall Ua Lochlainn who caused this bell to be made]
>
> OCUS DO DOMHNALL CHOMARBA PHATRAIC ICON DERNAD
> [and for Domhnall, the successor of Patrick, with whom it was made]
>
> OCUS DO CHATHALAN U MAELCHALLAND DO MAER IN CHLUIC
> [and for Cathalan Ua Melchallain, the keeper of the bell]
>
> OCUS DO CHONDULIG U INMAINEN CONA MACCAIB RO CUMTAIG
> [and for Condulig Ua hInmainen and his sons who covered it][70]

The shrine is securely dated between 1091 and 1105 based on Domnall Mac Amalgadha's time in office. While a range between 1094 and 1105 is usually given for the bell shrine, the 1094 date is based on Domnall Ua Lochlainn's contested claim to the high kingship of Ireland.[71] The lack of such a claim before 1094 would not have precluded Domnall from patronizing Armagh, given that he had been king of Cenél nEógain since 1083. Domnall Mac Amalgadha's term of office is firmly established in the Irish annals,[72] and it is on that evidence that the bell shrine should be dated.[73]

Notably, the Shrine of St. Patrick's bell was commissioned at a time when there was a direct royal connection between Norway and Ireland. Indeed, it is recorded that Magnús Barelegs, king of Norway (r. 1093–1103), was killed by the Ulaid in the northeastern part of Ireland in 1103 and subsequently buried at Downpatrick. Before this, Muirchertach Ua Briain, king of Munster (r. 1086–1119) and great-grandson of Brian Boru, who was a rival to Domnall Ua Lochlainn for the high kingship of Ireland, had allied with Magnús through both a marriage alliance between their children and an exchange of hostages.[74] It seems likely that diplomatic gifts, in the form of secular or religious objects, decorated in the Urnes style arrived in Ireland through Magnús and his emissaries. We know for certain that gifts were sent the other way. In 1102 the *Annals of the Four Masters* records, "A hosting of the men of Ireland to Ath-cliath [Dublin], to oppose Maghnus and the foreigners of Lochlann, who had come to plunder Ireland; but they made peace for one year with the men of Ireland; and Muircheartach gave his daughter to Sichraidh, son of Maghnus, and gave him many jewels and gifts."[75]

One of the more interesting royal gifts received by Muirchertach during his reign was a camel, presented to him by Edgar, king of Scotland, in 1105.[76] This reminds one of the camel depicted on the capital at Urnes (Plate 47), and it indicates that such animals, while certainly exotic, were known in northwestern Europe in the early twelfth century. This capital, and the Christian symbolism of the camel, is discussed in the chapters dealing with the interior of the twelfth-century church in the third section of this volume. Other exotic animals are represented on the back of the Shrine of

St. Patrick's bell: two peacocks flank and intertwine with the Tree of Life, a strong Christian image that symbolizes everlasting life.[77] Peacocks are depicted on late eleventh-century brooches in Scandinavia, including one from the hoard at Gresli, Trøndelag (Norway), dated 1085, and on an eleventh-century runestone from Harg, Uppland (Sweden). The actual remains of a peacock were found inside the early tenth-century ship burial at Gokstad in Vestfold, Norway.[78]

While not as spectacular as the Shrine of St. Patrick's bell, there is a small group of related Irish objects, dated stylistically to *c.* 1100, that also shows influence from the Urnes style; they probably came from a workshop under the patronage of King Muirchertach Ua Briain.[79] The best-known object is another bell shrine, the Bearnán Chúláin, from Glenkeen, Co. Tipperary (Fig. 5.8).[80] Like the Shrine of St. Patrick's bell, it is crowned by two animal heads that feature very elaborate whiskers. Both the style and techniques employed here, however—inlaid silver, copper, and niello— are very different from those on St. Patrick's bell shrine. The other objects that can be attributed to the same workshop, if not to the same craftsman, include a sword handle from the bed of Lough Derg near Curraghmore, Co. Tipperary,[81] and a large strap-end that was found at Bulford near Amesbury, Wiltshire, in England.[82] The workshop that produced these three objects may have been located in northern Munster, perhaps at Limerick or Killaloe, Co. Clare, where Muirchertach was based. There is suggestive evidence for metalworking activity at Killaloe from this period in the form of craftsmen's trial pieces (Fig. 5.9).[83] Limerick, as a Hiberno-Scandinavian town, would also have been a center of craftsmanship at the time, as suggested by the find of what may be a locally manufactured zoomorphic spout for a ewer from the Abbey River.[84]

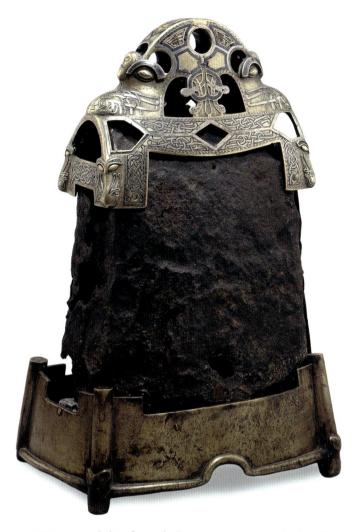

Fig. 5.8. Bearnán Chúláin, from Glenkeen, Co. Tipperary, Ireland, c. 1100, possibly patronized by Muirchertach Ua Briain (1086–1119), king of Munster. This incomplete bell shrine displays Scandinavian influence in style and decorative techniques. Photo: © British Museum.

It should be noted, however, that the two trial pieces from Killaloe bear no resemblance to the decoration on the Bearnán Chúláin. One of them, a well-known piece, has been identified as being in the Urnes style, and although its decoration is very different from that on the objects mentioned above, it is the only Irish piece to have been compared with examples of the Urnes style in England (Fig. 5.9).[85] This is noteworthy because Muirchertach Ua Briain has been credited with introducing Romanesque architecture to Ireland from England, as evidenced by St. Flannan's Oratory at Killaloe,

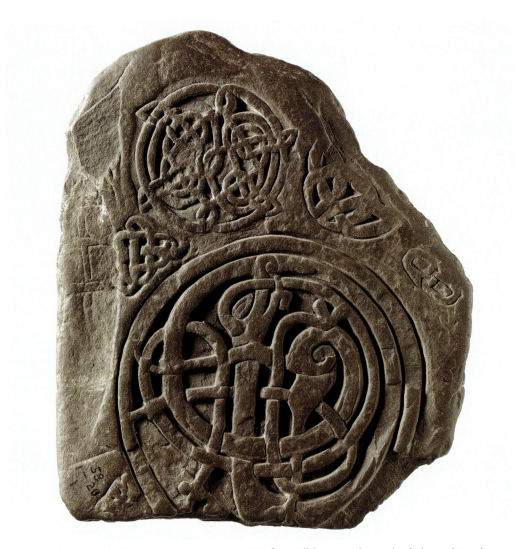

Fig. 5.9. Trial piece with Hiberno-Urnes ornament, c. 1100, from Killaloe, Co. Clare, Ireland, the traditional dynastic seat of Muirchertach Ua Briain. Photo: © British Museum.

and he was the patron of many of the churches with Romanesque features at Glendalough.[86] The spiral composition of the ornament on the Killaloe trial piece is also reminiscent of the ornament on the front of Shrine of St. Patrick's bell. Importantly, as Ó Floinn has noted, the death of a Dúnadach Ua hInmainén, *erenagh* of Tullylease, Co. Cork, is recorded in the annals in 1059, which indicates that the makers of Armagh's famous reliquary, Condulig Ua hInmainen and his sons, may have come from Munster in the south of Ireland.[87] The modern version of the name, Noonan, is still strongly associated with that part of Co. Cork.[88]

At Killaloe there is also a fragment of a stone cross featuring an inscription in Scandinavian runes and Irish ogham (Fig. 5.10). This is one of only seventeen known Scandinavian runic inscriptions in Ireland and the only one on a Christian monument.[89] It was initially discovered in the early twentieth century by Robert Macalister, built into the boundary wall in front of Killaloe Cathedral;

CHAPTER FIVE | THE EUROPEAN SIGNIFICANCE OF URNES

Fig. 5.10. Fragment of stone cross with runic inscription erected by Thorgrim at Killaloe, Co. Clare, Ireland, probably during the overwintering of King Magnús Barelegs's army in Ireland in 1102. Photo: Author.

it was subsequently removed and is now displayed inside the cathedral.[90] The fragment belongs to the upper shaft, just below the head, of a freestanding cross measuring 68 cm high, 47 cm wide, and 22 cm thick. The runic inscription occurs on one of the principal faces, while a figure, which has been interpreted by Peter Harbison as "probably a Christ Crucified," occupies the other.[91] The runes have been read as follows:

> Þorgrímr reisti kross þenna
> [Thorgrim erected this cross][92]

The ogham inscription, which is in scholastic ogham, occurs on one of the short sides of the cross and has been read most recently as:

289

BENDACHT FOR TOROQRIM
[a blessing on Thorgrim][93]

In the latest discussion of the runic inscription it was tentatively dated to *c.*1100.[94] Until recently no one had identified the named individual, nor had the form of the cross been the subject of much discussion. I have suggested that this individual was Thorgrím Furcap from the Upplands in Norway, one of the barons of Magnús Barelegs who accompanied him on his campaign to Ireland.[95] It was Thorgrím and his men who, according to the early thirteenth-century *Heimskringla*, abandoned Magnús and fled when they were under attack in Ulaid in northeastern Ireland.[96] We also know from the *Heimskringla* that Magnús and his forces overwintered in Ireland in 1102 when campaigning with Muirchertach: 'in the winter following, King Magnús dwelt in Connaught with King Mýrjartak [Muirchertach], putting his men to the defence of the land he had won. But when spring came the kings with their army marched west to Ulster and there had many battles and subdued the land, winning the greater part of Ulster. Thereupon Mýrjartak returned to Connaught.'[97] The Irish geographical locations are somewhat confused in the saga, which gives the location of overwintering as Connaught because it was thought, mistakenly, that Muirchertach was king of Connaught.[98] One should thus read "Munster" for "Connaught," which means that the place of overwintering is likely to have been in the Limerick–Killaloe area. It seems most likely that Thorgrím Furcap was in Killaloe in the winter of 1102. The form of this cross also supports the idea that it was erected by a Norwegian. The cross fragment is unique in Ireland, and it bears a striking similarity to Norwegian high crosses from the eleventh century and later, some of which (e.g., that at Stavanger) carry runic inscriptions on their principal faces.[99] It is wholly conceivable that one of Magnús's barons, Thorgrím, had a cross erected at Killaloe during their overwintering with Muirchertach in 1102, which accords with the tentative date for the cross proposed by runologists. Interestingly, the Norwegians may have seen St. Flannan's Oratory at Killaloe, as Richard Gem dates that building *c.*1100, making it Ireland's earliest surviving Romanesque church.[100] It appears that there was considerable activity at Killaloe around 1100, which became the seat of a bishopric in 1111.[101]

It would be naïve and incorrect to suggest that the Urnes style was introduced to Ireland by Magnús Barelegs, as the Hiberno-Scandinavian towns in Ireland, such as Dublin, Waterford, Limerick, and Cork, were highly receptive to cultural and artistic influence from abroad and particularly from Scandinavia.[102] Indeed, it appears that the inhabitants of these towns were still understood as ethnically and culturally different from the rest of the Irish population in the twelfth century, when they were still referred to as "foreigners" in the Irish annals, even though they had been settled for over two centuries. Notably, the Ringerike style had featured prominently across Ireland in the eleventh century, and there are also several objects that display both Ringerike and Urnes elements.[103] A worn knife handle decorated in the Urnes style was recovered from a mid- to late eleventh-century context at Christchurch Place in Dublin, demonstrating the contemporary occurrence of the style in Ireland at the time the older church at Urnes was built. The ornament on this knife handle has been compared directly with that on objects in Sweden and Norway.[104]

Poor preservation of early twelfth-century deposits in Dublin has probably contributed to a reduced amount of Urnes-style material being recovered from what was undoubtedly Ireland's

most important town.[105] Nevertheless, a classic Urnes animal head carved on a piece of wood was recovered in excavations at High Street,[106] while trial pieces in a Hiberno-Urnes style have been recovered from High and Winetavern streets and from a secondary context at Wood Quay.[107] Some of the other towns in Ireland have also produced trial pieces bearing Urnes-influenced designs, including one from an excavated house of late eleventh–early twelfth-century date on Peter Street in Waterford and another with hints of the style from a secondary context on Barrack Street in Cork.[108] These towns remain key, archaeologically, not only for reasons of dating but also as the major cultural and artistic receptors and innovators of Ireland in this period.

King Muirchertach Ua Briain of Munster is perhaps best known as the patron of the reform movement in the Irish Church and as one of the most outward-facing kings of Ireland.[109] He sponsored major reforming synods at the beginning of the twelfth century and also gave the Church such important gifts as the royal site of Cashel and eight ounces of gold (for the altar at Armagh).[110] He corresponded with the archbishop of Canterbury, and in the same year he made a marriage alliance with Magnús Barelegs he made another with the Norman Arnulf de Montgomery, brother of the earl of Shrewsbury.[111] In addition to strong political alliances with Wales and Norway, Muirchertach had control of the kingdom of Man and the Isles for a time.[112] He may have gained his international outlook through his kingship of Dublin, having been installed by his father, Turlough, in 1075 and ruling Dublin directly until 1086.[113] I have argued elsewhere that it was only when Irish kings started to rule directly over the Hiberno-Scandinavian towns, beginning in the middle of the eleventh century, that Viking art became popular across Ireland as a result of royal patronage.[114] Notably, there are several stone high crosses in Co. Clare, the home territory of the Uí Briain or Dál Cais dynasty, that bear ornament featuring Urnes-style influence and have been dated to the late eleventh or early twelfth century.[115] Muirchertach, as a result of his time in Dublin and with his international interests, may well have been influential in the initial popularizing of the Urnes style across Ireland.

The Apogee of the Hiberno-Urnes Style

The apogee of what I have termed the Hiberno-Urnes style appears to have been from about 1090 to 1130, when the Urnes style in Scandinavia, while still current, had passed its high point. This dating is based on several pieces of church metalwork and stone sculpture that are dated by their dedicatory inscriptions. This includes such objects as the Shrine of St. Patrick's bell, discussed above; the crosier from Lismore, Co. Waterford (1090?–1113),[116] as well as related metalwork;[117] and the arm shrine of St. Laichtín from Donoughmore, Co. Cork (1118–21).[118] Yet it may best be characterized by a series of works under the patronage of the high king Toirrdelbach Ua Conchobair in the west of Ireland, including the Cross of Cong and related metalwork, the high crosses at Tuam (1127), and the Corpus Missal.[119] A factor that unites many of these objects was their proximity to and/or political links with the Hiberno-Scandinavian towns, as I have previously discussed in relation to the arm shrine of St. Laichtín, the Cross of Cong, and related works.[120]

Fig. 5.11. Stone fragment from Donaghenry, near Stewartstown, Co. Tyrone, Ireland, decorated with ornament in the Hiberno-Urnes style similar to that found on the sarcophagus at Cashel (Fig. 5.12). Photo: © Ulster Museum.

Muirchertach Ua Briain may also have been a patron of Lismore around the time that the Lismore crosier was made. While he is not mentioned as a patron in the inscription on the crosier itself, this is not surprising, as it may have been seen as inappropriate for a secular ruler to be involved in commissioning an ecclesiastical symbol of office. Although there is no direct evidence that Muirchertach did patronize one of the most important monasteries in Ireland at the time, it seems highly likely that he did, given that he went into temporary retirement there in 1116.[121] Lismore's location is also likely to have been influential. It is located between the Hiberno-Scandinavian towns of Cork and Waterford and is relatively close to Dungarvan harbor, where there is also evidence for Hiberno-Scandinavian settlement.[122]

The Shrine of St. Patrick's bell is perhaps the outlier among the objects listed above, in that Armagh is far removed from any of the Hiberno-Scandinavian towns and King Domnall Ua Lochlainn seems to have had little connection with them. On one occasion he is known to have allied with Gofraid Meránach, king of Dublin, in an offensive against Muirchertach Ua Briain in 1094.[123]

CHAPTER FIVE | THE EUROPEAN SIGNIFICANCE OF URNES

However, a stone fragment discovered in 1989 at an early medieval church site in Donaghenry, near Stewartstown, Co. Tyrone, is decorated with Urnes-style ornament (Fig. 5.11).[124] This site is around 3 km southeast of Tullaghoge, a power base of Domnall Ua Lochlainn and the Cenél Eóghan in the eleventh century and the place of inauguration of their kings. While only a fragment, its decoration, as noted by Cormac Bourke, compares well with that on the sarcophagus at Cashel, Co. Tipperary (Fig. 5.12). The Cashel sarcophagus was published in detail by John Bradley, who argued that it may have been made for the burial of Tadhg Mac Carthaig, king of Desmond, who died at Cashel in 1124.[125] Tadhg is associated with the Hiberno-Urnes style because he was one of the patrons of the arm shrine of St. Laichtín.[126] However, it is possible that the sarcophagus is later, as its ornament, particularly its tightly wound spiral terminals, compares well with carvings on the Hemse stave church in Gotland, which is dated to 1145 (Fig. 4.5).[127] Therefore, another possibility, given its original location in the cathedral, is that it was made for archbishop Domnall Ua Longargáin (d.1158), who was related to the rival Uí Briain kings.[128] The Cashel sarcophagus is an impressive monument, reminiscent of the carvings at Urnes. Although the medium is stone, like Urnes it has animal ornament on a large scale and in high relief.

The comparison between the Donaghenry fragment and the Cashel sarcophagus may be significant, given that the makers of the Shrine of St. Patrick's bell appear to have been from Munster. In this context it is important to note that members of the Munster-based Uí Briain family held the kingship of Tullaghoge for a time in the later eleventh century. This branch of the family appears to have been exiled from Munster, and both Connor (d. 1078) and Cennétigh (d. 1084) Ua Briain held

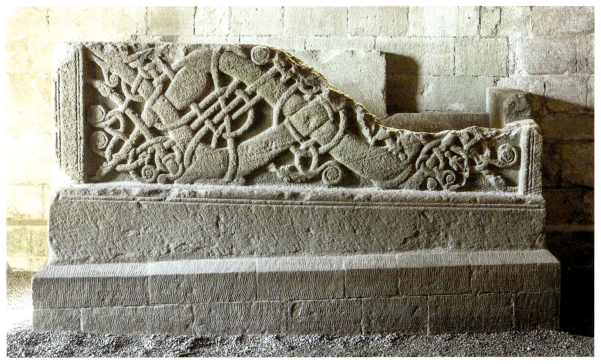

Fig. 5.12. Sarcophagus at Cashel, Co. Tipperary, Ireland, decorated in the Hiberno-Urnes style, early to mid-twelfth century. Photo: © National Monuments Service.

293

the kingship of Tullaghogue.[129] Notably, Bébhinn (d. 1110), a daughter of Cennétigh, was married to Domhnall Ua Lochlainn.[130] Given her strong Munster connections, I propose that it may have been Bébhinn who procured the services of Cú Duilig Ua hInmainen and his sons to make the Shrine of St. Patrick's bell. Women in Ireland were occasionally recorded as patrons of the Church in this period.[131] A well-known example is the patronage by Derbforgaill, daughter of the king of Meath, of the Cistercian monastery of Mellifont, Co. Louth, in 1157, and the Nuns' Church at Clonmacnoise, Co. Offaly, in 1167.[132] An inscription on the Romanesque church at Freshford, Co. Kilkenny, records the patronage of a woman and man, presumably wife and husband.[133] My proposal of Bébhinn as co-patron suggests that the role and influence of women in the patronage of art in medieval Ireland may be significantly underrepresented.

Urnes Style and Churches in Ireland

The shrine of St. Manchan, from Lemanaghan, Co. Offaly,[134] is the largest reliquary surviving from medieval Ireland (Fig. 5.13). I have argued that it is a product of Máel Ísu Mac Bratáin Uí Echach, the craftsman responsible for the Cross of Cong, under the patronage of Toirrdelbach Ua Conchobair, high king of Ireland (r. 1119–56).[135] It is a large gabled shrine for corporeal relics, and it has been argued that its form is based on the Ark of the Covenant.[136] It is also based on a church roof, steeply pitched like the contemporary roofs in Ireland discussed earlier in this chapter, and it features imitation end rafters at its gable ends. Although stylistically very different, it is related in form to the Breac Maodhóg from Drumlane, Co. Cavan, and to the wider European tradition of large church-shaped reliquaries.[137] Looking at the shrine's triangular gable ends, which are covered in Hiberno-Urnes–style ornament, one is strongly reminded of the surviving decorated gables from the eleventh-century church at Urnes (Fig. 2.17, Fig. 6.1, and Plate 12).[138]

An openwork plaque from a small church-shaped reliquary in the NMI emphasizes that what we are looking at in the Lemanaghan shrine is a reliquary modeled on a contemporary church roof.[139] This find is Irish, and, although not localized, it appears to have come from the same workshop.[140] The mount is from the gable end of the reliquary, and not only does it feature Hiberno-Urnes ornament in its triangular field but also finials, like the skeuomorphs from Irish stone churches at Church Island, Co. Kerry, and elsewhere (Fig. 5.3). The Lemanaghan shrine and the gable mount raise the intriguing question of whether there were timber churches in Ireland decorated in the Hiberno-Urnes style. As already discussed, timber churches and sophisticated wood carving were certainly a feature of eleventh- and early twelfth-century Ireland, and I believe that this may well have been the case.

Apart from Stalley's work on the stone sculpture at Tuam, no one has looked at the Hiberno-Urnes style used on Irish Romanesque churches in any detail. How much of this zoomorphic sculpture should be classified as Hiberno-Urnes is a question in itself. Nevertheless, there are a significant number of examples of churches featuring zoomorphic ornament that derive from the apogee of the Hiberno-Urnes style (1090–1130). These buildings have been dated considerably later, around the second half of the twelfth century, and include such examples as Killeshin, Co. Laois;

Kilmore, Co. Cavan; and Clonfert and Tuam, Co. Galway.[141] Some of the buildings have been dated as late as the 1180s and so represent what are likely to be the very last international vestiges of the Urnes style. This late development in the Hiberno-Urnes style in Ireland reflects what we see happening in Scandinavia in the first half of the twelfth century, in what Fuglesang has termed "Urnes-Romanesque," examples of which can be seen on the capitals of the Urnes church (e.g., Plate 59).[142] The latest occurrences of this style in Scandinavia appear to occur around 1150 in the stone sculpture of Sweden, particularly Gotland.[143]

It is currently thought that much of the zoomorphic ornament on Romanesque churches in Ireland was copied from metalwork,[144] but the examples cited, such as the Cross of Cong, date from one or two generations before these buildings. It is perhaps surprising that we do not see such ornamentation on the early Romanesque churches in Ireland, those more contemporary with the apogee of the Hiberno-Urnes style in metalwork.[145] Was there another source of inspiration for the decoration on these late Romanesque churches? This brings us back to the question of whether timber churches decorated with Hiberno-Urnes–style ornament existed in Ireland. Could the zoomorphic ornament found on later Romanesque stone churches come from a tradition of Irish timber churches in the late eleventh and early twelfth centuries? In Stalley's study of the sculpture at Tuam, he stated that some of the low-relief ornament seems to have copied wood carving and that the technique "recalls that used in Norwegian churches."[146]

The Lost Early Church Metalwork of Norway

It is also possible that the shrine of St. Manchan is based on Scandinavian church-shaped reliquaries (Fig. 5.13). One of the figures on the shrine carries an axe and was identified by David Wilson as St. Olaf (Óláfr), although there are other possibilities.[147] Reliquaries based on churches survive in Scandinavia from the late twelfth and thirteenth century, such as those from Vatnås, Hedalen, and Fillefjell in Norway and from Eriksberg and Jäla in Sweden, all of which feature animal-head finials.[148] An animal-head finial acquired in Chester, England, dated to the late twelfth century evidently comes from a similar form of shrine.[149] The mounts from Dollerup in Denmark appear to have come from a church-shaped reliquary of the late eleventh century, as one of the mounts is a stylized animal-head finial (Fig. 5.7). Two robust animal-head finials in the Urnes style, possibly also from shrines, survive from Gotland in Sweden, one of which is localized to the parish of Eskelhem.[150] Thus, the late twelfth- or thirteenth-century church-shaped shrines in Scandinavia seem to have had an earlier tradition. While these reliquaries have similarities with the centuries-earlier Insular house-shaped shrines discussed previously, in that both are modeled, at least partially, on churches and feature animal-head finials, they appear to stem from separate traditions. The Scandinavian shrines most likely derive from a contemporary Continental tradition to which the shrine of St. Manchan and the Breac Maedhóg from Ireland also belong. Unfortunately, we have lost most of the early church metalwork from Scandinavia; the metalwork that survives at Urnes itself appears to date to the late twelfth or thirteenth centuries.

The pair of impressive imported Limoges candlesticks preserved at Urnes encourages us to think about earlier metalwork objects from the church interior (Plate 111). They are similar to smaller pairs that survive from elsewhere in Scandinavia, including those from Midtre Gauldal, Trøndelag (Norway) and Øster Jølby on the island of Mors in Denmark; they can also be compared with examples now in the Metropolitan Museum of Art, New York, and the Kunstgewerbemuseum, Berlin, dated *c.*1200.[151] The Urnes examples are far larger than these others, however, and thus far more impressive. The iron candelabrum in the shape of a ship from Urnes, which is very similar to a smaller one from the Dale church in Luster, Sogn og Fjordane (Norway), is thought to be medieval, although its precise dating is debated (Plate 110). Erla Hohler and Henrik von Achen cautiously suggested a twelfth-century date for the example from Dale,[152] while Anders Bugge noted the strong similarity between the miniature weather-vanes on these two candelabra and the ship's vane from Norderhov, Ringerike, in Norway, which he dates to *c.*1300.[153] There is an iron boat-shaped candlestick, albeit in a different style, from the River Witham in Lincolnshire, England. It was found with five other candlesticks in the bed of the river near Kirkstead Abbey, which was founded in the twelfth century.[154] However, the Dale church itself was built in the early thirteenth century,[155] and there is a reference to a boat-shaped candelabrum in a secular context in connection with an inheritance from 1366, which supports a thirteenth- or fourteenth- century date for these objects.[156] Although there are no interior furnishings surviving from the eleventh-century church at Urnes, some of the ship's vanes that were attached to churches provide an idea of what complex early church metalwork in Scandinavia may have looked like.[157]

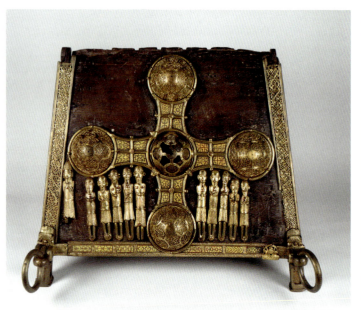 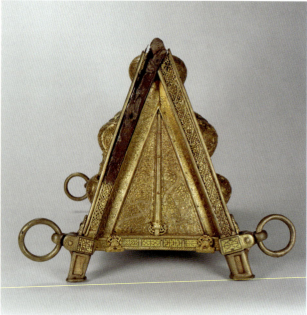

Fig. 5.13. Shrine of St. Manchan, from Lemanaghan, Co. Offaly, Ireland, *c.* 1115–35. This reliquary is based in part on a church roof, and its decorated gables are reminiscent of those surviving at Urnes. Photo: © National Museum of Ireland.

Conclusion

By examining the eleventh-century Urnes stave church and the Urnes style through an Insular lens, this chapter has provided some new perspectives on the subject. I have demonstrated that several aspects of Urnes and the other early Scandinavian stave churches were features of timber churches in the Insular world from at least the eighth century, which helps contextualize these churches in the wider northern European tradition to which they belong. Evidence from Insular hagiography also suggests one reason why material from the older church at Urnes was reused, although there may, of course, be other possibilities. I have also shown that there is strong circumstantial evidence to suggest that some timber churches in Ireland in the eleventh and early twelfth centuries may have been decorated with Hiberno-Scandinavian–style ornament. This was certainly the case for contemporary stone monuments and, later, for Romanesque stone churches in Ireland.

The study of the Urnes style in Ireland has so far been limited, and Hiberno-Norse relations in the late eleventh and early twelfth centuries deserve more detailed attention. Analysis in this chapter has shown that Magnús's campaign in Ireland left an archaeological as well as a historical legacy, in the form of a Norwegian-style stone high cross at Killaloe. I have also argued that Muirchertach Ua Briain, as a royal patron, may have had a pivotal role in the initial popularization of the Hiberno-Urnes style, while it has already been established that Toirrdelbach Ua Conchobair patronized several significant examples of the style in subsequent years. Indeed, the Hiberno-Urnes style appears to have enjoyed its high point in Ireland in the period from 1090 to 1130, but Urnes influence was current in Ireland both before and after that date range. One could even venture to say that Ireland was the last outpost of the Urnes style and, consequently, of what is termed Viking art. While much of the early church metalwork from Norway and the rest of Scandinavia is lost to us, the evidence from Ireland from the late eleventh and twelfth centuries help give some idea of what it might have been like. Leaving other places aside, the prevalence of the Hiberno-Urnes style in Ireland demonstrates the significance of the Urnes style as one of the most important Christian styles of the Middle Ages.

Notes

I would like to thank the following people for reading and commenting on earlier versions of this paper: John Sheehan, Tomás Ó Carragáin, Margrete Syrstad Andås, and Kirk Ambrose. I would also like to thank the various institutions for their assistance with imagery: National Museum of Ireland; British Museum; National Monuments Service; National Museums Northern Ireland; Trinity College, Dublin; and Cork Public Museum. My thanks to Maeve Sikora of the National Museum of Ireland, for commissioning new photography of the Dublin carved wood used in this chapter and for bringing my attention to the casts from Urnes held by that museum, and to Anne Pedersen of the National Museum, Copenhagen, for her help with the Dollerup mounts.

The following abbreviations are used in the notes:

AFM: *Annala Rioghachta Eireann: Annals of the Kingdom of Ireland by the Four Masters, from the Earliest Period to the Year 1616*, ed. and trans. John O'Donovan (Dublin, 1856; online ed., Cork, 2008), https://celt.ucc.ie//published/T100005B/index.html.

AI: *The Annals of Inisfallen (Ms Rawlinson B. 503)*, ed. and trans. Seán Mac Airt (Dublin, 1988).

AU: *The Annals of Ulster (to A.D. 1131)*, trans. Seán Mac Airt and Gearóid Mac Niocaill (Dublin, 1983).

CS: *Chronicon Scotorum*, trans. William M. Hennessy and Gearóid Mac Niocaill (Cork, 2010), https://celt.ucc.ie//published/T100016/index.html.

NMI: National Museum of Ireland

1. Knud J. Krogh, *Urnesstilens kirke: Forgængeren for den nuværende kirke på Urnes* (Oslo, 2011); and Terje Thun et al., "Dendrochronology Brings New Life to the Stave Churches: Dating and Material Analysis," in *Preserving the Stave Churches: Craftsmanship and Research*, ed. Kristin Bakken, trans. Ingrid Greenhow and Glenn Ostling (Oslo, 2016), 91–116, at 105–9.

2. Leif Anker, *The Norwegian Stave Churches*, trans. Tim Challman (Oslo, 2005), 12–15, 91–99; and Leif Anker, "What Is a Stave Church?," in Bakken, *Preserving the Stave Churches*, 17–22.

3. Håkon Christie, Olaf Olsen, and H. M. Taylor, 'The Wooden Church of St. Andrew at Greensted, Essex,' *Antiquaries Journal* 59.1 (1979): 92–112; and Ian Tyers et al., "List 80: Tree-Ring Dates from Sheffield University," *Vernacular Architecture* 28.1 (1997): 138–58, at 142.

4. Tomás Ó Carragáin, *Churches in Early Medieval Ireland: Architecture, Ritual, and Memory* (New Haven, CT, 2010), 15–47; and Claus Ahrens, *Die frühen Holzkirchen Europas* (Stuttgart, 2001). There is archaeological evidence for timber churches in Germany, Switzerland, Holland, France, Britain, and Ireland. For surviving timber churches from later medieval England, see Mark Gardiner, "Timber Churches in Medieval England: A Preliminary Study," in *Historic Wooden Architecture in Europe and Russia: Evidence, Study and Restoration*, ed. Evgeny Khodakovsky and Siri Skjold Lexau (Basel, 2015), 28–41.

5. Ó Carragáin, *Churches in Early Medieval Ireland*, 15–47; and Harold Leask, *Irish Churches and Monastic Buildings*, vol. 1, *The First Phases and the Romanesque* (Dundalk, 1955), 43–47.

6. Bernard of Clairvaux, *The Life and Death of Saint Malachy the Irishman*, trans. Robert T. Meyer (Kalamazoo, MI, 1978), 77.

7. E.g., the timber church of Mael Isu Ui Brolchan (*AU, AFM* 1116) probably at Lismore, Co. Waterford, and timber churches at Drumbo, Co. Down (*MIA*, 1130–31) and Clonmacnoise, Co. Offaly (*AFM* 1167). See Conleth Manning, "References to Church Buildings in the Annals," in *Seanchas: Studies in Early and Medieval Irish Archaeology, History, and Literature in Honour of Francis J. Byrne*, ed. Alfred P. Smyth (Dublin, 2000), 37–52.

8. See Ó Carragáin, *Churches in Early Medieval Ireland*, map 1; and Tadhg O'Keeffe, *Romanesque Ireland: Architecture and Ideology in the Twelfth Century* (Dublin, 2003), fig. 5, map.

9. Lorentz Dietrichson, *De norske stavkirker: Studier over deres system, oprindelse og historiske udvikling; et bidrag til Norges middelalderske bygningskunsts historie* (Kristiania, 1892), 62, 87–89, 162, 212–28.

10. Ó Carragáin, *Churches in Early Medieval Ireland*, 15–47.

11. Dublin, Trinity College, MS 58, fol. 202v. See Bernard Meehan, *The Book of Kells* (New York, 2012); https://digitalcollections.tcd.ie/concern/file_sets/zk51vh27m?locale=en.

12. Ó Carragáin, *Churches in Early Medieval Ireland*, 15–47; and Jane Hawkes, "Art and Society," in *The Cambridge History of Ireland*, vol. 1, 600–1550, ed. Brendan Smith (Cambridge, 2017), 76–106, at 95–96.

13. Leask, *Irish Churches and Monastic Buildings*, 47.

14. Ó Carragáin, *Churches in Early Medieval Ireland*, 40, 42; Leask, *Irish Churches and Monastic Buildings*, 46–47; and Michael J. O'Kelly, "Church Island near Valencia, Co. Kerry," *Proceedings of the Royal Irish Academy: Archaeology, Culture, History, Literature* 59 (1957–59): 57–136.

15. Aina Heen-Pettersen and Griffin Murray, 'An Insular Reliquary from Melhus: The Significance of Insular Ecclesiastical Material in Early Viking-Age Norway,' *Medieval Archaeology* 62.1 (2018): 53–82, at 65; Samuel Gerace, 'Wandering Churches: Insular House-Shaped Shrines and the Temple of Jerusalem,' in *Islands in a Global Context: Proceedings of the Seventh International Conference on Insular Art, Held at the National University of Ireland, Galway 16–20 July 2014*, ed. Conor Newman, Mags Mannion, and Fiona Gavin (Dublin, 2017), 84–91, at 89–91; Hawkes, 'Art and Society,' 93–96; and Ó Carragáin, *Churches in Early Medieval Ireland*, 24. For wider discussion on these objects, see Michael Ryan, 'House-Shaped Shrines,' in *Art and Architecture of Ireland*, vol. 1, Medieval, c.400–c.1600, ed. Rachel Moss (Dublin, 2014), 286–90; and Martin Blindheim, 'A House-Shaped Irish-Scots Reliquary in Bologna, and Its Place among the Other Reliquaries,' *Acta Archaeologica* 55 (1984): 1–53.

16. Ó Carragáin, *Churches in Early Medieval Ireland*, 22–23.

17. Ibid., 22. See Roger Stalley, *Early Irish Sculpture and the Art of the High Crosses* (London, 2020), 19–21, plates 6, 22, 64, 114, 147,166, 180; Peter Harbison, *The Golden Age of Irish Art: The Medieval Achievement, 600–1200* (London, 1999), plates 93–94, 101–2, 109; and Leask, *Irish Churches and Monastic Buildings*, 46–47, 53–54.

18. *AFM* (1104); *CS* (1113); *AU* (1125). See Manning, "References to Church Buildings." There is a reference to the "oratory" at Armagh having been roofed with lead in

1009 (*AU*), while it is recorded that the "great stone church with its lead roof" was destroyed by fire in 1020 (*AU*).

19 Ó Carragáin, *Churches in Early Medieval Ireland*, 20, 160.

20 Ibid., 20–21; Niall Brady, "*Hisperica famina* and Church Building," *Peritia* 11 (1997): 327–35; Michael W. Herren, ed., *The Hisperica famina: A New Critical Edition with English Translation and Philological Commentary*, vol. 1, *The A-Text* (Toronto, 1974), 108–9; and see discussion in C. E. Roth, "Some Observations on the Historical Background of the *Hisperica famina*," *Ériu* 29 (1978): 112–22.

21 Meyer, *Life and Death of Saint Malachy*, 32.

22 Hilary Murray, *Viking and Early Medieval Buildings in Dublin: A Study of the Buildings Excavated under the Direction of A. B. Ó Ríordáin in High Street, Winetavern Street and Christchurch Place, Dublin, 1962–63, 1967–76* (Oxford, 1983), 95–97, figs. 34, 38.

23 Nationalmuseet, Copenhagen, D2309. Henrik Adrian and Poul Grinder-Hansen, *Den romanske kirke: Billede og betydning* (Copenhagen, 1995), 35; and David M. Wilson and Ole Klindt-Jensen, *Viking Art* (London, 1966), 153, frontispiece.

24 Examples of some pre-Romanesque churches in Ireland with decorated doorways include Killoe, Co. Kerry; Clonamery, Co. Kilkenny; Inishmurray, Co. Sligo; Fore, Co. Westmeath; St. Mary's, Glendalough, Co. Wicklow. See Ó Carragáin, *Churches in Early Medieval Ireland*.

25 James T. Lang, *Viking-Age Decorated Wood: A Study of Its Ornament and Style*, Medieval Dublin Excavations 1962–81 Series B, vol. 1 (Dublin, 1988); and H. O'Neill Hencken et al., "Ballinderry Crannog No. 1," *Proceedings of the Royal Irish Academy: Archaeology, Culture, History, Literature* 43 (1935–37): 103–239.

26 Lang, *Viking-Age Decorated Wood*, 16, 18, 53–54, 58–59, cat. nos. DW12, DW27.

27 James Lang, "Eleventh-Century Style in Decorated Wood from Dublin," in *Ireland and Insular Art, AD 500–1200*, ed. Michael Ryan (Dublin, 1987), 174–78, at 177, plate I.

28 Howard B. Clarke, *Irish Historic Towns Atlas*, no. 11, *Dublin, Part I: To 1610* (Dublin, 2002), 4, 17.

29 Ó Carragáin, *Churches in Early Medieval Ireland*, 158–61.

30 For evidence of this in England, however, see Warwick Rodwell, "Appearances Can Be Deceptive: Building and Decorating Anglo-Saxon Churches," *Journal of the British Archaeological Association* 165 (2012): 22–60.

31 Sean Connolly and J.-M. Picard, "Cogitosus's *Life of St Brigit*: Content and Value," *Journal of the Royal Society of Antiquaries of Ireland* 117 (1987): 5–27, at 25–26.

32 See discussion in Chapter 4 in this volume.

33 James Graham-Campbell, *The Viking World*, 3rd ed. (London, 2001), 138–39.

34 Bibi Beekman and Richard N. Bailey, "A Painted Viking-Age Sculpture from York," *Yorkshire Archaeological Journal* 90 (2018): 59–66; Martin Carver, Justin Garner-Lahire, and Cecily Spall, *Portmahomack on Tarbat Ness: Changing Ideologies in North-East Scotland, Sixth to Sixteenth Century AD* (Edinburgh, 2016), 164; and Warwick Rodwell et al., "The Lichfield Angel: A Spectacular Anglo-Saxon Painted Sculpture," *Antiquaries Journal* 88 (2008): 48–108.

35 Harbison, *Golden Age of Irish Art*, 154; and Stalley, *Early Irish Sculpture*, 40–41.

36 Richard Gem, Emily Howe, and Richard Bryant, "The Ninth-Century Polychrome Decoration at St Mary's Church, Deerhurst," *Antiquaries Journal* 88 (2008): 109–64; and Rodwell, "Appearances Can Be Deceptive."

37 Connolly and Picard, "Cogitosus's *Life of St Brigit*," 26.

38 Bede, *The Ecclesiastical History of the English People, The Greater Chronicle, Bede's Letter to Egbert*, ed. Judith McClure and Roger Collins (Oxford, 1994), 136. For discussion of Bede's account see Ó Carragáin, *Churches in Early Medieval Ireland*, 25–26.

39 Ó Carragáin, *Churches in Early Medieval Ireland*, 156–58; and Con Manning, "A Puzzle in Stone: The Cathedral at Glendalough," *Archaeology Ireland* 16.2 (2002): 18–21.

40 James Graham-Campbell, *Viking Art*, 4th ed. (London, 2013), 133–50; and Signe Horn Fuglesang, "Stylistic Groups in Late Viking and Early Romanesque Art," *Acta ad archaeologiam et artium historiam pertinentia* 8.1 (1981): 79–125, at 89–96.

41 E.g., see Christoph Stiegemann, Martin Kroker, and Wolfgang Walter, eds., *Credo: Christianisierung Europas im Mittelalter* (Petersberg, 2013).

42 Harbison, *Golden Age of Irish Art*.

43 Griffin Murray, *The Cross of Cong: A Masterpiece of Medieval Irish Art* (Dublin, 2014); Griffin Murray, "The Art of Politics: The Cross of Cong and the Hiberno-Urnes Style," in *The Vikings in Ireland and Beyond: Before and after the Battle of Clontarf*, ed. Howard B. Clarke and Ruth Johnson (Dublin, 2015), 416–37; and Griffin Murray, "Changing Attitudes to Viking Art in Medieval Ireland," in *Viking Encounters: Proceedings of the Eighteenth Viking Congress, Denmark, August 6–12, 2017*, ed. Anne Pedersen and Søren M. Sindbæk (Aarhus, 2020), 426–34.

44 For its occurrence in England, see Olwyn Owen, "The Strange Beast That Is the English Urnes Style," in *Vikings and the Danelaw: Select Papers from the Proceedings of the Thirteenth Viking Congress, Nottingham and York, 21–30 August 1997*, ed. James Graham-Cambpell et al. (Oxford, 2001), 203–22.

45 Haakon Shetelig, "Urnesgruppen: Det sidste avsnit av vikingetidens stilutvikling," *Årbok: Foreningen til norske fortidsminnesmerkers bevaring* 65 (1909): 75–107.

46 NMI R2833, R2988, R4011.

47 George Coffey, *Guide to the Celtic Antiquities of the Christian Period Preserved in the National Museum, Dublin* (Dublin, 1909), 49, 62.

48 These are numbered from 213 to 217 in the plaster-cast collection in the NMI. My thanks to Ms. Maeve Sikora, Keeper of Irish Antiquities, National Museum of Ireland, for bringing the casts to my attention.

49 Mari Lending, "Traveling Portals," in *Place and Displacement: Exhibiting Architecture*, ed. Thordis Arrhenius et al. (Zurich, 2014), 197–212, at 209. The casts in the V&A (REPRO.1907-58) are currently on exhibition; see https://collections.vam.ac.uk/item/O40925/copy-of-a/.

50 Haakon Shetelig, "The Norse Style of Ornamentation in the Viking Settlements," *Acta Archaeologica* 19 (1948): 69–113, at 110–13; T. D. Kendrick, *Late Saxon and Viking Art* (London, 1949), 114–15; and Ole Henrik Moe, "Urnes and

51. Wilson and Klindt-Jensen, *Viking Art*, 155–60.

52. Máire De Paor and Liam De Paor, *Early Christian Ireland*, rev. ed. (London, 1964), 166–72. This book was first published in 1958.

53. Liam De Paor, "The Limestone Crosses of Clare and Aran," *Journal of the Galway Archaeological and Historical Society* 26.3–4 (1955–56): 53–71. Notably, in this paper he acknowledges his wife Máire's 'valuable assistance and criticism.'

54. Oxford, Corpus Christi College, MS 282; Françoise Henry, 'The Effects of the Viking Invasions on Irish Art,' in *The Impact of the Scandinavian Invasions on the Celtic-Speaking Peoples, c.800–1100 A.D.: Introductory Papers Read at Plenary Sessions of the International Congress of Celtic Studies held in Dublin, 6–10 July 1959*, ed. Brian Ó Cuív (Dublin, 1962), 61–72; Françoise Henry and G. L. Marsh-Micheli, 'A Century of Irish Illumination (1070–1170)," *Proceedings of the Royal Irish Academy: Archaeology, Culture, History, Literature* 62 (1961–63): 101–66; and Françoise Henry, *Irish Art in the Romanesque Period, 1020–1170 A.D.* (London, 1970), 190–210.

55. Wilhelm Holmqvist, *Övergångstidens metallkonst* (Stockholm, 1963).

56. Lorentz Dietrichson, *Den norske traeskjærerkunst, dens oprindelse og udvikling: En foreløbig undersøgelse* (Christiania, 1878), 8–11; and Dietrichson, *De norske stavkirker*, 165, 182, 189–93, 212–28.

57. Elisabeth Farnes, "Some Aspects of the Relationship between Late 11th and 12th Century Irish Art and the Scandinavian Urnes Style" (MA thesis, University College Dublin, 1975).

58. Signe Horn Fuglesang, *Some Aspects of the Ringerike Style: A Phase of 11th Century Scandinavian Art* (Odense, 1980), 53–54, 64, 76. Fuglesang also mentions Ireland in papers on late Viking art; see Signe Horn Fuglesang, "Stylistic Groups in Late Viking and Early Romanesque Art"; and Signe Horn Fuglesang, "Animal Ornament: The Late Viking Period," in *Tiere, Menschen, Götter: Wikingerzeitliche Kunststile und ihre neuzeitliche Rezeption; Referate gehalten auf einem von der Deutschen Forschungsgemeinschaft geförderten Internationalen Kolloquium der Joachim Jungius-Gesellschaft der Wissenschaften, Hamburg*, ed. Michael Müller-Wille and Lars Olof Larsson (Göttingen, 2001), 157–94, at 177.

59. James Graham-Campbell, *Viking Artefacts: A Select Catalogue* (London, 1980), 149–50, cat. nos. 505–7; James Graham-Campbell and Dafydd Kidd, *The Vikings: The British Museum, London; The Metropolitan Museum of Art, New York* (London, 1980), 175–76; James Graham-Campbell, "From Scandinavia to the Irish Sea: Viking Art Reviewed," in Ryan, *Ireland and Insular Art*, 144–52, at 151; Graham-Campbell, *Viking World*, 152; and Graham-Campbell, *Viking Art*, 154–57.

60. Roger Stalley, "The Romanesque Sculpture of Tuam," repr. in *Ireland and Europe in the Middle Ages: Selected Essays on Architecture and Sculpture* (London, 1994), 127–63.

61. Uaininn O'Meadhra, *Early Christian, Viking and Romanesque Art: Motif-Pieces from Ireland*, vol. 1, *An Illustrated and Descriptive Catalogue of the So-Called Artists' "Trial-Pieces" from c.5th–12th Cents. AD, Found in Ireland c.1830–1973* (Stockholm, 1979), cat. nos. 35, 39, 55; ibid., vol. 2, *A Discussion on Aspects of Find-Context and Function* (Stockholm, 1987), 39–55; Uaninn O'Meadhra, "Irish, Insular, Saxon, and Scandinavian Elements in the Motif-Pieces from Ireland," in Ryan, *Ireland and Insular Art*, 159–65; Uaininn O'Meadhra, "Copies or Creations? Some Shared Elements in Hiberno-Norse and Scandinavian Artwork," in Clarke and Johnson, *Vikings in Ireland and Beyond*, 373–402; and Lang, *Viking-Age Decorated Wood*.

62. Raghnall Ó Floinn, 'Viking and Romanesque Influence 1000 AD–1169 AD,' and cat. nos. 79–83, in *Treasures of Ireland: Irish Art, 3000 B.C.–1500 A.D.*, ed. Michael Ryan (Dublin, 1983), 58–69, 167–73; and Raghnall Ó Floinn, 'Irish and Scandinavian Art in the Early Medieval Period,' in *The Vikings in Ireland*, ed. Anne-Christine Larsen (Roskilde, 2001), 87–97, at 91–97.

63. Lise G. Bertelsen, *Vikingetidens kunst: En udstilling om kunsten i vikingernes verden og efterverden ca.1800–1250* (Jelling, 2002), 31, 69–71, cat. nos. 52–54.

64. Anne-Sofie Gräslund, 'Runstenar: Om ornamentik och datering,' *Tor* 23 (1991): 113–40; Anne-Sofie Gräslund, 'Runstenar: Om ornamentik och datering II," *Tor* 24 (1992): 177–201; and Anne-Sofie Gräslund, 'Rune Stones: On Ornamentation and Chronology,' in *Developments around the Baltic and the North Sea in the Viking Age: Twelfth Viking Congress*, ed. Björn Ambrosiani and Helen Clarke (Stockholm, 1994), 117–31.

65. Murray, *Cross of Cong*, 167–77; and Murray, "Art of Politics."

66. Murray, *Cross of Cong*, 176.

67. Shrines for early handbells are a form of medieval reliquary found only in Ireland and Scotland. Cormac Bourke, *The Early Medieval Hand-Bells of Ireland and Britain* (Dublin, 2020), 300–310, cat. no. 3; Cormac Bourke, "Shrine of St Patrick's Bell," in Moss, *Art and Architecture of Ireland*, 307–8; and Raghnall Ó Floinn, 'Iron Bell of St. Patrick and Its Shrine," in Ryan, *Treasures of Ireland*, 167–68.

68. Lise G. Bertelsen, "Urnesfibler i Danmark, "*Aarboger for nordisk oldkyndighed og historie*, 1992 (1994): 345–70.

69. Nationalmuseet (Denmark) D80/1958 and D81/1958. My sincere thanks to Anne Pedersen, Senior Researcher at the museum, for information relating to these objects.

70. Ó Floinn, 'Iron Bell of St. Patrick and Its Shrine.'

71. *AFM* (1121); Bourke, 'Shrine of St Patrick's Bell'; Ó Floinn, 'Iron Bell of St. Patrick and Its Shrine'; and Henry, *Irish Art in the Romanesque Period*, 95, but see the recent revised dating in Bourke, *Early Medieval Hand-Bells*, 308–9.

72. *AU* (1091); and *AU* (1105).

73. Perette Michelli dates the shrine between 1091 and 1094 on the basis that Domnall Ua Lochlainn is not mentioned as high king in the inscription, but the absence of evidence is not evidence for absence. Indeed, there is no mention of his kingship at all in the inscription, even though he had been king of Cenél nEógain since 1083. Michelli, 'The Inscriptions on Pre-Norman Reliquaries,' *Proceedings of the Royal Irish Academy: Archaeology, Culture, History, Literature* 96C.1 (1996): 1–48, at 22–23.

74. Rosemary Power, "Magnus Barelegs' Expeditions to the West," *Scottish Historical Review* 65.180, pt. 2 (1986): 107–

75 *AFM* (1102).

76 *AI* (1105).

77 Murray, *Cross of Cong*, 177, 200; Máire De Paor, "The Relics of Saint Patrick: A Photographic Feature with Notes on the Relics," *Seanchas Ardmhacha: Journal of the Armagh Diocesan Historical Society* 4.2 (1961–62): 87–91, at 89; and George Ferguson, *Signs and Symbols in Christian Art* (New York, 1958), 9.

78 Anne-Sofie Gräslund, 'En påfågel i Odensala? Några reflexioner om ikonografin på runstenarna vid Harg,' in *Situne Dei: Årsskrift för Sigtunaforskning och historisk arkeologi 2014*, ed. Anders Söderberg et al. (Sigtuna, 2014), 22–31; Graham-Campbell and Kidd, *Vikings*, 175, plate 104; Nicolay Nicolaysen, *The Viking-Ship Discovered at Gokstad in Norway* (Christiania, 1882), 46, 69.

79 This has been independently argued by Susan Youngs and me. See Susan Youngs, 'A Hiberno-Norse Strap-End from Bulford near Amesbury, Wiltshire,' 11–18, and Griffin Murray, 'The Bearnán Chúláin Bell-Shrine from Glenkeen, Co. Tipperary: An Archaeological and Historical Analysis," 19–27, both in *Journal of the Cork Historical and Archaeological Society*, ser. 2, 121 (2016).

80 British Museum 1854,0714.6.

81 NMI 1988:226; and Raghnall Ó Floinn, 'Sword Hilt,' in *From Viking to Crusader: The Scandinavians and Europe, 800–1200*, ed. Else Roesdahl and David M. Wilson (Copenhagen, 1992), 340, cat. no. 431.

82 Youngs, "A Hiberno-Norse Strap-End."

83 O'Meadhra, *Early Christian, Viking and Romanesque Art: Motif-Pieces*, 22, 24, 34, 85–87, cat. nos. 15, 114; and O'Meadhra, *Early Christian, Viking and Romanesque Art: A Discussion*, 31–32, 60–61.

84 Edmond O'Donovan, "Broad Street/George's Quay/Abbey River, Limerick," in *Excavations 1999: Summary Accounts of Archaeological Excavations in Ireland*, ed. Isabel Bennett (Bray, 2000), 169–71. My thanks to Raghnall Ó Floinn for discussion on the possible function of this object.

85 British Museum 1858,0120.1. See O'Meadhra, "Irish, Insular, Saxon, and Scandinavian Elements," 162; O'Meadhra, "Copies or Creations?," 380; and Graham-Campbell, *Viking Artefacts*, cat. no. 478.

86 Richard Gem, 'St Flannán's Oratory at Killaloe: A Romanesque Building of *c*.1100 and the Patronage of King Muirchertach Ua Briain," in *Ireland and Europe in the Twelfth Century: Reform and Renewal*, ed. Damian Bracken and Dagmar Ó Riain-Raedel (Dublin, 2006), 74–105; and Tomás Ó Carragáin, 'Rebuilding the 'City of Angels': Muirchertach Ua Briain and Glendalough, *c*.1096–1111," in *The Viking Age: Ireland and the West: Papers from the Proceedings of the Fifteenth Viking Congress, Cork, 18–27 August 2005*, ed. John Sheehan and Donnchadh Ó Corráin (Dublin, 2010), 258–70.

87 *AI* (1059); and Raghnall Ó Floinn, 'Schools of Metalworking in Eleventh- and Twelfth-Century Ireland,' in Ryan, *Ireland and Insular Art*, 179–87, at 186.

88 The modern version of Ó hIonmhaineán is Ó Nuanáin (Noonan). Edward MacLysaght, *The Surnames of Ireland*, 6th ed. (Dublin, 1985), 237.

89 There is a small cross inscribed on the only known runestone from Ireland, from Beginish, Co. Kerry, which may or may not be contemporary with the runes. See Michael J. O'Kelly with Séamus Kavanagh, 'An Island Settlement at Beginish, Co. Kerry,' *Proceedings of the Royal Irish Academy: Archaeology, Culture, History, Literature* 57 (1955–56): 159–94, at 171–75; and John Sheehan, Steffen Stummann Hansen, and Donnchadh Ó Corráin, 'A Viking-Age Maritime Haven: A Reassessment of the Island Settlement at Beginish, Co. Kerry," *Journal of Irish Archaeology* 10 (2001): 93–119, at 101–3. All other Scandinavian runic inscriptions in Ireland occur on objects; see Michael P. Barnes, Jan Ragnar Hagland, and R. I. Page, *The Runic Inscriptions of Viking Age Dublin* (Dublin, 1997), 53–56.

90 R. A. S. Macalister, "On a Runic Inscription at Killaloe Cathedral," *Proceedings of the Royal Irish Academy: Archaeology, Culture, History, Literature* 33 (1916–17): 493–98; R. A. S. Macalister, "Further Notes on the Runic Inscription in Killaloe Cathedral," *Proceedings of the Royal Irish Academy: Archaeology, Culture, History, Literature* 38 (1928–29): 236–39; and R. A. S. Macalister, *Corpus Inscriptionum Insularum Celticarum* (Dublin, 1945), 1:58–59.

91 Peter Harbison, *The High Crosses of Ireland: An Iconographical and Photographic Survey* (Bonn, 1992), 1:121.

92 Magnus Olsen, "Runic Inscriptions in Great Britain, Ireland and the Isle of Man," in Alexander O. Curle, Magnus Olsen, and Haakon Shetelig, *Viking Antiquities in Great Britain and Ireland*, part 6, *Civilisation of the Viking Settlers in Relation to Their Old and New Countries* (Oslo, 1954), 151–232, at 181–82; and Barnes, Hagland, and Page, *Runic Inscriptions of Viking Age Dublin*, 53–56.

93 Damian McManus, *A Guide to Ogam* (Maynooth, 1997), 130.

94 Michael Barnes and Jan Ragnar Hagland, "Runic Inscriptions and Viking-Age Ireland," in Sheehan and Ó Corráin, *Viking Age*, 11–18, at 12.

95 Griffin Murray, "Thorgrim, the Killaloe Cross, and the Norwegian Campaign in Ireland in 1102–1103," *Peritia* 30 (2019): 237–42.

96 Snorri Sturluson, *Heimskringla: History of the Kings of Norway*, trans. Lee M. Hollander (Austin, TX, 1992), 686, *Saga of Magnús Barelegs*, chap. 25; and Power, "Death of Magnus Barelegs."

97 Hollander, *Heimskringla*, 683–84, *Saga of Magnús Barelegs*, chap. 23.

98 Power, "Magnus Barelegs' Expeditions," 122.

99 Iris Crouwers, "Late Viking-Age and Medieval Stone Crosses and Cross-Decorated Stones in Western Norway: Forms, Uses and Perceptions in a Northwest-European Context and Long-Term Perspective' (PhD diss., University of Bergen, 2019); Sæbjørg Walaker Nordeide, 'Cross Monuments in North-Western Europe,' *Zeitschrift für Archäologie des Mittelalters* 37 (2009): 163–78; and Fridtjov Birkeli, *Norske steinkors i tidlig middelalder: et bidrag til belysning av overgangen fra norrøn religion til kristendom* (Oslo, 1973).

100 Gem, 'St Flannán's Oratory at Killaloe.'

101 Geoffrey Keating, *The History of Ireland*, vol. 3, *Containing the Second Book of the History*, ed. and trans. Patrick S. Dinneen (London, 1908), 300–301.

102 O'Meadhra, *Early Christian, Viking and Romanesque Art: Motif-Pieces*; Lang, *Viking-Age Decorated Wood*; Ó Floinn, 'Irish and Scandinavian Art'; Raghnall Ó Floinn, 'Appendix A: Decorative Sword Sheaths,' in Esther A. Cameron, *Scabbards and Sheaths from Viking and Medieval Dublin* (Dublin, 2007), 139–40; and Patrick F. Wallace, *Viking Dublin: The Wood Quay Excavations* (Kildare, 2016).

103 Fuglesang, *Some Aspects of the Ringerike Style*.

104 Lang, *Viking-Age Decorated Wood*, 27, 47, 67, cat. no. DW49, fig. 43; and O'Meadhra, "Copies or Creations?," 395–96, plate 21.

105 Cameron, *Scabbards and Sheaths*, 6.

106 Lang, *Viking-Age Decorated Wood*, 27, 67–68, cat. no. DW50 (back only illustrated); for illustration and discussion, see O'Meadhra, "Irish, Insular, Saxon, and Scandinavian Elements," 163–64, plate 1 d, e, fig. 5.

107 Wallace, *Viking Dublin*, 402, plate 11.16; O'Meadhra, *Early Christian, Viking and Romanesque Art: Motif-Pieces*, cat. nos. 35, 39, 55; O'Meadhra, *Early Christian, Viking and Romanesque Art: A Discussion*, 39–55; and O'Meadhra, "Irish, Insular, Saxon and Scandinavian Elements," 162–63. A Scandinavian Urnes-style brooch in the National Museum of Ireland is said to have come from an old Dublin collection, but its provenance is otherwise unknown; Ruth Johnson, *Viking Age Dublin* (Dublin, 2004), 44.

108 Uaininn O'Meadhra, "Motif-Pieces and Other Decorated Bone and Antler Work," in *Late Viking-Age and Medieval Waterford: Excavations 1986–1992*, ed. Maurice Hurley and Orla M. B. Scully, with Sarah W. J. McCutcheon (Waterford, 1997), 699–702, at 699–700, fig. 17:11.2; and Uaininn O'Meadhra, "Bone Motif-Piece, E 509-1304," in Madeline O'Brien, "Excavations at Barrack Street—French's Quay, Cork," *Journal of the Cork Historical and Archaeological Society* 98 (1993): 27–49, at 42.

109 On the career of Muirchertach Ua Briain, see Anthony Candon, "Muirchertach Ua Briain, Politics, and Naval Activity in the Irish Sea, 1075 to 1119," in *Keimelia: Studies in Medieval Archaeology and History in Memory of Tom Delaney*, ed. Gearóid Mac Niocaill and Patrick F. Wallace (Galway, 1988), 397–415; and Seán Duffy, "The Western World's Tower of Honour and Dignity": The Career of Muirchertach Ua Briain in Context,' in Bracken and Ó Riain-Raedel, *Ireland and Europe in the Twelfth Century*, 56–73.

110 AU (1103); and Máire Ní Mhaonaigh, *Brian Boru: Ireland's Greatest King?* (Stroud, 2007), 115.

111 AI (1102); and Donnchadh Ó Corráin, *Ireland before the Normans* (Dublin, 1972), 147.

112 Seán Duffy, 'Ireland and Scotland, 1014–1169: Contacts and Caveats,' in Smyth, *Seanchas*, 348–56, at 355; and Candon, "Muirchertach Ua Briain."

113 Later in his career, in 1111, he spent three months there. Ó Corráin, *Ireland before the Normans*, 137–38, 148.

114 Murray, "Art of Politics."

115 Rhoda Cronin, "Late High Crosses in Munster: Tradition and Novelty in Twelfth-Century Irish Art," in *Early Medieval Munster: Archaeology, History, and Society*, ed. Michael A. Monk and John Sheehan (Cork, 1998), 138–46; and De Paor, "Limestone Crosses."

116 NMI L1949:1. The dating of this crosier is based on its inscription, which names Nial Mc Meicc Aeducáin, who is recorded as bishop of Lismore on his death in 1113 (*AI, AT*). When he took up office is unknown, but a Mael Dúin Ua Rebachain *coarb* of Mochuda is recorded as having died in 1090 (*AI, AU, AFM*). Raghnall Ó Floinn, 'The Lismore Crozier,' in Ryan, *Treasures of Ireland*, 170–71.

117 See Griffin Murray, "The Makers of Church Metalwork in Early Medieval Ireland: Their Identity and Status," in *Making Histories: Proceedings of the Sixth International Conference on Insular Art, York 2011*, ed. Jane Hawkes (Donington, 2013), 162–73, at 170.

118 NMI 1884:690. Griffin Murray, "The Arm-Shaped Reliquary of St Lachtin: Technique, Style and Significance," in *Irish Art Historical Studies in Honour of Peter Harbison*, ed. Colum Hourihane (Dublin, 2004), 141–64.

119 Murray, *Cross of Cong*.

120 Ibid.; and Murray, "Arm-Shaped Reliquary of St Lachtin."

121 AI (1116).

122 Sheehan, Stummann Hansen, and Ó Corráin, 'Viking-Age Maritime Haven,' 115; Griffin Murray, "Early Medieval Shrine Fragments from Park North Cave, Co. Cork and Kilgreany Cave, Co. Waterford," in *Underground Archaeology: Studies on Human Bones and Artefacts from Ireland's Caves*, ed. Marion Dowd (Oxford, 2016), 150–58, at 156–57; and S. Elder et al., "Archaeological Excavation Report: 00E0422 ext, 01E0327 ext, 02E0809—Shandon td., Dungarvan, Co. Waterford; Medieval Moated Site," *Eachtra Journal* 14 (2012): 1–109; http://eachtra.ie/new_site/wp-content/uploads/2012/06/shandon-dungarvan-co-waterford.pdf.

123 AFM (1094); and Ó Corráin, *Ireland before the Normans*, 145.

124 Cormac Bourke, "Carved Stones from Donaghenry and Stewartstown," *The Bell: Journal of Stewartstown and District Local History Society* 5 (1995): 60–64. On this site, see Ann Elizabeth Hamlin, *The Archaeology of Early Christianity in the North of Ireland*, ed. Thomas R. Kerr (Oxford, 2008), 380, cat. no. 241.

125 John Bradley, "The Sarcophagus at Cormac's Chapel, Cashel, Co. Tipperary," *North Munster Antiquarian Journal* 26 (1984): 14–35; and AFM (1124).

126 Murray, "Arm-Shaped reliquary of St Lachtin."

127 See Chapter 4 in this volume; and Gunnar Almevik and Jonathan Westin, "Hemse Stave Church Revisited," *Lund Archaeological Review* 23 (2017): 7–25.

128 Aubrey Gwynn, *The Irish Church in the Eleventh and Twelfth Centuries*, ed. Gerard O'Brien (Dublin, 1992), 227.

129 AU 1078; AI 1078, 1084; Anthony Candon, 'Telach Óc and Emain Macha c.1100,' *Emania* 15 (1996): 39–46, at 41–42; and Anthony Candon, "Power, Politics and Polygamy: Women and Marriage in Late Pre-Norman Ireland," in Bracken and Ó Riain-Raedel, *Ireland and Europe in the Twelfth Century*, 106–27, at 116–18.

130 AU 1110.

131 Candon, "Power, Politics and Polygamy.'

132 Jenifer Ní Ghrádaigh, "But What Exactly Did She Give?" Derbforgaill and the Nuns' Church at Clonmacnoise," in *Clonmacnoise Studies*, vol. 2, *Seminar Papers, 1998*, ed. Heather A. King (Dublin, 2003), 175–207; and Jenifer Ní Ghrádaigh, 'The Occluded Role of Royal Women and

133 Ní Ghrádaigh, "Occluded Role of Royal Women," 53.

Lost Works of Pre-Norman English and Irish Art (Tenth to Twelfth Centuries)," *Journal of Medieval History* 42.1 (2016): 51–75, at 66–69.

134 Boher parish church, Co. Offaly.

135 Murray, *Cross of Cong*, 206–7, 230–61, cat. no. 3.

136 Ó Carragáin, *Churches in Early Medieval Ireland*, 76–77; and Cormac Bourke, "Corporeal Relics, Tents and Shrines in Early Medieval Ireland," *Ulster Journal of Archaeology* 74 (2017–18): 118–29, at 124.

137 Griffin Murray, 'The Breac Maodhóg: A Unique Medieval Irish Reliquary," in *Cavan: History and Society; Interdisciplinary Essays on the History of an Irish County*, ed. Jonathan Cherry and Brendan Scott (Dublin, 2014), 83–125, at 106–7.

138 Krogh, *Urnesstilens kirke*, figs. 22, 27, 111, 112; and Moe, "Urnes and the British Isles."

139 NMI R.2960

140 Murray, *Cross of Cong*, 297–98, cat. no. 15.

141 Stalley, "Romanesque Sculpture at Tuam"; Tadhg O'Keeffe, "The Romanesque Portal at Clonfert Cathedral and Its Iconography," in *From the Isles of the North: Early Medieval Art in Ireland and Britain; Proceedings of the Third International Conference on Insular Art Held in the Ulster Museum, Belfast, 7–11 April, 1994*, ed. Cormac Bourke (Belfast, 1995), 261–70; Tadhg O'Keeffe, "Diarmait Mac Murchada and Romanesque Leinster: Four Twelfth-Century Churches in Context," *Journal of the Royal Society of Antiquaries of Ireland* 127 (1997): 52–79; Roger Stalley, "Hiberno-Romanesque and the Sculpture of Killeshin," in *Laois: History and Society*, ed. Pádraig G. Lane and William Nolan (Dublin, 1999), 89–122; O'Keeffe, *Romanesque Ireland*; and Rachel Moss, "The Old Portal and Cathedral of Kilmore," *Breifne* 12.46 (2011): 203–36.

142 Fuglesang, "Stylistic Groups in Late Viking and Early Romanesque Art," 96–118.

143 However, a brooch decorated in Fuglesang's 'Urnes-Romanesque' style from a hoard at Alvidsjö, Öland, Sweden, was found with coins dated c.1170–97, suggesting the possibility of a longer time span; ibid., 112, fig. 26.

144 E.g. Stalley, "Hiberno-Romanesque and the Sculpture of Killeshin," 108–9; and Moss, "Old Portal and Cathedral of Kilmore," 213.

145 O'Keeffe, *Romanesque Ireland*.

146 Stalley, "Romanesque Sculpture of Tuam," 159.

147 David M. Wilson, "An Early Representation of St Olaf," in *Medieval Literature and Civilization: Studies in Memory of G. N. Garmonsway*, ed. D. A. Pearsall and R. A. Waldron (London, 1969), 141–45.

148 Eugen Kusch, *Ancient Art in Scandinavia* (Nuremberg, 1965), 45–46, 68, plates 72, 145; Roesdahl and Wilson, *From Viking to Crusader*, 212, 350, cat. no. 468; and Anker, *Norwegian Stave Churches*, 238, 240.

149 George Zarnecki, Janet Holt, and Tristram Holland, eds., *English Romanesque Art, 1066–1200* (London, 1984), 251, cat. no. 254.

150 Holmqvist, *Övergångstidens metallkonst*, 70, fig. 45; and Graham-Campbell, *Viking Artefacts*, 149, cat. no. 503.

151 NTNU University Museum, Trondheim, T4587; Niels-Knud Liebgott, *Middelalderens emaljekunst* (Copenhagen, 1986), 612, fig. 54; and Barbara Drake Boehm, "Candlestick," in *Enamels of Limoges, 1100–1350*, ed. John P. O'Neill (New York, 1996), 156–57, cat. no. 37.

152 Henrik von Achen and Erla Hohler, "Boat-Shaped Candlestick," in Roesdahl and Wilson, *From Viking to Crusader*, 391, cat. no. 616.

153 Anders Bugge, "The Golden Vanes of Viking Ships: A Discussion on a Recent Find at Källunge Church, Gothland,' *Acta Archaeologica* 2 (1931): 159–84, at 173–75, 177–78, figs. 13, 15.

154 Anon., "Appendix; November 19, 1801," *Archaeologia, or Miscellaneous Tracts Relating to Antiquity* 14 (1803): 279, plate LIV.

155 Øystein Ekroll and Morten Stige, *Kirker i Norge*, vol. 1, *Middelalder i stein* (Oslo, 2000), 180–85.

156 Bugge, "Golden Vanes of Viking Ships," 178.

157 Martin Blindheim, "Viking Ship Vanes, Their Use and Techniques," in *The Vikings*, ed. R. T. Farrell (London, 1982), 116–27; and Bugge, "Golden Vanes of Viking Ships."

PART TWO | THE ELEVENTH-CENTURY CHURCH

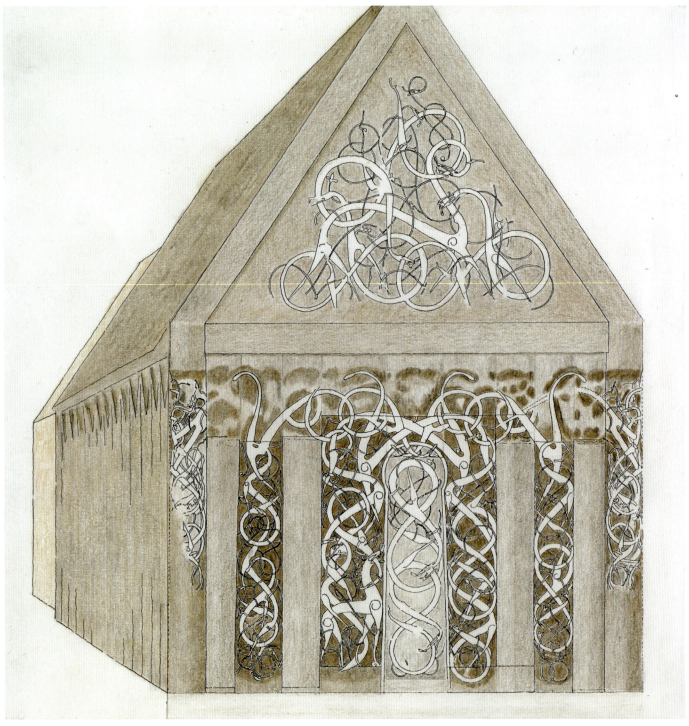

Fig. 6.1. Third Urnes church and west facade, c. 1070. Reconstruction in Knud J. Krogh, *Urnesstilens kirke: Forgængeren for den nuværende kirke på Urnes* (Oslo, 2011), 167. Drawing: Knud. J. Krogh, © Riksantikvaren.

CHAPTER 6

"Who is this King of Glory?": The Religious and Political Context of the Urnes Portal and West Gable

Margrete Syrstad Andås

A message expressed as a picture has qualities distinct from a message expressed in writing. Pictures (perhaps coloured) are catchy, quickly communicating and easy to understand (if creator and spectator share the same frame of references) and do not require the skill of reading letters. Pictures arranged on a large scale (as for instance on picture-rune-stones) can deliver messages over a distance in the landscape. . . . When picture and text unite—as on a picture-rune-stone—they form a coherent whole.[1]

In her introduction to an essay on eleventh-century runestones, Lise Gjedssø Bertelsen makes some observations that likewise pertain to a church like Urnes, placed high upon a hill, visible from afar, and equally colorful.[2] Church buildings and runestones were major monumental art forms of the period, and they afforded the elite a chance to manifest their agenda in the landscape. Admittedly, as far as we know, the church was not adorned with text like the runestones, but it still had a textual framework. Biblical references to the door are relevant, of course, but the eleventh-century liturgy, although diverse and varying in the late conversion period (c. 1020–1150), also had certain basic components that inform us about the meaning of entry. The sounds and movements of these performances are long gone, but the texts are still available to us.

Knud J. Krogh's recent publication discussed the remains of the church at Urnes from the early 1070s (see Chapter 2).[3] Based on dendrochronological analyses, measurements of the various planks, and study of the decoration where it remains, Krogh proposed a new reconstruction (Fig. 6.1).[4] The excavations in the postwar years revealed Christian graves predating the present church built in the 1130s,[5] and they seem to indicate that this is the fourth church built on the spot, as discussed in Chapter 2. The church in the Urnes style was the third. The decorated parts remaining from the third church include the narrow keyhole-shaped portal flanked by decorated jambs, the door leaf itself, several wall planks, a corner post, and the east and west gables (Plates 1–12). We have no complete

buildings from late eleventh-century Scandinavia, but Chapter 4 looks at what else survives of eleventh-century architectural decorations in the North and Chapter 5 demonstrates the similarity between Urnes and extant material from Ireland and England.

The decoration of the 1070s church at Urnes covered large parts of the facade in a carpetlike manner, in contrast with the decorative schemes of the Romanesque stone buildings that became the common form of religious building in Scandinavia only a generation later. The zoomorphic imagery may be considered mere decoration, a revival or prolongation of a long tradition of animal ornament with an often patternlike character. The art of entanglement and interlace had also dominated Scandinavian art in earlier periods. Yet the creatures we see at Urnes—serpents and serpentine types who bite large quadrupeds and one another—appear to convey an iconographic message. In what follows, I examine Urnes's relationship to the great Jelling stone to illuminate the meaning of the large quadruped in fierce combat on the left jamb of the church portal. I argue that biblical and liturgical references made this specific motif instrumental to the ruling elite in Scandinavia in a period of great structural changes. I also address the meanings of the motif on the west gable and of the interlacing loopwork on the facade.

The Exterior Decoration: Types and Species

Before venturing upon a discussion of the iconographic meaning of the famous eleventh-century decoration at Urnes, these carvings must be described briefly. What types of animals do we see, what are their poses, and how do they relate to the other creatures in the composition? Urnes is the last of the Viking-age stylistic groups, but unlike its immediate predecessor, the Ringerike style, vegetation is rare and there are no human figures. The Urnes style is zoomorphic and often appears primarily ornamental. Urnes-style decoration features three types of creatures: type I animals are quadrupeds seen in profile; type II are snakelike animals with one distinct limb and a second that combines a limb and a tail; and type III creatures are serpents without limbs.[6] All of these are represented on the Urnes church, but even though there are examples of winged bipeds in the earlier art of the North, those are absent here. The lower section of the left jamb of the doorway (reused on the north side of the present church) is dominated by a large standing quadruped with small ears atop its head and a wild but elegant mane (Plate 3). It has large pointed fangs and a long tapering snout (Plate 8). The upper lip extends into a lappet, a lobe folded back and down across the snout like a hook. The eye is drop-shaped and points to the front. The hips are marked by spirals, and the one preserved foot is pawlike. Its tail coils between its hind legs and then bends upward, ending in a trilobed leaf ornament that resembles a lily. The "diagnostic features" of the Urnes portal's quadruped are the mane, the fangs of the predator, and the pose of the feet, all of which confirm that this is a lion.[7]

The rest of the portal is framed by type II and III animals, ribbonlike serpentine creatures forming a pattern of loops and curves (Plate 3). One of the bipeds bites the lion's throat, and the lion bites back. The lion breaks up an otherwise nearly symmetrical overall composition. The apex of the

portal is undercut to create openwork interlace in the form of beasts hanging down above the head of one entering (Plates 4–6).

In stark contrast to the portal itself, the door leaf is executed in very flat relief and decorated with type II and III interlaced animals (Plate 3, Fig. 4.8). The wall planks and the corner post preserved from the 1070s church feature patterns of type II and III creatures (Plates 1 and 10). Even though it is dominated by a type II animal, the east gable also appears primarily ornamental (Plate 11), whereas the west gable resembles the portal, with a large quadruped as its main motif (Plate 12). This quadruped lacks the neck crest, fangs, and long tail of the one guarding the door, and it is clearly not a predator, but it bites its attacker just like the other one. The scene is one of struggle and combat, but the species of the large quadruped on the west gable is less obvious.

Previous Scholarship: From a Heathen Horse to the Lion of Judah

This essay is not the first to ask what the decoration at Urnes means. Excavations in the postwar years and the more recent dendrochronological dating of the portal have established that we are dealing with the remains of a Christian building, thus putting an end to the theories that Urnes was the height of "heathen" artistic expression and that the large quadruped is a horse.[8] More recently, in his discussion of Jelling, Eric Wamers described the quadruped of the Urnes portal as "deerlike," but he did not comment on the distinctive fang or the long tail of the Urnes beast.[9] Like the lion, the stag symbolizes Christ, albeit with more humble connotations.

Most scholars agree, however, that the quadruped by the door is a lion. Anders Bugge noted the preference in stave church portal sculpture for compositions in which creatures of different kinds are engaged in struggle, and this also pertains to the third church at Urnes.[10] The most important facet of Bugge's contribution was his assertion that the lion fighting the snake on the great Jelling stone (c.965) was a model for the Urnes portal's quadruped.[11] In making this claim, he looked past the formal elements of style and distinguished the scene as a specific motif.[12] The seminaturalistic beast accompanied by, or rather in combat with, a snake is a convention that was developed further in Mammen, Ringerike, and Urnes-style works. Bugge interpreted the large animal on the portal and the one on the west gable at Urnes as lions surrounded by serpents and concluded that this reflected the Christian notion of good forces fighting evil ones.[13] The visualization of this struggle at Urnes, in a larger composition of loopwork, was in Bugge's view derived from the old zoomorphic language of the North and the pagan world of ideas, comparable to the *kennings* in skaldic poetry.[14] A *kenning* is a poetic strategy that combines words as a metaphor for something else, a figurative language in place of another motif. He described the quadruped by the door at Urnes as "the Lion of Judah." In Revelation 5:5, the Lion of Judah is placed in an endgame of combat and struggle. In a later chapter of the same prophecy, the opponent is described as "that old serpent, who is called the devil" (Rev. 12:9). Although Bugge only made a brief reference to the composition at Urnes

and did not present a real argument, his ideas are important; later, Peter Anker voiced the same view.[15] With specific reference to Urnes, Thomas DuBois expanded on another theme discussed by Bugge in relation to stave church portals: that the combat motif is Christ's victory over evil and a form of *Ragnarök*, the end of the world in the old Norse belief system equated with the Christian Apocalypse.[16]

Urnes and Jelling: Power and Conversion

At Jelling, a royal site in late tenth-century Denmark, a three-sided runestone (DR 42) has been preserved from Haraldr blátǫnn ("Bluetooth") Gormsson's time. This stone introduced a new Christian iconography to the region. One side has a large quadruped and a serpent (Fig. 6.2), the second an entangled "crucified" Christ without the cross (Fig. 6.3), and the third a long runic inscription arranged in lines (Fig. 6.4). The two figural sides also have lines of text below the images.

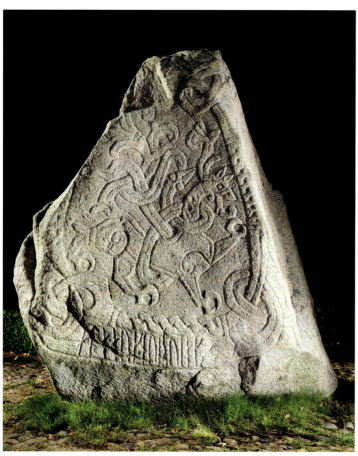

Fig. 6.2. Runestone of Haraldr blátǫnn Gormsson, Jelling, Denmark, side with quadruped and serpent, *c.* 965. National Museum of Denmark, Copenhagen, DR 42. Photo: Roberto Fortuna, © Nationalmuseet.

Signe Horn Fuglesang has underscored the link between the Urnes portal and the Jelling lion-and-snake motif in several articles.[17] As far as we know, Jelling represents the introduction of this motif to Scandinavia.[18] There are earlier examples of mammals with serpents, but they were always part of an ornamental context and not an independent motif.[19] The Jelling quadruped has a mane and a long tail with vegetal-like strands; its trefoil terminal is similar to that of the Urnes lion. The composition reflects this feature in the shape of the head lappet, and similar vegetal ornament entangles the Christ figure on another side of the stone.[20] A serpent whose head is seen from above twists around the great quadruped and entangles its neck, belly, and tail.

A full century separates Jelling and Urnes, but the gap is bridged by a number of other carved quadrupeds who fight or are entangled in serpentine creatures.[21] The motif was popular on runestones, and examples are found particularly in the eastern Swedish region of Uppland.[22] The runestones from Näle (U 248), Veckholm church (U 696), Sävsta (U 749), Surstad (U 251), and Mällösa (U 244) have

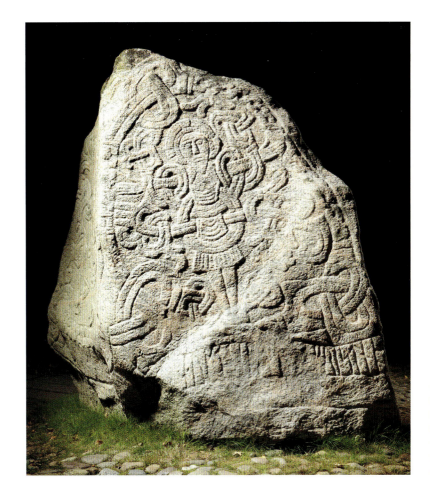

Fig. 6.3. Runestone of Haraldr blátǫnn Gormsson, Jelling, Denmark, side with Christ, c. 965. National Museum of Denmark, Copenhagen, DR 42. Photo: Roberto Fortuna, © Nationalmuseet.

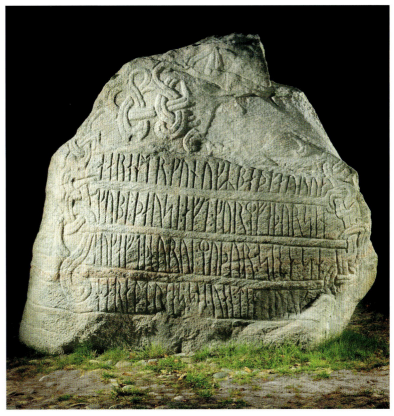

Fig. 6.4. Runestone of Haraldr blátǫnn Gormsson, Jelling, Denmark, inscription, c. 965. National Museum of Denmark, Copenhagen, DR 42. Photo: Roberto Fortuna, © Nationalmuseet.

309

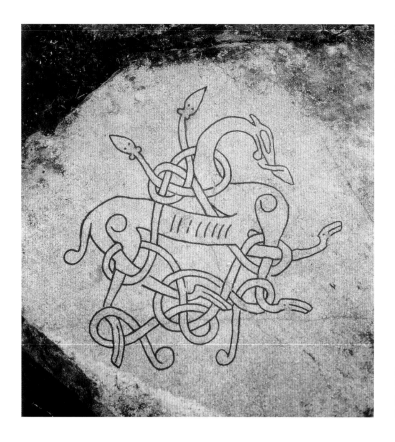

Fig. 6.5. Runestone from Näle, Uppland, Sweden (U 248), quadruped with serpent. National Museum of Denmark, Copenhagen. Photo: Harald Faith-Ell, © Riksantikvarieämbetet.

Fig. 6.6. Runestone from Mällösa, Uppland, Sweden (U 244), quadruped with serpent. Photo: Dylen Täckman, © Stockholms Läns Museum.

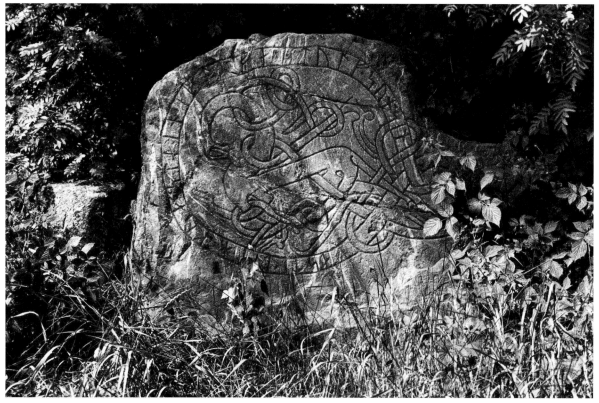

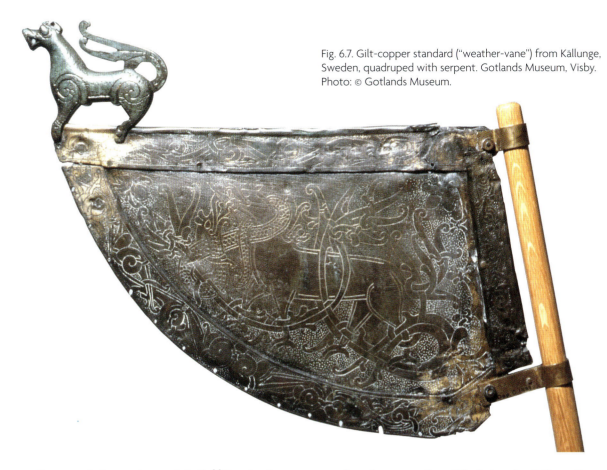

Fig. 6.7. Gilt-copper standard ("weather-vane") from Källunge, Sweden, quadruped with serpent. Gotlands Museum, Visby. Photo: © Gotlands Museum.

similar motifs (Figs. 6.5 and 6.6),[23] but it also appears elsewhere, on the gilded standard ("weather-vane") from Källunge (Fig. 6.7). St. Alkmund's Cross in Derby is an English case that has been related to the group. Similarly, the quadruped on the stone from St. Paul's cemetery in London is commonly understood as a lion, while its opponent resembles the serpentine bipeds of Urnes type II.[24]

An unpublished MPhil. thesis on Urnes by Elin Lønngeroth Pedersen notes that both Jelling and the eleventh-century runestones display a form of duality in texts and images, marking the new faith and new era of which they are consciously a part as well as continuity to place and kin.[25] Fuglesang relates the motif to ruler iconography and victory and suggests that its association with Jelling might explain its use in Scania (southern Sweden), while its popularity in Uppland may be due to a more general ruler symbolism or simply to the obvious Christological references that it carried.[26] She points to Psalm 90:13 (Vulgate numbering; now 91:13), "thou shalt walk upon the asp and the basilisk: and thou shalt trample under foot the lion and the dragon,"[27] a motif that appeared in the arts of the North beginning in Carolingian times, but here it is the lion, as a symbol of Christ, that tramples on the serpent.[28]

The Jelling complex is of the utmost importance for understanding late tenth-century Scandinavia, the process of conversion in general, and Urnes in particular.[29] At Jelling, a sturdy 360-m-long palisade surrounded the runestone under discussion, the stone erected by Haraldr's father King Gormr, the grave mounds, and the church.[30] The late tenth-century wooden church of Haraldr's days is long gone, but the stone of Haraldr is still in its original place right outside the south entrance to the Romanesque church (Fig. 6.2).[31] Attention has thus far focused on the

iconographic motif of the lion-snake, but the text accompanying this motif and the Christ figure is equally interesting, and its message is important to the present study. To arrange a runestone inscription in lines was a novelty in Viking-age Scandinavia, likely reflecting the bookish, high-status European culture associated with Haraldr.[32] The inscription, framed by a ribbon-shaped serpent, reads: "King Harald ordered these kumbls made in memory of Gormr, his father, and in memory of Þyrve, his mother; that Haraldr who won for himself all of Denmark and Norway and made the Danes Christian."[33] The stone is dated *c.*965 and is the first written use of the name Denmark.[34]

Erecting a stone was not Haraldr's innovation,[35] but with him the context changed. For Haraldr, setting up a stone, marking his land, and identifying himself as the one who Christianized his people, the Danes, was no insignificant move. It had a biblical precedent: the erection of a stone in Betel, described in Genesis.

> The land, wherein thou sleepest, I will give to thee and to thy seed. And thy seed shall be as the dust of the earth: thou shalt spread abroad to the west, and to the east, and to the north, and to the south: and in thee and thy seed all the tribes of the earth shall be blessed. And I will be thy keeper whithersoever thou goest, and will bring thee back into this land: neither will I leave thee, till I shall have accomplished all that I have said. And when Jacob awaked out of sleep, he said: Indeed the Lord is in this place, and I knew it not. And trembling, he said: How terrible [awesome] is this place! this is no other but the house of God, and the gate of heaven. And Jacob, arising in the morning, took the stone which he had laid under his head, and set it up for a title, pouring oil upon the top of it [Gen. 28:13–18] . . . And this stone, which I have set up for a title, shall be called the house of God: and of all things that thou shalt give to me, I will offer tithes to thee. [Gen. 28:22]

Knowing the story of Jacob's dream did not require deep knowledge of the Bible. For every new church erected, the story of Jacob would be recited and ritually reenacted during the consecration ceremony. The ceremonies that we know from the late Anglo-Saxons and the Ottonians, to which I shall return, were elaborate and highly symbolic. "Terribilis est locus iste" (How awesome is this place) was the incipit of the introit antiphon for the consecration of a new church.[36] As part of the consecration, oil and a mixture of other fluids were poured on the altar; thus, through ritual performance, the bishop repeated the acts of Jacob.[37]

Church building was a form of monumental art relatively new to Scandinavians in the late Viking Age, the period of Christian conversion. Even though members of the elite had erected memorial stones previously, the practice became increasingly popular at that time. Just as at Jelling, the stones are often found near churches of similar or later date. Like Urnes, the present stone church at Jelling (*c.*1100) is the fourth on the spot, and this is not an unusual pattern.[38] Churches did not last long; whether this was due to construction weaknesses, the wish to make one's mark and erect a new church, or simply that building for eternity was a concept alien to late Viking-age Scandinavia we do not know, but as a consequence, consecration ceremonies were neither few nor far apart. Furthermore, consecration was not merely a rite for the clergy; the patron was an active agent, and

any consecration was also a special day for the secular nobility. It represented an opportunity to invite people of standing from afar, reinforce networks, and demonstrate wealth by welcoming large crowds to the feast after the consecration and to the first mass. These events are described in medieval sources from the North.[39]

Accordingly, the reference to Jacob's stone would have been clear to contemporary elites. We know what company Haraldr blátǫnn kept in religious matters. His closest ally was a certain missionary referred to as Poppo. It is now generally agreed that Poppo was Folkmar, secretary to Archbishop Bruno of Cologne, who in turn was the brother of Emperor Otto I.[40] Folkmar later became archbishop of Cologne (r. 965/966–69). These people were among the elites of religious Europe, a community trained in allegorical thinking and certainly capable of forging a link between the king of the Danes and Jacob, the patriarch and forefather of the tribes of Judah. The Danish king held the rights to his land not only because of his bloodline but also, by analogy to Jacob, because the land was given to him by God.

This associative link between contemporary kings and biblical analogs makes entitlement to land a context for the iconographic motif of the large quadruped fighting the serpent. The biblical associations may well have traveled with the motif, so that repeating it implicitly made the patron, whether king or chieftain, the one who Christianized a place and opened to its people the path to salvation. Notably, the lion fighting the serpent does not occur in small-scale metalwork, such as Urnes-style brooches, which would be purchased in a marketplace by anyone who could afford them. Large bipeds or quadrupeds encased in serpentine loopwork were certainly common on such brooches, but they lack the distinguishing marks of the lion. Rather, the lion-snake motif seems to have been reserved for monumental contexts, such as runestones and church portals, where it was related to land and rulership, and to standards, which were carried with the ruler in battle. In other words, based on what is preserved, it seems that the motif followed those in power.[41]

Norway has preserved almost no textual sources from the eleventh century except for runic inscriptions and twenty-one fragments from liturgical manuscripts mainly of Anglo-Saxon origin.[42] Some of the latter feature sections of the *Dedicatio ecclesiae* ritual for the consecration and dedication of a church.[43] Missionaries presumably traveled with such written instructions, and we might have expected some to be preserved from the period of King Óláfr III kyrri Haraldsson (r. 1067–93), who is known to have been devout and concerned with matters of the church; among other things, he served as a deacon at mass and learned the psalms by heart.[44] There is one text, albeit not penned locally, that concerns Norway, and in it Jacob's dream is associated with kingship in this world. Around 1070 the chronicler Adam of Bremen wrote the history of the Scandinavian peoples on behalf of the bishop of Hamburg-Bremen. That diocese might have rivaled Cologne in matters of conversion, but its clergy were trained with the same allegorical mindset, always ready to apply biblical models in their writing. Adam, who belonged to a religiously trained elite, never visited Norway. When he writes about St. Óláfr (d. 1030), the king who led the Norwegian people to Christianity, he recounts how Óláfr, right before his martyrdom, lay down to sleep and dreamed, like Jacob, of a ladder reaching up to heaven. Adam thus drew a parallel between Óláfr and Jacob, men who were given their land by God and became leaders of their people.[45] Adam was thinking along the same lines as the Danes and their friends in Cologne a century earlier.

"Who is the King of Glory?" Christ as the Gate to Salvation

Some aspects of the consecration ceremony have already been discussed in regard to the erection of runestones. The reference to Jacob's God-given right to the land might, by way of association, have accompanied the lion-snake motif all the way to Urnes, affecting the local chieftain's choice of motif. The motif is given a prominent place on the Urnes facade. The cross is not present, but the lion guards the door, positioned near the point of entry. With Christianity came the idea that the world was polluted by evil spirits and that a church must be cleansed, and anointed like Christ, before mass could be celebrated there. The *dedicatio ecclesiae* rite defined sacred space and ascribed symbolism to the individual parts of the edifice.[46] Consecration rites of the eleventh century paid great attention to the act of entry, and there is no reason to assume that Norse customs differed much from those practiced in German or Anglo-Saxon domains, given what we know of the Christianization process. While cleansing the outside of the church, the bishop, the clergy, and laypeople walked in procession, circling the building three times.[47] A deacon inside engaged in a dialogue with the bishop outside. This part of the ritual is described in chapter 10 of the early twelfth-century Icelandic bishop's chronicle *Hungrvaka*,[48] one of the few textual sources that provides information about the consecration and dedication of a church from the province of Nidaros:[49]

> And when the church was finished at Skálholt, and the bishop [Klœngr] thought it fit for hallowing [*vígslo*], he made a great feast and noble to his friends, and bade thither Bishop Brand [Birne] and Abbot Nicholas [Nikulás], and many chiefs; and there was a very great number of guest bidden. They both hallowed the church in Skálholt, Clong [Klœngr] and Beorn [Biœrn], the one without and the other within [*annarr útan, en annerr innan*].[50]

It is no coincidence that this is the section of the ritual mentioned by the author of *Hungrvaka*. This enactment of Psalm 23 (now 24) was not only highly dramatic but also highly symbolic. The thirteenth-century liturgical commentator William Durandus described this performance. The bishop struck the lintel with his staff and asked for entry with the words "Lift up your doors, O princes" each time he arrived at the door; the deacon inside responded "Who is this King of Glory?," to which the bishop then replied, "Our mighty Lord."[51] The sequence also carried with it a reference to Matthew 7:7: "Ask, and it shall be given you; seek, and ye shall find; knock, and it shall be opened unto you." Finally, the third time, the bishop could enter the church to the words of the antiphon known as the "Tollite portas," reciting Psalm 23: "Who *is* this King of glory? The Lord strong and mighty, the Lord mighty in battle. Lift up your heads, O ye gates; even lift *them* up, ye everlasting doors; and the King of glory shall come in" (Ps. 23:8–10).

"Tollite portas" had been a prominent part of the consecration ceremony since Carolingian times and the Ordines Romani 41, and it is commonly found in Continental and Anglo-Saxon uses in the eleventh century.[52] It must have been well known in Scandinavia at the same time, when

large numbers of wooden churches were being built, rebuilt, and consecrated. Both the "Terribilis est locus iste" and the "Tollite portas" sequence exist in the fragmentary liturgical material from medieval Norway from the eleventh century onward.[53]

The "Tollite portas" also contained a well-known reference to the Gospel of Nicodemus and the Harrowing of Hell,[54] which in a sense is also a subtext for the victorious lion of Urnes. This dialogue was routinely found in Easter and Passion plays from the tenth century on:[55] three times Christ demanded that the gates should be opened, while the devil's counter-question was repeated until the doors of Hell were broken open.[56] Its dramatic reenactment and explicit meaning made it suitable in different contexts, and it figured as a vital symbolic element in patristic writing and ritual reenactment well before the eleventh century.[57] The Anglo-Saxons used the words from Psalm 23 in sermons and rituals.[58] Today this may seem to be a marginal and infrequent element, but to the early medieval worshipper it was not.

Bugge considered the lion on the Urnes portal a form of visual *kenning*. *Kennings* used to describe Christ during the conversion period have been discussed by Else Mundal.[59] Although the dates of the relevant poems are disputed, the *kennings* are considered reliable sources for images of Christ in the period between 1000 and 1150. This makes Mundal's observations relevant here. The lion is not among the twelve most common examples, but Mundal found different words for "king" and "ruler," often with connotations of war and combat, and the most common adjectives used to describe Christ are "strong" and "mighty."[60] In the poetry, the "king of the monks" (presumably meaning the early missionaries) is a king at war with other gods, but he is mightier than they are.

The poetry of the time was conceived in proximity to local rulers, as part of their court, where poets and clergymen lived, dined, and feasted alongside one another. In the liturgy, the words *strong* and *mighty* are commonplace. We cannot know whether these particular adjectives used in Norse poetry were derived directly from liturgical rituals —"The Lord strong and mighty, the Lord mighty in battle"—but it seems likely. If we accept that the lion near the door at Urnes is a symbol for Christ, then it is not the humble Christ figure who suffered and sacrificed himself. Rather, it is the "strong and mighty" Lord of the "Tollite portas," as also quoted in the *kennings*. It is the king "mighty in battle" who bites the throat of his aggressive attacker.

All that remains of the 1070s consecration of Urnes are traces of the (originally twelve) painted crosses that would have served as background for the candles lit during the ritual (Fig. 6.8).[61] The 1130s dedication, however, has left behind small, incised crosses, demonstrating that the church was indeed reconsecrated when it was rebuilt. The varying forms of these crosses might reflect different liturgical uses.[62] In the later ordinal for the province of Nidaros, recitation of "Tollite portas" is prescribed three times throughout the annual cycle. It is listed on the first Sunday of Advent, marking the opening of the church year and the hope in Christ, and thereafter for the individual church's dedication feast and for the dedication feast of the archiepiscopal cathedral of the Holy Trinity, which was celebrated across the province. The last two were important feast days, commemorating the moment when the community and the province were brought to Christianity. Through these feasts, and the singing of the "Tollite portas," memories of the first consecration were kept alive. The same applies to the antiphon referring to Jacob's dream and the sanctification of place, the "Terribilis est locus iste"; this was also prescribed on both of the annual dedication feasts.[63]

PART TWO | THE ELEVENTH-CENTURY CHURCH

Fig. 6.8. Urnes, third church, remains of consecration crosses, c. 1070. From Knud J. Krogh, *Urnesstilens kirke: Forgængeren for den nuværende kirke* på Urnes (Oslo, 2011), 177. Drawing: Knud J. Krogh, © Riksantikvaren.

Placing a symbol for Christ by the door at Urnes (and elsewhere) would make sense not only for the immediate participants and spectators at the consecration ceremony but also in a much more general sense. Pedersen notes that Christological symbolism is particularly relevant for a portal and that the portal itself is a symbol of initiation in baptism.[64] John 10:9, "I am the door. By me, if any man enter in, he shall be saved," uses the door as a metaphor. In later periods this text was placed above church doors and on church facades.[65] The door held a unique position in medieval Christian religiosity as the opening to the sacred for the faithful. Allegorical writing on the church as the temple of God and the door as a metaphor for Christ already had a long tradition by the time Christianity reached the North, as exemplified by Bede's (d. 735) *De templo*.[66] In a Norwegian homily book, of which the oldest manuscript is dated *c*.1200 but which contains older material,[67] the door

316

is a metaphor for true insight and the ability to separate good from evil, and it is also "the true faith that leads us into the common Church."[68] Looking at the narrow keyhole shape of the Urnes door, it is tempting to refer to Matthew's "enter through the narrow gate" (Matt. 7:13). The keyhole or horseshoe shape, which is unusual but not unique, is discussed in Chapter 4.

By the time the third church at Urnes was built, the only thing that would open the door from a theological point a view was baptism and faith in Christ. In the early Church, a neophyte could go in and out of the church while learning about Christ; he or she would only be excluded from attending mass. By the eleventh century, however, both theology and practice had changed: the church building was only for those who were baptized, and infidels and penitents were excluded. Even though there may have been neither infidels nor penitents at Urnes in the 1070s, religious ideas associated with the door and the act of entry were imported with the new faith. By the late eleventh century, baptism was also associated with the door. The progressive structure of the baptism ritual would have reminded a local worshipper of this symbolism: not only did the initial exorcism take place outside, in front of the church portal, but so did the "Effeta" (*apertio*), with the reopening of the senses.[69]

In the thirteenth-century liturgy of the Nidaros province, when processions made a station in front of the church door they commemorated moments when people had recognized the Messiah.[70] Such liturgical reenactments were not local inventions; they were practices that arrived in Norway with missionaries from Anglo-Saxon domains or from the archbishopric of Hamburg-Bremen. In such liturgical reenactments, the moment of entry marked the reception and recognition of truth.[71] The priest Symeon greeting the infant Jesus as the Messiah on Candlemas, early followers of Christ greeting their Messiah on Palm Sunday, or the local congregation celebrating their own reception of Christ as the Messiah at the first dedication of their local church—which was commemorated with a procession and ceremonial entrance every year thereafter—are all examples of such occasions.[72] Thus the door represents Christ in many ways, and the application of the lion motif at Urnes cannot be properly considered apart from this religious context.

The liturgy forged associative links between Christ as savior and the portal in a number of ways. The late Anglo-Saxon Leofric Missal and the Irish Leabhar Breac prescribe that that the corners of the church and the doorposts be anointed with chrism during the consecration ceremony.[73] Whether a similar practice existed in the Sogn district (where Urnes is located) in the 1070s is unclear, but the reuse of the portal and a corner post, as well as other materials—some of which have consecration crosses—suggest that these elements were anointed and thus embodied something sacred. Moreover, in the Norwegian regional laws, some of which may date to the eleventh century and the time of the third Urnes church, the portal emerges as an autonomous space that guaranteed truth: it was a place where oaths were sworn, in some areas by holding onto the portal itself.[74] Urnes may not have had any formal legal status, but the practice of swearing oaths in cases concerning kinship and inheritance or other legal practices may well have taken place there.[75] Associating church portals with judgment, justice, and legal activities is not unique to the North; it was reported frequently in Continental sources.[76] In sum, the medieval church portal is not like any other parts of the building. It carried a particular Christological and legal symbolism, and as such it was a meaningful location for the guardian lion as a symbol for Christ.

PART TWO | THE ELEVENTH-CENTURY CHURCH

The Lamb in the West Gable

The large animal in the west gable (Fig. 6.9 and Plate 12) is different from the one by the portal (Plate 3). Both are quadrupeds, seen in profile with almond-shaped eyes, small ears atop of their heads, and the typical Urnes-style lip-lappets, but on the west gable the creature lacks the mane, the fang, and the elongated tail. I propose that it should be interpreted as the Lamb of the book of Revelation.

As seen in the runestone from the Tierp church in Uppland (U 1144) (Fig. 6.10), lambs appeared in late Viking-age art. A central cross is flanked by two adoring quadrupeds accompanied by the typical serpentine beasts. Fuglesang has convincingly demonstrated that the large quadrupeds on the Tierp stone represent lambs.[77] The motif of the adoring lambs is well known from mosaics and other early Christian art in southern Europe;[78] in Ravenna, for example, they survive in architecture, mosaics,

Fig. 6.9. Urnes church, west gable, c. 1070. From Knud J. Krogh, *Urnesstilens kirke: Forgængeren for den nuværende kirke* på Urnes (Oslo, 2011), 38–39. Drawing: Knud J. Krogh © Riksantikvaren.

318

CHAPTER SIX | "WHO IS THIS KING OF GLORY?"

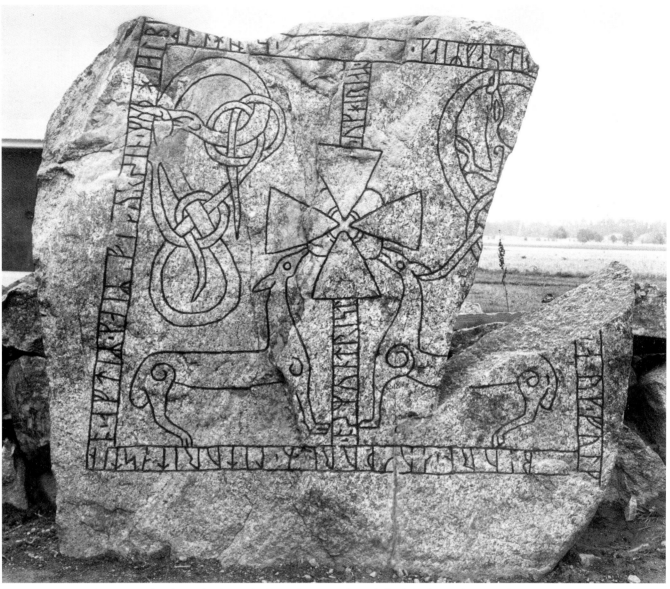

Fig. 6.10. Runestone from Tierp church, Uppland, Sweden (U 1144), two quadrupeds (lambs) adoring the cross. Photo: Iwar Anderson, © Antikvarisk-topografiska arkivet, Riksantikvarieämbetet.

and sarcophagi. The Tierp stone has been attributed to Ásmundr, a master active by the second quarter of the eleventh century and possibly even earlier.[79] However, while Ásmundr's quadrupeds have the typical hip spiral seen in the Urnes gable, they also have inward-bending hind legs, which differs from the execution of the creature on the gable, which has straight legs.

In the eleventh century, ordinary people of a certain wealth and standing might wear brooches, mostly openwork types in the Urnes style that were molded and produced in workshops in Scandinavia.[80] Some of these are known as *Agnus Dei* fibulae.[81] The lambs on these brooches resemble the apocalyptic Lamb found on Anglo-Saxon coins from the time of Æthelred "the Unready" (*c.* 1009), with an inward-bending hind leg and, in some versions, an unusually long neck.[82] These

319

coins are also found in great numbers in Scandinavia.[83] They resemble the lamb depicted on coins from the period of the Norwegian king Magnús (r. 1035–47), where the reverse side features not a bird, as on the Anglo-Saxon examples, but a cross.

Unlike the lambs on the Tierp runestone, the animal on the Urnes west gable was inspired not primarily by coins and brooches but, rather, by later runestones. The Urnes-style runestone from Litslena (U 753) is signed by Balli, which places it in the mid- to late eleventh century. The stone features two confronted quadrupeds with long tails.[84] The pose of the Litslena quadrupeds is akin to that of the large animal on the Urnes gable, with all four legs showing and the forelegs in the same position. These quadrupeds, too, are entangled in serpentine loopwork. The Urnes quadruped is more like the Tierp lambs in its details, but its pose is closer to those of the later Litslena quadrupeds. Litslena demonstrates the stylistic development from Ásmundr's adoring pair of lambs to the single lamb at Urnes.

It seems reasonable to conclude that the animal fighting the usual two types of serpentine beasts in the Urnes gable is a lamb. The biblical lamb figures in Isaiah, John, Acts of the Apostles, and 1 Peter, but in all likelihood the lamb of the gable is the one in the book of Revelation. Unlike the sacrificial lamb, this apocalyptic Lamb—Christ—takes part in the last battle: "These shall fight with the Lamb, and the Lamb shall overcome them, because he is Lord of lords, and King of kings" (Rev. 17:14). This is no meek lamb; rather, Revelation tells of the "wrath of the Lamb" (Rev. 6:16), and it is thus in dialogue with the idea of the Lord as "strong and mighty in battle."

In the gable as well as on the jambs of the Urnes west facade, most of the serpents terminate in three-lobed leaves that resemble lilies.[85] This is not an arbitrary detail. The lily tail has been discussed in relation to other Scandinavian material from the late Viking Age and especially the Romanesque period.[86] A reused lintel from Southwell Minster in England shows St. Michael fighting the dragon and David rescuing his flock from the lion.[87] The Southwell dragon has been described as threatening "to metamorphose into chaotic foliage,"[88] and dragons turning into vines or lilies are not unusual. The three-lobed acanthus ornament common in Scandinavian works has been seen as a *pars pro toto* representing the Tree of Life.[89] In the North, vines are commonly found in works of the Ringerike style, which preceded Urnes, and they are generally understood to have paradisiacal and regenerative connotations. In a period of conversion, a passage from the prophecy of Isaiah, cited by Bede, may have been especially relevant:[90] "The land that was desolate and impassable shall be glad, and the wilderness shall rejoice, and shall flourish like the lily. It shall bud forth and blossom" (Isa. 35:1–2). Bede's commentary rests on a long tradition of patristic writing in which the desolateness of the wilderness is a topos signifying the absence of divinity. The chapter in Isaiah ends with a reference to the return of the redeemer. Similarly, the book of Revelation says that, "the leaves of the tree were for the healing of the nations" (Rev. 22:2), which, like Isaiah, situates the lily/leaf in a salvation-conversion perspective with implicit references to both the Tree of Life and the Tree of Jesse.

Loopwork and Serpents

Thus far I have focused on the motifs of the left portal jamb and the west gable, but these are only a small part of the carved design at Urnes. On the eleventh-century facade serpentine creatures, with or without limbs, framed the doorway and covered wall planks and the corner post (Plates 1 and 10), crawling on their bellies while simultaneously attacking the quadrupeds and one another. They even bite the opening of the door (Plate 5).

Serpents were a popular motif on the runestones erected by the elites in late Viking-age Scandinavian art.[91] Animal ornament continues in Christian contexts across all parts of northwestern Europe, and its aesthetic appeal is clear.[92] At the same time, an ideological or religious meaning for these creatures has sometimes been proposed.[93] It is important to note that the serpents are not all alike;[94] some are snakelike with no limbs, whereas others have the heads of beasts and thus a greater resemblance to predators. In runestones from the 1020s some serpents are winged (e.g., U 1142).[95]

In Norse mythology the terms *ormr* (serpent) and *draki* (dragon) were often used as synonyms.[96] In the last stanza of the late tenth-century skaldic poem *Völuspá*,[97] penned around 1200, a dragon comes flying, but in the next sentence he is called a serpent, suggesting that by the time of the poem's composition no real difference was ascribed to the two. Early medieval Continental writers distinguished among a number of snakes and dragons, as Isidore of Seville elaborates in his *Etymologiae*. In his chapter on snakes he notes that the dragon is the largest of all the snakes, and the *Physiologus* also included a section on these reptiles.[98] The bestiary tradition rests on earlier sources, but in regard to the dragon some versions note that its main strength lies in its tail.[99]

The name *Ormr*, Serpent, was given to men of prominence both before and after the conversion. When it appears as a man's name in medieval chronicles and annals, it seems to be detached from any negative biblical references, as it belonged not only to men of the warrior elite but also to priests and monks. Snorri's *Saga Óláfs konúngs hins Helga (Saga of St. Óláfr)*, written in the early thirteenth century, records that the saint's sign was a white serpent.[100] The ship of St. Óláfr's Christian predecessor King Óláfr Tryggvason (r. c.995–99) was named "Ormr enn lagi" (the Log Serpent), and, according to the later description in *Fagrskinna*, it was adorned with golden dragon heads.[101] *Fagrskinna* also repeatedly mentions kings' "dragon ships."[102] Other ships that sailed with Óláfr in battle toward the Danes are named the "the Short Serpent" and "the Crane," using emblematic animals to demonstrate the power associated with the warships. That ships could indeed have such forceful dragons and other animals carved on their bow is evident from other media, such as the depiction of Noah's Ark in the Anglo-Saxon Caedmon manuscript or the ships in the Bayeux Embroidery.[103] In the story of the dragon Fáfnir, when the hero Sigurðr eats the dragon's heart, things are revealed to him and he can understand the language of birds. Sigurðr is frequently represented in the arts of late Viking-age Scandinavia, and it is possible that the serpent at that time was an ambiguous symbol with certain positive qualities.

From a Christian perspective, the positive connotations of serpents are few but significant. The conversion introduced a new, textually based meaning for the old reptile. In the Fall (Gen. 3:14) the serpent is given a very prominent role; its tongue tempts humans to question God, and this is what

makes man mortal. As punishment, the snake is condemned to crawl the earth: "upon thy breast shall thou go." When the lion at Urnes fights with the serpent, fending off its attack and conquering it, this brings man back to God and offers immortality. It may also explain the use of the lion-snake or cross-snake motifs in the runestone material, particularly in a sepulchral context. Still, it does not fully explain why the Urnes facade crawls with serpents, or why Óláfr would choose the serpent as his mark in battle.

While the Bible contains a number of negative references to serpents and dragons,[104] most prominently in Revelation 20:2, two positive examples stand out. When Christ sends the disciples out to preach in Matthew 10:16, he says to them, "Behold, I send you as sheep in the midst of wolves. Be ye therefore wise as serpents and simple as doves." More important in the present context is the role of a serpent in Numbers 21:4–9. The people began to doubt God, in a parallel to the Fall. God therefore sends "fiery serpents" that bite and kill, but he also commands Moses to set up a brazen serpent, offering people a chance to believe; the believers are cured when they look at the serpent. The brazen serpent was a long-standing type for Christ on the cross, so this may be relevant to understanding the use of serpentine loopwork in distinctly Christian contexts.

The story of the brazen serpent also exemplifies the notion that like wards off like: using the image of the plague conquers it. In the Middle Ages, the norm was that good symbols were used to ward off evil. The cross, the lamb, and eventually images of Mary or a saint would appear on jewelry, for instance, presumably intended as protective devices. However, we also learn that King Magnús (d. 1374) owned a "stone" taken from a toad's head, believed to sweat when it came near poison and thus to protect its owner from such threats, and snakes' tongues were charms against black magic and disease.[105] An earlier King Magnús (d. 1280) sent two snakes' tongues to the Icelandic bishop Árni (d. 1298), and in 1340 part of a snake's tongue was listed in the royal inventory of Bohus Castle (Sweden).[106] A snake's tongue is a rather specific item from a Judeo-Christian point a view, as this is what led to the Fall, and in real life it was a bearer of poison. Clearly, when it came to serpents, the learned medieval elite harbored some notion of "evil wards off evil."[107] It is not unlikely that such ideas were also present in the late Viking period. Seen through this lens, objects such as the Urnes-style brooch found at the Sör-Fron vicarage make sense (Fig. 6.11).[108] Here the large Urnes-style animal is not entangled in serpentine interlace; it is winged and appears to be a basilisk. Unless this offered protective powers for believers, as in the book of Numbers, it is difficult to understand why anyone in a Christianized society would choose to wear it. It is also possible that the loopwork in itself was perceived as apotropaic.[109] Eleventh-century religious architecture in the North had exteriors adorned with animal ornament and serpentine coils, whereas the interiors, if Danish Hörning and Norwegian Urnes are representative, did not have this.

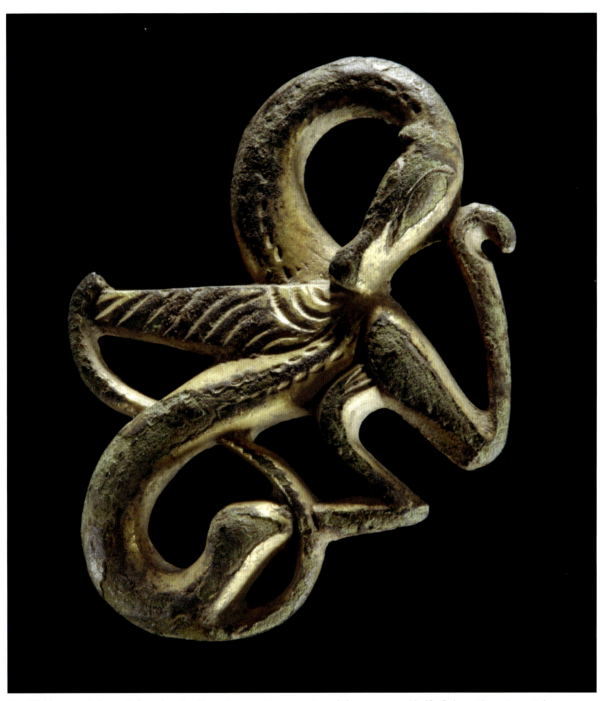

Fig. 6.11. Urnes-style brooch found at Sør-Fron vicarage, Norway, winged dragon, second half of eleventh century. Oslo University Museum C58123. Photo: Ellen Holte, © Historisk Museum Oslo.

Urnes in Context

At Urnes we see the Urnes style applied to an iconographic program. Certain elements are consciously used to break up the composition and emphasize the role of particular characters. Keeping in mind the "Tollite portas" rite with its cluster of references, not least the Harrowing of Hell, a relief from Jevington in Sussex, England, is interesting when seen in relation to Urnes (Fig. 6.12). It may have a comparable web of religious, textual, and performative associations. The motif is, admittedly, unlike the fighting lion on the Urnes jamb, but the content may not be so different. The date of the Jevington relief is uncertain, but it probably belongs to the immediate post-Conquest period or slightly earlier, which makes it contemporary with the Urnes portal.[110] According to the *Corpus of Anglo Saxon Stone Sculpture*, the relief was "originally fixed over [the] south door, inside"; thus this image too was part of the symbolic context of a church entrance.[111] In the Jevington relief, the standing Christ thrusts a cross-staff into the jaws of an animal while another crawls at his feet.[112] Both animals metamorphose into loopwork that is not far from the Urnes style, though lacking its thick and thin strands. The cross staff seems to signify that this is the Harrowing of Hell, but the careful differentiation of the two main animals in the relief has been interpreted as a deliberate reference to Psalm 90 (91):13, "Thou shalt walk upon the asp and the basilisk: and thou shalt trample under foot the lion and the dragon." It has been compared to Oxford, Bodleian Library, MS Douce 296, fol. 40r, which shows Christ treading on the beasts; the left animal is a lion and the right one a basilisk.[113] Yet arguing which of these motifs Jevington represents makes little sense. Given the textual and performative background discussed above, it may not be a matter of either-or but, rather, one image may well encompass both meanings.

Fig. 6.12. Stone relief in church of St. Andrew, Jevington, Sussex, England, with Christ treading on beasts, second half of eleventh century. Photo: © Simon I. Hill, Corpus of Anglo Saxon Stone Sculpture.

The motif of Christ treading on the beasts has been seen as a direct translation of the psalm.[114] Notably, Fuglesang brought up Psalm 90:13 in relation to the large quadruped fighting the serpent on the Jelling stone (Fig. 6.2).[115] She pointed out that the motif should be viewed in relation to the erect, cross-shaped figure of Christ on the other side of the

stone, and although it has connotations of rulership and power, it could also be read in light of such biblical references as Psalm 90:13. Fuglesang also cited Augustine's use of this line from the psalm, in which the animals are perceived as evil forces threatening the Church—a reference that would likely be as meaningful in the Jelling context of the late tenth century as it would be throughout the conversion period.[116] Psalm 90:13 was also part of the standard repertoire for compline; these words were to bring comfort to the soul in the last hour of the day, alluding to delivery from darkness into light.[117]

Scandinavian late Viking-age iconography was in many ways a *pars pro toto* visual language,[118] in which shorthand elements from codified Christian iconography were used on their own and became popular motifs. The presence of serpents alongside an image or symbol of Christ would effectively refer to Christ as the way to salvation. The Jevington fragment represents the same cluster of religious motifs as the Urnes portal, and in the same location; the difference is that the victorious Christ in Jevington is visualized as a man whereas at Urnes we see him in the shape of a lion. The other significant difference is that the Urnes lion is part of a larger composition; it is accompanied by the lamb, which adds another layer of meaning: that of the final judgment.

Conclusion

The exterior of the third church at Urnes featured a great number of serpents attacking two of the most prominent symbols of the Christian faith, the lion and the lamb. It is possible that this surface decoration of serpentine coils forming interlace patterns was intended to ward off evil. The inner space of the church was consecrated, but the outside was only cleansed and therefore, like the human soul, in constant combat with the forces of evil. Such an interpretation makes sense theologically. From a Christian perspective, the programmatic placement of the lion adjacent to the door is likewise meaningful. Due to its many biblical references, the lion held a special place in Scandinavian iconographic traditions that can be traced back to Jelling.

This chapter opened with a question from the book of Psalms: "Who is this King of Glory?" The question was performed in front of the church door during the dedication ritual; the deacon inside would ask it, and the bishop, accompanied by the chieftain and the people outside, had to answer. Only with the words "The Lord strong and mighty, the Lord mighty in battle" would the door be opened, as would the way to salvation for this particular congregation. It is indeed the Lord of the *kennings* and the liturgy that we see by the Urnes door, guarding the tall, narrow opening by fending off his crawling attackers. The same message prevails throughout the building: the forces of good are conquering evil, serpents blossom into lilies, and in their metamorphoses they offer the hope of salvation. For contemporary viewers of the Urnes carvings, living their lives in a society still undergoing great changes in belief, practices, and social organization, this must have made perfect sense.

Notes

I would like to thank Griffin Murray, Kirk Ambrose, Leif Anker, and Espen Karlsen for insightful comments on my paper.

1. Lise Gjedssø Bertelsen, "On Öpir's Pictures," in *Runes and Their Secrets: Studies in Runology*, ed. Marie Stoklund et al. (Copenhagen, 2006), 31–64, at 31. See also Lise Gjedssø Bertelsen, "The Cross Motif on Late Viking Age Picture Runestones in Västergötland," *Lund Archaeological Review* 20 (2014): 55–78. Bertelsen uses the term *picture-rune-stone*, but I use the more common term *runestone* to designate a stone with both text and picture.

2. On the use of color in late Viking-age monumental art, see David M. Wilson, *Vikingatidens konst*, trans. Henrika Ringbom (Lund, 1995), 186; Signe Horn Fuglesang, "Animal Ornament: The Late Viking Period," in *Tiere, Menschen, Götter: Wikingerzeitliche Kunststile und ihre neuzeitliche Rezeption: Referate gehalten auf einem von der Deutschen Forschungsgemeinschaft geförderten Internationalen Kolloquium der Joachim Jungius-Gesellschaft der Wissenschaften, Hamburg*, ed. Michael Müller-Wille and Lars Olof Larsson (Göttingen, 2001), 157–94, at 172–73; Henriette Lyngstrøm, "Farverige vikinger," in *Farverige vikinger: Studier i teknologi og kultur 4*, ed. Henriette Lyngstrøm (Copenhagen, 2018): 1–19; and Chapter 4 in this volume.

3. Knud J. Krogh, *Urnesstilens kirke: Forgængeren for den nuværende kirke på Urnes* (Oslo, 2011).

4. Ibid., 167.

5. Håkon Christie, "Urnes stavkirkes forløper: Belyst ved utgravninger under kirken," *Årbok: Foreningen til norske fortidsminnesmerkers bevaring* 113 (1959): 49–74.

6. Haakon Shetelig, "Urnesgruppen: Det sidste avsnit av vikingetidens stilutvikling," *Årbok: Foreningen til norske fortidsmindessmerkers bevaring* 65 (1909): 75–107; Ole Henrik Moe, "Urnes and the British Isles: A Study of Western Impulses in Nordic Styles of the 11th Century," *Acta Archaeologica* 26 (1955): 1–30; Griffin Murray, *The Cross of Cong: A Masterpiece of Medieval Irish Art* (Dublin, 2014); and Griffin Murray, "Some Aspects of the Relationship between Late 11th and 12th Century Irish Art and the Scandinavian Urnes Style" (MA thesis, University College Dublin, 1975).

7. Signe Horn Fuglesang, "Forholdet mellom dekorasjon i stein og tre," *Romanske stenarbejder* 5 (2003): 39–58, at 40; Signe Horn Fuglesang "Ikonographie der scandinavischen Runensteine der jüngeren Wikingerzeit," in *Zum Problem der Deutung frühmittelalerliche Bildinhalte: Akten des 1. Internationalen Kolloquiums in Marburg a.d. Lahn, 15. bis 19. Februar 1983*, ed. Helmut Roth (Sigmaringen, 1986), 183–210, at 189; Signe Horn Fuglesang, "Stylistic Groups in Late Viking and Early Romanesque Art," *Acta ad archaeologiam et artium historiam pertinentia* 8.1 (1981): 79–125.

8. In the early twentieth century Herman Major Schirmer, inspired by the runologist Ingvald Undset, argued that the quadruped was a manifestation of the horse as a cultic animal in Norse mythology. Roar Hauglid referred to the portal as "heathen." Schirmer, "Fra hedensk og kristen tid," *Årbok: Foreningen til norske fortidsminnesmerkers bevaring* 66 (1910): 97–140; and Hauglid, *Norske stavkirker: Dekor og utstyr* (Oslo, 1973), 67. This is also referenced in István Rácz and Peter Anker, *Norsk middelalderkunst* (Oslo, 1970), 17.

9. Egon Wamers, ". . . ok Dani gærði kristna . . . : Der große Jellingstein im Spiegel ottonischer Kunst," *Frühmittelalterliche Studien* 34 (2000): 132–58, at 149–50n61; This view is repeated by Oddgeir Hoftun, who also does not comment on the fangs. Oddgeir Hoftun with Gérard Franceschi and Asger Jorn, *Stabkirchen—und die mittelalterliche Gesellschaft Norwegens* (Cologne, 2003), 66.

10. Anders Bugge, *Norske stavkirker* (Oslo 1953), 14, 36; trans. by Ragnar Christophersen as *Norwegian Stave Churches* (Oslo, 1953); and Anders Bugge, "Arkitektur," in *Norsk kunstforskning i det tyvende århundre*, ed. Arne Nygård-Nilssen et al. (Oslo, 1945), 71–154, at 116–17.

11. Anders Bugge, *Kristendommens kunst: Fra keiser Constantinus til konsiliet i Konstanz* (Oslo, 1937), 129–30, 134–35.

12. Anders Bugge, "Norge," in *Kirkebygninger og deres udstyr*, ed. Vilhelm Lorenzen (Oslo, 1934), 189–270, at 192.

13. Anders Bugge, *Norsk kunst i middelalderen* (Oslo, 1937), 8–9; and Bugge, *Kristendommens kunst*, 134–35.

14. Bugge, *Kristendommens kunst*, 129–30, 134–35; and Bugge, *Norske stavkirker*, 14, 22, 36–38. In the latter book Bugge modified his earlier view and pointed only to the later designs known as the Sogn-Valdres type, such as the west portal of Hopperstad from the 1130s, as a *kenning* for Ragnarök. He was influence by the literary scholar Fredrik Paasche, who wrote about the use of *kennings* in the conversion period, a topic also much discussed by others in this period. Paasche, *Norges og Islands litteratur inntil utgangen av Middelalderen*, ed. Anne Holtsmark, 2nd rev. ed. (Oslo, 1957), 238–39; and Wolfgang Lange, *Studien zur christlichen Dichtung der Nordgermanen, 1000–1200* (Göttingen, 1958).

15. Most recently in Peter Anker, *De norske stavkirker* (Bergen, 1979), at 154, 267. See also Moe, "Urnes and the British Isles."

16. Peter Anker, *The Art of Scandinavia* (London, 1970), 2:415–16; and Thomas A. DuBois, *Nordic Religions in the Viking Age* (Philadelphia, 1999), 91, 150.

17. Fuglesang, "Animal Ornament."

18. Leslie Webster, *Anglo-Saxon Art: A New History* (Ithaca, NY, 2012), 191. See also Sune Lindqvist, "Den stora Jellingestenen," *Årsbok: Kungliga humanistiska vetenskaps-Samfundet i Uppsala*, 1952, 197–214; Hans Christiansson, "Jellingestenens bildvärld," *Kuml: Årbog for Jysk arkaelogisk selskab*, 1953, 72–101; Signe Horn Fuglesang, "Ikonographie der skandinavischen Runensteine der jüngeren Wikingerzeit," in Roth, *Zum Problem der Deutung frühmittelalterliche Bildinhalte*, 183–210; Wamers, ". . . ok Dani gærði kristna . . . "; and Sigmund Oehrl, *Zur Deutung anthropomorpher und theriomorpher Bilddarstellungen auf den spätwikingerzeitlichen Runensteinen Schwedens* (Vienna, 2006).

19. Fuglesang, "Ikonographie der scandinavischen Runensteine der jüngeren Wikingerzeit," 188.

20. Wamers (". . . ok Dani gærði kristna . . . ," 149–50 and n61) argues against the common perception that the Jelling beast is a lion and suggests instead that it is a stag. This assertion rests mainly on the interpretation of the ornament above the Jelling quadruped's head, which

Wamers perceives as antlers. In late tenth- and early eleventh-century Scandinavian art, tendrils spreading to create an almost separate ornament are not unusual, as seen in the later Ringerike style on the Norwegian Vang stone or on the stone from St. Paul's, London. On the Jelling stone, the ornament was probably intended to balance the composition rather than to add an iconographic element.

21 Elisabeth Farnes presents a list of examples of this motif in "Some Aspects of the Relationship between Late 11th and 12th Century Irish Art and the Scandinavian Urnes Style" (MA thesis, University College Dublin, 1975), 1:31, 39nn14, 15; and Haakon Shetelig, ed., *Osebergfundet III* (Kristiania, 1920), 323. Oehrl ("Zur Deutung anthropomorpher und theriomorpher Bilddarstellungen," 190, 212–25) gives examples of many versions of large animals in combat with serpentine creature(s).

22 Examples are U 692 from Väppeby and U 838 from the royal farm of Nysätra.

23 For the Swedish quadrupeds with and without serpents, see Sigmund Oehrl, *Vierbeinerdarstellungen auf schwedischen Runensteinen: Studien zur nordgermanischen Tier- und Fesselungsikonographie* (Berlin, 2010).

24 Webster, *Anglo-Saxon Art*, 191.

25 Elin Lønngeroth Pedersen describes the period as one focused on "honor and death, combat and victory, and the power of the king, as well as the power and superiority of the new faith." Pedersen, "Urnesportalen: Monumental ornamentikk eller dekorativt meningsverk?; En diskusjon om motiv og ikonografi" (MPhil. thesis, University of Oslo, 1997), 126. For the practice of religion in this period before the church organization was firmly established, see Dagfinn Skre, "Kirken før sognet: Den tidligste kirkeordningen i Norge" in *Møtet mellom hedendom og kristendom i Norge*, ed. Hans-Emil Lidén (Oslo, 1995), 170–233.

26 Fuglesang, "Ikonographie der scandinavischen Runensteine der jüngeren Wikingerzeit."

27 "super aspidem et basiliscum calcabis conculcabis leonem et draconem" (latinvulgate.com).

28 Fuglesang, "Ikonographie der skandinavischen Runensteine der jüngeren Wikingerzeit," 189nn24–26. See also Françoise Henry, *Irish Art in the Early Christian Period, to 800 A.D.*, rev. ed. (London, 1965), 205; and Maidie Hilmo, *Medieval Images, Icons, and Illustrated English Literary Texts: From the Ruthwell Cross to the Ellesmere Chaucer* (Burlington, VT, 2004), 39.

29 Fuglesang, "Animal Ornament," 158.

30 Recent excavations at Jelling led by Anne Pedersen uncovered new information, but the results are not yet fully published. Concerning the Jelling complex, Pedersen concludes that the placement of three 23-m-long buildings indicates a possible structure resembling the ring fortresses of the Viking Age. The houses appear to have been of the Trelleborg type and thus belong to the period of Haraldr blátǫnn or immediately after, toward the end of the tenth century. The two runestones are part of the larger monument, but while Haraldr's stone is still in its original setting, Gormr's has been moved. Gormr's stone is much smaller than Haraldr's (c.140cm), which is typical for the early and mid-tenth century. Anne Pedersen, "Jelling im 10. Jahrhundert: Alte Thesen, neue Ergebnisse," in *Die Wikinger und das Fränkische Reich: Identitäten zwischen Konfrontation und Annäherung*, ed. Kerstin P. Hoffmann, Hermann Kamp, and Matthias Wemhoff (Paderborn, 2014), 275–95; Anne Pedersen, "Monumenterne i Jelling: Fornyet tradition på tærsklen til en ny tid," in *At være i centrum: Magt og minde; højstatusbegravelser i udvalgte centre 950–1450; Rapport fra tværfagligt seminar afholdt I Odense, 10. Februar 2016*, ed. Mikael Manøe Bjerregaard and Mads Runge (Odense, 2017), 5–22; and Dagfinn Skre, ed., *Rulership in 1st to 14th Century Scandinavia: Royal Graves and Sites at Avaldsnes and Beyond* (Berlin, 2020). For the excavations from 1965 to 1979, see Knud J. Krogh " The Royal Viking-Age Monuments at Jelling in the Light of Recent Archaeological Excavations: A Preliminary Report," *Acta Archaeologica* 53 (1983): 183–216, at 210–14; and Knud J. Krogh, *Gåden om Kong Gorms grav: Historien om Nordhøjen i Jelling* (Herning, 1993).

31 It has been suggested that the first wooden church, which is only known from excavations, belonged to a later phase. See Klavs Randsborg, "Kings' Jelling: Gorm and Thyra's Palace, Harald's Monument and Grave, Svend's Cathedral," *Acta Archaeologica* 79 (2008): 1–23. The recent excavations, however, have dismissed this theory, dating the church to the time of Haraldr Bluetooth. For a survey of this and the original church, see Pedersen, "Monumentene i Jelling," 5–22.

32 Else Roesdahl, "Jellingstenen: En bog af sten," in *Menneskelivets mangfoldighed: Arkæologisk og antropologisk forskning på Moesgård*, ed. Ole Høiris et al. (Aarhus, 1999), 235–44; and Michael H. Gelting, "The Kingdom of Denmark," in *Christianization and the Rise of Christian Monarchy: Scandinavia, Central Europe and Rus' c.900–1200*, ed. Nora Berend (Cambridge, 2007), 73–120, at 80–82.

33 Erik Moltke, *Runes and Their Origin: Denmark and Elsewhere* (Copenhagen, 1985), 207. Quoting the translation of *Danske runeindskrifter*, http://runer.ku.dk.

34 For discussions of the date, see Wamers, ". . . ok Dani gærði kristna. . . ," 156n81.

35 The distribution and erection of stones in tenth-century Scandinavia has been studied as part of the large Jelling project, and attention has been paid to the large increase in the distribution of stones supposedly associated with Christian conversion: "With the adoption of Christianity the magnates lost the option of manifesting and maintaining old boundaries with lavish and costly funerals in existing burial areas. As a result the custom of erecting rune stones became popular. Erecting rune stones was an old and distinguished custom, but it was flexible; the rune stones could be placed wherever necessary and the textual content could be adapted to suit the new Christian ideology." Lisbeth Imer, "Rune Stones in Context 2011," Nationalmuseet, Jellingprojektet, http://jelling.natmus.dk/en/about-the-project/sub-projects/rune-stones-in-context-2011/.

36 For the use of this passage from Genesis in medieval sermons and music throughout the Middle Ages, see M. Jennifer Bloxham, "Preaching to the Choir? Obrecht's Motet for the Dedication of the Church," in *Music and Culture in the Middle Ages and Beyond: Liturgy, Sources, Symbolism*, ed. Benjamin Brand and David J. Rothenberg (Cambridge, 2016), 263–92.

37 Else Roesdahl ("Jellingstenen") has suggested that the stone might have functioned in relation to open-air services, but

38 The most recent overview is Steinar Magnell, "De første kirkene i Norge: kirkebyggingen og kirkebyggere før 1100-tallet" (MA thesis, University of Oslo, 2009). For a more substantial study, see Jørgen H. Jensenius, "Trekirkene før stavkirkene: En undersøkelse av planlegging og design av kirker før ca år 1100" (PhD diss., AHO, Oslo, 2001).

39 This is described, for example, in the Icelandic bishop's chronicle *Hungrvaka*, in Gudbrand Vigfusson and F. York Powell, eds., *Origines islandicae: A Collection of the More Important Sagas and Other Native Writings Relating to the Settlement and Early History of Iceland* (Oxford, 1905), 1:453–54. The text was put into writing soon after the better-known *Þorlák's saga*, before bishop Páll Jónsson's death in 1211. Ásdís Egilsdóttir, "The Beginnings of Local Hagiography in Iceland: The Lives of Bishop Þorlákr and Jón," in *The Making of Christian Myths in the Periphery of Latin Christendom (c.1000–1300)*, ed. Lars Boje Mortensen (Copenhagen, 2006), 121–34.

40 Gelting, "Kingdom of Denmark," 80–82.

41 Not excluding the motif's use in other high-status contexts, such as on the Cammin Shrine. See, e.g., William Anderson, "Vom Cordulaschrein im Domschatz zu Cammin," *Unser Pommernland* 14.3 (1929): 95–96; and Arnold Muhl, "Der Bamberger und der Camminer Schrein: Zwei im Mammenstil verzierte Prunkkästchen der Wikingerzeit," *Offa* 47 (1990): 241–420.

42 In the Norwegian National Archives, nineteen missals and two graduals are preserved from the eleventh century. See Gunnar I. Pettersen and Espen Karlsen, "Katalogisering av latinske membranfragmenter som forskningsprosjekt," *Arkivverkets forskningsseminar Gardermoen 2003* (Oslo, 2003), 43–88 at 58–88; and Espen Karlsen, "The Collection of Latin Fragments in the National Archives of Norway," in *The Beginning of Nordic Scribal Culture, ca.1050–1300: Report from a Workshop on Parchment Fragments, Bergen 28–30 October 2005*, ed. Åslaug Ommundsen (Bergen 2006), 17–22, at 20.

43 I am grateful to Espen Karlsen for examining these fragments for me in order to establish their content.

44 Bjørn Bandlien, *Olav kyrre* (Oslo, 2011), 107–14, 127–41. After the Norman invasion, a man named Turgot fled from England to Norway. He is the source for Symeon of Durham, who later described these aspects of life at Óláfr's court.

45 *Adam von Bremen: Hamburgische Kirchengeschichte*, ed. Bernhard Schmeidler (Hannover, 1917), 120 (bk. II, chap. 61).

46 See, e.g., Mette Birkedal Bruun and Louis I. Hamilton, "Rites for Dedicating Churches," in *Understanding Medieval Liturgy: Essays in Interpretation*, ed. Helen Gittos and Sarah Hamilton (Burlington, VT, 2016), 177–204, and Brian Repsher, *The Rite of Church Dedication in the Early Medieval Era* (Lewiston, NY, 1998). On the symbolism of the door, see Margrete Syrstad Andås, "Art and Ritual in the Liminal Zone," in *The Medieval Cathedral of Trondheim: Architectural and Ritual Constructions in Their European Context*, ed. Margrete Syrstad Andås et al. (Turnhout, 2007), 47–126; and Margrete Syrstad Andås, "Imagery and Ritual in the Liminal Zone" (PhD diss., University of Copenhagen, 2012), 96.

47 In most uses three times while chanting the litany, in others only once. Helen Gittos, *Liturgy, Architecture, and Sacred Places in Anglo-Saxon England* (Oxford 2013), 230–36.

48 *Hungrvaka* presents the history of the see of Skálholt from 1056 to 1178; see Egilsdóttir, "Beginnings of Local Hagiography in Iceland."

49 We do not have complete instructions for the consecration rite from the province of Nidaros; see Andås, "Imagery and Ritual," 62–64, 93–110.

50 Adapted from Vigfusson and Powell, *Origines islandicae*, 1:453–54.

51 William Durandus, *Guillelmi Duranti: Rationale divinorum officiorum I–IV*, ed. A. Davril and T. M. Thibodeau, CCCM 140 (Turnhout, 1995), I.iv.6, 62–63.

52 Of the ten liturgical prescriptions for this rite from Anglo-Saxon England discussed by Helen Gittos, only the Leofric Missal leaves out the "door dialogue," but all ten have the "Tollite portas" sequence. Gittos, *Liturgy, Architecture, and Sacred Places*, 221–22.

53 Espen Karlsen, "Introduction," in *Latin Manuscripts of Medieval Norway: Studies in Memory of Lilly Gjerløw*, ed. Espen Karlsen (Oslo, 2013), 13–26, at 17–18. Karlsen informs me that sections of the *dedicatio ecclesiae* are found in the following unpublished fragments at the Norwegian National Archives (Riksarkivet): frag. 56 (Mi 10e, provenance Bratsberg 1623), frag. 75–76 (Mi 11, Trondheim 1625), frag. 275–281 (Mi 31, Mandal 1629–30), frag. 651–652 (Mi 118, Hardanger/Halsnøy 1619), frag. 692–693 (Mi 131, Øvre Romerike 1611), frag. 925–926 (Gr 31, Bratsberg 1625–26), and frag. 952 (Gr 40, Nordland 1628). The seventeenth-century dates attached to these numbers refer to when the manuscripts were reused as binding materials for post-Reformation official accounts; the provenance indicates where they were reused. The latter may thus give some indication of the manuscript's origin; "Trondheim," for instance, may indicate that the manuscript came from the archbishop's seat.

54 John Harper, *The Forms and Orders of Western Liturgy from the Tenth to the Eighteenth Century: A Historical Introduction and Guide for Students and Musicians* (Oxford, 1991); and Gittos, *Liturgy, Architecture, and Sacred Places*, 231. Gittos cites Thomas Davies Kozachek, "The Repertory of Chant for Dedicating Churches in the Middle Ages: Music, Liturgy, and Ritual" (PhD diss., Harvard University, 1995).

55 The St. Gall Easter play utilized this element. Peter Macardle, *The St Gall Passion Play: Music and Performance* (Amsterdam, 2007), 333–56; and Rainer Warning, *The Ambivalences of Medieval Religious Drama*, trans. Steven Rendall (Stanford, 2001), 55–56. A cross was struck against the door of the choir to signify the redemption of the souls from limbo, before the door was opened at the third knock and the cross laid before the altar of the Virgin.

56 Warning, *Ambivalences of Medieval Religious Drama*, 45–65; and Nikolaus Henkel, "Inszenierte Höllenfahrt: Der 'Descensus ad inferos' in geistlichen 'Drama' des Mitttelalters," in *Höllen-Fahrten: Geschichte und Aktualität eines Mythos*, ed. Markwart Herzog (Stuttgart, 2006), 87–108, at 98–104.

57 See, e.g., Judith N. Garde, *Old English Poetry in Medieval Christian Perspective: A Doctrinal Approach* (Cambridge 1991), 132–47.

58 Ibid.

59 Else Mundal, "Kristusframstillinga i den tidlege norrøne diktinga," in *Møtet mellom hedendom og kristendom i Norge*, ed. Hans-Emil Lidén (Oslo, 1995), 255–68. See also Edith Marold, "Das Gottesbild der christlichen Skaldik," in *The Sixth International Saga Conference, 28.7–28.8 1985: Workshop Papers I–II*, ed. Jonna Louis-Jensen et al. (Copenhagen, 1985), 717–49. Marold examines representations of Christ and God in skaldic poetry c.1000–1200. Similar issues have been discussed more recently in Ruth Elizabeth Cheadle, "Representations of Christ in Christian Skaldic Poetry" (PhD diss., University College London, 2015), https://discovery.ucl.ac.uk/id/eprint/1471382/.

60 Terms such as *pure* and *flawless* also occur. Mundal, "Kristusframstillinga," 263–65; and Cheadle, "Representations of Christ in Christian Skaldic Poetry."

61 Krogh (*Urnesstilens kirke*, 175–79) presents excellent drawings of these crosses and notes their location.

62 The small incised crosses would have been cut with a knife, possibly by the bishop during the consecration. This act is not commonly prescribed in the preserved material from the period, but it is found, for instance, in the Irish manuscript Leabhar Breac. This prescribes that the bishop incise crosses with his knife on both the inside and outside of the church. Small knife-cut crosses are also seen in the nearby church of Kaupanger, possibly performed by the same bishop on the same visit given the solid dendrochronological date of both churches. Unfortunately, there are no indications of how the portal was treated. On the early rites of the British Isles, see Gittos, *Liturgy, Architecture, and Sacred Places*, 212–56, 274, esp. 220–21.

63 Andås, "Imagery and Ritual," 99–100, 130–33, 288–89, for texts from the Ordo Nidrosiense (the order of the Nidaros province).

64 Pedersen, "Urnesportalen," 127.

65 Calvin B. Kendall mentions the tympanum of the west portal of Alpirsbach in Baden-Württemberg and the mosaic on the interior wall above the west portal of San Marco in Venice. Kendall, *The Allegory of the Church: Romanesque Church Portals and Their Verse Inscriptions* (Toronto, 1998), 51, 117.

66 *Bede: On the Temple*, trans. and notes Seán Connolly (Liverpool, 1995).

67 Aidan Conti, "The Performative Text of the Stave Church Homily," in *The Performance of Christian and Pagan Storyworlds: Non-Canonical Chapters of the History of Nordic Medieval Literature*, ed. Lars Boje Mortensen and Tuomas M. S. Lehtonen with Alexandra Bergholm (Turnhout, 2013), 223–45.

68 "Dyrr kir kiunnar merkia trv retta þa er os læiðir inntil allmenilegrar cristni." *Gamal norsk homiliebok: Cod. AM 619 4°*, ed. Gustav Indrebø (Oslo, 1966), 96–97.

69 Margrete Syrstad Andås, "Making It Known to Man: The Portal in the Liturgical and Legal Practices of the North," in *Das Kirchenportal im Mittelalter*, ed. Stefan Albrecht, Stefan Breitling, and Rainer Drewello (Petersberg, 2019),

170–77; and Andås, "Imagery and Ritual in the Liminal Zone," 139–40.

70 Andås, "Making It Known to Man"; and Andås, "Imagery and Ritual in the Liminal Zone," 115–36.

71 For Norway, see Andås, "Art and Ritual in the Liminal Zone," 47–126; and Andås "Imagery and Ritual in the Liminal Zone," 93–110. For the Anglo-Saxons, see M. Bradford Bedingfield, *The Dramatic Liturgy of Anglo-Saxon England* (Woodbridge, UK, 2002).

72 On churching and Candlemas in medieval Scandinavia, see Margrete Syrstad Andås, "Entering the Temple of Jerusalem: Candlemas and Churching in the Lives of the Women of the North; A Study of Textual and Visual Sources," in *Tracing the Jerusalem Code*, vol. 1, *The Holy City: Christian Cultures in Medieval Scandinavia (ca.1100–1536)*, ed. Kristin B. Aavitsland and Line M. Bonde (Berlin, 2021), 340–74.

73 Gittos, *Liturgy, Architecture and Sacred Places*, 220–21.

74 Andås, "Making It Known to Man," 173–76.

75 On oaths in medieval Norway, see Ole-Albert Rønning Nordby, "The Judicial Oath in Medieval Norway: Compurgation, Community and Knowledge in the Thirteenth Century" (PhD diss., University of Oslo, 2018). On the law and the use of the church door, see Andås, "Imagery and Ritual," 163–72; and Andås, "Making It Known to Man," 173–76.

76 Barbara Deimling, "Medieval Church Portals and Their Importance in the History of Law," in *Romanesque: Architecture, Sculpture, Painting*, ed. Rolf Toman, trans. Fiona Hulse and Ian Macmillan (Cologne, 1997), 324–27; and Barbara Deimling, "Ad Rufam Ianuam: Die rechtsgeschichtliche Bedeutung von 'roten Türen' im Mittelalter," *Zeitschrift der Savigny-Stiftung für Rechtsgeschichte: Germanistische Abteilung* 115 (1998): 498–513.

77 Fuglesang "Animal Ornament," 183.

78 Ibid.

79 Signe Horn Fuglesang, "Swedish Runestones of the Eleventh Century: Ornament and Dating," in *Runeninschriften als Quellen interdisziplinärer Forschung: Abhandlungen des Vierten Internationalen Symposiums über Runen und Runeninschriften in Göttingen vom 4.–9. August 1995*, ed. Klaus Düwel (Berlin, 1998), 197–218. In this article Fuglesang also discusses the likelihood of there being two different masters by the name Ásmundr (Asmund), an idea she attributed to the work of Clairborn Thompson. See also Marjolein Stern, "Runestone Images and Visual Communication in Viking Age Scandinavia" (PhD diss., Nottingham University, 2013), 72–73.

80 Ingunn Marit Røstad, "En fremmed fugl: 'Danske' smykker og forbindelser på Østlandet i overgangen mellom vikingtid og middelalder," *Viking* 75 (2012): 181–210.

81 Ibid., 187–88. On Urnes broches of various types in Denmark, see Lise Gjedssø Bertelsen, "Præsentation af Ålborg-gruppen: En gruppe dyrefibler uden dyreslyng," *Aarbøger for nordisk oldkyndighed og historie*, 1991 (1992): 237–64; and Lise Gjedssø Bertelsen, "Urnesfibler i Danmark," *Aarbøger for nordisk oldkyndighed og historie*, 1992 (1994): 345–70.

82 Simon Keynes and Rory Naismith, "The *Agnus Dei* Pennies of King Æthelred the Unready," *Anglo-Saxon England* 40 (2012): 175–223.

83 Ibid.; and Elina Screen, "Small Doors on the Viking Age: The Anglo-Saxon Coins in Norway Project," *British Academy Review* 24 (2014): 42-45, https://www.thebritishacademy.ac.uk/documents/803/BAR24-13-Screen.pdf.

84 Stern ("Runestone Images and Visual Communication," 148n435) places U 753 in the group "non-specific quadrupeds."

85 I am grateful to Nathalie Le Luel for pointing this out to me.

86 Lise Gotfredsen, "Dragens hale," in *2. Skandinaviske symposium om romanske stenarbejder: 1999 i Silkeborg, Danmark*, ed. J. Vellev (Højbjerg, 2003), 59–68.

87 It has recently been dated to *c.*1110, as the typical Ringerike elements on one side are thought to predate the figural scene on the face of the lintel. See Philip Dixon, Olwyn Owen, and David Stocker, "The Southwell Lintel, Its Style and Significance," in *Vikings and the Danelaw: Select Papers from the Proceedings of the Thirteenth Viking Congress, Nottingham and York, 21–30 August 1997*, ed. James Graham-Campbell et al. (Oxford, 2001), 245–68. The tympanum was catalogued as *c.*1120 by George Zarnecki, but Pamela Tudor-Craig has suggested that it must belong to the pre-Conquest Southwell Minster, making it a late tenth- or early eleventh-century piece. George Zarnecki, Janet Holt, and Tristram Holland, eds., *English Romanesque Art, 1066–1200* (London, 1984), 123, 165; and Pamela Tudor-Craig, "Controversial Sculptures: The Southwell Tympanum, the Glastonbury Respond, the Leigh Christ," in *Anglo-Norman Studies XII: Proceedings of the Battle Conference 1989*, ed. Marjorie Chibnall (Woodbridge, UK, 1990), 211–33, at 219–24.

88 Tudor-Craig, "Controversial Sculptures," 221.

89 Gotfredsen, "Dragens hale," 63–65.

90 Bede describes a monastery at Lastingham. See Richard Morris, "'Calami et iunci': Lastingham in the Seventh and Eighth Centuries," *Bulletin of International Medieval Research* 11 (2005): 3–21.

91 More than 2,000 runic memorials are preserved in Sweden, of which 65 percent have crosses and 25 percent have invocations. Fuglesang, "Animal Ornament," 174; and Bertelsen, "On Öpir's Pictures," 52.

92 Fuglesang, "Animal Ornament," 158.

93 Anne-Sofie Gräslund, "Wolves, Serpents, and Birds: Their Symbolic Meaning in Old Norse Belief," in *Old Norse Religion in Long-Term Perspectives: Origins, Changes, and Interactions; An International Conference in Lund, Sweden, June 3–7, 2004*, ed. Anders Andrén, Kristina Jennbert, and Catharina Raudvere (Lund, 2006), 124–29.

94 Ibid., 125–27.

95 Fuglesang, "Animal Ornament"; and Fuglesang, "Swedish Runestones of the Eleventh Century," 209.

96 J. Bergström, "Drake," *Kulturhistorisk leksikon for nordisk middelalder: Fra vikingetid til reformationstid* (Copenhagen, 1980), 3: cols. 267–70.

97 For a Norse version of the text online, see https://heimskringla.no/wiki/Voluspå.

98 *The "Etymologies" of Isodore of Seville*, XII.iv, "De serpentibus," ed. and trans. Stephen A. Barney et al. (Cambridge, 2006), 255–58. See also Otto Seel, ed., *Der Physiologus: Tiere und ihre Symbolik* (Zurich, 2006), 19–21.

99 T. H. White, ed., *The Book of Beasts: Being a Translation from a Latin Bestiary of the Twelfth Century* (Stroud, 1954), 167.

100 *Ólafs konúngs hins helga*, chap. 49 in Snorri Sturluson, *Heimskringla*, vol. 2, *Óláfr Haraldsson (the Saint)*, trans. Alison Finlay and Anthony Faulkes (London, 2014).

101 Alison Finlay, *Fagrskinna, A Catalogue of the Kings of Norway: A Translation with Introduction and Notes* (Leiden, 2004), 123–25.

102 Ibid., 151, 194, 274. See also Finlay's comment (311) on how to understand the reference to "dragon-ships."

103 Noah's ark from the Caedmon manuscript, Oxford, Bodleian Library, MS Junius 11, pp. 66 and 68; digitized at https://digital.bodleian.ox.ac.uk/objects/d5e3a9fc-abaa-4649-ae48-be207ce8da15/.

104 Some examples are Exodus 7:1–13, where God allows miracles to happen using the image of the snake; Judith 8:25, where the unjust are destroyed and "perished by serpents"; Isaiah 14:29, "out of the root of the serpent shall come forth a basilisk"; and the prophecies of Isaiah 27:1, where God will punish Leviathan "the piercing serpent" and Leviathan "the crooked serpent."

105 Signe Horn Fuglesang, "Amulets as Evidence for the Transition from Viking to Medieval Scandinavia," in *The World of Ancient Magic: Papers from the First International Samson Eitrem Seminar at the Norwegian Institute at Athens, 4–8 May 1997*, ed. David R. Jordan, Hugo Montgomery, and Einar Thomassen (Bergen, 1999), 299–314, at 308.

106 Ibid.

107 Ibid.

108 Oslo University Museum, inv. no. C58123, Sør-Fron; see Røstad, "En fremmed fugl."

109 On apotropaic interlace, see, e.g., Ernst Kitzinger, "Interlace and Icons: Form and Function in Early Insular Art," in *The Age of Migrating Ideas: Early Medieval Art in Northern Britain and Ireland; Proceedings of the Second international Conference on Insular Art Held in the National Museums of Scotland and in Edinburgh, 3–6 January 1991*, ed. Michael R. Spearman and John Higgitt (Edinburgh, 1993), 3–15.

110 "The Jevington sculpture, then, on the evidence of both the figural and animal style, should be placed in the second half of the eleventh century, continuing pre-Conquest sculptural traditions into the post-Conquest period in a geographically remote region." D. Tweddle, "The Development of Sculpture *c.*950–1100," *The Corpus of Anglo Saxon Stone Sculpture in England*, vol. 4, *South-East England*, ed. Dominic Tweddle, Martin Biddle, and Birthe Kjølbye-Biddle (Oxford, 1995), chap. 7; http://www.ascorpus.ac.uk/vol4_chap7.php. The relief is also discussed elsewhere in the corpus: "Jevington," in ibid., http://www.ascorpus.ac.uk/catvol_search_results.php?id=1085. The reason for stating that this is post-Conquest rests on Wilson and Klindt-Jensen, who argue that the Urnes style did not reach Britain until after the Conquest, a view that has since then been disputed. David M. Wilson and Ole Klindt-Jensen, *Viking Art* (London, 1966), 153, 160; Olwyn Owen, "The Strange Beast That Is the English Urnes Style," in Graham-Campbell, *Vikings and the Danelaw*, 203–22.

111 "Jevington 01, Sussex," http://www.ascorpus.ac.uk/catvol_search_results.php?id=1085.

112 "The lower end is thrust into the mouth of an inward-facing animal at the foot of the figure. The head of the animal is up-turned and backward looking, with an open mouth, reversed lentoid eye, and pointed ears. Its body and front legs are naturalistically treated, but the front legs rest on interlacing loops developing from the back legs. A tail with a lobed tip curls down and across the hindquarters. To the figure's left is a second inward-facing animal. This has a low relief, contoured, ribbon-like body which develops into interlacing coils. The jaws are drawn out and back. There is a reversed lentoid eye and small oval ears. The animal is in combat with a second similar, but smaller, ribbon-like animal." Ibid.

113 Image online via Digital Bodleian, https://digital.bodleian.ox.ac.uk/objects/86dd3006-88da-4777-9dc9-5ff71fc10c59/surfaces/67914b14-36c4-4567-a4d8-deeb80968194/. This is discussed in Tweddle, "Jevington 01, Sussex," https://chacklepie.com/ascorpus/catvol4.php?pageNum_urls=61; and Tweddle, "Development of Sculpture *c*.950–1100," no. 79, 96–97, ill. 259; http://www.ascorpus.ac.uk/vol4_chap7.php.

114 Hilmo, *Medieval Images, Icons and Illustrated English Literary Texts*, 39.

115 Fuglesang, "Ikonographie der skandinavischen Runensteine der jüngeren Wikingerzeit," 189nn24–26.

116 Ibid., 189 and n25.

117 On the use of Psalm 90:13 in Compline, see Susan Boynton, "The Bible and the Liturgy," in *The Practice of the Bible in the Middle Ages: Production, Reception, and Performance in Western Christianity*, ed. Susan Boynton and Diane J. Reilly (New York, 2011), 10–33, at 16.

118 Bertelsen, "Cross Motif on Late Viking Age Picture Runestones"; and Gotfredsen "Dragens hale."

PART THREE | THE TWELFTH-CENTURY CHURCH

CHAPTER 7

Soft Architecture: Textiles in the Urnes Stave Church

Ingrid Lunnan Nødseth

THE INTERIOR OF THE URNES STAVE CHURCH preserves much of its medieval appearance, including the Calvary group sculptures and carved capitals.[1] Yet, looking at its bare, unpainted walls, it is hard to imagine how different this small space would have appeared with entire wall surfaces in the choir and nave covered with colorful textiles. Written sources and preserved fragments permit insight into the wealth of textiles that once clothed medieval stave churches, and traces of nails and holes along interior walls are a lasting remnant of such textile arrangements. Creating tentlike structures in the built space, textile walls, baldachins, and curtains created a soft, textile architecture that could be changed easily according to liturgical season or for great feast days. In doing so, these embroidered, woven, and painted textiles were instrumental to the visual and spatial experience of medieval stave church interiors. This chapter focuses on these textiles, a subject that is rarely mentioned in stave church scholarship.

Norse Wall Hangings: *Refil* and *Tjeld*

Medieval sources described great halls dressed with two different textile wall hangings, *refil* and *tjeld*.[2] While the earliest mentions of interior *tjeld*ing refer to the textile dressings of great halls, written sources confirm that this practice continued inside ecclesiastical spaces after the conversion of Norway.[3] Only fragments of such textiles are preserved, many of them from stave churches, including Urnes.[4] To unveil how these textiles may have been used at Urnes, we must depend largely on written sources. The most comprehensive and informative collection of such sources is preserved in the Icelandic *Máldagar*, records of church property, land, and inventory, including textiles and art.[5] The *Máldagar* describe the inventory of over 450 churches and abbeys in medieval Iceland, and the total corpus exceeds 1,200 inventories.[6] They are perhaps the most comprehensive inventories preserved from western medieval Europe. Fredrik Wallem, who in 1910 published his doctoral thesis

on these documentary sources, compared them to papal records: "Where else can one find inventories from all churches in two adjacent bishoprics carefully described with inventories of their property not only for each year but, more often, several times per year, over the course of several centuries."[7] Wallem argues that because inventories from Norway are scarce, the Icelandic ones can shed light on the appearance of Norwegian medieval church interiors and that the decoration of Icelandic churches with of textiles, sculptures, and other artworks had currency across Scandinavia.[8]

From the Icelandic inventories, we know that the walls of churches were often entirely covered by *refil* and *tjeld*. *Tjeld* probably described several lengths of woven cloth sewn together horizontally or vertically to cover large wall surfaces. The term is complicated, however, because in some instances it seems to describe the whole textile furnishing of the church.[9] In other cases the terminology is more specific, indicating layers of wall textiles that include a first layer of *tjeld* closest to the wall (described as an "under-*tjeld*") with more elaborate textiles on top.[10] Virtually every Icelandic church is listed as having *tjeld* in the choir, and the richest churches also have textiles covering the ceiling and gables as well as the walls in both choir and nave, describing the church as "allover *tjeld*" (*alltiolldud*) or with "*tjeld* in the entire church" (*tiolld vm alla kirku*).[11] In some cases several layers of wall hangings were used, including a plain under-*tjeld* to protect the more costly and decorated top layer against moisture or staining from the cold, damp wall, while also providing extra warmth. *Tjeld* hangings could be woven, embroidered, or have painted motifs on a linen or hemp background fabric.

The materials and arrangement of *refil* and *tjeld* probably varied depending on the textiles available and the financial resources of the church or patron. The *refil* could have more elaborate narrative scenes and was hung at a higher level as a textile frieze with *tjeld* suspended below. *Refil*s usually measured between 10 and 30 *alen* in length (*c.* 5–15 m).[12] Icelandic inventories lists *refil*s with narratives from saints' lives, such as Martin, Nicholas, or Charlemagne.[13] The most famous example of such textiles is the eleventh-century Bayeux Embroidery, contemporary with the third church at Urnes.[14] Textile techniques in the Bayeux Embroidery closely resemble Norwegian fragments: the similarity between the laid couched work at Bayeux and Norse wool embroideries has long been acknowledged, especially the small Røn fragment from Valdres.[15] In Norway, eight different fragments of medieval *refil*s are preserved, testifying to a continuing tradition of *refil*s from the Viking Age to the fourteenth century.[16]

Two inventories from fourteenth-century Norway reveal important information about textile usage in small stave churches similar to Urnes. The inventory from the Holdhus church (also known as Håland) from 1306 describes wall hangings and textile friezes for the choir that include *tjeld* with *refil*s and under-*tjeld*. The nave was likewise covered with two layers of wall hangings (*tjeld*).[17] Ylmheim (also known as Yhlheim or Ølheim) was a stave church near the Sognefjord southwest of Urnes (Fig. I.2). Its inventories from 1321 and 1323 list *refil*s, *tjeld*, and under-*tjeld* for the choir and nave.[18] In both Holdhus and Ylmheim, the use of multilayered wall textiles shows the complexity of textile walls with two or more layers of *tjeld* and embroidered and figurative textile friezes (*refil*). Unfortunately, these inventories do not describe the materials or motifs of the wall hangings, but it is worth noting that the *refil*s from Ylmheim are described as old (Old Norse *fornom*), suggesting that these textiles considerably predated the fourteenth-century inventory.

Tjeld, Tents, Textile Spaces

The etymology of the term *tjeld* attests to the centrality of textiles in Viking-age interior spaces. Originally denoting a tent used for ceremonial occasions, the term establishes a parallel between the dressing of interior walls, gables, and roofs and the appearance and spatial experience of entering a large tent.[19] Large *tjeld*s were used to construct tents over the open space in Viking ships, and other textile tents were used on land to erect tents during travels (*land-tjeld*).[20] According to Icelandic historian Snorri Sturluson, King Óláfr Tryggvason (r. c.995–99) held mass in a tent at the small peninsula of Moster, in western Norway, an event often referred to as the starting point for the country's conversion.[21] It is likely that elaborate tents were used for mass during the period of Christianization, when there were few churches. Therefore, the first ecclesiastical spaces were almost certainly soft, textile architecture. Ceremonial tents were erected with richly decorated gable boards, known from the Gokstad ship burial c.900 (Fig. 7.1).[22] The gaping horse heads evoke the animal heads well known from stave church roofs.

Lines can be drawn between the Norse tradition of using decorative tents and the tradition of

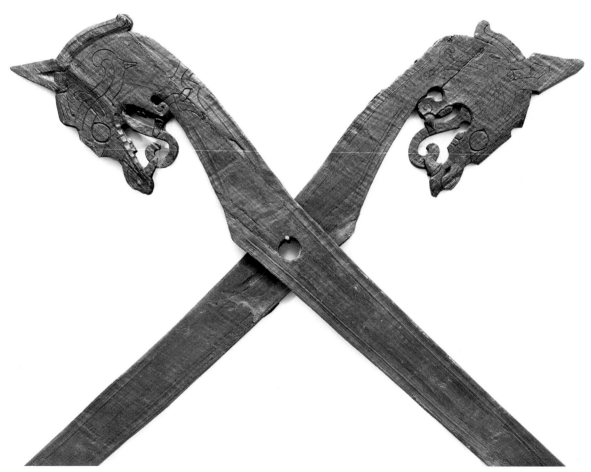

Fig. 7.1. Gokstad ship burial, Norway, oak tent boards, approx. L 350 cm, c.900. Museum of Cultural History, University of Oslo, inv. no. C10409. Photo: Kulturhistorisk Museum, UiO.

covering the entire interior surface of houses with textiles, including ceilings and gables.[23] The verb *att tjelde* (to *tjeld*) can mean both to put up a tent and to cover surfaces with stretched-out lengths of fabric.[24] Helen Engelstad suggests that the development of wooden structures was linked with the use of textiles. Written sources reveal that walls, gables, and roofs could be entirely covered by textile *tjeld* on special occasions. Fabrics would clothe the built architecture and transform the space into what resembled a textile architectural structure within the building. This soft architecture may have influenced the decoration (both painted and carved) of medieval churches, especially smaller stave churches. As Engelstad has pointed out, there is a certain "textile quality" to the painted vaults at Ål and Torpo, and she proposes that such vault painting may have been inspired by the embroidered baldachins described in the Icelandic inventories.[25] Entering a small church fully dressed with layers of textiles clothing the walls, and framing and enclosing altars and sculptures in curtains and textile baldachins (as discussed below), could evoke the experience of walking into a textile space, such as a tent, within the building itself.

The idea of textile walls as interior tents recalls the nineteenth-century architect and art historian Gottfried Semper's "principle of dressing" (*Bekleidungsprinzip*). Exploring the connections between architectural spaces and textiles, Semper argued in his seminal 1870s work *Style in the Technical and Tectonic Arts, or, Practical Aesthetics* that the importance of weaving, fabric making, and tent construction in early cultures directly affected the evolution of architecture.[26] For Semper, the decorative surfaces of a building were instrumental to its aesthetic, symbolic, and spiritual significance as enclosing structures that both physically and symbolically dressed architecture. The relationship between textiles and solid or built architecture has more recently been explored by Heidi Helmhold, who argues that textiles manifest themselves as soft, flexible architecture:

They are not just means of beautification or embellishment but agents of subversion: they are unsettling, they can be used and worn, they inflate with presence, they fold up inconspicuously, they bear permanent spaces, they can be destroyed quickly, and they cannot be burdened with any claim of permanence. Nonetheless, they are always *present*: textile architectures are inscribed into the spaces of solid architecture.[27]

Such textile structures as wall hangings, carpets, pillows, and upholstery are discussed by Helmhold as "counter-architectures" to the solid or built space.[28] In contrast to this solid architecture, textiles are flexible, migrant, and performative, qualities that have not been fully recognized in the dominant discipline of solid architecture. Semper's *Bekleidungsprinzip*, however, pointed precisely to the celebratory, playful, or festive potential of textiles to transform a space in fundamental ways.[29] Textiles could also create an "occasion," understood here in Paul Binski's sense as the context and purpose of an image, a process in which both audience and artifact participate.[30] We know very little about how medieval audiences experienced textiles in stave churches such as Urnes because there are very few written accounts. Still, the laborious manufacture of woven and embroidered textiles covering large wall surfaces, together with the material and economic resources that went into their making, indicate that textile surfaces were important for the visual appearance of medieval churches. Their flexible and performative qualities enabled interchangeable walls to facilitate a transformation of the interior space according to liturgical season or feast day. One example is found in the thirteenth-century *Laxdæla saga*, where a church built by chieftain Þorsteinn Egilsson at his

farm, Borg, in Iceland is described as dressed in its white clothes (*í hvítavoðum*) since it was newly consecrated.[31] The qualities of woolen cloth, *vaðmál*, varied greatly, and the finer woven *vaðmál* cloths (with the highest thread counts) were so highly valued that they could be used to pay tithes to the church.[32] Thus, the *hvítavoðum* described in the *Laxdæla saga* could refer to wall hangings of white and finely woven wool, clothing the church for the consecration ceremony. According to the Old Frostaþing Law (late 1220s) and Archbishop Jon Raude's Ecclesiastical Law (1270s), a minimum of 12 *alen* (approx. 7–8 m) of *vaðmál* or linen cloth was required for the consecration of churches, likely used as wall hangings.[33] Icelandic inventories describe both elaborate ornate *tjeld*s and humbler Lenten wall hangings for the wealthiest churches, indicating that one church could own several sets of wall hangings, tailored to different occasions.[34]

Refil as Narrative

Any visitor to Urnes in the wintertime, or even on chilly summer days, can appreciate the warmth and shelter that layers of woolen wall textiles would have provided. Beyond this practical function, wall textiles are often labeled in scholarly literature "applied arts," "decorative arts," or "minor arts." This modern reception of textiles belies their medieval importance: in contrast to the central and highly valued position of ornate textiles in medieval visual culture, postmedieval attitudes toward textile art relegated it to the margins of artistic expression.[35] The textile walls discussed in this chapter could work in multivalent ways, creating an aesthetic experience and establishing occasion, but also as vehicles for storytelling. Textile walls offered large areas where stories could be told, whether these were drawn from the life of a saint, the Virgin, or Christ, or from legends with a more secular character. In Old Norse religion, the act of weaving and embroidering narratives was understood as a way of writing stories. The communicative or rhetorical potential of textiles has been acknowledged since antiquity and is reflected in the frequent use of textile words in broader language contexts.[36] Texts and stories are often compared to fabric; they are spun, woven, knitted, quilted, sewn, or pieced together.[37] The word *text* stems from the Latin verb *textere*, meaning to weave or construct, underlining the parallels between the making of a textile and a text.[38] In both cases, separate entities are assembled to form a structure that is complex and full of meaning. The use of textile metaphors is found across cultures. In Norse society, the word *bók* (book) could refer to both a written book and a large woven or embroidered wall hanging.[39]

The creation of tapestries, such as the *refil* and *tjeld* discussed above, was described as an act of writing. Thus, female embroiderers and textile makers were "writing" stories with needle and thread. The communicative potential in Norse textiles is evident in a scene from the thirteenth-century *Völsunga saga* describing how Guðrun, the widow of Sigurðr Fáfnisbani (Sigurd the Dragon Slayer), made a tapestry to tell the story of her husband's heroic deeds.[40] As Lena Norrman has pointed out, Guðrun's weaving is described as a form of writing, using the Norse *skrifaði*, wrote: "Guðrun wrote heroic deeds on the tapestry."[41] Thus, in the Viking tradition, weaving had significant meaning through the semiotics of cloth, framing the act of weaving as writing a story. An early example of

CHAPTER SEVEN | SOFT ARCHITECTURE: TEXTILES IN THE URNES STAVE CHURCH

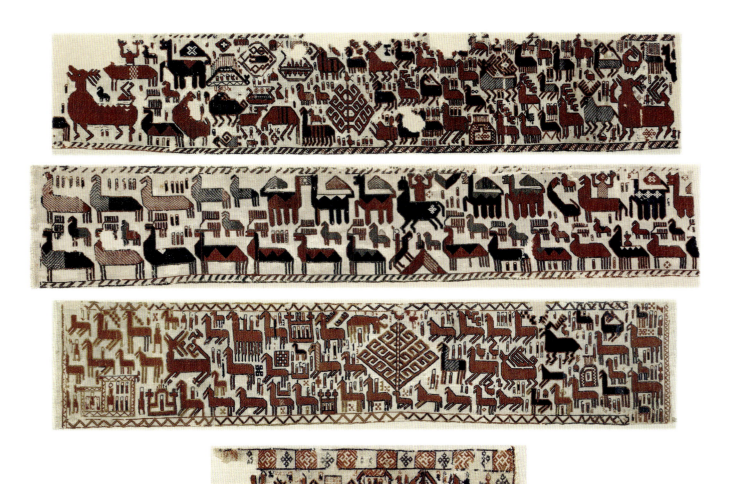

Fig. 7.2. Överhögdal tapestries, Sweden, wool and linen, tapestry Ia, Ib, II, and III from top down, c.800–1100. Jamtli Museum, Östersund, Sweden. Photo: Jämtlands läns museum.

tapestries in the *refil* format are those woven with dyed wool and linen from Överhogdal, in Sweden's Härjedalen province, dated between 800 and 1100 (Fig. 7.2).[42] Interpreting the Överhogdal motifs as a series of "micro-narratives" intended to be read from right to left (following the weave structure), Norrman argues that the tapestry tells the story of Sigurðr Fafnisbana.[43] Weavers of the Överhogdal tapestry were familiar with the Norse religion as well as with Christianity, but Norrman stresses that the textile represents not a "clash of faith" but, rather, a continuous textile tradition for storytelling, "a form of art and poetry [that] survived into the Christian era."[44] Sigurðr imagery is also found in church art after the conversion period, for instance in the carved stave church portal at Hylestad, in southern Norway.[45]

PART THREE | THE TWELFTH-CENTURY CHURCH

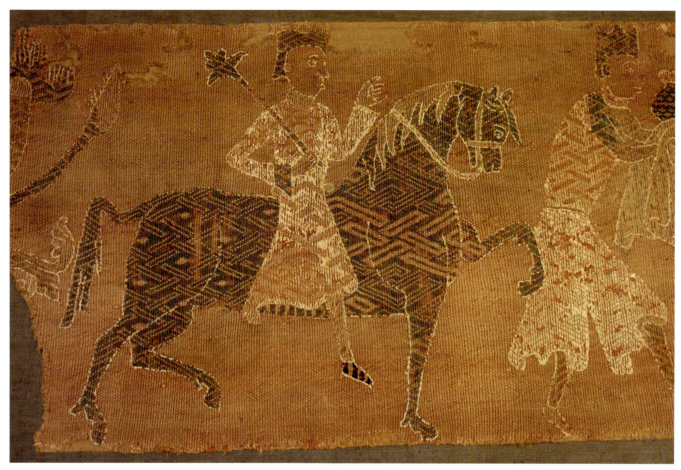

Fig. 7.3. Høylandet embroidery, Norway, detail, wool and linen, 211 × 44 cm, late twelfth century. Norwegian University of Science and Technology, Trondheim, inv. no. T 389. Photo: Author.

One of the most intriguing examples of embroidered *refils* preserved in Norwegian collections is the Høylandet embroidery (Fig. 7.3). Sometimes described erroneously as a tapestry (*Høylandsteppet*), this textile is in fact a large-scale embroidered image frieze measuring more than 2 m in length. Found in the Høylandet church in central Norway, it depicts scenes of the infancy of Christ and the arrival of the Magi.[46] From the left the embroidery shows a horseman and the three kings approaching the Virgin and Child enthroned in an architectural structure. The sleeping men on the right may have illustrated the dream of the Magi.[47] Torn at both edges, the fragment was originally part of a much longer wall hanging. The colors are now quite faded and brownish, but the background fabric was originally bright red with embroidery in multicolored wool yarns. The date most often suggested for the Høylandet embroidery is *c.*1200, but this has been much debated. While both the textile techniques and the predominantly "Romanesque" stylistic vocabulary suggest that the textile was made in the twelfth century, scholars have been reluctant to propose an earlier date.[48] Engelstad described the embroidery as "rather naïve" and "clumsy," suggesting that the eleventh-century style was due to "stylistic retardation" found in remote areas like Høylandet.[49] During a comprehensive reconstruction project in the 1990s, however, it became apparent that the embroidery was indeed

made with high artistic skill and precision.[50] One example is the minute execution of a variety of geometric patterns filling out the shape of the horse in the *smøyg* or pattern-darning technique.[51] More recently, Lasse Hodne has argued for a date after 1170 based on the specific *Virgo virga* iconography, the Virgin holding a flower or twig.[52] Thus, the Høylandet embroidery was not only made by highly skilled embroiderers but also imitated new iconographic models, probably from England.[53]

The tradition of weaving and embroidering large-scale narratives in *refils* was continued from the Viking Age well into the medieval period. Groups of women could work together to create stories "written" with the loom or embroidery needle. Such textiles could narrate tales from Old Norse mythology or local legends, but the tradition continued into the conversion period with biblical narratives, as seen in the Høylandet embroidery, that incorporated contemporary iconography and high artistic skill.

Textile Wall Hangings and Painted or Carved Wall Decoration

A handful of stave churches still have medieval painted wall decoration.[54] The best-preserved example is the Torpo baldachin, where the back is painted in a geometric pattern that evokes woven textiles. At Urnes, the painted walls of the choir, executed in 1601, are in remarkably good condition, showing draped textiles with flowers and landscapes above.[55] However, no traces of medieval wall paintings were discovered during the extensive documentation and conservation by the Directorate for Cultural Heritage.[56] The few painted examples from stave churches, such as the Hopperstad and Torpo baldachins, evoke textiles, reflecting a broader tradition of painting walls of ecclesiastical spaces with textile drapery. A wall-plate from the Hørning church in Denmark displays medieval wall paintings that evoke the pictorial structure of the textile *refils* (Fig. 4A.13b).[57] We can imagine that the upper horizontal wall-plates of stave church interiors could be painted in the manner of *refils*, with larger woven tapestries hung below in the manner of *tjeld*.

Wall textiles allowed for the kind of visual storytelling known from the large corpus of painted walls (lime-chalk painting), especially those in medieval Danish churches.[58] Although elaborate interior paintings were not uncommon in twelfth-century stave church interiors, wooden wall surfaces did not lend themselves as easily to painting as did their stone counterparts. The distemper (Norwegian *limfarge*) technique required more preparation work compared to paintings in stone churches, where the paint was worked into the lime base (*kalkfundering*). Nevertheless, textile walls were not a more affordable alternative to large-scale painted wall programs. In fact, painting was both faster and cheaper than making or commissioning textiles to cover interior walls. Engelstad argues that the presence of carved or painted wall surfaces in medieval churches did not exclude textile wall hangings; the aforementioned thirteenth-century *Laxdæla saga* describes a great hall with carved wall and roof decoration being adorned in textiles in preparation for a feast.[59] In other words, the use of textile hangings does not imply the absence of carved or painted wall decoration.

Urnes: Fragments and Traces

In several of the Norwegian stave churches we can still find iron nails used for hanging curtains and tapestries, a permanent record in the solid, wooden architecture of the textiles once present there.[60] In the late nineteenth century, architect Peter Andreas Blix produced a watercolor depicting how he imagined colorful textiles were suspended along the walls and around the triforium level at the Hopperstad stave church (Fig. 7.4). Even though Blix based his reconstruction on preserved holes and nails found in the church, there are some inaccuracies; his reconstruction shows a draped textile wall reminiscent of curtains rather than the Norse tradition of *refil* and *tjeld*. During the excavations and restorations at Kaupanger and Urnes at the beginning of the twentieth century, nails and nail holes were found in both churches, prompting architect Håkon Christie to suggest that the walls were covered with textiles.[61] Similar traces of holes and nails are known from Hurum (Høre), Lomen,[62] and Heddal. In Heddal, an uneven series of holes runs across the upper walls of both nave and choir, in some cases with remains of the wooden dowels still intact.[63]

Despite the fact that wall hangings are frequently mentioned in written sources and that traces of textile walls were found in many stave churches during twentieth-century restorations, the impact of such textile walls for the visual and spatial experience of medieval stave church interiors has rarely been addressed. Indeed, art historian Roar Hauglid argued in his 1971 examination of the interiors of stave churches that wall hangings were the exception rather than the rule in medieval churches.[64] His main objections were the varying heights of nails and holes on the walls (up to 4 m above the floor in some cases), the fact that nails are not found in the choir, and that no traces of hanging textiles are found in stone churches or secular houses. Furthermore, Hauglid questioned their aesthetic and practical function, arguing that draped wall hangings would make the room appear darker (by covering the small wall openings) and in some cases would cover medieval painted wall decoration.[65]

Hauglid's view of textile interiors is too limited. The estimated measurements of *refil*s, ranging in height from 13 to 35 cm, and *tjeld*s, measuring up to 2 m high, would combine to create textile walls at least 2 to 3 m high. Therefore, the varying heights of preserved nails and holes does not contradict the use of textile wall hangings. Moreover, Hauglid's claim that nails or traces of textile wall hangings are not found in the choir is inaccurate.

The lack of corresponding evidence from secular buildings and stone churches is beyond the scope of this chapter, but we should note that the interior walls of stone churches were repeatedly re-chalked (whitewashed) in postmedieval times,[66] and this likely erased traces of textile use. Even though the multilayered textile walls described in this chapter would cover small window openings, they provided much-needed warmth. Ornate *tjeld*s and *refil*s with brightly colored patterns and narrative scenes, embellished with golds and silk, would animate the walls in the flickering lights of a candlelit church. In other words, Hauglid's idea of textile-clad spaces as dark and unattractive may well reflect a modern aesthetic value. For all these reasons I contest Hauglid's rejection of a Norse tradition of dressing stave churches with textiles, but a systematic documentation and examination of preserved traces, such as nails and holes, would be very valuable for future research.[67]

CHAPTER SEVEN | SOFT ARCHITECTURE: TEXTILES IN THE URNES STAVE CHURCH

Fig. 7.4. Hopperstad church, Norway, interior with textiles, drawing by architect Peter Andreas Blix, 51.28 × 66.69 cm. Photo: Riksantikvaren.

During the seminar held in situ in preparation for this book, I had the chance to examine the walls at Urnes, Hopperstad, and Kaupanger. In Kaupanger there are still metal hooks at regular intervals on the wall-plates in both the nave and the choir. In Urnes, holes in the wall-plates of the nave ambulatory and choir were found at more or less regular intervals. When the former custodian at Urnes was made aware of them, she retrieved a cardboard box from the attic of one of the farm buildings, kept there since the early twentieth-century restorations of the church.[68] This old box

341

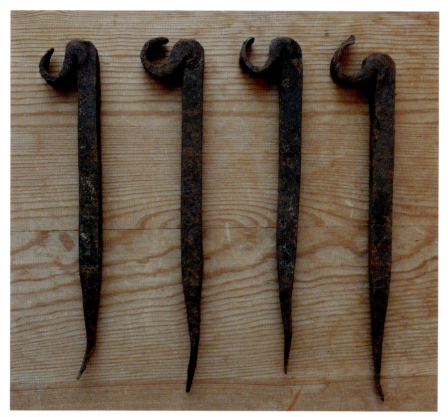

Fig. 7.5. Urnes church, iron hooks, L c.16 cm. Photo and copyright: Kjartan Hauglid.

contained seven nails with a *U*-shaped hook (20–21 cm long); four hooks (16–17 cm long); two longer nails (27 cm long); and four nails with a *U*-shaped hook (17 cm long) (Fig. 7.5). Some smaller nails and a metal hasp were also in the box. Although these nails and hooks have not been examined technically, specialists have confirmed that they are most likely from the medieval period. They would have been suitable for hanging large and somewhat heavy textiles along the walls and choir of the church.

The interior walls at Urnes were well suited for textile hangings. Window openings are small and few, and the absence of columns and niches creates large, uninterrupted surfaces that could be entirely covered with textiles suspended from hooks on the upper parts of the walls. The more three-dimensional surfaces of Gothic churches and cathedrals, interrupted by large vertical windows, coincided with a change in textile wall coverings. Among the many wall hangings and textiles that Archbishop Aslak Bolt brought to Trondheim in 1429 was a magnificent new hanging that measured over 20 m in length, displaying large-scale images of saints Óláfr and Sunniva interspersed with sections of lacework (*sprang*).[69] This Gothic cloth was thus more transparent than the multilayered textiles of earlier centuries.

Preserved fragments provide an idea of how the textile wall hangings at Urnes might have looked. During the archaeological excavations, several textile fragments were found under the floor by the north wall. These preserved fragments are presented in Table 1: four small pieces embroidered

TABLE 1: Preserved Textile Fragments from Urnes

Cat. no.:	Museum:	Museum number:	Description:	Measurements:
1	Bergen University Museum	MA 78	Embroidered fragment in *refilsaum* in two threads of S-spun wool in red, blue, and yellow. Contours in stem stitch in dark brown (undyed) wool. Ground fabric is almost completely disintegrated.	18 × 17 cm
2	De Heibergske Samlinger / Sogn Folk Museum	3017b	Embroidered fragment in *refilsaum* in two threads of S-spun wool in red, blue, brownish, and yellow-green. Contours in stem stitch in dark brown (undyed) wool. Ground fabric of undyed twist tabby with 7 × 8 double linen threads per 1 cm	23 × 15 cm
3	De Heibergske Samlinger / Sogn Folk Museum	3019b	Embroidered fragment in *refilsaum* in two threads of S-spun wool in red, blue, brownish, and yellow-green. Contours in stem stitch in dark brown (undyed) wool. Ground fabric of undyed twist tabby with 7 × 8 double linen threads per 1 cm. Cat. nos. 1, 2, and 3 are known as "Signe's Weave."	5 × 6.5 cm
4	De Heibergske Samlinger / Sogn Folk Museum	3019a	Embroidered fragment in *refilsaum*, *smøyg*, and silk stiches in two threads of S-spun wool of fine quality in blue, red, yellow-green, and dark brown. Ground fabric of undyed tabby (twist) with 12 × 19 linen threads per 1 cm. Pattern: diagonal band of geometric braid and knot motifs and parts of figural or plant motifs, described by Engelstad as "Romanesque" in style.	17 × 18 cm
5	De Heibergske Samlinger / Sogn Folk Museum	3017a	Woven fragment. Double weaving with warp one thread Z-spun dark gray linen or hemp, weft is one thread S-spin wool in yellow-beige and brownish red. Similarities with cat. no. 6, but significantly coarser work. Engelstad suggests European workshop, late medieval.	36 × 21cm
6	De Heibergske Samlinger / Sogn Folk Museum	3017c	Small woven fragment. Difficult to measure because fabric has disintegrated. Double weaving with warp in one thread Z-spun linen or hemp, weft in one thread S-spun bright blue or yellow wool. Engelstad proposes European workshop, late medieval. Both cat. nos. 5 and 6 have stylistic and technical similarities with other preserved double-weave tapestries, such as Baldishol, Oppdal, and Heiberg.	N/A
7	De Heibergske Samlinger / Sogn Folk Museum	N/A	Small linen fragment with painted drapery.	N/A

in wool, two woven fragments, and a painted fragment depicting drapery. Unfortunately, the Urnes fragments are too worn and disintegrated to say anything conclusive about their motifs or original size. Nevertheless, textile fragments from stave churches across Norway provide important information about the wealth of textiles that once adorned their interiors. From these small pieces, we know that wool on linen embroidery in the *refilsaum* technique, a form of laid and couched work, was common.[70] Designs were drawn freely on the ground and worked in multicolored woolen yarns. In most cases a ground of tabby-woven linen was entirely covered by *refilsaum* in wool, but examples of silk, linen, and metal threads are also known.[71] A larger fragment from the Røn stave church is dated to *c.*1200. The fragment depicts part of a horse, a tree, and seven people lying atop one another, possibly a scene of the Seven Sleepers of Ephesus (Fig. 7.6).[72] In the lower right corner are helmets and sword hilts. As mentioned above, the Røn fragment's embroidery technique, *refilsaum*, closely resembles that of the Bayeux Embroidery.[73] Stave church fragments, including those from Urnes, suggest that this technique was widely used for ecclesiastical wall hangings in medieval Norway.

An early twentieth-century eyewitness account provides some interesting information about the Urnes fragments.[74] An old man present at the excavations reportedly recognized three of the fragments as belonging to an old, worn textile that used to hang on the north wall in Urnes. It was known locally as "Signe's Weave" (*Signes vev*) because it depicted the tragic love story of Hagbard and Signe.[75] The preserved "Signe's Weave" fragments include one at the University Museum in Bergen and two in the Heiberg Collections at Sogn Folk Museum, Kaupanger (Table 1, cat. nos. 1–3). The Bergen fragment measures 18 × 17 cm.[76] The ground fabric has disintegrated and only the *refilsaum* embroidery remains, with S-spun wool in two strands, now yellow, red, and blue (Fig. 7.7). The two similar fragments in the Heiberg Collections measure 23 × 15 cm and 5 × 6.5 cm. Both have wool *refilsaum* embroidery on a linen ground; the embroideries are in S-spun two-stranded wool, in colors that are now red, blue, brownish, and yellow-brown. All of the fragments are discussed by Engelstad, who describes them as medieval, but no technical analysis has been executed to narrow down their date or origin.[77]

The legend of Hagbard and Signe was known across Scandinavia, and there are many adaptations that connect the legend to local places.[78] In Urnes, it was said that King Rögnvaldr (Ragnvald) of Urnes had a daughter called Signe who was secretly in love with the Viking prince Hagbard of the Vetti farm in Årdal, some 30 km east of Urnes.[79] Due to a feud between the two families their courtship was forbidden, but Hagbard managed to sneak into Signe's chamber disguised in women's clothes. One of Signe's maids suspected the visitor was a man and alerted King Ragnvald. In the battle that followed, both Hagbard and Ragnvald were killed. Destroyed by grief, Signe set her chambers on fire, killing herself and her maids. The place where her bower was located, in the hills above the Urnes church, was known locally as Signe's Hall.

The "Signe's Weave" wall hanging was first described by Icelandic historian Þormóður Torfason in the 1680s. He noted that the old wall hanging was thought by locals to depict the popular legend, but in his opinion the textile depicted two old images of saints.[80] Almost 150 years later, the Bergen bishop Jacob Neumann (1772–1848) published a report from his travels in Sogn.[81] According to his comprehensive description of Urnes, one of the most enigmatic objects in the stave church was an

CHAPTER SEVEN | SOFT ARCHITECTURE: TEXTILES IN THE URNES STAVE CHURCH

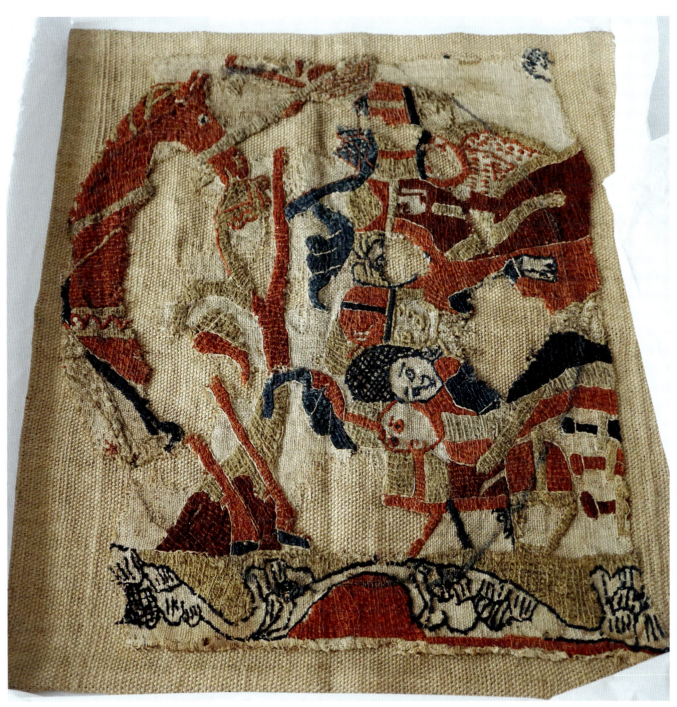

Fig. 7.6. The Røn embroidery, Norway, *refilsaum* embroidery in multicolored wools on linen tabby. University of Oslo Cultural History Museum. Photo: Author.

345

PART THREE | THE TWELFTH-CENTURY CHURCH

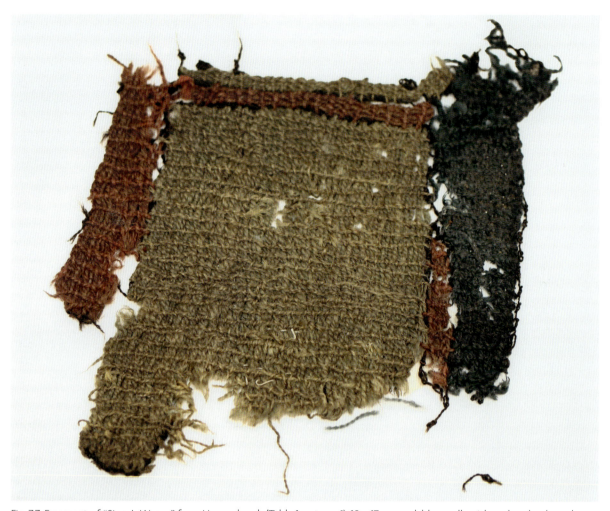

Fig. 7.7. Fragment of "Signe's Weave" from Urnes church (Table 1, cat. no. 1), 18 × 17 cm, red, blue, yellowish and undyed wool, medieval. Bergen University Museum, inv. no. MA 78. Photo: Author.

old wall hanging surrounded by local myths. However, the bishop concluded that the textile depicted "mediocre" catholic imagery rather than an adaptation of Signe and Hagbard's tale: "Yes, the peasants even believed they owned a lifelike image of Signe and Hagbor inside the church, although it after all was nothing less than a mediocre Madonna image, which could not flatter the beauty of Signe, and the image of an apostle or saint, which only alludes to the force of Habor."[82] Neumann's report is also discussed in Chapter 1.

The wall hanging known as "Signe's Weave" was probably a medieval woven or embroidered tapestry with imagery of saints and the Virgin. By 1824 it was very worn and damaged, partly because parts were cut off and given to people in the parish as powerful relics; Bishop Neumann himself was given a piece of the textile to take home.[83] According to Neumann, the locals told him the wall hanging originally measured almost 31 m long. In terms of technique and motif, his description of how the motifs are "embroidered to look like weave" suggests that the wall hanging was made in *smøyg* or *refilsaum*. *Smøyg* is a form of pattern darning in which the stitches follow

the ground fabric's grain lines, creating geometric patterns that resemble weaves.[84] *Refilsaum*, as discussed above, is laid work that allows large surfaces to be entirely covered by embroideries, requiring far less stitching than *smøyg*. It is a less time-consuming technique that would be well suited for a large wall hanging like the one at Urnes. Furthermore, to an inexperienced eye *refilsaum* looks like weave, so there is no way to know for certain which technique Neumann meant. (The famous textile in Bayeux is still widely mislabeled a tapestry, meaning a woven work, rather than an embroidery, its proper technique and name.) The colors described by Neumann—yellow with detailing in red, blue, and brown—correspond to those of the three preserved "Signe's Weave" fragments from Urnes.

In addition to these fragments from Urnes, one of finer quality displays parts of plants or animals, framed by a band of geometric knotted and plaited motifs (Table 1, cat. no. 4). Engelstad points to similarities with the fantastic creatures of the Urnes capitals, but the motifs are so fragmented that stylistic similarities cannot be firmly ascertained. The so-called Romanesque style of tendrils, leaves, and encircled animals prevailed for centuries in Scandinavian embroidery and can be found in *refil* work well into the fifteenth century.[85]

The fragments discussed thus far belonged to embroidered wall hangings, but two other very small fragments, also found under the floor by the north wall, may come from larger woven wall hangings resembling *tjeld* (Table 1, cat. nos. 5–6). These small fragments are woven in multicolored wools with a warp of linen or hemp threads. Engelstad notes that one is very similar to the preserved tapestries from Baldishol, Oppdal, and the so-called Heiberg tapestry, a group of double-weave tapestries with bright colors and extensive patterning.[86] Engelstad's drawing of one of the Urnes tapestry fragments shows bands of alternate-facing birds with elongated necks similar to the designs found on the Heiberg and Baldishol pieces. These woven fragments prove that larger woven wall hangings with rich patterns and vibrant colors were part of the late medieval textile space at Urnes.

The last fragment from Urnes is a small piece of linen with painted drapery (Table 1, cat. no. 7).[87] This small fragment can be seen in the context of larger groups of painted linen or hemp tabby-weave fragments from other stave churches, such as those from Uvdal (Fig. 7.8). When the church floor at Uvdal was excavated in the 1970s, archaeologists found a large number of small textile pieces. They have only been mentioned briefly in previous research.[88] Indeed, the substantial number of textile fragments found in twentieth-century stave church excavations is rarely considered, even though they provide valuable information about textile usage in medieval Norway. The Uvdal painted fragments are all made of linen or another plant fiber, woven in a simple tabby weave, and have traces of paint or printed motifs.[89] The quality of the weave and the decoration vary greatly, from finely woven fabrics to loose and coarse weaves.[90] Likewise, some fragments have traces of broad and sloppy brushstrokes while others have detailed and precise motifs.

What was the original use for this corpus of linen fragments? From the Icelandic inventories we learn about *tjeld* wall hangings of *stæind* (painted) cloth.[91] Covering the wooden walls of a stave church with lengths of undyed or bleached linen would provide large surfaces on which narratives or figures could be painted in a manner similar to the wall paintings of stone churches. No examples are preserved, but the substantial corpus of linen fragments, many of which have traces of paint, indicates extensive use of painted linen wall hangings in Norwegian stave churches. This was a

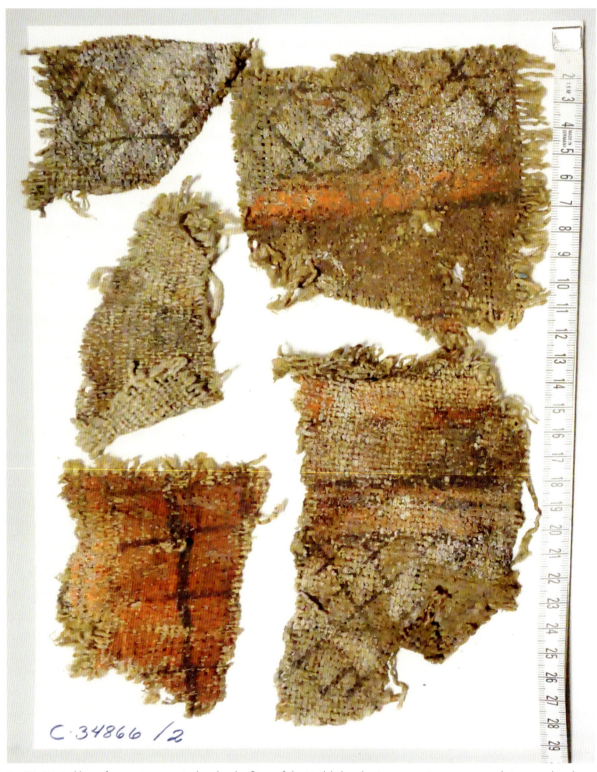

Fig. 7.8. Painted linen fragments excavated under the floor of the Uvdal church, Norway, various weaves and sizes, medieval. University of Oslo Cultural History Museum, inv. nos. C 34866/565; C 34866/2373; C 34866/2; C 34866/732. Photo: Author.

CHAPTER SEVEN | SOFT ARCHITECTURE: TEXTILES IN THE URNES STAVE CHURCH

Fig. 7.9. Painted linen fragment from Kaupanger church, Norway, 15 × 18 cm, medieval. Bergen University Museum. Photo: Author.

relatively quick and simple way to decorate large wall surfaces. A fragment from the Kaupanger stave church measuring 15 × 18 cm has a "painted stone-frame" similar to the frames of preserved altar frontals dated between 1250 and 1350 (Fig. 7.9). Quatrefoils with imagery—perhaps the four Evangelist symbols—can also be seen in the painted textile. Another fragment from Kaupanger depicts part of a man holding a sword; it currently measures over 30 cm in height, but it was probably much larger originally. While the first example may have been used as an altar cloth, the scale of the latter indicates a larger format, perhaps a large-scale painted cloth that decorated the church walls.

Textiles discussed this far clad the walls and in some cases the gables and roofs of medieval churches. The Urnes fragments, together with most of the others from stave church excavations, were probably from wall hangings such as *refil* or *tjeld*. Another group of textiles was also present in the Urnes church: the liturgical textiles required for celebrating mass. The only primary source for liturgical textiles at Urnes is the postmedieval inventory discussed by Øystein Ekroll in Chapter 1. It lists an old chasuble that may have been a medieval vestment. Since no such vestments, either clerical garments or altar clothing, are preserved from Urnes, the following discussion addresses some features of liturgical textiles in medieval Scandinavia more generally.

349

Liturgical Textiles in the Stave Church

Liturgical textiles reflecting European practice in the eleventh century certainly would have been present in the Urnes choir space. Signe Horn Fuglesang argues that even though the sources are scant, the ecclesiastical objects that were most likely present in the earliest Christian churches in Scandinavia were those considered absolutely necessary for performing the liturgy. This included a Gospel book, a chalice and paten, altar linens, and possibly a pyx and a cross.[92] One or more layers of white linen cloth were used to cover the altar surface.[93] The corporal was a small, rectangular linen cloth for wrapping the consecrated host, and it is among the oldest liturgical textiles.[94] The earliest literary source that describes a textile altar frontal in medieval Scandinavia is a ninth-century letter from the famous liturgist Hrabanus Maurus, abbot of Fulda (r. 822–42), to a Swedish missionary. Hrabanus sent specific liturgical equipment with the letter: three sets of altar linens, corporals, and three sets of priestly vestments that include chasubles and albs.[95] For the priest to perform the liturgy and read liturgical texts, candlesticks providing light around the altar space were also needed. Fuglesang suggests that these could have been made of wood and placed on the floor, because smaller candlesticks made of iron and placed on the altar itself were a later addition.[96]

Thus, the liturgical textiles in the earliest Urnes churches were white linen cloths to dress the altar and wrap the host, as well as a simple garment worn by the priest serving in the church. Despite the unadorned and modest visual appearance of the altar linens, they held great religious significance. Corporals symbolized the burial cloth of Christ, a symbolism that can be traced back to a pre-Carolingian missal and that prevailed throughout the medieval period.[97] An Old Norse late twelfth-century homily for the dedication feast, known as the "Stave Church Homily," describes the altar cloths as symbols of the apostles, adorning the altar with their good deeds and virtues.[98]

The complexity of liturgical textiles may have increased significantly in the fourteenth century. Inventories from the nearby Ylmheim stave church list eight altar cloths, of which three were decorated with goldwork or *pell*; nine textile altar frontals, including some in red and green silks, *pell*, and striped silks; and three cloth frontals, probably of linen.[99] Altar textiles could also be part of freestanding structures above or around the high altar, in the form of curtains and baldachins; curtains of striped silk were arranged around the Ylmheim main altar.[100] The fifteenth-century Uppsala archbishop Nils Ragvaldsson prescribed curtains around the altar (*cortinæ lateribus alterum*) in the statutes for his diocese.[101] There are many mentions of textiles above altars and sculptures in the Icelandic inventories (*dúkr yfir altari, sótdri*).[102] The Swedish archbishop Nils Alleson of Uppsala stated in 1297 that cloths were to be suspended above the main altar to prevent dirt and dust from falling onto the altar from the ceiling: "propter immundicias expellendas."[103] Likewise, the floor in front of the altar could be covered by carpets of animal skin: the Ylmheim inventory and several Icelandic ones mention bearskins covering the church floor, presumably before the altar (*bjarnfell, felldr, bjarnskinn, fótaklæði, fótaskinn*).[104] In other words, the altar could be framed by textiles as well as dressed in layer upon layer of precious cloth.

In contrast to the lavish silks and embroideries used for feast days and masses throughout the year, the textiles used during Lent were of a much humbler appearance. Liturgical texts describe how crucifixes and sculptures should be wrapped in white linen, and the ornate altar decorations

were removed. The altar was dressed in plain linen cloths and frontals, but by the fifteenth century these Lenten linen textiles could also have printed or painted motifs with Passion iconography. A cloth used for wrapping the crucifix, embellished with goldwork or *pell*, is listed in the Ylmheim inventory together with two larger linen *tjeld* described as "Lenten *tjeld*" (*postutjalld*). These larger textiles may have been used as Lenten veils, separating the choir and nave during the season of Lent.[105] Such textiles demonstrate the performativity of textile interiors. Closing off the choir and wrapping sculptures and crucifixes, they communicated humility and piety, resonating with the visual restrictions and focus on abstinence and penance during Lent. On Easter Sunday the Lenten veils and cloths covering crucifixes were removed, signifying the resurrection of Christ.[106] At the same time, all of the elaborate and precious liturgical textiles and the church's ornaments in gold and silver were reintroduced, creating a visual feast and a saturated sensorium of music, incense, and tactile surfaces.[107] Lenten textiles were important for framing and enhancing the sensory experience during the weeks leading up to this joyful celebration.

Conclusion

Stave church interiors were textile spaces with wall hangings (*refil* and *tjeld*), often in several layers, clothing the walls. Written sources, textile fragments, and visual clues preserved in the churches themselves, such as holes and nails, testify to the importance and extensive use of wall hangings. Since few examples are preserved, stave church research has focused more on carved wood sculpture and on construction and architectural design. This chapter has argued for a more holistic understanding of stave churches, one that incorporates the use and performative aspect of textiles, including their rhetorical potential. Textiles were important for the worshippers' visual experience, through narrative stories "written" with needles and as aesthetic and tactile surfaces animating the dark space. I have argued that the concept of textiles as soft architecture can be applied to church interiors of medieval Scandinavia, especially stave churches, as these spaces displayed a wealth of textiles that covered walls, floors, parts of the roof, and other structures, framing and enclosing sacred spaces and objects. In contrast to the built church structure, textiles were interchangeable: they could be displayed and removed, opened and closed, according to the liturgical year. Furthermore, this textile architecture was important beyond decoration and visual experience; in ecclesiastical spaces, textiles were instrumental in framing sacred space and enhancing the liturgy.

Notes

1. A comprehensive discussion of the medieval interior in Urnes Church is presented in Margrethe C. Stang, "Luksus i Luster: Høgendekirken Urnes," *Årbok: Foreningen til norske fortidsminnesmerkers bevaring* 171 (2017): 159–78.
2. The most thorough discussion of the medieval practice of covering walls and sometimes even gables and ceilings with textiles in the manner of *refil* and *tjeld* is found in Helen Engelstad, *Refil, bunad, tjeld: Middelalderens billedtepper i Norge* (Oslo, 1952). Although textile wall hangings are discussed in this chapter in their specifically Norse contexts, there is ample evidence for textiles as soft furnishing in ecclesiastical as well as domestic use in Continental Europe, Britain, and Ireland in the same period. See, e.g., the discussion of textiles as soft furnishings (wall hangings, carpets, cushions, curtains and baldachins) in Anglo-Saxon interiors in Elizabeth Coatsworth, "Soft Furnishings and Textiles: Ante-1100," in *Encyclopedia of Medieval Dress and Textiles of the British Isles, c.450–1450*, ed. Gale R. Owen-Crocker, Elizabeth Coatsworth, and Maria Hayward (Leiden, 2012), 526–30.
3. Engelstad, *Refil, bunad, tjeld*, 19.
4. The Urnes woven fragments, possibly *tjeld*, are discussed below.
5. The *Máldagar* are written in a mix of Norse, old Icelandic, German, and Latin. They are published in *Diplomatarium Islandicum* but not yet translated. *Diplomatarium Islandicum: Íslenzkt fornbréfasafn*, 16 vols. (Copenhagen, 1857–1952).
6. Fredrik B. Wallem, *De Islandske kirkers udstyr i middelalderen* (Kristiania, 1910), 8.
7. "Hvor finder man ellers to bispedømmers samtlige kirker beskrevet indgående med registrering af deres eiendele ikke blot i et enkelt aar, men for manges vedkommende gjentagende gange i løbet af flere aarhundrer." Ibid., 6.
8. Ibid.
9. The term *tjeld* is complicated because in some instances it seems to describe the whole textile furnishing of the church, but in others the terminology is more specific, describing layers of wall textiles that includes a first layer of *tjeld* closest to the wall (under-*tjeld*) with more elaborate textiles on top of it. Ibid., 26.
10. Ibid., 32.
11. Such as *tjöld umhverfis, tjöld um alla kirkju, kirkjutjöld öll*. Ibid., 25.
12. Engelstad, *Refil, bunad, tjeld*, 19.
13. From Hvammr I Laxárdal there was a *refil* 24 *alen* long depicting "er á Kalla magnuss saga" (the life of Karl the Great), and the church of Grenjaðarstaður owned a "Martinius refill" (the legend of St. Martinius). Wallem, *De islandske kirkers*, 27–28.
14. Bibliography on the Bayeux Embroidery is increasingly vast and includes hundreds of publications. In a recent publication, art historian Christopher Norton presented new research on the linen fabrics and argued that the wall hanging's measurements fit perfectly with the dimensions of the eleventh-century nave of Bayeux Cathedral. Christopher Norton, "Viewing the Bayeux Tapestry, Now and Then," *Journal of the British Archaeological Association* 172.1 (2019): 52–89. Norton's analysis (81–82) supports the theory that Bishop Odo of Bayeux (d. 1097) was a patron, suggesting that the textile was made for the cathedral's grand consecration ceremony in 1077.
15. Similarities between the laid couched work in the Bayeux Embroidery and Norse wool embroideries has long been acknowledged, especially the small Røn fragment from Valdres, Norway (Museum of Cultural History, UiO, in Oslo). See George Wingfield Digby, "Technique and Production," in *The Bayeux Tapestry: A Comprehensive Survey*, ed. F. M. Stenton (London, 1957), 37–55.
16. Engelstad, *Refil, bunad, tjeld*, 21.
17. "Jtem allar koren tialdadr med ræflum ok vndir tioldum Jtem oll forkirkian tialdat med ræflum ok vndir tiolldum (Item, the entire choir dressed with *refils*, Item the entire nave dressed with *refils* and *tjeld*). *Diplomatarium Norvegicum* (hereafter *DN*), 23 vols. (Christiania–Oslo, 1847–2011), 21:7.
18. *DN* XV:8.
19. In Old Norse, *tjeld* denoted tents or coverings as well as wall hangings and bedcovers. Leiv Heggstad, Finn Hødnebø, and Erik Simensen, *Norrøn Ordbok*, 5th ed. (Oslo, 2012), 636.
20. Engelstad, *Refil, bunad, tjeld*, 17.
21. "Olav now sailed east on the sea and reached the coast by Moster. There he first came to land in Norway and had mass sung there in a land tent; in that same spot a church was afterwards built." Snorri Sturluson, *Heimskringla, or The Lives of the Norse Kings*, ed. Erling Monsen, trans. Monsen and A. H. Smith (New York, 1990), 153.
22. Engelstad, *Refil, bunad, tjeld*, 17. Carved tent gables were also found in the Oseberg burial, *c*.834. Museum of Cultural History, UiO, in Oslo: C 55000/219, about 480 cm long.
23. Engelstad, *Refil, bunad, tjeld*, 18. The documentary sources that describe interior spaces of churches and halls entirely covered with textiles (all-*tjeld*) all date *c*.1200 or later, but it is generally accepted that this textile strategy was rooted in an older tradition of using textiles to cover and elevate spaces in the Norse world.
24. Ibid.; and Hjalmar Falk, *Altwestnordische Kleiderkunde: Mit besonderer Berücksichtigung der Terminologie* (Kristiania, 1919), 201.
25. Engelstad, *Refil, bunad, tjeld*, 21.
26. Gottfried Semper, *Style in the Technical and Tectonic Arts, or, Practical Aesthetics*, trans. Harry Francis Mallgrave and Michael Robinson (repr., Los Angeles, 2004).
27. Heidi Helmhold, "Affect," in *Textile Terms: A Glossary*, ed. Anika Reineke et al. (Zurich, 2017), 19–22.
28. Ibid., 20.
29. Ibid.
30. The rhetorical concept of Occasion in relation to architecture (specifically monumental portals) is discussed in Paul Binski, *Gothic Sculpture* (New Haven, CT, 2019), 20.
31. *Laxdæla saga* (also known as *Laxdœla saga, Laxdoela saga, Laxdaela saga* or *The Saga of the People of Laxárdalr*). See *Laksdøla saga*, trans. Fr. Bie (Kristiania, 1924), 151. For the Icelandic version, see https://sagadb.org/laxdaela_saga.is. Although the saga was written in the first half of the thirteenth century, the events described date to just after the year 1000.
32. Michèle Hayeur Smith, "Weaving Wealth: Cloth and Trade in Viking Age and Medieval Iceland," in *Textiles and the*

Medieval Economy: Production, Trade, and Consumption of Textiles, 8th–16th Centuries, ed. Angela Ling Huang and Carsten Jahnke (Oxford, 2014), 23–40, at 34.

33 The Frostaþing law II:8 requests "xij. alna langt lerept eða vaðmal"; see Peter Andreas Munch and Rudolf Keyser, eds., *Norges gamle Love indtil 1387*, vol. 1, *Norges Love ældre end Kong Magnus Haakonssøns Regjerings-Tiltrædelse i 1263* (Oslo, 1846), 133. However, the usage of this *vaðmál* is uncertain; in addition to clothing the church and altar (as described in the *Laxdæla saga*), *vaðmál* cloth was also a legal form of currency.

34 Lenten textiles are discussed below.

35 See Laura Weigert, "The Art of Tapestry: Neither Minor nor Decorative," in *From Minor to Major: The Minor Arts in Medieval Art History*, ed. Colum Hourihane (University Park, PA, 2012), 103–21.

36 Hedwig Röckelein, "Textus," in Reineke et al. *Textile Terms*, 276–79, at 277.

37 Kathryn Sullivan Kruger, *Weaving the Word: The Metaphorics of Weaving and Female Textual Production* (Selinsgrove, PA, 2001), 31.

38 As discussed in Roland Barthes, "From Work to Text," in *Textual Strategies: Perspectives in Post-Structuralist Criticism*, ed. Josué V. Havari (Ithaca, NY, 1976), 73–81, at 76. Barthes argues that that text and textile are analogous because "etymologically the text is a cloth."

39 Lena Elisabeth Norrman, *Viking Women: The Narrative Voice in Woven Tapestries* (Amherst, NY, 2008), 3.

40 In Old Norse tradition Sigurðr is known as "fafnisbani" because he killed the dragon Fafnir. The *Völsunga saga* (prose and poetic versions), written *c.*1200–70, is based on a Norse (Icelandic) tradition of oral storytelling and belongs to the so-called mythical-heroic sagas, the "fornaldarsögur." Sigurðr, the grandson of King Völsung, plays a central role in the saga through his battle with Fafnir and the fatal love triangle between Sigurðr, Brynhildr, and Guðrún. See ibid., 113–14.

41 Ibid., 32; cited in Nancy L. Wicker, "Nimble-Fingered Maidens in Scandinavia: Women as Artists and Patrons," in *Reassessing Women's Roles as "Makers" of Medieval Art and Architecture*, ed. Therese Martin (Leiden, 2012), 2:865–902, at 892.

42 Margareta Nockert and Göran Possnert, *Att datera textilier* (Hedemora, 2002), 69–75. Five fragments known as Överhogdal 1a, 1b, II, III, and IV are carbon-14 dated between 900 and 1100.

43 Norrman, *Viking Women*, esp. chap. 3 for her reading of the Överhogdal tapestry, concerning tapestries 1a and 1b, dated 900–1000.

44 Ibid., 73–174.

45 The Hylestad stave church was demolished in 1838. For the portal carvings, see Erla Bergendahl Hohler, *Norwegian Stave Church Sculpture* (Oslo, 1999), 2:179–80, cat. no. 114.

46 The Høylandet embroidery is now in the collection of NTNU University Museum. It is embroidered in *smøyg* (pattern darning) with yellow, green, and blue woolen yarn on red twist weave. Figures are outlined with white linen yarn in stem stitch and filled with darning in a great variety of stitches. Another fragment in the same technique is from the Lom church, Norway.

47 For a comprehensive discussion of the iconography, see Lasse Hodne, "From Centre to Periphery: The Propagation of the *Virgo virga* Motif and the Case of the 12th Century Høylandet Tapestry," *Il Capitale Culturale: Studies on the Value of Cultural Heritage* 10 (2014): 23–41.

48 Engelstad, *Refil, bunad, tjeld*, suggests late twelfth century, while Marta Hoffmann argues for a date well into the thirteenth century, probably in the first half. Hoffmann, "Tekstil," in *Norges kunsthistorie*, vol. 2, *Høymiddelalder og Hansa-tid*, ed. Hans-Emil Lidén et al. (Oslo, 1981), 315–49, at 339.

49 Engelstad, *Refil, bunad, tjeld*, 71.

50 Turid Svarstad Flø, "Høylandsteppet: En rekonstruksjon av et midt-norsk middelalderteppe," *SPOR* 12.2 (1997): 16–19.

51 In this rather small area, one or more embroiderers combined nine different geometric patterns to create a varied and complex textile surface.

52 Hodne, "From Centre to Periphery," 35.

53 Ibid., 26–27.

54 The following churches have painted wall decoration from the Middle Ages: Torpo, Rollag, Nore, Heddal, Hopperstad, Hedalen, and Høyord. See Kristin Bakken, ed., *Bevaring av stavkirkene: Håndverk og forskning* (Oslo, 2016), 75.

55 See the report on the Urnes wall painting by the Directorate of Cultural Heritage: Mille Stein and Tone M. Olstad, "A 285: Urnes Stavkirke; Konsolidering av limfargedekoren i koret," NIKU Oppdragsrapport 160/2012, 3; https://ra.brage.unit.no/ra-xmlui/handle/11250/176377. The year 1601 is included in wall paintings on the choir south wall.

56 The 1601 distemper wall paintings at Urnes were cleaned and consolidated in 2011. Ibid., 3–4.

57 The Hørning wall-plate measures 91 × 57 × 12 cm and displays carving in the Urnes style in red, yellow, gray, and black. Henriette Lyngstrøm, "Kongehallen i Lejre: Overvejelser om forsøg med vikingetidens bemalede træoverflader," in *Farverige vikinger: Studier i teknologi og kultur 4*, ed. Henriette Lyngstrøm (Copenhagen, 2018), 109–20, at 113.

58 See, e.g., Ulla Haastrup, ed., *Danske kalkmalerier*, vol. 1, *Romansk tid, 1080–1175* (Copenhagen, 1986); and Ulla Haastrup, ed., *Danske kalkmalerier*, vol. 3, *Tidlig gotik, 1275–1375* (Copenhagen, 1989).

59 Engelstad, *Refil, bunad, tjeld*, 19. Engelstad refers to the *Laxdæla saga*; see Bie, *Laksdøla Saga*, 75.

60 Traces of textile hangings in the form of holes, sometimes with nails, and removed (loose) nails and hooks are known from Urnes, Hopperstad, Hurum (Høre), Lomen, Kaupanger, and Heddalen; further investigations may reveal similar patterns in other stave churches as well. For the first four churches, see Roar Hauglid, *Norske stavkirker: Dekor og utstyr* (Oslo, 1973), 388, 402–8. For Heddalen, see Barbro Wedvik, "A 167: Heddal stavkirke; Konsolidering av limfargedekor i skip og sørvegg i koret," NIKU rapport 121/2009, 10; https://ra.brage.unit.no/ra-xmlui/handle/11250/176397.

61 As discussed in Wedvik, "A 167: Heddal stavkirke," 2.

62 According to Engelstad (*Refil, bunad, tjeld*, 20), there are still wooden hooks preserved in the walls of the choir at Lomen stave church, approximately 2–10 m from ground level (five

63. Wedvik, "A 167: Heddal stavkirke," 10 and appendix 7.

64. Hauglid, *Norske stavkirker*, 402.

65. Ibid, 406.

66. Very few secular houses are preserved, and to my knowledge, their interior wall surfaces have not been documented sufficiently to exclude traces of hanging textiles.

67. Such an investigation could reveal patterns in height, width, and intervals between the holes; technical examinations of preserved nails and hooks; and traces of textiles in and around the holes.

68. I want to thank the custodian of the Urnes church, Marit Bøen, for bringing this to my attention.

69. DN V:586. See translation by Jan Ragnar Hagland in *Nidaros Domkirkes og geistlighets kostbarheter: Belyst ved 17 skriftlige kilder 1307–1577 med oversettelser og kommentarer*, ed. Audun Dybdahl (Trondheim, 2002), 147–51.

70. *Refilsaumur* is the Old Norse term for this technique. Main outlines are worked in stem stitch, chain stitch, couching, or split stitch. The ground is covered by one or more strands of yarn (in the manner of surface satin stitch) held in place by spaced, crosswise bars, usually of finer yarn in the same color. Each of these strands is fastened down with small, more or less irregularly spaced stitches. See the description in Elsa E. Guðjónsson, *Traditional Icelandic Embroidery* (Reykjavík, 1985), 16.

71. Ibid., 17.

72. The Røn fragment is embroidered with two red, two blue, and one yellow strand of woolen yarn on a linen or hemp twist weave.

73. For discussion of embroidery techniques, see, most recently, Anne Marie Franzén and Margareta Nockert, *Prydnadssömmar under medeltiden* (Stockholm, 2012), 46.

74. Engelstad, *Refil, bunad, tjeld*, 81.

75. The legend of Signe and Hagbard (Hagbart, Habor) comes from a larger epic that is now lost. Versions exist across Scandinavia, known as *skillingsviser* or broadside ballads. The legend is found in both verse and prose forms in the *Saxo Grammaticus*. It inspired the well-known medieval ballad "Bendik og Årolilja."

76. Inv. no. MA 78

77. Engelstad, *Refil, bunad, tjeld*, 100–101, cat. nos. 5–6.

78. In Norway, adaptations of Signe and Hagbard's legend are known from Steigen in Lofoten and Larvik, among other places.

79. The Vetti farm is located in Utladalen Valley, Årdal, about 30 km due east of Urnes.

80. "TSB D 430 Hagbard og Signe," in *Norske mellomalderballadar: Riddarballadar 2 (TSB D)*, ed. Velle Espeland et al. (Oslo, 2016); https://www.bokselskap.no/boker/riddarballadar2/tsb_d_430_hagbardogsigne.

81. J. Neumann, "Bemærkninger paa en reise i Sogn og Søndfjord 1823," *Budstikken* (1824): vol. 5, nos. 67–73 at cols. 556–62.

82. Ibid., 558. My translation.

83. As far as I know, this fragment was later lost; the only known fragments of this textile in the Bergen and Heiberg collections are from much later archaeological excavations.

84. The descriptions in this paragraph are from ibid., 557–60.

85. One example is an embroidered *refil* from the Hvammur church, Iceland, with animals in interlaced circles, dated to the second half of the fifteenth century. Now in the National Museum of Denmark, Copenhagen, inv. no. CLII 1819.

86. Engelstad, *Refil, bunad, tjeld*, 103.

87. De Heiberske Samlinger/Sogn Folkemuseum, inv. no. 3017. The fragment of linen or hemp measures 36 × 21 cm.

88. The Uvdal fragments include both coarse and undyed linen weaves, a precious tablet-woven band (C 34866/323), and a gold-embroidered figure (C 34866/2586).

89. Museum of Cultural History, UiO, in Oslo: inv. nos. C 34866/2, C 34866/732, C 34866/1595, C 34866/2373, C 34866/69, C 34866/1602.

90. The thread count of a fabric is the number of yarns per inch, both lengthwise (warp) and crosswise (filling). The thread count of these fragments varies from 18/12 per cm to 4/ 4 per cm.

91. Engelstad, *Refil, bunad, tjeld*, 20.

92. Signe Horn Fuglesang, "Kristningstidens kirkeinventar: Objekter og symboler," in *Middelalderens symboler*, ed. Ann Christensson, Else Mundal, and Ingvild Øye (Bergen, 1997), 106–25, at 108.

93. Joseph Braun, *Handbuch der Paramentik* (Freiburg im B., 1912), 210.

94. Ibid., 233–34

95. Hj. Holmquist, "De äldsta urkunderna rörande ärkestiftet Hamburg-Bremen och den nordiska missionen," *Kyrkohistorisk årsskrift* 9 (1908): 241–83, at 271. The letter also lists a sacramentary, lectionary, a Psalter and, an Acts of the Apostles. The terms used for the vestments are chasubles (*casulae*) and albs (*camisae*).

96. Fuglesang, "Kristningstidens kirkeinventar," 109.

97. Ibid., 117.

98. Astrid Salvesen and Erik Gunnes, *Gammelnorsk homiliebok* (Oslo, 1971), 101. The "Stave Church Homily" is from the Old Norse Homily Book (*Gammelnorsk homiliebok*), a collection of sermons in the vernacular from the beginning of the twelfth century, but the material is probably older. Some of the sermons were written and collected around 1150. Fuglesang ("Kristningstidens kirkeinventar" 116) argues that the symbolic interpretations in the homily can be applied to earlier material because they reflect allegorical readings commonly found in eleventh-century Europe.

99. DN XV:8.

100. Ibid.

101. Dagny Arbman, "Altarets klädsel," in *Kulturhistorisk leksikon for nordisk middelalder: Fra vikingetid til reformationstid* (Oslo, 1956), 1:115–20, at 119. Archbishop Nils Ragvaldsson (r. 1438–48) is also known by the Latinized form Nicolaus Ragvaldi. His statues are published in Henrik Reuterdahl and Magnus von Celse, *Statuta Synodalia Veteris Ecclesiae Sveogothicae* (Lund, 1841).

102. Such as "sotdrippt med lierept yfer alltari." See Wallem, *De islandske kirkers*, 58, 69.

103 Arbman, "Altarets klädsel," 119.

104 Wallem, *De islandske kirkers*, 33, e.g., V 298: "biarnfelldur aa altari." Wallem points out that *fótakleði* can mean other textiles/covering before the altar, as well as bearskin.

105 The liturgical function of Lenten veils is discussed by the liturgist and papal administrator William Durandus (*ca.*1230–96) in his *Rationale divinorum officiorum*, written *c.*1286. Timothy M. Thibodeau, trans., *The Rationale Divinorum Officiorum of William Durand of Mende: A New Translation of the Prologue and Book One* (New York, 2007), 43–44, i.35–39. This eight-volume treatise became one of the most influential medieval liturgical commentaries and was copied widely across Europe. It was part of the book collection at Trondheim Cathedral: *DN* XII:673. For parallels between the Norse material and Lenten textiles from other European contexts, see Laura Weigert, "*Velum Templi*: Painted Cloths of the Passion and the Making of Lenten Rituals in Reims," *Studies in Iconography* 24 (2003): 199–229.

106 Thibodeau, *Rationale Divinorum Officiorum*, 43–44.

107 The concept of a medieval church as a "saturated sensorium" is explored in Hans Henrik Lohfert Jørgensen, Henning Laugerud, and Laura Katrine Skinnebach, *The Saturated Sensorium: Principles of Perception and Mediation in the Middle Ages* (Aarhus, 2015).

CHAPTER 8

Trueing the Capitals at Urnes

Kirk Ambrose

THE TWELFTH-CENTURY CUSHION CAPITALS in the stave church at Urnes present difficulties for developing a sufficient interpretive language. Carved in wood, these capitals' very material offered a range of possibilities, including technical and formal, that the sculptors fully leveraged. Yet, despite the skill evident in their execution, these works have been largely characterized by modern scholars as derivative from stone models. One of UNESCO's stated criteria for designating Urnes a World Heritage site succinctly manifests this tendency: "It is an outstanding example of the use of wood to express the language of Romanesque stone architecture."[1] How might we speak of wood monuments without presuming their stone counterparts to be normative or preeminent?

This is a difficult question, for stone monuments occupy a central position in Western conceptions of civilization itself. The final lines of W. H. Auden's celebrated poem "In Praise of Limestone," written in Italy in 1948, exemplify the richness of the lithic imaginary that has developed over the centuries:

> . . . In so far as we have to look forward
> To death as a fact, no doubt we are right: But if
> Sins can be forgiven, if bodies rise from the dead,
> These modifications of matter into
> Innocent athletes and gesticulating fountains,
> Made solely for pleasure, make a further point:
> The blessed will not care what angle they are regarded from,
> Having nothing to hide. Dear, I know nothing of
> Either, but when I try to imagine a faultless love
> Or the life to come, what I hear is the murmur
> Of underground streams, what I see is a limestone landscape.[2]

Auden attends to stone monuments south of Rome as he entwines images of the (resurrected) human body, civilization, and nature. Alan France observed parallel processes at work in the poem's

cosmology: "in nature, human material is formed into civilization as the forces of geology formed limestone: by sedimentation."[3] This concretization of history, whether of the earth, of an individual body, or of a civilization, is by no means eternal, for limestone, Auden stresses at the outset, "dissolves in water." Even if ultimately ephemeral, however, this lithic material affords glimpses into a transcendent, divine order.

This metaphoric web of stone, civilization, and even of cosmos has deep-rooted analogs within medieval art histories. In the nineteenth century John Ruskin's *Stones of Venice* inscribed a difference between northern and southern Europe to invest stone with a quasi-sacral aspect.[4] In contrast to the warped wooden gables of English cottages, the stones of Italy stood as more effective bulwarks against time and the elements, while likewise evoking God's calling forth dry land from the waters. Following in the footsteps of Victor Hugo (1802–85) and Eugène Emmanuel Viollet-le-Duc (1814–79), Émile Mâle (1862–1954) at the turn of the twentieth century influentially described medieval sculptors as "writers in stone," a mirror of God's Word.[5] While the hermeneutic implications of this lexical metaphor have been critically assessed,[6] its material basis remains normative in the subfield of Romanesque sculpture studies, which have historically centered almost exclusively on stone monuments.

The predominance of stone monuments within scholarly discourse persists to the present day, although some recent studies by Thomas E. A. Dale and Shirin Fozi, to name two notable examples, have more systematically incorporated other sculptural media into their analyses.[7] That surviving medieval buildings in Europe are largely stone doubtless contributes to and, to a certain extent, even justifies this state of affairs. As the 2019 fire in the roof of Notre-Dame in Paris tragically reminded us, masonry is less susceptible than wood to fire and the ravages of time. In addition to such practical considerations, this building material could likewise hold metaphoric significance when used in churches, palpably evoking, for one, Matthew 16:18: "And I say to thee: That thou art Peter; and upon this rock I will build my church, and the gates of hell shall not prevail against it." By the middle decades of the twelfth century such symbolic associations tend to be absent from medieval accounts of church construction on the Continent. A history of the Premonstratensian abbey church at Vicogne, France, informs us that between 1132 and 1139 the members of the community rebuilt a wood chapel in stone.[8] We learn that the existing chapel was too small to accommodate the number of brothers, that the Virgin had appeared at the site, and that the building campaign was launched with a mass, attended by rich and poor. But, like so many contemporary sources on church architecture, nowhere is the symbolic import of building in stone discussed. More likely than not medieval builders and patrons could, if prompted, offer layered justifications for their material choices, but the very lack of such an explanation in the Vicogne account attests to the deep cultural predisposition for stone that had emerged by the twelfth century across much of Europe.

Many contemporary builders in Scandinavia and the eastern Baltic area bucked this trend, engaging in new wooden church construction during the eleventh and twelfth centuries, roughly contemporary with the lengthy process of conversion to Christianity of the peoples in this region. Eleventh-century legislation from Norway that imposed fines for delays in the construction of shire churches differentiates between wood and stone construction, suggesting there was a choice.[9] Wooden

structures all functioned as parish or manorial churches, serving the needs of local populations. As is well known, there were long-established traditions of building in wood, most celebratedly in the Viking ships, such as those housed in museums in Oslo, Roskilde, and elsewhere. In both shipbuilding and architecture, great care was taken in the selection of wood, with trees cultivated to produce suitable beams and other features. As Griffin Murray persuasively argues in Chapter 5, the architecture at Urnes can likewise be viewed more broadly in terms of northern European (including Germany and Russia) and Insular building traditions, evident in textual accounts and in the far-flung fragmentary archaeological remains that survive from medieval wood churches.

Such a dynamic interplay between local and international practices can be identified in the cushion capitals of Urnes. There is doubtless an engagement with the forms of stone architecture, as the UNESCO report rightly recognized. The use of arcades in the porch and church interior, difficult to realize in wood, suggests models from stone masonry, as does the very use of capitals, which are not an intrinsic feature of stave architecture; the nearby church at Borgund, *c.*1180, incorporates continuous staves, uninterrupted by capitals. Moreover, the profiles of Urnes's cushion capitals have close formal parallels in Jutish and German stone churches. Other stave churches, such as Hopperstad, dated *c.*1130, feature capitals with similar profiles, but Urnes is unique in its incorporation of figural imagery on their shield-shaped sides. Erla Bergendahl Hohler has noted that many of these carved motifs, such as eagles and lions, had currency in Denmark, England, and Germany.[10] Yet, the capitals do much more than simply reemploy northern European models, for the subjects on several capitals, including the Bactrian camel and the beard pullers, have roots in pictorial traditions that developed hundreds, even thousands, of miles from Norway. Regardless of the specific mode of transmission, the subjects of several carvings repeatedly draw from visual cultures that lie beyond the regional artistic orbit, but they are formally articulated in the terms of the vernacular. In this way, these capitals offer insights into processes of cultural transmission and translation, both materially (i.e., from various artistic sources into wood) and formally (i.e., international source materials adapted to a local context or language). Finbarr Barry Flood's words on the notion of transculturation are here instructive: "Cultural formations are always already hybrid and in process, so that translation is a dynamic activity that takes place both *between* and *within* cultural codes, forms, and practices."[11]

Dynamic processes of fashioning and refashioning can be observed in the very fabric of Urnes, which was rebuilt four times on the site. Wood construction techniques of stave churches allowed for rather easy disassembly, reassembly, refashioning, and even relocation. Such is the building history, for instance, of the stave church at Haltdale, dated to the 1170s. At Urnes, two distinct phases of sculpture can now be observed in the building's fabric, corresponding to the third and fourth building campaigns on the site. The third campaign, dating to approximately 1070, consists of the north exterior wall of the church, which incorporates a portal, elaborately carved timbers, and a column. In addition, a number of shallow reliefs on the gables date to this period. These works were slightly modified, or trued up, when they were incorporated into the present church, the fourth on the site, which includes the cushion capitals of the interior and is dated by dendrochronology to 1130/31.[12] Significantly for our purposes, this fourth campaign, likely sponsored by the local chief, Gautr of Ornes,[13] was not a response to a disaster, such as a

fire, but appears to manifest an interactive engagement with and reincorporation of past building materials toward the construction of a new church design. This use of refashioned planks and carvings from a previous building campaign implicitly acknowledges the past, likely with all the associations of venerability and authority.

A semiotic reading of wood presents one potentially productive line of inquiry for Urnes, mapping the conversion to Christianity and institutionalization of the Church over the course of the eleventh and twelfth centuries in Norway. Urnes's very material basis might be seen to embody a supersessionist history of the wood of the Cross supplanting Yggdrasil, the immense tree central to Norse mythology.[14] The crucifix, the site of Christ's suffering and death, was hewn, just like the timbers of the church, a contrast to the living ash that connects the nine worlds in Nordic belief systems. Yet the promise of resurrection is perhaps evoked by the living vines carved on several nave capitals, aligned with contemporary representations of the cross as *lignum vitae*, most resplendently in the apse mosaic of the upper church of San Clemente in Rome. A host of potential metaphoric readings seem possible, for wood stood at the center of both Christian salvation history and Nordic cosmologies, thereby offering rich material for articulating the relationship, complementary, antagonistic, or otherwise, between these two belief systems.

The following remarks attend less to the materiality of the Urnes capitals than to the sculptors' work in wood, borrowing from the woodworking notion of trueing—modifying an existing piece of carved wood to adapt it to the needs of a new construction—as an interpretive lens to approach the cultural work observable among the cushion capitals. This process of trueing is considered here from several perspectives. First, regarding the handling of artistic forms, there are a remarkably limited number of animal motifs observable among the capitals, mostly consisting of aquiline (four examples), leonine (twenty-six), and dragonlike (three) beasts. These creatures not only have strong intraspecific affinities, with, say, many of the eagles strongly resembling one another, but interspecific resemblances as well. For example, one of the "eagles" has the ears of a lion (Plate 55), a dragon has the head of a lion (Plate 59), and a stag is rendered with feline feet, not hooves (Plate 46). The artists drew on a handful of stock animal motifs, with long traditions in local artistic practices, and adapted them in various combinations to create ever new animal forms. Second, the choice of several subjects had a decidedly international scope, trued up in terms of a regional formal language. This suggests that Urnes, despite its seemingly remote location in western Norway, was imbricated in a pan-Eurasian network of visual culture. The precise meaning of specific borrowings can be difficult to establish, but in one case there is evidence of an anti-Semitic image. In other words, the process of trueing up could likewise relate to ideology, to fashion a true Christian faith through a process of Othering. Finally, a gesture of alignment with broader European trends might be identified in the introduction of a wooden crucifixion scene into the space of the nave (Plate 106). Strongly resembling contemporary crucifixions from across western Europe, this carving can be seen as a pivot away from regional representational modes to an embrace of broader institutional norms of the Church.

PART THREE | THE TWELFTH-CENTURY CHURCH

Trueing Forms

In comparison to the plastic rendering of forms in many of the relief sculptures in the third church at Urnes, the carving of the eighteen cushion capitals consistently employs a shallow relief that accentuates planar effects. Each capital features reliefs on two or three of its sides for a total of forty-eight sculpted scenes, two of which are today concealed. Incised lines serve as the primary vehicle for articulating heavily outlined forms, occasionally variegated with restrained chisel marks. This planar visual language has a long tradition in Scandinavian culture, including an eleventh-century interlace wall-plate from Hørning, Jutland (Fig. 4A.13), and it likely would have complemented that of textiles, which, as discussed in Chapter 7, frequently decorated stave church interiors, although no surviving twelfth-century examples can be linked to Urnes.

The Urnes sculptors capitalized on the formal possibilities of shallow relief through subtle variations in the representation and positioning of animal bodies. In many cases they drew on animal motifs that had an established history in northern European art, including birds, leonine forms, and dragons. Much in the forms of these works aligns with traditions, but the artists likewise carved out a space for invention. The four scenes of aquiline creatures, likely eagles, are here instructive about this working mode. Each body includes variegated fields of delineated feathers and smooth, uncarved surfaces. The disposition of these figures in the shield shape of the capital likewise changes from capital to capital: one features two addorsed birds (Plate 69); a second has a single creature arranged frontally and horizontally with what appears to be a human leg dangling from its neck (Plate 68); a third represents a bird profile, with wings disposed in angles that are nearly perpendicular in their arrangement (Plate 43); and a fourth is similar to the third, but with its left wing positioned upward rather than downward (Plate 54). In addition, the sculptor has added what appear to be animal ears—perhaps feline—to the head of the fourth, disrupting any semblance of verisimilitude in favor of a strategy of mixing.

This "kaleidoscopic development" of forms, to borrow Otto Pächt's felicitous phrase from manuscript studies, works on at least two fronts.[15] Single bodies combine a variety of animal and vegetal forms: the front half of one feline animal transmogrifies into

Fig. 8.1. Oseberg ship burial, Norway, animal-head post, ninth century. Viking Ship Museum, Oslo. Photo: A. Davey.

three spiraling foliate tendrils, one of which it bites with its maw. Sculptors also mixed the same motif across multiple carvings. For example, the eagle head with catlike ears repeats on another capital, but in the second instance it is appended to a lion's body with a serpentine tail (Plate 61). This latter carving might be identified as a griffin, but, out of step with many pictorial traditions, it lacks wings. To be sure, some creatures strongly resemble pictorial traditions surrounding lions, including feline paws, gaping maws, and elaborated tails. At the same time, the sculptors were interested in manipulating forms in visually interesting ways. On the capital featuring two lions, for example, the hind legs of the creatures appear addorsed whereas the torsos appear affronted; this visual sleight of hand seems of great, even paramount, concern.

The Urnes sculptors pushed the forms of leonine bodies to extremes. One group has extremely elongated necks (e.g., Plates 63 and 84) that visually evoke the spiraling of the vegetal tendrils and tails observable throughout the carvings of the nave, not to mention the tradition of elongated "lion" necks of Viking ships (Fig. 8.1) and the jamb of the eleventh-century north portal at Urnes (analyzed in Chapter 6). Urnes's numerous leonine bodies manifest a delight in manipulating variously articulated loops, twisting postures, and knotted tongues. These dynamic postures align with Meyer Schapiro's notion of force and violence that he identified as characteristic of Romanesque animal sculptures.[16] That so many of these carved animals bite themselves might further conform to Schapiro's reading of this posture as a pictogram of the medieval Latin *remorsus*—literally to bite oneself—from which we derive the English *remorse*. Michael Camille, in contrast, suggested that the biting animal maws that pervade Romanesque sculpture evoke a multiplicity of concerns, from intellectual to somatic, such as anxiety among monks regarding consumption of meat, homoerotic desires, and the metaphors of mastication used to describe the rumination and interpretation of texts.[17] But, from a different perspective, these multiple scenes of animal autophagy perhaps embody the very building processes employed at Urnes, in which, as we have seen, materials are masticated, trued up, and reemployed within a new structure.[18]

Similar autophagic processes are evoked elsewhere among the imagery of the nave capitals. In two scenes (Plates 57 and 58), a dragon twists and turns as it gnaws its own body, a visual inversion of the directionality of the vegetation that spews from the masks' mouths on three capital faces (Plates 63, 74, and 75). These contrary modes of ingestion and regurgitation vividly evoke the processes of formal play that the sculptors exercised across the capitals. All three dragon capitals employ combinations of leonine heads, wings, serpentine bodies, and floriate flourishes that, in their disposition, bear strong resemblances to the foliate capitals, the mask capitals, and even certain passages of the various leonine capitals. Looped dragon bodies evoke the vegetal tendrils of foliate capitals that, in turn, resemble the intertwined tails of the addorsed lions, and so on. The use of a limited formal vocabulary, disposed on the unarticulated surface of the capitals' faces, makes these combinations and visual similarities all the more manifest and lays bare the generative grammar that underlies the creatures found across the nave carvings.

Hohler has suggested that the Urnes capitals were simply ornamental,[19] but it is entirely possible, and even likely, that medieval audiences would have assigned meanings to these creatures. In Chapter 10 Elizabeth den Hartog identifies intellectual underpinnings for the capitals' carved animals, identifying Augustinian canons as a likely source, and in Chapter 11 Dale relates these

creatures to indigenous traditions of shape-shifting and animals in bestiary manuscripts, ultimately identifying a theme of conversion and transformation. Similarly, more than a generation ago, Ellen Marie Magerøy offered a specific reading of the cleric (Plate 85), whom she tentatively identified as St. Anthony.[20] Accordingly, the monstrous creatures of the nave, especially the figure of an adjacent "centaur," could evoke the creatures the saint encountered in the desert as he sought Paul the Hermit, an episode described in Jerome's (d. 420) *Vita Pauli* and many subsequent retellings, including the Icelandic *Páll saga eremita*. Magerøy further suggested that the many monsters of the nave could evoke the attacks of monstrous hordes described by Athanasius in his *Life of Anthony*, episodes reprised, for one, in the *Antóníús saga*. These interpretations postulate a fixed identity for the creatures of the nave.

We might, however, approach the capitals from an alternative perspective, one that regards the identities of many of the carved creatures as unstable. Unlike bestiary manuscripts, which typically make ostensive textual and pictorial gestures to specific animals, many of the Urnes carvings are less definitive in their articulation, combining body parts from a range of animals in any number of inventive ways, often deviating from pictorial traditions, such as the feline-eared eagles or the "lions" whose bodies are stretched and manipulated in various ways, the griffin that lacks wings, and so on. The figure commonly identified as a centaur (Plate 87) combines the upper body of a human (whose head is crowned with three curious knobs that loosely resemble the headgear on the beard-pullers capital, Plate 77) with a lion's body, including feline paws and tail, not a horse's.[21] Such formal play in many cases overrides adherence to pictorial conventions, therefore making it difficult to establish certain identities. The sculptors, I suggest, were in many cases interested in pursuing a combinational strategy in their artistic inquiries, drawing on a limited number of stock animal motifs to generate a host of imaginative beasts that in many cases do not conform neatly to pictorial or textual traditions.

The slipperiness of animal forms, and in many cases identities, of so many carvings at Urnes perhaps spoke powerfully to a culture that over the course of the eleventh and twelfth centuries was in transition toward an increasingly institutionalized Christianity. While King Óláfr's baptism at Rouen in 1010 has sometimes been cast as a watershed moment, the actual process of conversion in Norway was slow and complex, with the Church occupying a relatively weak position until the second half of the twelfth century.[22] The formal and semantic diffuseness of Urnes's carved creatures may have been deemed advantageous or apt in this society in flux between two very different belief systems, indigenous and Christian. The bodies of animals could be simultaneously broad and specific in their signification, evoking or resonating with pre-Christian mythologies in which animals commonly feature (e.g., the struggles with the monsters in *Beowulf*), but likewise having the capacity to align with Christian traditions, including the symbolic meanings of lions and eagles in the Bible and in any number of exegetical texts. Such an approach, which tended to embrace ambiguity over definiteness, may help explain the reticence in carving Christian themes or narratives. Indeed, the only unambiguously Christian image among the nave capitals represents a cleric, though it is worth noting that his staff terminates with an animal head (Plate 85). There are contemporary crosiers with similar heads, but, in the space of the nave, this detail aligns with the spiraling and twisting animal forms found across the capitals.

Mary Carruthers has questioned the tendency of modern scholars to moralize all medieval art, to

regard literature, music, and the plastic arts as seamless extensions of theological positions.[23] Drawing on Johan Huizinga's notion of *homo ludens*, she identified a widespread horizon of expectations for a playful space within the medieval arts, independent of religious agendas.[24] A generation ago, Ilene Forsyth similarly drew on the work of Clifford Geertz to identify deep play among Romanesque Burgundian carvings of cockfights, a theme that could not be reduced to any simple theological message but, rather, is characterized by ambiguity and humor, sometimes decidedly profane.[25] The inventiveness of the Urnes capital sculptors and their choice of subjects, only one of which has any obvious Christian import (i.e., the cleric), seemingly engage in a similar kind of play, not necessarily or primarily driven by theological concerns. In this way, these works might prompt us to examine critically the deeply moralizing hermeneutic framework charted by figures such as Mâle and Ruskin over a century ago and still holding great currency in scholarship today. The Urnes capitals can provide a vehicle to imagine alternative frameworks for future medieval art histories.

Trueing the International

Urnes overlooks the Lustrafjord, the innermost arm of the Sognefjord, which extends roughly 200 km inland from the Norwegian Sea. In this mountainous and glaciated landscape, this major waterway offers the most expeditious mode of transportation, as discussed in Chapter 3. Even today, when tunnels and bridges punctuate the landscape, many villages along the Sognefjord are more readily reached by boat than by road. It is appropriate, then, that the capitals of this church, which incorporate motifs developed in foreign contexts, face a body of water that connected this remote site to much of the known world. An iron candle-holder, variously dated to the twelfth or thirteenth century, that sits on the main altar of Urnes has the form of a boat and palpably evokes this history of seafaring (Plate 110).

That travel could intersect with international trade networks is suggested by one capital featuring a camel (Plate 47), a creature not used in Scandinavian traditions of carving. Based on their absence from the textual and archaeological record, it appears that Norway was not home to camels during the twelfth century, a claim that may not be as obvious as it seems. While camels are today linked with Africa and western Asia, archaeological and textual evidence suggests that ancient Romans used them as pack animals in Spain, France, and Italy. This practice continued into the Carolingian period in parts of Europe and, in Italy, until at least the twelfth century. In 1121, at the order of Pope Calixtus II, the antipope Gregory VIII was paraded through the streets of Rome seated backward on a camel and subjected to "the crudest mockery," a form of humiliation that had parallels in Mediterranean cultures, including Byzantium.[26] In addition to the potential for crossing paths with these beasts in western Europe, Norwegian soldiers serving in the Byzantine emperor's army and crusaders from Norway likely saw camels during their travels. According to sagas, King Sigurd "the Crusader," who reigned until 1130, traveled widely around the eastern Mediterranean and returned to Norway with relics, including a piece of the True Cross that he purchased in Jerusalem, an altar that he ordered in Greece, and a missal that he received from the

patriarch of Constantinople.[27] In addition to the potential for Mediterranean objects to provide models for images of camels, real-life encounters could likewise make a lasting impression. Patronymics suggest this potential. Snorri Sturluson's twelfth-century saga of King Óláfr names a certain Brynjólfr úlfaldi, or Brynjolv the Camel.[28]

A cursory examination of the Urnes camel suggests that the sculptor never directly observed this animal, or, if he did, he relied more heavily on pictorial and textual conventions than on personal observations. Recent animal studies tend to consider aspects of animal/human cohabitation, of understanding the real presence behind representations,[29] but the Urnes camel seems a different beast altogether, for it is fundamentally and likely exclusively mediated by texts and images. In general, there is a strained articulation in this creature's physiognomy, with its small head, hooved feet, and bushy tail that more closely resembles that of a horse. Indeed, another face of the camel capital features a scene of a rider on a horse with hooves and a bushy tail (Plate 45). Despite these divergences from natural anatomy, the humps of the Urnes camel secure its identity, for these were hallmarks in ancient and medieval texts. Both Pliny (d. 79 CE) and Isidore of Seville (c. 560–636),[30] for example, point out that camels have either one or two humps. Similarly, visual representations of camels consistently feature humps, such as ceramic ampullae of St. Menas (Fig. 8.2), flanked by two camels, produced in Egypt from the sixth through the eighth centuries and found across Europe, as far away as Germany.[31] Beasts on these terra-cotta objects feature distinctive humps and, typically, bushy tails. An illustration of Genesis 24 from an eleventh-century Old English Hexateuch in the British Library features the ten camels that a servant of Abraham took with him as he sought a wife for Isaac.[32] The camels of this illumination and the Urnes capital share physiognomic features, including bushy tails and hooves.

A heavily mediated relationship with nature can even be found in representations of animals that would have been well known to the sculptors at Urnes. In the third carved scene on the camel capital, a dog chasing a stag, deer, or reindeer—all hooved creatures native to Norway—the prey has extremely elongated toes (Plate 46). Analogs for this articulation of the feet can be found on many of the leonine creatures in the nave, perhaps suggesting that there was a conscious effort to employ similar motifs across that space. Or perhaps the sculptor relied on a model of a hunt scene, a theme with great currency in medieval visual culture, that contained similar feet. In either case, the sculptor privileged aesthetic considerations over direct observation in producing imagery for the capitals.

The meaning of the Urnes camel is difficult to specify. Viewed through a Christian lens, this creature could allude to any number of virtues, such as Jesus's short parable, relayed in the synoptic Gospels, that it is easier for a camel to go through an eye of a needle than for a rich man to enter the kingdom of heaven. Complementing this rejection of avarice was unsubstantiated lore from the fifteenth century, perhaps with roots as far back as the ninth, that identified the needle of this parable as a gate in Jerusalem that was so narrow that only an unburdened camel could pass through.[33] Such associations might afford insight into the placement of the camel capital: originally visible immediately to the right as one entered the church, it is now partially obscured by a postmedieval gallery. In addition to any potential religious connotations, camels are associated with the broader vocabulary of luxury goods, including textiles and ivories, such as on the

CHAPTER EIGHT | TRUEING THE CAPITALS AT URNES

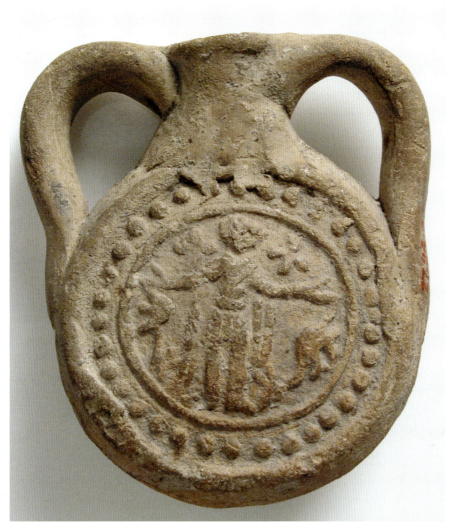

Fig. 8.2. St. Menas ampulla, from Egypt, earthenware, late sixth–mid-eighth century. Metropolitan Museum of Art, Rogers Fund, 1927. Photo: Metropolitan Museum of Art.

celebrated mantle of King Roger II of Sicily.[34] There was a broad tradition of incorporating such associations of richness within the ornaments of the church.

A second motif among the Urnes capitals that has strong international roots is the two men pulling their own beards (Plate 77). As Zehava Jacoby has scrupulously documented, images of beard pullers have a long history in Central Asia, with sculptors in France and Spain widely adopting this theme over the course of the twelfth century.[35] The overall symmetry of the Urnes capital recalls textile designs, and the tripartite hats of the men have parallels in Persian silks. Perhaps, given the penchant for textiles in Norway, such an object inspired artists. Regardless of the ultimate source of the motif, contemporary sculptures across Europe feature isolated figures pulling at their own beards, whereas scenes with multiple figures typically show individuals pulling at others' beards, what Jacoby identified as engaging the theme of conflict. That the Urnes figures tug at their own beards might represent one instance of an artist creatively transforming

365

an international pictorial tradition to address local needs, although, like the camels, the specific meaning proves difficult to specify.

Regardless of the meaning of motifs in twelfth-century Norway, the camel and beard pullers point to an expansive programmatic vision that has a distinctly international aspect, for the sculptors at Urnes employed imagery that had currency outside the immediate Scandinavian and Insular orbit. The very presence of these images attests to the fact that Urnes participated in an international network of visual cultural exchange. While cosmopolitanism seems a bit of an exaggerated descriptor for this phenomenon given the limited number of clear examples of international borrowings, there clearly was value placed on motifs drawn from outside the region. These may have served to evoke foreign travels, perhaps even the crusades that are so vividly evoked in the sagas.

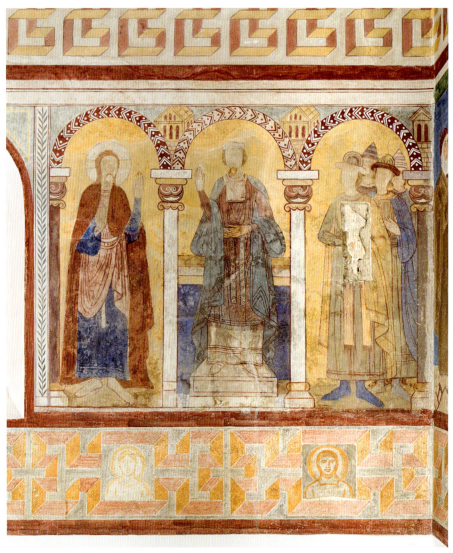

Fig. 8.3. Fresco in Jelling church, Denmark, Jews listening to John the Baptist, c.1100. Photo: Martin Jurgensen.

Trueing Ideology

Despite the diffuse or ambiguous meaning of many of the capitals at Urnes, there is one instance of the sculptors adopting decidedly anti-Semitic tropes, which were ascendant in the visual arts over the course of the twelfth century.[36] Of the many carved leonine creatures, one has a single human arm, clothed in a sleeve, with a hand that bears an axe (Plate 76). This creature's long floriated tail entwines this weapon, a visual flourish that links animality with violence, while the profiled human head atop the long neck features a beard, large nose, a pointed ear, and what appears to be a *Judenhut*.[37] Many of these attributes had currency in contemporary Scandinavian images of Jews. An early example is a fresco at Jelling, Denmark, of *c*.1100 that features a group of Jews listening to John the Baptist (Fig. 8.3). This work is known through an 1874 restoration by Julius Magnus-Peterson, conducted after the original paintings were damaged by humidity shortly after their discovery.[38] The scene includes a group of clean-shaven figures who lack somatic markers, such as hooked noses, beards, or dark skin, that would come to stigmatize Jews in much of later European art. Only the sartorial marker of hats, variously conical or rounded in profile, serves to distinguish these figures visually as exotic Others. The variety of hat forms does not individualize the figures, whose facial features are remarkably uniform, but rather aligns with what Robert Cole has identified as a tendency in Old Norse literature, as well as in some medieval images, to organize Jews in undifferentiated groups that "act as one, speak as one, and plot, scheme, and rage as one."[39] Thirteenth-century paintings in Norway continued to use the visual marker of the *Judenhut*.[40]

There is evidence of somatic marking of Jews in the visual arts of Denmark by 1125. A fresco of the Adoration of the Magi at Råsted includes a man with hooked nose, hat, and beard (Fig. 8.4), features that Ulla Haastrup has identified as conforming to the pictorial type of the "evil Jew."[41] This figure's facial physiognomy shares much with the Urnes carving, though without turning the figure into a beast. A remarkably close parallel for this strategy appears in a thirteenth-century miniature of a manticore in an English bestiary that racializes the creature by depicting it with a hooked nose, beard, and Phrygian cap (Fig. 11.8), what Debra Higgs Strickland in another context dubs a "grotesque Jewish profile."[42] This vicious representational strategy is heightened by the dismembered human leg that the beast clenches in its teeth. Medieval artists took particular license in rendering the anatomies of manticores, including those in bestiary manuscripts that

Fig. 8.4. Fresco in Råsted church, Denmark, detail of a Jewish man in Adoration of the Magi scene, *c*.1125. Photo: Martin Jurgensen.

share nearly identical texts.[43] Some representations feature human heads, others leonine ones, an anatomical variation that can likewise be observed in Romanesque sculptures of these creatures.[44]

The Urnes composite beast, which may have been intended to represent a manticore, combines somatic and sartorial markers to racialize an embodied difference that articulates an anti-Semitic message. It is important to characterize this pictorial work as more than a statement against the religious tenets of Judaism, which medieval Christian theologians had long condemned in the *contra Iudaeos* genre.[45] Works from Augustine (354–430) to Peter the Venerable (*c.*1092–1156) tended to focus on doctrinal or theological issues of Judaism, regardless of the accuracy of those characterizations, in the attempt to make an argument for conversion to Christianity. An implication of this rhetorical strategy was often that religious belief and identity is a choice. By contrast, anti-Semitism casts Otherness not in terms of ideology but as rooted inextricably within the body. The caricatured facial features of the Urnes figure append a monstrous or deviant body, explicitly cast as violent through the inclusion of a brandished weapon. In the context of a church, the inclusion of this stigmatized, bodily Other serves as a foil with which to construct Christian identity.

The Urnes capital stands as an early visual articulation of anti-Semitic sentiments in medieval Norway, but it may not be a unique example in contemporary church decoration. The twelfth-

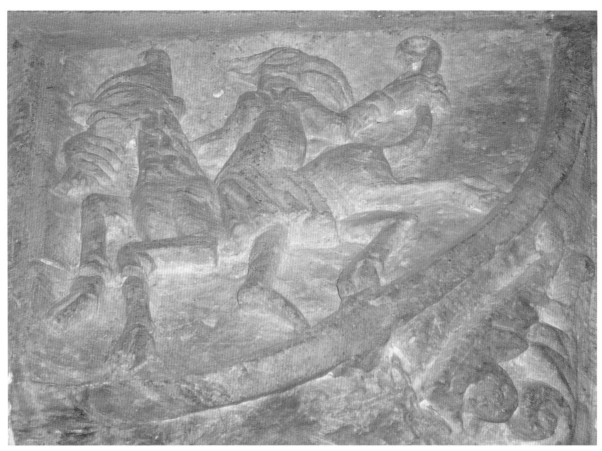

Fig. 8.5. Stavanger Cathedral, Norway, capital with human-headed beast, *c.*1130–50. Photo: Arne Kvitrud.

century base of the stone font at Bro, Sweden, features a leonine body with the upper body of a human.[46] This bearded creature wears a pointed cap and wields an axe. Similar imagery is carved on a stone capital in Stavanger Cathedral (Norway), dated *c.*1130–50, which includes a creature that resembles contemporary manticores (Fig. 8.5).[47] The human-headed beast sports a Phrygian cap as well as a beard. One might see in this physiognomy another instance of anti-Semitic visual tropes embedded within the representation of a human/animal hybrid.

Further negative inflections might be identified on the Stavanger capital in the figure of the bird-headed man who rides the "manticore" backward, a position that, as noted above with Pope Gregory VIII and the camel, could signal humiliation in European culture. Similarly, illustrations in the *Sachsenspiegel* picture books include images of figures riding backward as a form of ridicule.[48] The significance of the bird's head appears to be more enigmatic. Bird- and animal-headed figures are found in thirteenth- and fourteenth-century Ashkenazi illuminations,[49] but even if similar Jewish pictorial traditions existed in twelfth-century Norway, it seems a remote possibility that this sculptor would have been familiar with them. Birds played an important role in Nordic belief systems. For example, the thirteenth-century *Poetic Edda*, which draws on earlier Norse material, includes Huginn (Old Norse for "thought") and Muninn (Old Norse for "memory" or "mind"), two ravens that fly over the world to bring information to the god Óðinn.[50] Some bracteates and helmets show birds accompanying a rider, perhaps a visualization of Óðinn and his ravens. An eighteenth-century Icelandic manuscript of this text has a miniature in which the ravens sit on Óðinn's shoulder, although I am unaware of a hybrid image of the god with a bird's head.[51]

If specific features of the Urnes and Stavanger "manticores" remain enigmatic, both capitals integrate animal features with bodily and sartorial markers associated with Jews. This representational strategy renders Jews as less than human, and such strategies of dehumanization likewise occur in contemporary Scandinavian literature. For example, Jews in certain Norse miracle texts were described as dogs, a trope with pan-European parallels.[52] In an Old Norse account of the 1330 host-desecration trial in Güstrow, Germany, the Jews allegedly responsible for the crime were described as "hinu vondu hundar" (those evil dogs).[53] Much work remains to be done on the (visual) history of Jews in Scandinavia, but it seems important for our purposes that Urnes constructs a Christian space that includes an anti-Semitic gesture.

Scholarship on Urnes has generally situated this monument somewhere on a continuum along two poles, Viking and Christian. What I want to suggest is that the imagery at Urnes was inflected at least partly by another vector, anti-Semitism, that is directly incorporated into the fabric of the church. Like the camels and beard pullers, the presence of anti-Semitism marks another trace of the broader, international influences that left their mark at Urnes. It also testifies to the potential dark side of cross-cultural exchange. While contact among social groups had the potential to expand perceptual horizons for good, these encounters could likewise disseminate hate.

PART THREE | THE TWELFTH-CENTURY CHURCH

Epilogue: Institutional Trueing

The process of multiple rebuildings of Urnes that characterized its first seventy or so years ended with the completion of the fourth church around 1130. The next major adjustment to the fabric of the church dates to the seventeenth century, when the choir was extended. This hiatus of construction activity coincided with the embrace of stone as a construction material for churches in Norway over the course of the twelfth century, when builders increasingly followed architectural conventions that had long flourished on the Continent. Beyond any potential practical motivations for adopting pan-European conventions, this shift in building materials may have had ideological or institutional drivers as well. Eric Fernie, for one, has observed that no wooden cathedrals were ever built in Norway.[54] The earliest cathedral, begun at Stavanger in the first decades of the twelfth century, appears to have been conceived from the outset as a stone building. The impetus behind this decision may partly be linked with the fact that Reinald, the first bishop of Stavanger, had likely served as a monk at Winchester, where a limestone cathedral was consecrated in 1093. All subsequent Norwegian cathedrals, including that of the archbishopric of Trondheim, were masonry constructions. From an institutional perspective, building in stone seems to have been deemed decorous, perhaps palpably and materially aligning it with other cathedrals across western Christendom. Over the course of the twelfth century, the position of the Church in Norway became increasingly institutionalized in the wake of the establishment of bishops' seats c.1100; at about the same time, the first Benedictine monasteries were established. In the following years, this ecclesiastical infrastructure was codified across this region.

There are twelfth-century artworks at Urnes that might point to a similar process of conformity to broader European trends. The polychromed wooden scene of the crucifixion, which includes the figures of Mary and John (Plate 106), features fully articulated human figures whose plasticity stands in stark contrast to the planar visual language of the capitals. Shirin Fozi and Gerhard Lutz have recently demonstrated how ubiquitous wooden crucifixes were in church interiors across Europe during the twelfth century.[55] This very ubiquity can make dating difficult. For the Urnes crucifixion group, suggestions range from the figures being coeval with the c.1130 building campaign to their being a later addition, crafted toward mid-century.[56] Regardless of their precise date, the strong resemblance—material, iconographic, and stylistic—of the Urnes group to Continental counterparts may represent more than traces of international influence: it may signal a more complete embrace of the institutional, international Church than is evident in the imagery of the capitals.

Notes

I thank Margrete Syrstad Andås, Adam S. Cohen, Griffin Murray, and Kathryn Smith for their insightful suggestions.

1. https://whc.unesco.org/en/list/58/. In her monumental two-volume study, Erla Bergendahl Hohler identifies some examples of sculptural forms particular to wood but generally seeks stone models for carvings in stave churches. Hohler, *Norwegian Stave Church Sculpture* (Oslo, 1999). Michael Baxandall has arguably developed the most sustained language for wood sculpture, although the works he analyzes are not intrinsic to architecture. Baxandall, *The Limewood Sculptures of Renaissance Germany* (New Haven, CT, 1980).

2. For the complete, standard version of the poem see W. H. Auden, *Collected Poems*, ed. Edward Mendelson (New York, 1992), 540–42.

3. Alan W. France, "Gothic North and the Mezzogiorno in Auden's 'In Praise of Limestone,'" *Renascence* 42.3 (1990): 141–48, at 148.

4. I consulted the following edition: John Ruskin, *The Stones of Venice* (New York, 1907).

5. Kirk Ambrose, "Émile Mâle," in *The Routledge Companion to Medieval Iconography*, ed. Colum Hourihane (New York, 2016), 65–74, at 66–67.

6. See, e.g., Xavier Barral i Altet, *Contre l'art roman?: Essai sur un passé réinventé* (Paris, 2006); and Jean Nayrolles, *L'invention de l'art roman à l'époque moderne (XVIIIe–XIXe siècles)* (Rennes, 2005).

7. Thomas E. A. Dale, *Pygmalion's Power: Romanesque Sculpture, the Senses, and Religious Experience* (University Park, PA, 2019); and Shirin Fozi, *Romanesque Tomb Effigies: Death and Redemption in Northern Europe, 1000–1200* (University Park, PA, 2021).

8. "Seniores terrae, locum frequenter invisentes, cum audissent et vidissent numerum fratrum ampliatum ac diversorium valde angustum, hortati sunt abbatem oratorium lapideum construerere, suum ei spondentes auxilium artificibus conducendis atque pascendis, ceterisque necessariis non defore. Quorum monitis, non de propriis viribus praesumens aut opibus, sed divinis fidens muneribus, abbas annuit, effossisque lapidibus, quaeque forent ad opus necessaria preparavit. Diebus itaque sanctis Paschae, facta processione ad locum quo construendum erat oratorium, ibidemque missa celebrate, locata sunt fundamenta in honore Dei ac beatissimae semper Virginis Mariae, Godefrido, comite Austrebatensium, cum infinito coetu divitum et pauperum, astante. Siquidem oratoriolum, quo eo tempore, immo et ante, celebrabantur divina in honore Dei et beati Sebastiani martyris, a venerabili patre Widone ex lignis compactum, in pomoerio situm fuerat, ubi etiam tunc temporis claustrum erat, atrio ibidem consecrato. Porro ecclesia B. Mariae sex annis consumata." Victor Mortet and Paul Deschamps, eds., *Recueil de textes relatifs à l'histoire de l'architecture et à la condition des architectes en France, au Moyen-Âge, XIIe–XIIIe siècles* (Paris, 1929), 2:19–20.

9. Laurence M. Larson, *The Earliest Norwegian Laws: Being the Gulathing Law and the Frostathing Law* (New York, 1935), 228–29. On this passage, see Leif Anker, *The Norwegian Stave Churches* (Oslo, 2005), 88; and Jørgen Jensenius, "Var det krav om høye stenkirker i middelalderen?," *Viking* 60 (1997): 85–94.

10. Erla Bergendahl Hohler, "The Capitals of Urnes Church and Their Background," *Acta Archaeologica* 46 (1975): 1–75. Martin Blindheim briefly observed that the specific source materials for the capitals remain obscure: Blindheim, *Norwegian Romanesque Decorative Sculpture, 1090–1210* (London, 1965), 36. For a general discussion of animal motifs, see also George Zarnecki, "Germanic Animal Motifs in Romanesque Sculpture," *Artibus et Historiae* 11.22 (1990): 189–203.

11. Finbarr B. Flood, *Objects of Translation: Material Culture and Medieval "Hindu-Muslim" Encounter* (Princeton, NJ, 2009), 9.

12. For a discussion of dating, see Terje Thun et al., "Dendrochronology Brings New Life to the Stave Churches: Dating and Material Analysis," in *Preserving the Stave Churches: Craftsmanship and Research*, ed. Kirstin Bakken, trans. Ingrid Greenhow and Glenn Ostling (Oslo, 2016), 105–9. See also the foundational study, with many illuminating drawings, of Knud J. Krogh, *Urnesstilens kirke: Forgængeren for den nuværende kirke på Urnes* (Oslo, 2011).

13. Hallvard Magerøy, "Urnes stavkyrkje, Ornes-ætta og Ornes-godset," *Historisk tidsskrift* 67.2 (1988): 121–44.

14. On the importance of trees in Norse medieval culture, see, e.g., Carole M. Cusack, *The Sacred Tree: Ancient and Medieval Manifestations* (Newcastle upon Tyne, 2011).

15. Otto Pächt, "The Pre-Carolingian Roots of Early Romanesque Art," in *Romanesque and Gothic Art*, Studies in Western Art: Acts of the Twentieth International Congress on the History of Art, ed. Millard Meiss (Princeton, NJ, 1963), 67–75. It is worth noting that a later Icelandic pattern book attests to this: Harry Fett, *En islandsk tegnebog fra middelalderen* (Kristiania, 1910).

16. Meyer Schapiro, *Romanesque Architectural Sculpture: The Charles Eliot Norton Lectures*, ed. Linda Seidel (Chicago, 2006), 185–209.

17. Michael Camille, "Mouths and Meaning: Towards an Anti-Iconography of Medieval Art," in *Iconography at the Crossroads: Papers from the Colloquium Sponsored by the Index of Christian Art, Princeton University, 23–24 March 1990*, ed. Brendan Cassidy (Princeton, NJ, 1993), 43–58.

18. The question of how specific motifs traveled remains an open question, whether, say, by memory, by portable *ars sacra*, or by manuscripts. Though much later in date, a fifteenth-century Icelandic sketchbook (formerly Copenhagen, University Library; now Reykjavík, Árni Magnússon Institute for Icelandic Studies, AM 673 a III 4°) includes a number of stock subjects, as well as vegetal and zoomorphic patterns. Interestingly for our purposes, one sketch includes repeated leonine creatures with subtle variations in form; illustrated in Fett, *En islandsk tegnebog*, plate 31.

19. Hohler, "Capitals of Urnes."

20. Ellen Marie Magerøy, "'Biskopen' i Urnes stavkirke," *Årbok: Foreningen til norske fortidsminnesmerkers bevaring* 126 (1971): 13–24.

21. Most unusually for Romanesque centaurs, the Urnes creature wears a tunic. An example at Saint-Andoche, Saulieu, likewise wears a tunic and a head-covering that can be described as a turban. This sartorial detail perhaps

references anti-Islamic sentiments: Kirk Ambrose, *The Marvellous and the Monstrous in the Sculpture of Twelfth-Century Europe* (Rochester, NY, 2013), 57–63.

22 Robert Bartlett, "From Paganism to Christianity in Medieval Europe," in *Christianization and the Rise of Christian Monarchy: Scandinavia, Central Europe and Rus', c.900–1200*, ed. Nora Berend (Cambridge, 2007), 47–72; Sverre Bagge, "Christianization and State Formation in Early Medieval Norway," *Scandinavian Journal of History* 30.2 (2005): 107–34; and Brit Solli, "Narratives of Encountering Religions: On the Christianization of the Norse around AD 900–1000," *Norwegian Archaeological Review* 29.2 (1996): 89–114. See also Sverre Bagge, "The Making of a Missionary King: The Medieval Accounts of Olaf Tryggvason and the Conversion of Norway," *Journal of English and Germanic Philology* 105.4 (2006): 473–513.

23 Mary Carruthers, *The Experience of Beauty in the Middle Ages* (Oxford, 2013), 1–13.

24 Johan Huizinga, *Homo Ludens: A Study of the Play-Element in Culture* (London, 1949). The discussion is in Carruthers, *Experience of Beauty*, 16–44.

25 Ilene H. Forsyth, "The Theme of Cockfighting in Burgundian Romanesque Sculpture," *Speculum* 53.2 (1978): 252–82.

26 Caitlin R. Green, "Camels in Early Medieval Western Europe: Beasts of Burden & Tools of Ritual Humiliation," https://www.caitlingreen.org/2016/05/camels-in-early-medieval-western-europe.html.

27 Krijnie N. Ciggaar, *Western Travellers to Constantinople: The West and Byzantium, 962–1204; Cultural and Political Relations* (Leiden, 1996), 111–12.

28 Snorri Sturluson, *Heimskringla: History of the Kings of Norway*, trans. Lee M. Hollander (Austin, TX, 1964), 258, *Saga Ólafs konúngs hins Helga*, chap. 17.

29 See, e.g., Joan B. Landes, Paula Young Lee, and Paul Youngquist, eds., *Gorgeous Beasts: Animal Bodies in Historical Perspective* (University Park, PA, 2012). The earliest study in this collection focuses on the early modern period.

30 Pliny, *Natural History*, VIII.26; and Isidore, *Etymologies*, XII.1:35.

31 Susanne Bangert, "Menas Ampullae: A Case Study of Long-Distance Contacts," in *Incipient Globalisation: Long-Distance Contacts in the Sixth Century*, ed. Anthea Harris (Oxford, 2007), 27–33.

32 British Library, MS Cotton Claudius B IV, fol. 39r; digitized at http://www.bl.uk/manuscripts/Viewer.aspx?ref=cotton_ms_claudius_b_iv.

33 Leon Morris, *The Gospel According to Matthew* (Grand Rapids, MI, 1992), 493.

34 https://www.trc-leiden.nl/trc-needles/individual-textiles-and-textile-types/secular-ceremonies-and-rituals/mantle-of-roger-ii-of-sicily.

35 Zehava Jacoby, "The Beard Pullers in Romanesque Art: An Islamic Motif and Its Evolution in the West," *Arte medievale*, ser. 2, 1 (1987): 65–85. See also Ekaterina Endoltseva and Andrey Vinogradov, "Beard Pulling in Medieval Christian Art: Various Interpretations of a Scene," *Anastasis: Research in Medieval Culture and Art* 3.1 (2016): 88–98.

36 The literature on the rise of anti-Jewish imagery during the twelfth century is enormous. For an elegant account, see Sara Lipton, *Dark Mirror: The Medieval Origins of Anti-Jewish Iconography* (New York, 2014).

37 I thank Asa Mittman for his probing insights on this carving.

38 Ulla Haastrup, "Representations of Jews in Danish Medieval Art," in *Danish Jewish Art / Jews in Danish Art*, ed. Mirjam Gelfer-Jørgensen, trans. W. Glyn Jones (Copenhagen, 1999), 113–67.

39 Richard Cole, "One or Several Jews: The Jewish Massed Body in Old Norse Literature," *Postmedieval: A Journal of Medieval Cultural Studies* 5 (2014): 346–58, at 346.

40 I am grateful to Margrethe C. Stang for sharing a draft of a book chapter prior to its publication: Stang, "Enemies of Christ in the Far North: Tales of Saracens, Jews and the Saami in Norwegian Medieval Paintings," in *Tracing the Jerusalem Code*, vol. 1, *The Holy City: Christian Cultures in Medieval Scandinavia (c.1100–1536)*, ed. Kristin B. Aavitsland and Line M. Bonde (Berlin, 2021), 477–99.

41 Ulla Haastrup, "Representations of Jews in Danish Medieval Art—Can Images Be Used as Source Material on Their Own?," in *History and Images: Towards a New Iconology*, ed. Axel Bolvig and Phillip Lindley (Turnhout, 2003), 341–56, at 343. Haastrup argues that there was a Jewish population in Scandinavia during the High Middle Ages, although, as she acknowledges, there is no firm proof for this.

42 Debra Higgs Strickland, *Saracens, Demons, and Jews: Making Monsters in Medieval Art* (Princeton, NJ, 2003), 136.

43 Elizabeth Morrison with Larisa Grollemond, eds., *Book of Beasts: The Bestiary in the Medieval World* (Los Angeles, 2019), 42, 124, and 144.

44 See, e.g., Neil Stratford, *Le pilier roman de Souvigny: Chronos et cosmos* (Souvigny, 2005), which discusses various examples, including a capital from Saint-Sauveur, Nevers. Interestingly, the Nevers capitals, which feature a range of beasts from the bestiary, likewise represent a camel.

45 See, e.g., Ora Limor and Guy G. Strousma, eds., *Contra Iudaeos: Ancient and Medieval Polemics between Christians and Jews* (Tübingen, 1996).

46 Johnny Roosvaal, *Die Steinmeister Gottlands: Eine Geschichte der führenden Taufsteinwerkstätte des schwedischen Mittelalters, ihrer Voraussetzungen und Begleit-erscheinungen* (Stockholm, 1918), 171, 186. See also Evert Lindkvist, *Gotlands romanska stenskulptur: Visuella budskap i sten* (Burksvik, 2015).

47 See the recent discussion of this capital by Morten Stige, "Livstrekapitélet?: Bestiariet som kilde til Stavangerrelieffenes ikonografi," in *Bilder i marginalen: Nordiska studier i medeltidens konst*, ed. Kersti Markus (Tallinn, 2006), 175–92. Relating this carving to bestiaries, Stige offers a moral interpretation, but does not consider potential relations to anti-Semitic tropes.

48 Ruth Mellinkoff, "Riding Backwards: Theme of Humiliation and Symbol of Evil," *Viator* 4 (1973): 153–76; and Madeline H. Caviness and Charles G. Nelson, *Women and Jews in the Sachsenspiegel Picture-Books* (London, 2018).

49 See, e.g., Marc Michael Epstein, *The Medieval Haggadah: Art, Narrative and Religious Imagination* (New Haven, CT, 2011), 45–128.

50 John Lindow, *Norse Mythology: A Guide to the Gods, Heroes, Rituals, and Beliefs* (Oxford, 2001), 184–86.

51 Reykjavík, The Árni Magnússon Institute for Icelandic Studies, SÁM 66.

52 Kenneth Stow, *Jewish Dogs: An Image and Its Interpreters; Continuity in the Catholic-Jewish Encounter* (Stanford, 2006).

53 *Mariu saga: Legender om jomfru Maria og hendes jertegn*, ed. C. R. Unger (Kristiana, 1871), 255–56. Passage cited, translated, and discussed by Richard Cole, "Kyn/Fólk/Þjóð/Ætt: Proto-Racial Thinking and Its Application to Jews in Old Norse Literature," in *Fear and Loathing in the North: Jews and Muslims in Medieval Scandinavia and the Baltic Region*, ed. Cordelia Heß and Jonathan Adams (Boston, 2015), 239–68, at 264.

54 Eric Fernie, *Romanesque Architecture: The First Style of the European Age* (New Haven, CT, 2014), 172. The practice of building cathedrals exclusively in stone was not observed across Scandinavia. In twelfth-century Iceland, which at that stage was politically independent, Bishop Klœingr Þorsteinsson built a cathedral at Skálholt in wood imported from Norway; M. C. J. Leith, trans., *Stories of the Bishops of Iceland* (London, 1895), 60–61. On this passage, see the discussion of Jørgen H. Jensenius, "Viking and Medieval Wooden Churches in Norway as Described in Contemporary Texts," in *Historic Wooden Architecture in Europe and Russia: Evidence, Study and Restoration*, ed. Evgeny Khodakovsky and Siri Skjold Lexau (Berlin, 2016), 56–67, at 61–62.

55 Shirin Fozi and Gerhard Lutz, eds., *Christ on the Cross: The Boston Crucifix and the Rise of Monumental Wood Sculpture, 970–1200* (Turnhout, 2020).

56 Manuela Beer, *Triumphkreuze des Mittelalters: Ein Beitrag zu Typus und Genese im 12. und 13. Jahrhundert; Mit einem Katalog der erhaltenen Denkmäler* (Regensburg, 2005), 377–81.

PART THREE | THE TWELFTH-CENTURY CHURCH

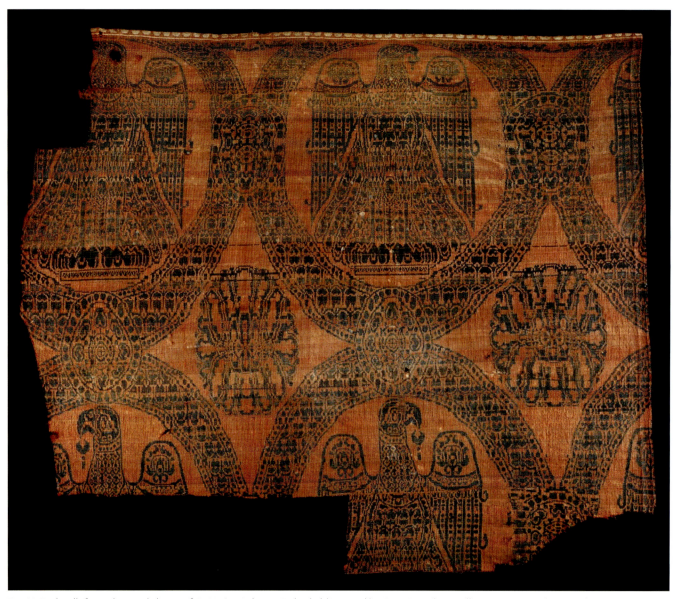

Fig. 9.1. Eagle silk from the royal shrine of St. Knútr, Odense Cathedral (Denmark), 110 × 133 cm (originally c.195 × 230 cm), second half of eleventh century. Odense Cathedral crypt. Photo: Nationalmuseet, Copenhagen.

CHAPTER 9

Norse Encounters with the Mediterranean and Near Eastern Worlds in the Capitals of Urnes

Kjartan Hauglid

THE INTERIOR CAPITALS OF URNES are executed in shallow relief and depict exotic motifs with symmetrically arranged vegetation, humans, animals, and birds. One capital shows a pair of addorsed beard pullers with bent knees and short pleated skirts, another a camel, and a third a sword-juggling acrobat. Such scenes are unprecedented in the arts of the North. Indeed, this ensemble is something one might expect to find on textiles or other media in Islamic art or in regions influenced by it. Whereas architectural decoration from Andalusi Spain or the eastern Mediterranean and Near East was widely adopted in the great pilgrimage churches of France, they are mostly absent in the North, and the occurrence of such architectural elements at Urnes in the twelfth century warrants explanation.[1]

In the later Middle Ages, the church at Urnes was owned by one of the richest aristocratic families in Norway. It is thus reasonable to assume that the patron of the 1130s church was the local lord and that the stave church belonged to a large manorial estate (see Chapter 2). In this essay, I argue that the foreign and exotic motifs can be explained as mementoes of Norwegian expeditions to the Mediterranean and the Near East and possibly of the elite's participation in the early crusade movement. The rich sculptural ensemble should be seen as a conscious act, a collection of motifs meaningful to the patron and his household.

Before examining the iconography, another striking feature should be considered: the suppression of plastic values. The architectural decoration of later stave churches is carved in the round and treated three-dimensionally; edges are rounded. In the capitals of Urnes, by contrast, the surfaces of the reliefs on the capitals are perfectly flat, with the sides cut straight down (Plates 39–91). This two-plane relief also occurs on the exterior late eleventh-century gables (Plates 11 and 12) and door leaf (Plate 3). A similar technique was used in ornamental woodcarving in the early stave churches of Bjølstad in Heidal (Innlandet),[2] Torpo I (Viken),[3] and Hørning in Denmark.[4] We find it, too, in stone reliefs made in the earlier Ringerike style, such as the famous stone slab from St. Paul's churchyard in

London.[5] Yet the two-plane relief used at Urnes is unusual in Scandinavian figural sculpture in wood in the first half of the twelfth century. The sources and origin of this mode of artistic expression, with its shallow reliefs and isolated motifs on a plain background, have not been satisfactorily explained.

The Two-Plane Relief

Unlike all other figural stave church sculpture of the twelfth century, the motifs at Urnes are rendered in two planes in a shallow relief that is only 0.75 cm high.[6] This is the most striking stylistic aspect of the interior decoration; there is almost no attempt at modeling in the round. Nor were the reliefs modeled with color: a recent examination of the capitals by conservator Tine Frøysaker did not find traces of paint, and because the building was always roofed and in use, the capitals must never have been painted.[7] Peter Anker pointed out that most of the leaves in the foliate capitals were made with an unusual chip-carving technique with sharp contours, giving the reliefs a clear light-and-shadow effect and making details visible from a distance.[8] The chip-carving technique (French *encoche*, German *Kerbschnitt*), leaves smooth, single facets with deep grooves and sharp ridges. This technique was unknown in the art of the Vikings.[9] Evidence suggests that chip carving was a novelty in Norway in the late eleventh century and that there were no Scandinavian predecessors in wood before the motif appeared in Romanesque architectural sculpture. The earliest known occurrence of chip carving in wood in Scandinavia is a blind arcade on the west facade of the church of St. Peter at Vågå, reused from the previous stave church. The design of the wall arcade is reminiscent of Anglo-Saxon architecture, but the sunken star is unknown in Anglo-Saxon art and appears in England only after the Norman Conquest. The dating of Vågå is disputed, from the late eleventh century to the early twelfth. In any case, there are no other examples of such an early use of this motif in wood in Norway.[10]

If the two-plane relief of the Urnes capitals is unusual in wooden architectural decoration, there are some early parallels in stone in the *lapidarium* of Trondheim Cathedral. The Norman-style fragments are thought to have come from the earliest stone churches in Trondheim, dated to the first decades of the twelfth century.[11] The main difference between these and the capitals is that in the latter the edges are rounded and appear much softer. While the flat relief at Urnes is uncommon in Norway, it is more typical of Italian, Spanish, and French Romanesque sculpture of the eleventh and early twelfth centuries. It was also used in Islamic Andalusia from the eighth to the tenth century, and Jerrilynn Dodds has described the use of this carving style in Romanesque sculpture as a loan from a Spanish Islamic context.[12] Similar bas-reliefs, together with such other Islamic architectural features as intersecting arches and roll corbels, were used in French Romanesque architecture from the middle of the eleventh century.[13] In the second half of that century the two-plane style became widespread in Normandy and was used in Caen, Bernay, Troarn, Rouen, and Cerisy-la-Forêt.[14] As I have argued elsewhere, it was this style that in the late eleventh or early twelfth century found its way to Norway, together with such other Norman features as volute capitals and the "sunken star" motif.[15]

Theories on the Sources for the Imagery at Urnes

The most substantial analysis of the capitals at Urnes is by Erla Bergendahl Hohler, and some of her points must be revisited here. Writing in the 1970s, before the days of dendrochronology, she argued that the capitals were made "in the 1160s" and pointed to the Danish granite carvings from Jutland as the primary source of influence.[16] This material is poorly dated, but scholars now agree that most of Hohler's cited parallels belong to the mid-twelfth century or later.[17] Now that dendrochronology has placed the final phase of Urnes in *c.*1130, those works can no longer be considered models.[18] Apart from the cathedral in Lund, the preserved stone sculpture in Sweden and Gotland postdates Urnes.

Despite being convinced of the Danish connection, Hohler admitted that none of the Urnes griffins, unicorns, camels, or addorsed animals and men at Urnes appear in works from Jutland.[19] Instead, she saw the decorative style and symmetry of the Urnes capitals as the product of "Oriental" or "Eastern" influence, mostly from textiles,[20] in which twisted, confronted, or addorsed animals paired in roundels are common.[21] Hohler suggested that these motifs were transmitted through Anglo-Norman art, such as the Bayeux Embroidery.[22]

That eastern textiles were known in Scandinavia in the early twelfth century is confirmed by the Eagle Silk from the royal shrine of St. Knútr in Odense Cathedral (Fig. 9.1). On 10 July 1086, the Danish king Knútr (Canute IV) was killed in front of the altar in the church of St. Alban's Priory in Odense. In 1098 the martyred king was recognized as a saint by Pope Urban II. His body was wrapped in a precious silk with an eagle motif before he was enshrined and installed at the high altar of the newly built Odense Cathedral. The silk may have been a gift from Adela of Flanders, widow of King Knútr inn ríki. In 1092 she became the duchess of Apulia by marriage to Duke Roger Borsa, and as the mother of Duke William II (1095–1127), she was regent of Apulia from 1111 to 1115. The silk was famous in its time, and the shrine and its silk were described by the Benedictine monk Ælnoth of Canterbury in his *Life and Passion of St. Cnut* (1120): "A magnificent shrine for the sacred bones, shining like silver and in the reddish flame of gold ornamented with lovely blue and yellowish stones, in it the sacred bones of the saint shall rest. Silk, saffron-yellow, precious stones, all in the most splendid trappings."[23]

Hohler mentioned other possible influences for the imagery at Urnes, such as metalwork, ivories, and manuscripts, all as portable as textiles and thus potentially visible and known to the artist.[24] She also brought up oliphants, ivory horns carved in the Mediterranean region in the eleventh or early twelfth century.[25] Although it is not possible to point to details that might indicate a direct relationship, some oliphants do feature many of the motifs seen at Urnes. The oliphant from Chartreuse des Portes has a depiction of a unicorn with lowered head and a short horn that Hohler compared to the creature on an Urnes capital that she interpreted as a unicorn (Plate 61).[26] The Borradaile oliphant, possibly from southern Italy or Sicily (Fig. 9.2), features lions, birds, griffins, and dragons with almond-shaped eyes, as at Urnes, and symmetrically arranged birds and lions in "heraldic" positions, the lions with legs lifted, heads turned, and tails terminating in leaves. All these figures are cut in sharp two-plane relief and isolated within their frames against a plain background.[27]

Hohler thought that oliphants were unknown in Scandinavia in the twelfth century and were

PART THREE | THE TWELFTH-CENTURY CHURCH

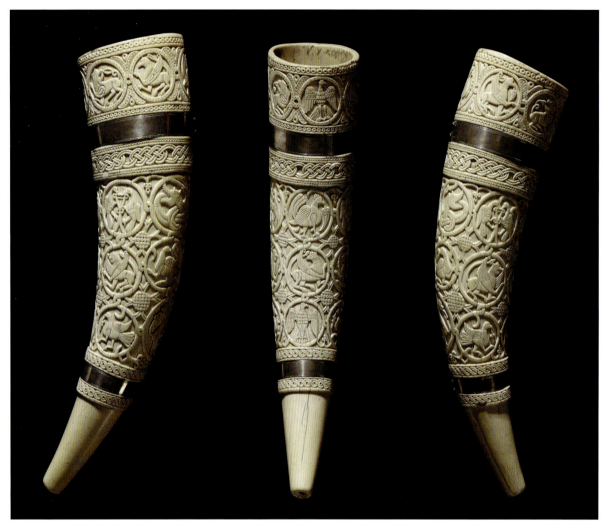

Fig. 9.2. Borradaile oliphant, from southern Italy or Sicily, ivory, eleventh or early twelfth century. London, British Museum, inv. no. 1923,1205.3. Photo: British Museum.

unlikely to be a direct source,[28] but this may not be entirely correct. The medieval treasury of Lund Cathedral mentions an elephant tusk (*dente eburneo*), hanging below the huge cross in the center of the church, in which relics were kept.[29] Moreover, in the eleventh century a Scandinavian nobleman, Ulph, son of Thorold, donated an oliphant to York Minster. The so-called Horn of Ulph was first recorded in 1393 and is still in the cathedral treasury.[30] The potential relevance of this material is clear, but not all of the motifs at Urnes (such as the beard pullers and the acrobat) can be found on oliphants. For much of the imagery on the Urnes capitals we must consider other sources from the south, and these likely traveled via the medium of manuscripts.

CHAPTER NINE | NORSE ENCOUNTERS WITH THE MEDITERRANEAN AND NEAR EASTERN WORLDS

The Camel

The Icelandic chronicler Snorri Sturluson (d. 1241) relates that Óláfr II Haraldsson (c.995–1030) went to Spain in 1014/15 and stayed for nine months.[31] Shortly after his journey, he gave a sword to Brynjólfr úlfaldi and made him one of his landed-men (*lendr maðr*). *Úlfaldi* is the Norse word for camel. In the same chapter, Snorri tells the story of another man who traveled both east and west on his raids. We cannot know if this also applied to Brynjólfr úlfaldi, but it is feasible that his travels gave him his nickname. The camel was not unknown to the Norse nobility, and Lev Kapitaikin has argued that "the camel was indeed perceived by the Normans [in Sicily] as an exotic animal particularly associated with the 'Saracens.'"[32] In a local context like Urnes, the camel may even have indicated the high social status of someone who traveled widely. If not common, camels do appear in the arts of the period. They can be found in the Bayeux Embroidery and in textiles from western and Central Asia; because the one at Urnes is a two-hump Bactrian camel (Plate 47), a possible Sasanian origin has been suggested.[33] In a seminal study, Francis Klingender demonstrated that the fauna of Romanesque art included most of the larger animals, with a few exceptions.[34] The horse is almost invariably depicted as mounted and is thus appears only in certain situations, and the same is true for the camel, which is rarely represented. The cornice of the porch tower of Saint-Hilaire-le-Grand in Poitiers (1049) is exceptional in eleventh-century architectural sculpture because it has the earliest dated camel. Nearby are a dragon, a centaur armed with a crossbow hunting a bird, and a palm tree, all executed in the same two-plane style as at Urnes.[35]

A camel contemporary with Urnes is depicted in a wall painting in the hermitage of San Baudelio de Berlanga in the Spanish province of Soria.[36] Soria was reconquered in 1124 by King Alfonso VII, and the Mozarabic wall paintings were likely executed soon after this event. The paintings are divided into two groups, with the upper walls decorated with scenes from the life of Christ and the lower register with seemingly unrelated scenes of animals, including the camel, as well as hunting scenes like those at Urnes (Fig. 9.3). The motifs at San Baudelio are thought to derive from earlier Islamic objects.[37] Dodds has argued that the camel and the hunting scenes are among the most common images of

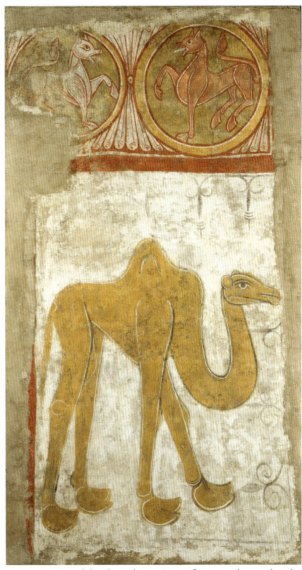

Fig. 9.3. San Baudelio de Berlanga, Spain, fresco with camel and beast roundels, 340.3 × 165.1 cm, c.1125. Metropolitan Museum of Art, New York, The Cloisters Collection, 1961, inv. no. 61.219. Photo: The Metropolitan Museum of Art.

379

aristocratic power and pursuits that characterize the courtly arts of the Umayyad caliphate and the succeeding *taifa* monarchies.[38] Several camels were represented in the 1130s on the painted ceiling of the Cappella Palatina in Palermo, Sicily, and the beast is also found on the mantle of King Roger II, which was produced in the royal workshop in Palermo.[39] An Arabic inscription dates the cloak to 528 AH (1133–34 CE). On it, two lions attack two camels, and the images were interpreted by Willy Hartner and Richard Ettinghausen as follows:

> As an official and public vestment, its iconography had to underline in a like manner these proud royal claims and do so in the symbolic language of the native population. Indeed, the recent conquest of and rule over an Arab land, as well as Roger's concern for the conversion of the "Saracens," could not be better expressed than by the age-old motif of the lion slaying a big but weaker animal. In this case, the latter was appropriately given in the shape of a camel instead of that of a bull.[40]

This ties in with Kapitaikin's observation that the camel at this point in time was associated with the "Saracens."

The camel also featured in patristic theology in a collection of heresies by the Syrian monk Yuhanna ibn Mansur ibn Sarjun, better known as John of Damascus (c.675–749). John is considered the last of the Church fathers and was himself experiencing the new challenge of Islam. He grew up in the former Christian city of Damascus, which in 634 had become the capital of the new Umayyad state. John refuted Islam theologically as a heresy and considered the Muslims idolaters. One of his works, titled "Heresy of the Ishmaelites," begins by tracing the genealogy of the Muslims.[41] John had knowledge of the Qur'an and most of the "heresies" are based on suras. One tells the story of "the Camel of God." John ridicules the tale by asking questions about the camel: "Was it begotten? Why didn't Muhammad find out more about the camel? Was it taken up to heaven? Did it drink up the river of water in heaven leaving only the river of milk and the river of wine?"[42] Only parts of the story about a she-camel sent to God are found in the Qur'an (there is no sura called "The Camel of God"), but John thought the whole tale reflected Muslim belief.[43] He used the camel to condemn such belief. What is important here is that John's critique of Islam in "Heresy of the Ishmaelites" featured in Christian polemics for centuries. In particular, the story of the camel was current at the time of the crusades in the early twelfth century. Therefore, a possible interpretation of the camel at Urnes is that it is associated with one of the early Norwegian expeditions to the Mediterranean, to be discussed below. Through this association it may have communicated cosmopolitan flair, as a detail familiar only to those who knew something of the wider, multicultural world.[44]

CHAPTER NINE | NORSE ENCOUNTERS WITH THE MEDITERRANEAN AND NEAR EASTERN WORLDS

The Griffin and the Female Acrobat

Two of the capitals of Urnes are hidden behind the railings of a seventeenth-century balustrade, so their motifs were unknown to Hohler and others who have written about these capitals. During restoration work in the 1970s the railings must have been removed, and wax rubbings of the hidden capitals were made. The drawings were published in Denmark in 1997 and in Germany in 2002 but have gone unnoticed by scholars. There are good reasons to trust these drawings, however, as they accord well with what is visible behind the railings.[45]

The first is a winged quadruped, possibly a griffin, with its foreleg raised and an elegant tail swung upward across the body (Plate 51). Most of the head is missing, but a long beard is visible. This suggests a connection with another example of a decorated cushion capital from the same period, in the nave of Stavanger Cathedral, built just before or at the same time as Urnes. The hitherto unknown hybrid beast at Urnes shares several features with the Stavanger beast, especially in the design of the hindquarters and the long tail.[46]

Fig. 9.4. Roda Bible, Catalonia, eleventh century. Worshipping the idol, from the book of Daniel; two acrobats with swords appear among the musicians in the upper right corner. Paris, Bibliothèque nationale de France, MS lat. 6, vol. 3, fol. 64v. Photo: Bibliothèque nationale de France.

381

PART THREE | THE TWELFTH-CENTURY CHURCH

Fig. 9.5. New Testament from Bury St. Edmunds, England, second quarter of twelfth century. The feast of Herod, including Salome dancing with swords. Cambridge, Pembroke College, MS 120, fol. 5v. Photo: Cambridge University Library.

The second shows a female acrobat (Plate 86). Her head points downward, her body is bent in an elegant curve, and she wears a long dress with long "butterfly" sleeves. In both hands she holds swords. Female acrobats are not known from twelfth-century Norwegian art, but there are Swedish and Danish examples.[47] Acrobats with swords are not novel; they clearly belong within the rest of the group of motifs discussed here. An early example of entertainers juggling swords may be seen in a richly decorated Catalan Bible from Sant Pere de Rodes (the Roda Bible), dated to the eleventh century (Fig. 9.4).[48]

There are numerous examples of female acrobats doing somersaults in medieval art, often in conjunction with musicians and jugglers entertaining at large banquets or royal feasts. Yet the motif can also be more specific: it is often associated with Salome dancing before Herod. According to the Gospels (Mark 6:14–29; Matt. 14:1–12), Herod had John the Baptist imprisoned because John had

CHAPTER NINE | NORSE ENCOUNTERS WITH THE MEDITERRANEAN AND NEAR EASTERN WORLDS

Fig. 9.6. Prayers and Meditations of St. Anselm, England, twelfth century. The feast of Herod, including Salome dancing with swords. Oxford, Bodleian Library, MS Auct. D.2.6 (S.C.3636), fol. 166v. Photo: The Bodleian Libraries, The University of Oxford.

been teaching that Herod's recent marriage to Herodias, his half-brother wife, was a violation of God's law. During a banquet, Herodias's daughter danced before Herod, who was so enchanted that he promised her a favor. At her mother's behest, she asked for the head of John the Baptist. The king has the head delivered to her on a plate (*in disco*).[49] The name of Herodias's daughter is not given in the New Testament, but according to Flavius Josephus's *Antiquities of the Jews*, her name was Salome.

The dance of Salome in medieval art is most thoroughly discussed in a dissertation by Torsten Hausamann.[50] Hausamann does not refer to any Scandinavian examples, but he collected and categorized a large number of dancing female acrobats in medieval art. Most of these can be identified as Salome. Hausamann divides the various images into types, one of which is the dance with the sword,[51] which, he argues, originated in English manuscripts. Two of these shows remarkable similarities with Urnes. The first is a miniature in a New Testament from Bury St. Edmunds. The manuscript begins with twelve apparently inserted pages that contain forty scenes from the life of Christ. The one on fol. 5v depicts Salome dancing below Herod's table with swords in both hands (Fig. 9.5).[52] With her feet over her head, she rests on her elbows and on the hilts of the two swords that she holds. The scene to the right shows the beheading of the Baptist with a sword, and, in the middle, Salome holds a dish with the Baptist's head. In both scenes she alone wears a long dress

383

with long sleeves. Scholars have debated whether the miniatures on these pages belonged to the Gospel book or were made originally for a Psalter, and the date of the manuscript is also uncertain, but C. M. Kauffmann relates the images to other manuscripts in Bury St. Edmunds and argues for a c.1130 date, which coincides with the capitals at Urnes.[53]

Another miniature depicting a dancing Salome with swords is in a book that contains the prayers and meditations of St. Anselm of Canterbury (d. 1109).[54] The manuscript has eighteen historiated initials and small miniatures joined to initials. In one of the latter Salome is doing a somersault with swords in both hands while two other swords float in the air (Fig. 9.6). Her dress has long sleeves, as at Urnes. The large initial *S* to the right frames the beheading of the Baptist below Salome holding his head on a charger. Kauffmann proposes a date of c.1150, two decades later than Urnes and the Bury manuscript.[55]

It is likely that the female acrobat at Urnes is ultimately based on the Salome character. The coincidence in time with the English manuscripts and the similarities in the swords and the long-sleeved dress support this interpretation. Whether the female Urnes acrobat is simply an acrobat with swords, as in the Catalan manuscript, or if she was intended to be Salome, is an open question, akin to whether the man fighting the lion on one of the other Urnes capitals is Samson (Plate 79). In the case of Salome, her place in the biblical narrative may be less important than her role as a courtly entertainer. This aspect of the acrobatic sword-dance accords with another of the more unusual motifs at Urnes: the dancing addorsed beard pullers.

The Beard Pullers

The beard pullers at Urnes were first discussed by Per Gjærder in 1964 (Plate 77).[56] He explained their bent feet as necessary for fitting the figures into the frame, and he noted the "curious head-cover shaped like three buds or leaves held together by a knot or a ring twist" and argued that this indicated crowns.[57] The hand gestures were read as commanding respect, adopted by kings and others in medieval representations.[58] Gjærder pointed to the early tenth-century cross of Muiredach at Monasterboice (Co. Louth, Ireland), on which men pull each other's beards, but he also suggested a source in Spain, where there is a striking resemblance to the Urnes image on two capitals in the monastery of San Juan de las Abadesas in Catalonia, and also the famous pair of beard pullers on a capital from Saint-Hilaire-le-Grand in Poitiers.[59] In addition to the examples cited by Gjærder, the closest parallel is the two addorsed beard pullers wearing short pleated skirts on a capital on the west facade of Saint-Jouin-de-Marnes (Deux-Sèvres).[60] In any case, the two beard pullers at Urnes are unique in the art of medieval Scandinavia.[61]

Scholars generally agree that the beard-pulling motif is Islamic in origin. The fundamental work on the topic is Zehava Jacoby's 1987 article,[62] in which she drew on literary and artistic sources to argue convincingly that the motif was ultimately inspired by the art of Sasanian Iran. Together with depictions of banqueting and hunting scenes, it later became a popular motif illustrating Islamic courtly entertainment, and the motif has also been related to troubadour poetry.[63]

CHAPTER NINE | NORSE ENCOUNTERS WITH THE MEDITERRANEAN AND NEAR EASTERN WORLDS

For the Urnes viewers, the beards of the griffin and the dancing men may have prompted specific associations with non-Europeans. In the Latin West, men were almost all clean-shaven during the eleventh and early twelfth century. With few exceptions, only Muslims, Byzantines, and Jews were bearded.[64] In the Bayeux Embroidery the French are beardless, and according to William of Malmesbury, English spies had reported to King Harold before the invasion that all the Norman soldiers were priests, "because they have their entire face, with both lips, shaved, whereas the English left the upper lip uncut, with the hairs ceaselessly flourishing."[65] Giles Constable also noted this in his introduction to a medieval text on beards, the "Apologia de barbis"; by the second half of the eleventh century many, perhaps most men in northern Europe, especially in France and England, shaved their beards.[66] Arabic chroniclers describe the European participants in the First Crusade as beardless men.[67] When the crusaders started to grow beards during the siege of Antioch in 1098, the French bishop Adhemar of Le Puy urged them to shave, "fearing that they might be confused in battle with the Muslims owing to the likeness of their beards."[68]

In certain cases the church had an almost hostile attitude towards beards. In the writings of Serlo, the bishop of Séez (Orne), bearded men are said to take after goats "whose filthy lasciviousness

Fig. 9.7. Josephus, *Jewish Antiquities*, England, first half of twelfth century. Confronted beard pullers intertwined with snakes and dragons. Cambridge, St. John's College (formerly Canterbury, Christ Church), MS A.8, fol. 91r. By permission of the Master and Fellows of St John's College, Cambridge.

385

is shamefully imitated by fornicators and sodomites."[69] Another example is provided by Godfrey, the bishop of Amiens, who on Christmas Day 1105 refused to celebrate mass for those wearing beards.[70] The practice was also invested with theological meaning. At the end of the thirteenth century William Durandus explained, "Hence, we shave our beards that we may seem purified by innocence and humility and that we may be like the angels, who always remain in the bloom of youth."[71]

What the beard pullers at Urnes have in common with the same motif in manuscripts is their juxtaposition with fierce animals, such as snakes, dragons, or lions. An elaborately decorated Josephus manuscript has a symmetrical arrangement of two beard pullers that has several similarities with Urnes. The manuscript is dated *c.*1100–40, so it is either contemporary with Urnes or slightly earlier (Fig. 9.7).[72] The two works share a common stock of motifs; the Jewish hats are drawn in the same manner as the Urnes manticore, leaf-sprouting masks are frequent, and birds, axes, and other familiar elements are present. Two dragons compose the initial *M*, which also features a pair of beard pullers.[73] The confronted pair is naked, entangled in serpents while holding onto their beards. The Josephus text tells the story of the Jews in biblical and Roman times, and the beard pullers accompany a long section where histories of conflicts with other groups, including the Arabs, also unfold. The illuminated letter may merely be ornamental, but the general use of symbols in the illuminations makes it likely that the beard pullers represent nonbelievers. Support for this interpretation can be found in the early twelfth-century mosaic of the Last Judgment at Santa Maria Assunta in Torcello, Italy. Among the damned in the lower register are groups of sinners being tormented in hell, and in the darkness at the far right are two naked men pulling their beards.[74]

Wilhelm Neuss attributed the tendency toward symmetry and stylization of the plants in early Catalan Bibles to Sasanian textiles brought to Spain by the Arabs.[75] Yet the beard pullers are not found in textiles, and therefore, unlike some of the other motifs at Urnes, their inspiration did not come from portable Eastern silks. Most of the imagery at Urnes can be found elsewhere in Romanesque architectural sculpture, but some combinations of features and certain creatures are seldom represented together in church decoration in the Latin West. The symmetrical arrangement of the beard pullers at Urnes and the two-plane relief might indicate a new, more direct influence of models related to or inspired by Islamic art, rather than a reuse of a motif already incorporated into the Romanesque stockpile.

The Beatus and Two Illustrated Catalan Bibles

Urnes boasts an interesting ensemble on its capitals: an acrobat, beard pullers, a centaur (Plate 87), a deer hunt (Plate 46), a camel, lions, dragons, and (possibly) Samson and the lion (Plate 79). To understand these motifs, it may be helpful to look at some influential manuscripts from the period just before the capitals were carved. The Spanish Beatus manuscripts are relevant not only because they depict beard pullers but also because they also contain several other motifs found at Urnes, such as camels, centaurs, and multiheaded beasts. These manuscripts were initially compiled by the Spanish monk Beatus of Liébana (Cantabria) in 776, based on Daniel and the book of Revelation.

CHAPTER NINE | NORSE ENCOUNTERS WITH THE MEDITERRANEAN AND NEAR EASTERN WORLDS

Beatus's commentary was widely copied and the text was often extensively illustrated.[76] The Saint-Sever Beatus of the mid-eleventh century depicts a pair of beard pullers similar to those at Urnes.[77] On fol. 3r, two angels stand in an arched setting below the winged lion of Mark (Fig. 9.8). Above the capitals of the arch, two balding men clad in short tunics stand symmetrically back to back while they pull their beards. To the right side, a simian is pointing to one of the beard pullers. John Williams suggested that the scene represents "an element of mockery," but no further explanation for the beard pullers in the Saint-Sever Beatus has been put forward.[78]

Meyer Schapiro emphasized that the Beatus manuscripts were made at a time of revived resistance to the Muslims and argued that the Apocalypse interested Christians in Spain because it foretold the victory over Antichrist, the destruction of Babylon (which was identified with the unbelievers), and the final Christian triumph. Schapiro also discussed the inclusion of the illustrated text of Jerome's commentary on the book of Daniel, which confirmed his interpretation of anti-Islamic ideology in the Beatus manuscripts: "it prophesies the fall of the godless kingdoms and the restoration of captive Israel."[79]

Related to the Beatus manuscripts are two Catalan manuscripts of the eleventh century, the Ripoll Bible and the previously mentioned Roda Bible. Both include pictorial cycles from the Old Testament. The Roda Bible is relevant because of an uncommonly extensive Daniel cycle, which in turn is linked to the Beatus manuscripts. When Neuss published the manuscript in 1922, he noted a strong influence from Mozarabic art and commented that the griffin, the lion with the leaf-shaped tail end, and the head of the cattle turned to the right look very similar to how these motifs appear in "Spanish-Moorish" reliefs.[80]

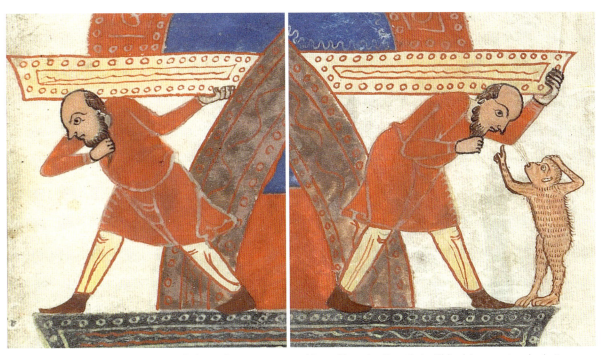

Fig. 9.8. Saint-Sever Beatus, France, mid-eleventh century, Two addorsed beard pullers. Paris, Bibliothèque nationale de France, MS lat. 8878, fol. 9r. Photo: Bibliothèque nationale de France.

387

PART THREE | THE TWELFTH-CENTURY CHURCH

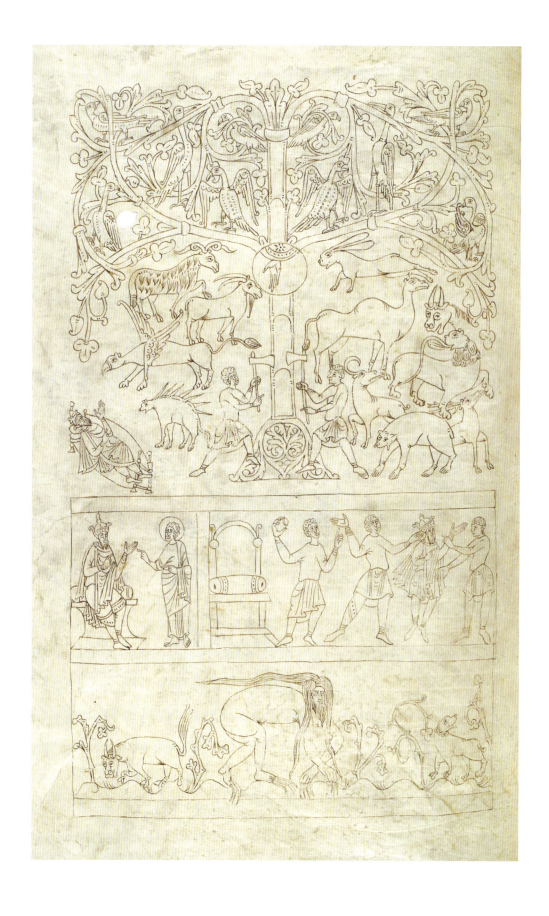

CHAPTER NINE | NORSE ENCOUNTERS WITH THE MEDITERRANEAN AND NEAR EASTERN WORLDS

LEFT AND ABOVE: Fig. 9.9a–c. Details from Roda Bible, Catalonia, eleventh century. Animals in Nebuchadnezzar's dream, from the book of Daniel. Paris, Bibliothèque nationale de France, MS lat. 6, vol. 3, fol. 65v. Photo: Bibliothèque nationale de France.

There are other similarities between the imagery at Urnes and the Roda Bible (Fig. 9.9). The birds, beasts and animals in the tree of Nebuchadnezzar's dream are in many ways similar to the fauna at Urnes: symmetrically arranged birds, a lion with its tail in the mouth, a griffin with beak and wings, a unicorn, a beast with several heads and, not least, a camel. Chapter four in the book of Daniel contains Nebuchadnezzar's dream of a great tree.[81] It is not only the fauna in Nebuchadnezzar's tree that reminds one of Urnes but also the flora: at Urnes the capitals of the four corner posts are all decorated with vegetation like the branches of a huge tree. These capitals differ from the others in that they are much larger and have a single astragal, whereas the others have three (Plates 48–49, 63–64, 74–75, and 88–89).

The two intertwined and fighting winged dragons in the Roda Bible also have stylistic parallels to the winged beasts at Urnes (Fig. 9.10). They are also closely related to the two dragons in the twelfth-century Josephus manuscript with the beard pullers, but there it is unclear what the miniature represents. Isolated

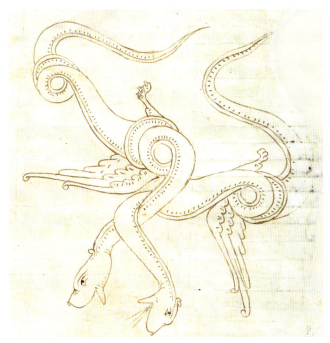

Fig. 9.10. Roda Bible, Catalonia, eleventh century. Winged dragons in Mardochai's dream, from the book of Esther. Paris, Bibliothèque nationale de France, MS lat. 6, vol. 2, fol. 122v. Photo: Bibliothèque nationale de France.

389

scenes found in the Roda Bible appear in the Beatus manuscripts, but there are also comparisons in architectural sculpture, such as a carved plinth in the porch of the church of Saint-Pierre in Airvault (Deux-Sèvres).[82] On a capital at Notre-Dame de Gargilesse (Indre), the fallen king Nebuchadnezzar is rendered as a quadruped next to a centaur and a deer hunt. The sculptor had a literary precedent for likening Nebuchadnezzar to a centaur in Jerome's commentary on Daniel.[83]

The Nebuchadnezzar capital in Gargilesse is part of a larger cycle of sculpted capitals.[84] Eight of them show the twenty-four elders of the Apocalypse, with three elders seated on each capital.[85] One in the south transept shows Samson and the lion (possibly also represented at Urnes) and Samson and Delilah. Also, in the south transept, a camel is depicted with two men sitting astride it. This scene was interpreted by Adelheid Heimann as Joseph sold to the Ishmaelites, a motif that has precedents in a Spanish context in the so-called Pamplona Bible. Another capital in this rich ensemble depicts a winged dragon between a lion and a man with a sword and kite-shaped shield.[86] The capitals in Gargilesse are dated slightly later than those at Moissac and Souillac, perhaps *c.*1140–45.[87] There are influences from Spain both in style and iconography.[88] Although the Gargilesse capitals depict a number of unconnected events, several seem to be closely connected to the illustrated Beatus commentaries.[89]

Penelope Mayo has demonstrated that, in 1120, Lambert of Saint-Omer's *Liber floridus* connected Daniel's interpretation of Nebuchadnezzar's second dream with the triumph of the First Crusade. In one of the miniatures, Nebuchadnezzar's tree is cut down by a crusader king, such that the evil ruler is symbolically destroyed by the crusader.[90] Several scholars have argued that the illuminated Beatus manuscripts were often freighted with anti-Islamic ideology. John Williams stated that in these manuscripts, Muslims "came to be identified with the anti-Christian forces of the Apocalypse and the book of Daniel."[91]

Sermons in the early twelfth century could also be filled with anti-Islamic rhetoric.[92] When referring to the capture of a prominent crusader, the congregation "prayed for God to deliver him, just as he had delivered Daniel 'and the three children and the other sons of the Babylonian Captivity under Nebuchadnezzar.'"[93] Such crusader chroniclers as William of Tyre and Fulcher of Chartres "often reminded their readers that Nebuchadnezzar and the Babylonians destroyed the Temple."[94] As early as Isidore of Seville's commentary on the book of Daniel in the early seventh century, Babylon was "the symbolic kingdom of heretics" and by the late eleventh century, Babylon was the "mystical capital of the infidel"; when referring to the Muslim control of Jerusalem, it was described as her "Babylonian captivity," and by the twelfth century, Babylon obviously represented the Arab Muslims.[95] At the First Lateran Council in 1123 Calixtus granted indulgence to anyone defending Christendom against the "tyranny of the infidel" both in Spain and the Levant.[96]

In a 1944 article about Vézelay by Adolf Katzenellenbogen, Romanesque architectural sculpture was for the first time related to the crusades.[97] Since the 1970s Linda Seidel has also explored Islamic features in French Romanesque architectural sculpture and their relation to the crusades. Focusing on western France, she observed that some motifs closely resemble Muslim workmanship and explains this as result of both appreciation and intentional appropriation of the arts of Islam.[98] Seidel identified the image of the rider in Romanesque facades with the struggle against Islam and posited that, "Perhaps by imitating Islam's forms and by popularizing them, the West thought it

could mitigate the powerful challenge of its enemy."[99] In another study she connected polylobed arches on church facades in Aquitaine with the idea of triumph, as "elegant souvenirs of conquest: the tangible fruits of victory framed by the borrowed symbol of triumph."[100]

Crusade Propaganda or Exotic Souvenirs?

How did these motifs come to Urnes, and what cultural horizon might they reflect? There are no parallels preserved elsewhere in Scandinavia for this unusual ensemble. Such formal and iconographic features as the two-plane relief, the isolation of objects within a frame, symmetry, and, not least, beard pullers and exotic animals like the camel point to the Mediterranean region. Islamic and Byzantine cultures had for centuries served as an active source of inspiration for European artists.[101] Several of the motifs and formal features in the Urnes capitals are found in Byzantine art.[102]

The earliest Norse travelers are nameless, but sources indicate that Norsemen went into the Byzantine imperial service as Varangian mercenaries under the Byzantine emperors as early as the ninth century. In the tenth century there are better sources, and Emperor Basil II (r. 976–1025) is known to have had several Varangians of Norse origin among his personal bodyguards.[103] In addition, Old Norse kings' sagas and foreign sources record that several named Norwegian aristocrats went to the Mediterranean and the Holy Land in the eleventh and early twelfth centuries, for various reasons.[104] When King Óláfr II Haraldsson (c.995–1030) went to Spain in 1014 or 1015, the incident was also documented by the skald Sigvatr Þórðarson, active in the first half of the eleventh century. In one of his poems, we are told that Óláfr sailed all the way to Seljupollar (the Guadalquivir River in southern Spain) where he fought a battle and conquered a castle named Gunnvaldsbor, where he captured the local earl, Geirfith.[105] Shortly after this we hear of Brynjólfr "the Camel."[106]

Snorri also relates that the Norwegian nobleman Einarr Þambarskelfir sailed across the sea in c.1023 and made his way to Rome, returning the following summer.[107] In an expanded version of the Separate Saga of St. Óláfr we are also told that Óláfr's skald Sigvatr Þórðarson went to Rome in 1029 with another Icelandic skald named Bersi Skáldtorfuson.[108] The source value of the kings' sagas is debated because the events were written down at a later stage and compiled into books only in the thirteenth century, but foreign sources also document that a considerable number of Scandinavians journeyed to the Mediterranean and western Asia in the eleventh and twelfth centuries. One such source is the *Verbrüderungsbuch* from Reichenau, which contains about 700 names of Scandinavian travelers to the south in those two centuries.[109]

The earliest Norwegian journey to the Holy Land mentioned in the kings' sagas was Þórir hundr (Thorir the Hound), who is said to have traveled to Jerusalem shortly after the fall of King Óláfr Haraldsson in 1030.[110] A few years later, King Óláfr's half-brother Haraldr Sigurðarsonar harðráði ("the hard ruler") went to Sicily and "Serkland" (Saracen Land). Haraldr became the most notable of all the Norse Varangians, and he stayed there as a mercenary and military commander from 1034 to 1043. In c.1036 he visited Jerusalem and bathed in the River Jordan, a symbolically charged incident

also documented in other sources.[111] Snorri also stated that Haraldr "made great gifts to our Lord's sepulcher as well as to the Holy Cross and other sacred places in Jerusalem Land."[112]

From Norwegian chronicles we learn that several members of the Scandinavian elite went on journeys to the Mediterranean and the Near East during the eleventh and early twelfth centuries.[113] The first Norwegian to initiate a crusade was Skopti Ǫgmundarson, who belonged to the aristocratic Arnmoeðlingar family in western Norway. Skopti was one of the king's landed men who left Norway after a dispute with King Magnús berfœttr ("Barelegs"; r. 1093–1103). Skopti's expedition was accompanied by five warships. A typical large warship could have twenty-five pairs of oars, and with each oar powered by two men, the crew would total about 100 men for each ship. The sources also state that "many district chieftains and other powerful men" participated in the journey. Skopti died in Rome and his son Þórðr in Sicily, but Snorri tells that in 1103, the men who had gone abroad with Skopti returned from the Holy Land.[114] The most famous of the Norwegian journeys was King Sigurðr Magnússon (r. 1103–30); his crusading campaign to the Holy Land in 1108–11 was the first in which a European king participated. On his return to Norway, Sigurðr received the nickname "Jórsalafari" (Jerusalem-goer). The expedition was well known in Europe in the twelfth century and was recorded by several chroniclers, including Fulcher of Chartres, Albert of Aix, William of Malmesbury, and William of Tyre.[115]

When King Sigurðr left for his great expedition, he was accompanied by sixty ships, a number confirmed by Fulcher of Chartres. The number of men who participated is more difficult to estimate; earlier historians assumed as many as 10,000 men, but a more careful estimate is "not less than 6000–8000 men."[116] Before Sigurðr arrived in the Holy Land in 1110, he stayed for a longer time in England, Spain, and Sicily, where he met Count Roger of Sicily, the future King Roger II. In Jerusalem he was warmly welcomed by King Baldwin I. That same year, he helped capture the coastal city of Sidon, and before his return to Norway he received a splinter from the True Cross as a precious relic.

In a letter written a few years later, in 1119, Pope Calixtus II greeted the two Norwegian kings Sigurðr and his brother Eysteinn Magnússon (r. 1103–23) as "his beloved sons in Christ."[117] Four years later, in 1123, the Abbot Peter of Cluny ("the Venerable") referred to King Sigurðr as a friend of Cluny.[118] The international orientation of the Norwegian aristocracy is confirmed not least by a letter from the famous abbot, who thanked Sigurðr because he had declared himself a protector of the church of God and because he "by land and sea had driven back the enemies of the faith, not only from his land but also in distant lands to the south and the east."[119]

When the first timber logs for the new church at Urnes were felled in 1129–30, Sigurðr was still ruler of Norway. We can assume that planning the church and its interior decoration had begun at least a year in advance. We know nothing about the relationship between King Sigurðr and the anonymous patron at Urnes, but later in the twelfth century, the local lord was firmly attached to the king as one of his landed-men—the Norse equivalent of a Continental baron.[120] The Norwegian aristocracy was closely tied together through kinship, friendship, or alliances.[121] It is thus probable that there is a connection between the traveling Norwegian elites and the aristocratic family at Urnes, and men from Urnes may well have traveled with the king.

One of the potential explanations for the exceptional sculpture at Urnes could be a desire to evoke visually memories of expeditions to the Mediterranean and Near East in the eleventh and early

34 Francis Klingender, *Animals in Art and Thought to the End of the Middle Ages*, ed. Evelyn Antal and John Harthan (London, 1971).

35 Marie-Thérèse Camus, *Sculpture romane du Poitou: Les grands chantiers du XIe siècle* (Paris, 1992), 109–11; and Walter Cahn, *The Romanesque Wooden Doors of Auvergne* (New York, 1974), ill. 55.

36 Jerrilynn D. Dodds, "Wall Paintings," in *The Art of Medieval Spain: A.D. 500–1200* (New York, 1993), 223–28, cat. no. 103.

37 Juan Zozaya, "Algunas observaciones en torno a la ermita de San Baudelio de Casillas de Berlanga," *Cuadernos de la Alhambra* 12 (1976): 307–38.

38 Dodds, "Wall Paintings," 226.

39 Willy Hartner and Richard Ettinghausen, "The Conquering Lion, the Life Cycle of a Symbol," *Oriens* 17 (1964): 161–71, at 164; and see also Kapitaikin, "Paintings of the Aisle-Ceilings," 119–20, fig. 20.

40 Hartner and Ettinghausen, "Conquering Lion," 164.

41 "There is also a coercive religion of the Ishmaelites which prevails at this time and deceives the people, being the forerunner of the Anti-Christ. It originates from Ishmael, who was brought forth from Hagar unto Abraham, and for this very reason they are called Hagarenes or Ishmaelites. They are also called Saracens from the word 'Σάρρας κενούς' because of what was said by Hagar to the angel, 'Sarah has sent me away empty.'" Daniel J. Janosik, *John of Damascus, First Apologist to the Muslims: The Trinity and Christian Apologetics in the Early Islamic Period* (Eugene, OR, 2016), appendix C, 260–68, at 260.

42 Ibid., 214.

43 Norman Daniel, *Islam and the West: The Making of an Image* (Edinburgh, 1960), 13–14.

44 Snorri Sturluson, *Heimskringla: Nóregs konunga sǫgur*, ed. Finnur Jónsson (Copenhagen, 1911), chaps. 61–62.

45 The drawings of the hidden capitals are published in Flemming Distler, *Stavkirkernes billedsprog: Fordybelse og tolkning* (Aarhus, 1997), 30, 36, 70, and 114.

46 Christopher Hohler, "The Cathedral of St. Swithun at Stavanger in the Twelfth Century," *Journal of the British Archaeological Association*, ser. 3, 27 (1964): 92–118.

47 The other Scandinavian examples are discussed in Jan Svanberg, "Salomes dans i Nordens medeltida konst," in *Kvindebilleder: Eva, Maria og andre kvindemotiver i middelalderen*, ed. Karin Kryger, Louise Lillie, and Søren Kaspersen (Copenhagen, 1989), 201–17.

48 BnF, MS lat. 6, vol. 3, fol. 64v. See https://archivesetmanuscrits.bnf.fr/ark:/12148/cc620519; digitized at https://gallica.bnf.fr/ark:/12148/btv1b85388130/f132.item.

49 For a recent discussion of the motif, see Barbara Baert, *Revisiting Salome's Dance in Medieval and Early Modern Iconology* (Leuven, 2016).

50 Torsten Hausamann, *Die tanzende Salome in der Kunst von der christlichen Frühzeit bis um 1500: Ikonographische Studien* (Zurich, 1980).

51 Ibid., 391–97.

52 Cambridge, Pembroke College, MS 120, fol. 5v.

53 C. M. Kauffmann, *Romanesque Manuscripts, 1066–1190*, A Survey of Manuscripts Illuminated in the British Isles 3 (London, 1975), 74–75, cat. no. 35; and Hausamann, *Die tanzende Salome*, 391.

54 Oxford, Bodleian Library, MS Auct. D. 2. 6, fol. 166v. See https://medieval.bodleian.ox.ac.uk/catalog/manuscript_438; digitized at https://digital.bodleian.ox.ac.uk/objects/1f893d08-f517-4fa8-9e20-02c225c70b71/surfaces/e3eb7535-d73d-42f2-9f26-3cb72f22171c/.

55 Kauffmann, *Romanesque Manuscripts*, 103–4, cat. no. 75; and Hausamann *Die tanzende Salome*, 392.

56 Per Gjærder, "The Beard as an Iconographical Feature in the Viking Period and the Early Middle Ages," *Acta Archaeologica* 35 (1964): 95–114.

57 Ibid. 112.

58 Ibid.

59 Ibid., figs. 21, 22, and 24. See also Roger Stalley, *Early Irish Sculpture and the Art of the High Crosses* (London, 2020), 76, plate 98.

60 Katherine Watson, *French Romanesque and Islam: Andalusian Elements in French Architectural Decoration c.1030–1180* (Oxford, 1989); and Bernhard Rupprecht, *Romanische Skulptur in Frankreich* (Munich, 1975), plate 105.

61 Gjærder, "Beard as an Iconographical Feature," 114.

62 Zehava Jacoby, "The Beard Pullers in Romanesque Art: An Islamic Motif and Its Evolution in the West," *Arte medievale*, ser. 2, 1 (1987): 65–85.

63 Ibid., 78; and Marc Sandoz, "Le chapiteau 'de la dispute' du Musée des Beaux-Arts de Poitiers," in "Dibutade VII," special supplement to *Bulletin des amis des Musées de Poitiers*, 1960, 11–33, at 11.

64 Reginald Reynolds, *Beards: An Omnium Gatherum* (London, 1950), 71–94.

65 Ibid.

66 Giles Constable, "Introduction to *Burchardi, ut videtur, Abbatis Bellevallis Apologia de Barbis*," in *Apologiae duae: Gozechini Epistola ad Walcherum; Burchardi, ut videtur, abbatis Bellevallis Apologia de barbis*, ed. R. B. C. Huygens (Turnhout, 1985), 46–130, at 95.

67 Ibid., 67–68.

68 Cited in Jacoby, "Beard Pullers in Romanesque Art," 66.

69 Cited in Reynolds, *Beards*, 94.

70 Ibid.

71 William Durandus, *Rationale Divinorum officiorum*, vi.86; cited in ibid., 19.

72 C. R. Dodwell, *The Canterbury School of Illumination: 1066–1200* (Cambridge, 1954), 22.

73 Josephus, *Jewish Antiquities XV–XX*, in Cambridge, St. John's College (formerly Canterbury, Christ Church), MS A.8, fol. 91r. See https://www.joh.cam.ac.uk/library/special_collections/manuscripts/medieval_manuscripts/medman/A_8.htm; digitized at https://www.joh.cam.ac.uk/library/special_collections/manuscripts/medieval_manuscripts/medman/A/Web%20images/A8f91r.htm.

74 Visited by the author, May 2008. The gestures of the damned in Torcello are discussed in Moshe Barasch, *Gestures of Despair in Medieval and Early Renaissance Art* (New York, 1976), 3. However, Barasch does not

mention the beard pullers among the group of suffering sinners being tormented in hell. Several scholars have suggested that the Torcello mosaic was the model for the Last Judgment scene at Hólar Cathedral in Iceland. See Selma Jónsdóttir, *An 11th Century Byzantine Last Judgement in Iceland* (Reykjavík, 1959); and Hörður Ágústsson, *Dómsdagur og helgir menn á Hólum* (Reykjavík, 1989).

75 Wilhelm Neuss, *Die katalanische Bibelillustration um die Wende des ersten Jahrtausends und die altspanische Buchmalerei: Eine neue Quelle zur Geschichte des Auslebens der altchristlichen Kunst in Spanien und zur frühmittelalterlichen Stilgeschichte* (Bonn, 1922), 91.

76 John Williams, *The Illustrated Beatus: A Corpus of the Illustrations of the Commentary on the Apocalypse*, 5 vols. (London, 1994–2003). Williams lists twenty-six extant illustrated commentaries of Beatus. A further copy appeared in Switzerland in 2007, Geneva, Bibliothèque de Genève MS lat. 357.

77 BnF, MS lat. 8878. Ibid., 2:44–57, cat. no. 13; and https://archivesetmanuscrits.bnf.fr/ark:/12148/cc62407d.

78 Ibid., 3:51. Image at https://gallica.bnf.fr/ark:/12148/btv1b52505441p/f9.item.

79 Meyer Schapiro, "The Beatus Apocalypse of Gerona," *ARTnews* 16.9 (1963): 36–50, at 50.

80 Ibid., 91.

81 "This was the vision of my head in my bed: I saw, and behold a tree in the midst of the earth, and the height thereof was exceeding great. The tree was great, and strong: and the height thereof reached unto heaven: the sight thereof was even to the ends of all the earth. Its leaves were most beautiful, and its fruit exceeding much: and in it was food for all: under it dwelt cattle and beasts, and in the branches thereof the fowls of the air had their abode: and all flesh did eat of it" (Dan. 4:10–12). Ibid.

82 Anat Tcherikover, "The Fall of Nebuchadnezzar in Romanesque Sculpture (Airvault, Moissac, Bourg-Argental, Foussais)," *Zeitschrift für Kunstgeschichte* 49.3 (1986): 288–300. Tcherikover also notes that the style in Airvault could have been influenced by the neighboring church at Saint-Jouin-de-Marnes, dated to the early twelfth century. The beard pullers on a capital on the west facade (illustrated in Rupprecht, *Romanische Skulptur*, plate 105) have a close resemblance to those at Urnes.

83 Tcherikover, "Fall of Nebuchadnezzar," 298; and Gleason L. Archer Jr., trans., *Jerome's Commentary on Daniel* (Grand Rapids, MI, 1958), 512–13.

84 Adelheid Heimann, "The Master of Gargilesse: A French Sculptor of the First Half of the Twelfth Century," *Journal of the Warburg and Courtauld Institutes* 42 (1979): 47–64, at 52.

85 Ibid., 49.

86 Ibid., 57.

87 Ibid., 63.

88 Ibid., 54.

89 Ibid., 51. Heimann also comments (49) that twelfth-century representations of the Elders all depend ultimately on illustrated Spanish Beatus manuscripts.

90 Penelope C. Mayo, "The Crusaders under the Palm: Allegorical Plants and Cosmic Kingship in the *Liber Floridus*," *Dumbarton Oaks Papers* 27 (1973): 29–67; and Anne Derbes, "Crusading Ideology and the Frescoes of S. Maria in Cosmedin," *Art Bulletin* 77.3 (1995): 460–78, at 474.

91 John Williams, *Early Spanish Manuscript Illumination* (New York, 1977), 27; and Derbes, "Crusading Ideology," 476.

92 Derbes, "Crusading Ideology," 473.

93 Orderic Vitalis, cited in ibid., 474.

94 Ibid.

95 Ibid.

96 Ibid., 475.

97 Adolf Katzenellenbogen, "The Central Tympanum at Vézelay: Its Encyclopedic Meaning and Its Relation to the First Crusade," *Art Bulletin* 26.3 (1944): 141–51.

98 Linda V. Seidel, "Holy Warriors: The Romanesque Rider and the Fight against Islam," in *The Holy War*, ed. Thomas Patrick Murphy (Columbus, OH, 1976), 33–77.

99 Ibid., 44–45.

100 Linda Seidel, *Songs of Glory: The Romanesque Façades of Aquitaine* (Chicago, 1981), 75.

101 John M. MacKenzie, *Orientalism: History, Theory, and the Arts* (Manchester, 1995), xiii.

102 Pulling one's hair or beard is a sign of sorrow in Byzantine art; see, e.g., https://digi.vatlib.it/view/MSS_Vat.gr.1754, fol. 6r. Henry Maguire, "The Depiction of Sorrow in Middle Byzantine Art," *Dumbarton Oaks Papers* 31 (1977): 123–74; and Henry Maguire, "The Asymmetry of Text and Image in Byzantium," *Perspectives médiévales: Revue d'épistémologie des langues et littératures du Moyen Âge* 38 (2017), https://journals.openedition.org/peme/12218.

103 Sigfús Blöndal, *The Varangians of Byzantium: An Aspect of Byzantine Military History*, trans., rev., and rewritten by Benedikt S. Benedikz (Cambridge, 1978).

104 The medieval sources are discussed in Pål Berg Svenungsen, "Norge og korstogene: En studie av forbindelsene mellom det norske riket og den europeiske korstogsbevegelsen, ca.1050–1380" (PhD diss., University of Bergen, 2016); https://bora.uib.no/bora-xmlui/bitstream/handle/1956/11579/dr-thesis-2016-P%c3%a5l-Berg-Svenungsen.pdf. See also Kurt Villads Jensen, *Crusading at the Edges of Europe: Denmark and Portugal, c.1000–c.1250* (London, 2017).

105 Snorri, *Heimskringla*, ed. Hollander, 257–58, *Saint Olaf's saga*, chap. 17. Óláfr's stay in Spain is also documented by contemporary Spanish sources; see Rui Pinto de Azevedo, "A expedição de Almançor a Santiago de Compostela em 997, e de piratas normandos à Galiza em 1015–16 (Dois testemunhos inéditos das depredações a que então esteve sujeito o Território Portugalense entre Douro e Ave)," *Revista portuguesa de história* 14 (1974): 73–93; and Jensen, *Crusading at the Edges of Europe*, 77–78.

106 Snorri, *Heimskringla*, ed. Hollander, 294–95, *Saint Olaf's saga*, chaps. 61–62.

107 Ibid., chap. 121.

108 *Saga Óláfs konungs hins Helga: Den store saga om Olav den hellige, efter pergamenthåndskrift i Kungliga bibliotheket i Stockholm nr. 2 4to med varianter fra andre håndskrifter*, ed. Oscar Albert Johnsen and Jón Helgason (Oslo, 1941), 2:830. See also Bersi Skáld-Torfuson, https://skaldic.abdn.ac.uk/m.php?p=skald&i=20.

109 Johanne Autenrieth, Dieter Geuenich, and Karl Schmid, eds., *Das Verbrüderungsbuch der Abtei Reichenau: Einleitung, Register, Faksimilie* (Hannover, 1979); see also Svenungsen, "Norge og korstogene," 41. Zurich, Zentralbibliothek, MS Rh. hist. 27, digitized at https://www.e-codices.unifr.ch/en/list/one/zbz/Ms-Rh-hist0027.

110 Snorri, *Heimskringla*, ed. Hollander, 549, *Saga of Magnús the Good*, chap. 11.

111 Ibid., 586–87, *Saga of Harald Sigurðarsonar*, chaps. 11–12; and Blöndal, *Varangians of Byzantium*, 54–102.

112 Snorri, *Heimskringla*, ed. Hollander, 587, *Saga of Harald Sigurðarsonar*, chap. 12. See also *Morkinskinna: The Earliest Icelandic Chronicle of the Norwegian Kings (1030–1157)*, trans. Theodore M. Andersson and Kari Ellen Gade (Ithaca, NY, 2000), 144–51, *Haraldr's Journey to Jerusalem*, chap. 13.

113 Jensen, *Crusading at the Edges of Europe*, 77–78; and Svenungsen, "Norge og korstogene."

114 Snorri, *Heimskringla*, ed. Hollander, 688, *Saga of the Sons of Magnus*, chap. 1. See also Blöndal, *Varangians of Byzantium*, 136–37.

115 Rudolf Keyser, "Bidrag til Kong Sigurd Jorsalfarers Historie," in *Samlinger til det norske folks sprog og historie* (Christiania, 1833), 1:87–128.

116 Blöndal, *Varangians of Byzantium*, 137.

117 "Calixtus episcopus servus servorum Dei dilectis in Christo filiis Aistano et Siwardo Norvegiæ regibus salutem et apostolicam benedictionem." Eirik Vandvik, ed. and trans., *Latinske dokument til norsk historie fram til år 1204* (Oslo, 1959), 34–35, 138 (no. 3).

118 "Nobilissimo regum et nostrae societatis amico Sigiuardo Noruuegiae regi." Giles Constable, ed., *The Letters of Peter the Venerable* (Cambridge, MA, 1967), 1:140.

119 "qualiter uos protectorem aecclesiae dei constitueritis, qualiter inimicos crucis Christi, a fidelium dominatione non tantum in uestris, sed etiam in remotissimis meridiei et orientis finibus, ui bellica terra marique et olim reppuleritis." Ibid., 1:141 (letter 44); and 2:128. See also Svenungsen, "Norge og korstogene," 9–10, 70–71.

120 Hallvard Magerøy, "Urnes stavkyrkje, Ornes-ætta og Ornesgodset," *Historisk tidsskrift* 67.2 (1988): 121–44; and Jo Rune Ugulen, "Kring ætta på Ornes og Mel i mellomalderen, samt noko om Rane Jonssons etterkomarar og slekta Hjerne (Hjärne)," *Norsk slektshistorisk tidsskrift* 39.1 (2004): 235–316.

121 Jón Viðar Sigurðsson, *Viking Friendship: The Social Bond in Iceland and Norway, c.900–1300* (Ithaca, NY, 2017).

122 Jaroslav Folda, "Commemorating the Fall of Jerusalem: Remembering the First Crusade in Text, Liturgy, and Image," in *Remembering the Crusades: Myth, Image, and Identity*, ed. Nicholas Paul and Suzanne Yeager (Baltimore, 2012), 125–45.

123 Trans. in Jensen, *Crusading at the Edges of Europe*, 105. "Quid aliud uos, o Galli Germanique populi, quid aliud uos Daci et Norici, barbarie uirtuteque feroces, quorum alii terreno, alii marino itinere sacrum locum bellicis sudoribus, fuso cruore, sed praeclara uictoria a iugo / Persarum et Arabum eruistis ; quid aliud, inquam, mercedis pro tantis laboribus sustinuistis?" Giles Constable, "Petri Venerabilis sermones tres," *Revue Bénédictine* 64 (1954): 224–72, at 246.

124 The manual is transcribed and edited by Kurt Villads Jensen (2007), http://www.jggj.dk/saracenos.htm.

125 Derbes, "Crusading Ideology," 460.

126 Ibid.

127 Dodds, "Wall Paintings," 227.

128 Seidel, *Songs of Glory*, 75.

PART THREE | THE TWELFTH-CENTURY CHURCH

Fig. 10.1. Hopperstad church, Norway, cushion capital in nave, twelfth century. Photo: Author.

CHAPTER 10

Plants, Beasts, and a Barefoot Cleric

Elizabeth den Hartog

Introduction

OF AN ESTIMATED TWELVE HUNDRED STAVE CHURCHES that once existed in Norway, the church of Urnes is the oldest of the thirty to have survived.[1] By means of dendrochronology, the present church, which had three predecessors, is securely dated between *c.*1129 and 1131.[2] The relatively small size and timber construction of the Urnes church do not imply that it was either a run-of-the-mill or a folkish building, as even kings erected important structures in wood in early twelfth-century Norway.[3] Indeed, the church stands out for its unusually rich sculptural decoration.

Along the four sides of the nave interior, a series of eighteen posts support cushion capitals carved with dragons, animals, birds, hybrids, plants, and men on their inward-facing sides. The abatements supporting the roof beams are covered with tapering strips of ornament. As in the stave churches at Hopperstad and Borgund, the church used to be enveloped by a pentice, of which only the western section has survived. Its varied supports include seven plain cushion capitals and one decorated specimen; there were probably more such carved capitals originally.[4] Two badly damaged twelfth-century capitals with dragons flank the church's western doorway (Plates 41 and 95). Was the ornamental richness of the Urnes church as unique as it now seems? One of the aims of this chapter is to find an answer to this question.

Before addressing the capitals themselves, I first provide an overview of what little is known about the church's history. Next, to consider the origin of the Urnes workshop, I discuss the derivation of the strangely elongated cushion capitals and ask whether the capital sculpture of the pentice was part of the 1129–31 campaign or was added later, a topic debated in the literature on Urnes. Some of the graffiti in the church is quite similar to imagery on the capitals and is thought to have been made by the workforce building the church. This needs to be evaluated to see what clues the graffiti provide about the provenance of the workforce. I devote the final part of the chapter to the sculptural iconography and its significance in the context of early twelfth-century Norway.

The Church's History

Unfortunately, little is known about the history of either Urnes or its church. *Sverris saga* mentions a Gautr from Ornesi among the men who joined King Magnús Erlingsson in battle at Bergen in 1181.[5] In 1309 Urnes belonged to Bjarne Erlingsson of Bjarkøy, then one of the richest men in Norway.[6] The Urnes estate appears to have been wealthy, for the tithes due to the bishop were as high as those of the churches of Hafslo and Dale, which were supported by large parishes (the church's economy is discussed further in Chapter 2). The church itself is first mentioned in 1323 and is thought to have been a private (burial) chapel belonging to a manor or estate, servicing the lord of the estate, his family, and retainers as well as people from the outlying farms.[7]

As for the ecclesiastical affiliation of Urnes, by the late eleventh century Norway's conversion was sufficiently advanced for dioceses to be formed at Bergen (previously Selja), Trondheim, and Oslo. The division into ecclesiastical districts followed that of the four law districts: Gulaþing (Bergen), Frostaþing (Trondheim), Borgarþing, and Eidsifaþing (Oslo).[8] Urnes belonged to the bishopric of Bergen. The three early Norwegian bishoprics were initially subject to the archbishopric of Hamburg-Bremen (Germany). Of these bishoprics, Trondheim had pride of place, as it was in this region that St. Óláfr was murdered around 1030, and his relics were kept in the town. There was even a rule that only descendants of St. Óláfr could be kings of Norway, and their main task was to spread the faith and build churches. In 1104, with the help of the Danish king Erik "the Good" and Pope Paschal II, the bishopric of Lund (then part of Denmark), which until then had been a suffragan diocese of Hamburg-Bremen, was established as a Scandinavian archbishopric in its own right. The three Norwegian bishoprics became suffragan dioceses of Lund, whose first archbishop was Asser Thorkilsen (d. 1137).[9] In short, the paucity of historical evidence means that the Urnes church has to tell its own story through its architecture and decoration.

The Shape of the Urnes Capitals

In this section I focus on the rather unusual shape of the Urnes cushion capitals, which may tell us something about their workshop's provenance. The capitals are of the so-called cushion type, which can be described as follows: "The cushion capital makes the transition from the circular section of the shaft to the square section of the abacus or springing points of the arch by means of a sphere interpenetrating with a cube, forming a lunette shape or shield on each of its four faces."[10] Most of the cushion capitals in the nave at Urnes consist of an astragal, or necking, of three bands surmounted by an elongated shield of unusual proportions, with a height-width ratio of 7:8 rather than the 4:8 proportions generally employed for cushion capitals in Continental Europe. The Urnes capital shields are consistently framed by a ring consisting of a keel, groove, and fillet, with a simple horizontal edging on top that is surmounted, as part of the same block, by a nonprojecting impost decorated with a fillet between two grooves. The area between necking and shields is cut away "in such a sharp concave curve as to give the impression the shields are actually overhanging."[11] As

some of the posts were insufficiently wide to achieve the cushion form, a number of capitals needed to have additional corners pegged onto them.[12] The two capitals on the church's axis are smaller and have a necking consisting of a single roll (Plates 42–44; and 68–70). The eastern axis capital (Plates 68–70), moreover, has leaves on its lower angles with stems that spill onto the column below where they interconnect, while being constrained, as it were, by the astragal that embraces them.

The fact that some capitals were widened by pegging on extra parts to enlarge the space for imagery may also explain why the arcade arches rest directly on the capitals and not, as is usual in stone architecture, on impost blocks (abaci). At Urnes, the blocks of wood required to make the abaci would have had to be very large indeed, or made up of parts, in which case they would have weakened the construction. In the Hopperstad stave church, which dates to the same time as Urnes and which may well have been built by the same workshop, the capitals are only slightly wider than the columns, so there the problem would not have occurred, and abaci mark the transition between the capitals and arches. The Hopperstad capitals have semicircular rather than elongated shields, and, instead of the profiled edging, a simple broad band set off between two incised lines with no horizontal top edge frames the shield. The lower corners of the capital bulge out and the necking has just one roll (Fig. 10.1).

Other stave churches with cushion capitals include those at Ål, Borgund, Kaupanger, Fortun, Vangsnes, Torpo, and Nore, but these capitals differ in their proportions from those at Urnes. The only similar profiles are on a cupboard of *c.*1200 from the church of Årdal in Sogn, now in the Bergen University Museum.[13] Finding no parallels for the Urnes capitals in wooden architecture, Martin Blindheim argued in 1965 that their form derived from Germany or from the German-influenced art of southern Scandinavia.[14] In a 1976 article Erla Bergendahl Hohler largely concurred with this assessment. Noting the presence in wooden stave churches of many architectural elements derived from stone architecture, among them the capitals, she concluded that architecture in stone provided the ultimate prototype for the Urnes church. She found this thesis difficult to confirm, however, for very little Romanesque architecture of the first half of the twelfth century has survived from the main ecclesiastical centers in Norway. Not only is there a "nearly complete absence in the country of decent-looking cushion capitals" but the two great twelfth-century artistic centers in Norway, Bergen and Trondheim, seem to have preferred "any other type of capital—volute, scallop, and Corinthian respectively—to the plain cushion."[15] Hohler also held that figurative cushion capitals (and bases) were only to be found in the Telemark region, most notably in the portals of the small churches at Nes (*c.*1150) and Lunde.[16]

According to Hohler, the cushion-type capital derived from Jutland, especially the area around Viborg, where the elongated cushion form (Bjerregrav, Linaa, Kobberup, and Sjørslev), corner leaves (Tanderup), and nonprojecting abaci (Sjørslev) also appear. The inspiration for these Danish capitals probably came from the now lost Viborg Cathedral, which was staffed by Augustinian canons from its foundation in 1080. From this she concluded that the forms and motifs of the Urnes capitals derived from the granite sculpture of Jutland, whereas the details derived from the mid-twelfth-century artistic milieu of Trondheim. This led Hohler to date the Urnes church to the third quarter of the twelfth century.[17] In a later study, she redated the carvings to the second quarter of the twelfth century.[18] Now that dendrochronology has firmly established a *c.*1130 date for Urnes, the link with

PART THREE | THE TWELFTH-CENTURY CHURCH

Fig. 10.2. Church of St. Michael, Hildesheim, Germany, pre–World War II photograph of second cushion capital from the east, north nave arcade, 1015–22. Photo: from Hartwig Beseler and Hans Roggenkamp, *Die Michaeliskirche in Hildesheim* (Hildesheim, 1954), plate 16.

Trondheim has become tenuous, as most of the sculpture Hohler used for her comparisons postdates the Urnes capitals.

Although it cannot be ruled out that the inspiration for the Urnes capitals came from Jutland or southern Scandinavia, it is clear that these early stone cushion capitals generally lack the figurative decoration that makes the Urnes examples stand out. What is more, cushion capitals were not a Scandinavian invention, so it is necessary to pay some attention to the geographical spread, development, and decoration of this type of capital throughout western Europe to learn more about their possible derivation.

Cushion capitals have a long history indeed, with sporadic use in the Roman Empire.[19] Around 1000 they became very popular in Germany, especially in buildings erected by the Ottonian imperial family and their close associates.[20] Early examples occur on the westwork of St. Pantaleon in Cologne (c. 1000), in the nave of St. Martin in Zyfflich (c. 1000), in the crypt of St. Gertrude of Nivelles, and in the cathedral of Liège (1015).[21] Whereas all these examples have semicircular shields, those in the transepts of St. Michael of Hildesheim, dated between 1015 and 1022, are elongated, as at Urnes (Fig. 10.2).

From the middle of the eleventh century onward, cushion capitals came to be enriched with single or multiple shield rings or, less commonly, with ornaments derived from the world of plants and animals. Early examples of figurative cushion capitals occur in the Wolfgangskrypta of St. Emmeram in Regensburg (dedicated 1052), in the crypt of the cathedral of St. Peter in Bremen (built between 1042 and 1101), and in the nave of St. Servatius in Quedlinburg (between 1070 and 1129).[22] The capitals in the cloister of Bonn Minster, some of which are of the cushion variety with shields decorated with plant and animal motifs, are considerably later (c. 1150), as are those in the Premonstratensian abbey church of Knechtsteden (built between 1138 and 1181) and the church of the Augustinian canons of Hamersleben (c. 1150–60).[23] Later still are the cushion capitals of the church of Weissendorf in Bavaria.[24] Although cushion capitals are largely a German phenomenon, they do appear elsewhere, typically in institutions with a German connection. In today's France, cushion capitals occur mainly in areas neighboring Germany, such as Lotharingia and Alsace, both regions that once belonged to the Ottonian Empire.[25]

Cushion capitals made an occasional appearance in Anglo-Saxon architecture, which is unsurprising given the strong cultural and ecclesiastical ties between England and the Holy Roman Empire. Following the Conquest, however, cushion capitals came to be used there on a much grander scale in both secular and ecclesiastical architecture, and again the Holy Roman Empire was their ultimate source.[26] The capitals and bases of St. Augustine's Abbey in Canterbury were even shipped readymade from Boulogne in Flanders. Given that cushion capitals appear at such major sites as Canterbury Cathedral (rebuilt from 1070 onwards), the transept of Winchester Cathedral (1079), and the crypt of Worcester Cathedral (1084), it is unlikely that this simple capital type was employed as a cost-saving device. The first decorated examples are those in the Canterbury crypt, dating to the 1120s.[27] In the 1130s decorated cushion capitals spread to Romsey Abbey and Durham Cathedral.[28] None of the English examples have the elongated shields we see at Urnes. In fact, the scalloped cushion capital soon took over in England, with the first examples in St. John's Chapel in the Tower of London *c.*1070. This type of capital, more easily adapted to the heavy round piers used in early English Romanesque architecture, became the norm in England, at the expense of the German type of cushion capital with large shields. The scallop type, with very compressed shields, also made its way to Stavanger, in southwest Norway, which was established as a bishopric in the 1120s. A monk from Winchester was the first bishop of Stavanger, so the English idiom of these capitals is unsurprising.[29]

Romanesque Italy also has some interesting figurative cushion capitals, all in Lombardy. Late eleventh- and twelfth-century examples survive from Santa Maria del Popolo in Pavia,[30] Santa Maria d'Aurona in Milan, San Pietro in Cremella (a former convent), San Romedio in Anaunia (Trento), and Santa Maria del Tiglio in Gravedona.[31] Particularly interesting are two from Sant'Abbondio in Como, one decorated with a small lion, the other with a dragon.[32] While these capitals all have rather small shields, the elongated Urnes type occurs on a series of four plain capitals from the church of San Giovanni in Borgo, Pavia.[33]

In the Netherlands, decorated cushion capitals of *c.*1123 adorn the eastern parts of the nave at Rolduc, a monastery for regular canons with strong connections to the reformed Rottenbuch Abbey (Bavaria) and Salzburg Cathedral (Austria). As in Como, the shield rings terminate under the upper horizontal edge. In addition to the carved cushion capitals in the nave, three decorated bases along the wall of the southern aisle of the Rolduc church show a mermaid holding up her two tails, flanked by a dragon on each side; two crossed lions; and two confronted griffins devouring winged snakes. These motifs, as well as the style, suggest that the workforce had strong ties with northern Italian workshops. The chronicles of Rolduc Abbey, known as the *Annales Rodenses* and written *c.*1160, describe the history of the monastery from its foundation in 1108 until 1157 and mention that the church was built "scemate longobardino," according to a Lombard plan.[34]

It appears that the form of the Urnes capitals does not provide us with any clear clues about its potential models, but it seems significant that figurative cushion capitals generally appear in cathedrals, minsters, and monasteries rather than in simple parish or private churches. The above overview also shows that capitals with decorated shields were state-of-the-art around 1130. Capitals with simple decoration tend to be quite small and of the normal cushion variety, but when there was a program, artists tended to enlarge either the capitals or the shields. To my mind, then, the

extraordinary shape of the Urnes capitals resulted from the wish to maximize the space available for decoration. In the nearby parish church of Hopperstad, which may have been built by the same workshop, carved decoration was of no concern and the normal cushion shape was used. This underscores the likelihood that the Urnes church was a high-status building and its patron a person of high standing who was well informed about contemporary architecture.

The Pentice

The style of the one remaining decorated pentice capital differs from that of the porch and nave capitals. Because of this, the date of the pentice has been debated (see Chapter 2). A good parallel for the Urnes pentice capital is provided by one of the cloister capitals, dated c.1125–30, from the royal Benedictine abbey of Hyde (formerly Newminster) that was transferred outside the walls of Winchester by order of King Henry I in 1110.[35] The parallel with the Hyde Abbey sculpture suggests that the Urnes pentice capital was carved by a sculptor different from the one working in the nave.

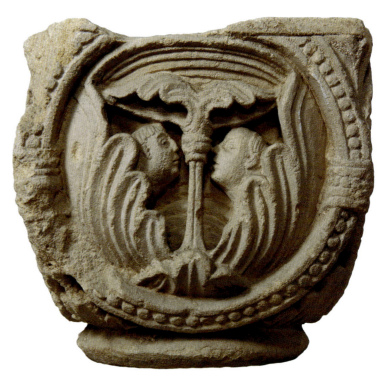

Fig. 10.3a–b. (a) Urnes church, capital from pentice, twelfth-century. Photo: Author; and (b) Hyde Abbey, near Winchester, England, capital from cloister, c.1125–30. Photo: © John Crook, Winchester.

While the pentice is thus part of the same building campaign as the nave, it may have been the last element to be added (Fig. 10.3 and Plates 26–28). The differing styles of the pentice and nave capitals provide clear evidence that the Urnes workshop was in touch with various important centers and that no single artistic influence dominated. In addition, the stylistic parallel to the sculpture of Henry I's royal abbey adds more weight to the idea that the Urnes church was a building of high status.

Runes and Graffiti

Graffiti found at the Urnes church, in the form of crude drawings and runes, are thought to be contemporary with the building and may therefore have some bearing on the question of the workshop's origins.[36] There are twenty-two runes in all: five on the exterior, two in the choir, and fifteen in the nave. Some are too fragmentary to make sense. A few invoke saints, such as Mary (N327) and Magnus (N323), and in some runes the soul of a named person is commended: "May the Holy Lord hold [his] hand over Brynjolf's spirit" (N319). Others just provide names: Hróarr, Beine (an Icelandic name), Arnfinnr, Ásgrímr, Gautr, and Jón. Interestingly, an 8-cm-long piece of wood found under the church floor in 1906 says "Árni the priest wants to have Inga" (N337).[37]

Drawings appear on all four sides of the Urnes nave interior, generally at eye level, while the chancel has only a few half-erased examples, small fragments and isolated marks.[38] As in other stave churches, the Urnes drawings represent boats, dragons, lions, human heads, and geometric figures. In his 1985 study of graffiti in stave churches, Martin Blindheim pointed out that some of the graffiti at Urnes resembles the imagery on its capitals; in particular, one of the lions carved on the south wall "is turning his hind quarters up into the air exactly in the way that one of the lions carved in low relief on one of the capitals is doing" (Fig. 10.4 and Plate 54).[39] According to Blindheim, the same type of lion's head that appears at Urnes recurs in the stave churches of Hopperstad and Gol, which in his view indicated that one hand was responsible for cutting them, as "such common traits would not have been possible had the drawings been carried out by different people visiting the church over a period of many years, not to mention centuries."[40] From this he conjectured that it was primarily the builders who made

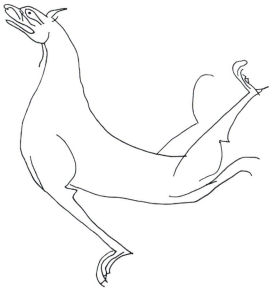

Fig. 10.4a–b. (a) Urnes church, nave graffito, perhaps a preliminary study for a nave capital; (b) Urnes church, nave capital with somersaulting lion. Photo: Author. Drawing by author: after Martin Blindheim, *Graffiti in Norwegian Stave Churches, c.1150–c.1350* (Oslo, 1985), plate LXXII-1.

405

the drawings, prior to the consecration of the church, and not, say, bored choirboys or visitors.[41] He therefore posited that the inscribed names commemorated members of the building's workshop, indicating their Scandinavian origins.[42] Although this is one possible explanation, as there are runes in other churches referring to members of workshops, this is stretching the evidence because runic inscriptions in churches also mention patrons, priests, and other persons.[43]

The Imagery on the Capitals

On the east side of the Urnes nave, birds and contorted quadrupeds dominate. The south side features mainly humans or hybrids: dancing men holding their beards (Plate 77); a manticore with an axe (Plate 76); a man fighting a lion (Plate 79); a long-haired figure doing a sword dance (Plate 86; no longer visible); a rather unusual four-legged hybrid, perhaps a centaur, whose lower half resembles that of a lion while his upper half is that of a man with three spikes on his head, wielding a sword and shield (Plate 87); and a barefoot cleric wearing a traveling cap and bearing a cross and crosier (Plate 85). On the west side there is a stooping Bactrian camel (Plate 47) and a hunting scene, which extends over two shields, with a horseman spearing a stag that is being chased by a hound (Plates 45 and 46). The north side (Plate 34) has birds, acrobatic quadrupeds, and a rather unusual animal with two heads (Plate 53).

At first sight this appears to be a strange and chaotic mixture of motifs, which is why Hohler considered the capitals' imagery to be purely decorative, mere doodles adopted by the artists from a general Romanesque repertoire.[44] Blindheim held similar ideas: "None of the motifs seem in any way to be connected with one another, and one gets the impression of subject material which has been detached from the great context to which it may, at an earlier stage and under different circumstances, originally have belonged."[45] Yet some of the images found on the Urnes capitals are not very common in Romanesque sculpture; an example is the camel. This is even more true of the imagery of the north side of the central capital on the east side, directly under the crucifixion group, which shows a bird flying with a human leg in its beak (Plate 68). A very similar image, with a bird sitting on the leg of a pig, does occur in one of the two *Physiologus* manuscripts from Iceland (Fig. 10.5), where it illustrates a gloss on Psalm 103 (now 104):17: "In Hebrew one finds *house of the kite*, the kite grabs its prey sharply and swallows it. It signifies holy men seizing the kingdom of heaven, as in this quote: 'The kingdom of heaven has suffered violence.'"[46] In bestiaries and in Hugh of Fouilloy's *Aviary*, written shortly after 1152, the kite is merely referred to as a creature that delights in carnal pleasures and as a symbol of the devil preying on the weak in spirit. The rather obscure interpretation of the Icelandic *Physiologus*, however, fits the location of the capital under the crucifix because the passage "the kingdom of heaven suffereth violence" recalls Christ's own words in Matthew 11:12, which ends with the phrase, "and the violent bear it away."

In view of the above, it is unlikely these creatures came from the standard Romanesque repertoire, as Hohler suggested, and neither does it seem probable that knowledge of such creatures reached Norway by means of traveling artists or model books. It is more likely that some of the creatures

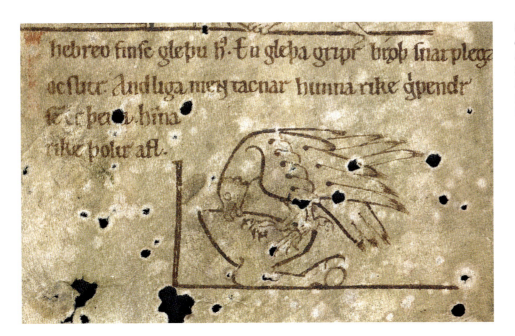

Fig. 10.5. *Physiologus B*, Iceland, c.1200, the kite. Reykjavík, Árni Magnússon Institute for Icelandic Studies, Arnamagnæan Collection, MS AM 673 a II 4o, fol. 5v. Photo: Árni Magnússon Institute for Icelandic Studies, Reykjavík.

were copied from one or various illustrated treatises, which suggests that a cleric or scholar was overseeing the work and providing the sculptors with models to imitate. This suggests that the selection of creatures is likely to have been more meaningful than might at first appear.

If I am correct, this again points to Urnes having been an important site in the early decades of the twelfth century, for in the 1130s Christianity was still quite new in Norway and books were a scarce commodity, even though availability increased as the century progressed. The earliest books in Norway were imports, and few of these would have been illustrated, as is clear from an incident in Snorri Sturluson's *Heimskringla* (c.1230). Snorri mentions how King Sigurd (Sigurðr) "the Crusader" (c.1090–1130), who had tendencies toward madness, "seized the holy book which he had brought with him from abroad, and which was written all over with gilded letters; so that never had such a costly book come to Norway" and threw it in the fire, from which it was saved by an attentive courtier.[47] Only about sixty to seventy medieval manuscripts with a Norwegian provenance have survived. Of these, only five—four in Latin and one in Old Norse—predate 1225, and three of these are "histories" of Norway.[48] There are additional fragments of some five to six hundred books that were written before 1225. About half of these may derive from books manufactured in Norway, where the earliest securely dated scriptoria, located in Bergen and Trondheim, were established between c.1150 and 1180; the others were imported from England, France, and the Low Countries.[49]

The Urnes Capitals and Their Meaning

In his 2005 book on stave churches, Leif Anker observed that all the capitals with plants were placed in the corners of the nave (nos. 4, 9, 13, and 18), suggesting that there was some order in the seeming chaos.[50] Indeed, to understand the imagery of the remainder of the capitals, it helps

to understand that they can be divided into five categories—plants, animals, birds, hybrids, and humans—which suggests that we are dealing with images that represent the natural world created by God. In medieval times, God's creatures were all thought to carry specific meanings. The animals shown are birds and "creatures such as lions, panthers and tigers, wolves and foxes, dogs and apes, and all that roar and rage with their mouth or tongue," as the Oxford Bestiary (Oxford, Bodleian Library, MS Bodley 764), dated to the second quarter of the thirteenth century, has it.[51] Such beasts, the text continues, are called wild because, like mankind, they possess their natural freedom and act as they themselves have willed. This possession of free will is important, as it raised questions about what set mankind apart from the beasts. In the medieval view, humankind had been provided with reason (*ratio*), which enabled him to make the right choices, whereas animals were driven only by their senses (*sensibilitas*). According to the *Hexaemeron* of Basil of Caesarea, written *c.*370 and much read in the twelfth century, a person led only by his senses, not by the things of higher importance, was no better than an animal and would be eternally doomed.[52] Animals were thus symbols of man's lesser self and showed what he was like when he lost his way. To retrace his way to God, the beholder was required to use his *ratio*, or as the twelfth-century Scholastic Hugh of Saint-Victor put it, reason enabled Man "to know of each thing not only whether it exists, but of what nature it is, and of what properties, and even for what purpose." Nature thus acted as a guide: "By contemplating what God has made we realize what we ourselves ought to do. Every nature tells of God; every nature teaches Man."[53]

Some animals, despite being devoid of *ratio*, managed to behave better than humans. Such animals were set in front of mankind as positive exempla, to make him mend his ways, while bad beasts were used as negative exempla, to show him what he should not do. The qualities of each creature were described in the *Physiologus* manuscripts and in bestiaries, books that were popular with both ecclesiastical and lay audiences. As noted, such books also found their way to Scandinavia. The oldest surviving examples produced in the North are the fragments of two *Physiologus* manuscripts of *c.*1200 from Iceland, the earliest illustrated manuscripts that survive from that country.[54] The first fragment contains five allegories of animals; the second has eighteen, as well as additional commentaries on the Bible.

Two creatures from the Urnes nave capitals suffice to illustrate how such exempla functioned. According to the Oxford Bestiary, the camel, which in Urnes appears on the north side of the western colonnade (Plate 47), signifies:

> the humility of Christ, who bears all our sins, or the Gentiles converted to the Christian faith. In the Gospel it says: "It is easier for a camel to go through the eye of a needle, than for a rich man to enter the Kingdom of God" (Matthew 19:24), meaning that it is easier for Christ to suffer for those who are enamoured of this world than for such men to be converted to Christ. He was willing to assume the part of a camel, in taking upon Himself the burdens of our weakness which he did out of humility. This is the meaning of the verse: "The greater thou art, the more humble thyself (Ecclesiasticus 3:18)."[55]

As a symbol of Christ's humility, the camel was thus a positive exemplum.

The centaur (Plate 87), on the same capital in the south colonnade as the cleric with his cross and crosier (Plate 85), is a creature whose meaning is more difficult to grasp due to its dual nature as man and beast. The centaur originated in antiquity as a symbol of lust and utter barbarity. The Bible knows only the onocentaur, an evil creature half man, half ass. In the Septuagint it appears in two passages, Isaiah 13:21–22 and 34:11–14. In the Vulgate the onocentaur is mentioned only in Isaiah 34:11–14, where it is called a demon.[56] The bestiary written by the Anglo-Norman poet Philippe of Thaon shortly after 1121 holds that the two-part nature of the beast symbolized the hypocrite who speaks of doing good but actually does evil; "man was rightly called man when he was truthful, but an ass when he did evil."[57]

The above-mentioned Icelandic *Physiologus* fragments also mention the onocentaur. The first manuscript describes him as follows:

> *Honocentaurus* is the name of the beast that we call *finngálkan* [i.e., a sort of hybrid monster]. It is a man in front and an animal behind, and by its shape it signifies insincere men. In learned speech it is said to be false and beastlike if a man flatters those who are near him, although he speaks falsely. A good man must always speak truthfully about every matter, whether he is rich or poor.[58]

The text of the second manuscript differs, but describes the creature in equally negative terms:

> The honocentaurus has the shape of a man above, but an animal's shape below, and it has two voices and heads out into the meadows to speak to people. As the Apostle says, "Those having a promise of mercy, but denying its power." And as the prophet David says, "Man, when he was in glory, had no understanding, and he is equal to foolish animals and has become like them."[59]

Nevertheless, other authors had more positive things to say about the centaur. Jerome (c. 345–420), in his *Vita Pauli*, considered the creature a being uncorrupted by civilization, while Statius (c. 45–c. 96) in his *Achilleid* described the centaur Chiron as the exemplary teacher of Achilles.[60] The ambiguity of the centaur's meaning conforms entirely to the spirit of the *Physiologus* and bestiary texts, which hold that every creature has a twofold nature, both praiseworthy and reprehensible.[61] It is left to the beholder to consider the meanings of a specific creature, to take a moral stance and follow those aspects that merit imitation. After all, that is why God endowed man with reason.

Plants, animals, hybrids—all were monsters, that is, images that imparted messages to the viewer to make him reflect on his conduct. The two-headed creature on the north side of the Urnes nave is significant in this context (Plate 53). On the authority of Augustine's influential treatise *De civitate Dei*, this creature can be understood as a symbol of God's omnipotence. In describing precisely such a creature, Augustine held that they:

> are called "monsters," because they demonstrate or signify something; "portents," because they portend something; and so forth. . . . Yet, for our part, these things which

happen contrary to nature, and are said to be contrary to nature . . . and are called monsters, phenomena, portents, prodigies, ought to demonstrate, portend, predict that God will bring to pass what He has foretold regarding the bodies of men, no difficulty preventing Him, no law of nature prescribing to Him His limit.[62]

The general message that the Urnes capitals conveyed was thus a very common one, based on the idea, typical in medieval theological circles, that man, having caused earthly chaos by repeatedly countering God's commands, needed to follow the path toward redemption to find the way out of this chaos, which led straight to everlasting damnation. This implied heeding God's word by refraining from sin and accepting the Church's authority and teachings, exemplified by the cleric with his cross and crosier. The positive and negative images of men, animals, hybrids, and plants were intended to help the contrite Christian find his way, by setting before him a series of positive and/or negative exempla, rather like a series of do's and don'ts.[63] The underlying stories that these images represented were undoubtedly made familiar to the medieval audience through preaching. The crucifixion group at the nave's east end visualizes Christ's sacrifice whereby salvation was brought within the reach of all mankind (Plate 106).[64]

The Urnes Capitals and the "Stave Church Homily"

If the above interpretation of the Urnes capitals is correct, there may well be a parallel here with the interpretation of the various parts of the church given in the so-called "Stave Church Homily," a text transmitted in Old Norse and Icelandic manuscripts that is dated *c.* 1200 but probably contains much older material.[65] In sermons such as this one, the dual significance of the church—as a building housing the congregation and as a metaphor for the community of believers—was expounded to the faithful. In this particular homily, the Christian community is described as the hall of God. The component parts of the building are interpreted as the various people who share the Christian faith: those who are already with God (the chancel) and those who are still on earth (the nave). The altar represents Christ and the entrance into the church the Christian faith, leading believers into the community. The floorboards signify the humble: the more they are trodden on, the more they bear the weight of the Christians. The long walls are the pagans and the Jews, the west wall is Christ who unites them, and the rood screen is the Holy Spirit through which one passes to heaven. The corner posts are the Gospels and the roof an image of the believer who looks towards heaven. From here the homily jumps to the individual Christian, a temple of the Holy Spirit by his good works, and all the parts of the church are named as mnemonic devices to induce the beholder to be virtuous and focus on good works.[66]

It is the first part of the homily, in which the meaning of the different parts of the church is expounded, that concerns us here, for it may be used as a interpretative framework for the Urnes capitals and their locations within the nave. The distinction between the chancel and the nave is made clear by the absence of capitals in the former (those who are already with God have no need of

moralistic exempla) and by the figure of the crucified Christ, flanked by Mary and John, high up on the eastern wall of the nave. Visible from the nave, the figure of Christ shows the churchgoer that Christ suffered death on the cross for the salvation of all. As already noted, the four capitals of the corner posts are the only ones with foliage, representing growth and life, which does not contradict the idea expressed in the "Stave Church Homily" that they represent the Gospels. The homily also holds that the long walls represent the pagans and Jews and the west wall Christ who unites them. Although this does not quite fit the imagery at Urnes, the capitals' iconography does seem to be concerned with good and bad, with leading a humble life versus earthly pursuits, and in this way the churchgoer is urged to make the right choices in life in order to obtain life everlasting in Christ. To guide him there are the exempla of good and bad behavior and the cleric on the southwestern column of the nave.

The Barefoot Cleric and His Attire

The cleric is shown barefoot, wearing a traveling cap and a short mantle that leaves his calves uncovered.[67] By his cross he can be distinguished as a missionary and by his crosier he can be identified as either a bishop or an abbot (Plate 85). Yet his attire is quite unusual for one holding so high an office. In this section I discuss the significance of the cleric's unusual outfit to discover whether we are dealing with a bishop or an abbot and what light this might shed on the iconographic program at Urnes.

The Gospel of Mark (6:9) mentions that the apostles were allowed to wear sandals. As the Church extended into more northern and colder regions, this precept of open footwear was abandoned, and in medieval Europe the secular clergy were generally shod. Sandals were only worn in the monasteries and sometimes by bishops. Indeed, in the first half of the ninth century Amalarius of Metz devoted a lengthy passage to the difference between the sandal of the bishop and the footwear of priests in his day. Concerning episcopal footwear, he wrote: "The bishop has a band (*ligatura*) in his sandals, which the presbyter has not. It is the duty of the bishop to travel throughout the length and breadth of his diocese (*parochia*) to govern the inhabitants; and lest they should fall from his feet, his sandals are bound. The moral of this is, that he who mingles with the vulgar crowd must secure fast the courses of his mind (*gressus mentis*)."[68]

In Matthew 10:9–10, Christ urges the apostles to go into the world to spread his word and not to "possess gold, nor silver, nor money in your purses: Nor scrip for your journey, nor two coats, nor shoes, nor a staff." Although this text was meant metaphorically, Christ's words came to be taken literally in certain Orthodox monasteries where monks discalced. By the eleventh century the idea of the discalced monk had spread to Latin Europe; the bare feet were a symbol of apostolic poverty and contempt for the world, a sign of the monk's voluntary alienation from society and a return to the austere practices of Christ and his followers.[69] Although the practice had been frowned upon by such early commentators as Jerome and Benedict (480–547), by the thirteenth century, "bare feet had become the sign of a superior religious ideal that conferred greater spiritual authority because

of its emulation of apostolic poverty and abnegation."[70] In a Christian context, going barefoot was considered a sign of humility, of penance, and of laying down one's sins in the face of God, as Moses did when he was ordered to take off his shoes when approaching the burning bush (Exod. 3:5). The Urnes discalced cleric is thus represented as a humble follower of the apostles, a traveler who brings to others the word of God, as exemplified by the missionary cross.

That said, in medieval art bishops are never shown barefoot, even though from the late tenth century onward there were some occasions during which (arch)bishops did present themselves discalced. These occurrences were probably recorded precisely because they were so unusual. The oldest known instance concerns St. Adalbert, who in 999 was made bishop of Prague. At the city gate he undid the straps of his sandals and entered barefoot with a humble and repentant heart, much to the elation of the local people.[71] In the same year Heribert, who was confirmed but not yet consecrated bishop of Cologne, sent all of his insignia, including the pallium, ahead of him as he approached the city and entered it barefoot during a very severe winter. Rapt in prayer, he did not feel the cold. The idea was to show the citizens and clergy that he had not accepted the office for the sake of social position and the expected benefits, but merely as a humble servant of the Lord to whose will he submitted.[72] Among others who acted likewise were Bishop Otto of Bamberg in 1103; Frederick, bishop of Lyons, at the synod of Reims in 1118; and Abbot Theoger of St. George's in the Black Forest, who became bishop of Metz in the same year.[73] Such tokens of humility did not always meet with approval, however. Thietmar of Merseburg (c.975–1018), in addressing Bishop Egidius of Meissen's habit of walking around barefoot, understood Egidius's desire to lead a life of humility and mortification, but added: "We, contemporary people, did not like his way of living by reason of our wickedness, just as he did not approve of ours."[74] This indicates that, on the whole, being barefoot was not considered to be appropriate episcopal attire. In monastic houses, on the other hand, newly elected abbots were sometimes prescribed to enter their new house barefoot, as in the consuetudinary of the Benedictine abbey of Abingdon in 1185.[75]

As remarkable as his lack of footwear is the cleric's short tunic, baring his calves, which was not normal for clerical attire either inside or outside of church. As Maureen Miller has shown, from the ninth century onward the secular clergy was increasingly robed in gold-ornamented vestments made of precious materials, like silk, that showed them to be the successors of the Old Testament Temple priests. These precious vestments symbolically underlined the clergy's chastity, wisdom, justice, and charity. They also underlined their increasing worldly power, asserting the sacredness of all clerics and claiming for them "a status higher than any layperson's." This new ornate attire was to be worn only when celebrating the liturgy.[76]

As the Urnes cleric is clearly not represented in church but, rather, in the outside world, the Church's regulations concerning outdoor attire are even more relevant to assess the significance of his outfit. As was stipulated from the sixth century onward, a cleric was to be recognizable as a man of the church when outside it, but no further specifics were given. In 506 the Council of Agde decreed that a cleric should not wear "indecent clothing or arms." The mid-seventh-century Council of Bordeaux ordered that "clerics ought to wear religiously the dress conceded to them, and they should not bear or have lances, other arms, or any secular attire." Again, the sources fail to specify what items of clothing they should wear and in what ways the clergy's attire was to differ

from that of other people. It was not until the thirteenth century that sources provide more clarity on this issue. The Council of Montpellier of 1215, for instance, required bishops to wear long robes and linen shirts over other garments when outside or when interacting with the secular world in secular affairs. The Synod of Trier in 1227 prescribed "vestes decenter longae" or full cloaks. By this time, clerical streetwear was sober, modestly long, and closed so that the limbs were not exposed.[77]

That such rules are likely to have applied to earlier times as well can be illustrated by the following examples. In 1093 Marbod, bishop of Rennes, reproached Robert of Arbrissel, a critic of the luxuriously dressed clergy of his time, for the strangeness of his ragged clothes, which he considered inappropriate for a canon and priest. Robert had indeed discarded his canonical dress and went barefoot with his legs half naked, wearing nothing but a worn-out cowl full of holes, with his beard long and his hair trimmed at the brow. According to Marbod, this was the "outfit of a lunatic."[78] The eleventh-century reformer Peter Damian addressed the issue as follows: "In the hermitage it is indeed the rule to go bare legged and barefoot, but in the marketplace this penance is viewed as an indiscretion."[79] Interestingly, when Norbert of Xanten, founder of the Premonstratensian order, became bishop of Magdeburg in 1126, he entered the episcopal city barefoot and was not permitted to enter the palace after the ceremony because of his modest attire. In the winter of 1118–19 he had apparently preached in southern France while wandering barefoot around the country. This behavior was typical of reformers and, according to Jacek Maciejewski, was intended "to be a contrast to the immoral and disorganized life of the metropolitan clergy."[80]

This suggests that the Urnes cleric's bare feet and calves would have made contemporaries raise their eyebrows, even though this type of apparel harked back to biblical and patristic precedents and even though, in monastic circles and among the regular clergy, simplicity of dress was advocated. That the strange apparel of the Urnes cleric has nothing to do with the artists never having seen a bishop is evident from the graffiti inside the church. Post 2 on the north side of the nave, counting from the east, was incised with three superimposed heads, the lowest of which is that of a bishop wearing a miter.[81] The strange apparel of the Urnes cleric must therefore have served a purpose and provided viewers with a message concerning the cleric's status and way of life. No Scandinavian bishop would have gone about in such attire in the 1130s, so the Urnes cleric is likely to represent an abbot, and one of a reformed order at that. Indeed, according to Peter Damian, "Those alone are apt for the *officium praedicationis* . . . who have the benefit of no terrestrial wealth and who, because they have nothing for themselves, possess everything in common."[82]

Perhaps we can be even more specific. Although in the early decades of the twelfth century monks and regular canons had similar lifestyles, and both claimed a right to the *cura animarum*, Caroline Walker Bynum has shown that in treatises describing the obligations of ordinary cloistered brothers, canonical authors see canons as teachers and learners whereas monastic authors see monks only as learners. She writes: "What distinguishes regular canons from monks is the canon's sense of a responsibility to edify his fellow men both by what he says and what he does," describing them as teachers "verbo et exemplo."[83] This edification is generally meant for the canons' fellow brothers, but it could also be used to teach the laity. As Anselm of Havelberg put it, "being generally sought out by rude people, [the regular canon] is chosen and accepted and, like a lantern lighting a dark place, teaching by word and example, is loved and honored."[84] The regular canon was responsible in

whatever he said or did not only for the state of his own soul but also for the progress of his neighbor, for, as Hugh of Saint-Victor said, "And, although a man ought in no place to desert his discipline, it ought however to be preserved more diligently and more solicitously there where being neglected it will cause scandal to many and being kept will cause an example of good imitation."[85] The canons' affinity with the precepts of the *vita apostolica* made them shift toward a pastoral or evangelical ideal, "combining a stress on individual perfection with pastoral activity."[86]

The discalced abbot on the Urnes capital seems to be more in line with the precepts of the regular canons than with those of monks, as canons held pastoral activities to be one of their tasks. As far as we know, regular canons did not found monasteries in Norway until later in the twelfth century, but there is no reason why an individual patron with a knowledge of the world could not have been influenced by their teachings. It is even possible that a house of reformed canons was contacted to help devise the iconographic program. Indeed, the extraordinary presence of the image of an abbot holding a missionary cross suggests close relations between the Urnes church and an actual monastery.

At the time the church was under construction, monasteries in Norway were few and far between. The earliest monasteries—Selja, Nidarholm (Trondheim), and Munkeliv (Bergen)—were Benedictine, all apparently established in the late eleventh century. Their founders were kings or members of the aristocracy, while the first monks generally came from abroad. There were also some Benedictine nunneries. From 1146 the Cistercians established themselves in Norway, with the founding convents usually coming from England. The Augustinian canons also had several convents in Norway, but their history is poorly documented until the middle of the twelfth century. In fact, it is generally assumed that the Augustinians did not arrive in Norway until between 1160 and 1180. Their houses at Halsnøy, Utstein, and Bergen (Jonsklosteret) are likely to have been established with the aid of foreign canons.[87]

As we have seen, however, the one surviving figural capital in the Urnes pentice is stylistically close to a capital from the cloister of Hyde Abbey near Winchester. It was during Henry I's rule, in the early decades of the twelfth century, that foundations of regular canons were supported by bishops as a first step to introducing order into the diocese.[88] The evidence suggests that the Augustinian houses were centers of learning in which a significant number of books were stocked as well as made. Anne Mathers-Lawrence even sees the Augustinians as a "colonizing order" and suggests that they were used as "a powerful force for breaking Northumbria from its past, for introducing genuine ecclesiastical reform, and for consolidating the hold of a new baronial and spiritual elite in the region."[89] Forty-three Augustinian foundations in England date to Henry's reign, and, of these, thirty-three show evidence of some form of royal involvement. Churchmen turned secular colleges and minsters into Augustinian houses, and archbishops and bishops managed to get members of the laity to invest, financially and spiritually, in the canons. It is also thought that "the intended pastoral function of the canons is reflected by their heavy endowment with parish churches," even though there is little evidence, perhaps due to the scarcity of sources, for canons servicing the parish churches.[90]

In Scandinavia, the cathedral chapter of Viborg in Denmark was composed of Augustinian canons (and we might recall that the elongated cushion form of the Urnes capitals is also found in the

area around Viborg, in all likelihood reflecting the architecture of the now lost Viborg Cathedral).[91] The bishop of Lund seems to have had a close knowledge of Augustinian houses, as can be inferred from his dealings with Hermann, the son of one of the founders of the abbey of Rolduc. Hermann left Rolduc after a quarrel to become abbot of the Augustinian abbey of Dünnwald near Cologne, which had been founded in 1117. Not liking it there, he made his way to Denmark to join the retinue of the bishop of Lund, who sent him to Rome to negotiate with Pope Innocent II after the pope had reunited Lund with the archbishopric of Hamburg-Bremen in 1133. Apparently Hermann was successful, and Lund again became an autonomous bishopric. Hermann then joined the retinue of the Danish king, who in 1138 appointed him bishop of Schleswig. Unfortunately for Hermann, a local candidate's claim to the bishopric proved more successful.[92] This connection between the bishop of Lund and the one-time Augustinian canon Hermann is intriguing, given that Urnes belonged to the archdiocese of Lund at the time. In sum, there were myriad ways by which the patron of the Urnes church could have become acquainted with the ideals of the order of reformed canons that seem to be exemplified by the capital imagery, above all by the presence of the discalced abbot with his crosier and missionary cross, long before such orders came to Norway and founded their first monasteries there.

Conclusion

In the early 1130s, when the fourth Urnes church was built, the decorated cushion capital was still quite novel. In Germany, Italy, the Low Countries, and England, it was found exclusively in the grander collegiate churches and cathedrals, not in parish churches. This suggests that the patron of Urnes was planning something out of the ordinary. Indeed, the parallel between the pentice capital and a capital from Hyde Abbey, a monastery patronized by the English king, indicates that the Urnes patron was aware of the more important building sites in western Europe when he decided to erect his own church. Urnes's state-of-the-art capital sculpture is therefore likely to have been unique among stave churches at that time, although there may have been parallels with the king's own foundations, which unfortunately are only known from brief descriptions in the sagas.

The capital imagery comprises a fairly loose but comprehensive program that shows the laity ways to reach salvation, confronting viewers with a range of creatures that represented a series of do's and don'ts that were undoubtedly expounded further by means of sermons. The bookishness of the subject matter suggests that images in manuscripts were used as models for the carvings. Because illustrated books were still rare commodities in early twelfth-century Norway, this points not only to a wealthy patron but also to a learned person overseeing the program. The figure of the barefoot abbot may indicate that this person may have had an interest in or good connections with the reformed orders, which, as far as we know, had not yet settled in Norway; and this again shows that the Urnes patron found inspiration for his church abroad. To conclude: in spite of the poor survival rate of Norwegian stave churches, the church of Urnes rebuilt in the 1130s seems always to have been a unique building. It is quite possible that it is precisely these unique qualities that have guaranteed the church's survival to the present day.

Notes

1. Leif Anker, *The Norwegian Stave Churches*, trans. Tim Challman (Oslo, 2005), 13–15.
2. Terje Thun et al., "Dendrochronology Brings New Life to the Stave Churches: Dating and Material Analysis," in *Preserving the Stave Churches: Craftsmanship and Research*, ed. Kristin Bakken, trans. Ingrid Greenhow and Glenn Ostling (Oslo, 2016), 91–116, at 105–6.
3. Anker, *Norwegian Stave Churches*, 97.
4. For a detailed description, see Erla Bergendahl Hohler, *Norwegian Stave Church Sculpture* (Oslo, 1999), 2 vols., 1:234–41, 294–304.
5. Jo Rune Ugulen, "Kring ætta på Ornes og Mel i mellomalderen, samt noko om Rane Jonssons etterkomarar og slekta Hjerne (Hjärne)," *Norsk slektshistorisk tidsskrift* 39.1 (2004): 235–316.
6. *Diplomatarium Norvegicum* volume XV:1; online version www.dokpro.uio.no/dipl_norv/diplom_field_eng.html. Charter, 25 January 1308 (9): Hr. Bjarne Erlingssön i Bjarkö gjör sit Testamente og vælger sit Gravsted I Christkirken i Nidaros samt skjænker store Gaver til Kirker, Klostre, Slægtninge og Venner.
7. Erla Bergendahl Hohler, "The Capitals of Urnes Church and Their Background," *Acta Archaeologica* 46 (1975): 1–75, at 8n9; and Anker, *Norwegian Stave Churches*, 118. For the burials at Urnes, see Håkon Christie, *Urnes stavkirkes: Den nåværende kirken på Urnes* (Oslo, 2009), 49–74. The excavations were not carried out systematically from the point of view of stratigraphy, but some of the graves are undoubtedly older than the present church. There is a medieval stone grave slab at the site with a ringed cross.
8. Sigríður Júlíúsdóttir, "The Oldest Churches in Norway," in *Church Centres: Church Centres in Iceland from the 11th to the 13th Century and Their Parallels in Other Countries*, ed. Helgi Þorláksson (Reykholt 2005), 187–200, at 199; and Gudmund Sandvik and Jón Viðar Sigurðsson, "Laws," in *A Companion to Old Norse–Icelandic Literature and Culture*, ed. Rory McTurk (Oxford, 2005), 223–45, at 234.
9. Stefan Brink, "Early Ecclesiastical Organization of Scandinavia, especially Sweden," in *Medieval Christianity in the North: New Studies*, ed. Kirsi Salonen, Kurt Villads Jensen, and Torstein Jørgensen (Turnhout, 2013), 23–41.
10. Eric Fernie, *The Architecture of Norman England* (Oxford, 2000), 278.
11. Hohler, "Capitals of Urnes," 5–6.
12. Ibid.
13. Inv. no. MA 126. The cupboard was donated to the museum by Vicar Schydtz from Årdal in 1867.
14. Martin Blindheim, *Norwegian Romanesque Decorative Sculpture, 1090–1210* (London, 1965), 36.
15. Hohler, "Capitals of Urnes," 9. The important Norwegian monuments in which cushion capitals are used are the Gamle Aker church (present-day Oslo, *c.* 1100–30), St. Nicholas church at Gran, Hadeland (eastern Norway), and Stavanger Cathedral (*c.* 1120s). The capitals of these churches are very squat, quite unlike the Urnes capitals with their elongated shield shapes; they are more like English pier capitals. See also Harry Fett, *En bygdekirke* (Oslo, 1941), 17–30.
16. Hohler, "Capitals of Urnes," 9.
17. Ibid., 8–10.
18. Hohler, *Norwegian Stave Church Sculpture*, 1:240.
19. Fernie, *Architecture of Norman England*, 278n66.
20. For a brief overview of the development of cushion capitals, see Roya Piontek, "Würfelkapitelle," in *Kapitelle des Mittelalters: Ein Leitfaden*, ed. Uwe Lobbedey (Münster, 2004), 43–51.
21. Günther Binding, "Köln oder Hildesheim? Die 'Erfindung' des Würfelkapitells," *Wallraf-Richartz-Jahrbuch* 66 (2005): 7–38.
22. Peter Morsbach, *St. Emmeram zu Regensburg: Ehem. Benediktiner-Abteikirche* (Regensburg, 1993), 11–12; Siegfried Fliedner, "Der frühromanische Dom zu Bremen," in *Der Bremer Dom: Baugeschichte, Ausgrabungen, Kunstschätze; Handbuch und Katalog zur Sonderausstellung vom 17. Juni bis 30. Sept. 1979 in Bremer Landesmuseum (Focke-Museum)* (Bremen, 1979), 9–55, at 13, 25; and Klaus Voigtländer, *Die Stiftskirche St. Servatii zu Quedlinburg: Geschichte ihrer Restaurierung und Ausstattung* (Berlin, 1989), 63–66, 186.
23. Piontek, "Würfelkapitelle," 48; Wilhelm Jung, *Die ehemalige Prämonstratenser-Stiftskirche Knechtsteden* (Düsseldorf, 1956), 117–22; and Anne-Christin Schöne, *Die romanische Kirche des ehemaligen Augustinerchorherrenstiftes in Hamersleben* (Cologne, 1999), 290.
24. Gottfried Weber, *Die Romanik in Oberbayern: Architektur, Skulptur, Wandmalerei* (Pfaffenhofen, 1985), 416–21.
25. Piontek, "Würfelkapitelle," 44.
26. For English cushion capitals, see Richard D. H. Gem, "Canterbury and the Cushion Capital: A Commentary on Passages from Goscelin's De miraculis Sancti Augustini," in *Romanesque and Gothic: Essays for George Zarnecki*, ed. Neil Stratford (Woodbridge, UK, 1987), 1:83–101; Fernie, *Architecture of Norman England*, 278–79; and Plant, *English Romanesque and the Empire*, 177–202.
27. Deborah Kahn, *Canterbury Cathedral and Its Romanesque Sculpture* (London 1991), 35–37.
28. Kahn, *Canterbury Cathedral*, 71.
29. Blindheim, *Norwegian Romanesque Decorative Sculpture*, 3, 5.
30. Adriano Peroni, *Pavia: Musei civici del Castello visconteo* (Bologna, 1975), 48, cat. nos. 223 and 224.
31. For Cremella and Gravedona, see Oleg Zastrow, *Scultura carolingia e romanica nel Comasco: Inventario territoriale* (Como, 1978), 98; and for Anaunia, see Bruno Passamani, *La scultura romanica del Trentino* (Trento, 1963), 116–31.
32. Zastrow, *Scultura e romanica nel Comasco*, 76, cat. no. 12/16, and 62, cat. no. 12/12.
33. Peroni, *Pavia*, 67–68, cat. nos. 305–8.
34. L. Augustus and J. T. J. Jamar, *Annales Rodenses: Kroniek van Kloosterrade; Tekst en vertaling* (Maastricht, 1995), 86–87; and Elizabeth den Hartog, "On Dating the Abbey Church of Rolduc (Klosterrath) and Its Romanesque Sculpture," *Zeitschrift für Kunstgeschichte* 74.1 (2011): 3–28.
35. George Zarnecki, Janet Holt, and Tristram Holland, eds., *English Romanesque Art, 1066–1200* (London, 1984), 172–73. The capitals are now preserved at St. Bartholomew's church in Hyde.

36. Martin Blindheim, *Graffiti in Norwegian Stave Churches, c.1150–c.1350* (Oslo, 1985), 12.

37. The N numbers correspond to rundata-net (2018), the Scandinavian runic text database, where the Urnes runes are numbered N319–N343. See also Kristel Zilmer, "Christian Prayers and Invocations in Scandinavian Runic Inscriptions from the Viking Age and Middle Ages," *Futhark: International Journal of Runic Studies* 4 (2013): 129–71, at 143.

38. Blindheim, *Graffiti in Norwegian Stave Churches*, 48–50.

39. Ibid., 49.

40. Ibid., 14.

41. Ibid., 11–16.

42. Ibid., 50.

43. Hohler, *Norwegian Stave Church Sculpture*, 2:42–43; Peter Anker, "Om dateringsproblemet i stavkirkeforskningen," *Historisk tidsskrift* 56.2 (1977): 103–42; and Annette Jones, "Portals to the Past: Distribution Patterns in Stave Church Inscriptions," Preprints to the 7th International Symposium on Runes and Runic Inscriptions, Oslo 2010, 1–8; https://www.khm.uio.no/english/research/publications/7th-symposium-preprints/.

44. Hohler, "Capitals of Urnes," 1–60.

45. Blindheim, *Norwegian Romanesque Decorative Sculpture*, 36.

46. Reykjavík, Árni Magnússon Institute for Icelandic Studies, AM 673 a II 4°, fol. 5v; https://handrit.is/en/manuscript/imaging/is/AM04-0673a-II#page/5v++(10+of+24)/mode/2up. Verner Dahlerup, "Physiologus i to islandske bearbejdelser: Med indledning og oplysninger," *Aarbøger for nordisk oldkyndighed og historie* 4 (1889): 199–290, plate 10; and James W. Marchand, "Two Notes on the Old Icelandic Physiologus Manuscript," *MLN* 91.3 (1976): 501–5, at 502–3.

47. Snorri Sturluson, *The Heimskringla, or, Chronicle of the Kings of Norway*, trans. Samuel Laing (London, 1844), 3:186, *Saga XII*, chap. 29.

48. Lars Boje Mortensen, "The Anchin Manuscript of *Passio Olaui* (Douai 295), William of Jumièges, and Theodoricus Monachus, New Evidence for Intellectual Relations between Norway and France in the 12th Century," *Symbolae Osloenses* 75 (2000): 165–89.

49. Michael Gullick and Åslaug Ommundsen, "Two Scribes and One Scriptorium Active in Norway c.1200," *Scriptorium* 66.1 (2012): 25–54. The illuminated Gospels known as the Dalby Book of c.1100 is regarded as the first example of a manuscript produced in Denmark (Copenhagen, Royal Library, MS GKS 1325, 4°).

50. Anker, *Norwegian Stave Churches*, 114.

51. Richard Barber, *Bestiary: Being an English Version of the Bodleian Library, Oxford, M.S. Bodley 764; With All the Original Miniatures Reproduced in Facsimile* (Woodbridge, UK, 1999), 23.

52. Elizabeth den Hartog, *Romanesque Sculpture in Maastricht* (Maastricht, 2002), 202–3. For Basil, *Hom. IX in Hexaemeron*, 2, see *S. Basilii Magni, Opera omnia*, in *Patrologiae Cursus Completus: Series Graecae*, ed. J.-P. Migne, 29 (Paris, 1857), cols. 191–92.

53. For Hugh of Saint-Victor's *Didascalicon*, III.3, see *The "Didascalicon" of Hugh of St. Victor: A Medieval Guide to the Arts*, trans. and ed. Jerome Taylor, 2nd ed. (New York, 1968), 50, 145.

54. Reykjavík, Árni Magnússon Institute for Icelandic Studies, AM 673 a I 4° and AM 673 a II 4°: https://handrit.is/en/manuscript/view/is/AM04-0673a-I and https://handrit.is/en/manuscript/view/is/AM04-0673a-II.

55. Barber, *Bestiary*, 96.

56. William J. Travis, "Of Sirens and Onocentaurs: A Romanesque Apocalypse at Montceaux-l'Étoile," *Artibus et Historiae* 23.45 (2002): 29–62, at 32–35.

57. Emmanuel Walberg, ed., *Le bestiaire de Philippe de Thaün* (Lund, 1900), 42, lines 1119–22; and Valentine A. Pakis, "Contextual Duplicity and Textual Variation: The Siren and Onocentaur in the Physiologus Tradition," *Mediaevistik* 23 (2010): 115–87.

58. Fragment A, trans. Ben Waggoner, *Sagas of Imagination: A Medieval Icelandic Reader* (Philadelphia, 2018), 107. For the word *finngálkan*, see Pakis, "Contextual Duplicity and Textual Variation," 129–30n51.

59. Fragment B, trans. in Waggoner, *Sagas of Imagination*, 111.

60. Kirk Ambrose, *The Marvellous and the Monstrous in the Sculpture of Twelfth-Century Europe* (Rochester, NY, 2013), 27–32, 57–63.

61. Otto Seel, ed., *Der Physiologus: Tiere und ihre Symbolik* (Zurich, 2006), 6.

62. Augustine, *De civitate Dei*, XXI.8. See Marcus Dods, trans., *The City of God by Saint Augustine* (New York 1950), 778; and Hartog, *Romanesque Sculpture in Maastricht*, 193.

63. For a broadly similar program, Hartog, *Romanesque Sculpture in Maastricht*, 200–18.

64. As a necessary complement to the capitals' iconography, the Urnes crucifixion group is likely to be contemporaneous with the church itself, although it is generally dated somewhat later, c.1150. Hildegunn Gullåsen, "The Medieval Calvary Group in Norway: Context and Functions," *Collegium Medievale* 19 (2006): 5–30, at 6; and Manuela Beer, *Triumphkreuze des Mittelalters: Ein Beitrag zu Typus und Genese im 12. und 13. Jahrhundert; Mit einem Katalog der erhaltenen Denkmäler* (Regensburg, 2005), 378.

65. Gabriel Turville-Petre, "The Old Norse Homily on the Dedication," *Mediaeval Studies* 11 (1949): 206–18; and Mette Birkedal Bruun and Louis I. Hamilton, "Rites for Dedicating Churches," in *Understanding Medieval Liturgy: Essays in Interpretation*, ed. Helen Gittos and Sarah Hamilton (Burlington, VT, 2016), 177–204, at 192–95.

66. For mnemonics, see Frances A. Yates, *The Art of Memory* (London, 2006; first ed. 1966); Mary Carruthers, *The Craft of Thought: Meditation, Rhetoric, and the Making of Images, 400–1200* (Cambridge, 1998); and Mary Carruthers, *The Book of Memory: A Study of Memory in Medieval Culture*, 2nd ed. (New York, 2008).

67. In the scholarly literature this figure has been described as a bishop, mainly on account of the crosier and possibly also because of his hat, which may have been perceived as an early form of miter. I see no evidence for the latter assumption, however. Even early miters looked quite different and were always close-fitting around the head. [Editors' note: Thomas Dale maintains this alternative identification in Chapter 11.]

68. R. A. S. Macalister, *Ecclesiastical Vestments: Their Development and History* (London, 1896), 92–93.
69. Livio Pestilli, "Apostolic Bare Feet in Masaccio's *Tribute Money*: Early Christian and Medieval Sources," *Source: Notes in the History of Art* 26.1 (2006): 5–14, at 5, 8–9.
70. Ibid., 9.
71. Jacek Maciejewski, "*Nudo pede intrat urbem*: Research on the *Adventus* of a Medieval Bishop through the First Half of the Twelfth Century," *Viator* 41.1 (2010): 89–100, at 96–99.
72. Ibid., 94.
73. Ibid., 93.
74. Ibid., 100n60.
75. [Francis Aidan] Gasquet, *English Monastic Life*, 2nd ed. (London, 1904), 47–48.
76. Maureen C. Miller, *Clothing the Clergy: Virtue and Power in Medieval Europe, c.800–1200* (Ithaca, NY, 2014), 11–50.
77. Ibid., 19–21, 39–46.
78. Ibid., 226, 233.
79. Owen Blum and Irvin M. Resnick, trans., *The Letters of Peter Damian: Letters 31–60* (Washington, DC, 1990), 2:226.
80. Maciejewski, "*Nudo pede intrat urbem*," 92.
81. Blindheim, *Graffiti in Norwegian Stave Churches*, 49 and plate LXVIII.
82. Ernest W. McDonnell, "The *Vita Apostolica*: Diversity or Dissent," *Church History* 24.1 (1955): 15–31, at 16.
83. Caroline Walker Bynum, "The Spirituality of the of Regular Canons," in *Jesus as Mother: Studies in the Spirituality of the High Middle Ages* (Berkeley, CA, 1982), 22–58, at 36.
84. Ibid., 40.
85. Ibid., 41, quoting Hugh of Saint-Victor, *De Institutione* III, in *Patrologiae Cursus Completus: Series Latina*, ed. J.-P. Migne, 176 (Paris, 1854): col. 927C.
86. Giles Constable, "Renewal and Reform in Religious Life: Concepts and Realities," in *Renaissance and Renewal in the Twelfth Century*, ed. Robert L. Benson and Giles Constable with Carol D. Lanham (Cambridge, MA, 1982), 37–67, at 54–55.
87. Synnøve Myking, "The Universal and the Local: Religious Houses as Cultural Nodal Points in Medieval Norway," in *Foreigners and Outside Influences in Medieval Norway*, ed. Stian Suppersberger Hamre (Oxford, 2017), 75–95, at 75–82.
88. Janet Burton, "The Regular Canons and Diocesan Reform in Northern England," in *The Regular Canons in the Medieval British Isles*, ed. Janet Burton and Karen Stöber (Turnhout, 2011), 41–57.
89. Anne Mathers-Lawrence, "The Augustinian Canons in Northumbria: Region, Tradition, and Textuality in a Colonizing Order," in ibid., 59–78, at 77.
90. Janet Burton and Karen Stöber, "Introduction," in ibid., 1–16, at 4–5.
91. Tore Nyberg, *Monasticism in North-Western Europe, 800–1200* (Aldershot, UK, 2000), chap. 8.
92. Augustus and Jamar, *Annales Rodenses*, 149.

CHAPTER 11

Monstrosity, Transformation and Conversion: The Program of the Urnes Capitals in Its European Context

Thomas E. A. Dale

Introduction: An Invitation to Conversion

NEAR THE SOUTHWEST CORNER OF THE NAVE of the Urnes stave church, a Christian bishop confronts a warrior centaur on adjacent faces of the same capital (Plates 85 and 87).[1] The bishop, vested in an alb and chasuble adorned with orphreys, stands frontally facing north toward the nave as he holds a cross in his right arm and a crosier in his left. The centaur, shown in profile, approaches from the bishop's right, brandishing a sword in his right hand and a shield in his left. Together these figures offer a crucial pathway into a programmatic reading of the nave capitals as representations of transformation and conversion.

Conversion, as Ira Katznelson and Miri Rubin have suggested, "whether slow or fast, induced or forced, an individual or group act . . . [a]s the Latin *convertere* implies . . . is a fundamental spiritual reorientation . . . a process of unmooring and crossing boundaries."[2] The term encompasses sacred rituals, social and political change, and interior states of mind, as well as the physical marking of bodies, places, spaces, and objects. In the case of medieval Norway, the late conversion period, between *c.*1020 and 1150, entailed the transition from Viking warrior culture to a universalizing Christian culture brought from Continental Europe, Britain, and Ireland, and, in turn, a new social order governed by the Church hierarchy and a centralized monarchy.[3] While Christianity was already well established in Norway by *c.*1130 when the Urnes capitals were carved, the theme of conversion continued to resonate in the literature of kingship, as discussed below, but it also served to highlight the continual process of individual conversion and spiritual renewal.

In medieval European Christianity, conversion was understood to be an ongoing process of

419

reflection and improvement in dialogue with the embodied self, which, as Brian Stock has shown, can be traced back to St. Augustine.[4] In Augustine's thought, conversion entails an examination of two kinds of memory images. *Phantasiae* (fantasies) are "images of things he has seen" that represent the past he is leaving behind, whereas *phantasmata* (phantasms) are the memories of "things he has learned about from the reports of others" that offer models (e.g., the lives of Christ and early ascetic saints) for reform and "the self he wants to become."[5] Building on Augustinian thought, theologians in the late eleventh century, such as St. Anselm of Bec, advocated a deepening exploration of self through *meditatio* (meditation) with the goal of recovering "within himself things that he has not previously realized."[6] In the monastic context, this involved a two-stage process beginning with an unburdening of the mind and self-isolation to explore "the innermost recesses of the soul."[7]

This concept of conversion as self-discovery has concrete ramifications for the church building and its figural imagery. John Onians characterizes movement through the space of the church as potentially fostering "psychological transformations and the dramatic realization of some bold metaphor such as rebirth or salvation. From the moment of decision to enter the portal to the experience of baptism and the Eucharist, the worshipper was in constant movement and transformation."[8] Mary Carruthers further stresses that the metaphorical journey through sacred space is "not only psychological and interior, but one made with feet and eyes through physical spaces, and colored by bodily sensation and emotion."[9] Carruthers goes on to affirm that images encountered on the exterior and interior of Romanesque churches in Europe were, along with the emotions they stimulated, the "primary engines of the way"—the *ductus* or pathway of prayer and meditation that foster spiritual rebirth or conversion.[10] Carruthers traces how the fear and terror evoked by viewing chaotic images of monsters and demons in a Romanesque church portal could offer the necessary "emotional jolt" to turn the mind to its journey of meditation, while the serene representation of the Heavenly City offered the ultimate goal of the journey.[11] Similarly, the carved capitals of church interiors are described as marking "recollective stages" along the way from "conversion" to "restlessness," leading through examples of spiritual struggle against monsters and demons, as well as exemplars of learning and salvation, and finally to the heavenly radiance of the choir.[12]

Emphasizing beasts and monstrous hybrids, the Urnes capitals appear, at least on the surface, to constitute a form of pictorial bestiary. Drawing from ancient and late antique sources, including the *Physiologus*, Pliny's *Natural History*, and Isidore of Seville's *Etymologies*, medieval bestiaries came into their own in the early twelfth century, at precisely the time the Urnes capitals were carved. While the most detailed study of the capitals describes them as "pure ornament" and insists they "do not individually have any discoverable religious significance," I would argue that the zoomorphic images parallel the bestiaries themselves, which were designed not as catalogues of natural history but as images that would provoke meditation and self-examination.[13] As Ron Baxter has emphasized, bestiaries themselves cannot be considered unitary works, either in their selection and order of texts or in their images; they project distinct messages and narratives linked to specific contexts.[14] Rather than simply offering a catalogue of positive and negative moral signs—virtues and vices outlined in the bestiary's moralizations—the individual beasts, hybrid monsters, and humans represented in the capitals of Urnes interact in ways that suggest conflicting identities and ongoing spiritual struggles

in early twelfth-century Norway. Unlike the bestiary manuscripts, in which one can assume a prescribed sequence of reading and viewing, the subjects on the capitals must be contextualized more in terms of meaningful juxtapositions on adjacent capitals or contiguous faces of the same capital, or on the basis of location within distinctive functional parts of the church—the entrance, nave, and sanctuary.

In exploring multiple meanings, I take up Sarah Kay's reconceptualization of bestiary animals in relation to skins and garments as physical manifestations and coverings of identity and the soul.[15] For Kay, "One side of the paradox [of the Fall] identifies skin according to the traditional understanding of *tunicas pellicias*, representing the mortality and fleshly concerns or faults of human beings as in some sense animal—bestial, even. But its other side places the capacity to assume a new skin on the side of incarnation and resurrection, in which a mortal skin is exchanged for one of immortality."[16]

That process of conversion and transformation, incarnation and resurrection, is further alluded to, I suggest, by the formal language of the capitals. Carved in very low relief, the capitals seem to represent the process of becoming; they offer a seemingly deliberate contrast with the principal devotional image of the church interior, the monumental Calvary group, fashioned in the round in living color. Images of transformation and conversion are thus oriented toward the heightened reality of the crucified Christ. This chapter proposes that the iconography and formal language of the Urnes capitals complements the conversion theme by expressing affiliation with an emerging, pan-European Christendom in opposition to the non-Christian "Other," even while retaining or adapting aspects of the region's pre-Christian past.

The Program of the Urnes Capitals

Urnes is one of the best preserved of twenty-eight surviving stave churches in Norway.[17] The present building, erected on the site of three predecessors, is thought to have been commissioned by a powerful local lord, a certain Gautr of Ornes (Urnes), whose two sons, Jón and Munán Gautsson, said to be among the most trusted men of King Magnús Erlingsson (r. 1161–84), are named in the runic graffiti on the interior.[18] Incorporating relief carvings on the exterior from an eleventh-century church, the wood of which was felled in 1069–70, the current church was likely constructed between 1129 and 1140, a time of significant transition from local or royal authority to archiepiscopal authority over the Christian Church throughout Norway and a period in which art and literature were assimilating European models.[19] It is distinguished from other Norwegian stave churches by its historiated capitals, dated by dendrochronology between 1129 and 1131.[20] The very form of the capitals, which resembles that of cushion capitals in stone, reinforces ecclesiastical connections with Europe.[21] From the early eleventh century until 1104, the archbishop of Hamburg-Bremen presided over all the clergy of the Scandinavian Churches, but Norwegian kings frequently exercised their own authority to choose bishops from Anglo-Saxon England.[22]

The Urnes nave capitals are striking for their range of subjects, including double-bodied lions, centaurs, griffins, dragons, and biting motifs, as well as disembodied, monstrous mouths. There are

also a limited number of human subjects, including kneeling men pulling their beards, a hunter, and a single religious figure, a bishop. This emphasis on the monstrous and the bestial, and a certain concentration of images that highlight the process of transformation from one species to another, even from man to beast, echoes a common thematic focus for Romanesque stone sculpture in Continental Europe. Indeed, the repertory of subjects coincides well with the cloister capitals described by St. Bernard of Clairvaux.[23] Set within the context of a broader critique of the distraction and expense of artworks in monasteries, Bernard's cloister carvings include double-bodied lions joined to a single head, centaurs, hunters, and fighting men. Bernard eloquently describes the "deformed beauty and beautiful deformity" of the creatures portrayed, but he is critical of such carvings because they distract the monk from reading and meditation. Although Bernard's text has often been understood as suggesting that these subjects either have no meaning or are products of a secular, even subversive imagination, recent interpretations of monsters in Romanesque sculpture have explored the meaning of monsters in the religious contexts for which they were designed.[24] Considering the predominantly monstrous images of the cloister capitals of Saint-Michel-de-Cuxa, for example, I have sought to show how monsters embody spiritual deformity and diabolical nightmares, encouraging the monk to convert by purifying his imagination from diabolical images in order to achieve a purely spiritual vision. In the case of Urnes, I argue that monsters and beasts in the nave capitals, while drawing on traditional notions of shape-shifting or metamorphosis in Old Norse literature, complement the human subjects to convey a message of spiritual struggle and transformation.

Before looking more closely at the capitals, it will be helpful to recall briefly their historical context. The conversion of Viking Norway was a gradual and uneven process that included a number of reversals.[25] Medieval sources associate the introduction of Christianity in Norway with Hákon góði ("the Good") (r. 934–61). Raised in England, which had already converted to Christianity more than two centuries earlier, Hákon started the process, but his immediate successor Hákon Sigurðarson Jarl reverted to paganism. It was left to Óláfr Tryggvason (r. c.995–99) and Óláfr Haraldsson (r. 1015–28) to consolidate his efforts. Óláfr Tryggvason extended Christianity to Norse settlements in the west, including the Faroes, Orkney, Shetland, Iceland, and Greenland, but he faced a backlash against his kingship and the imposition of Christianity and was slain at the Battle of Svolder in 1000. Óláfr Haraldsson, later known as St. Óláfr, attempted to enhance royal power while promoting the complete Christianization of the country, but he was defeated by the Danish king Knútr inn ríki (Cnut IV) and his allies at Stiklestad in 1030. Between the eleventh and mid-twelfth centuries, the kings of Norway used Christianity as the means to consolidate a unified kingdom, in which the office of king had authority over the Church and the bishops served at his pleasure, despite the official authority of the archbishop of Hamburg-Bremen in Germany. In 1154, a couple of decades after the reconstruction of the church of Urnes and the carving of its capitals, Pope Anastasius IV supported Norway's clerical reform movement and raised the bishop of Trondheim to the status of archbishop and metropolitan of the Church of Norway.

As Gro Steinsland and Anders Winroth have argued, Christianity brought to Scandinavia a fundamental ideological shift in the conception of religion and rulership.[26] Whereas traditional Nordic religion had been localized and lacked a priestly hierarchy or a fixed architecture for sacred

rituals, Christianity brought with it claims to universality and a strongly centralized hierarchy of the priesthood. Scandinavian rulers came to see this centralized administrative system as supporting their own claims to rule unified kingdoms in which the king was mediator of God's authority and guarantor of justice. This new ideology of kingship imported from Europe was nevertheless adapted to local tradition, as witnessed in literary accounts of the origins of the Norwegian Christian dynasty. Steinsland has shown, for example, how there was a persistent claim to the inheritance of a pre-Christian warrior culture, and even Christian kings were believed to reside after death in Óðinn's Valhöll (Valhalla). Maintaining the connections with warrior culture served to legitimize the ruling dynasty and strengthen territorial claims. Kings and earls also connected themselves with traditional pagan myths in which the dynastic founder mated with female giants from the Underworld as a means of protecting the dynasty and keeping the forces of the deities and giants in peaceful balance.

This cohabitation of disparate cultural and religious traditions in the emerging Christian kingdom of Norway is reflected in the carved capitals at Urnes. The nave ceiling of the stave church is supported by eighteen wooden columns, each surmounted by a cushion capital articulated with semicircular shields on all four sides. Fifty of these shields are carved in low relief, barely emerging from the background in sharply contoured planar figures facing the central nave. Amid the cacophonous visual imagery of the capitals, the four corner capitals are adorned with symmetrical foliate patterns dominated by vine scrolls (Plates 48–49, 63–64, 74–75, and 88–89), but both carved faces of the easternmost capitals show the vine emerging from the mouth of a monstrous feline mask with pointed ears (Plates 63, 64, 74, and 75). The life-giving force of the vine brings alive the wooden timbers that sustain the fabric of the church building, evoking both the biblical image of the vine as the Church and the kingdom of heaven in John 15 and the idea of the cross as the Tree of Life.[27] These corner capitals thus establish literally and figuratively the framework for the entire program of the carved capitals: the flourishing Church is conveyed by the vine. By contrast, the monstrous masks caution against the diabolic threat to the inhabitants of the vine-church, alluding in their form to fearsome lions in various biblical texts or even to the Hellmouth.[28]

This interpretation is supported by an Old Norse sermon for the dedication of churches—the so-called "Stave Church Homily," included in the Old Norse Homily Book (Reykjavík, Árni Magnússon Institute for Icelandic Studies, Cod. AM 237 a fol., *c.*1150).[29] According to this sermon, the church building "symbolizes the people and how the Christian people may be called the palace of God. . . . [and just as] the church is constructed of many diverse objects assembled together, so the people are assembled in one faith from diverse races and tongues."[30] The sermon affirms that the "four corner-posts in the church signify the four gospels, for the teachings contained in them are the stoutest supports of all Christianity," while the "roof of the church signifies those who raise their spiritual eyes above all earthly things to heavenly glory and thus shelter Christianity from temptation by their prayers."[31] Furthermore, "the two walls of the church signify the two peoples joined in one Christendom, one of the Jews and the other of the heathen tribes," an expression that could apply not only to the Roman pagans but also to the non-Christian peoples of Norway and their conversion.[32] Couched in terms of universalism and inclusion, the sermon and the imagery of the capitals, as we shall see, also project a racially tinged argument of supersession and replacement.[33]

The composition of these capitals may have been drawn from foliate initials in an English or

PART THREE | THE TWELFTH-CENTURY CHURCH

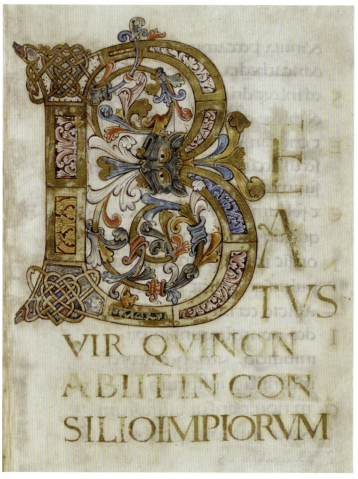

Fig. 11.1. Ramsey Psalter, England, fourth quarter of tenth century, *Beatus vir* initial. London, British Library, MS Harley 2904, fol. 4r. Photo: © The British Library Board.

Continental manuscript. Meaningful parallels are found in *Beatus* initials, including that of the tenth-century Ramsey Psalter (Fig. 11.1), the earliest example that has a feline mask at the intersection of the spirals of the vine scrolls forming the B.[34] Commonly understood by Christian commentaries to refer to Christ himself, the first psalm describes as blessed the man "who hath not walked in the counsel of the ungodly, nor stood in the way of sinners . . . but his will is in the law of the Lord" (Vulgate translation); in verse 3 he is described, in contrast to the wicked, as being "like a tree which is planted near the running waters" that yields fruit and does not wither. This very contrast is embodied by the treelike vine—the Tree of Life—which is threatened by, but also emerges from, the monstrous Hellmouth, bringing life out of the forces of death.

Although the form of the vine scrolls on the Urnes capitals is English or Continental, the theme of the Tree of Life as the Church also has a particular Scandinavian resonance in connection with Yggdrasil, the World Tree on which the Norse god Óðinn hanged himself. As Ronald Murphy and Henning Kure suggest, the Jelling stone (Fig. 11.2), erected by Haraldr blátǫnn ("Bluetooth") Gormsson in 965 to commemorate the conversion of Denmark to Christianity, superimposes the figure of Christ on an indigenous image of the interlaced tree rather than a cross, as if to bridge the pagan faith of his parents and his own new one.[35] The combination of the crucified Christ and the vine may also evoke another significant northern European tradition, embodied in the Old English "Dream of the Rood": here the cross becomes a living tree that speaks and sings of the Passion and resurrection of Christ on the cross.[36] In the case of Urnes, the sculpture of Christ on the cross placed at the entrance to the sanctuary may be linked at least conceptually to the Tree of Life theme of these capitals at the four corners of the Living Church.

Opposite: Fig. 11.2. Runestone of Haraldr blátǫnn Gormsson, Jelling, Denmark, side with crucified Christ, *c*.965. Photo: Author.

424

CHAPTER ELEVEN | MONSTROSITY, TRANSFORMATION AND CONVERSION

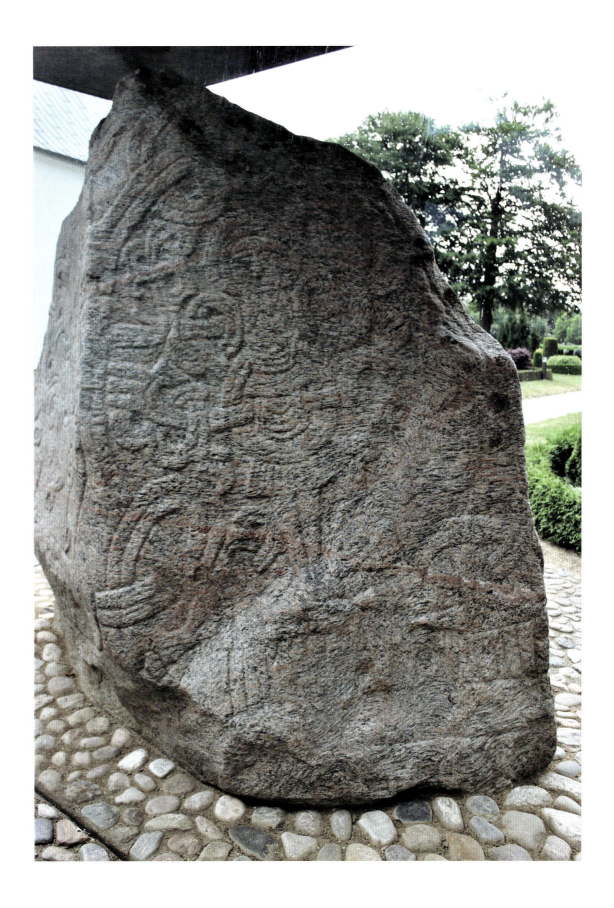

Human Metaphors for Conversion

Only six of the Urnes capitals depict humans.[37] In addition to the bishop already mentioned, there is a hunter on horseback pursuing a stag or hart on adjacent faces of the same capital at the west end of the church (Plates 45 and 46). The hunter prepares to launch a lance in the direction of the deer as it flees a dog and another lance, already launched in the same direction. It is tempting to see this scene as a reference to the aristocratic patron of the church, as hunting was a particular occupation of the elites by the twelfth century in most of Europe, but in Norway and Sweden the best hunting grounds were shared by all classes in common up to the fifteenth century.[38]

Scorned in antiquity as timid, prideful, and lascivious, the stag was recast by the *Physiologus* as a figure for Christ and for baptized Christians.[39] The *Physiologus* begins with Psalm 41 ("Sicut cervus," Vulgate numbering; now Ps. 42), which was sung during the baptismal liturgy at the Easter Vigil: "As the hart panteth after the fountains of water, so my soul panteth after thee, O God."[40] Then it describes the stag as "enemy of the dragon" and explains how it spits out water into the cracks where the dragon is hiding and kills him. The *Physiologus* gives the following interpretation: "Thus did our Lord kill the huge dragon, the devil, with heavenly waters of indescribable wisdom. The dragon cannot bear water, and the devil cannot bear heavenly words. If you also have intelligible dragons hidden in your heart, call upon Christ in the Gospels with prayers and he will kill the dragon."[41] Toward the end of the stag entry, the *Physiologus* cites Psalm 103 (104):18 ("The high hills are a refuge for the harts") to describe the creatures as "faithful men who attain to knowledge of Christ through the apostles, prophets and priests."[42] Medieval bestiary texts going back to the twelfth century recast stags as "enemies of serpents" and add new material. Oxford, Bodleian Library, MS Bodley 764 emphasizes the stag's capacity for rebirth, affirming that "after they have eaten a snake, they hasten to a spring and, drinking from it, their grey hairs and all signs of old age vanish."[43] It is this confrontation of the stag and serpent that is illustrated in the early twelfth-century English bestiary Oxford, Bodleian Library, MS Laud Misc. 247, fol. 160r (Fig. 11.3).

Deer hunting frequently appears in Romanesque capitals inside Continental churches. This reinforces the contrast between good and evil, implied in oppositional pairings elsewhere in the capital series, with the hunters as the forces of evil pursuing the Christian soul.[44] Indeed, Kirk Ambrose notes that hunting more generally was understood as a metaphor for conversion.[45] The representation of St. Eustace hunting, found on one of the nave capitals of the abbey church of Sainte-Marie-Madeleine, Vézelay (Fig. 11.4), makes this message apparent. Appealing particularly to the aristocratic patrons of the Urnes church, St. Eustace was a nobleman who converted to Christianity when a crucifix appeared in the antlers of a deer he was pursuing. What is more, this is a theme that was represented elsewhere in medieval Norway, including on the Bilden tapestry, a Romanesque textile formerly in the stave church at Bilden on Hadeland.[46]

A third male figure, to which I will return shortly, is depicted astride a lion, grasping its muzzle; he is usually identified as Samson fighting the lion (Plate 79). Finally, two men dressed in long pleated tunics, wearing distinctive headdresses or crowns with three fleurets, are each shown with one hand on the hip and the other pulling his own beard (Plate 77). The two figures turn away from each other and almost seem to fall forward with knees bent. It is possible that this motif was known to

CHAPTER ELEVEN | MONSTROSITY, TRANSFORMATION AND CONVERSION

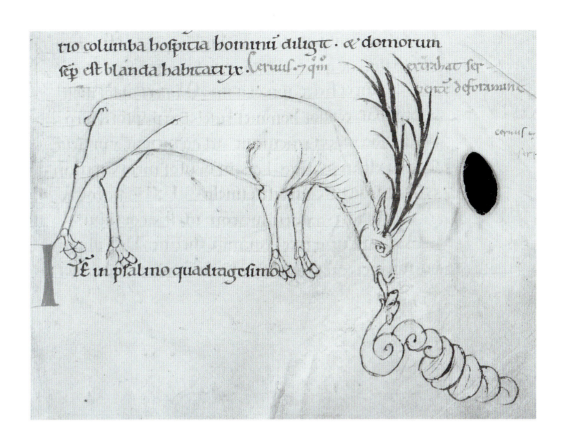

Fig. 11.3. Bestiary, England, early twelfth century, confrontation of stag and serpent. Oxford, Bodleian Library, MS Laud. Misc.247, fol. 160r. Photo: The Bodleian Libraries, University of Oxford.

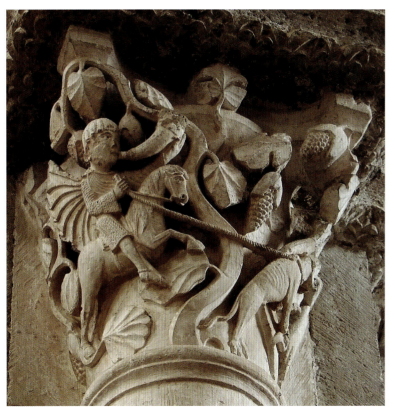

Fig. 11.4. Vézelay, France, abbey of Sainte-Marie-Madeleine, *c.*1120, nave capital with St. Eustace hunting a stag. Photo: Vassil, Wikimedia Commons.

427

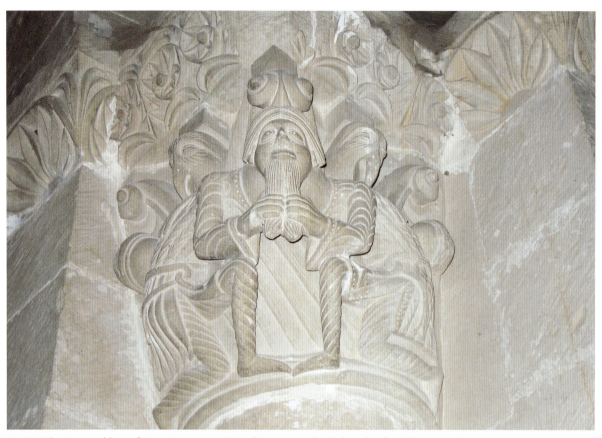

Fig. 11.5. Silos, Spain, abbey of Santo Domingo, c.1120, cloister capital with beard pullers. Photo: Author.

Norwegian artists via Hiberno-Saxon or Anglo-Saxon intermediaries. The Book of Kells features two men pulling each other's beard in the initial N in the text of Luke 16.[47] Bernard Meehan has interpreted the Kells beard pullers as an allusion to the phrase "Nemo servus potest duobus dominis servire" (No servant can serve two masters; Luke 16:13).[48] By contrast, the Urnes figures show no signs of conflict and are stroking their own beards; they also lack the specific pretext provided by the Gospel text in the Book of Kells.

On the basis of their costume and symmetrical composition, one can find closer comparisons in European sculpture, including an example at Silos in northern Spain (Fig. 11.5).[49] Placed on one flank of the Puerta de las Virgenes, the Silos capital depicts two male figures, dressed in short tunics, kneeling on one knee; each grasps the beard of the single head to which their bodies are joined at the capital's corner. Elizabeth Valdez del Álamo has identified the costume as Islamic, and she has noted the connection with the inscription associated with the portal referring to possibly lost figures of "Moors."[50] Costumed as the Muslim "Other," the beard pullers at Silos are associated with a larger group of acrobats, lion tamers, and entertainers.[51] Zehava Jacoby has confirmed the Islamic origins of the motif by comparison with an eleventh-century relief on a marble basin from Xátiva, and she plausibly suggested that Islamic Spain served as conduit for the diffusion of the beard pullers throughout Europe.[52] As for the meaning of the beard pulling in this instance, Valdez del Álamo

interpreted the gesture as one of anger or inner turbulence, pointing to the figure of Herod stroking his beard as he considers the Massacre of the Innocents.[53] The crown-headdresses with drooping fleurets, which seem to anticipate later medieval jesters' caps, are intended as mock crowns.[54]

Identifying the beard pullers at Urnes as Muslims suggests that they represent an example of non-Christian Others as targets for conversion, a theme that is more explicit elsewhere in the program. As in the Silos portal, one could argue that the Muslims represented the heresy of unbelievers that one had to "overcome in order to achieve salvation."[55] That this exotic motif was incorporated into the series of capitals at Urnes should not be surprising, given the now extensive documentation of Viking–Muslim encounters between the ninth and twelfth centuries, which included the acquisition of substantial material goods ranging from coins to textiles.[56] Scandinavian Christians were also increasingly coming into conflict with Muslims as they participated in the crusades in the Middle East beginning in the twelfth century.[57] Furthermore, the appropriation of ideas from Continental European romances contributed to the casting of so-called Saracens as idolatrous infidels, comparable in status to pre-Christian Nordic heathens.[58] Although it is but one subject among the many more traditional ones at Urnes with Christian, biblical, or secular connections, the beard pullers prompt us to consider what Nahir Otaño Gracia has conceptualized as a "decentered Global North Atlantic."[59] The Muslim beard pullers represent a racial marking akin to the literary "racial profiling" used to dehumanize the enemies of the Northern hero, be they black "Saracens" from Spain or North Africa or such indigenous Others as the Sami. These distinctive Muslims, along with exotic animals like the camel (Plate 47) or ancient mythical hybrids such as the centaur (Plate 87), offer a counter-narrative to the myth of an all-white, "pre-racial," Nordic Middle Ages.[60]

Lions and Feline Predators

Almost half of the nave capital images depict feline creatures, designated in Erla Bergendahl Hohler's catalogue as lions.[61] The most common form depicts the feline in profile (Plates 43, 56, and 70), *en passant*, but there is considerable variation in the details of the pose and morphology of the head. All the felines have pointed ears, large eyes, and an elongated neck, but only three depict a distinct mane of long, flamelike hair that is also seen in the eleventh-century reliefs on the exterior (Plates 61, 65, and 70), and one of these creatures seems intended to be a griffin (Plate 61; see below). Thus, it is possible that many of the other felines should be construed as lionesses or panthers. A capital in the south aisle displays the lion type closest to European conventions, with the body in profile and the head facing toward the viewer frontally with wide eyes (Plate 78). When the head is depicted in profile, the elongated neck is more prominent and sometimes combined with the spiraling ribbonlike tail (as in Plates 52, 56, and 70), so that the beast recalls the earlier Urnes-style lion with its flamelike mane on the exterior of the church (Plate 3). Not content to repeat the same template, the artist also animates the beasts by showing the head upside-down looking upward (Plate 52) or playfully biting its own leg (Plates 82 and 84), or by twisting the body so that the hind legs are projected up in the air on the opposite side of the body from the forelegs (Plate 54). In many cases the tail is transformed

into a leaf at the end, assuming a dynamic spiral form that sometimes engulfs the body. Most of the lions seem to stick out their tongues, which sprout what appears to be a leaf, and in one instance a lion begins to devour a winged serpent or dragon by the tail (Plate 66). Two further variations are the rampant lions facing each other on one capital (Plate 80) and a lion with two heads joined to a common body (Plate 53). Finally, another variant depicts creatures with only the forelegs, neck, and head of a feline while the back is attenuated to form a serpentlike tail with spirals (Plate 81), thus effecting a formal transformation toward the dragon-serpents considered below.

Lions are among the most common subjects in Romanesque sculpture, and they frequently appear both as individual creatures *en passant* and as rampant pairs, suggesting a heraldic device. An interesting comparison, reinforcing connections with the German Church, is from the cloister of the Bonn Minster dedicated to St. Martin, completed under Provost Gerhard von Are around 1140 (Fig. 11.6).[62] A cushion capital with a lion and dragon fills semicircular shields carved in shallow, flat relief. This lion, though marked by a clear mane, appears quite close to the Urnes lions on two capitals (Plates 70 and 78), with its body shown in profile, the head facing the viewer frontally, and the tail terminating in a leaflike motif. We see essentially the same design translated into an early twelfth-century low-relief tympanum at the north portal of Værnes, Norway.[63] Paired rampant lions or double-bodied lions joined to a single head are particularly common in French and Spanish cloister capitals, as seen at Silos and Cuxa (Fig. 11.7), and such motifs also appear in Scandinavian Romanesque stone sculpture, likely mediated by German models.[64] The particular mode of carving the cushion capitals at Urnes with four independent semicircular faces is less congenial to these more complicated compositions, however. The one example of paired lions at Urnes is found on capital 15E (Plate 80), and the diminished scale of the lions in this composition makes it less legible from below, a factor that may have prompted the sculptor to focus on single animals in most of the other capitals.

As "king of the beasts," according to the *Physiologus*, and a symbol of biblical kingship connected to the tribe of Judah (Gen. 49:9–10), the lion was an ideal emblem for medieval rulers.[65] It is therefore tempting to connect these felines with a presumed princely patronage of the church, but it is more likely, given their setting in the nave, that these imported creatures suggested other connections that pertain more generally to the spiritual realm.[66] Because lions were foreign to Scandinavia, models likely would have come from illustrated bestiaries, small-scale carvings, or drawings based on other media.[67] By 1200, bestiary texts and images were in circulation in Scandinavia, as witnessed by two fragmentary Icelandic translations of the Latin *Physiologus* into Old Norse, now in the Árni Magnússon Institute for Icelandic Studies in Reykjavík, but the source manuscripts must have been in circulation earlier in the twelfth century, likely from England, as Vittoria Dolcetti Corazza has proposed.[68] The *Physiologus* gives a primarily positive view of the lion, associating it with Christ on three counts: the lion effaces its tracks with its tail, analogous to how Christ concealed his divinity from all except his followers; it sleeps with its eyes open, much as Jesus, though physically dead after the crucifixion, remained alive in his divine nature; and the lion roars over its stillborn cubs to bring them to life, evoking the resurrection.[69]

Biblical references, by contrast, emphasize the lion's threatening aspect. In the book of Daniel (6), the Jewish youth Daniel, a valued counselor to the Babylonian king Darius, was thrown into a lions' den for praying to his own god rather than the king. He was miraculously saved by an angel who shut

CHAPTER ELEVEN | MONSTROSITY, TRANSFORMATION AND CONVERSION

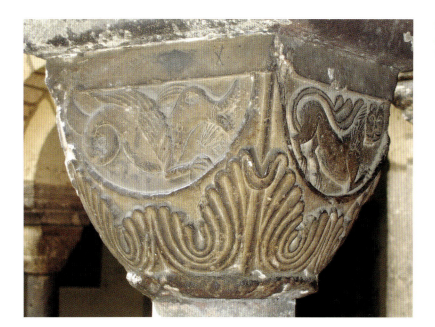

Fig. 11.6. Bonn, Germany, St. Martin (Bonn Minster), c.1140, cloister capital with lion and griffin. Photo: Author.

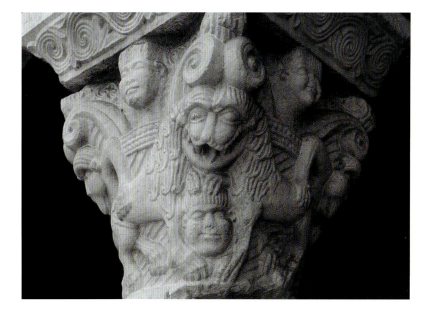

Fig. 11.7. Saint-Michel-de-Cuxa, France, c.1130-40, cloister capital with double-bodied lions menacing men. Photo: Author.

the lions' mouths, and Daniel was then released by the king. The lion also figures prominently in the book of Psalms. The threat to spiritual life is evoked using the metaphor of the monstrous devouring mouth in Psalm 21:22 (22:21): "Save me from the lion's mouth." Similarly Psalm 90 (91):13 includes the lion among the four monstrous beasts trampled by the Lord—the lion and the adder, the basilisk and the dragon. In monastic liturgy based on the Benedictine rule, this psalm was designated to be sung during compline as a form of battle hymn to protect the senses from diabolical interference in dreams and nightmares when the monks were asleep.[70] What is more, within medieval Norwegian hagiographic tradition, the singing of the psalms becomes a substitute for physical warfare in the Legend of St. Magnús.[71]

431

The theme of spiritual combat is reinforced by the presence of a man wrestling a lion (Plate 79). Shown in a long robe astride the beast's back, the figure reaches over to hold its muzzle. The most obvious identity is the biblical hero Samson, but Kirk Ambrose has cautioned that combats between men and lions in Romanesque sculpture can have multiple interpretations, including other biblical figures such as David and pagan protagonists such as Hercules, and that ambiguity was often desirable.[72] The very imprecision of the hero's identity, and the fact that he wears the garb of a more fashionable medieval courtly figure, a long flowing robe with long sleeves and pointed shoes, and does not sport the beard and long hair typical for Samson,[73] suggests that a local lord might project himself onto the identity of the biblical or mythical figure.

Dragons, Griffins, and Birds of Prey

The feline predators are complemented by dragons, griffins, and birds of prey. Despite the frequent appearance of dragons framing stave church portals, where they appear in cosmic struggles with lions and serpents,[74] only one of the Urnes interior capitals depicts dragons, and they appear on all three sides that are carved (Plates 57–59). The dragons represent a kind of metamorphosis of the lion's body. They have the same head type as the lions, with pointed ears and almond-shaped eyes, as well as a single leonine foreleg and paw joined to the thickest part of the body, to which a single wing is added. Yet the dragons' ribbonlike bodies are arranged in circular loops that evoke the earlier Urnes-style zoomorphic interlace in the carved ornament from the eleventh century displayed on the north exterior wall and west gable of the church (Plates 3 and 11). Like many of the lions, they seem almost in conflict with themselves, biting their own bodies or tails.

The dragons are complemented by the eight pilaster strips that support the beams of the ceiling. Only one of the pilasters (VII; Plate 102) includes another beast, pursued by the dragon: a quadruped from above, spread-eagled. Hohler notes that it displays the pointed ears and paws of the felines, but almost all animals—the horse, the camel, the stag in the hunting scene—are depicted with the same paws and ears. This prompts another interpretation of the quadruped. I would suggest that the forked projections from either side of its nose might represent the antlers of a stag. If this is indeed the case, it would evoke the traditional encounter of the stag and the serpent found in the *Physiologus*.

The bestiary casts the dragon as the largest of a number of evil serpents, including the asp and basilisk mentioned in Psalm 90:13. It notes specifically its capacity to deceptively transform itself "into an angel of light, deceiving fools with hopes of vainglory and human pleasures."[75] The version of the *Physiologus* known as the *Dicta Chrysostomi* describes the dragon as the "greatest of serpents," able to kill with its poisonous breath and by blows of its tail, which it uses to encircle even such larger creatures as the elephant. Associating the dragon with the biblical Leviathan, the text offers this moralization:

> The dragon, the greatest of all serpents, is the devil, the king of all evil. As it deals death with its poisonous breath and blow of its tail, so the devil destroys men's souls by thought,

> word and deed. He kills their thoughts by the breath of pride; he poisons their words with malice; he strangles them by the performance of evil deeds, as it were with his tail. By the dragon the air is set in motion, and so is the peace of spiritually minded people often disturbed in that way. . . . The dragon is the enemy of a pure animal; likewise is the devil the enemy of the Virgin's son.[76]

The "pure animal" is likely the stag, which, as we have already seen in looking at the image of the hunt (Plate 46), is understood to represent the Christian faithful, based on the exegesis of Psalm 41 (42):1.[77]

The winged dragons are joined by two other aerial creatures: predatory birds and a griffin. On the central axis of the nave, adjacent to the sanctuary, a pair of birds with hooked beaks and overlapping tails faces out from the center (Plate 69). The shape of the beak and position on the privileged axis, juxtaposed with the Calvary group over the original sanctuary screen, suggests that these should be understood as eagles. While eagles, like lions, have aristocratic and even imperial associations, a number of biblical texts have contributed to their interpretation as symbols of rejuvenation or resurrection and thus the complementary idea of conversion. The text of Psalm 102 (103):5, "Renovabitur sicut aquilae iuventus tua" (thy youth shall be renewed like the eagle's), inspired bestiary texts to emphasize its self-renewal as a type for spiritual renewal and vision. According to the *Physiologus*, the eagle is known for its very long life, living to one hundred years; when it becomes old and its back is bent and its eyes dimmed, it renews itself by flying up to the sun to burn off its old feathers and the mist covering its eyes and then plunges into water three times. The accompanying moralization again evokes the metaphor of changing skins or garments:

> Therefore, you also, if you have the old clothing and the eyes of your heart have grown dim, seek out the spiritual fountain who is the Lord. "They have forsaken me, the fountain of living water" [Jer. 2:13]. As you fly into the height of the sun of justice [Mal. 4:2], who is Christ as the Apostle says, he himself will burn off your old clothing which is the devil's. . . . Be baptized in the everlasting fountain, putting off the old man and his actions and putting on the new, you who have been created after the likeness of God [cf. Eph. 4:24] as the Apostle said. Therefore, David said, "Your youth will be renewed like the eagle's" [Ps. 103:5].[78]

The eagle may thus be understood in relation to the spiritual renewal of conversion, sealed by the ritual of baptism.

The vulture, known for feeding on corpses, may readily be identified with the bird on the north face of the same capital (Plate 68) because it is shown flying with a human leg in its mouth. According to Hugh of Fouilloy (c.1096/1111–72), in his widely disseminated treatise on the nature of birds, *Aviarium* (or *De avibus*), composed between 1132 and 1152, "the nature of the vulture is said to be such that any sinner can be understood through the vulture. . . . It feeds upon the corpses of the dead, because [the sinner] delights in the carnal desires which produce death."[79] Yet Hugh begins his discussion of the vulture by quoting Job 28:7 ("The bird hath not known the path, neither hath the

eye of the vulture"), which he connects with Christ who "by His ascension lifted up into heaven the human body which he assumed." Hugh goes on to affirm that:

> by the name "vulture" is rightly designated God's Mediator and our redeemer of men, who, abiding in the heights of His divinity, as if in a kind of exalted flight, saw the corpse of our mortality in the abyss and betook Himself from the heights into the depths. Indeed, He deigned to be made man for us; and while the dead animal perished, so He who was in essence immortal met with death among us.[80]

Furthermore, the *Physiologus* affirms that the vulture refrains from eating for up to forty days, and this prompts comparison with the fasting of Lent, the season of spiritual self-exploration that anticipates the resurrection of the Lord and prepares the newly converted for baptism.[81]

Another traditionally winged beast included at Urnes is the griffin (Plate 61). In a departure from the norm, this example, despite combining the body, legs, and shaggy mane of a lion with the head and beak of an eagle, lacks wings.[82] Another possible variation is the winged, leonine creature biting its long curved neck on capital 12W (Plate 73). Like many exotic hybrids, the griffin is associated with the eastern Other—with the Hyperborean mountains, Ethiopia, or the Indian desert.[83] Hugh of Fouilloy describes how it has a particular appetite for human flesh, and if it kills a man it gives the body to its children as food. Together with the vulture, lions, and manticore, to be considered below, this creature adds to the theme of anthropophagic imagery, which uses the threat to the human body as a reminder of the theme of hell as a devouring mouth that consumes the resurrected bodies of the damned.[84]

The Camel and Conversion

One more domesticated beast is included at Urnes: the camel (Plate 47). Near the northwest corner, on the same capital that depicts the hunter pursuing stags, this two-humped Bactrian camel comes from the Middle East, thus evoking the biblical Holy Land. The camel was not unknown in northwestern Europe: the *Annals of Innisfallen* record that a "camel, an animal of remarkable size, was brought from the King of Alba [Scotland] to Muirchertach Ua Briain in 1105"; and William of Malmesbury (c.1095–c.1143) refers to King Henry I having a fenced-in zoo with such exotic animals as camels, lions, leopards, lynxes, and porcupines at his palace in Woodstock, Oxfordshire.[85] Norse crusaders, including King Sigurðr (Sigurd) and his band, would have seen them firsthand when they visited Jerusalem. Apart from being depicted in biblical manuscripts in the Genesis narrative, camels were also associated with the "Wonders of the East," and it is the two-humped Bactrian camel that appears in Anglo-Saxon manuscripts of the Wonders in conjunction with dog-sized ants.[86] The Bodleian bestiary text takes the camel's role as beast of burden as a sign of the "the humility of Christ, who bears all our sins or the Gentiles converted to the Christian faith"; further emphasizing the theme of conversion, the bestiary text then refers to "the camel passing through the eye of the

needle" citing Christ (Matt. 19:24, Mark 10:25, Luke 18:25) to explain how difficult it is for a wealthy person to enter the kingdom of heaven. The bestiary once again evokes the metaphor of clothing, pairing the parable of the camel passing through the needle with Paul's idea of the baptized clothing themselves in a new identity with Christ. The text explains that:

> it is easier for Christ to suffer for those who are enamoured of this world than for such men to be converted to Christ. He was willing to assume the part of a camel, in taking on Himself the burdens of our weakness which he did out of humility. This is the meaning of the verse: "The greater thou art, the more humble thyself" [Ecclesiasticus 3:18]. The needle reminds us of pricks, the pricks of pain He underwent in His Passion. The eye of the needle is the straitness of Our Lord's passion, by which He in some measure rent the clothing of our nature, that is, He deemed it worthy to be put on, so that after the fall we should be remade in better fashion, rejoicing in the Apostle's words: "For as many of you as have been baptised into Christ have put on Christ" [Galatians 3:27].[87]

The camel, then, may be understood as one of the many animal identities that the newly baptized Norse Christian might take on, and the position of this image near the west entrance to the church might relate to the promised journey toward the heavenly Jerusalem anticipated by entering the church building and the institutional Church through the soul's conversion.[88] Indeed, this metaphorical journey of conversion is another of the themes emphasized in the Old Norse sermon for the dedication of churches mentioned earlier. According to this symbolic interpretation of the church building, the portal "signifies the true faith, through which we are led into the community of Christianity," while the "rood-screen between the nave and the chancel signifies the Holy Ghost, for just as we enter Christianity by way of Christ, so also do we enter heavenly glory through the gate of mercy of the Holy Spirit."[89]

Berserkr: Hybridity and Shape-Shifting Metaphors for Transformation

The fighter who is closely engaged with the lion as he stands astride its back (Plate 79) is perhaps deliberately juxtaposed with an image facing the nave on an adjacent capital that blurs distinctions between man and animal through hybridity resulting from metamorphosis (Plate 76). Here the typical striding lion in profile is transformed by the superimposition of a male, bearded head with a pointed headdress and the substitution of a human arm holding a battle-axe for the right front leg. This invented monster might have been suggested by a bestiary illustration of a manticore (Fig. 11.8), which combines the body of a lion, red in color, with the head of a man and a scorpion's tail. Although it was not included in the *Physiologus*, the manticore is described in detail by Pliny (d. 79 CE) in his *Natural History*, drawing on Ctesias (active *ca.*400 BCE) for the physical description and habits. Among the earliest medieval references to this hybrid, Fulcher of Chartres describes it in his *Historia*

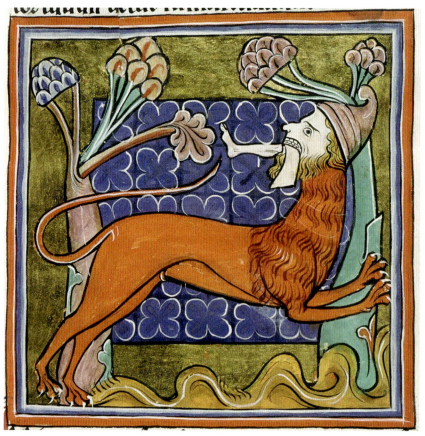

Fig. 11.8. Bestiary, England, second quarter of thirteenth century, the manticore. Oxford, Bodleian Library MS Bodley 764, 25r. Photo: The Bodleian Libraries, University of Oxford.

Hierosolymitana (1095–1127) as being "among the diverse kinds of beasts and serpents" in "terra Sarracenorum," thus associating the creature with the Muslim enemies of the crusaders.[90] Drawing from Pliny, Fulcher describes how the manticore has a voice like a panpipe blended with a trumpet, runs very fast, and has a special appetite for human flesh. A slightly later account is found in the text of MS Bodley 764: said to come from India, the manticore is described as having a triple row of teeth, the face of a man, gray eyes, a lion's body, blood-red in color, a pointed tail with a sting like that of a scorpion, and a hissing voice.[91] Both text and image in this work emphasize that the creature delights in eating human flesh. In this instance, then, blurring between man and animal is indicated both by the manticore's human face and its consumption of human flesh. By equipping it with a human hand and weapon, the Urnes sculptor has enhanced the connection of the hybrid with so-called monstrous races and non-Christian Others.[92] This strengthens the reference to race on this capital, which, as already discussed, depicts the Muslim beard pullers on its east face.

While the manticore visualizes a broader metaphor for non-Christians, its hybrid makeup suggests a connection with shape-shifting in pre- and post-conversion Old Norse literature. Siv Kristoffersen has traced the hybrid human-animal creatures in the Nordic art of pre-Christian Scandinavia to the "transgressive relationship between animals and humans" found in Old Norse poetry.[93] He further proposes that the animal-human hybrids evoke the magical force that makes such transformations

possible, transferring that power to the objects they adorn. Lyonel Perabo explores more specifically the mechanisms by which shape-shifting is affected by magic and the supernatural in Old Norse and Icelandic literature and how particular populations are related through shape-shifting to specific animals.[94] He associates shape-shifting with the term *hamr*, which, following Aðalheiður Guðmundsdóttir, refers not merely to an animal pelt but to the "shape, the appearance and form of someone who is able to change shape."[95] *Hamr* is used extensively in the Norse-Icelandic corpus in both historical and mythical literature, ranging from tenth-century skaldic poetry to late medieval *rímur* poems. It is described as a "physical garment that can be worn and removed and which in and of itself can be a cause for transformation."[96] Furthermore, in the medieval sagas, the idea of changing one's skin could be understood as conveying transformation of one's mental or magical state of being. Surveying numerous literary sources, Perabo shows a vast range of creatures into which humans, giants, and deities are transformed, including many of the ones depicted on the Urnes capitals: eagles, lions, dragons, serpents, and deer or reindeer.

Shape-shifting between the animal and human is also associated with heroic warriors and the term *berserkr*. In modern parlance "berserk" is interpreted as a crazed, frenzied state, but Old Norse literature suggests different resonances. Roderick Dale has shown how the term applied to a calculated ritual preparation and posturing by warriors before a battle, which included, among other things, the wearing of wolfskins and other animal attributes on their helmets.[97] Dale points out that the term was applied to the king's warriors and foes as well as to Christian warriors. Ármann Jakobsson, focusing on the *Egils saga*—a heroic poem preserved in a thirteenth-century Icelandic version attributed to Snorri Sturluson, which claims to quote original works from the time of its tenth-century protagonists—describes the berserks of Old Norse texts as conveying the power of frightening warriors in a range of ways.[98] The term *berserkr*, applied to Egill Skallagrímsson in battle, can be interpreted as *ber-serkr*, literally "in the skin of a bear"; and in turn, it might be understood by medieval readers and audiences for oral recitations of the poems as warriors who were either metaphorically transformed into beasts, literally wearing the skin of a bear or other creature to convey their change of state as a warrior, or magically transformed into a beast through the power of shape-shifting. Jakobsson further observes that the term *berserkr* was applied to other peoples, such as the Sami, who were associated with magic and bestiality. The ambiguous nature of Egill Skallagrímsson, who commits acts of cannibalism in battle, can be connected with his genealogy, as he counts a *berserkr* as his great-grandfather and the shape-shifters Skallagrímr and Kveldúlfr as his father and grandfather. The fact that the battle-axe was a preferred weapon of contemporary warfare and figured in the name of the Norwegian king Eiríkr blóðøx ("Blood-Axe") Haraldsson, who appears as opponent to Egill's family in the saga, further strengthens the connection with the Urnes manticore. What is more, the axe and metalsmithing are key metaphors driving the larger narrative, as William Sayers has demonstrated.[99] The externally beautiful axe given by King Eiríkr to Egill's father turns out to be internally flawed, deliberately doomed to fail its recipient.

A persistent preoccupation with shape-shifting might also explain the human trousers worn by one of the Urnes lions on the west face of the same capital (Plate 78), as well as the granting of sword and shield to the centaur (Plate 87). The centaur was among the beasts from antiquity

most commonly represented in Romanesque sculpture in Europe, frequently in monastic cloisters including Moissac and Silos, and it is shown alongside the siren in illustrated Latin bestiaries, drawing biblical authority from the Vulgate translation of Isaiah 13:21–22.[100] The centaur appears in both versions of the Icelandic *Physiologus* and is illustrated in *Physiologus B*, now in Reykjavík's Árni Magnússon Institute for Icelandic Studies (Fig. 11.9). Its combination of a human torso with the body of a quadruped, either a horse or a donkey, made it an example of the potential transformation and degradation of man's spiritual nature brought about by succumbing to animal impulses. The Icelandic translation of the Latin text in *Physiologus A* describes the beast as "a man in its fore part and an animal in its hind part [which] symbolizes unfaithful men in its appearance."[101] The *Physiologus B* manuscript elaborates on the story:

> *Honocentaurus* has its fore part like a man and its hind part like an animal; it has a double tongue and lingers in the meadows to talk with men. So as the Apostle says: "He promises gentleness, but denies his force"; and the Prophet David: "Man, when he was in Glory, did not understand, and is considered to be like a foolish animal and has become similar to them."[102]

This second version reinforces the interpretation of the centaur as a monstrous debasement of the human soul, its transformation into a foolish, unreasoning animal. The message of this image within the broader program of the carved capitals at Urnes can readily be discerned when it is viewed in relation to the bishop on the adjacent face of the same capital. The centaur, who wears a tunic with flared sleeves, gallops toward the frontal figure of the bishop, brandishing a stout sword in its right hand and holding a shield behind him with the left. The ancient Greek hybrid has been transformed into a medieval warrior.

Entering the Church: The Bishop's Call to Conversion

This brings us back to the interpretation of the bishop on the same capital (Plates 85 and 87). The bishop holds in one hand his pastoral staff, the crosier, which is an emblem of his role as protector of the flock and symbol of his authority as overseer of the local church;[103] in the other he holds what may be described as either a cross staff or a processional cross, alluding to the historic sacrifice of Christ on the cross and the symbol of conversion to Christianity. Although the figure likely represents the ecclesiastical office rather than a specific individual, Urnes would have been under the authority of the bishop of Bergen, whose office was established under King Óláfr III kyrri, who founded that city during his reign (r. 1067–93). With the conversion of the region from traditional Norse religion to Christianity largely complete by the mid-eleventh century, the significance of the encounter of the centaur and the bishop may be construed both as a retrospective narrative of conversion and as emphasizing the ongoing conversion of souls performed with each baptism in the community.

CHAPTER ELEVEN | MONSTROSITY, TRANSFORMATION AND CONVERSION

Fig. 11.9. *Physiologus B*, Iceland, c.1200, the centaur. Reykjavík, Árni Magnússon Institute for Icelandic Studies, Arnamagnæan Collection, MS AM 673 a II 4o, fol. 4r. Photo: Arnamagnæan Collection, Copenhagen University.

439

PART THREE | THE TWELFTH-CENTURY CHURCH

Fig. 11.10. Västerplana font, Gotland, Sweden, early twelfth century. Photo: Lennart Karlsson, The Swedish History Museum, Stockholm.

Thomas DuBois has shown, despite the fact that St. Óláfr was preceded by two other proponents of conversion, kings Hákon "the Good" and Óláfr Tryggvason, Óláfr became known as the "true Christianizer of Norway," emulating Constantine I in his devotion to the cross.[104] The cross acquired additional significance in the early twelfth century. King Sigurðr the Crusader (r. 1103–30) connected the relics of the cross and the action of crusading. After participating in knightly combats in England, Spain, and Sicily, Sigurðr and his men reached the new crusader kingdom, where they were entrusted with a relic of the Holy Cross by King Baldwin II and the patriarch of Jerusalem, with the understanding that he would "work with all his might to further Christianity and bring an archbishop's seat into his land if possible, and that the Cross would be placed where St. Óláfr rests."[105] As it turned out, Sigurðr did not take the cross relic to Trondheim to rest with the relics of St. Óláfr, but instead built a church dedicated to the Holy Cross at Kongshella (Kungälv). Snorri writes critically that, "by placing the Cross at the eastern edge of the realm, he thought it would protect the entire land, but it was most unwise to place the holy relic so nearly under the power of pagan men, as it turned out later."[106] Here we see that even in the early twelfth century, just a short time before the Norwegian metropolitan was established at Trondheim (1154), thus consolidating the Church's hegemony in Norway, there is still the threat of "pagan men." The pagans were no longer so much the adherents of older Norse religion at home but, rather, the Pomeranian Slavs, also known as the Wends, on the Baltic coast, who paralleled the so-called Saracens in Spain and the Holy Land as focal points for holy war or "Reconquista." Similarly, the cross, in the form of relics, was used to consecrate the northern frontier of Christendom as a New Jerusalem.[107]

To understand why the Urnes bishop is shown confronting a centaur warrior rather than a contemporary pagan, it is instructive to return to the bestiary as it was known in Norse tradition (Fig. 11.9). In the Icelandic manuscript of *Physiologus B*, the somewhat diminutive and bald centaur is shown in animated conversation with two men: one is fully clothed, wearing what appears to be

440

a crown or princely headdress and holding a sword, and the other is a naked figure whom the first is covering with his cloak. Dolcetti Corazza interprets the two figures as the interlocutors described in the moralization, the nude one as a man deceived by the flattery of the centaur or devil, the clothed one beating him back with the sword as the one who has succeeded in overcoming temptation.[108] The image at Urnes seems to underline instead the shifting power structure in medieval Norway, from a secular society based on warfare and magical pre-Christian traditions embodied in shape-shifting and the magic of dragons and other hybrid beasts, to a new, more unified state in which the king's power was complemented by the universalizing authority of the Church.

The allusions to pre-Christian, Viking traditions of shape-shifting alongside visual representations of "spiritual combat" and of animals and peoples construed as non-Christian Others ultimately may be understood in the context of conversion of the individual within sacred space. It is therefore instructive to find parallels on baptismal fonts for the combination of images in the Urnes capitals. The early twelfth-century Västerplana font in Gotland (Fig. 11.10), for example, depicts a centaur with sword and shield doing battle with a winged dragon; a king on horseback firing an arrow at a lion; and a frontal bishop with crosier in hand flanked by an eagle and Tree of Life.[109] This iconographic selection offers a succinct summary of the sacramental power of baptism, as mediated by the state-sponsored Church (represented by the king and bishop), in purifying the initiate of sin, renouncing evil forces (the lion, centaur, and dragon), and gaining the promise of new life.[110]

Conversion through baptism means participating in the sacrament of the Eucharist and believing in the real presence of the fleshly body and blood of Christ, sacrificed on the cross, in the consecrated bread and wine. This presence is made visible in the Calvary group at Urnes, with Mary and John interceding before the crucified body of Christ on the cross (Plate 106). Although sometimes dated to the later twelfth century, the Calvary group is more likely to have been commissioned in tandem with the consecration of the new sacred space in the 1130s, originally placed lower down over the chancel screen. The schematic approach to rendering the rib cage and torso of Christ, and his enlarged almond-shaped eyes and angular nose, favor an earlier twelfth-century date; and, as Martin Blindheim has pointed out, the inclination of the head and knees to the figure's right (the "right-sinking tradition") seems to draw on English models from the end of the eleventh century in manuscript illumination, but also found in copper-alloy crucifixes *c.*1125–50.[111] Furthermore the schematic modeling in the Urnes crucifix adheres closely to the style of both the Hauge crucifix, which Blindheim dates *c.*1100, and the one from Grindaker, which he places in the first half of the twelfth century.[112] Recent technical analysis of the structure and pigments of the Urnes Calvary group is also consistent with a dating contemporary with the capitals.[113]

If we accept the idea that the Urnes Calvary group was planned as part of the interior decoration at the time the capitals were made, then we can argue for a meaningful connection between these two elements of the sculptural program. In keeping with a long-standing tradition in Continental Europe and England going back to the late Carolingian period, the life-size sculpted crucifix, made particularly vivid through polychromy, would have served as a reminder of real presence in the sacrament, a focal point for the veneration of the cross on Good Friday, and a stimulus throughout the year for individual devotion.[114]

The figure of the bishop, turning toward the central part of the nave, alludes to the crucifix with the cross staff held in his right hand, thus directing attention to the focal point of the visual program. At the same time, a clear hierarchy favors the crucifix as a devotional image. It conveys the real presence that derives from both sculpture in the round and polychromy, enhancing the potential for the Pygmalion effect, the sculpture's coming alive in the imagination of the faithful as they participate in the liturgy.[115] Perhaps the congregants would also have had in mind the sentiments expressed in such sermons as the Old Norse "Stave Church Homily," mentioned earlier.[116] The body of Christ on the cross, the rood, evokes spiritual food, the mediator of entrance into heaven, and the model of mortification of the flesh. Thus the sermon affirms that "the crosses and roods signify mortification of the flesh, that is fasting and vigils" and, further, that "just as we receive spiritual food in church, i.e. *corpus domini*, so must we give bodily food to those in need."[117] The sermon further encourages the faithful to see that the "rood-screen between the nave and the chancel signifies the Holy Ghost, for just as we enter Christianity by way of Christ, so also do we enter heavenly glory through the gate of mercy of the Holy Spirit."[118]

By contrast, the figural capitals of the nave are carved in shallow relief on a much smaller scale. In later Italian wall painting it was common to depict allegorical imagery, including spiritual combat and battles of Virtues and Vices, in the form of fictive curtains with outline drawings, or as fictive low reliefs in stone, in contrast with full-color biblical images.[119] An explanation for these distinct modes of representation is that the outline drawings or, in the case of Urnes, the low reliefs, offer the outlines or shadows of that which is to come, that which is to be completed through the spiritual exercises inside the church. Indeed, they represent that which is the process of conversion itself, from the earthly struggles to union with the body of Christ.

Conclusion: Conversion as Physical and Spiritual Journey within Sacred Space

When viewing these capitals, starting with the figure of the bishop near the entrance, both long-standing members of the Urnes congregation and the newly baptized would imagine their own transformation and purification in the depictions of shape-shifting and struggle and would find models for the metaphorical journey mapped by the passage through the nave of the church to the crucifixion sculpture and the sanctuary.[120] In the words of the "Stave Church Homily," the church is a metaphor for each individual body as "temple of the Holy Spirit":

> As the church conducts us to God by means of the baptismal font, so must we conduct our neighbours from transgression by means of the font of tears, in weeping for their sins, for tears purify sins like the baptismal font. . . . If we celebrate temporal festivals with such devotion, then we shall win the eternal festival in heaven with our Saviour, the Lord Jesus Christ, who lives and rules as God with the Father and Holy Spirit *per omnia saecula saeculorum. Amen.*[121]

Notes

1. On the identification of the bishop, see Ellen Marie Magerøy, "'Biskopen' i Urnes stavkirke," *Årbok: Foreningen til norske fortidsminnesmerkers bevaring* 126 (1971): 13–24. [Editors' note: Elizabeth den Hartog proposes an alternative identification in Chapter 10.]

2. Ira Katznelson and Miri Rubin, "Introduction," in *Religious Conversion: History, Experience and Meaning*, ed. Ira Katznelson and Miri Rubin (Farnham, UK, 2014), 1–30, esp. 3–4.

3. Sverre Bagge, *From Viking Stronghold to Christian Kingdom: State Formation in Norway, c.900–1350* (Copenhagen, 2010), 137–78.

4. Brian Stock, "Self, Soliloquy, and Spiritual Exercises in Augustine and Some Later Authors," *Journal of Religion* 91.1 (2011): 5–23.

5. Ibid., 12.

6. Ibid., 15.

7. Ibid., 17.

8. John Onians, *Bearers of Meaning: The Classical Orders in Antiquity, the Middle Ages, and the Renaissance* (Princeton, NJ, 1988), 60.

9. Mary Carruthers, *The Craft of Thought: Meditation, Rhetoric, and the Making of Images, 400–1200* (Cambridge, 1998), 262.

10. Ibid., 263.

11. Ibid., 263–65.

12. Ibid., 94, 263.

13. Erla Bergendahl Hohler, "The Capitals of Urnes Church and Their Background," *Acta Archeologica* 46 (1975): 1–60. On ideology in the bestiaries, see Debra Hassig, *Medieval Bestiaries: Text, Image, Ideology* (Cambridge, 1995), esp. xv–xvii, 4–8 for the source texts.

14. Ron Baxter, *Bestiaries and Their Users in the Middle Ages* (Stroud, 1998), 183–209. See also the essays dealing with different functions of the bestiary in Elizabeth Morrison with Larisa Grollemond, eds., *Book of Beasts: The Bestiary in the Medieval World* (Los Angeles, 2019), esp. 31–85.

15. Sara Kay, *Animal Skins and the Reading Self in Medieval Latin and French Bestiaries* (Chicago, 2017), 41–62, 128–48.

16. Ibid., 43.

17. For history and documentation, see Roar Hauglid, *Norske stavkirker: Bygningshistorisk bakgrunn og utvikling* (Oslo, 1976); and Leif Anker, *De norske stavkirkene* (Oslo, 2005).

18. Hallvard Magerøy, "Urnes stavkyrkje, Ornes-ætta og Ornes-godset," *Historisk tidsskrift* 67.2 (1988): 121–44.

19. For the eleventh-century church, see Knud J. Krogh, *Urneststilens kirke: Forgængeren for den nuværende kirke på Urnes* (Oslo, 2011).

20. For the dating, see Terje Thun et al., "Dendrochronology Brings New Life to the Stave Churches: Dating and Material Analysis," in *Preserving the Stave Churches: Craftsmanship and Research*, ed. Kristin Bakken, trans. Ingrid Greenhow and Glenn Ostling (Oslo, 2016), 91–116, esp. 105–9. For the iconography of the capitals, see Hohler, "Capitals of Urnes Church"; and Erla Bergendahl Hohler, *Norwegian Stave Church Sculpture*, 2 vols. (Oslo, 1999), 1:238–40.

21. Hohler, "Capitals of Urnes Church," 10–11.

22. Anders Winroth, *The Conversion of Scandinavia: Vikings, Merchants, and Missionaries in the Remaking of Northern Europe* (New Haven, CT, 2012), 152–56.

23. For the *Apologia*, see Conrad Rudolph, *The "Things of Greater Importance": Bernard of Clairvaux's "Apologia" and the Medieval Attitude toward Art* (Philadelphia, 1990).

24. Thomas E. A. Dale, "Monsters, Corporeal Deformities, and Phantasms in the Cloister of St-Michel-de-Cuxa," *Art Bulletin* 83.3 (2001): 402–36; Mary J. Carruthers, "*Varietas*: A Word of Many Colours," *Poetica* 41.1–2 (2009): 11–32; and Thomas E. A. Dale, "The Monstrous" in *A Companion to Medieval Art: Romanesque and Gothic in Northern Europe*, ed. Conrad Rudolph, 2nd ed. (Oxford, 2019), 357–81.

25. On conversion of Norway, see Sverre Bagge, "The Making of a Missionary King: The Medieval Accounts of Olaf Tryggvason and the Conversion of Norway," *Journal of English and Germanic Philology* 105.4 (2006): 473–513; Sverre Bagge, "Christianization and State Formation in Early Medieval Norway," *Scandinavian Journal of History* 30.2 (2005): 107–34; Robert Bartlett, "From Paganism to Christianity in Medieval Europe," in *Christianization and the Rise of Christian Monarchy: Scandinavia, Central Europe and Rus' c.900–1200*, ed. Nora Berend (Cambridge, 2007), 47–72; and Brit Solli, "Narratives of Encountering Religions: On the Christianization of the Norse around AD 900–1000," *Norwegian Archaeological Review* 29.2 (1996): 89–114.

26. Gro Steinsland, "Introduction: *Ideology and Power in the Viking and Middle Ages; Scandinavia, Iceland, Ireland, Orkney and the Faeroes*," in *Ideology and Power in the Viking and Middle Ages: Scandinavia, Iceland, Ireland, Orkney and the Faeroes*, ed. Gro Steinsland et al. (Leiden, 2011), 1–12, esp. 3–6, 9–10.

27. An explicit use of the vine scroll to represent the Church in the era of Gregorian Reform is found in the early twelfth-century apse mosaic of San Clemente in Rome; see Hélène Toubert, "Le renouveau paléochrétien à Rome au début du XIIe siècle," *Cahiers archéologiques* 20 (1970): 99–154; and Mary Stroll, *Symbols as Power: The Papacy following the Investiture Contest* (Leiden, 1991), 118–31. For an interpretation of the vine in Norwegian stave church sculpture, see Hohler, *Norwegian Stave Church Sculpture*, 2:56.

28. For the various ways in which the "Beatus vir" conveys the struggle against evil, see Howard Helsinger, "Images on the *Beatus* Page of Some Medieval Psalters," *Art Bulletin* 53.2 (1971): 161–76.

29. https://handrit.is/en/manuscript/view/is/AM02-0237a. Gabriel Turville-Petre, "The Old Norse Homily on the Dedication," in *Nine Norse Studies* (London, 1972), 79–101. I thank Margrete Syrstad Andås for suggesting this connection. For a fuller discussion of the sermon in relation to the Urnes capitals, see Chapter 10.

30. Trans. Turville-Petre, "Old Norse Homily," 94.

31. Ibid., 96.

32. Ibid., 95.

33. Denise Kimber Buell, "Early Christian Universalism and Modern Forms of Racism," in *The Origins of Racism in the West*, ed. Miriam Eliav-Feldon, Benjamin Isaac, and Joseph Ziegler (Cambridge, 2009), 109–31; and Geraldine Heng, *The Invention of Race in the European Middle Ages* (Cambridge, 2018), 31–33.

34 Leslie Webster, *Anglo-Saxon Art: A New History* (London, 2012), 177.

35 G. Ronald Murphy, *Tree of Salvation: Yggdrasil and the Cross in the North* (Oxford, 2013), 7–12; and Henning Kure, "Hanging in the World Tree," in *Old Norse Religion in Long-Term Perspectives: Origins, Changes, and Interactions; An International Conference Held in Lund, Sweden, June 3–7, 2004*, ed. Anders Andrén, Kristina Jennbert, and Catharina Raudvere (Lund, 2006), 68–71.

36 Murphy, *Tree of Salvation*, 125–53.

37 As I was completing the edits to this article, Margrete Syrstad Andås kindly informed me that the drawing of a sixth figural subject, an acrobat brandishing a sword, has recently been rediscovered by Kjartan Hauglid and is interpreted in Chapter 9 as depicting Salome. The drawing was made by a student of Rudolf Steiner during a visit to Urnes in the 1970s, when the bracing must have been removed temporarily to reveal this subject and another winged lion.

38 Arnved Nedkvitne, "Hunting," in *Medieval Scandinavia: An Encyclopedia*, ed. Phillip Pulsiano and Kirsten Wolf (New York, 1993), 307–8. For aristocratic privileges in England, see Hassig, *Medieval Bestiaries*, 48–49.

39 Hassig, *Medieval Bestiaries*, 40–45.

40 *Physiologus*, trans. Michael J. Curley (Austin, TX, 1979), 58. For the Latin text, see Francis J. Carmody, *Physiologus latinus: Editions préliminaires, versio B* (Paris, 1939), 50. See also Helsinger, "Images on the *Beatus* Page," 164.

41 Curley, *Physiologus*, 58; and Carmody, *Physiologus latinus*, 51: "Ita et dominus noster Iesus Christus, videns inimicum diabolum in omni humani generis natione in quodam speleo inhabitantem, habens in semetipso divinae sapientiae fontem, cuius non potest antiquus draco sufferre sermones."

42 Curley, *Physiologus*, 60.

43 Richard Barber, *Bestiary: Being an English Version of the Bodleian Library, Oxford, M.S. Bodley 764; With All the Original Miniatures Reproduced in Facsimile* (Woodbridge, UK, 1999), 51.

44 Helsinger, "Images on the *Beatus* Page," 165.

45 Kirk Ambrose, *The Nave Sculpture of Vézelay: The Art of Monastic Viewing* (Toronto, 2006), 46–48.

46 See Chapter 7; and Ingrid Lunnan Nødseth, "Bildentekstilet; et tapt antependium fra norsk middelalder?," *Årbok: Foreningen til norske fortidsminnesmerkers bevaring* 167 (2013): 225–36.

47 Book of Kells, in Dublin, Trinity College, MS 58, fol. 253r.

48 Bernard Meehan, "New Narrative Scenes in the Book of Kells," in *Making Histories: Proceedings of the Sixth International Conference on Insular Art, York 2011*, ed. Jane Hawkes (Donington, 2013), 242–45.

49 Zehava Jacoby, "The Beard Pullers in Romanesque Art: An Islamic Motif and Its Evolution in the West" *Arte medievale*, ser. 2, 1 (1987): 65–85.

50 Elizabeth Valdez del Álamo, *Palace of the Mind: The Cloister of Silos and Spanish Sculpture of the Twelfth Century* (Turnhout, 2012), 183–95.

51 The newly discovered drawing of an acrobat (see above, note 37) similarly complements the beard pullers at Urnes and thus amplifies a theme of ostensibly "secular" subjects, and if the acrobat is interpreted as Salome, it perhaps alludes to profane love and lust. See Anthony Weir and James Jerman, *Images of Lust: Sexual Carvings on Medieval Churches* (London, 1986), 40–47. By contrast, William Chester Jordan, "Salome in the Middle Ages," in "Essays in Honor of Kenneth Stow," special issue, *Jewish History* 26.1–2 (2012): 5–15, has shown that while the dancing Salome was indeed interpreted as a figure of lust or of Jewish carnality, she was viewed by some medieval exegetes as a redemptive figure

52 Jacoby, "Beard Pullers in Romanesque Art," 81–83.

53 Valdez del Álamo, *Palace of the Mind*, 195–96.

54 Françoise Piponnier and Perrine Mane, *Dress in the Middle Ages*, trans. Caroline Beamish (New Haven, CT, 1997), 148.

55 Valdez del Álamo, *Palace of the Mind*, 195.

56 See, e.g., Egil Mikkelsen, "Islam and Scandinavia during the Viking Age," in *Byzantium and Islam in Scandinavia: Acts of a Symposium at Uppsala University June 15–16 1996*, ed. Elisabeth Piltz (Jonsered, 1998), 39–51; and Sunhild Kleingärtner and Gareth Williams, "Contacts and Exchange," in *Vikings: Life and Legend*, ed. Gareth Williams, Peter Pentz, and Matthias Wemhoff (Ithaca, NY, 2014), 30–68. For the coin evidence, see Kolbjørn Skaare, *Coins and Coinage in Viking-Age Norway: The Establishment of a National Coinage in Norway in the XI Century, with a Survey of the Preceding Currency History* (Oslo, 1976); and Christoph Kilger, "Kaupang from Afar: Aspects of the Interpretation of Dirham Finds in Northern and Eastern Europe between the Late 8th and Early 10th Centuries," in *Means of Exchange: Dealing with Silver in the Viking Age*, ed. Dagfinn Skre (Aarhus, 2007), 199–252.

57 Kurt Villads Jensen, "Crusading at the End of the World: The Spread of the Idea of Jerusalem after 1099 to the Baltic Sea Area and to the Iberian Peninsula," in *Crusading on the Edge: Ideas and Practice of Crusading in Iberia and the Baltic Region, 1100–1500*, ed. Torben K. Nielsen and Iben Fonnesberg-Schmidt (Turnhout, 2016), 153–76, esp. 166–67.

58 See Sverrir Jakobsson, "Saracen Sensibilities: Muslims and Otherness in Medieval Saga Literature," *Journal of English and Germanic Philology* 115.2 (2016): 213–38.

59 Nahir I. Otaño Gracia, "Towards a Decentered Global North Atlantic: Blackness in *Saga af Tristram ok Ísodd*," in "Critical Race and the Middle Ages," special issue, *Literature Compass* 16.9–10 (2019): 1–16.

60 On the conceptualization of premodern "race" and racialized systems of representation, see Heng, *Invention of Race*, esp. 15–54.

61 Hohler, *Norwegian Stave Church Sculpture*, 1:239–40, a 1,3; n 1,2; b 1–3; c 3; d 1,2; e 1–3; f 1; g 3; I 1,2; k 1,3; m 1, 3; n 3; and o 2,3.

62 Stefan Bodemann, *Mitten im Leben vom Tod umfangen: Der Kreuzgang des Bonner Münsters* (Bonn 2009).

63 Morten Stige, "The Lion in Romanesque Art, Meaning or Decoration?," *Tahiti: Taidehistoria tieteenä Konsthistorien som vetenskap* 4 (2016): fig. 14; http://tahiti.fi/04-2016/tieteelliset-artikkelit/the-lion-in-romanesque-art-meaning-or-decoration/.

64 For French examples, see Bernhard Rupprecht, *Romanische Skulptur in Frankreich* (Munich, 1984), figs. 223 (Cuxa), 224, 228 (Serrabonne), 230 (Canigou). For Scandinavian parallels, see Vilhelm Slomann, *Bicorporates: Studies in Revivals and Migrations of Art Motifs* (Copenhagen, 1967), figs. 106, 110,

144, 148 for the Hov baptismal font in Jutland; and Søren Kaspersen, "Døbefonte og 'statsdannelse': Refleksioner over de jyske dobbeltløvefonte," in *Ecce Leones! Om djur och odjur i bildkonsten*, ed. Lars Berggren and Annette Landen (Lund, 2018), 61–113.

65 Margaret Haist, "The Lion, Bloodline, and Kingship," in *The Mark of the Beast: The Medieval Bestiary in Art, Life, and Literature*, ed. Debra Hassig (London, 1999), 3–16.

66 For the interpretation of lions in Romanesque art, see Stige, "Lion in Romanesque Art."

67 Hohler, *Norwegian Stave Church Sculpture*, 2:76–83.

68 Formerly Copenhagen, University Library; now Reykjavík, Árni Magnússon Institute for Icelandic Studies, AM 673 a I, 40 (https://handrit.is/en/manuscript/view/is/AM04-0673a-I) and AM 673 a II, 40 (https://handrit.is/en/manuscript/view/is/AM04-0673a-II). See Vittoria Dolcetti Corazza, "Crossing Paths in the Middle Ages: The *Physiologus* in Iceland," in *The Garden of Crossing Paths: The Manipulation and Rewriting of Medieval Texts; Venice, October 28–30, 2004*, ed. Marina Buzzoni and Massimiliano Bampi, rev. ed. (Venice, 2007), 225–48. For a critical edition of the text, see Carla Del Zotto Tozzoli, *Il "Physiologus" in Islanda* (Pisa, 1992); for digital facsimiles see https://handrit.is/en/manuscript/imaging/is/AM04-0673a-I#page/2v++(4+of+11)/mode/2up (Physiologus A) and https://handrit.is/en/manuscript/imaging/is/AM04-0673a-II/1r-7v#page/4v++(8+of+14)/mode/2up (Physiologus B).

69 Carmody, *Physiologus latinus*, I, 11–12; and Baxter, *Bestiaries and Their Users*, 37–39.

70 Dale, "Monsters, Corporeal Deformities, and Phantasms," 427–28.

71 Maria-Claudia Tomany, "Sacred Non-Violence, Cowardice Profaned: St Magnus of Orkney in Nordic Hagiography and Historiography," in *Sanctity in the North: Saints, Lives, and Cults in Medieval Scandinavia*, ed. Thomas A. DuBois (Toronto, 2008), 128–53, esp. 133, 144.

72 Kirk Ambrose, "Samson, David, or Hercules? Ambiguous Identities in Some Romanesque Sculptures of Lion Fighters," *Konsthistorisk tidskrift/Journal of Art History* 74.3 (2005): 131–47; and Kirk Ambrose, *The Marvellous and the Monstrous in the Sculpture of Twelfth-Century Europe* (Woodbridge, UK, 2013), 77–78.

73 The muscular bearded figure with long hair wrestling the lion on the facade of Saint-Trophime in Arles, for example, appears more clearly identified with Samson.

74 See, e.g., Hohler, *Norwegian Stave Church Sculpture*, 2:55–57; and Kristine Ødeby, "Through the Portal: Viking Motifs Incorporated in the Romanesque Style in Telemark, Norway," *Papers from the Institute of Archaeology* 23.1 (2013): article 15, 1–19; https://student-journals.ucl.ac.uk/pia/article/id/490/.

75 Trans. in Barber, *Bestiary*, 183–84.

76 London, British Library, MS Sloane 278, fols. 57r-v, www.bl.uk/manuscripts/Viewer.aspx?ref=sloane_ms_278_fs001r; translated by G. C. Druce, "The Elephant in Medieval Legend and Art," *Archaeological Journal* 76 (1919): 1–73; quote at 34–35. Although the text follows Hugh of Fouilloy's *De avibus*, this section is now identified as the *Dicta Chrysostomi*, of which the earliest manuscript dates to the eleventh century.

77 On the stag and the serpent, see Marcelle Thiébaux, *The Stag of Love: The Chase in Medieval Literature* (Ithaca, NY, 1974), esp. 41–42.

78 Trans. in Michael J. Curley, *Physiologus: A Medieval Book of Nature Lore* (Chicago, 2009), 13. The Latin text of Physiolgus B gives a slight variation: "Ergo et tu, homo, sive Iudaeus sive gentilis, qui vestimentum habes vetus [cf. Eph. 4.22], et caligantur oculi cordis tui, quaere spiritalem fontem domini, qui dixit: Nisi quis renatus fuerit ex aqua et spiritu sancto, non potest intrare in regnum dei caelorum [Ioh. 3.5]. Nisi ergo: Baptizatus fueris in nomine patris et filii et spiritus sancti [Matt. 28.19], et sustuleris oculos cordis tui ad dominum, qui est sol iustitiae [Mal. 4.2], non renovabitur ut aquilae iuventus tua." Carmody, *Physiologus latinus*, 19.

79 Hugh of Fouilloy, *Aviarium* XLIII, *De vulture*, ed. and trans. Willene B. Clark, *The Medieval Book of Birds: Hugh of Fouilloy's "Aviarium"* (Binghamton NY, 1992), 198–203, esp. 200: "Sed natura vulturis talis esse dicitur, ut per vulturem quisque peccator intellegi videatur. . . . Mortuorum cadaveribus vescitur, quia carnalibus desideriis quae mortem generant delectatur."

80 Ibid., 200: "Recte ergo Mediator Dei et hominum Redemptor noster vulturis significatione appellatur, qui manens in altitudine divinitatis suae, quasi quodam volatu sublimi, cadaver mortalitatis nostrae conspexit in infimis, et sese de caelestibus ad ima summisit. Fieri quippe propter nos homo dignatus est, et dum mortuum animal periit, mortem apud nos qui apud se erat immortalis invenit."

81 *Sancti Patris Nostri Epiphanii, Episcopi Constantiae Cypri, ad Physiologum: Eiusdem in Die Festo Palmarum Sermo* (Antwerp, 1588), Cap. VII, *De vulture*, Digital facsimile and commentary, University of Victoria Special Collections at http://spcoll.library.uvic.ca/Digit/physiologum/commentary/tran_physiologus.htm#tpVulture: "Tu igitur, spiritualis homo, qui in quadragesimali jejunio Dominicam resurrectionem exspectas, noli ventri fœde indulgere, ne quadragesimalis abstinentiæ meritum perdas."

82 Hohler, *Norwegian Stave Church Sculpture*, 1:239, m.2, describes this creature as "essentially a lion with mane, but with a beak, like a griffin, and a fluttering forelock which may be intended to represent a unicorn's horn."

83 Hugh of Fouilloy, *De bestiis*, III.4, in *Patrologiae Cursus Completus: Series Latina*, ed. J.-P. Migne (hereafter *PL*, ed. Migne), 177 (Paris, 1854): col. 84C: "Gryphs, seu, ut Isidorus scribit, gryphes est animal pennatum et quadrupes, quod in hyperboreis nascitur montibus, omni parte corporis, leoni, alis et facie aquilis simile, equis vehementer infestum. Nam et homines vivos discerpit. et integros in nidum asportat."

84 See Dale, "Corporeal Deformities," 420–24; and Caroline Walker Bynum, *The Resurrection of the Body in Western Christianity, 200–1336* (New York, 1995), 117–57, 192–99.

85 *Annals of Inisfallen* AI1105.7; CELT, Corpus of Electronic Texts, https://celt.ucc.ie/published/T100004/text066.html. For Henry's zoo-park see William of Malmesbury, *Gesta Regum*, II. 485; and Austin Lane Poole, *From Domesday Book to Magna Carta, 1087–1216*, 2nd ed., repr. (Oxford, 1987), 19. Both examples are cited in Caitlin R. Green, "Were There Camels in Medieval Britain? A Brief Note on Bactrian Camels and Dromedaries in Fifteenth-Century Kent," https://www.caitlingreen.org/2018/09/were-there-camels-in-medieval-britain.html.

86 London, British Library, MS Cotton Tiberius B V, part 1, fol. 80v (http://www.bl.uk/manuscripts/FullDisplay.aspx?ref=Cotton_MS_Tiberius_B_V/1); and London, British Library, MS Cotton Vitellius A XV, fol. 101v http://www.bl.uk/manuscripts/FullDisplay.aspx?ref=cotton_ms_vitellius_a_xv). See "How the Camel Got Its Hump," *Medieval Manuscripts* blog, British Library, 30 April 2013, at https://blogs.bl.uk/digitisedmanuscripts/2013/04/how-the-camel-got-the-hump.html.

87 Barber, *Bestiary*, 96.

88 Elizabeth den Hartog suggested the reference to the camel passing through the eye of the needle at the Urnes colloquium in 2018. See Elizabeth den Hartog, "Nudis pedibus: A Bare-Footed Cleric in Urnes, Norway," *Leiden Medievalists* blog, 28 December 2018; leidenmedievalistsblog.nl/articles/nudis-pedibus-a-bare-footed-cleric-in-urnes-norway.

89 Turville-Petre, "Old Norse Homily," 95.

90 Fulcher of Chartres, *Historia Hierosolymitana ab anno 1095 ad annum usque 1127*, in *PL*, ed. Migne, 155 (Paris, 1854): col. 932D: "*Mantichora* nomine inter haec nascitur, triplici dentium ordine coeunte, vicibus alternis, facie hominis, glaucis oculis, sanguineo colore, corpore leonino, cauda velut scorpionis, aculeo spiculata, voce tantum sibila, ut imitetur modulos fistularum. Humanas carnes avidissime affectat, pedibus sic viget, saltu sic potest, ut morari eam nec extentissima spatia possint, nec obstacula latissima."

91 Barber, *Bestiary*, 63–64.

92 For the tradition of "monstrous races" in the Middle Ages, see John Block Friedman, *The Monstrous Races in Medieval Art and Thought* (Cambridge, MA, 1981). Asa Simon Mittman has questioned the application of "races" to the monstrous peoples described in the Wonders of the East: see "Are the 'Monstrous Races' Races?," *Postmedieval: A Journal of Medieval Cultural Studies* 6 (2015): 36–51. The Urnes manticore is discussed further in Chapter 8 in this volume.

93 Siv Kristoffersen, "Half Beast–Half Man: Hybrid Figures in Animal Art," *World Archaeology* 42.2 (2010): 261–72, at 261.

94 Lyonel D. Perabo, "Shapeshifting in Old Norse-Icelandic Literature," *Roda da Fortuna: Revista Eletrônica sobre Antiguidade e Medioevo* 6.1 (2017): 135–58.

95 Ibid., 137.

96 Ibid., 137.

97 Roderick Thomas Duncan Dale, "Berserkir: A Re-Examination of the Phenomenon in Literature and Life" (PhD diss., University of Nottingham, 2014), esp. 180–83 on the application to Christian heroes in the romances.

98 Ármann Jakobsson, "Beast and Man: Realism and the Occult in *Egils saga*," *Scandinavian Studies* 83.1 (2011): 29–44.

99 William Sayers, "An Ill-Tempered Axe for an Ill-Tempered Smith: The Gift of King Eiríkr *blóðøx* to Skallagrímr Kveldúlfsson in *Egils saga Skallagrímssonar*," *Scandinavian-Canadian Studies/Études scandinaves au Canada* 24 (2017): 16–37; https://scancan.net/sayers_1_24.htm.

100 William J. Travis, "Of Sirens and Onocentaurs: A Romanesque Apocalypse at Montceaux-l'Étoile," *Artibus et Historiae* 23.45 (2002): 29–62.

101 Dolcetti Corazza, "Crossing Paths in the Middle Ages," 231.

102 Ibid., 232.

103 Robert L. Benson, *The Bishop-Elect: A Study in Medieval Ecclesiastical Office* (Princeton, NJ, 1968).

104 Thomas A. DuBois, *Nordic Religions in the Viking Age* (Philadelphia, 1999), 166–68.

105 Snorri Sturluson, *Heimskringla: Magnussona saga*, chap. 11, ed. Bjarni Aðalbjarnason (Reykjavík, 1951), 3:250; cited in DuBois, *Nordic Religions*, 169.

106 Ibid.

107 Jensen, "Crusading at the End of the World."

108 Dolcetti Corazza, "Crossing Paths in the Middle Ages," 239.

109 I thank Margrete Syrstad Andås for referring me to this parallel. For images and a brief catalogue entry, see http://medeltidbild.historiska.se/medeltidbild/visa/foremal.asp?objektid=920516F5#. For a brief reference to the font attributed to the "Bestiarius Master," see C. S. Drake, *The Romanesque Fonts of Northern Europe and Scandinavia* (Woodbridge, UK, 2002), 160, 185.

110 For the association of images of fighting or wrestling figures and men battling with beasts and monstrous creatures on baptismal fonts with the struggle of the soul or *psychomachia*, see Drake, *Romanesque Fonts*, 21; Fölke Nordstrom, *Medieval Baptismal Fonts: An Iconographical Study* (Umeå, 1984), 132; and Frances Altvater, *Sacramental Theology and the Decoration of Baptismal Fonts: Incarnation, Initiation, Institution* (Newcastle upon Tyne, 2017), 67. Altvater (66–67) suggests that a bishop appears on fonts to represent not only the institution of the Church but also the specific sealing of baptism in confirmation.

111 Martin Blindheim, *Painted Wooden Sculpture in Norway, c.1100–1250* (Oslo, 1998), 47–48, cat. no. 9. Blindheim's dating and reasoning are followed by Manuela Beer, *Triumphkreuze des Mittelalters: Ein Beitrag zu Typus und Genese im 12. und 13. Jahrhundert; Mit einem Katalog der erhaltenen Denkmäler* (Regensburg, 2005), 377–80.

112 Blindheim, *Painted Wooden Sculpture in Norway*, 29–30, 46–47, cat. nos. 6, 7.

113 See Tine Frøysaker and Kaja Kollandsrud, "The Calvary Group in Urnes Stave Church, Norway: A Technological Examination," in *Medieval Painting in Northern Europe: Techniques, Analysis, Art History; Studies in Commemoration of the 70th Birthday of Unn Plahter*, ed. Jilleen Nadolny et al. (London, 2007), 43–58. Confirming that "the technical aspects of the sculptures—original methods and materials—are totally consistent with the twelfth-century date that has been proposed for them" (55), the authors affirm that the "tripartite system of joining (consisting of two arms set into main section comprising head and body)" is found in other crucifixes that date *c.*1150. Other features are evidenced in works from a wider span of time, e.g., the use of chalk from England based on trade with Norway that lasted from 1100 to *c.*1250; the use of lapis lazuli, orpiment, vermilion, and imitation gold using tin and yellow glaze is "typical of the early period"; and the application of yellow-glazed tin gilding is found not only on the Grindaker crucifix, dated by Blindheim to the first half of the twelfth century, but also on the Horg crucifix, dated by Blindheim to the end of the twelfth century, and the Skafsa crucifix, ca. 1225.

114 On the devotional functions of the Urnes Crucifixion group and other Norwegian medieval crucifixes, see Hildegunn Gullåsen, "The Medieval Calvary Group in Norway: Context and Functions," *Collegium Medievale* 19 (2006): 5–30.

115 Thomas E. A. Dale, *Pygmalion's Power: Romanesque Sculpture, the Senses, and Religious Experience* (University Park, PA, 2019), 1–15, esp. 1–3 (on the Pygmalion effect), 17–32 (on sculpted crucifixes coming alive).

116 Gullåsen, "Medieval Calvary group," 23, also refers to this sermon in relation to the Crucifixion as marking the *via sacra* into the sanctuary.

117 Turville-Petre, "Old Norse Homily," 98, 99.

118 Ibid., 95.

119 Thomas E. A. Dale, *Relics, Prayer, and Politics in Medieval Venetia: Romanesque Painting in the Crypt of Aquileia Cathedral* (Princeton, NJ, 1997), 73–76; and Jill Bain, "Signifying Absence: Experiencing Monochrome Imagery in Medieval Painting," in *A Wider Trecento: Studies in 13th- and 14th-Century European Art Presented to Julian Gardner*, ed. Louise Bordua and Robert Gibbs (Leiden, 2012), 5–20. For the idea of leaving outline of a design deliberately unfinished as a metaphor for the process of incarnation, see Benjamin C. Tilghman, "Pattern, Process, and the Creation of Meaning in the Lindisfarne Gospels," *West 86th* 24.1 (2017): 3–28.

120 On the portal itself as liminal space, fostering with its imagery a form of ritual purification, prior to the journey into the church, see Margrete Syrstad Andås, "The Octagon Doorway: A Question of Purity and Danger?," in *Ornament and Order: Essays on Viking and Northern Medieval Art for Signe Horn Fuglesang*, ed. Margrethe C. Stang and Kristin B. Aavitsland (Trondheim, 2008), 97–134; Carruthers, *Craft of Thought*, 264–66; and Dale, *Pygmalion's Power*, 85–87, 164, and 174.

121 Turville-Petre, "Old Norse Homily," 99.

Bibliography

See note in Introduction about alphabetical ordering.

Aavitsland, Kristin B. "Ornament and Iconography: Visual Orders in the Golden Altar from Lisbjerg, Denmark." In *Ornament and Order: Essays on Viking and Northern Medieval Art for Signe Horn Fuglesang*, edited by Margrethe C. Stang and Kristin B. Aavitsland, 57–97. Trondheim, 2008.

Aavitsland, Kristin B., and Line M. Bonde, eds. *Tracing the Jerusalem Code*. Vol. 1, *The Holy City: Christian Cultures in Medieval Scandinavia (ca.1100–1536)*. Berlin, 2021.

Ackerman, James S. "Style." In *Art and Archaeology*, edited by James S. Ackerman and Rhys Carpenter, 164–86. Englewood Cliffs, NJ, 1963.

Adam of Bremen. *Adam von Bremen: Hamburgische Kirchengeschichte*. Edited by Bernhard Schmeidler. Hannover, 1917.

Adrian, Henrik, and Poul Grinder-Hansen. *Den romanske kirke: Billede og betydning*. Copenhagen, 1995.

Ágústsson, Hörður. *Dómsdagur og helgir menn á Hólum*. Reykjavík, 1989.

Ahrens, Claus. *Frühe Holzkirchen im nördlichen Europa*. Hamburg, 1981.

———. *Die frühen Holzkirchen Europas*. 2 vols. Stuttgart, 2001.

Albrecht, Uwe, ed. *Corpus der mittelalterlichen Holzskulptur und Tafelmalerei in Schleswig-Holstein*. Vol. 2, *Schloss Gottorf*. Kiel, 2016.

Allen, Terry. *A Classical Revival in Islamic Architecture*. Wiesbaden, 1986.

Almevik, Gunnar, and Jonathan Westin. "Hemse Stave Church Revisited." *Lund Archaeological Review* 23 (2017): 7–25.

Altvater, Frances. *Sacramental Theology and the Decoration of Baptismal Fonts: Incarnation, Initiation, Institution*. Newcastle upon Tyne, 2017.

Ambrose, Kirk. "Émile Mâle." In *The Routledge Companion to Medieval Iconography*, edited by Colum Hourihane, 65–74. New York, 2016.

———. *The Marvellous and the Monstrous in the Sculpture of Twelfth-Century Europe*. Rochester, NY, 2013.

———. *The Nave Sculpture of Vézelay: The Art of Monastic Viewing*. Toronto, 2006.

———. "Samson, David, or Hercules? Ambiguous Identities in Some Romanesque Sculptures of Lion Fighters." *Konsthistorisk tidskrift/Journal of Art History* 74, no. 3 (2005): 131–47.

Ambrosiani, Björn, and Helen Clarke, eds. *Developments around the Baltic and the North Sea in the Viking Age: Twelfth Viking Congress*. Stockholm, 1994.

Anderson, William. "Vom Cordulaschrein im Domschatz zu Cammin." *Unser Pommernland* 14, no. 3 (1929): 95–96.

Andås, Margrete Syrstad. "Art and Ritual in the Liminal Zone." In *The Medieval Cathedral of Trondheim: Architectural and Ritual Constructions in Their European Context*, edited by Margrete Syrstad Andås, Øystein Ekroll, Andreas Haug, and Nils Holger Petersen, 47–126. Turnhout, 2007.

———. "Entering the Temple of Jerusalem: Candlemas and Churching in the Lives of the Women of the North; A Study of Textual and Visual Sources." In Aavitsland and Bonde, *Tracing the Jerusalem Code*, 340–74.

———. "Imagery and Ritual in the Liminal Zone." PhD diss., University of Copenhagen, 2012.

———. "Making It Known to Man: The Portal in the Liturgical and Legal Practices of the North." In *Das Kirchenportal im Mittelalter*, edited by Stefan Albrecht, Stefan Breitling, and Rainer Drewello, 170–77. Petersberg, 2019.

———. "The Octagon Doorway: A Question of Purity and Danger?" In *Ornament and Order: Essays on Viking and Northern Medieval Art for Signe Horn Fuglesang*, edited by Margrethe C. Stang and Kristin B. Aavitsland, 97–134. Trondheim, 2008.

Anker, Leif. "Between a Temple and a House of Cards: The Stave Churches and Research." In Bakken, *Preserving the Stave Churches*, 135–66.

———. *De norske stavkirkene*. Oslo, 2005.

———. *The Norwegian Stave Churches*. Translated by Tim Challman. Oslo, 2005.

———. "Om stokk og stein: Middelalderens stav- og steinkirker i Sogn i lys av økonomiske forhold." *Årbok: Foreningen til norske fortidsminnesmerkers bevaring* 155 (2001): 97–109.

———. "Stave Church Research and the Norwegian Stave Church Programme: New Findings–New Questions." In Khodakovsky and Lexau, *Historic Wooden Architecture in Europe and Russia*, 94–109.

———. "Stokk eller stein? Kirker, byggemåter og mulige byggherrer i indre Sogn omlag 1130–1350 belyst ved et utvalg kirker fra perioden." MA thesis, University of Oslo, 2000.

———. "What Is a Stave Church?" In Bakken, *Preserving the Stave Churches*, 17–22.

Anker, Peter. *The Art of Scandinavia*. vol 1. London, 1970.

———. *L'art scandinave*. La Pierre-qui-Vire, 1969.

———. *De norske stavkirker*. Bergen, 1979.

———. "Om dateringsproblemet i stavkirkeforskningen." *Historisk tidsskrift* 56, no. 2 (1977): 103–42.

———. "Retardering eller renessanse? Om draker og rabarbrablader i 16–1700-årenes folkelige kunsthåndverk." *By og Bygd* 30 (1983–84): 13–44.

———. *Stavkirkene, deres egenart og historie*. Oslo 1997.

Annala Rioghachta Eireann: Annals of the Kingdom of Ireland by the Four Masters, from the Earliest Period to the Year 1616. Edited and translated by John O'Donovan. Dublin, 1856. Online ed. Cork, 2008. https://celt.ucc.ie//published/T100005B/index.html.

Annals of Inisfallen. CELT: The Corpus of Electronic Texts. https://celt.ucc.ie/published/T100004/.

The Annals of Inisfallen (Ms Rawlinson B. 503). Edited and translated by Seán Mac Airt. Dublin, 1988.

The Annals of Ulster (to A.D. 1131). Edited and translated by Seán Mac Airt and Gearóid Mac Niocaill. Dublin, 1983.

Archer, Gleason L., Jr., trans. *Jerome's Commentary on Daniel*. Grand Rapids, MI, 1958.

Assmann, Jan. "Communicative and Cultural Memory." In *Cultural Memory Studies: An International and Interdisciplinary Handbook*, edited by Astrid Erll and Ansgar Nünning, 109–18. Berlin, 2008.

Auden, W. H. *Collected Poems*. Edited by Edward Mendelson. New York, 1992.

Augustine. *The City of God by Saint Augustine*. Translated by Marcus Dods. New York 1950.

Augustus, L., and J. T. J. Jamar. *Annales Rodenses: Kroniek van Kloosterrade; Tekst en vertaling*. Maastricht, 1995.

Autenrieth, Johanne, Dieter Geuenich, and Karl Schmid, eds. *Das Verbrüderungsbuch der Abtei Reichenau: Einleitung, Register, Faksimilie*. Hannover, 1979.

Azevedo, Rui Pinto de. "A expedição de Almançor a Santiago de Compostela em 997, e de piratas normandos à Galiza em 1015–16 (Dois testemunhos inéditos das depradações a que então esteve sujeito o Território Portugalense entre Douro e Ave)." *Revista portuguesa de história* 14 (1974): 73–93.

Baert, Barbara. *Revisiting Salome's Dance in Medieval and Early Modern Iconology*. Leuven, 2016.

Bagge, Sverre. "Christianization and State Formation in Early Medieval Norway." *Scandinavian Journal of History* 30, no. 2 (2005): 107–34.

———. *From Viking Stronghold to Christian Kingdom: State Formation in Norway, c. 900–1350*. Copenhagen, 2010.

———. "The Making of a Missionary King: The Medieval Accounts of Olaf Tryggvason and the Conversion of Norway." *Journal of English and Germanic Philology* 105, no. 4 (2006): 473–513.

Bain, Jill. "Signifying Absence: Experiencing Monochrome Imagery in Medieval Painting." In *A Wider Trecento: Studies in 13th- and 14th-Century European Art Presented to Julian Gardner*, edited by Louise Bordua and Robert Gibbs, 5–20. Leiden, 2012.

Bakken, Kristin, ed. *Bevaring av stavkirkene: Håndverk og forskning*. Oslo, 2016.

———, ed. *Preserving the Stave Churches: Craftsmanship and Research*. Translated by Ingrid Greenhow and Glenn Ostling. Oslo, 2016.

Bandlien, Bjørn. *Olav kyrre*. Oslo, 2011.

Bangert, Susanne. "Menas Ampullae: A Case Study of Long-Distance Contacts." In *Incipient Globalisation: Long-Distance Contacts in the Sixth Century*, edited by Anthea Harris, 27–33. Oxford, 2007.

Barasch, Moshe. *Gestures of Despair in Medieval and Early Renaissance Art*. New York, 1976.

Barber, Richard. *Bestiary: Being an English Version of the Bodleian Library, Oxford, M.S. Bodley 764; With All the Original Miniatures Reproduced in Facsimile*. Woodbridge, UK, 1999.

Barndon, Randi, and Asle Bruen Olsen. "En grav med smedverktøy fra tidlig vikingtid på Nordheim i Sogndal: En analyse av gravgods, handlingsrekker og symbolikk." *Viking* 81 (2018): 63–88.

Barnes, Michael, and Jan Ragnar Hagland. "Runic Inscriptions and Viking-Age Ireland." In Sheehan and Ó Corráin, *Viking Age*, 11–18.

Barnes, Michael P., Jan Ragnar Hagland, and R. I. Page. *The Runic Inscriptions of Viking Age Dublin*. Dublin, 1997.

Barral i Altet, Xavier. *Contre l'art roman?: Essai sur un passé réinventé*. Paris, 2006.

Barthes, Roland. "From Work to Text." In *Textual Strategies: Perspectives in Post-Structuralist Criticism*, edited by Josué V. Havari, 73–81. Ithaca, NY, 1976.

Bartholin, Thomas. "Bjølstad kapell i Heidal, Sel kommune." Doc. no. 16/00622–1. 0450099.115.Skibet.Bjølstad.foto. doc.

Bartlett, Robert. "From Paganism to Christianity in Medieval Europe." In Berend, *Christianization and the Rise of Christian Monarchy*, 47–72.

Basil the Great. *S. Basilii Magni, Opera omnia*. In *Patrologiae Cursus Completus: Series Graecae*. Edited by J.-P. Migne, 29 (Paris, 1857).

Baug, Irene. "Soapstone Finds." In *Things from the Town: Artefacts and Inhabitants in Viking-Age Kaupang*, edited by Dagfinn Skre, 311–37. Aarhus, 2011.

Baxandall, Michael. *The Limewood Sculptures of Renaissance Germany*. New Haven, CT, 1980.

Baxter, Ron. *Bestiaries and Their Users in the Middle Ages*. Stroud, 1998.

Baylé, Maylis. *Les origines et les premiers développements de la sculpture romane en Normandie*. Caen, 1992.

Bede. *The Ecclesiastical History of the English People, The Greater Chronicle, Bede's Letter to Egbert*. Edited by Judith McClure and Roger Collins. Oxford, 1994.

Bede: On the Temple. Translation and notes by Seán Connolly. Liverpool, 1995.

Bedingfield, M. Bradford. *The Dramatic Liturgy of Anglo-Saxon England*. Woodbridge, UK, 2002.

Beekman, Bibi, and Richard N. Bailey. "A Painted Viking-Age Sculpture from York." *Yorkshire Archaeological Journal* 90 (2018): 59–66.

Beer, Manuela. *Triumphkreuze des Mittelalters: Ein Beitrag zu Typus und Genese im 12. und 13. Jahrhundert; Mit einem Katalog der erhaltenen Denkmäler*. Regensburg, 2005.

Bendixen, B. E. "Lidt om stavkirker i Hordaland og Sogn." *Aarsberetning: Foreningen til norske fortidsminnesmerkers bevaring*, 1903 (1904): 154–57.

Benson, Robert L. *The Bishop-Elect: A Study in Medieval Ecclesiastical Office*. Princeton, NJ, 1968.

Berend, Nora, ed. *Christianization and the Rise of Christian Monarchy: Scandinavia, Central Europe and Rus', c. 900–1200*. Cambridge, 2007.

Berg, Arne. *Norske tømmerhus frå mellomalderen*. 6 vols. Oslo, 1989–98.

———. "Die Stabkirche von Vang und ihre lange Reise." In Ahrens, *Frühe Holzkirchen im nördlichen Europa*, 481–98.

———. "Stavkyrkja frå Vang og hennar lange ferd." *Årbok: Foreningen til norske fortidsminnesmerkers bevaring* 134 (1980): 105–40.

Berg, Knut, Fuglesang, Signe Horn, Christie, Håkon, Hohler, Erla Bergendahl, Reimers, Egil, and Anker, Peter, eds. *Norges kunsthistorie*. Vol. 1, *Fra Oseberg til Borgund*. Oslo, 1981.

Bernard of Clairvaux. *The Life and Death of Saint Malachy the Irishman*. Translated by Robert T. Meyer. Kalamazoo, MI, 1978.

———. *Sancti Bernardi Opera*. Edited by Jean Leclercq, C. H. Talbot, and Henri Rochais. Vol. 3. Rome, 1957.

Bertelsen, Lise Gjedssø. "The Cross Motif on Late Viking Age Picture Runestones in Västergötland." *Lund Archaeological Review* 20 (2014): 55–78.

———. "On Öpir's Pictures." In Stoklund, Nielsen, Holmberg, and Fellows-Jensen, *Runes and Their Secrets*, 31–64.

———. "Præsentation af Ålborg-gruppen: En gruppe dyrefibler uden dyreslyng." *Aarbøger for nordisk oldkyndighed og historie*, 1991 (1992): 237–64.

———. "Urnesfibler i Danmark." *Aarbøger for nordisk oldkyndighed og historie*, 1992 (1994): 345–70.

———. *Vikingetidens kunst: En udstilling om kunsten i vikingernes verden og efterverden ca.1800–1250*. Jelling, 2002.

Binding, Günthe. „Köln oder Hildesheim? Die Erfindung' des Würfelkapitells." *Wallraf-Richartz-Jahrbuch* 66 (2005): 7–38.

Binski, Paul. *Gothic Sculpture*. New Haven, CT, 2019.

Bjerknes, Kristian. "Urnes stavkirke: Har det vært to bygninger forut den nuværende kirke?" *Årbok: Foreningen til norske fortidsminnesmerkers bevaring* 113 (1959): 75–96.

Blennow, Anna. *Sveriges medeltida latinska inskrifter 1050–1250: Edition med språklig og paleografisk kommentar*. Stockholm, 2016.

Blindheim, Martin. *Graffiti in Norwegian Stave Churches, c. 1150–c. 1350*. Oslo, 1985.

———. "A House-Shaped Irish-Scots Reliquary in Bologna, and Its Place among the Other Reliquaries." *Acta Archaeologica* 55 (1984): 1–53.

———. *Norwegian Romanesque Decorative Sculpture, 1090–1210*. London, 1965.

———. *Painted Wooden Sculpture in Norway c. 1100–1250*. Oslo, 1998.

———. "Primær bruk av farve og tjære ved utsmykning av norske stavkirker." *Årbok: Universitetets oldsaksamling*, 1986–88 (1989): 109–32.

———. "The Romanesque Dragon Doorways of the Norwegian Stave Churches: Traditions and Influences." *Acta ad archaeologiam et artium historiam pertinenta* 2 (1965): 177–93.

———. "Viking Ship Vanes, Their Use and Techniques." In *The Vikings*, edited by R. T. Farrell, 116–27. London, 1982.

Blix, Peter. *Nogle undersøgelser i Borgund og Urnæs kirker med bemærkninger vedkommende Hoprekstadkirken*. Kristiania, 1895.

Blom, Grethe Authén. *Trondheims bys historie*. Trondheim, 1957.

Blöndal, Sigfús. *The Varangians of Byzantium: An Aspect of Byzantine Military History*. Translated, revised, and rewritten by Benedikt S. Benedikz. Cambridge, 1978.

Bloxham, M. Jennifer. "Preaching to the Choir? Obrecht's Motet for the Dedication of the Church." In *Music and Culture in the Middle Ages and Beyond: Liturgy, Sources, Symbolism*, edited by Benjamin Brand and David J. Rothenberg, 263–92. Cambridge, 2016.

Bodemann, Stefan. *Mitten im Leben vom Tod umfangen: Der Kreuzgang des Bonner Münsters*. Bonn 2009.

Bonde, Niels. Unpublished NNU Report, Nationalmuseets Naturvidenskabelige undersøgelser, J. no. A. 4340. Copenhagen, 1991.

———. "Vrigstad Kyrka, Småland, Sverige." NNU rapportblad 1997, j.nr. A7875, Dendro tsb 4" (Nationalmuseet, Copenhagen). https://natmus.dk/fileadmin/user_upload/Editor/natmus/nnu/Dendro/1997/A7875delrap.pdf.

Bonnier, Ann Catherine. "Medeltidens kyrkor." In *Östergötland: Landskapets kyrkor*, edited by Ingrid Sjöström and Marian Ullén, 32–62. Stockholm, 2004.

Bourke, Cormac. "Carved Stones from Donaghenry and Stewartstown." *The Bell: Journal of Stewartstown and District Local History Society* 5 (1995): 60–64.

———. "Corporeal Relics, Tents and Shrines in Early Medieval Ireland." *Ulster Journal of Archaeology* 74 (2017–18): 118–29.

———. *The Early Medieval Hand-Bells of Ireland and Britain*. Dublin, 2020.

———. "Shrine of St Patrick's Bell." In Moss, *Art and Architecture of Ireland*, 307–8.

Boynton, Susan. "The Bible and the Liturgy." In *The Practice of the Bible in the Middle Ages: Production, Reception, and Performance in Western Christianity*, edited by Susan Boynton and Diane J. Reilly, 10–33. New York, 2011.

Bracken, Damian, and Dagmar Ó Riain-Raedel, eds. *Ireland and Europe in the Twelfth Century: Reform and Renewal*. Dublin, 2006.

Bradley, John. "The Sarcophagus at Cormac's Chapel, Cashel, Co. Tipperary." *North Munster Antiquarian Journal* 26 (1984): 14–35.

Brady, Niall. "*Hisperica famina* and Church Building." *Peritia* 11 (1997): 327–35.

Brate, Erik. *Södermanlands runinskrifter*. Stockholm, 1924.

Braun, Joseph. *Handbuch der Paramentik*. Freiburg im B., 1912.

Bregnhøi, Line, and Mads Chr. Christensen. "Sagnlandet Lejre: Vikingetidens farvepalet." *Nationalmuseet, Bevaring & Naturvidenskab*, 1–8. https://natmus.dk/fileadmin/user_upload/Editor/natmus/historisk-viden/Viking/Vikingernes_farvepalet/Vikingetidens_farvepalet_Rapport.pdf.

Brendalsmo, Jan. "Kirker og sogn på den trønderske landsbygda ca. 1000–1600." In *Ecclesia Nidrosiensis 1153–1537: Søkelys på Nidaroskirkens og Nidarosprovinsens historie*, edited by Steinar Imsen, 233–53. Trondheim, 2003.

Brendalsmo, Jan, and Jan-Erik G. Eriksson. *Kildegjennomgang: Middelalderske kirkesteder i Sogn og Fjordane fylke*. Oslo, 2016.

Brink, Stefan. "Early Ecclesiastical Organization of Scandinavia, especially Sweden." In *Medieval Christianity in the North: New Studies*, edited by Kirsi Salonen, Kurt Villads Jensen, and Torstein Jørgensen, 23–41. Turnhout, 2013.

———. "Iakttakelser rörende namnen på –hem i Sverige." In *Heiderskrift til Nils Hallan på 65-årsdagen 13. desember 1991*, edited by Gulbrand Alhaug, Kristoffer Kruken, and Helge Salvesen, 66–80. Oslo, 1991.

———. "Political and Social Structures in Early Scandinavia: A Settlement-Historical Pre-Study of the Central Place." *Tor* 28 (1996): 235–81.

———. "Who Were the Vikings?" In Brink and Price, *Viking World*, 4–7.

Brink, Stefan, with Neil Price, eds. *The Viking World*. Abingdon, UK, 2008.

Bruun, Mette Birkedal, and Louis I. Hamilton. "Rites for Dedicating Churches." In *Understanding Medieval Liturgy: Essays in Interpretation*, edited by Helen Gittos and Sarah Hamilton, 177–204. Burlington, VT, 2016.

Buell, Denise Kimber. "Early Christian Universalism and Modern Forms of Racism." In *The Origins of Racism in the West*, edited by Miriam Eliav-Feldon, Benjamin Isaac, and Joseph Ziegler, 109–31. Cambridge, 2009.

Bugge, Anders. "Arkitektur." in *Norsk kunstforskning i det tyvende århundre: Festskrift til Harry Fett*, edited by Arne Nygård-Nilssen, Anders Bugge, Thor Kielland, and Haakon Shetelig, 71–154. Oslo, 1945.

———. "The Golden Vanes of Viking Ships: A Discussion on a Recent Find at Källunge Church, Gothland." *Acta Archaeologica* 2 (1931): 159–84.

———. *Kristendommens kunst: Fra keiser Constantinus til konsiliet i Konstanz*. Oslo, 1937.

———. "Norge." In *Kirkebygninger og deres udstyr*, edited by Vilhelm Lorenzen, 189–270. Oslo, 1934.

———. *Norske stavkirker*. Oslo, 1953.

———. *Norsk kunst i middelalderen*. Oslo, 1937.

———. *Norwegian Stave Churches*. Translated by Ragnar Christophersen. Oslo, 1953.

Burton, Janet. "The Regular Canons and Diocesan Reform in Northern England." In Burton and Stöber, *Regular Canons in the Medieval British Isles*, 41–57.

Burton, Janet, and Karen Stöber. "Introduction." In Burton and Stöber, *Regular Canons in the Medieval British Isles*, 1–16.

Burton, Janet, and Karen Stöber, eds. *The Regular Canons in the Medieval British Isles*. Turnhout, 2011.

"Bygninger og omgivelser 33/2006 B-176 Vindlausloftet, Vest-Telemark Museum." NIKU Report, doc. 06/00370-4.

Bynum, Caroline Walker. "The Spirituality of the of Regular Canons." In *Jesus as Mother: Studies in the Spirituality of the High Middle Ages*, 22–58. Berkeley, CA, 1982.

———. *The Resurrection of the Body in Western Christianity, 200–1336*. New York, 1995.

Bødal, Sigmund Matias. "Vik i Sogn 750–1030: Lokalsamfunn med overregionale kontakter." MA thesis, University of Bergen, 1998.

———. "Vik og Sogn i tida kring førre årtusenskiftet." *Årbok: Vik Historielag*, 2000, 42–60.

Cahn, Walter. *The Romanesque Wooden Doors of Auvergne*. New York, 1974.

Camille, Michael. "Mouths and Meaning: Towards an Anti-Iconography of Medieval Art." In *Iconography at the Crossroads: Papers from the Colloquium Sponsored by the Index of Christian Art, Princeton University, 23–24 March 1990*, edited by Brendan Cassidy, 43–58. Princeton, NJ, 1993.

Campion, Chris. "In the Face of Death." *The Guardian*, 20 February 2005.

Camus, Marie-Thérèse. *Sculpture romane du Poitou: Les grands chantiers du XIe siècle*. Paris, 1992.

Candon, Anthony. "Muirchertach Ua Briain, Politics, and Naval Activity in the Irish Sea, 1075 to 1119." In *Keimelia: Studies in Medieval Archaeology and History in Memory of Tom Delaney*, edited by Gearóid Mac Niocaill and Patrick F. Wallace, 397–415. Galway, 1988.

———. "Power, Politics and Polygamy: Women and Marriage in Late Pre-Norman Ireland." In Bracken and Ó Riain-Raedel, *Ireland and Europe in the Twelfth Century*, 106–27.

———. "Telach Óc and Emain Macha c. 1100." *Emania* 15 (1996): 39–46.

Carmody, Francis J. *Physiologus latinus: Editions préliminaires, versio B*. Paris, 1939.

Carruthers, Mary. *The Book of Memory: A Study of Memory in Medieval Culture*. 2nd ed. New York, 2008.

———. *The Craft of Thought: Meditation, Rhetoric, and the Making of Images, 400–1200*. Cambridge, 1998.

———. *The Experience of Beauty in the Middle Ages*. Oxford, 2013.

———. "*Varietas*: A Word of Many Colours." *Poetica* 41, nos. 1–2 (2009): 11–32.

Carver, Martin, Justin Garner-Lahire, and Cecily Spall. *Portmahomack on Tarbat Ness: Changing Ideologies in North-East Scotland, Sixth to Sixteenth Century AD*. Edinburgh, 2016.

Caviness, Madeline H., and Charles G. Nelson. *Women and Jews in the Sachsenspiegel Picture-Books*. London, 2018.

Cheadle, Ruth Elizabeth. "Representations of Christ in Christian Skaldic Poetry." PhD diss., University College London, 2015.

Christensen, Mads Chr. "Painted Wood from the Eleventh Century: Examination of the Hørning Plank." In Nadolny, Kollandsrud, Sauerberg, and Frøysaker, *Medieval Painting in Northern Europe*, 34–42.

Christiansson, Hans. "Jellingestenens bildvärld." *Kuml: Årbog for Jysk arkaelogisk selskab*, 1953, 72–101.

Christie, Håkon. "Stavkirkene: Arkitektur." In Berg, Fuglesang, Christie, Hohler, Reimers, Anker, *Norges kunsthistorie*, Vol 1, 139–252.

———. *Urnes stavkirke: Den nåværende kirken på Urnes*. Oslo, 2009.

———. "Urnes stavkirkes forløper: Belyst ved utgravninger under kirken." *Årbok: Foreningen til norske fortidsminnesmerkers bevaring* 113 (1959): 49–74.

Christie, Håkon, Olaf Olsen, and H. M. Taylor. "The Wooden Church of St. Andrew at Greensted, Essex." *Antiquaries Journal* 59, no. 1 (1979): 92–112.

Chronicon Scotorum. Translated by William M. Hennessy and Gearóid Mac Niocaill. Cork, 2010. https://celt.ucc.ie//published/T100016/index.html.

Ciggaar, Krijnie N. *Western Travellers to Constantinople: The West and Byzantium, 962–1204; Cultural and Political Relations*. Leiden, 1996.

Clark, Willene B. *The Medieval Book of Birds: Hugh of Fouilloy's "Aviarium."* Binghamton NY, 1992.

Clarke, Howard B. *Irish Historic Towns Atlas*. No. 11, *Dublin, Part I: To 1610*. Dublin, 2002.

Clarke, Howard B., and Ruth Johnson, eds. *The Vikings in Ireland and Beyond: Before and after the Battle of Clontarf*. Dublin, 2015.

Coatsworth, Elizabeth. "Soft Furnishings and Textiles: Ante-1100." In *Encyclopedia of Medieval Dress and Textiles of the British Isles, c. 450–1450*, edited by Gale R. Owen-Crocker, Elizabeth Coatsworth, and Maria Hayward, 526–30. Leiden, 2012.

Coffey, George. *Guide to the Celtic Antiquities of the Christian Period Preserved in the National Museum, Dublin*. Dublin, 1909.

Cole, Richard. "Kyn/Fólk/Þjóð/Ætt: Proto-Racial Thinking and Its Application to Jews in Old Norse Literature." In *Fear and Loathing in the North: Jews and Muslims in Medieval Scandinavia and the Baltic Region*, edited by Cordelia Heß and Jonathan Adams, 239–68. Boston, 2015.

———. "One or Several Jews: The Jewish Massed Body in Old Norse Literature." *Postmedieval: A Journal of Medieval Cultural Studies* 5 (2014): 346–58.

Conkey, Margaret W. "Experimenting with Style in Archaeology: Some Historical and Theoretical Issues." In *The Uses of Style in Archaeology*, edited by Margaret W. Conkey and Christine A. Hastorf, 5–17. Cambridge, 1993.

Connolly, Sean, and J.-M. Picard. "Cogitosus's *Life of St Brigit*: Content and Value." *Journal of the Royal Society of Antiquaries of Ireland* 117 (1987): 5–27.

Constable, Giles. "Introduction to *Burchardi, ut videtur, Abbatis Bellevallis Apologia de Barbis*." In *Apologiae duae: Gozechini Epistola ad Walcherum; Burchardi, ut videtur, abbatis Bellevallis Apologia de barbis*, edited by R. B. C. Huygens, 46–130. Turnhout, 1985.

———, ed. *The Letters of Peter the Venerable*. Vol. 1. Cambridge, MA, 1967.

———. "Petri Venerabilis sermones tres." *Revue Bénédictine* 64 (1954): 224–72.

———. "Renewal and Reform in Religious Life: Concepts and Realities." In *Renaissance and Renewal in the Twelfth Century*, edited by Robert L. Benson and Giles Constable with Carol D. Lanham, 37–67. Cambridge, MA, 1982.

Conti, Aidan. "The Performative Text of the Stave Church Homily." In *The Performance of Christian and Pagan Storyworlds: Non-Canonical Chapters of the History of Nordic Medieval Literature*, edited by Lars Boje Mortensen and Tuomas M. S. Lehtonen with Alexandra Bergholm, 223–45. Turnhout, 2013.

Cronin, Rhoda. "Late High Crosses in Munster: Tradition and Novelty in Twelfth-Century Irish Art." In *Early Medieval Munster: Archaeology, History, and Society*, edited by Michael A. Monk and John Sheehan, 138–46. Cork, 1998.

Crouwers, Iris. "Late Viking-Age and Medieval Stone Crosses and Cross-Decorated Stones in Western Norway: Forms, Uses and Perceptions in a Northwest-European Context and Long-Term Perspective." PhD diss., University of Bergen, 2019.

Curley, Michael J., trans. *Physiologus*. Austin, TX, 1979.

———. *Physiologus: A Medieval Book of Nature Lore*. Chicago, 2009.

Curman, Sigurd, and Erik Lundberg. *Östergötland*. Vol. 2, *Vreta klosters kyrka*. Stockholm, 1935.

Curman, Sigurd, Erik Lundberg, Stellan Mörner, and Bertil Waldén. *Kyrkor i Glanshammars härad: Sydvästra delen; Konsthistoriskt inventarium*. Stockholm, 1961.

Cusack, Carole M. *The Sacred Tree: Ancient and Medieval Manifestations*. Newcastle upon Tyne, 2011.

Dahl, J. C. *Denkmale einer sehr ausgebildeten Holzbaukunst aus den frühesten Jahrhunderten in den innern Landschaften Norwegens*. Dresden, 1837.

Dahlerup, Verner. "Physiologus i to islandske bearbejdelser: Med indledning og oplysninger." *Aarbøger for nordisk oldkyndighed og historie* 4 (1889): 199–290.

Dale, Roderick Thomas Duncan. "Berserkir: A Re-Examination of the Phenomenon in Literature and Life." PhD diss., University of Nottingham, 2014.

Dale, Thomas E. A. "Monsters, Corporeal Deformities, and Phantasms in the Cloister of St-Michel-de-Cuxa." *Art Bulletin* 83, no. 3 (2001): 402–36.

———. "The Monstrous." In *A Companion to Medieval Art: Romanesque and Gothic in Northern Europe*, edited by Conrad Rudolph, 357–81. 2nd ed. Oxford, 2019.

———. *Pygmalion's Power: Romanesque Sculpture, the Senses, and Religious Experience*. University Park, PA, 2019.

———. *Relics, Prayer, and Politics in Medieval Venetia: Romanesque Painting in the Crypt of Aquileia Cathedral.* Princeton, NJ, 1997.

Daniel, Norman. *Islam and the West: The Making of an Image.* Edinburgh, 1960.

Deimling, Barbara. "Ad Rufam Ianuam: Die rechtsgeschichtliche Bedeutung von 'roten Türen' im Mittelalter." *Zeitschrift der Savigny-Stiftung für Rechtsgeschichte: Germanistische Abteilung* 115 (1998): 498–513.

———. "Medieval Church Portals and Their Importance in the History of Law." In *Romanesque: Architecture, Sculpture, Painting*, edited by Rolf Toman, 324–27. Translated by Fiona Hulse and Ian Macmillan. Cologne, 1997.

Del Zotto Tozzoli, Carla. *Il "Physiologus" in Islanda.* Pisa, 1992.

De Paor, Liam. "The Limestone Crosses of Clare and Aran." *Journal of the Galway Archaeological and Historical Society* 26, nos. 3–4 (1955–56): 53–71

De Paor, Máire. "The Relics of Saint Patrick: A Photographic Feature with Notes on the Relics." *Seanchas Ardmhacha: Journal of the Armagh Diocesan Historical Society* 4, no. 2 (1961–62): 87–91.

De Paor, Máire, and Liam De Paor. *Early Christian Ireland.* Rev. ed. London, 1964.

Derbes, Anne. "Crusading Ideology and the Frescoes of S. Maria in Cosmedin." *Art Bulletin* 77, no. 3 (1995): 460–78.

Dietrichson, Lorentz. *De norske stavkirker: Studier over deres system, oprindelse og historiske udvikling; et bidrag til Norges middelalderske bygningskunsts historie.* Kristiania, 1892.

———. *Den norske Træskjærerkunst, dens oprindelse og udvikling: En foreløbig undersøgelse.* Christiania, 1878.

Dietrichson, Lorentz, and H. Munthe. *Die Holzbaukunst Norwegens in Vergangenheit und Gegenwart.* Berlin, 1893.

Digby, George Wingfield. "Technique and Production." In *The Bayeux Tapestry: A Comprehensive Survey*, edited by F. M. Stenton, 37–55. London, 1957.

Diplomatarium Islandicum: Íslenzkt fornbréfasafn. 16 vols. Copenhagen, 1857–1952.

Diplomatarium Norvegicum. 23 vols. Christiania–Oslo, 1847–2011.

Distler, Flemming. *Stavkirkernes billedsprog: Fordybelse og tolkning.* Aarhus, 1997.

Dixon, Philip, Olwyn Owen, and David Stocker. "The Southwell Lintel, Its Style and Significance." In Campbell, Hall, Jesch, and Parsons, *Vikings and the Danelaw*, 245–68.

Dodds, Jerrilynn D. *Architecture and Ideology in Early Medieval Spain.* University Park, PA, 1990.

———. "Wall Paintings." In *The Art of Medieval Spain: A.D. 500–1200*, 223–28. New York, 1993.

Dodwell, C. R. *The Canterbury School of Illumination: 1066–1200.* Cambridge, 1954.

Dolcetti Corazza, Vittoria. "Crossing Paths in the Middle Ages: The *Physiologus* in Iceland." In *The Garden of Crossing Paths: The Manipulation and Rewriting of Medieval Texts; Venice, October 28–30, 2004*, edited by Marina Buzzoni and Massimiliano Bampi, 225–48. Rev. ed. Venice, 2007.

Dommasnes, Liv Helga, and Alf Tore Hommedal. "One Thousand Years of Tradition and Change on Two West-Norwegian Farms AD 200–1200." In *The Farm as a Social Arena*, edited by Liv Helga Dommasnes, Doris Gutsmiedl-Schümann, and Alf Tore Hommedal, 127–69. Münster, 2016.

Drake, C. S. *The Romanesque Fonts of Northern Europe and Scandinavia.* Woodbridge, UK, 2002.

Druce, G. C. "The Elephant in Medieval Legend and Art." *Archaeological Journal* 76 (1919): 1–73.

DuBois, Thomas A. *Nordic Religions in the Viking Age.* Philadelphia, 1999.

Duffy, Seán. "Ireland and Scotland, 1014–1169: Contacts and Caveats." In Smyth, *Seanchas*, 348–56.

———. "'The Western World's Tower of Honour and Dignity': The Career of Muirchertach Ua Briain in Context." In Bracken and Ó Riain-Raedel, *Ireland and Europe in the Twelfth Century*, 56–73.

Dybdahl, Audun. "Agrarkrisa i Årdal, Lærdal og Borgund." In *Seinmiddelalder i norske bygder: Utvalgte emner fra det nordiske ødegårdsprosjekts norse punktundersøkelser*, edited by Lars Ivar Hansen, 141–88. Oslo, 1981.

———, ed. *Nidaros Domkirkes og geistlighets kostbarheter: Belyst ved 17 skriftlige kilder 1307–1577 med oversettelser og kommentarer.* Trondheim, 2002.

Egilsdóttir, Ásdís. "The Beginnings of Local Hagiography in Iceland: The Lives of Bishop Þorlákr and Jón." In *The Making of Christian Myths in the Periphery of Latin Christendom (c. 1000–1300)*, edited by Lars Boje Mortensen, 121–34. Copenhagen, 2006.

Eithun, Bjørn, Magnus Rindal, and Tor Ulset, eds. *Den eldre Gulatingslova.* Oslo, 1994.

Ekhoff, Emil. *Svenska stavkyrkor: Jämte iakttagelser över de norska samt redogörelse för i Danmark och England kända lämningar av stavkonstruktioner.* Stockholm, 1914–16.

Ekroll, Øystein. "State Church and Church State: Churches and Their Interiors in Post-Reformation Norway, 1537–1705." In *Lutheran Churches in Early Modern Europe*, edited by Andrew Spicer, 277–309. Farnham, UK, 2012.

Ekroll, Øystein, and Morten Stige. *Kirker i Norge*. Vol. 1, *Middelalder i stein*. Oslo, 2000.

Elder, S., E. Dennehy, J. Tierney, D. Noonan, and A. Doolan. "Archaeological Excavation Report: 00E0422 ext, 01E0327 ext, 02E0809—Shandon td., Dungarvan, Co. Waterford; Medieval Moated Site." *Eachtra Journal* 14 (2012): 1–109. http://eachtra.ie/new_site/wp-content/uploads/2012/06/shandon-dungarvan-co-waterford.pdf.

Eldjárn, Kristján. "Carved Panels from Flatatunga, Iceland." *Acta Archaeologica* 24 (1953): 81–101.

———. "Forn útskurður frá Hólum í Eyjafirði." *Àrbók hins Íslenzka fornleifafélag* 64 (1967): 5–24.

Elsner, Jás. "Style." In *Critical Terms for Art History*, edited by Robert S. Nelson and Richard Shiff, 98–109. 2nd ed. Chicago, 2003.

Endoltseva, Ekaterina, and Andrey Vinogradov. "Beard Pulling in Medieval Christian Art: Various Interpretations of a Scene." *Anastasis: Research in Medieval Culture and Art* 3, no. 1 (2016): 88–98.

Engelstad, Helen. *Refil, bunad, tjeld: Middelalderens billedtepper i Norge*. Oslo, 1952.

Epstein, Marc Michael. *The Medieval Haggadah: Art, Narrative and Religious Imagination*. New Haven, CT, 2011.

Esch, Arnold. "Spolien: Zur Wiederverwendung antiker Baustücke und Skulpturen im Mittelalterlichen Italien." *Archiv für Kulturgeschichte* 51, no. 1 (1969): 1–64.

Falk, Hjalmar. *Altwestnordische Kleiderkunde: Mit besonderer Berücksichtigung der Terminologie*. Kristiania, 1919.

Farnes, Elisabeth. "Some Aspects of the Relationship between Late 11th and 12th Century Irish Art and the Scandinavian Urnes Style." MA thesis, University College Dublin, 1975.

Ferguson, George. *Signs and Symbols in Christian Art*. New York, 1958.

Fernie, Eric. *The Architecture of Norman England*. Oxford, 2000.

———. *Romanesque Architecture: The First Style of the European Age*. New Haven, CT, 2014.

Fett, Harry. *En bygdekirke*. Oslo, 1941.

———. *En islandsk tegnebog fra middelalderen*. Christiania, 1910.

———. *Norges kirker i middelalderen*. Kristiania, 1909.

Fett, Per. *Luster Prestegjeld*. Bergen, 1954.

———. *Vik Prestegjeld*. Bergen, 1954.

Finlay, Alison. *Fagrskinna, A Catalogue of the Kings of Norway: A Translation with Introduction and Notes*. Leiden, 2004.

Fischer, Dorothea. "Tidlig-romanske stenfunn." In *Domkirken i Trondheim: Kirkebygget i middelalderen*, edited by Gerhard Fischer, 2:549–64. Oslo, 1965.

Fliedner, Siegfried. „Der frühromanische Dom zu Bremen." In *Der Bremer Dom: Baugeschichte, Ausgrabungen, Kunstschätze; Handbuch und Katalog zur Sonderausstellung vom 17. Juni bis 30. Sept. 1979 in Bremer Landesmuseum (Focke-Museum)*, 9–55. Bremen, 1979.

Flood, Finbarr B. *Objects of Translation: Material Culture and Medieval "Hindu-Muslim" Encounter*. Princeton, NJ, 2009.

Flø, Turid Svarstad. "Høylandsteppet: En rekonstruksjon av et midt-norsk middelalderteppe." *SPOR* 12, no. 2 (1997): 16–19.

Folda, Jaroslav. "Commemorating the Fall of Jerusalem: Remembering the First Crusade in Text, Liturgy, and Image." In *Remembering the Crusades: Myth, Image, and Identity*, edited by Nicholas Paul and Suzanne Yeager, 125–45. Baltimore, 2012.

Folkvord, Aase. "Dekorerte tresaker fra folkebibliotekstomta i Trondheim: Beskrivelse, analyse og vurdering." 2 vols. MA thesis, Art History, University of Oslo, 2007.

Forsyth, Ilene H. "The Theme of Cockfighting in Burgundian Romanesque Sculpture." *Speculum* 53, no. 2 (1978): 252–82.

Fozi, Shirin. *Romanesque Tomb Effigies: Death and Redemption in Northern Europe, 1000–1200*. University Park, PA, 2021.

Fozi, Shirin, and Gerhard Lutz, eds. *Christ on the Cross: The Boston Crucifix and the Rise of Monumental Wood Sculpture, 970–1200*. Turnhout, 2020.

France, Alan W. "Gothic North and the Mezzogiorno in Auden's 'In Praise of Limestone.'" *Renascence* 42, no. 3 (1990): 141–48.

Franzén, Anne Marie, and Margareta Nockert. *Prydnadssömmar under medeltiden*. Stockholm, 2012.

Friedman, John Block. *The Monstrous Races in Medieval Art and Thought*. Cambridge, MA, 1981.

Frøysaker, Tine. "Kalvariegruppen i Urnes stavkirke." *Årbok: Foreningen til norske fortidsminnesmerkers bevaring* 157 (2003): 125–36.

Frøysaker, Tine, and Kaja Kollandsrud. "The Calvary Group in Urnes Stave Church, Norway: A Technological Examination." In Nadolny, Kollandsrud, Sauerberg, and Frøysaker, *Medieval Painting in Northern Europe*, 43–58.

Frøysaker, Tine, Francesco Caruso, and Sara Mantellato. "Preliminary Report, Urnes Stave Church Project following Mission on 19–20 October 2019." Department of Archaeology, Conservation, and History, University of Oslo (2020). Unpublished report, Urnes stavkirke doc. 20/12364-1. Riksantikvaren, Archives.

Fuglesang, Signe Horn. "Amulets as Evidence for the Transition from Viking to Medieval Scandinavia." In *The World of Ancient Magic: Papers from the First International Samson Eitrem Seminar at the Norwegian Institute at Athens, 4–8 May 1997*, edited by David R. Jordan, Hugo Montgomery, and Einar Thomassen, 299–314. Bergen, 1999.

———. "Animal Ornament: The Late Viking Period." In *Tiere, Menschen, Götter: Wikingerzeitliche Kunststile und ihre neuzeitliche Rezeption: Referate gehalten auf einem von der Deutschen Forschungsgemeinschaft geförderten Internationalen Kolloquium der Joachim Jungius-Gesellschaft der Wissenschaften, Hamburg*, edited by Michael Müller-Wille and Lars Olof Larsson, 157–94. Göttingen, 2001.

———. "Art." In Roesdahl and Wilson, *From Viking to Crusader*, 176–83.

———. "The Axehead from Mammen and the Mammen Style." In *Mammen: Grav, kunst og samfund i vikingetid*, edited by Mette Iversen, 83–107. Højbjerg, 1991.

———. "Dekor, bilder og bygninger i kristningstiden." In *Religionsskiftet i Norden: Brytinger mellom nordisk og europeisk kultur 800–1200 e. Kr*, edited by Jón Viðar Sigurðsson, Marit Myking, and Magnus Rindal, 197–294. Oslo, 2004.

———. "Forholdet mellom dekorasjon i stein og tre." *Romanske stenarbejder* 5 (2003): 39–58.

———. "Ikonographie der scandinavischen Runensteine der jüngeren Wikingerzeit." In *Zum Problem der Deutung frühmittelalterliche Bildinhalte: Akten des 1. Internationalen Kolloquiums in Marburg a.d. Lahn, 15. bis 19. Februar 1983*, edited by Helmut Roth, 183–210. Sigmaringen, 1986.

———. "Kirkenes utstyr i kristningstiden." In *Fra hedendom til kristendom: Perspektiver på religionsskiftet i Norge*, edited by Magnus Rindal, 78–104. Oslo, 1996.

———. "Kristningstidens kirkeinventar: Objekter og symboler." In *Middelalderens symboler*, edited by Ann Christensson, Else Mundal, and Ingvild Øye, 106–25. Bergen, 1997.

———. *Some Aspects of the Ringerike Style: A Phase of Eleventh Century Scandinavian Art*. Odense, 1980.

———. "Stylistic Groups in Late Viking and Early Romanesque Art." *Acta ad archaeologiam et artium historiam pertinentia* 8, no. 1 (1981): 79–125.

———. "Swedish Runestones of the Eleventh Century: Ornament and Dating." In *Runeninschriften als Quellen interdisziplinärer Forschung: Abhandlungen des Vierten Internationalen Symposiums über Runen und Runeninschriften in Göttingen vom 4.–9. August 1995*, edited by Klaus Düwel, 197–218. Berlin, 1998.

———. "Vikingtidens kunst." In Berg, Fuglesang, Christie, Hohler, Reimers, and Anker. *Norges Kunsthistorie*, 36–138.

———. "Vikingtidens ristninger: Dekorasjonsteknikk, skisse og tidtrøyte." In *Ristninger i forhistorie og middelalder: Det norske Arkeologmøtet Symposium, Voksenåsen, Oslo 1979*, edited by Diana Stensdal Hjelvik and Egil Mikkelsen, 19–36. Oslo, 1980.

Fuglesang, Signe Horn, and Gerd Stamsø Munch. "Den dekorerte planken fra Haug i Hadsel." *Årbok: Foreningen til norske fortidsminnesmerkers bevaring* 145 (1991): 245–52.

Fulcher of Chartres. *Historia Hierosolymitana ab anno 1095 ad annum usque 1127*. In *Patrologiae Cursus Completus: Series Latina*. Edited by J.-P. Migne, 155. Paris, 1854.

Garde, Judith N. *Old English Poetry in Medieval Christian Perspective: A Doctrinal Approach*. Cambridge 1991.

Gardelin, Gunilla. *Kyrkornas Lund*. Lund, 2015.

Gardiner, Mark. "Timber Churches in Medieval England: A Preliminary Study." In Khodakovsky and Lexau, *Historic Wooden Architecture in Europe and Russia*, 28–41.

Garipzanov, Ildar, with Rosalind Bonté, eds. *Conversion and Identity in the Viking Age*. Turnhout, 2014.

Gasquet, [Francis Aidan]. *English Monastic Life*. 2nd ed. London, 1904.

Gelting, Michael H. "The Kingdom of Denmark." In Berend, *Christianization and the Rise of Christian Monarchy*, 73–120.

Gem, Richard D. H. "Canterbury and the Cushion Capital: A Commentary on Passages from Goscelin's De miraculis Sancti Augustini." In *Romanesque and Gothic: Essays for George Zarnecki*, edited by Neil Stratford, 1:83–101. Woodbridge, UK, 1987.

———. "St Flannán's Oratory at Killaloe: A Romanesque Building of *c.* 1100 and the Patronage of King Muirchertach Ua Briain." In Bracken and Ó Riain-Raedel, *Ireland and Europe in the Twelfth Century*, 74–105.

Gem, Richard, Emily Howe, and Richard Bryant. "The Ninth-Century Polychrome Decoration at St Mary's Church, Deerhurst." *Antiquaries Journal* 88 (2008): 109–64.

Gerace, Samuel. "Wandering Churches: Insular House-Shaped Shrines and the Temple of Jerusalem." In *Islands in a Global Context: Proceedings of the Seventh International Conference on Insular Art, Held at the National University of Ireland, Galway 16–20 July 2014*, edited by Conor Newman, Mags Mannion, and Fiona Gavin, 84–91. Dublin, 2017.

Gittos, Helen. *Liturgy, Architecture, and Sacred Places in Anglo-Saxon England*. Oxford 2013.

Gjærder, Per. "The Beard as an Iconographical Feature in the Viking Period and the Early Middle Ages." *Acta Archaeologica* 35 (1964): 95–114.

———. *Norske pryd-dører fra middelalderen*. Bergen, 1952.

Gjerland, Berit, and Christian Keller. "Graves and Churches of the Norse in the North Atlantic: A Pilot Study." *Journal of the North Atlantic* 2, special issue 2 (2009): 161–77.

Gotfredsen, Lise. "Dragens hale." In Vellev, *2. Skandinaviske symposium om romanske stenarbejder*, 59–68.

Graham, Heather, and Lauren G. Kilroy-Ewbank. "Introduction: Visualizing Sensuous Suffering and Affective Pain in Early Modern Europe and the Spanish Americas." In *Visualizing Sensuous Suffering and Affective Pain in Early Modern Europe and the Spanish Americas*, edited by Heather Graham and Lauren G. Kilroy-Ewbank, 1–34. Leiden, 2018.

Graham-Campbell, James. "From Scandinavia to the Irish Sea: Viking Art Reviewed." In Ryan, *Ireland and Insular Art*, 144–52.

———. *Viking Art*. 3rd ed. London, 2001. 4th ed. London, 2013.

———. *Viking Artefacts: A Select Catalogue*. London, 1980.

Graham-Campbell, James, and Dafydd Kidd. *The Vikings: The British Museum, London; The Metropolitan Museum of Art, New York*. London, 1980.

Graham-Campbell, James, R. A. Hall, Judith Jesch, and David Parsons, eds. *Vikings and the Danelaw: Select Papers from the Proceedings of the Thirteenth Viking Congress, Nottingham and York, 21–30 August 1997*. Oxford, 2001.

Gräslund, Anne-Sofie. "Dating the Swedish Viking-Age Rune Stones on Stylistic Grounds." In Stoklund, Nielsen, Holmberg, and Fellows-Jensen, *Runes and Their Secrets*, 117–39.

———. "En påfågel i Odensala? Några reflexioner om ikonografin på runstenarna vid Harg." In *Situne Dei: Årsskrift för Sigtunaforskning och historisk arkeologi*, edited by Anders Söderberg, Rune Edberg, Magnus Källström, and Elisabet Claesson, 22–31. Sigtuna, 2014.

———. "The Late Viking Age Runestones of Västergötland: On Ornamentation and Chronology." *Lund Archaeological Review* 20 (2014): 39–53.

———. "Runensteine." In *Reallexikon der germanischen Altertumskunde*, edited by Heinrich Beck, Dieter Geuenich, and Heiko Steuer, 25:585–91. 2nd ed. Berlin, 2003.

———. "Rune Stones: On Ornamentation and Chronology." In Ambrosiani and Clarke, *Developments around the Baltic and the North Sea in the Viking Age*, 117–31.

———. "Runstenar: Om ornamentik och datering." *Tor* 23 (1991): 113–40.

———. "Runstenar: Om ornamentik och datering II." *Tor* 24 (1992): 177–201.

———. "Similarities or Differences? Rune Stones as a Starting Point for Some Reflections on Viking Age Identity." In *Viking Settlements & Viking Society: Papers from the Proceedings of the Sixteenth Viking Congress, Reykjavík and Reykholt, 16th–23rd August 2009*, edited by Svavar Sigmundsson, 147–61. Reykjavík, 2009.

———. "Wolves, Serpents, and Birds: Their Symbolic Meaning in Old Norse Belief." In *Old Norse Religion in Long-Term Perspectives: Origins, Changes, and Interactions; An International Conference in Lund, Sweden, June 3–7, 2004*, edited by Anders Andrén, Kristina Jennbert, and Catharina Raudvere, 124–29. Lund, 2006.

Gräslund, Anne-Sofie, and Linn Lager. "Runestones and the Christian Missions." In Brink and Price, *Viking World*, 629–38.

Green, Caitlin R. "Camels in Early Medieval Western Europe: Beasts of Burden & Tools of Ritual Humiliation." https://www.caitlingreen.org/2016/05/camels-in-early-medieval-western-europe.html.

———. "Were There Camels in Medieval Britain? A Brief Note on Bactrian Camels and Dromedaries in Fifteenth-Century Kent." https://www.caitlingreen.org/2018/09/were-there-camels-in-medieval-britain.html.

Grieg, Sigurd. "Lahellnavnet i arkeologisk og kulturhistorisk lys." *Årbok: Universitetets Oldsaksamlings*, 1969 (1972): 5–66.

Gudstjenestebok for Den norske kirke: del II, Kirkelige handlinger. Oslo, 1992.

Guðjónsson, Elsa E. *Traditional Icelandic Embroidery*. Reykjavík, 1985.

Gullbekk, Svein H., and Anette Sættem. *Norske myntfunn 1050–1319: Penger, kommunikasjon og fromhetskultur*. Oslo, 2019.

Gullbrandsson, Robin. "Myresjö gamla kyrka." Jönköping Läns Museum, Byggnadsvårdsrapport 2007:22, 12.

https://jonkopingslansmuseum.se/wp-content/uploads/2018/01/Myresjo-gamla-kyrka.pdf.

Gullick, Michael, and Åslaug Ommundsen. "Two Scribes and One Scriptorium Active in Norway c. 1200." *Scriptorium* 66, no. 1 (2012): 25–54.

Gullåsen, Hildegunn. "The Medieval Calvary Group in Norway: Context and Functions." *Collegium Medievale* 19 (2006): 5–30.

Gundhus, Grete. "Fragmenter forteller: Verdslig middelaldermaleri i Lydvaloftet på Voss." *Årbok: Foreningen til norske fortidsminnesmerkers bevaring* 155 (2001): 206–16.

Gunnell, Terry, and Annette Lassen, eds. *The Nordic Apocalypse: Approaches to "Vǫluspá" and Nordic Days of Judgement*. Turnhout, 2013.

Gwynn, Aubrey. *The Irish Church in the Eleventh and Twelfth Centuries*. Edited by Gerard O'Brien. Dublin, 1992.

Haastrup, Ulla, ed. *Danske kalkmalerier*. Vol. 1, *Romansk tid, 1080–1175*. Copenhagen, 1986.

———, ed. *Danske kalkmalerier*. Vol. 3, *Tidlig gotik, 1275–1375*. Copenhagen, 1989.

———. "Representations of Jews in Danish Medieval Art." In *Danish Jewish Art / Jews in Danish Art*, edited by Mirjam Gelfer-Jørgensen, 113–67. Translated by W. Glyn Jones. Copenhagen, 1999.

———. "Representations of Jews in Danish Medieval Art—Can Images Be Used as Source Material on Their Own?" In *History and Images: Towards a New Iconology*, edited by Axel Bolvig and Phillip Lindley, 341–56. Turnhout, 2003.

Hagland, Jan Ragnar, and Jørn Sandnes. *Frostatingslova*. Oslo, 1994.

Haist, Margaret. "The Lion, Bloodline, and Kingship." In *The Mark of the Beast: The Medieval Bestiary in Art, Life, and Literature*, edited by Debra Hassig, 3–16. London, 1999.

Hamlin, Ann Elizabeth. *The Archaeology of Early Christianity in the North of Ireland*. Edited by Thomas R. Kerr. Oxford, 2008.

Hansen, Birgit Als. "Arkæologiske spor efter døbefontens placering i kirkerummet gennem middelalderen." *Hikuin* 22 (1995): 27–41.

Hansen, Gitte, Øystein J. Jansen, and Tom Heldal. "Soapstone Vessels from Town and Country in Viking Age and Early Medieval Western Norway: A Study of Provenance." In *Soapstone in the North: Quarries, Products and People, 7000 BC–AD 1700*, edited by Gitte Hansen and Per Storemyr, 249–328. Bergen, 2017.

Harbison, Peter. *The Golden Age of Irish Art: The Medieval Achievement, 600–1200*. London, 1999.

———. *The High Crosses of Ireland: An Iconographical and Photographic Survey*. Vol. 1. Bonn, 1992.

Harðardóttir, Guðrún. "A View on the Preservation History of the Last Judgement Panels from Bjarnastaðahlið, and Some Speculation on the Medieval Cathedrals at Hólar." In Gunnell and Lassen, *Nordic Apocalypse*, 205–20.

Harper, John. *The Forms and Orders of Western Liturgy from the Tenth to the Eighteenth Century: A Historical Introduction and Guide for Students and Musicians*. Oxford, 1991.

Hartner, Willy, and Richard Ettinghausen. "The Conquering Lion, the Life Cycle of a Symbol." *Oriens* 17 (1964): 161–71.

Hartog, Elizabeth den. "Nudis pedibus: A Bare-Footed Cleric in Urnes, Norway." *Leiden Medievalists* blog, 28 December 2018. leidenmedievalistsblog.nl/articles/nudis-pedibus-a-bare-footed-cleric-in-urnes-norway.

———. "On Dating the Abbey Church of Rolduc (Klosterrath) and Its Romanesque Sculpture." *Zeitschrift für Kunstgeschichte* 74, no. 1 (2011): 3–28.

———. *Romanesque Sculpture in Maastricht*. Maastricht, 2002.

Hassig, Debra. *Medieval Bestiaries: Text, Image, Ideology*. Cambridge, 1995.

Hauglid, Kjartan. "A Deliberate Style: The Patronage of Early Romanesque Architecture in Norway." In *Intellectual Culture in Medieval Scandinavia, c. 1100–1350*, edited by Stefka Georgieva Eriksen, 103–35. Turnhout, 2016.

———. "Understanding Islamic Features in Norwegian Romanesque Architecture." In *The Locus of Meaning in Medieval Art: Iconography, Iconology and Interpreting the Visual Imagery of the Middle Ages*, edited by Lena Liepe, 163–93. Kalamazoo, MI, 2018.

Hauglid, Roar. "Bjølstad kirke i Heidal: Datering og konstruksjon." *Årbok: Foreningen til norske fortidsminnesmerkers bevaring* 112 (1958): 119–34.

———. *Norske stavkirker: Bygningshistorisk bakgrunn og utvikling*. Oslo, 1976.

———. *Norske stavkirker: Dekor og utstyr*. Oslo, 1973.

———. "Urnes stavkirke i Sogn." *Årbok: Foreningen til norske fortidsminnesmerkers bevaring* 124 (1970): 34–69.

Hausamann, Torsten. *Die tanzende Salome in der Kunst von der christlichen Frühzeit bis um 1500: Ikonographische Studien*. Zurich, 1980.

Hawk, Brandon W. *Preaching Apocrypha in Anglo-Saxon England*. Toronto, 2018.

Hawkes, Jane. "Art and Society." In *The Cambridge History of Ireland*. Vol. 1, *600–1550*, edited by Brendan Smith, 76–106. Cambridge, 2017.

Hayeur Smith, Michèle. "Weaving Wealth: Cloth and Trade in Viking Age and Medieval Iceland." In *Textiles and the Medieval Economy: Production, Trade, and Consumption of Textiles, 8th–16th Centuries*, edited by Angela Ling Huang and Carsten Jahnke, 23–40. Oxford, 2014.

Hedvall, Rikard, and Hanna Menander. *Inventering av tidigkristna gravmonument i Linköpings stift*. Linköping, 2009.

Heen-Pettersen, Aina, and Griffin Murray. "An Insular Reliquary from Melhus: The Significance of Insular Ecclesiastical Material in Early Viking-Age Norway." *Medieval Archaeology* 62, no. 1 (2018): 53–82.

Heggstad, Leiv, Finn Hødnebø, and Erik Simensen. *Norrøn Ordbok*. 5th ed. Oslo, 2012.

Heiberg, G. F. "Sogns kirker i fortid og nutid." *Tidsskrift utgjeve av historielaget for Sogn* 23 (1970): 7–56.

Heimann, Adelheid. "The Master of Gargilesse: A French Sculptor of the First Half of the Twelfth Century." *Journal of the Warburg and Courtauld Institutes* 42 (1979): 47–64.

Helland, Amund. *Tagskifere, heller og vekstene*. Kristiania, 1893.

Helle, Knut, and Arnved Nedkvitne. "Sentrumsdannelser og byutvikling i norsk middelalder." In *Urbaniseringsprosessen i Norden: Det 17. Nordiske historikermøte, Trondheim 1977*. Vol. 1, *Middelaldersteder*, edited by Grethe Authén Blom, 189–286. Oslo, 1977.

Helmhold, Heidi. "Affect." In Reineke, Röhl, Kapustka, and Weddigen, *Textile Terms*, 19–22.

Helsinger, Howard. "Images on the *Beatus* Page of Some Medieval Psalters." *Art Bulletin* 53, no. 2 (1971): 161–76.

Hencken, H. O'Neill, Gwyneth Harrington, H. L. Movius Jr., A. W. Stelfox, and Geraldine Roche. "Ballinderry Crannog No. 1." *Proceedings of the Royal Irish Academy: Archaeology, Culture, History, Literature* 43 (1935–37): 103–239.

Heng, Geraldine. *The Invention of Race in the European Middle Ages*. Cambridge, 2018.

Henkel, Nikolaus. "Inszenierte Höllenfahrt: Der 'Descensus ad inferos' in geistlichen 'Drama' des Mittelalters." In *Höllen-Fahrten: Geschichte und Aktualität eines Mythos*, edited by Markwart Herzog, 87–108. Stuttgart, 2006.

Henry, Françoise. "The Effects of the Viking Invasions on Irish Art." In *The Impact of the Scandinavian Invasions on the Celtic-Speaking Peoples, c. 800–1100 A.D.: Introductory Papers Read at Plenary Sessions of the International Congress of Celtic Studies held in Dublin, 6–10 July 1959*, edited by Brian Ó Cuív, 61–72. Dublin, 1962.

———. *Irish Art in the Early Christian Period, to 800 A.D.* Rev. ed. London, 1965.

———. *Irish Art in the Romanesque Period, 1020–1170 A.D.* London, 1970.

Henry, Françoise, and G. L. Marsh-Micheli. "A Century of Irish Illumination (1070–1170)." *Proceedings of the Royal Irish Academy: Archaeology, Culture, History, Literature* 62 (1961–63): 101–66.

Hermanns-Auðardóttir, Margrét. "Hringaríkisstíll frá Gaulverjabæ." In *Gersemar og þarfaþing: Úr 130 ára sögu Þjóðminjasafns Íslands*, edited by Árni Björnsson, 234–35. Reykjavík, 1994.

Herren, Michael W., ed. *The Hisperica famina: A New Critical Edition with English Translation and Philological Commentary*. Vol. 1, *The A-Text*. Toronto, 1974.

Hilmo, Maidie. *Medieval Images, Icons, and Illustrated English Literary Texts: From the Ruthwell Cross to the Ellesmere Chaucer*. Burlington, VT, 2004.

Hodne, Lasse. "From Centre to Periphery: The Propagation of the *Virgo virga* Motif and the Case of the 12th Century Høylandet Tapestry." *Il Capitale Culturale: Studies on the Value of Cultural Heritage* 10 (2014): 23–41.

Hoffman, Marta. "Tekstil." In Lidén, Anker, Wichstrøm, and Hoffmann, et al., *Norges kunsthistorie*, Vol 2, 315–49.

Hoftun, Oddgeir, with Gérard Franceschi and Asger Jorn. *Stabkirchen—und die mittelalterliche Gesellschaft Norwegens*. Cologne, 2003.

Hohler, Christopher. "The Cathedral of St. Swithun at Stavanger in the Twelfth Century." *Journal of the British Archaeological Association*, ser. 3, 27 (1964): 92–118.

Hohler, Erla Bergendahl. "The Capitals of Urnes Church and Their Background." *Acta Archaeologica* 46 (1975): 1–60. Reprint. Copenhagen, 1976.

———. *Norwegian Stave Church Sculpture*. 2 vols. Oslo, 1999.

———. "Stavkirkeportaler og deres symbolikk." *Årbok: Foreningen til norske fortidsminnesmerkers bevaring* 149 (1995): 169–90.

———. "Wood-Carving." In Roesdahl and Wilson, *From Viking to Crusader*, 206–7.

———. "Two Wooden Posts Found in Novgorod: A Note on Their Date and Stylistic Connection." *Collegium Medievale* 16 (2003): 37–50.

Holmquist, Hj. "De äldsta urkunderna rörande ärkestiftet Hamburg-Bremen och den nordiska missionen." *Kyrkohistorisk årsskrift* 9 (1908): 241–83.

Holmqvist, Wilhelm. *Övergångstidens metallkonst*. Stockholm, 1963.

———. "Viking Art in the Eleventh Century." *Acta Archaeologica* 22 (1951): 1–56.

Holmsen, Andreas. "Økonomisk og administrativ historie." In *Sogn*, edited by Hans Aall, G. F. Heiberg, Gustav Indrebø, Robert Kloster, and Haakon Shetelig, 39–103. Norske bygder 4. Oslo, 1937.

Hommedal, Alf Tore. "Ei stavkyrkje ved Bergens museum? Om flytteplanane for Hopperstad stavkyrkje." *Årbok for Universitetsmuseet i Bergen*, 2017, 33–42

"Hopperstad Stave Church." NIKU Report 103/2016, doc. no 06/02080–28.

"How the Camel Got Its Hump." *Medieval Manuscripts* blog, British Library. 30 April 2013. https://blogs.bl.uk/digitisedmanuscripts/2013/04/how-the-camel-got-the-hump.html.

Hugh of Fouilloy. *De bestiis*. In *Patrologiae Cursus Completus: Series Latina*. Edited by J.-P. Migne, 177. Paris, 1854.

Hugh of Saint-Victor. *De Institutione*. In *Patrologiae Cursus Completus: Series Latina*. Edited by J.-P. Migne, 176. Paris, 1854.

———. *The "Didascalicon" of Hugh of St. Victor: A Medieval Guide to the Arts*. Translated and edited by Jerome Taylor. 2nd ed. New York, 1968.

Huizinga, Johan. *Homo Ludens: A Study of the Play-Element in Culture*. London, 1949.

Hødnebø, Finn, ed. *Bergens kalvskinn: AM 329 fol. i Norges Riksarkiv*. Oslo, 1989.

———. "Innledning." In *Norges kongesagaer*, edited by Finn Hødnebø and Hallvard Magerøy, ix–xxi. Oslo, 1979.

Imer, Lisbeth. "Rune Stones in Context 2011." Nationalmuseet, Jellingprojektet. http://jelling.natmus.dk/en/about-the-project/sub-projects/rune-stones-in-context-2011/.

Indrebø, Gustav, ed. *Gamal norsk homiliebok: Cod.AM. 619 4°*. Oslo, 1966.

Isidore of Seville. *The "Etymologies" of Isidore of Seville*. Translated by Stephen A. Barney, W. J. Lewis, J. A. Beach, and Oliver Berghof. Cambridge, 2006.

Iversen, Frode. "Var middelalderens lendmannsgårder kjerner i eldre godssamlinger?: En analyse av romlig organisering av graver og eiendomsstruktur i Hordaland og Sogn og Fjordane." MA thesis, University of Bergen 1997.

———. *Var middelalderens lendmannsgårder kjerner i eldre godssamlinger? En analyse av romlig organisering av graver og eiendomsstruktur i Hordaland og Sogn og Fjordane*. Bergen, 1999.

Jacoby, Zehava. "The Beard Pullers in Romanesque Art: An Islamic Motif and Its Evolution in the West." *Arte medievale*, ser. 2, 1 (1987): 65–85.

Jakobsson, Ármann. "Beast and Man: Realism and the Occult in *Egils saga*." *Scandinavian Studies* 83, no. 1 (2011): 29–44.

Jakobsson, Sverrir. "Saracen Sensibilities: Muslims and Otherness in Medieval Saga Literature." *Journal of English and Germanic Philology* 115, no. 2 (2016): 213–38.

Janosik, Daniel J. *John of Damascus, First Apologist to the Muslims: The Trinity and Christian Apologetics in the Early Islamic Period*. Eugene, OR, 2016.

Jensen, Kurt Villads. *Crusading at the Edges of Europe: Denmark and Portugal, c. 1000–c. 1250*. London, 2017.

———. "Crusading at the End of the World: The Spread of the Idea of Jerusalem after 1099 to the Baltic Sea Area and to the Iberian Peninsula." In *Crusading on the Edge: Ideas and Practice of Crusading in Iberia and the Baltic Region, 1100–1500*, edited by Torben K. Nielsen and Iben Fonnesberg-Schmidt, 153–76. Turnhout, 2016.

Jensenius, Jørgen H. "Trekirkene før stavkirkene: En undersøkelse av planlegging og design av kirker før ca år 1100." PhD diss., AHO, Oslo, 2001.

———. "Var det krav om høye stenkirker i middelalderen?" *Viking* 60 (1997): 85–94.

———. "Viking and Medieval Wooden Churches in Norway as Described in Contemporary Texts." In Khodakovsky and Lexau, *Historic Wooden Architecture in Europe and Russia*, 56–67.

Johannessen, Ole-Jørgen. *Bergens kalvskinn*. Oslo, 2016.

Johnson, Ruth. *Viking Age Dublin*. Dublin, 2004.

Jones, Annette. "Portals to the Past: Distribution Patterns in Stave Church Inscriptions." Preprints to the 7th International Symposium on Runes and Runic Inscriptions, Oslo 2010, 1–8. https://www.khm.uio.no/english/research/publications/7th-symposium-preprints/.

Jordan, William Chester. "Salome in the Middle Ages." In "Essays in Honor of Kenneth Stow," special issue, *Jewish History* 26, nos. 1–2 (2012): 5–15.

Jónsdóttir, Selma. *An 11th Century Byzantine Last Judgement in Iceland*. Reykjavík, 1959.

Júlíúsdóttir, Sigríður. "The Oldest Churches in Norway." In *Church Centres: Church Centres in Iceland from the 11th to the 13th Century and Their Parallels in Other Countries*, edited by Helgi Þorláksson, 187–200. Reykholt 2005.

Jung, Wilhelm. *Die ehemalige Prämonstratenser-Stiftskirche Knechtsteden*. Düsseldorf, 1956.

Jørgensen, Hans Henrik Lohfert, Henning Laugerud, and Laura Katrine Skinnebach, eds. *The Saturated Sensorium: Principles of Perception and Mediation in the Middle Ages*. Aarhus, 2015.

Kahn, Deborah. *Canterbury Cathedral and Its Romanesque Sculpture*. London 1991.

Kapitaikin, Lev. "The Paintings of the Aisle-Ceilings of the Cappella Palatina, Palermo." *Römisches Jahrbuch der Bibliotheca Hertziana* 35 (2003–4): 115–48.

Karlsen, Espen. "The Collection of Latin Fragments in the National Archives of Norway." In *The Beginning of Nordic Scribal Culture, ca.1050–1300: Report from a Workshop on Parchment Fragments, Bergen 28–30 October 2005*, edited by Åslaug Ommundsen, 17–22. Bergen 2006.

———. "Introduction." In *Latin Manuscripts of Medieval Norway: Studies in Memory of Lilly Gjerløw*, edited by Espen Karlsen, 13–26. Oslo, 2013.

Karlsson, Lennart. *Nordisk form: Om djurornamentik*. Stockholm, 1976.

———. *Romansk träornamantik i Sverige = Decorative Romanesque Woodcarving in Sweden*. Stockholm, 1976.

Kaspersen, Søren. "Døbefonte og 'statsdannelse': Refleksioner over de jyske dobbeltløvefonte." In *Ecce Leones! Om djur och odjur i bildkonsten*, edited by Lars Berggren and Annette Landen, 61–113. Lund, 2018.

Katzenellenbogen, Adolf. "The Central Tympanum at Vézelay: Its Encyclopedic Meaning and Its Relation to the First Crusade." *Art Bulletin* 26, no. 3 (1944): 141–51.

Katznelson, Ira, and Miri Rubin. "Introduction." In *Religious Conversion: History, Experience and Meaning*, edited by Ira Katznelson and Miri Rubin, 1–30. Farnham, UK, 2014.

Kauffmann, C. M. *Romanesque Manuscripts, 1066–1190*, A Survey of Manuscripts Illuminated in the British Isles 3. London, 1975.

Kay, Sara. *Animal Skins and the Reading Self in Medieval Latin and French Bestiaries*. Chicago, 2017.

Keating, Geoffrey. *The History of Ireland*. Vol. 3, *Containing the Second Book of the History*. Edited and translated by Patrick S. Dinneen. London, 1908.

Kendall, Calvin B. *The Allegory of the Church: Romanesque Church Portals and Their Verse Inscriptions*. Toronto, 1998.

Kendrick, T. D. *Late Saxon and Viking Art*. London, 1949.

Keynes, Simon, and Rory Naismith. "The *Agnus Dei* Pennies of King Æthelred the Unready." *Anglo-Saxon England* 40 (2012): 175–223.

Keyser, Rudolf. "Bidrag til Kong Sigurd Jorsalfarers Historie." In *Samlinger til det norske folks sprog og historie*. Vol. 1. Christiania, 1833.

Khodakovsky, Evgeny, and Siri Skjold Lexau, eds. *Historical Wooden Architecture in Europe and Russia: Evidence, Study and Restoration*. Basel, 2015.

Kielland, Jens Z. M. "Undersøgelser ved Urnæs, Undredal, Gaupne og Røldal kirker: Samt iagttagelser paa en reise gjennem Valdres." *Aarsberetning: Foreningen til norske fortidsminnesmerkers bevaring*, 1902 (1903): 158–201.

Kilger, Christoph. "Kaupang from Afar: Aspects of the Interpretation of Dirham Finds in Northern and Eastern Europe between the Late 8th and Early 10th Centuries." In *Means of Exchange: Dealing with Silver in the Viking Age*, edited by Dagfinn Skre, 199–252. Aarhus, 2007.

Kirmeier, Josef, Bernd Schneidmüller, Stefan Weinfurter, and Evamaria Brockhoff, eds. *Kaiser Heinrich II: 1002–1024*. Augsburg, 2002.

Kitzinger, Ernst. "Interlace and Icons: Form and Function in Early Insular Art." In *The Age of Migrating Ideas: Early Medieval Art in Northern Britain and Ireland; Proceedings of the Second international Conference on Insular Art Held in the National Museums of Scotland and in Edinburgh, 3–6 January 1991*, edited by Michael R. Spearman and John Higgitt, 3–15. Edinburgh, 1993.

Kleingärtner, Sunhild, and Gareth Williams. "Contacts and Exchange." In *Vikings: Life and Legend*, edited by Gareth Williams, Peter Pentz, and Matthias Wemhoff, 30–68. Ithaca, NY, 2014.

Klingender, Francis. *Animals in Art and Thought to the End of the Middle Ages*. Edited by Evelyn Antal and John Harthan. London, 1971.

Klæsøe, Iben Skibsted. "Hvordan de blev til: Vikingetidens stilgrupper fra Broa til Urnes." *Hikuin* 29 (2002): 75–104.

Knagenhjelm, Christoffer. "Kaupanger i Sogn: Etablering, vekst og bydannelse." In *De første 200 årene: Nytt blikk på 27 skandinaviske middelalderbyer*, edited by Hans Andersson, Gitte Hansen, and Ingvild Øye, 57–71. Bergen, 2008.

Kolchin, B. A. *Wooden Artefacts from Medieval Novgorod*. Oxford, 1989.

Kozachek, Thomas Davies. "The Repertory of Chant for Dedicating Churches in the Middle Ages: Music, Liturgy, and Ritual." PhD diss., Harvard University, 1995.

Krag, Anne Hedeager. "Oriental and Byzantine Silks in St Cnut's Reliquary Shrine." In *Life and Cult of Cnut the Holy: The First Royal Saint of Denmark; Report from an Interdisciplinary Research Seminar in Odense, November 6th to 7th 2017*, edited by Steffen Hope, Mikael Manøe Bjerregaard, Anne Hedeager Krag, and Mads Runge, 42–49. Odense, 2019.

Kristjánsdóttir, Þóra. "Islandsk kirkekunst." In *Kirkja ok Kirkjuskrud: Kirker og Kirkekunst på Island og i Norge i middelalderen*, edited by Lilja Árnadóttir and Ketil Kiran, 53–60. Oslo, 1997.

———. "A Nocturnal Wake at Hólar: The Judgement Day Panels as Possible Explanation for a Miracle Legend?" In Gunnell and Lassen, *Nordic Apocalypse*, 221–31.

Kristoffersen, Siv. "Half Beast–Half Man: Hybrid Figures in Animal Art." *World Archaeology* 42, no. 2 (2010): 261–72.

Krogh, Knud J. "Bygdernes kirker: Kirkerne i de middelalderlige, norrøne grønlandske bygder." *Tidsskriftet Grønland* 8–9 (1982): 263–74.

———. *Erik den Rødes Grønland*. Copenhagen, 1982.

———. *Gåden om Kong Gorms grav: Historien om Nordhøjen i Jelling*. Herning, 1993.

———. "Kirkene på Urnes." *Aarbøger for nordisk oldkyndighed og historie*, 1971, 146–94.

———. "The Royal Viking-Age Monuments at Jelling in the Light of Recent Archaeological Excavations: A Preliminary Report." *Acta Archaeologica* 53 (1983): 183–216.

———. *Urnesstilens kirke: Forgængeren for den nuværende kirke på Urnes*. Oslo, 2011.

Krogh, Knud J., and Olfert Voss. "Fra hedenskab til kristendom i Hørning: En vikingetids kammergrav og en trækirke fra 1000tallet under Hørning kirke." *Nationalmuseets Arbejdsmark*, 1961, 5–34.

Kröll, Karola. "Eine wikingerzeitliche Stabkirche in Südjütland? Studien zu einem verzierten Eichenbalken aus Humptrup, Kreis Nordfriesland." *Offa* 56 (1999): 421–79.

Kruger, Kathryn Sullivan. *Weaving the Word: The Metaphorics of Weaving and Female Textual Production*. Selinsgrove, PA, 2001.

Kulturhistorisk leksikon for nordisk middelalder: Fra vikingetid til reformationstid. 22 vols. Copenhagen, 1956–78. Reprint. Copenhagen, 1980–82.

Kure, Henning. "Hanging in the World Tree." In *Old Norse Religion in Long-Term Perspectives: Origins, Changes, and Interactions; An International Conference Held in Lund, Sweden, June 3–7, 2004*, edited by Anders Andrén, Kristina Jennbert, and Catharina Raudvere, 68–71. Lund, 2006.

Kusch, Eugen. *Ancient Art in Scandinavia*. Nuremberg, 1965.

Laberg, Jon. *Hafslo: Bygd og ætter*. Bergen, 1926.

Lager, Linn. "Art as a Medium in Defining 'Us' and 'Them': The Ornamentation on Runestones in Relation to the Question of 'Europeanisation.'" In *The European Frontier: Clashes and Compromises in the Middle Ages; International Symposium of the Culture Clash or Compromise (CCC) Project and the Department of Archaeology, Lund University, Held in Lund October 13–15 2000*, edited by Jörn Staecker, 147–55. Lund, 2004.

Lagerlöf, Erland. "Bysantinsk måleri från en gotländsk stavkyrka." In *Den ljusa medeltiden: Studier tillägnade Aron Andersson*, edited by Lennart Karlsson et al., 123–32. Stockholm, 1984.

———. "De bysantinska målningarna från Sundre kyrka." In *Gotlandia irredenta: Festschrift für Gunnar Svahnström zu seinem 75. Geburtstag*, edited by Robert Bohn, 143–51. Sigmaringen, 1990.

———. *Medeltida träkyrkor II*. Stockholm, 1985.

Lagerlöf, Erland, and Bengt Stolt. *Eke kyrka*. Stockholm, 1974.

———. *Stånga kyrka*. Stockholm, 1968.

Laksdøla saga. Translated by Fr. Bie. Kristiania, 1924.

Landes, Joan B., Paula Young Lee, and Paul Youngquist, eds. *Gorgeous Beasts: Animal Bodies in Historical Perspective*. University Park, PA, 2012.

Lang, James. "Eleventh-Century Style in Decorated Wood from Dublin." In Ryan, *Ireland and Insular Art*, 174–78.

———. *Viking-Age Decorated Wood: A Study of Its Ornament and Style*, Medieval Dublin Excavations 1962–81, Series B. Vol. 1. Dublin, 1988.

Langberg, Harald. *Stavkirker: En hilsen til Norge i anledning af rigsjubilæet 872–1972*. Copenhagen, 1972.

Lange, Wolfgang. *Studien zur christlichen Dichtung der Nordgermanen, 1000–1200*. Göttingen, 1958.

Larson, Laurence M. *The Earliest Norwegian Laws: Being the Gulathing Law and the Frostathing Law*. New York, 1935.

Laxdæla saga. Translated by Muriel A. C. Press. Project Gutenberg e-book, 2006. https://www.gutenberg.org/files/17803/17803-h/17803-h.htm.

Leask, Harold. *Irish Churches and Monastic Buildings*. Vol. 1, *The First Phases and the Romanesque*. Dundalk, 1955.

Leith, M. C. J., trans. *Stories of the Bishops of Iceland*. London, 1895.

Lending, Mari. "Traveling Portals." In *Place and Displacement: Exhibiting Architecture*, edited by Thordis Arrhenius, Mari Lending, Wallis Miller, and Jérémie Michael McGowan, 197–212. Zurich, 2014.

Lexow, Einar. *Norske glassmalerier fra laugstiden*. Oslo, 1938.

Lia, Vibeke. "Ornes i Luster: En arkeologisk landskapsanalyse med punktundersøkelser i innmark." MA thesis, University of Bergen, 2005.

Lidén, Hans-Emil, ed. *Møtet mellom hedendom og kristendom i Norge*. Oslo, 1995.

———. *Nicolay Nicolaysen: Et blad av norsk kulturminneverns historie*. Oslo 2005.

———. "The Predecessors of the Stave Church of Kaupanger." In *The Stave Churches of Kaupanger: The Present Church and Its Predecessors*, edited by Kristian Bjerknes and Hans-Emil Lidén, 9–46. Translated by Elisabeth Tschudi-Madsen. Oslo, 1975.

Lidén, Hans-Emil, Peter Anker, Anne Wichstrøm, Marta Hoffmann et al., eds. *Norges kunsthistorie*. Vol. 2, *Høymiddelalder og Hansa-tid*. Oslo, 1981.

Lie, Hallvard. "Heimskringla." in *Kulturhistorisk leksikon for nordisk middelalder fra vikingetid til reformationstid*. 2nd ed. Viborg, 1981.

Liebgott, Niels-Knud. *Middelalderens emaljekunst*. Copenhagen, 1986.

Liepe, Lena. "Om stil och betydelse i romansk stenskulptur." In Vellev, *2. Skandinaviske symposium om romanske stenarbejder*, 161–76.

Limor, Ora, and Guy G. Strousma, eds. *Contra Iudaeos: Ancient and Medieval Polemics between Christians and Jews*. Tübingen, 1996.

Lindkvist, Evert. *Gotlands romanska stenskulptur: Visuella budskap i sten*. Burksvik, 2015.

Lindow, John. *Norse Mythology: A Guide to the Gods, Heroes, Rituals, and Beliefs*. Oxford, 2001.

Lindqvist, Sune. "Den stora Jellingestenen." *Årsbok: Kungliga humanistiska vetenskaps-Samfundet i Uppsala*, 1952, 197–214.

Lipton, Sara. *Dark Mirror: The Medieval Origins of Anti-Jewish Iconography*. New York, 2014.

Ljung, Cecilia. "Early Christian Grave Monuments and Ecclesiastical Developments in 11th-Century Sweden." *Medieval Archaeology* 63, no. 1 (2019): 154–90.

———. "Under runristad häll: Tidigkristna gravmonument i 1000-talets Sverige." *Stockholm Studies in Archaeology* 67, nos. 1–2 (2016).

Loftsgarden, Kjetil. "Marknadsplasser omkring Hardangervidda: Ein arkeologisk og historisk analyse av innlandets økonomi og nettverk i vikingtid og mellomalder." PhD diss., University of Bergen, 2017.

Lucas, Peter J., and Angela M. Lucas. *Anglo-Saxon Manuscripts in Microfiche Facsimile*. Vol. 18, *Manuscripts in France*. Binghamton, NY, 2012.

Lyngstrøm, Henriette. "Farverige vikinger." In Lyngstrøm, *Farverige vikinger*, 1–19.

———, ed. *Farverige vikinger: Studier i teknologi og kultur 4*. Copenhagen, 2018.

———. "Kongehallen i Lejre: Overvejelser om forsøg med vikingetidens bemalede træoverflader." In Lyngstrøm, *Farverige vikinger*, 109–20.

Macalister, R. A. S. *Corpus Inscriptionum Insularum Celticarum*. Vol. 1. Dublin, 1945.

———. *Ecclesiastical Vestments: Their Development and History*. London, 1896.

———. "Further Notes on the Runic Inscription in Killaloe Cathedral." *Proceedings of the Royal Irish Academy: Archaeology, Culture, History, Literature* 38 (1928–29): 236–39.

———. "On a Runic Inscription at Killaloe Cathedral." *Proceedings of the Royal Irish Academy: Archaeology, Culture, History, Literature* 33 (1916–17): 493–98.

Macardle, Peter. *The St Gall Passion Play: Music and Performance*. Amsterdam, 2007.

Maciejewski, Jacek. "*Nudo pede intrat urbem*: Research on the *Adventus* of a Medieval Bishop through the First Half of the Twelfth Century." *Viator* 41, no. 1 (2010): 89–100.

MacKenzie, John M. *Orientalism: History, Theory, and the Arts*. Manchester, 1995.

MacLysaght, Edward. *The Surnames of Ireland*. 6th ed. Dublin, 1985.

Magerøy, Ellen Marie. "'Biskopen' i Urnes stavkirke." *Årbok: Foreningen til norske fortidsminnesmerkers bevaring* 126 (1971): 13–24.

———. "Flatatunga Problems." *Acta Archaeologica* 32 (1961): 153–72.

———. "Tilene fra Mödrufell i Eyjafjord." *Viking* 17 (1953): 43–62.

Magerøy, Ellen Marie, and Håkon Christie. "Dómsdagur og helgir menn á Hólum: Bokanmeldelse." *Årbok: Foreningen til norske fortidsminnesmerkers bevaring* 144 (1990): 227–32.

Magerøy, Halvard. "Urnes stavkyrkje, Ornes-ætta og Ornes-godset." *Historisk tidsskrift* 67, no. 2 (1988): 121–44.

Magnell, Steinar. "De første kirkene i Norge: kirkebyggingen og kirkebyggere før 1100-tallet." MA thesis, University of Oslo, 2009.

Maguire, Henry. "The Asymmetry of Text and Image in Byzantium." *Perspectives médiévales: Revue d'épistémologie des langues et littératures du Moyen Âge* 38 (2017). https://journals.openedition.org/peme/12218.

———. "The Depiction of Sorrow in Middle Byzantine Art." *Dumbarton Oaks Papers* 31 (1977): 123–74.

Maixner, Birgit. "*Sæheimr: Just a Settlement by the Sea? Dating, Naming Motivation and Function of an Iron Age

Maritime Place Name in Scandinavia." *Journal of Maritime Archaeology* 15, no. 1 (2020): 5–39.

Malik, Barbara. "Relikty przedrománskiej decoracji plecionkowej na Wawelu." *Studia Waweliana* 9–10 (2000–2001): 195–204.

Manning, Con [Conleth]. "A Puzzle in Stone: The Cathedral at Glendalough." *Archaeology Ireland* 16, no. 2 (2002): 18–21.

———. "References to Church Buildings in the Annals." In Smyth, *Seanchas*, 37–52.

Marchand, James W. "Two Notes on the Old Icelandic Physiologus Manuscript." *MLN* 91, no. 3 (1976): 501–5.

Mariu saga: Legender om jomfru Maria og hendes jertegn. Edited by C. R. Unger. Kristiana, 1871.

Marold, Edith. "Das Gottesbild der christlichen Skaldik." In *The Sixth International Saga Conference, 28.7–28.8 1985: Workshop Papers I–II*, edited by Jonna Louis-Jensen, Christopher Sanders, and Peter Springborg, 717–49. Copenhagen, 1985.

Marumsrud, Hans, and Kristen Aamodt. "Nore og Uvdal Stavkirker: Tømmerkvaliteter og materialframstilling." Unpublished report, in the library, Riksantikvaren. Oslo, 2002.

Mathers-Lawrence, Anne. "The Augustinian Canons in Northumbria: Region, Tradition, and Textuality in a Colonizing Order." In Burton and Stöber, *Regular Canons in the Medieval British Isles*, 59–78.

Mayo, Penelope C. "The Crusaders under the Palm: Allegorical Plants and Cosmic Kingship in the *Liber Floridus*." *Dumbarton Oaks Papers* 27 (1973): 29–67.

Mágnússon, Þór. "Hringaríkisútskurður frá Gaulverjabæ." *Árbók hins íslenzka fornleifafélags* 71 (1974): 63–74. https://timarit.is/page/2053926#page/n55/mode/2up.

McDonnell, Ernest W. "The *Vita Apostolica*: Diversity or Dissent." *Church History* 24, no. 1 (1955): 15–31.

McManus, Damian. *A Guide to Ogam*. Maynooth, 1997.

McNeill, John. "*Veteres statuas emit Rome*: Romanesque Attitudes to the Past." In McNeill and Plant, *Romanesque and the Past*, 1–24.

McNeill, John, and Richard Plant, eds. *Romanesque and the Past: Retrospection in the Art and Architecture of Romanesque Europe*. Leeds, 2013.

McNeill, John T., and Helena M. Gamer. *Medieval Handbooks of Penance: A Translation of the Principal "Libri poenitentiales" and Selections from Related Documents*. New York, 1938.

Meehan, Bernard. *The Book of Kells*. New York, 2012.

———. "New Narrative Scenes in the Book of Kells." In *Making Histories: Proceedings of the Sixth International Conference on Insular Art, York 2011*, edited by Jane Hawkes, 242–45. Donington, 2013.

Mellinkoff, Ruth. "Riding Backwards: Theme of Humiliation and Symbol of Evil." *Viator* 4 (1973): 153–76.

Michelli, Perette E. "The Inscriptions on Pre-Norman Reliquaries." *Proceedings of the Royal Irish Academy: Archaeology, Culture, History, Literature* 96C, no. 1 (1996): 1–48.

Mikkelsen, Egil. "Islam and Scandinavia during the Viking Age." In *Byzantium and Islam in Scandinavia: Acts of a Symposium at Uppsala University June 15–16 1996*, edited by Elisabeth Piltz, 39–51. Jonsered, 1998.

Miller, Maureen C. *Clothing the Clergy: Virtue and Power in Medieval Europe, c. 800–1200*. Ithaca, NY, 2014.

Mittman, Asa Simon. "Are the 'Monstrous Races' Races?" *Postmedieval: A Journal of Medieval Cultural Studies* 6 (2015): 36–51.

Moe, Ole Henrik. "Urnes and the British Isles: A Study of Western Impulses in Nordic Styles of the 11th Century." *Acta Archaeologica* 26 (1955): 1–30.

Moltke, Erik. *Runes and Their Origin: Denmark and Elsewhere*. Copenhagen, 1985.

Morkinskinna: The Earliest Icelandic Chronicle of the Norwegian Kings (1030–1157). Translated by Theodore M. Andersson and Kari Ellen Gade. Ithaca, NY, 2000.

Morris, Leon. *The Gospel According to Matthew*. Grand Rapids, MI, 1992.

Morris, Richard. "'Calami et iunci': Lastingham in the Seventh and Eighth Centuries." *Bulletin of International Medieval Research* 11 (2005): 3–21.

Morrison, Elizabeth, with Larisa Grollemond, eds. *Book of Beasts: The Bestiary in the Medieval World*. Los Angeles, 2019.

Morsbach, Peter. *St. Emmeram zu Regensburg: Ehem. Benediktiner-Abteikirche*. Regensburg, 1993.

Mortensen, Lars Boje. "The Anchin Manuscript of *Passio Olaui* (Douai 295), William of Jumièges, and Theodoricus Monachus, New Evidence for Intellectual Relations between Norway and France in the 12th Century." *Symbolae Osloenses* 75 (2000): 165–89.

Mortet, Victor, and Paul Deschamps, eds. *Recueil de textes relatifs à l'histoire de l'architecture et à la condition des architectes en France, au Moyen-Âge, XIIe–XIIIe siècles*. Vol. 2. Paris, 1929.

Moss, Rachel, ed. *Art and Architecture of Ireland*. Vol. 1, *Medieval, c. 400–c. 1600*. Dublin, 2014.

———. "The Old Portal and Cathedral of Kilmore." *Breifne* 12, no. 46 (2011): 203–36.

Mowinckel, Rolf. "De eldste norske stavkirker." *Universitetets Oldsaksamlings skrifter* 2 (1929): 383–424.

———. *Vor nationale billedkunst i middelalderen*. Oslo, 1926.

Muhl, Arnold. "Der Bamberger und der Camminer Schrein: Zwei im Mammenstil verzierte Prunkkästchen der Wikingerzeit." *Offa* 47 (1990): 241–420.

Müller-Wille, Michael. "Der frühmittelalterliche Schmied im Spiegel skandinavischer Grabfunde." *Frühmittelalterliche Studien* 11 (1977): 127–201.

Munch, Peter Andreas. *Registrum prædiorum et redituum ad ecclesias diocesis Bergensis sæculo P.C. de XIVto pertinentium, vulgo dictum "Bergens kalvskind" (Björgynjar kálfskinn)*. Christiania, 1843.

Munch, Peter Andreas, and Rudolf Keyser, eds. *Norges gamle Love indtil 1387*. Vol. 1, *Norges Love ældre end Kong Magnus Haakonssøns Regjerings-Tiltrædelse i 1263*. Christiania, 1846.

Mundal, Else. "Kristusframstillinga i den tidlege norrøne diktinga." In Lidén, *Møtet mellom hedendom og kristendom i Norge*, 255–68.

Murphy, G. Ronald. *Tree of Salvation: Yggdrasil and the Cross in the North*. Oxford, 2013.

Murray, Griffin. "The Arm-Shaped Reliquary of St Lachtin: Technique, Style and Significance." In *Irish Art Historical Studies in Honour of Peter Harbison*, edited by Colum Hourihane, 141–64. Dublin, 2004.

———. "The Art of Politics: The Cross of Cong and the Hiberno-Urnes Style." In Clarke and Johnson, *Vikings in Ireland and Beyond*, 416–37.

———. "The Bearnán Chúláin Bell-Shrine from Glenkeen, Co. Tipperary: An Archaeological and Historical Analysis." *Journal of the Cork Historical and Archaeological Society*, ser. 2, 121 (2016): 19–27.

———. "The Breac Maodhóg: A Unique Medieval Irish Reliquary." In *Cavan: History and Society; Interdisciplinary Essays on the History of an Irish County*, edited by Jonathan Cherry and Brendan Scott, 83–125. Dublin, 2014.

———. "Changing Attitudes to Viking Art in Medieval Ireland." In *Viking Encounters: Proceedings of the Eighteenth Viking Congress, Denmark, August 6–12, 2017*, edited by Anne Pedersen and Søren M. Sindbæk, 426–34. Aarhus, 2020.

———. *The Cross of Cong: A Masterpiece of Medieval Irish Art*. Dublin, 2014.

———. "Early Medieval Shrine Fragments from Park North Cave, Co. Cork and Kilgreany Cave, Co. Waterford." In *Underground Archaeology: Studies on Human Bones and Artefacts from Ireland's Caves*, edited by Marion Dowd, 150–58. Oxford, 2016.

———. "The Makers of Church Metalwork in Early Medieval Ireland: Their Identity and Status." In *Making Histories: Proceedings of the Sixth International Conference on Insular Art, York 2011*, edited by Jane Hawkes, 162–73. Donington, 2013.

———. "Thorgrim, the Killaloe Cross, and the Norwegian Campaign in Ireland in 1102–1103." *Peritia* 30 (2019): 237–42.

———. "Viking Influence in Insular Art: Considering Identity in Early Medieval Ireland." In *Peopling Insular Art: Practice, Performance, Perception*, edited by Cynthia Thickpenny, Katherine Forsyth, Jane Geddes, and Kathe Matthis, 51–57. Oxford, 2020.

Murray, Hilary. *Viking and Early Medieval Buildings in Dublin: A Study of the Buildings Excavated under the Direction of A. B. Ó Ríordáin in High Street, Winetavern Street and Christchurch Place, Dublin, 1962–63, 1967–76*. Oxford, 1983.

Myking, Synnøve. "The Universal and the Local: Religious Houses as Cultural Nodal Points in Medieval Norway." In *Foreigners and Outside Influences in Medieval Norway*, edited by Stian Suppersberger Hamre, 75–95. Oxford, 2017.

Møller, Elna, and Olaf Olsen. "Danske trækirker." *Nationalmuseets Arbejdsmark*, 1961, 35–58.

Mårtensson, Anders W. "Stavkyrkor i Lund." *Hikuin* 9 (1983): 143–62.

Nadolny, Jilleen, with Kaja Kollandsrud, Marie Louis Sauerberg, and Tine Frøysaker, eds. *Medieval Painting in Northern Europe: Techniques, Analysis, Art History; Studies in Commemoration of the 70th Birthday of Unn Plahter*. London, 2006. Reprint. 2007.

Nayrolles, Jean. *L'invention de l'art roman à l'époque moderne (XVIIIe–XIXe siècles)*. Rennes, 2005.

Nedkvitne, Arnved. "Hunting." In *Medieval Scandinavia: An Encyclopedia*, edited by Phillip Pulsiano and Kirsten Wolf, 307–8. New York, 1993.

Neumann, Jacob. "Bemærkninger paa en Reise i Sogn og Søndfjord 1823." *Budstikken* (1824): 84–90.

Neuss, Wilhelm. *Die katalanische Bibelillustration um die Wende des ersten Jahrtausends und die altspanische Buchmalerei: Eine neue Quelle zur Geschichte des Auslebens der altchristlichen Kunst in Spanien und zur frühmittelalterlichen Stilgeschichte*. Bonn, 1922.

Nicolaysen, Nicolay. *Mindesmerker af middelalderens kunst i Norge*. Christiania, 1854–55.

———. *Norske bygninger fra fortiden*. Christiania, 1859.

———. "Om hov og stavkirker." *Historisk tidsskrift*, ser. 2, 6 (1888): 265–305.

———. *The Viking-Ship Discovered at Gokstad in Norway*. Christiania, 1882.

Ní Ghrádaigh, Jenifer. "'But What Exactly Did She Give?' Derbforgaill and the Nuns' Church at Clonmacnoise." In *Clonmacnoise Studies*, vol. 2, *Seminar Papers, 1998*, edited by Heather A. King, 175–207. Dublin, 2003.

———. "The Occluded Role of Royal Women and Lost Works of Pre-Norman English and Irish Art (Tenth to Twelfth Centuries)." *Journal of Medieval History* 42, no. 1 (2016): 51–75.

Ní Mhaonaigh, Máire. *Brian Boru: Ireland's Greatest King?* Stroud, 2007.

Nockert, Margareta. "Textilkonsten." *Signums svenska konsthistoria* 2 (1995): 336–55.

Nockert, Margareta, and Göran Possnert. *Att datera textilier*. Hedemora, 2002.

Nordby, Ole-Albert Rønning. "The Judicial Oath in Medieval Norway: Compurgation, Community and Knowledge in the Thirteenth Century." PhD diss., University of Oslo, 2018.

Nordeide, Sæbjørg Walaker. "Cross Monuments in North-Western Europe." *Zeitschrift für Archäologie des Mittelalters* 37 (2009): 163–78.

———. *The Viking Age as a Period of Religious Transformation: The Christianization of Norway from AD 560–1150/1200*. Turnhout, 2011.

Nordrumshaugen, Stig. "Stavkyrkja på Rinde i Feios." In *Rinde kyrkjestad: Feios kyrkje 150 år*, edited by Jan Magne Borlaug Rinde, 59–93. Feios, 2016.

Nordstrom, Fölke. *Medieval Baptismal Fonts: An Iconographical Study*. Umeå, 1984.

Norrman, Lena Elisabeth. *Viking Women: The Narrative Voice in Woven Tapestries*. Amherst, NY, 2008.

Norske mellomalderballadar: Riddarballadar 2 (TSB D). Edited by Velle Espeland et al. Oslo, 2016.

Norton, Christopher. "Viewing the Bayeux Tapestry, Now and Then." *Journal of the British Archaeological Association* 172, no. 1 (2019): 52–89.

Nyberg, Tore. *Monasticism in North-Western Europe, 800–1200*. Aldershot, UK, 2000.

Nødseth, Ingrid Lunnan. "Bildentekstilet; et tapt antependium fra norsk middelalder?" *Årbok: Foreningen til norske fortidsminnesmerkers bevaring* 167 (2013): 225–36.

———. "Clothing the Sacred: Ecclesiastical Textiles from Late Medieval Scandinavia." PhD diss., Norwegian University of Science and Technology, 2020.

Ó Carragáin, Tomás. *Churches in Early Medieval Ireland: Architecture, Ritual, and Memory*. New Haven, CT, 2010.

———. "Rebuilding the 'City of Angels': Muirchertach Ua Briain and Glendalough, c. 1096–1111." In Sheehan and Ó Corráin, *Viking Age*, 258–70.

Ó Corráin, Donnchadh. *Ireland before the Normans*. Dublin, 1972.

O'Donovan, Edmond. "Broad Street/George's Quay/Abbey River, Limerick." In *Excavations 1999: Summary Accounts of Archaeological Excavations in Ireland*, edited by Isabel Bennett, 169–71. Bray, 2000.

Oehrl, Sigmund. *Vierbeinerdarstellungen auf schwedischen Runensteinen: Studien zur nordgermanischen Tier- und Fesselungsikonographie*. Berlin, 2010.

———. *Zur Deutung anthropomorpher und theriomorpher Bilddarstellungen auf den spätwikingerzeitlichen Runensteinen Schwedens*. Vienna, 2006.

Ó Floinn, Raghnall. "Appendix A: Decorative Sword Sheaths." In Esther A. Cameron, *Scabbards and Sheaths from Viking and Medieval Dublin*, 139–40. Dublin, 2007.

———. "Irish and Scandinavian Art in the Early Medieval Period." In *The Vikings in Ireland*, edited by Anne-Christine Larsen, 87–97. Roskilde, 2001.

———. "Iron Bell of St. Patrick and Its Shrine." In Ryan, *Treasures of Ireland*, 167–68.

———. "The Lismore Crozier." in Ryan, *Treasures of Ireland*, 170–71.

———. "Schools of Metalworking in Eleventh- and Twelfth-Century Ireland." In Ryan, *Ireland and Insular Art*, 179–87.

———. "Sword Hilt." in Roesdahl and Wilson, *From Viking to Crusader*, 340.

———. "Viking and Romanesque Influence 1000 AD–1169 AD." in Ryan, *Treasures of Ireland*, 58–69.

Oftestad, Eivor Andersen, and Kristin Bliksrud Aavitsland. "Minnekultur." In *Å minnes de døde: Døden og de døde i Norge etter Reformasjonen*, edited by Tarald Rasmussen, 69–90. Oslo, 2019.

O'Keeffe, Tadhg. "Diarmait Mac Murchada and Romanesque Leinster: Four Twelfth-Century Churches in Context." *Journal of the Royal Society of Antiquaries of Ireland* 127 (1997): 52–79.

———. *Romanesque Ireland: Architecture and Ideology in the Twelfth Century*. Dublin, 2003.

———. "The Romanesque Portal at Clonfert Cathedral and Its Iconography." In *From the Isles of the North: Early Medieval Art in Ireland and Britain; Proceedings of the Third International Conference on Insular Art Held in the Ulster Museum, Belfast, 7–11 April, 1994*, edited by Cormac Bourke, 261–70. Belfast, 1995.

O'Kelly, Michael J. "Church Island near Valencia, Co. Kerry." *Proceedings of the Royal Irish Academy: Archaeology, Culture, History, Literature* 59 (1957–59): 57–136.

O'Kelly, Michael J., with Séamus Kavanagh. "An Island Settlement at Beginish, Co. Kerry." *Proceedings of the Royal Irish Academy: Archaeology, Culture, History, Literature* 57 (1955–56): 159–94.

Olsen, Magnus. *Norges innskrifter med de yngre runer*. Vol. 1, *Østfold fylke, Akershus fylke og Oslo, Hedmark fylke, Opland fylke*. Oslo, 1941.

———. "Runic Inscriptions in Great Britain, Ireland and the Isle of Man." In Alexander O. Curle, Magnus Olsen, and Haakon Shetelig, *Viking Antiquities in Great Britain and Ireland*, part 6, *Civilisation of the Viking Settlers in Relation to Their Old and New Countries*, 151–232. Oslo, 1954.

O'Meadhra, Uaininn. "Bone Motif-Piece, E 509-1304." In Madeline O'Brien, "Excavations at Barrack Street—French's Quay, Cork," *Journal of the Cork Historical and Archaeological Society* 98 (1993): 27–49, at 42.

———. "Copies or Creations? Some Shared Elements in Hiberno-Norse and Scandinavian Artwork." In Clarke and Johnson, *Vikings in Ireland and Beyond*, 373–402.

———. *Early Christian, Viking and Romanesque Art: Motif-Pieces from Ireland*. Vol. 1, *An Illustrated and Descriptive Catalogue of the So-Called Artists' "Trial-Pieces" from c.5th–12th Cents. AD, Found in Ireland c.1830–1973*. Stockholm, 1979.

———. *Early Christian, Viking and Romanesque Art: Motif-Pieces from Ireland*. Vol. 2, *A Discussion on Aspects of Find-Context and Function*. Stockholm, 1987.

———. "Irish, Insular, Saxon, and Scandinavian Elements in the Motif-Pieces from Ireland." In Ryan, *Ireland and Insular Art*, 159–65.

———. "Motif-Pieces and Other Decorated Bone and Antler Work." In *Late Viking-Age and Medieval Waterford: Excavations 1986–1992*, edited by Maurice Hurley and Orla M. B. Scully, with Sarah W. J. McCutcheon, 699–702. Waterford, 1997.

Onians, John. *Bearers of Meaning: The Classical Orders in Antiquity, the Middle Ages, and the Renaissance*. Princeton, NJ, 1988.

Otaño Gracia, Nahir I. "Towards a Decentered Global North Atlantic: Blackness in *Saga af Tristram ok Ísodd*." In "Critical Race and the Middle Ages," special issue, *Literature Compass* 16, nos. 9–10 (2019): 1–16.

Owen, Olwyn. "The Strange Beast That Is the English Urnes Style." In Campbell, Hall, Jesch, and Parsons, *Vikings and the Danelaw*, 203–22.

Ødeby, Kristine. "Through the Portal: Viking Motifs Incorporated in the Romanesque Style in Telemark, Norway." *Papers from the Institute of Archaeology* 23, no. 1 (2013): article 15, 1–19. https://student-journals.ucl.ac.uk/pia/article/id/490/.

Øye, Ingvild. "Introduction." In *"Utmark": The Outfield as Industry and Ideology in the Iron Age and the Middle Ages*, edited by Ingunn Holm, Sonja Innselset, and Ingvild Øye, 9–20. Bergen, 2005.

———. "Kaupangen i Sogn i komparativ belysning." *Viking* 52 (1989): 144–65.

———. "Sogndal i mellomalderen ca.1050–1537." In *Sogndal bygdebok*, vol. 1, *Allmen bygdesoge: Tida før 1800*, edited by Per Sandal, 239–419. Sogndal, 1986.

Paasche, Fredrik. *Norges og Islands litteratur inntil utgangen av Middelalderen*. Edited by Anne Holtsmark. 2nd rev. ed. Oslo, 1957.

Pächt, Otto. "The Pre-Carolingian Roots of Early Romanesque Art." In *Romanesque and Gothic Art*, Studies in Western Art: Acts of the Twentieth International Congress on the History of Art, edited by Millard Meiss, 67–75. Princeton, NJ, 1963.

Pakis, Valentine A. "Contextual Duplicity and Textual Variation: The Siren and Onocentaur in the Physiologus Tradition." *Mediaevistik* 23 (2010): 115–87.

Passamani, Bruno. *La scultura romanica del Trentino*. Trento, 1963.

Pedersen, Anne. "Jelling im 10. Jahrhundert: Alte Thesen, neue Ergebnisse." In *Die Wikinger und das Fränkische Reich: Identitäten zwischen Konfrontation und Annäherung*, edited by Kerstin P. Hoffmann, Hermann Kamp, and Matthias Wemhoff, 275–95. Paderborn, 2014.

———. "Monumenterne i Jelling: Fornyet tradition på tærsklen til en ny tid." In *At være i centrum: Magt og minde; højstatusbegravelser i udvalgte centre 950–1450; Rapport fra tværfagligt seminar afholdt I Odense, 10. Februar 2016*, edited by Mikael Manøe Bjerregaard and Mads Runge, 5–22. Odense, 2017.

Pedersen, Elin Lønngeroth. "Urnesportalen: Monumental ornamentikk eller dekorativt meningsverk?: En diskusjon om motiv og ikonografi." MPhil. thesis, University of Oslo, 1997.

Pedersen, Ragnar. "A Complex Field of Knowledge: Empiricism and Theory in Stave Church Research." In Bakken, *Preserving the Stave Churches*, 167–90.

Perabo, Lyonel D. "Shapeshifting in Old Norse-Icelandic Literature." *Roda da Fortuna: Revista Eletrônica sobre Antiguidade e Medioevo* 6, no. 1 (2017): 135–58.

Peroni, Adriano. *Pavia: Musei civici del Castello visconteo*. Bologna, 1975.

Pestilli, Livio. "Apostolic Bare Feet in Masaccio's *Tribute Money*: Early Christian and Medieval Sources." *Source: Notes in the History of Art* 26, no. 1 (2006): 5–14.

Peter Damian. *The Letters of Peter Damian: Letters 31–60*. Translated by Owen Blum and Irvin M. Resnick. Vol. 2. Washington, DC, 1990.

Petersen, Jan. "Jernbarrer." *Oldtiden: Tidsskrift for norsk forhistorie* 7 (1918): 171–86.

Petersén, Anna. "Klemenskirke, Kongekirke, Olavskult, symbolikk og skjulte budskap." *SPOR: Arkeologi og Kulturhistorie* 1 (2020): 18–24.

Petersén, A., I. Sæhle, P. N. Wood, and K. Brink. "Arkeologiske undersøkelser i Søndre gate 7–11, Peter Egges Plass, Krambugata 2–4 m.fl., Trondheim, Trøndelag (TA 2016/21, TA 2017/03)." Del 1, *Landskapsutvikling, tidlig urban aktivitet og middelaldersk kirkested*. NIKU Report 90/2019. Trondheim, 2020.

Pettersen, Gunnar I., and Espen Karlsen. "Katalogisering av latinske membranfragmenter som forskningsprosjekt." In *Arkivverkets forskningsseminar Gardermoen 2003*, 43–88. Oslo, 2003.

Piontek, Roya. "Würfelkapitelle." In *Kapitelle des Mittelalters: Ein Leitfaden*, edited by Uwe Lobbedey, 43–51. Münster, 2004.

Piponnier, Françoise, and Perrine Mane. *Dress in the Middle Ages*. Translated by Caroline Beamish. New Haven, CT, 1997.

Plahter, Unn. "Kapitél-løven fra Vossestrand, en maleteknisk undersøkelse." *Årbok: Universitetets oldsaksamling*, 1986–88 (1989): 133–41.

Poole, Austin Lane. *From Domesday Book to Magna Carta, 1087–1216*. 2nd ed. Reprint. Oxford, 1987.

Popov, Victor A., and Nadezhda N. Tochilova. "The Archaeological Study of the Wooden Religious Architecture of Medieval Novgorod." In Khodakovsky and Lexau, *Historic Wooden Architecture in Europe and Russia*, 42–57.

Power, Rosemary. "The Death of Magnus Barelegs." *Scottish Historical Review* 73, no. 196, pt. 2 (1994): 216–23.

———. "Magnus Barelegs' Expeditions to the West." *Scottish Historical Review* 65, no. 180, pt. 2 (1986): 107–32.

Rácz, István, and Peter Anker. *Norsk middelalderkunst*. Oslo, 1970.

Randsborg, Klavs. "Kings' Jelling: Gorm and Thyra's Palace, Harald's Monument and Grave, Svend's Cathedral." *Acta Archaeologica* 79 (2008): 1–23.

Reineke, Anika, Anne Röhl, Mateusz Kapustka, and Tristan Weddigen, eds. *Textile Terms: A Glossary*. Zurich, 2017.

Repsher, Brian. *The Rite of Church Dedication in the Early Medieval Era*. Lewiston, NY, 1998.

Resi, Heid Gjöstein, Else Ausdahl, Björg E. Alfsen, and Olav H. J. Christie. *Die Specksteinfunde aus Haithabu*. Neumünster, 1979.

Reuterdahl, Henrik, and Magnus von Celse. *Statuta Synodalia Veteris Ecclesiae Sveogothicae*. Lund, 1841.

Reynolds, Reginald. *Beards: An Omnium Gatherum*. London, 1950.

Risbøl, Ole. "Socialøkonomiske aspekter ved vikingetidens klæberstenshandel i Sydskandinavien." *Lag* 5 (1994): 115–61.

Robberstad, Knut, ed. *Gulatingslovi*. Oslo, 1952.

Röckelein, Hedwig. "Textus." In Reineke, Röhl, Kapustka, and Weddigen, *Textile Terms*, 276–79.

Rodionova, Marina A., Victor A. Popov, and Nadezhda N. Tochilova. "'Oak-Wood Cathedral of St. Sophia' Pillars from 11th Century Novgorod: Some Aspects of Russian and Scandinavian Wood Carvings in the Middle Ages." https://www.academia.edu/11766404/OAK_WOOD_CATHEDRAL_OF_ST_SOPHIA_PILLARS_FROM_11th_CENTURY_NOVGOROD.

Rodwell, Warwick. "Appearances Can Be Deceptive: Building and Decorating Anglo-Saxon Churches." *Journal of the British Archaeological Association* 165 (2012): 22–60.

Rodwell, Warwick, Jane Hawkes, Emily Howe, and Rosemary Cramp. "The Lichfield Angel: A Spectacular Anglo-Saxon Painted Sculpture." *Antiquaries Journal* 88 (2008): 48–108.

Roesdahl, Else. "Dendrochronology and Viking Studies in Denmark, with a Note on the Beginning of the Viking Age." In Ambrosiani and Clarke, *Developments around the Baltic and the North Sea in the Viking Age*, 106–16.

———. "Jellingstenen: En bog af sten." In *Menneskelivets mangfoldighed: Arkæologisk og antropologisk forskning på*

Moesgård, edited by Ole Høiris, Hans Jørgen Madsen, Torsten Madsen, and Jens Jellev, 235–44. Aarhus, 1999.

Roesdahl, Else, and David M. Wilson, eds. *From Viking to Crusader: The Scandinavians and Europe, 800–1200*. Copenhagen, 1992.

Roosvaal, Johnny. *Die Steinmeister Gottlands: Eine Geschichte der führenden Taufsteinwerkstätte des schwedischen Mittelalters, ihrer Voraussetzungen und Begleit-erscheinungen*. Stockholm, 1918.

Rosengren, Inger. "Style as Choice and Deviation." *Style* 6, no. 1 (1972): 3–18.

Roth, C. E. "Some Observations on the Historical Background of the *Hisperica famina*." *Ériu* 29 (1978): 112–22.

Rudolph, Conrad. *The "Things of Greater Importance": Bernard of Clairvaux's "Apologia" and the Medieval Attitude toward Art*. Philadelphia, 1990.

Rupprecht, Bernhard. *Romanische Skulptur in Frankreich*. Munich, 1975. Reprint. 1984.

Ruskin, John. *The Stones of Venice*. New York, 1907.

Ryan, Michael. "House-Shaped Shrines." In Moss, *Art and Architecture of Ireland*, 286–90.

———, ed. *Ireland and Insular Art, AD 500–1200*. Dublin, 1987.

———, ed. *Treasures of Ireland: Irish Art, 3000 B.C.–1500 A.D.* Dublin, 1983.

Rydbeck, Monica. "The Two Fragments of a Timber Church at Brågarp: A Supplement." *Meddelanden från Lunds Universitets Historiska Museum*, 1946, 110–14.

Rygh, O. *Norske gaardnavne: Oplysninger samlede til brug ved matrikelens revision*. 20 vols. Kristiania, 1897–1924.

———. *Norske oldsager*. Christiania, 1885.

Røstad, Ingunn Marit. "En fremmed fugl: 'Danske' smykker og forbindelser på Østlandet i overgangen mellom vikingtid og middelalder." *Viking* 75 (2012): 181–210.

Saga Óláfs konungs hins Helga: Den store saga om Olav den hellige, efter pergamenthåndskrift i Kungliga bibliotheket i Stockholm nr. 2 4to med varianter fra andre håndskrifter. Edited by Oscar Albert Johnsen and Jón Helgason. Oslo, 1941.

Saga Sverris konúngs. Copenhagen, 1834.

Salvesen, Astrid, and Erik Gunnes. *Gammelnorsk homiliebok*. Oslo, 1971.

Sancti Patris Nostri Epiphanii, Episcopi Constantiae Cypri, ad Physiologum: Eiusdem in Die Festo Palmarum Sermo. Edited by Finnur Magnússon. Antwerp, 1588.

Sandoz, Marc. "Le chapiteau 'de la dispute' du Musée des Beaux-Arts de Poitiers." In "Dibutade VII," special supplement to *Bulletin des amis des Musées de Poitiers*, 1960, 11–33.

Sandvik, Gudmund, and Jón Viðar Sigurðsson. "Laws." In *A Companion to Old Norse–Icelandic Literature and Culture*, edited by Rory McTurk, 223–45. Oxford, 2005.

Sauerländer, Willibald. "Style or Transition? The Fallacies of Classification Discussed in the Light of German Architecture 1190–1260." *Architectural History* 30 (1987): 1–29.

Sayers, William. "An Ill-Tempered Axe for an Ill-Tempered Smith: The Gift of King Eiríkr *blóðøx* to Skallagrímr Kveldúlfsson in *Egils saga Skallagrímssonar*." *Scandinavian-Canadian Studies/Études scandinaves au Canada* 24 (2017): 16–37.

Schapiro, Meyer. "The Beatus Apocalypse of Gerona." *ARTnews* 16, no. 9 (1963): 36–50.

———. *Romanesque Architectural Sculpture: The Charles Eliot Norton Lectures*. Edited by Linda Seidel. Chicago, 2006.

Schei, Tore, and Frederik Zimmer, eds. *Norges lover: 1685–1991*. Oslo, 1992.

Schirmer, Herman M. "Fra hedensk og kristen tid." *Årbok: Foreningen til norske fortidsminnesmerkers bevaring* 66 (1910): 97–140.

Schmidt, Holger. "Om rekonstruktion av stavkirken fra Hørning." in *Beretning fra femtende tværfaglige vikingesymposium*, edited by Preben Meulengracht Sørensen and Else Roesdahl, 56–64. Højbjerg, 1996.

Schmidt, Tom. "Marked, torg og kaupang: Språklige vitnemål om handel i middelalderen." *Collegium Medievale* 13 (2000): 79–102.

Schnell, Ivar. *Kyrkorna i Södermanland*. Nyköping, 1965.

Schöne, Anne-Christin. *Die romanische Kirche des ehemaligen Augustinerchorherrenstiftes in Hamersleben*. Cologne, 1999.

Screen, Elina. "Small Doors on the Viking Age: The Anglo-Saxon Coins in Norway Project." *British Academy Review* 24 (2014): 42–45.

Seel, Otto, ed. *Der Physiologus: Tiere und ihre Symbolik*. Zurich, 2006.

Seidel, Linda V. "Holy Warriors: The Romanesque Rider and the Fight against Islam." In *The Holy War*, edited by Thomas Patrick Murphy, 33–77. Columbus, OH, 1976.

———. *Songs of Glory: The Romanesque Façades of Aquitaine*. Chicago, 1981.

Sellevold, Berit J. *Kistebegravelser i Urnes stavkirke*, NIKU Rapport Antropologiske undersøkelser 1 (2008). http://hdl.handle.net/11250/176389.

Semper, Gottfried. *Style in the Technical and Tectonic Arts, or, Practical Aesthetics*. Translated by Harry Francis Mallgrave and Michael Robinson. Reprint. Los Angeles, 2004.

Shalem, Avinoam. *The Oliphant: Islamic Objects in Historical Context*. Leiden, 2004

Shalem, Avinoam, with Maria Glaser, eds. *Die mittelalterlichen Olifante*. Berlin, 2014.

Sheehan, John, and Donnchadh Ó Corráin, eds. *The Viking Age: Ireland and the West; Papers from the Proceedings of the Fifteenth Viking Congress, Cork, 18–27 August 2005*. Dublin, 2010.

Sheehan, John, Steffen Stummann Hansen, and Donnchadh Ó Corráin. "A Viking-Age Maritime Haven: A Reassessment of the Island Settlement at Beginish, Co. Kerry." *Journal of Irish Archaeology* 10 (2001): 93–119.

Shetelig, Haakon. "The Norse Style of Ornamentation in the Viking Settlements." *Acta Archaeologica* 19 (1948): 69–113.

———, ed. *Osebergfundet III*. Kristiania, 1920.

———. "Urnesgruppen: Det sidste avsnit av vikingetidens stilutvikling." *Årbok: Foreningen til norske fortidsminnesmerkers bevaring* 65 (1909): 75–107.

Sigurðsson, Jón Viðar. *Viking Friendship: The Social Bond in Iceland and Norway, c. 900–1300*. Ithaca, NY, 2017.

Sigurkarlsdóttir, Karen Þóra. "Varðveislusaga Bjarnastaðahlíðarfjala á Þjóðminjasafni Íslands." In *Á efsta degi: Bysönsk dómsdagsmynd frá Hólum*, edited by Bryndís Sverrisdóttir, 41–47. Reykjavík, 2007.

Skaare, Kolbjørn. *Coins and Coinage in Viking-Age Norway: The Establishment of a National Coinage in Norway in the XI Century, with a Survey of the Preceding Currency History*. Oslo, 1976.

Skjølsvold, Arne. *Klebersteinsindustrien i vikingetiden*. Oslo, 1961.

Skre, Dagfinn. "Kirken før sognet: Den tidligste kirkeordningen i Norge." In Lidén, *Møtet mellom hedendom og kristendom i Norge*, 170–233.

———, ed. *Rulership in 1st to 14th Century Scandinavia: Royal Graves and Sites at Avaldsnes and Beyond*. Berlin, 2020.

Slomann, Vilhelm. *Bicorporates: Studies in Revivals and Migrations of Art Motifs*. Copenhagen, 1967.

Smyth, Alfred P., ed. *Seanchas: Studies in Early and Medieval Irish Archaeology, History, and Literature in Honour of Francis J. Byrne*. Dublin, 2000.

Snorri Sturluson. *Heimskringla*. Vol. 2, *Óláfr Haraldsson (the Saint)*. Translated by Alison Finlay and Anthony Faulkes. London, 2014.

———. *Heimskringla: History of the Kings of Norway*. Translated by Lee M. Hollander. Austin, TX, 1964. Reprint. Austin, 1992.

———. *Heimskringla: Magnussona saga*. Edited by Bjarni Aðalbjarnarson. Reykjavík, 1951.

———. *Heimskringla: Nóregs konunga sögur*. Edited by Finnur Jónsson. Copenhagen, 1911.

———. *The Heimskringla, or, Chronicle of the Kings of Norway*. Translated by Samuel Laing. London, 1844.

———. *Heimskringla, or The Lives of the Norse Kings*. Edited by Erling Monsen. Translated by Erling Monsen and A. H. Smith. New York, 1990.

Solberg, Bergljot. *Jernalderen i Norge: Ca. 500 f. Kr.–1030 e. Kr.* Oslo, 2000.

Solhaug, Mona Bramer. *Middelalderens døpefonter i Norge*. 2 vols. Oslo, 2001.

Solli, Brit. "Narratives of Encountering Religions: On the Christianization of the Norse around AD 900–1000." *Norwegian Archaeological Review* 29, no. 2 (1996): 89–114.

Stalley, Roger. *Early Irish Sculpture and the Art of the High Crosses*. London, 2020.

———. "Hiberno-Romanesque and the Sculpture of Killeshin." In *Laois: History and Society*, edited by Pádraig G. Lane and William Nolan, 89–122. Dublin, 1999.

———. "The Romanesque Sculpture of Tuam." Reprinted in *Ireland and Europe in the Middle Ages: Selected Essays on Architecture and Sculpture*, 127–63. London, 1994.

Stang, Margrethe C. "Enemies of Christ in the Far North: Tales of Saracens, Jews and the Saami in Norwegian Medieval Paintings." In Aavitsland and Bonde, *Tracing the Jerusalem Code*, 477–99.

———. "Luksus i Luster: Høgendeskirken Urnes." *Årbok: Foreningen til norske fortidsminnesmerkers bevaring* 171 (2017): 159–78.

Stein, Mille. *Sikring og oppbevaring av kunst og inventar i A 284 Urnes stavkirke, Luster kommune, i forbindelse med bygningsarbeid i kirken*. NIKU Rapport Kunst og inventar 8 (2008). https://ra.brage.unit.no/ra-xmlui/handle/11250/176421.

Stein, Mille, and Tone M. Olstad. "A 285: Urnes Stavkirke; Konsolidering av limfargedekoren i koret." NIKU Oppdragsrapport 160/2012, 3. https://ra.brage.unit.no/ra-xmlui/handle/11250/176377.

Steinnes, Guttorm. "Mål, vekt og verderekning i Noreg i millomalderen og ei tid etter." In *Maal og vægt*, edited by Svend Aakjær, 84–154. Stockholm, 1936.

Steinsland, Gro. "Introduction: *Ideology and Power in the Viking and Middle Ages; Scandinavia, Iceland, Ireland, Orkney and the Faeroes.*" In *Ideology and Power in the Viking and Middle Ages: Scandinavia, Iceland, Ireland, Orkney and the Faeroes*, edited by Gro Steinsland, Jón Viðar Sigurðsson, Jan Erik Rekdal, and Ian B. Beuermann, 1–12. Leiden, 2011.

Stenton, F. M., ed. *The Bayeux Tapestry: A Comprehensive Survey*. London, 1957.

Stern, Marjolein. "Runestone Images and Visual Communication in Viking Age Scandinavia." PhD diss., Nottingham University, 2013.

Stiegemann, Christoph, Martin Kroker, and Wolfgang Walter, eds. *Credo: Christianisierung Europas im Mittelalter*. Petersberg, 2013.

Stige, Morten. "The Lion in Romanesque Art, Meaning or Decoration?" *Tahiti: Taidehistoria tieteenä Konsthistorien som vetenskap* 4 (2016). http://tahiti.fi/04-2016/tieteelliset-artikkelit/the-lion-in-romanesque-art-meaning-or-decoration/.

———. "Livstrekapitélet?: Bestiariet som kilde til Stavangerrelieffenes ikonografi." In *Bilder i marginalen: Nordiska studier i medeltidens konst*, edited by Kersti Markus, 175–92. Tallinn, 2006.

———. "Tingelstadfløyen: Skipsfløy på land." In *Gamle Tingelstad: Liten kirke med stort innhold*, edited by Morten Stige and Kjartan Hauglid, 93–119. Gran, 2020.

Stock, Brian. "Self, Soliloquy, and Spiritual Exercises in Augustine and Some Later Authors." *Journal of Religion* 91, no. 1 (2011): 5–23.

Stocker, David, and Paul Everson. "Rubbish Recycled: A Study of the Re-Use of Stone in Lincolnshire." In *Stone: Quarrying and Building in England, AD 43–1525*, edited by David Parsons, 83–101. Chichester, 1990.

Stoklund, Marie, Michael Lerche Nielsen, Bente Holmberg, and Gillian Fellows-Jensen, eds. *Runes and Their Secrets: Studies in Runology*. Copenhagen, 2006.

Storemyr, Per, and Tom Heldal. "Soapstone Production through Norwegian History: Geology, Properties, Quarrying, and Use." In *Interdisciplinary Studies on Ancient Stone: Proceedings of the Fifth International Conference of the Association for the Study of Marble and Other Stones in Antiquity, Museum of Fine Arts, Boston, 1998*, edited by John J. Hermann Jr., Norman Herz, and Richard Newman, 359–69. London, 2002.

Stow, Kenneth. *Jewish Dogs: An Image and Its Interpreters; Continuity in the Catholic-Jewish Encounter*. Stanford, 2006.

Stratford, Neil. *Le pilier roman de Souvigny: Chronos et cosmos*. Souvigny, 2005.

Strickland, Debra Higgs. *Saracens, Demons, and Jews: Making Monsters in Medieval Art*. Princeton, NJ, 2003.

Stroll, Mary. *Symbols as Power: The Papacy following the Investiture Contest*. Leiden, 1991.

Strömbäck, Dag. "The Epiphany in Runic Art: The Dynna and Sika Stones." *The Dorothea Coke Memorial Lecture in Northern Studies delivered at University College London 22 May 1969*, 1–19. London, 1970.

Stylegar, Frans-Arne, and Oliver Grimm. "Place-Names as Evidence for Ancient Maritime Culture in Norway." *Årbok: Norsk sjøfartsmuseum*, 2002, 79–109.

Støylen, K., ed. *Peder Palladius' Visitasbok*. Oslo, 1945.

Svanberg, Jan. "Salomes dans i Nordens medeltida konst." In *Kvindebilleder: Eva, Maria og andre kvindemotiver i middelalderen*, edited by Karin Kryger, Louise Lillie, and Søren Kaspersen, 201–17. Copenhagen, 1989.

Svenungsen, Pål Berg. "Norge og korstogene: En studie av forbindelsene mellom det norske riket og den europeiske korstogsbevegelsen, ca.1050–1380." PhD diss., University of Bergen, 2016.

Swarzenski, Hanns. "Two Oliphants in the Museum." *Bulletin of the Museum of Fine Arts* 60, no. 320 (1962): 27–45.

Sørheim, Helge. "Three Prominent Norwegian Ladies with British Connections." *Acta Archaeologica* 82 (2011): 17–54.

Tcherikover, Anat. "The Fall of Nebuchadnezzar in Romanesque Sculpture (Airvault, Moissac, Bourg-Argental, Foussais)." *Zeitschrift für Kunstgeschichte* 49, no. 3 (1986): 288–300.

Teitelbaum, Benjamin J. *Lions of the North: Sounds of the New Nordic Radical Nationalism*. Oxford, 2017.

Thiébaux, Marcelle. *The Stag of Love: The Chase in Medieval Literature*. Ithaca, NY, 1974.

Thompson, Claiborne W. "Review of Dag Strömbäck, *The Epiphany in Runic Art: The Dynna and Sika Stones*." *Scandinavian Studies* 44, no. 1 (1972): 130–31.

Thun, Terje. "Dendrochronological Constructions of Norwegian Conifer Chronologies Providing Dating of Historical Material." DPhil. diss., Norwegian University of Science and Technology, 2002.

Thun, Terje, Jan Michael Stornes, Thomas Seip Bartholin, and Helene Løvstrand Svarva. "Dendrochronology Brings New Life to the Stave Churches: Dating and Material

Analysis." In Bakken, *Preserving the Stave Churches*, 91–116.

Tilghman, Benjamin C. "Pattern, Process, and the Creation of Meaning in the Lindisfarne Gospels." *West 86th* 24, no. 1 (2017): 3–28.

Tochilova, Nadezhda N. "Transition Style in Scandinavian Art, Late 11th–First Half of 12th Century." In *Migrations in Visual Art*, edited by Jelena Erdeljan, Martin Germ, Ivana Prijatelj Pavičić, and Marina Vicelja Matijašić, 151–63. Belgrade, 2018.

Tochilova, Nadezhda N., and Anna Slapinia. "From Wawel Hill to Volkhov River Bank: To the Question of the Presumptive Influence of the Pre-Romanesque Polish Architecture to the Decoration of So-Called 'Columns of Oak Sophia from Novgorod.'" *Quaestiones Medii Aevi Novae* 23 (2018): 405–26.

Tomany, Maria-Claudia. "Sacred Non-Violence, Cowardice Profaned: St Magnus of Orkney in Nordic Hagiography and Historiography." In *Sanctity in the North: Saints, Lives, and Cults in Medieval Scandinavia*, edited by Thomas A. DuBois, 128–53. Toronto, 2008.

Toubert, Hélène. "Le renouveau paléochrétien à Rome au début du XIIe siècle." *Cahiers archéologiques* 20 (1970): 99–154.

Travis, William J. "Of Sirens and Onocentaurs: A Romanesque Apocalypse at Montceaux-l'Étoile." *Artibus et Historiae* 23, no. 45 (2002): 29–62.

Trotzig, Gustaf. "Holzkirchen archäologie auf Gotland und der Sonderfall von Silte." In Ahrens, *Frühe Holzkirchen im nördlichen Europa*, 227–93.

Tryti, Anna Elisa. "Fra åsatro til reformasjon." In *Vestlandets Historie*, vol. 3, *Kultur*, edited by Knut Helle, Ottar Grepstad, Arnvid Lillehammer, and Anna Elisa Tryti, 55–103. Bergen, 2006.

———. "Kirkeorganisasjonen i Bergen bispedømme i første halvdel av 1300-tallet." MA thesis, University of Bergen, 1987.

Tudor-Craig, Pamela. "Controversial Sculptures: The Southwell Tympanum, the Glastonbury Respond, the Leigh Christ." In *Anglo-Norman Studies XII: Proceedings of the Battle Conference 1989*, edited by Marjorie Chibnall, 211–33. Woodbridge, UK, 1990.

Turville-Petre, Gabriel. "The Old Norse Homily on the Dedication." *Mediaeval Studies* 11 (1949): 206–18.

———. "The Old Norse Homily on the Dedication." In *Nine Norse Studies*, 79–101. London, 1972.

Tweddle, D. "The Development of Sculpture c. 950–1100." In *The Corpus of Anglo Saxon Stone Sculpture in England*, vol. 4, *South-East England*, edited by Dominic Tweddle, Martin Biddle, and Birthe Kjølbye-Biddle, chap. 7. Oxford, 1995. http://www.ascorpus.ac.uk/vol4_chap7.php.

Tyers, Ian, Cathy Groves, Jennifer Hillam, and Gretel Boswijk. "List 80: Tree-Ring Dates from Sheffield University." *Vernacular Architecture* 28, no. 1 (1997): 138–58.

Ugulen, Jo Rune. "Kring ætta på Ornes og Mel i mellomalderen, samt noko om Rane Jonssons etterkomarar og slekta Hjerne (Hjärne)." *Norsk slektshistorisk tidsskrift* 39, no. 1 (2004): 235–316.

Ullén, Marian. "Bygga i trä." In *Den romanska konsten*, edited by Lennart Karlsson, Mereth Lindgren, Margareta Nockert, Anders Piltz, Jan Svanberg, Peter Tängeberg, and Marian Ullén, 35–52. Lund, 1995.

———. "Holzkirchen im mittelalterlichen Stift Växjö." In Ahrens, *Frühe Holzkirchen im nördlichen Europa*, 321–42.

———. *Medeltida träkyrkor I*. Stockholm, 1983.

———. "Medeltidens kyrkor." In Ullén, *Småland*, 41–98.

———, ed. *Småland: Landskapets kyrkor*. Stockholm, 2006.

Valdez del Álamo, Elizabeth. *Palace of the Mind: The Cloister of Silos and Spanish Sculpture of the Twelfth Century*. Turnhout, 2012.

Vandvik, Eirik, ed. and trans. *Latinske dokument til norsk historie fram til år 1204*. Oslo, 1959.

Vasilyeva, Svetlana. "Bysantinska traditioner i Gotlands konst under 1100-talet." *Fornvännen* 104, no. 2 (2009): 97–111.

Vellev, Jens, ed. *Romanske stenarbejder*. 6 vols. Aarhus, 1981–2009.

———. *2. Skandinaviske symposium om romanske stenarbejder: 1999 i Silkeborg*. Højbjerg, 2003.

Venit, Marjorie Susan. "Theatrical Fiction and Visual Bilingualism in the Monumental Tombs of Ptolemaic Alexandria." In *Alexandria: A Cultural and Religious Melting Pot*, edited by George Hinge and Jens A. Krasilnikoff, 42–65. Aarhus, 2009.

Vigfusson, Gudbrand, and F. York Powell, eds. *Origines islandicae: A Collection of the More Important Sagas and Other Native Writings Relating to the Settlement and Early History of Iceland*. Vol. 1. Oxford, 1905.

Voigtländer, Klaus. *Die Stiftskirche St. Servatii zu Quedlinburg: Geschichte ihrer Restaurierung und Ausstattung*. Berlin, 1989.

Waggoner, Ben, ed. and trans. *Sagas of Imagination: A Medieval Icelandic Reader*. Philadelphia, 2018.

Walberg, Emmanuel, ed. *Le bestiaire de Philippe de Thaün*. Lund, 1900.

Wallace, Patrick F. *Viking Dublin: The Wood Quay Excavations*. Kildare, 2016.

Wallem, Fredrik B. *De Islandske kirkers udstyr i middelalderen*. Kristiania, 1910.

Wamers, Egon. *Insularer Metallschmuck in wikingerzeitlichen Gräbern Nordeuropas: Untersuchungen zur skandinavischen Westexpansion*. Neumünster, 1985.

———. "... ok Dani gærði kristna ...: Der große Jellingstein im Spiegel ottonischer Kunst." *Frühmittelalterliche Studien* 34 (2000): 132–58.

Warning, Rainer. *The Ambivalences of Medieval Religious Drama*. Translated by Steven Rendall. Stanford, 2001.

Watson, Katherine. *French Romanesque and Islam: Andalusian Elements in French Architectural Decoration c. 1030–1180*. Oxford, 1989.

Weber, Gottfried. *Die Romanik in Oberbayern: Architektur, Skulptur, Wandmalerei*. Pfaffenhofen, 1985.

Webster, Leslie. *Anglo-Saxon Art: A New History*. Ithaca, NY, 2012.

Wedvik, Barbro. "A 167: Heddal stavkirke; Konsolidering av limfargedekor i skip og sørvegg i koret." NIKU rapport 121/2009, 10. https://ra.brage.unit.no/ra-xmlui/handle/11250/176397.

Weigert, Laura. "The Art of Tapestry: Neither Minor nor Decorative." In *From Minor to Major: The Minor Arts in Medieval Art History*, edited by Colum Hourihane, 103–21. University Park, PA, 2012.

———. "*Velum Templi*: Painted Cloths of the Passion and the Making of Lenten Rituals in Reims." *Studies in Iconography* 24 (2003): 199–229.

Weir, Anthony, and James Jerman. *Images of Lust: Sexual Carvings on Medieval Churches*. London, 1986.

Wessén, Elias, and Sven B. F. Jansson, eds. *Sveriges runinskrifter*. Vol. 8, *Upplands runinskrifter*. Stockholm, 1949–51.

Westwood, J. O. *Fac-similes of the Miniatures and Ornaments of Anglo-Saxon and Irish Manuscripts*. London, 1868.

White, T. H., ed. *The Book of Beasts: Being a Translation from a Latin Bestiary of the Twelfth Century*. Stroud, 1954.

Wichstrøm, Anne. "Maleriet i høymiddelalderen." In Lidén, Anker, Wickstrøm, Hoffmann and Nordhagen, eds. *Norges kunsthistorie*. Vol. 2, 252–314.

Wicker, Nancy L. "Nimble-Fingered Maidens in Scandinavia: Women as Artists and Patrons." In *Reassessing Women's Roles as "Makers" of Medieval Art and Architecture*, edited by Therese Martin 2:865–902. Leiden, 2012.

———. "Would There Have Been Gothic Art without the Vikings? The Contribution of Scandinavian Medieval Art." In "Confronting the Borders of Medieval Art," edited by Jill Caskey, Adam S. Cohen, and Linda Safran, 198–229. Special issue, *Medieval Encounters* 17, nos. 1–2 (2011).

William Durandus. *Guillelmi Duranti: Rationale divinorum officiorum I–IV*. Edited by A. Davril and T. M. Thibodeau. Turnhout, 1995.

———. *The Rationale Divinorum Officiorum of William Durand of Mende: A New Translation of the Prologue and Book One*. Translated by Timothy M. Thibodeau. New York, 2007.

Williams, John. *Early Spanish Manuscript Illumination*. New York, 1977.

———. *The Illustrated Beatus: A Corpus of the Illustrations of the Commentary on the Apocalypse*. 5 vols. London, 1994–2003.

Wilson, David M. "The Development of Viking Art." In Brink and Price, *Viking World*, 323–40.

———. "An Early Representation of St Olaf." In *Medieval Literature and Civilization: Studies in Memory of G. N. Garmonsway*, edited by D. A. Pearsall and R. A. Waldron, 141–45. London, 1969.

———. *Vikingatidens konst*. Translated by Henrika Ringbom. Lund, 1995.

Wilson, David M., and Ole Klindt-Jensen. *Viking Art*. London, 1966.

Wilson, H. A., ed. *The Missal of Robert of Jumièges*. London, 1896.

Winroth, Anders. *The Conversion of Scandinavia: Vikings, Merchants, and Missionaries in the Remaking of Northern Europe*. New Haven, CT, 2012.

Wisløff, Carl Fr. *Norsk kirkehistorie*. Vol. 1. Oslo, 1966.

Yates, Frances A. *The Art of Memory*. Reprint. London, 2006. First published 1966.

Youngs, Susan. "A Hiberno-Norse Strap-End from Bulford near Amesbury, Wiltshire." *Journal of the Cork Historical and Archaeological Society*, ser. 2, 121 (2016): 11–18.

Zarnecki, George. "Germanic Animal Motifs in Romanesque Sculpture." *Artibus et Historiae* 11, no. 22 (1990): 189–203.

Zarnecki, George, Janet Holt, and Tristram Holland, eds. *English Romanesque Art, 1066–1200*. London, 1984.

Zastrow, Oleg. *Scultura carolingia e romanica nel Comasco: Inventario territoriale*. Como, 1978.

Zilmer, Kristel. "Christian Prayers and Invocations in Scandinavian Runic Inscriptions from the Viking Age and Middle Ages." *Futhark: International Journal of Runic Studies* 4 (2013): 129–71.

Zozaya, Juan. "Algunas observaciones en torno a la ermita de San Baudelio de Casillas de Berlanga." *Cuadernos de la Alhambra* 12 (1976): 307–38.

Index

A

abatements, 171, 399, pls. 96–105, fig. 1.9
abbot, *see* monk
Abraham, biblical patriarch, 364
acrobat, 375, 378, 381–84, 386, 406, 428, 444n37, pl. 86, fig. 9.4
Adam of Bremen, 313, 328n45
Adoration of the Magi, 367, fig. 8.4
altar, 278, 312, 328n37, 335.
 See also Lisbjerg altar
 Armagh, 291
 as representing Christ, 410
 Borgund, 126
 clothing of, 349–51, 353n33
 Hopperstad, 131
 Hólar, 239
 Odense, 377
 Urnes
 main, 116, 127, 128, 131, 133, 134, 135, 136, 137, 363, pl. 123
 side, 116, 128, 131, 134, 144, 148, 161, 163, fig. 1.13, fig. 2.7
Amalarius of Metz, 411
Anastasius IV, pope, 422
Andalusia, *see* Spain
Anglo-Saxons, 201, 312, 315, 329
animals, *see* specific animals
Anselm of Bec, 384, 420
Antichrist, 387
Antioch, 385
anti-Semitism, *see* Jews
antlers, 180, 193, 327n20, 426, 432
Apocalypse, 308, 387, 390,
 see also Revelation, book of
Apulia, 377
Aquitaine, 391
Armagh, 278, 285, 286, 288, 291, 292, 298n18. *See also* altar, Armagh
Arnbjørn Jonnson, 149
Asser Thorkilsen, 400
Athanasius, 362
Augustine, 325, 368, 409, 420
Augustinians, *see* canons

Ásmundr, 200, 201, 202, 235, 261, 272n181, 319, 320, 329n79

B

bagall, 149, *see also* crosier
baldachin, 332, 335, 339, 350, 352n2
Balli, 225n39, 320
baptism, 131, 135, 136, 149n45, 316, 317, 362, 420, 426, 433, 434, 438, 441
bare feet, *see* feet
barrel vault, 130, 134, 136
basilisk, 311, 322, 324, 330n104, 431, 432
Bayeux Embroidery, 321, 333, 344, 347, 352n14, 377, 379, 385
beard pullers, 365, 366, 389, 375, 396n74, 396n102, 422, 428, 436, figs. 9.7, 9.8, 11.5
 Urnes, 358, 362, 365–66, 369, 375, 378, 384–86, 391, 406, 426 pl. 77
beards, 367, 369, 381, 384–87, 413, 429, 432, 435
Bearnán Chúláin, 287, fig. 5.8
Beatus manuscripts, 386–91, fig. 9.8
Bede, 282, 316, 320, 330n90
bell, 128, 137, 140n36, 266, fig. 1.12
bell shrines, *see* Bearnán Chúláin and shrines, St. Patrick's bell
bell tower, 128
Bergen, 12, 15, 115, 116, 117, 136, 149, 164, 283, 400, 407, 414, 438
 Old Bergen Museum, 157
 University Museum, 116, 126, 130, 131, 133, 134, 141n55, 245, 343, 344, 401, fig. 4A10
Bernard of Clairvaux, 14, 19, 169, 276, 422
berserkr, 19, 435–37
bestiary, 18, 321, 362, 409, 420–21, 430, 433–36, 440, fig. 11.8
 Oxford, 367, 408, 426, 433, figs. 11.3, 11.8
Bilden, 426

birds, 169, 201, 320, 321, 347, 369, 377, 379, 389, 432–33
 at Urnes, 14, 153, 360, 375, 386, 393, 399, 406, 408, pls. 44, 55, 68, 69
 See also individual birds
bishops, 116, 117, 134, 140n20, 149, 211, 215, 232, 313, 314, 322, 325, 328n62, 346, 370, 385, 386, 400, 403, 411–14, 415, 417n67, 419, 421, 422, 426, 438, 440–42, 443n1, 446n110
Bjarnastaðahlíð, 215, 216, 221–22, 229–32, fig. 4A.1. *See also* Flatatunga
Bjarne Erlingsson, 149, 400
Bjølstad, 171, 199, 204, 214, 216, 218, 232–34, 261, 262, 375, fig. 4A.2
Bonn, St. Martin, 402, 430, fig. 11.6
Book of Kells, *see* Kells
Borgund, stave church, 117, 126, 127, 128, 134, 153, 358, 399, 401
brooches, 287, 303n143, 319
 Urnes style, 25, 200–01, 203, 211, 225n41, 284, 285, 302n107, 313, 320, 322, fig. 6.11
Bruno of Cologne, 313
Brynjólfr úlfaldi ("the Camel"), 364, 379
Bräckstad, 261
Brågarp, 171, 211, 216, 217, 218, 227n110, 235–36, fig. 4A.3
Byzantine architecture, 117
Byzantine art, influence of, 209, 222, 229, 237, 391

C

Caedmon manuscript, 321
Calixtus II, pope, 363, 390, 392
Calvary, *see* crucifix
camel
 capital at Gargilesse, 390
 capital at Urnes, 169, 286, 358, 353–54, 375, 377, 386, 389, 391, 406, 408, 429, 432, 434–35, pl. 47
 encounters with, 363–64, 391, 434

474

INDEX

fresco at San Baudelio de Berlanga, 379, fig. 9.3
 significance of, 366, 369, 379–80, 408, 429
candle-ship, 134, 296, 363, pl. 110
candlesticks, Limoges, 116, 128, 134, 137, 296, pl. 111
canons
 Augustinian, 361, 401, 402, 414, 415
 regular, 403, 413, 414
canopy, 134, 135, 136
Canterbury, 226n79, 291, 403
Canute, *see* Knútr
capitals, cushion, 170, 358, 400, 401–04, 414–15, 416n15, 421
 at Hildesheim, fig. 10.2
 at Hopperstad, fig. 10.1
 at Rinde, 173
 at Stavanger, 381
 at Urnes
 nave, 14, 127, 128, 131, 168, 169, 170, 356, 358, 359–60, 399, 401, 414, 421, 423, 430
 west portal, 128, 131, 170
capitals, scalloped, 401, 403
Cashel, 291
 sarcophagus, 293, fig. 5.12
casts, 283
Catalonia, *see* Spain
Cathach, 243
centaur, 21n12, 169, 209, 211, 256, 362, 371n21, 379, 386, 390, 406, 419, 421, 422, 429, 437, 440, 441, pl. 87, fig. 11.9
 onocentaur, 409, 438
chalice, 136, 137, 350
chancel, 16, 126–28, 133–38, 140n38, 144, 146, 157, 159, 161, 163, 168, 169, 171, 172, 173, 405, pls. 1, 33, 115, 116, figs. I.5, 1.8, 2.5, 2.7, 2.11, 2.13, 2.16, 2.18
 as signifying Holy Ghost, 435, 442
 as signifying those with God, 410
 at Brågarp, 236
 at Flatatunga, 239
 at Glanshammar, 242
 at Hørning, 249
 at Vrigstad, 268
 See also choir screen
chandelier, 130, 137, 140n39, 146
chasuble, 137, 349, 350, 354n95, 419
choir screen, 116, 131, 136, 144, 148, 161, 410, 4355, 441, fig. 2.7, fig. 2.16
Christianization, 13, 176n52, 314, 334, 422

Church council, *see* council
churching ceremony, 136, 329n72
Cistercians, 294, 414
cleric, 169, 286, 362, 363, 406, 407, 409, 410, 411–15, pl. 85
Clonmacnoise, 278, 283, 294, 298n7
clothing, 412, 433, 435
Cluny, 392, 393
coins, 157, 162, 172, 176n49, 180, 203, 225n41, 278, 280, 303n143, 319–320, 429
Cologne, 313, 402, 412, 415
Como, 403
confessional, 137
consecration
 ceremony, 198, 312, 313–317, 328n39, 329n62, 336, 352n14, 406, 441
 crosses, 221, 251, 315, 317, fig. 6.8
Constantinople, 364
conversion, 368, 380, 419–20, 429, 433, 435
 in art, 362, 421, 426–29, 433–39, 441, 442
 process in Scandinavia, 19, 21n19, 201, 224n1, 252, 305, 308–13, 315, 320, 321, 325, 326, 327n35, 332, 334, 337, 339, 357, 359, 362, 400, 422–24, 440
 See also Christianization
Cork, 288, 290, 291, 292, fig. 5.3
council, 390, 412, 413
crosier, 149, 169, 283, 291, 292, 302n116, 362, 406, 409, 410, 411, 415, 417n67, 419, 438, 441, pl. 85
cross, veneration of, 441
Cross of Cong, 283, 284, 291, 294, 295
crucifix, 350–51, 359, 370, 426, 441, 442, 446n113, 447n115
Crucifixion, 136, 137, 223, 359, 430, 447n116
 Calvary group at Urnes, 115, 137, 144, 332, 359, 370, 406, 410, 417n64, 421, 433, 441, 442, pls. 106–09
 1688 painting at Urnes, 137, pl. 126
Crucifixion group, *see* crucifix
crusades, 15, 363, 366, 375, 380, 385, 390, 391–93, 429, 434, 436, 440
cushion capitals, *see* capital

D
Dale (church), 134, 175n32, 296, 400
Daniel, book of, 386, 387, 389, 390, 430, 431, figs. 9.4, 9.9
deer, 170, 364, 386, 390, 426, 437

dendrochronology, 12, 14, 15, 16, 17, 126, 157, 161–62, 166, 172, 196, 197, 203–08, 214, 215, 216, 223, 236, 237, 249, 252, 254, 265, 266, 268, 269n35, 278, 281, 305, 307, 329n62, 358, 377, 399, 401, 421
dog, 169, 364, 408, 426, 434, pl. 46
Dollerup, 285, 295, fig. 5.7
Donaghenry, 293, fig. 5.11
dragon
 as ornament, 170
 Bayeux embroidery, 379
 Borradaile oliphant, 377
 Bible, 321, 324
 in manuscript illumination, 386, 389, figs. 9.7, 9.10
 in Norse mythology, 321, 353n40
 in late Viking art, 19, fig. 6.11
 Gargilesse, 390
 Humptrup, 248
 Rolduc, 403
 Saint Michael fighting, 320
 Sant'Abbondio in Como, 403
 Sogn-Valdres composition, 12, 218
 Southwell, 320
 symbolism of, 166, 311, 426, 432–34, 441
 Torpo plank, 218, 261
 Urnes
 capitals, 14, 169, 272n181, 359, 360, 361, 385, 399, 405, 421, 430, 437, pls. 39–41, 57–59, 66–67, 93–95
 Staves, 169
 west portal, 170, 399
 Västerplana, 441
Dream of the Rood, 424
Dublin, 243, 278, 279, 283, 284, 286, 290, 291, 292, figs. 5.4, 5.5
ductus, 420
Dynna stone, *see* runestones

E
eagle, 358–62, 377, 433–34, 437, 441, fig. 9.1
Egidius of Meissen, 412
Eiríkr blóðøx ("Blood-Axe") Haraldsson, 437
Eke, 206, 211, 216, 217, 218, 222, 226n68, 228n140, 236–37, fig. 4A.4
embroidery, 137, 338, 339, 344, 347, 353n46, figs. 7.3, 7.6. *See also* Bayeux embroidery
Eskilstuna, 234, 241, 243, 245, 269n23
exempla, 408, 410, 411

475

F

Fagrskinna, see sagas
feet, 164, 169, 202, 214, 232, 234, 261, 306, 324, 359, 364, 383, 394
 bare, 222, 229, 411, 413
Feios, 171, 182, 190, 258. *See also* Rinde
feline, 359, 360, 361, 362, 423, 424, 429–34. *See also* lion
fibulae, see brooches
finial, 276, 278–81, 294, 295, fig. 5.3
finngálkan, see centaur
Fishamble street, *see* Dublin
Flatatunga, 215, 216, 221, 222, 232, 238–39, fig. 4A.5. *See also* Bjarnastaðahlið
Folkmar, 313
font
 Bro, 369
 in "Stave church Homily," 442
 removal of medieval, 131
 Trondheim, 199
 Urnes, 130, 136
 cover, 115, pl. 113
 post-medieval enclosure for, pl. 120
 Västerplana, 441, fig. 11.10
Fortun, 172, 401
Frederik III, 136
frieze, 158, 159, 166, 209, 214, 217, 219, 220, 221, 241, 249, 254, 265
 textile, 333, 338
Frostaþing, *see* law
Fulcher of Chartres, 390, 392, 435–36

G

Gargilesse, 390
Gaulverjabæ, 240, fig. 4A.6
Gautr of Ornes, 149, 358, 400, 421
Gautsson, Jón and Munán, 421
Germany, 11, 117, 134, 205, 216, 247, 358, 364, 369, 381, 400, 422
 baptismal dish from, 136
 chairs and benches from, 134
 cushion capitals in, 401, 402, 415
 timber churches in, 298n4, 358
Glanshammar, 211, 216, 217, 241–42, fig. 4A.7
Glendalough, 282, 288
Gol, 405
Gospel(s)
 book, 350, 383
 Christ in, 426
 of John, 382
 of Mark, 382
 of Matthew, 382, 408
 of Nicodemus, 315

posts symbolizing, 410–11, 423
 synoptic, 364
 text of, 428
Gotland, 19, 203, 206, 209, 211 236, 242, figs. 4.5, 4A.4
 picture stones, 217, 220
 Romanesque sculpture of, 208, 225, 295, 377, 441, fig. 11.10
 wooden churches on, 222, 293
graffiti, 130, 198, 252, 399, 405, 413, 421, fig. 10.4a-b
gravestone, 128, 241, 245
Greensted, 145, 275
Gregory VIII, 363, 369
griffin, 209–11, 256, 361, 362, 377, 381, 385, 387, 389, 403, 421, 429, 432, 433, 434, 445n82, fig. 11.6
Gulaþing, *see* law
Güstrow, 369

H

Hadseløy, 211, 216, 217, 242–43, fig. 4A.8
Hafslo, 175n28, 178n110, 181–82, 190, 193, 400
Hagbard, 116, 344, 346, 354n75
Hagebyhögda, 206, 209
Haltdale, 358
Hamburg-Bremen, 313, 317, 400, 415, 421, 422
Hamersleben, 402
Hammarby, 211, 216, 217, 241, 244–45, fig. 4A.9
hamr, see shape-shifting
Haraldr blátǫnn ("Bluetooth") Gormsson, 308, 313, 327n31, 424
Haraldr Sigurðarsonar harðrádí, 391
Hákon góði ("the Good"), 422
Heddal (Hitterdal), 117, 174n13, 340, 353n54
Hemse, 171, 206, 208, 209, 211, 237, 238, 293, fig. 4.5
Henry I, 404, 405, 414, 434
Heribert of Cologne, 412
Herod, 382, 383, 429, figs. 9.5, 9.6
Hexaemeron, 408
Hiberno-Urnes style, 291–94, 295, 297, figs. 5.6, 5.9
high cross, 276, 281, 283, 290, 291, 297
Holdhus (Håland), 333
Holy Sepulcher, 392, 393
Hopperstad, figs. I.4, 4.6, 7.4, 10.1
 apse of, 127
 arches, 141n47
 capital profile, 338, 401, 404

carving style, 170, 171, 211, 217, 248, 326n14, 405
chancel, 131
date of, 16, 172, 177n99, 214
female burial at, 186–87
fragments from, 173, 205, 216, 245–46, fig. 4A.10
relation to other churches, 14, 16, 192, 399
struggle motif at, 218
textiles in, 130, 340
wall hooks, 341, 353n54, 353n60
wall paintings, 339
Hove, 16, 190, 192
Hólar, 215, 216, 221, 232, 239, 246–47, 396n74, fig. 4A.11
Hugh of Fouilloy, 406, 433–34, 445n76
Hugh of St. Victor, 408, 414
Humptrup, 205, 211, 216, 217, 247–48, fig. 4A.12
Hungrvaka, 314, 328n39
hunting, 14, 169–70, 189, 364, 379, 384, 386, 390, 393, 406, 426, 432, fig. 11.4
Hurum (Høre), 340, 353n60
hybrids, 14, 19, 223, 358, 369, 381, 399, 406, 408, 410, 420, 429, 434, 435–36, 438, 441
Hyde, 404, 414, 415, 416n35, fig. 10.3b
Hørning
 bilingualism of, 221
 dendrochronology for, 203, 205
 figure, 221
 wall-plate, 168, 178n104, 216, 217, 220, 221, 236, 247, 249, 258, 279, 281, 339, 353n57, 360, 375, fig. 4A.13a-b
 painting of, 218–19, 222
 style, 222, 266
 Urnes style and, 171, 209, 211, 214
Høylandet, 338, 339, fig. 7.3
Hånger, 222, 227n116, 266

I

Iceland, 196, 422
 architectural ornament in, 198, 200, 215, 219, 220, 222, 256
 bishop in, 322
 churches in, 145, 221, 333, 354n85
 inventories from, 333, 335, 336, 347, 350
 Mammen- and Ringerike-style elements in, 221

manuscripts from, 369, 371n18, 406, 408, 409, 410, 437, 438, 440, figs. 10.5, 11.9
 storytelling in, 353n40
 textual sources from, 225n39, 314, 328n39, 332, 352n5, 362
 See also specific sites
Icelandic *Physiologus*, *see* Old Norse *Physiologus*
Imshaug, 261
Ingvald stones, *see* runestones
Innocent II, 415
iron
 candle-ship, 134, 296, 363, pl. 110
 candlesticks, 350
 chandelier, 130, 137, 140n39, 146
 extraction, 187, 189
 hooks, 130, 340, fig. 7.5
 Ingots, 187, 188, fig. 3.5
 "outfield" resource, 180, 192
 pigment, 249
 production, 188, 193
 ring, 131
 tools, 189
Isidore of Seville, 321, 364, 390, 420

J
Jacob, biblical patriarch, 312–13, 314, 315
Jelling, 284
 fresco, 367, fig. 8.3
 legacy, 234
 snake motif, 166
 stave construction, 162
 stone, 18, 165, 177n68, 306, 307, 308–13, 324–25, 327n20, 424, figs. 6.2, 6.3, 6.4, 8.3, 11.2
Jerome, 223, 362, 387, 389, 409, 411
Jerusalem, 363, 364, 390, 391, 392, 393, 394n31, 424, 435, 440
 Entry into, 214, fig. 4.12
 Heavenly, 137, pl. 124
 Temple of, 276, fig. 5.2
Jesus, 317, 364, 430, 442
Jevington, 324, 325, 330n110, fig. 6.12
Jews, 367, 369, 385, 386, 410, 411, 423, fig. 8.3
anti-Semitism, 359, 367–69, 372n47
Job, book of, 433
John of Damascus, 380
Jordan River, 391
Judenhut, 367
jugglers, 382
Jutland, 169, 170, 249, 285, 360, 377, 401, 402, 445n64

K
Kaupanger, 14, 16, 127, 172, 185, 189, 192, 329n62, 340, 341, 344, 349, 353n60, 401, figs. I.5, 7.9
Kells, Book of, 276–81, 428, fig. 5.2
kenning, 307, 315, 325, 326n14
Kildare, 281
Killaloe, 287, 288, 289, 290, 297, figs. 5.9, 5.10
kingship, 286, 291, 293, 294, 300n73, 313, 419, 422, 423, 430
Klœngr, 314
Knechtsteden, 402
Knútr inn ríki (Canute IV), 377, 422
Kvikne, 171, 198, 251–52, figs. 4.2, 4A.14
Källunge, 311, fig. 6.7

L
Lambert of Saint-Omer, 390
law, 138, 153, 189, 195n35, 317, 329n75, 336, 353n33, 383, 400, 410, 424
Leabhar Breac, 317, 329n62
Lemanaghan, 294, fig. 5.13
Lenten textiles, 336, 351, 355n105
Leofric Missal, 317, 328n52
lignum vitae, 359
Lilla Valla, 203, 242, 245, fig. 4.4
Limerick, 287, 290
Limoges, *see* candlesticks
lion
 David rescuing flock from, 320
 as threatening, 430–31
 at Bonn, 430, fig. 11.6
 at Cuxa, 430, fig. 11.7
 at Gargilesse, 390
 at Jelling, 165, 177n68, 308
 at Rolduc, 403
 at Sant'Abondono in Como, 403
 features of, 359 361, 434, 436
 imperial associations of, 433
 in Bernard of Clairvaux's writing, 19, 422
 in Oxford Bestiary, 408
 in Psalm 90, 324
 in Urnes drawings, 405m 10.4
 lion-and-snake motif, 308, 312, 313, 314, 322
 of Mark, 387
 of Mammen and Ringerike, 201, 211
 on London stone, 311
 on Mantle of Roger II, 380
 on oliphant, 377
 on textiles, 393
 on Urnes capitals, 14, 169, 170, 200, 358, 361, 362, 384 386, 387, 389, 406, 421, 423, 426, 429–32, 435, 437, 441, 444n37, pls. 42, 43, 52–54, 56, 60–62, 79
 of Urnes north portal, 139, 165–66, 306, 307–08, 314–15, 317, 322, 324, 325, pl.
 tamers, 428
Lisbjerg altar, 208, 223, fig. 4.7
Lismore, 291, 292, 298n7, 302n116
Litslena, 320
liturgy
 apses and, 127
 attire of, 412
 baptismal, 426
 changes in, 116, 134, 135
 commentaries on, 135, 221, 315
 language of, 315
 manuscripts for, 313, 350
 mass, 349
 monastic, 431
 of Nidaros province, 317
 portal and, 127, 168, 305, 306, 317, 325
 Processions, 393
 sculpture and, 137, 442
 seasons of, 332, 335, 351
 textiles in, 350–51
Lom, 180, 353n46
Lombardy, 217, 403
Lomen, 340, 353n60
London, 219, 283, 311, 327n20, 376, 403
Lund, 162, 200, 211, 235, 236, 377, 378, 394n29, 400, 415
Lunde, 401

M
Magnús berfœttr (Barelegs) (d. 1103), 286, 290, 291, 392, fig. 510
Magnús Eriksson (d. 1374), 322
Magnús Erlingsson (d. 1184), 149, 400, 421
Magnús Haakonsson (d. 1280), 322
Magnús Olafsson (d. 1047), 320
Mammen Style, 199–201, 215, 221, 246, 247, 255, 256, 307
manor, 15, 128, 138, 358, 375, 400
manticore, 367–69, 386, 406, 434, 435–37, figs. 8.5, 11.8
Mary, 322, 357, 405
 altar of, 328n55
 holding flower, 339
 in Cavalry group, 115, 116, 144, 370, 411, 441, pls. 106, 108, 116

life of, 336
 enthroned, 223, 338
 with saints, 347
meditation, 384, 420, 422
missionaries, 313, 315, 317, 350, 411, 412, 414, 415
Monasterboice, 278, 384
monastery, 134, 292, 294, 330n90, 370, 384, 403, 411, 414, 415, 422
monk, 130, 315, 321, 361, 370, 377, 380, 386, 403, 411, 413, 414, 422, 431
 abbot, 169, 314, 350, 392, 411–15
monster, 18, 222, 232, 362, 409, 410, 420, 422, 435
monstrous races, 436
Mosjö, 215, 216, 220, 221, 252–53, fig. 4A.15
musician, 382, fig. 9.5
Muslims, 380, 385, 387, 390, 429
Myresjö, 198, 205, 214, 216, 217, 254, fig. 4A.16
mythology, Norse, 220, 321, 326n8, 339, 359
Möðrufell, 215, 216, 221, 255–56, fig. 4A.17

N

Nebuchadnezzar, 389–90
 dream of, fig. 9.9
Nes, 175n32, 181, 401
Nidaros, 127, 260, 314, 315, 317, 328n49
Norderhov, 134, 296
Nore, 174n14, 353n54, 401
Normandy, 13, 376
Normans, 379
Novgorod, 196, 200, 209, 211, 216, 256–57, fig. 4A.18

O

Odense, 377, fig. 9.1
Óðinn, 369, 423, 424
ogham, 288, 289
Óláfr II Haraldsson, saint (d. 1030), 199, 295, 321, 322, 342, 370, 399, 422, 440
Óláfr III kyrri Haraldsson (d. 1093), 214, 313
Óláfr Tryggvason (d. 999), 199, 321, 334, 422, 440
Old Norse *Physiologus B*, 406–07, 408, 409, 430, 438, 440, figs. 10.5, 11.9
oliphant, 377, 378, fig. 9.2
onocentaur, *see* centaur

Ornes peninsula, 14, 180–90, 192, 193, fig. 2.1
Oslo, 12, 117, 123, 261, 283, 358, 400
othering, 359
 Others, 201, 367, 429, 436, 441
Otley, 241
Ottonian art, 221
Ottonians, 201, 312, 402
outfield resources, 180, 189, 192
Oxford Bestiary, *see* bestiary

P

Palermo, *see* Sicily
Palladius, Peder, 135
Paris, 283, 357
parish, 135, 139, 153, 172, 175n28, 180, 346, 400
 borders, 182, 193
 church, 137, 138, 149, 153, 178n102, 258, 358, 403, 384, 414, 415
 of Eskelhem, 295
 of Hafslo, 181, 182, 193, 400
 of Solvorn, 139, 144
 priests, 134
 tithe, 138
Paschal II, 400
peacock, 287
pentice, 126–28, 140n26, 144, 157, 170–71, 178n101, 260, 399, 404–05, 414, 415, pls. 21–28, figs. 1.8, 2.2
Peter Damian, 413
Physiologus, 321, 408, 420, 426, 430, 432, 433, 434, 435, *see also* Old Norse *Physiologus*
Pliny, 364, 420, 435, 436
poems, *see* sagas
Poetic Edda, 369
Poitiers, 379, 384
polychromy, 219, 281, 441, 442
Poppo, *see* Folkmar
portal, 12, 17, 116, 138, 140n38, 141n47, 145, 196, 197, 199, 217–18, 234, 235, 260, 261, 268, 272n188, 283, 401, 420, 428, 432
 Hemse, 206, 209, 211, fig. 4.5
 Hopperstad, chancel, 16
 Hopperstad, west, 218, fig. 4.6
 Hylestad, 337
 iconography of, 164, 168, 171, 172, 197, 223, 325, 435
 Urnes, north, 13, 117, 127, 128, 131, 143, 144, 157, 162, 164, 168, 170, 199, 209, 264–65, 306, 307, 316, 317, 321, 358, 361,
 432, pls. 1–8, figs. 1.4, 1.6, 1.8, 2.13
 Urnes, west, 16, 127, 128, 131, 144, 166, 169, 170, 171, 172, 218, 264, pl. 29
 Silos, 429
 Værnes, 430
 Vågå, 262
Premonstratensians, 357, 402, 413
Psalms (Vulgate numbering)
 1, 424
 21, 431
 23, 314, 315
 41, 426, 433
 90, 311, 324, 325, 331n117, 432
 102, 413
 103, 406
pulpit, 126, 130, 135, 136, 137, 144, pl. 117, fig. 2.10

R

race, 423, 436. *See also* monstrous races
Ramsey Psalter, 424, fig. 11.1
refil, 332–33, 336–39, 340, 347, 349, 351, 352n2
refilsaum, 343, 344, 346, 347, 354n70 fig. 7.6
Reformation
 Lutheran of 1537, 116, 117, 128, 131, 145, 183
 post-, 14, 117, 126, 130, 131, 134–35, 137, 178n106, 232, 239, 328n53
Reichenau, 391
Reinald, 370
reindeer, 189, 193, 364, 427
reliquary, 285, 288, 294, 300n67, fig. 5.7. *See also* shrine
 church-shaped, 294, 295, fig. 5.13
Resmo, 236, 261
retable, 126, 134, 136, 137, pl. 114, figs. 9.4, 9.9, 9.10
Revelation, book of, 307, 318, 320, 322, 386
Rinde, 171, 172, 173, 178n102, 205, 214, 216, 217, 258, fig. 4A.19
Ringerike style, 222, 238, 240, 241, 243, 244, 280, 296, 320, 327n20, 310n87, 375, fig. 5.5
 and Mammen style, 199–201, 215, 221, 246, 247, 255, 256, 307
 and Urnes style, 199–201, 202, 203, 211, 215, 218, 234, 290, 306, 307
 color in, 219
 in Ireland, 284, 290

478

wings in, 209–11
Robert of Arbrissel, 413
Roda Bible, 381–82, 387, 389–90, figs. 9.9, 9.10
Rolduc, 403, 415
Rome, 356, 359, 353, 391, 392, 415
Roskilde, 358
Rouen, 362, 376
runes, 227n115, 288, 301n89, 405–06
runestones
 artists of, 201, 219
 as expression of identity, 220
 at Jelling, 18, 165, 308–11, 327n30, figs. 6.2, 6.3, 6.4, 11.2
 carved by Ásmundr, 200 261
 designs of, 219
 Dynna stone, 204
 erection of, 314
 in Ireland, 301n89
 in Uppland, 202, 236, 287
 lambs on, 318, 320, fig. 6.10
 lion-snake motif on, 313
 paint on, 219, 281, 305
 serpents on, 321, 322
 style of, 164, 236, 241, 242, 248, 271n114
 stylistic development of, 209, 234, fig. 4.3
 Swedish, 18, 166, 173, 201, 256, 268 284
 text on, 305, 311
 Urnes style, 225n39, 261, 272n185
 winged beasts on, 215, 261, 321
Rødven
 reused portal fragments, 199, 204, 212, 259–60, figs. 4.10a-b, 4A.20
 date of, 214, 216
 style of, 217, 219, 220
 vegetal motifs on, 213
 use of Christian symbols, 223
Røn, 333, 344, 352n15, 354n72, fig. 7.6
Råsted, 367, fig. 8.4

S
Sachsenspiegel, 369
sacristy, 126, 137, 138, 254
sagas
 AntónÍús saga, 362
 Bishop Jón's, 328n39
 Egils saga, 437
 Fagrskinna, 321
 Fridtjof, 117
 Heimskringla, 174n18, 290, 407
 Húsdrápa, 220
 Laxdæla, 335, 336, 339, 352n31, 353n33
 Ólafs konúngs hins Helga (Saga of St. Óláfr), 321
 Páll saga eremita, 362
 Sverris, 149, 185, 400
 Völsunga, 336
Saint-Michel-de-Cuxa, 422, 430, fig. 11.7
saints, *see also* individual authors, kings, shrines
 Aidan, 282
 Anthony, 169, 362
 Brigit, 281–82
 Eustace, 426, fig. 11.4
 John the Baptist, 366, 367, 382, 383, fig. 8.3
 John the Evangelist, 137, 320, 370, 411, 441, pls. 106, 109
 Lawrence, 131
 Malachy, 276, 278
 Menas, 364, fig. 8.2
 Patrick, *see* shrine, St. Patrick's Bell
 Paul the Hermit, 362
 Peter, 320, 357
 Stephen, 131
Salome, 382–84, 444n37, figs. 9.5, 9.6
Sami, 429, 437
Samson, 384, 386, 390, 426, 432
sandals, *see* shoes
sarcophagi, 319, *see also* Ekilstuna
 Cashel, 293, fig. 5.12
Sasanian art, 379, 384, 386
scriptoria, 407
sermon on dedication, *see* "Stave Church Homily"
sermons, 131, 135, 315, 327n36, 354n98, 390, 393, 410, 415, 442
 of Peter the Venerable, 393
 of Humbert of Romans, 393
serpents, 21n12, 234, 236, 272n185, 312, 437
 dragon-serpents, 430
 Christ treading on, 232, 311, 324, 325, fig. 6.12
 lion-snake motif, 166, 308, 312, 313, 314
 lions with, 432
 Mammen- and Ringerike-style, 221
 on Hørning panel, 209, 218
 quadruped with, 201, 308, 313, 318, 327n21, figs. 6.2, 6.5, 6.6, 6.10
 snakes, 167, 321, 322, 330n104, 386, 403, 426
 stags with, 426, fig. 11.3
 symbolism of, 168, 306, 307, 313, 320–22, 436

Urnes style, 200, 214, 215–16, 242, 248, 249, 264, 265–66, 268n20, 311
 with beard pullers, 386, fig. 9.7
shape-shifting, 19, 362, 422, 435–438, 441, 442
 skin-changing, 433, 437
shingles, 124, 126, 148, 276, 278, pl. 18
ships, 193, 303, 321, 334, 358, 362, 392
 boats, 15, 180, 363
 warships, 321, 392
shoes, 411–12, 432
 sandals, 411–12
shrines, 243, 276, 298n67
 St. Laichtín, 291, 293
 St. Manchan, 294, 295, fig. 5.13
 St. Patrick's bell, 283, 285–289, 291, 292–94, fig. 5.6
Sicily, 13, 365, 377, 379, 391, 392, 393, 440
 Palermo, 380, 394
"Signe's Weave," 116, 343, 344, 346, 347, figs. 7.7, 7.8
Sigurðr, hero, 321, 336, 353n40
Sigurðr Magnússon, king and crusader, 392, 393, 407, 434, 440
silk, 340, 343, 344, 350, 365, 377, 386, 412, fig. 9.1
sill-beam, 127, 128, 130, 131, 133, 157, 162, 168, 278
Silos, 428, 429, 430, 438, fig. 11.5
skald, 391
skin-changing, *see* shape-shifting
Skopti Ǫgmundarson, 392
snakes, *see* serpents
Snorri Sturluson, *see* sagas
soapstone, 134, 180, 189, 190, 192, 193, fig. 3.6
Society for the Preservation of Ancient Norwegian Monuments, 116, 117, 126, 127, 139, 144
Sognefjord, 15, 115, 180, 333, 363, fig. 1.2
 inner, 143, 181–93, figs. 3.1–3.6
Sogn-Valdres design, 12, 170, 218, 227n110, 326n14
Solvorn, 138–39, 144, 175n32, 182, 185, 193
Southwell, 320
Spain, 363, 365, 375, 379, 384, 386, 390, 391, 392, 393, 396n105, 438, 429, 440
 Andalusia, 375, 376
 Catalonia, 384
stag, 201, 326n20, figs. 11.3, 11.4

symbolism of, 307, 426
Urnes, 169, 359, 364, 406, 426, 432–34, pl. 46
standard, *see* weather-vane
Stavanger, 290, 369, 370, 381, 403, 416n15, fig. 8.5
"Stave Church Homily," 350, 354n98, 410–11, 423, 442
sword
acrobat or dancer with, 375, 382, 406, 444n37, pl. 86
centaur with, 169, 419, 437, 438, 441, pl. 87
gift of, 379
handle or hilt, 287, 344
Herod scene with, 383–84, figs. 9.5, 9.6
man with, 349, 390, 441
symmetry, 200, 242, 285, 386
of Lisbjerg altar, 223
of Urnes capitals, 170, 355, 377, 391
Sör-Fron, 322

T
tabernacle, 131, 133, fig. 1.14
tapestry, 116, 128, 130, 140n35, 336, 337, 338, 339, 340, 343, 346, 347, 426, fig. 7.2
textiles, *see* embroidery; *refil*; silk; tapestry; *tjeld*
Thorgrím Furcap, 290
Tierp, 318, 319, 320, fig. 6.10
tjeld, 332–33, 334–36, 339, 340, 347, 349, 351, 352
Torcello, 232, 386, 395n74
Torpo, 171, 172, 178n110, 200, 204, 214, 216, 218, 261–62, 272n180, 335, 339, 353n54, 375, 401, fig. 4A.21
Tree of Life, 287, 320, 424
trial pieces, 243, 284, 287, 291, fig. 5.9
Troarn, 376
Trondheim, 212, 342, 400, 440
bishopric, 400
cathedral, 143, 168, 355n105, 370, 376
excavation, 203
metropolitan, 370, 422, 440
monastery, 414
St. Clement, church, 199
sculpture of, 164, 211, 214, 216, 236, 243, 258, 260, 262, 376, 400, 401–02, figs. 4.9, 4A.22a-b
scriptoria, 407
True Cross, 359, 363, 392, 440

trueing, 18, 19, 359
Tuam, 284, 291, 294, 295
Tullaghogue, 294

U
Ua Briain, Muirchertach, 286, 287, 291, 292, 293, 297, 434, fig. 5.9
Ua Conchobair, Toirdelbach, 291, 294, 297
Ua Lochlainn, Domnall, 286, 292, 293, 300n73
Umayyads, 186, 380
unicorn, 377, 389, 445n82
Urban II, 377
Urnes-Romanesque style, 19, 200, 295
Uvdal, 174n14, 347, 354n88, fig. 7.8

V
Vamlingbo, 245
Vangsnes, 117, 172, 173, 181, 183, 185, 190, 401
Varangians, 391
Vézelay, 390, 426, fig. 11.4
Viborg, 285, 401, 414–15, fig. 5.7
Vicogne, 357
Vikings, 209, 218, 376
Vikøyri, 182, 184, 185, 186, 187, 189, 190
vine scroll, 17, 136, 170, 200, 201, 220, 221, 246, 249, 259, 261, 266, 273n204, 320, 359, 423, 424, 443n27, pl. 115
Virgin Mary, *see* Mary
Vrigstad, 200, 205, 209, 216, 217, 265–68, fig. 4A.23
Værnes, 430
Västerplana, 441, fig. 11.10
Väversunda, 206, 222
Völuspá, 321
Vågå, 262, 272n188, 376

W
wall bench, 130, 162
wall-plate, 196, 217, 241, 244, 265, 268
Humptrup, 227, 247–48, fig. 4A.12
Hørning, 168, 171, 178n104, 209, 217, 218–19, 220, 221, 222, 247, 249, 258, 266, 279, 281, 339, 353n57, 360, figs. 4A.12, 4A.13a-b
Kaupanger, 341
Kells, 278, 279
Urnes, 130, 148, 161, fig. 2.13
warships, *see* ships
Waterford, 290, 291, 292, 298n7
weather-vane, 134, 296, fig. 6.7

William Durandus, 221, 314, 355n105, 386
William of Malmesbury, 385, 392, 434
Winchester, 17, 370, 403, 404, 414
style, 213, 260
women
as artists, 339
as patrons, 294
clothing of, 344
seating in church, 135, 136–37
World Heritage List, 11, 115, 139, 143, 356

Y
Yggdrasil, 359, 424
Ylmheim (Ølheim), 333, 350, 351

Þórir hundr (Thorir the Hound), 391
Östra Skrukeby, 236
Överhogdal, 337, 353n42, fig. 7.2
Ål, 335, 401
Årdal, 134, 178n110, 344, 354n79, 401, 416n13